Janson's History of Art

PORTABLE EDITION

Janson's History of Art

THE WESTERN TRADITION

Seventh Edition

The Ancient World

PENELOPE J. E. DAVIES

The Ancient World

DAVID L. SIMON

The Middle Ages

WALTER B. DENNY

Islamic Art

ANN M. ROBERTS

The Renaissance through the Rococo

FRIMA FOX HOFRICHTER

The Renaissance through the Rococo

JOSEPH JACOBS

The Modern World

Prentice Hall

Upper Saddle River, London, Singapore, Toronto,
Sydney, Hong Kong, and Mexico City

LIBRARY OF CONGRESS CATALOGING-IN-PUBLICATION DATA

Janson, H. W. (Horst Woldemar),
 Janson's history of art: the western tradition/Penelope J. E. Davies . . . [et al.]—7th ed.
 p.cm
 Includes bibliographical references and index.
 ISBN 10: 0-205-69739-9 | ISBN 13: 978-0-205-69739-7
 1. Art—History. I. Title: History of art. II. Davies, Penelope J. E., 1964-III.
Janson, H.W. (Horst Woldemar), 1913–History of art. IV. Title

N5300.J3 2007
709—dc22 2005054647

Editor-in-Chief: **SARAH TOUBORG**
Sponsoring Editor: **HELEN RONAN**
Editor in Chief, Development: **ROCHELLE DIOGENES**
Senior Development Editor: **ROBERTA MEYER**
Development Editors: **KAREN DUBNO, CAROLYN VIOLA-JOHN**
Editorial Assistant: **JACQUELINE ZEA**
Editorial Intern: **AIZA KEESEY**
Media Project Manager: **ANITA CASTRO**
Director of Marketing: **BRANDY DAWSON**
Assistant Marketing Manager: **ANDREA MESSINEO**
Marketing Assistant: **VICTORIA DeVITA**
AVP, Director of Production and Manufacturing: **BARBARA KITTLE**
Senior Managing Editor: **LISA IARKOWSKI**
Senior Production Editor: **HARRIET TELLEM**
Production Assistant: **MARLENE GASSLER**
Manufacturing Manager: **NICK SKLITSIS**
Manufacturing Buyer: **SHERRY LEWIS**
Creative Design Director: **LESLIE OSHER**
Art Directors: **NANCY WELLS, AMY ROSEN**
Interior and Cover Design: **BTDnyc**
Design Layout: **GAIL COCKER-BOGUSZ**
Line Art Coordinator: **MARIA PIPER**
Line Art Studio: **ARGOSY PUBLISHING INC.**
Cartographer: **CARTOGRAPHICS**
Text Research and Permissions: **MARGARET GORENSTEIN**
Pearson Imaging Center
 Manager: **JOSEPH CONTI**
 Project Coordinator: **CORIN SKIDDS**
 Scanner Operators: **RON WALKO AND CORIN SKIDDS**
Picture Editing, Research and Permissions:
 LAURIE PLATT WINFREY, FAY TORRES-YAP
 MARY TERESA GIANCOLI, CRISTIAN PEÑA, CAROUSEL RESEARCH, INC.
Director, Image Resource Center: **MELINDA REO**
Manager, Rights and Permissions: **ZINA ARABIA**
Manager, Visual Research: **BETH BRENZEL**
Image Permission Coordinator: **DEBBIE LATRONICA**
Copy Editor: **STEPHEN HOPKINS**
Proofreaders: **BARBARA DEVRIES, NANCY STEVENSON, PATTI GUERRIERI**
Text Editor: **CAROL PETERS**
Composition: **PREPARÉ**
Cover Printer: **PHOENIX COLOR CORPORATION**
Printer/Binder: **RR DONNELLEY**
Portable Edition Composition & Management: **SANDRA REINHARD, BLACK DOT**
Portable Edition Production Editor: **BARBARA TAYLOR-LAINO**
Portable Edition Cover Design: **PAT SMYTHE**

COVER PHOTO: Second Style wall painting from the Villa of the Mysteries, Pompeii. *Scenes of Dionysiac Mystery Cult.* ca, 60–50 BCE. Massimo Listri / Corbis Art / CORBIS

Credits and acknowledgements borrowed from other sources and reproduced, with permission, in this textbook appear on the appropriate page within text or on the credit pages in the back of this book.

Prentice Hall
is an imprint of

www.pearsonhighered.com

10 9 8 7 6 5 4 3 2 1

ISBN 10: 0-205-69739-9
ISBN 13: 978-0-205-69739-7

Contents

Preface xiii

Faculty and Student Resources for
Teaching and Learning with
Janson's History of Art xix

Introducing Art xxi

PART ONE
THE ANCIENT WORLD

1. Prehistoric Art 1

PALEOLITHIC ART 2

Interpreting Prehistoric Painting 6

Paleolithic Carving 8

NEOLITHIC ART 12

Settled Societies and Neolithic Art 12

Architecture in Europe: Tombs and Rituals 16

■ **MATERIALS AND TECHNIQUES:**
Cave Painting 5

■ **INFORMING ART: *Telling Time:***
Labels and Periods 10

2. Ancient Near Eastern Art 21

SUMERIAN ART 22

Temple Architecture: Linking Heaven and Earth 23

Sculpture and Inlay 25

Visual Narratives 27

Cylinder Seals 29

ART OF AKKAD 29

Sculpture: Power and Narrative 29

NEO-SUMERIAN REVIVAL 31

Architecture: The Ziggurat of Ur 31

Sculpture: Figures of Gudea 32

BABYLONIAN ART 33

The Code of Hammurabi 33

ASSYRIAN ART 34

Art of Empire: Expressing Royal Power 34

LATE BABYLONIAN ART 37

The Royal Palace 37

REGIONAL NEAR EASTERN ART 38

The Hittites 38

The Phoenicians 38

IRANIAN ART 39

Early Iranian Art 39

The Persian Empire: Cosmopolitan Heirs to the Mesopotamian Tradition 40

Mesopotamia Between Persian and
Islamic Dominion 43
■ MATERIALS AND TECHNIQUES: *Mud Brick* 23
■ PRIMARY SOURCES: *The Gilgamesh Epic* 25
Texts on Gudea Figures from Lagash and
Surrounding Areas, ca. 2100 32
The Code of Hammurabi 34
■ THE ART HISTORIAN'S LENS:
Losses Through Looting 42

3. Egyptian Art 47
PREDYNASTIC AND EARLY
 DYNASTIC ART 48
The Palette of King Narmer 48
THE OLD KINGDOM: A GOLDEN AGE 50
Old Kingdom Funerary Complexes 50
*The Pyramids at Giza: Reflecting a
 New Royal Role* 52
Representing the Human Figure 55
THE MIDDLE KINGDOM: REASSERTING
 TRADITION THROUGH THE ARTS 59
*Royal Portraiture: Changing
 Expressions and Proportions* 59
Funerary Architecture 60

THE NEW KINGDOM: RESTORED GLORY 62
Royal Burials in the Valley of the Kings 62
Temples to the Gods 64
Block Statues 67
Images in New Kingdom Tombs 68
AKHENATEN AND THE AMARNA STYLE 69
The Amarna Style 70
Tutankhamen and the Aftermath of Amarna 72
PAPYRUS SCROLLS: *THE
 BOOK OF THE DEAD* 73
LATE EGYPT 74
■ MATERIALS AND TECHNIQUES:
Building the Pyramids 75
■ INFORMING ART: *Major Periods in
Ancient Egypt* 51
■ PRIMARY SOURCES:
*Excerpt from the Pyramid Text of Unis
(r. 2341–2311 BCE)* 56
Love Song 70
The Book of the Dead 73
■ THE ART HISTORIAN'S LENS: *Interpreting
Ancient Travel Writers* 76

4. Aegean Art 79

EARLY CYCLADIC ART 80
MINOAN ART 82
The Palace at Knossos 82
*Wall Paintings: Representing Rituals
 and Nature* 86
Minoan Pottery 88
Carved Minoan Stone Vessels 89
Late Minoan Art 91
MYCENAEAN ART 92
Architecture: Citadels 92
Mycenaean Tombs and Their Contents 96
Sculpture 98
■ **MATERIALS AND TECHNIQUES:**
 Cyclopean Masonry 94
■ **THE ART HISTORIAN'S LENS:**
 Two Excavators, Legend, and Archeology 85

5. Greek Art 101

**THE EMERGENCE OF GREEK ART:
 THE GEOMETRIC STYLE** 102
Geometric Style Pottery 103
Geometric Style Sculpture 105
**THE ORIENTALIZING STYLE:
 HORIZONS EXPAND** 105
Miniature Vessels 105
ARCHAIC ART: ART OF THE CITY-STATE 108
*The Rise of Monumental
 Temple Architecture* 108

Stone Sculpture 112
*Architectural Sculpture:
 The Building Comes Alive* 115
*Vase Painting: Art of the
 Symposium* 119
THE CLASSICAL AGE 121
Classical Sculpture 122
*Architecture and Sculpture on
 the Athenian Akropolis* 128
THE LATE CLASSICAL PERIOD 141
*Late Classical Architecture: Civic
 and Sacred* 141
Painting in the Late Classical Age 145
**THE AGE OF ALEXANDER AND THE
 HELLENISTIC PERIOD** 146
*Architecture: The Scholarly Tradition
 and Theatricality* 146
City Planning 149
*Hellenistic Sculpture: Expression and
 Movement* 150
Hellenistic Painting 157
■ **MATERIALS AND TECHNIQUES:**
 The Indirect Lost-Wax Process 124
■ **INFORMING ART:** *The Greek
 Gods and Goddesses* 102
■ **PRIMARY SOURCES:**
 Aristotle (384–322) BCE 127
 Plutarch (ca. 46–after 119 CE) 131
■ **THE ART HISTORIAN'S LENS:**
 The Parthenon Frieze: A New Interpretation 136

 J.J. Winckelmann and The Apollo Belvedere 156

6. Etruscan Art 161

FUNERARY ART 162

Tombs and Their Contents 162

ARCHITECTURE 169

City Planning 170

SCULPTURE 171

*Dynamism in Terra Cotta and
 Bronze* 171

■ **MATERIALS AND TECHNIQUES:**
 Etruscan Gold-Working 164

7. Roman Art 177

EARLY ROME AND THE REPUBLIC 177

Architecture: The Concrete Revolution 179

Sculpture 185

Painting 190

THE EARLY EMPIRE 191

Portrait Sculpture 191

Relief Sculpture 195

Architecture 203

**ART AND ARCHITECTURE IN
 THE PROVINCES** 209

DOMESTIC ART AND ARCHITECTURE 212

THE LATE EMPIRE 219

Portrait Sculpture 219

Relief Sculpture 221

Architecture 223

**LATE ROMAN ARCHITECTURE IN
 THE PROVINCES** 225

■ MATERIALS AND TECHNIQUES:
Copying Greek Sculptures 188

■ PRIMARY SOURCES:

Cicero (106–43 BCE) 186

Polybius (ca. 200–ca. 118 BCE) 190

Josephus (37/8–ca. 100 CE) 198

Vitruvius 212

Philostratus (170–247 CE) 218

■ THE ART HISTORIAN'S LENS: *Recognizing Copies: The Case of the Laocoön* 179

■ ADDITIONAL PRIMARY SOURCES FOR PART ONE:
The Code of Hammurabi 230

A Hymn to Aten 230

Pliny the Elder (23–79 CE) 230

Vergil (70–19 BCE) 231

Vitruvius (1st Century BCE) 232

Glossary Glossary 1
Bibliography Bibliography 1
Index Index 1
Credits Credits 1

Preface

WELCOME TO THE SEVENTH EDITION OF JANSON'S CLASSIC TEXTBOOK, officially renamed *Janson's History of Art* to reflect its relationship to the book that introduced many generations of students to art history. For many of us who teach introductory courses in the history of art, the name Janson is synonymous with the subject matter we present.

When Prentice Hall first published the *History of Art* in 1962, John F. Kennedy occupied the White House, and Andy Warhol was an emerging artist. Janson offered his readers a strong focus on Western art, an important consideration of technique and style, and a clear point of view. The *History of Art,* said Janson, was not just a stringing together of historically significant objects, but the writing of a story about their interconnections—a history of styles and of stylistic change. Janson's text focused on the visual and technical characteristics of the objects he discussed, often in extraordinarily eloquent language. Janson's *History of Art* helped to establish the canon of art history for many generations of scholars.

Although largely revamped, this new edition follows Janson's lead in important ways: It is limited to the Western tradition, with the addition of a chapter on Islamic art and its relationship to Western art. (Those of us with early Janson editions will remember that Islamic art was included in the first edition.) It keeps the focus of the discussion on the object, its manufacture, and its visual character. It considers the contribution of the artist as an important part of the analysis. This edition is organized along the lines established by Janson, with separate chapters on the Northern European Renaissance, the Italian Renaissance, Baroque art, and the High Renaissance, with stylistic divisions for key periods of the modern era. This edition also creates a narrative of how art has changed over time in the cultures that Europe has claimed as its patrimony and that Americans have claimed through their connection to Europe.

WHAT'S NEW IN *JANSON'S HISTORY OF ART?*

"The history of art is too vast a field for anyone to encompass all of it with equal competence."

—H. W. JANSON, from the Preface to the first edition of *History of Art*

Janson's History of Art, seventh edition, is the product of careful revision by a team of scholars with different specialties, bringing great depth to the discussions of works of art. We incorporate new discoveries in our fields into the text, including new archeological finds, such as the Charioteer of Motya; new documentary evidence, such as that pertaining to Uccello's *Battle of San Romano;* and new interpretive approaches, such as the importance of nationalism in the development of Romanticism.

New Organization and Contextual Emphasis

Most of the chapters have been reorganized to integrate the media into chronological discussions instead of discussing them in isolation from one another, which reflected the more formalistic approach used in earlier editions. Even though we draw connections among works of art, as Janson did, we emphasize the patronage and function of works of art and the historical circumstances in which they were created. We explore how works of art have been used to shore up political or social power.

Interpreting Cultures

Western art history encompasses a great many distinct chronological and cultural periods, which we wish to treat as distinct entities. So we present Etruscan art as evidence for Etruscan culture, not as a precursor of Roman or a follower of Greek art. Recognizing the limits of our knowledge about certain periods of history, we examine how art historians draw conclusions from works of art. The boxes called *The Art Historian's Lens* allow students to see how the discipline works. They give students a better understanding of the methods art historians use to develop art-historical arguments. *Primary Sources,* a distinguishing feature of Janson for many editions, have been incorporated throughout the chapters to support the analysis provided and to further inform students about the cultures discussed.

Women in the History of Art

Another important feature of this edition of *Janson's* is the greater visibility of women, whom we discuss as artists, as patrons, and as an audience for works of art. Inspired by contemporary approaches to art history, we also address the representation of women as expressions of specific cultural notions of femininity or as symbols.

Objects, Media, and Techniques

Many new objects have been incorporated into this edition to reflect changes in the discipline. Approximately 25 percent of the objects we discuss are new to the book. The mediums we discuss have been expanded to include not only modern art forms such as installations and earth art, but also the so-called minor arts of earlier periods—such as tapestries, metalwork, and porcelain. Discussions in the *Materials and Techniques* boxes illuminate this dimension of art history.

The Images

Not only have new objects been introduced, but every reproduction in the book also has been refreshed and expertly examined for fidelity to the original. We have obtained new photographs directly from the holding institutions to ensure that we have the most accurate and authoritative illustrations. Every image that could be obtained in color has been acquired. To further assist both students and teachers, we have sought permission for electronic educational use so that instructors who adopt *Janson's History of Art* will have access to an extraordinary archive of high quality (over 300 dpi) digital images for classroom use. (See below for more detail on the Prentice Hall Digital Art Library.)

Chapter by Chapter Revisions

With six different specialists examining every chapter, and an exhaustive peer review process, the revisions to the text are far too extensive to enumerate in detail. Every change a`ims to make the text more useful to instructors and students in art history classrooms. The following list includes the major highlights of this new edition:

INTRODUCING ART
Completely new, this section provides models of art-historical analysis and definitions of art-historical terms, while providing an overview of the important questions in the discipline.

CHAPTER 1: PREHISTORIC ART
Lengthened to include more information on the various contexts in which works of art are found. Expands upon the methods scholars (both art historians and anthropologists) use to understand artwork. Offering a wider range of interpretations, the text clarifies why scholars reconstruct the prehistoric world as they do.

CHAPTER 2: ANCIENT NEAR EASTERN ART
Expanded and reorganized to isolate cultures flourishing contemporaneously in the ancient Near East.

CHAPTER 3: EGYPTIAN ART
Includes an updated discussion of the Egyptian worldview, and relates Egyptian artworks to that view. Incorporates a greater number of works featuring women, such as the extraordinary *Portrait of Queen Tiy.*

CHAPTER 4: AEGEAN ART
Examines how we construct our knowledge of an ancient society through studying works of art and architecture. Focuses also on individuals who contributed to our understanding of these societies, such as Heinrich Schliemann and Sir Arthur Evans.

CHAPTER 5: GREEK ART
Significant new artworks have been added to this chapter, such as the spectacular Charioteer of Motya. The organization is altered radically to adhere more closely to a chronological, rather than medium-based, sequence. Expands discussions of the architecture of the Athenian Akropolis and Hellenistic art as a whole.

CHAPTER 6: ETRUSCAN ART
Discussion of Etruscan art is altered in order to characterize it as a visual culture in its own right rather than as an extension of Greek art or a precursor of Roman art. The palatial architecture at Murlo is included.

CHAPTER 7: ROMAN ART
Features a greatly expanded section on art of the Republic, and a greater discussion of architecture in general. New works, such as the magnificent Theater of Pompey, are included. The organization is also radically altered to follow a chronological, rather than medium-based, sequencing.

CHAPTER 8: EARLY CHRISTIAN AND BYZANTINE ART
Accentuates changes and political dimensions in Early Christian art that occurred when Christianity became an accepted religion of the Roman Empire. Architecture is discussed in greater depth, stressing how the buildings were experienced. The iconography (i.e., meaning) of the forms employed is examined. The chapter expands the discussion of icons and of the iconoclastic controversy.

CHAPTER 9: ISLAMIC ART
Reintroduces Islamic art to the text. Seeks both to give a good general overview of Islamic art and to emphasize the connections between Islamic art and the art of the European West. The many common values of both types of art are examined.

CHAPTER 10: EARLY MEDIEVAL ART
Enlarges discussion of early minor arts. Discusses Irish manuscripts more thoroughly in terms of meaning and in relationship to Roman art. Expands the discussion of Charlemagne's political and social goals and the use of art to further that agenda. Places more emphasis on how women were viewed and represented.

CHAPTER 11: ROMANESQUE ART

Expands discussion of the art of the pilgrimage road, including Sant Vincenç at Cardona and Saint-Genis-des-Fontaines. Focuses on the role of women as subject and patron. Reorganization of chapter allows integration of the various mediums to promote understanding that, despite intrinsic differences, the works demonstrate common aspirations as well as fears.

CHAPTER 12: GOTHIC ART

Reconfigured to remove Italian art (now in Chapter 13) and some International Style monuments (now in Chapter 14). Treats development of Gothic architecture more cogently by the introduction of new examples (e.g., the interiors of Notre-Dame of Laon and Notre-Dame of Paris). Discussion of Sainte-Chapelle and Spanish Gothic art is added.

CHAPTER 13: ART IN THIRTEENTH- AND FOURTEENTH-CENTURY ITALY

Separates the thirteenth-and fourteenth-century Italian situation from the rest of Europe to highlight its specific role as a bridge between medieval and Renaissance art. New works include Simone Martini's *Annunciation* and Andrea da Firenze's *Way of Salvation* in the Spanish Chapel. New section added on northern Italy in the fourteenth century.

CHAPTER 14: ARTISTIC INNOVATIONS IN FIFTEENTH-CENTURY NORTHERN EUROPE

Now placed before the Italian fifteenth-century chapter, the new structure of the chapter integrates works of art of a particular time and place to emphasize historical context. Updates discussions of key works. Treats printmaking and the printed book in detail.

CHAPTER 15: THE EARLY RENAISSANCE IN FIFTEENTH-CENTURY ITALY

Situates art in specific moments or geographic regions and discusses different mediums in relation to their context. Emphasizes role of patronage. Introduces new sections on art outside of Florence. Treats *cassone* panels and other works of art for domestic contexts. Fra Angelico's *Annunciation* at San Marco, Brunelleschi's *Ospedale degli Innocenti,* Piero della Francesca's work for the court of Urbino, and Mantegna's *Camera Picta* in Mantua are included.

CHAPTER 16: THE HIGH RENAISSANCE IN ITALY, 1495–1520

Explains why a group of six key artists continue to be treated in monographic fashion. Focuses on the period 1495–1520, removing late Michelangelo and Titian to Chapter 17. Leonardo's drawing of the *Vitruvian Man* and Michelangelo's Roman *Pietà* are added. Updates discussions of art, including Leonardo's *The Virgin of the Rocks* and Giorgione's *The Tempest.*

CHAPTER 17: THE LATE RENAISSANCE AND MANNERISM IN SIXTEENTH-CENTURY ITALY

Follows a geographic structure, starting with Florence under the Medici dukes, and then moves among the regions of Rome, northern Italy, and Venice. Stresses courtly and papal patronage, as well as the founding of the Accademia del Disegno in Florence. Integrates late Michelangelo and Titian into these discussions. New discussions included for Bronzino, Titian's *Venus of Urbino,* and the work of Lavinia Fontana.

CHAPTER 18: RENAISSANCE AND REFORMATION IN SIXTEENTH-CENTURY NORTHERN EUROPE

Describes works of art in five different geographical regions. Considers the spread of Italian Renaissance style and the development of local traditions, among discussions of the Reformation and other crises. Includes new discussion of the *Isenheim Altarpiece.*

CHAPTER 19: THE BAROQUE IN ITALY AND SPAIN

Examines Caravaggio's and Bernini's roles in the Counter-Reformation. Discusses religious orders and the papacy, and develops an understanding of the role of women, women artists, the poor, street people, and the full nature of seventeenth-century life. New works include Bernini's *Baldacchino* and his *bozzetto* for a sculpture, as well as the portrait of *Juan de Pareja* by Velasquez and Gentileschi's *Self-Portrait as the Allegory of Painting.*

CHAPTER 20: THE BAROQUE IN THE NETHERLANDS

Examines political and religious differences and artistic connections in the Netherlands. Explores the importance of Rubens through an examination of his workshop. The concept of an open market is treated in a discussion of the Dutch landscape, the still life, and the genre painting of Northern Europe. Works by Judith Leyster and Clara Peeters added, and with Rachel Ruysch the discussion focuses on the new status of these women artists.

CHAPTER 21: THE BAROQUE IN FRANCE AND ENGLAND

Considers concept of classicism in the paintings of Poussin and the architecture of Jones and Wren. New works include Poussin's *Death of Germanicus* and *Landscape with St. John on Patmos,* as well as Le Brun's diagram of facial expressions and Wren's steeple of St. Mary-Le-Bow.

CHAPTER 22: THE ROCOCO

Explores the Age of Louis XV using new examples by Watteau and Fragonard, including *Gersaint's Signboard* and *The Swing.* Pastel painting by Rosalba Carriera and Vigée-Lebrun's *Portrait of Marie Antoinette with Her Children* are introduced. An example of Sevrès porcelain emphasizes the importance of decorative arts in this era.

CHAPTER 23: ART IN THE AGE OF THE ENLIGHTENMENT, 1750–1789

Rewritten to focus more on the time period from roughly 1750 to 1789 than on Neoclassicism in particular. Emphasizes Neoclassicism's reliance on logic, morality, and the Classical past, while also pointing to the burgeoning importance placed on emotion, the irrational, and the sublime. Includes works by Mengs, Batoni, Hamilton, Wright of Derby, Gabriel, and Peyre.

CHAPTER 24: ART IN THE AGE OF ROMANTICISM, 1789–1848

This entirely restructured chapter defines Romanticism and emphasizes the importance of emotion, individual freedom, and personal experience. It examines imagination, genius, nature, and the exotic. Puts Romanticism into the context of the perceived failures of the Enlightenment and French Revolution. More strongly states the idea of nationalism as a Romantic theme.

CHAPTER 25: THE AGE OF POSITIVISM: REALISM, IMPRESSIONISM, AND THE PRE-RAPHAELITES, 1848–1885

Organizes around the concept of Positivism, the reliance on hard fact, and the dramatic social transformations that artists recorded. Expands the photography discussion. Focuses on the use of iron in engineering and architecture, especially in the Crystal Palace and the Eiffel Tower. Associates Rodin with Symbolism. Includes Daumier and Millet in the discussion of Realism.

CHAPTER 26: PROGRESS AND ITS DISCONTENTS: POST-IMPRESSIONISM, SYMBOLISM, AND ART NOUVEAU, 1880–1905

Emphasizes historical context rather than the Modernist tradition. Stresses disturbing psychology of the period and its manifestation in art. Places Frank Lloyd Wright here and into the context of the Chicago School. Photography section now includes Käsebier's *Blessed Art Thou Among Women,* which is dealt with in a feminist context. Includes a work by Lartigue.

CHAPTER 27: TOWARD ABSTRACTION: THE MODERNIST REVOLUTION, 1904–1914

First of three chapters on modern art that are radically restructured using chronology; internally reorganized on a thematic basis. Emphasizes the social forces that resulted in radical formal and stylistic developments between 1904 and 1914 that culminated in abstractionism. Places significant emphasis on Duchamp. Additions include Braque's *The Portuguese* and Duchamp's *Nude Descending a Staircase, No. 2.* Significantly revamps American art.

CHAPTER 28: ART BETWEEN THE WARS

Structured around the impact of World War I and the need to create utopias and uncover higher realities, especially as seen in Surrealism.

Treats Dada chronologically and geographically. Includes lengthy discussion of Duchamp in New York, with *Fountain* added. Represents films as seen in the work of Man Ray and Dali. Integrates discussion of Mondrian and De Stijl architecture, as well as Bauhaus artists and architects.

CHAPTER 29: POSTWAR TO POSTMODERN, 1945–1980

Emphasizes the impact Cage and Rauschenberg had on the development of American Art. Adds Conceptual Art of Brecht and the happenings and environments of Kaprow. Other additions include Ruscha, Flavin, and Serra, with new explorations of Paik and Hesse. Focuses on ethnic identity and gender issues with the newly added artists David Hammons and Judy Chicago.

CHAPTER 30: THE POSTMODERN ERA: ART SINCE 1980

Presents the concept of Postmodernism in clear, simple terms. Emphasizes the period's pluralism and the view of art as having no limits. Adds architects Venturi, Moore, Johnson, Hadid, Libeskind, and Piano; and artists Basquiat, Holzer, Polke, Viola, Gonzalez-Torres, Smith, Hirst, and Cai Guo-Qiang.

The **BIBLIOGRAPHY** has been thoroughly updated by Mary Clare Altenhofen, Fine Arts Library, Harvard College Library.

NEW FEATURES OF EVERY CHAPTER

THE INTRODUCTORY ART HISTORY STUDENT IS TRYING TO MASTER MANY DIFFERENT SKILLS—*Janson's History of Art* assists students with its beautiful reproductions and strong narrative approach. It also includes new boxed features to enhance student learning:

- **MATERIALS AND TECHNIQUES**
- **THE ART HISTORIAN'S LENS**
- **ART IN TIME**
- **PRIMARY SOURCES**
- **SUMMARIES**

MATERIALS AND TECHNIQUES:
Illustrations and explanations of processes used by artists.

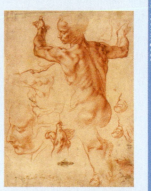

Drawings

Medieval artists had used the technique of drawing to record monuments they had seen or to preserve compositions for future use. These drawings were usually made with pen and ink on parchment. During the Renaissance, the increasing availability of paper expanded the uses of drawings and encouraged artists to use a variety of media in making them.

Pen and ink on paper were used most often, as the liquid ink could be transferred to the paper using a sharp quill pen or stylus. Sometimes the forms drawn with ink were further elaborated with a wash (usually diluted ink) applied with a brush. Some artists preferred to work with liquid media and thin brushes to render all the forms.

Artists also drew on the relatively rough surface of paper using charcoal or chalk. These naturally occurring materials are both dry and crumbly enough to leave traces when the artist applies them to the paper. The lines they leave can be thick or thin, rendered with carefully descriptive marks, or with quick evocative strokes. Artists could smudge these soft media to soften contours and fill in shadows, or to produce parallel lines called hatching to describe shadows. See, for example, the variety of strokes Michelangelo used to make the red chalk study for the *Libyan Sibyl* on the Sistine Chapel ceiling.

More difficult to master was the technique of silverpoint. This entailed using a metal stylus to leave marks on a surface. Silver was the most prized metal for this technique, though lead was also used. Mistakes could not be undone, so it took great skill to work in silverpoint. To make silver leave traces on paper, the paper had to be stiffened up by coating it with a mixture of finely ground bone and size (a gluelike substance). Such coatings were sometimes tinted. When the silver stylus is applied, thin delicate lines are left behind that darken with age.

Renaissance artists also expanded the uses of drawings. Apprentices learned how to render forms using drawings; artists worked out solutions to visual problems with drawings. Drawings were also used to enable artists to negotiate contracts and to record finished works as a kind of diary or model book.

Artists also made cartoons, or full-scale patterns, for larger works such as frescoes or tapestries (see fig. 16.27). Transferring designs from drawings onto larger surfaces could be achieved in a number of ways. A grid could be placed over the design to serve as a guide for replicating the image on a larger scale. Or cartoons for frescoes could be pricked along the main lines of the design; through these tiny holes a powder was forced to reproduce the design on the wall. This is called pouncing.

In the sixteenth century, drawings became prized in their own right and were collected by artists, patrons, and connoisseurs. The drawing was thought to reveal something that a finished work could not: the artist's process, the artist's personality, and ultimately, the artist's genius.

Michelangelo. *Studies for the Libyan Sibyl.* Red chalk, 11⅜ × 8⁷/₁₆" (28.9 × 21.4 cm). The Metropolitan Museum of Art, New York. The Purchase, Joseph Pulitzer Bequest, 1924 (24.197.2)

Michelangelo's deep study of ancient sculpture, which he hoped to surpass. Since the cleaning of the frescoes in the 1980s, scholars have come to appreciate the brilliance of Michelangelo's colors, and the pairing of complementary colors he used in the draperies. (See *The Art Historian's Lens,* page 573.)

A similar energy pervades the center narratives. *The Fall of Man* and *The Expulsion from the Garden of Eden* (fig. 16.20) show the bold, intense hues and expressive body language that characterize the whole ceiling. Michelangelo's figures are full of life, acting out their epic roles in sparse landscape settings. To the left of the Tree of Knowledge, Adam and Eve form a spiral composition as they reach toward the forbidden fruit,

while the composition of *The Expulsion from the Garden of Eden* is particularly close to Masaccio's (see fig. 15.18) in its intense drama. The nude youths (*ignudi*) flanking the main sections of the ceiling play an important visual role in Michelangelo's design. They are found at regular intervals, forming a kind of chain linking the narratives. Yet their meaning remains uncertain. Do they represent the world of pagan antiquity? Are they angels or images of human souls? They hold acorns, a reference to the pope's family name, delle Rovere (Rovere means "oak"). The ignudi also support bronze medallions that look like trophies, reminding the viewer of Julius's military campaigns throughout Italy.

CHAPTER 16 THE HIGH RENAISSANCE IN ITALY, 1495–1520 **571**

THE ART HISTORIAN'S LENS:
Topics that provide a glimpse into the
working methods of art historians.

An Artist's Reputation and Changes in Art Historical Methodology

A change in the methodology of art history can sometimes affect scholars' attitudes toward artists, sometimes resurrecting figures who had once been renowned but had gradually disappeared from the history books. A case in point is the American painter John Singer Sargent (1856–1925). In his day, he was one of the most famous and financially successful artists. He can even be considered the quintessential American artist, for he lived and worked in Europe and his art appeared to embrace the European values that so many nouveau riche Americans aspired to emulate.

Sargent was born and raised in Florence, studied at the École des Beaux-Arts in Paris, and by 1879 was winning medals at the salons. In part due to the encouragement of novelist Henry James, he moved permanently to London in 1886. He made his first professional trip to America in 1887, and immediately became the portraitist to high society, painting William Henry Vanderbilt, of New York and Isabella Stewart Gardner of Boston, among others. By 1892, he was the most fashionable portraitist in London and perhaps on the Continent as well. Sargent's success was in part based on the luxuriousness of his imagery—expensive fabrics and furnishings—reinforced by his dramatic sensual brushwork.

Sargent was a proponent of the avant-garde. He befriended Claude Monet and admired his paintings as well as Manet's. His own work reflects the painterly bravura of Manet, and like Manet he admired Velázquez. He also made numerous Impressionist landscapes and urban views, often in watercolor. Ironically, Sargent fell into oblivion because of the Modernism that evolved in the twentieth century. His consummate handling of paint may have had the abstract qualities that the Modernists admired, but his work was perceived as conservative. It failed to offer anything new. Worse yet, his avant-garde brushwork was carefully packaged in the old-fashioned formulas of society portraiture.

Sargent's reevaluation began in the 1950s, with a renewed appreciation of the paint handling in his Impressionist watercolors. In succeeding decades his reputation gradually inched its way up as Modernism was replaced by Post-Modernism and its broader values (see Chapter 30). Representational art became fashionable again, and art historians began to appreciate art for the way in which it reflected the spirit of its age. Sargent's portraiture was now perceived as the embodiment of Victorian and Edwardian society and of the later Gilded Age.

For example, gender studies, which began appearing in the 1970s, looked at his daring presentation of women, as can be seen in his 1897 portrayal of New York socialite Edith Stokes in *Mr. and Mrs. I. N. Phelps Stokes*. Instead of giving us a demure and feminine woman, Sargent presents a boldly aggressive Mrs. Stokes, who represents the "New Woman" who emerged in the 1890s (see page 903). In a period when the women's movement was fiercely advocating equal rights, women were asserting their independence and challenging conventional gender roles. This New Woman was independent and rebelled against the conventional respectability of the Victorian era that sheltered women in domesticity. She went out in public; she was educated, and she was athletic, spirited,

and flaunted her sexual appeal. Not only did she wear comfortable clothes, she even wore men's attire, or a woman's shirtwaist based on a man's shirt. Instead of self-sacrifice, she sought self-fulfillment. Sargent presents Edith Stokes as just such a woman, even having her upstage her husband. For its time, this was a radical presentation of a woman and a reflection not only of the sitter's personality and identification with women's issues but also of Sargent's willingness to buck portrait conventions and societal expectations.

John Singer Sargent. *Mr. and Mrs. I.N. Phelps Stokes*, 1897. Oil on canvas, 84¹⁄₄ × 39³⁄₄" (214 × 101 cm). Metropolitan Museum of Art, New York. Bequest of Edith Minturn Phelps Stokes (MRS. I. N.), 1938. (38.104)

890 PART IV THE MODERN WORLD

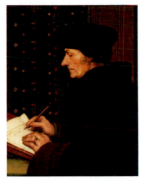

1509, twenty years later Henry was seeking to annul their union, for they had failed to produce a male heir to the throne. Thwarted by the Catholic Church, he broke away from Catholicism and established himself as the head of the Church of England. His desire for a male heir to the throne led Henry into a number of marriages, most of which ended either in divorce or in the execution of his wife. He had three children, who succeeded him as Edward VII, Mary I, and Elizabeth I.

Holbein's *Henry VIII* (fig. 18.27) of 1540 captures the supreme self-confidence of the king. He uses the rigid frontality that Dürer had chosen for his self-portrait to convey the almost divine authority of the absolute ruler. The king's physical bulk creates an overpowering sense of his ruthless, commanding personality. The portrait shares with Bronzino's *Eleonora of Toledo* (fig. 17.7) an immobile pose, an air of unapproachability, and the

18.26. Hans Holbein the Younger. *Erasmus of Rotterdam*. ca. 1523. Oil on panel, 16¹⁄₂ × 12¹⁄₂" (42 × 31.4 cm). Musée du Louvre, Paris

The spread of the Reformation disrupted the Humanist circle in Basel. By 1525, followers of Zwingli preached the sole authority of Scripture, while more radical reformers preached that images were idols. To escape this climate, Holbein sought employment elsewhere. He had traveled to France in 1523–1524, perhaps intending to offer his services to Francis I. Hoping for commissions at the court of Henry VIII, Holbein went to England in 1527. He presented the portrait of Erasmus as a gift to the humanist Thomas More, who became his first patron in London. Erasmus, in a letter recommending Holbein to More, wrote: "Here [in Basel] the arts are out in the cold." By 1528, when Holbein returned to Basel, he witnessed Protestant mobs destroying religious images, a scene Erasmus described in a letter: "Not a statue has been left in the churches . . . or in the monasteries; all the frescoes have been whitewashed over. Everything which would burn has been set on fire, everything else hacked into little pieces. Neither value nor artistry prevailed to save anything." Holbein resolved to return to London.

ENGLAND: REFORMATION AND POWER

Holbein's patron in England was the ambitious Henry VIII, who reigned from 1509 to 1547. Henry wanted England to be a power broker in the conflicts between Francis I of France and the Emperor Charles V, although his personal situation complicated these efforts. Married to Catherine of Aragon in

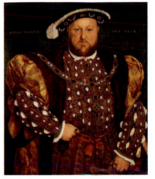

18.27. Hans Holbein the Younger. *Henry VIII*. 1540. Oil on panel, 32¹⁄₂ × 29" (82.6 × 74.9 cm). Galleria Nazionale d'Arte Antica, Rome

CHAPTER 18 RENAISSANCE AND REFORMATION IN SIXTEENTH-CENTURY NORTHERN EUROPE 645

ART IN TIME
- 1502—Peter Henlein of Nuremberg invents pocket watch
- ca. 1509—Grünewald's *Isenheim Altarpiece*
- 1521—Diet of Worms condemns Luther
- 1525—Peasants' War ignited by Reformation
- 1526—Albrecht Dürer's *Four Apostles* presented to city of Nuremberg
- 1555—Peace of Augsburg between Catholics and Lutherans

ART IN TIME: Frequent chronologies situate
the works of art in their era of origin.

Karel van Mander Writes About Pieter Bruegel the Elder

From *The Painter's Treatise (Het Schilder Boeck)* 1604

Van Mander's biography of Pieter Bruegel the Elder remains an important source of information about the artist, whose talent he appreciated fully.

On his journeys Bruegel did many views from nature so that it was said of him, when he traveled through the Alps, that he had swallowed all the mountains and rocks and spat them out again, after his return, on to his canvases and panels, so closely was he able to follow nature here and in his other works. . . .

He did a great deal of work [in Antwerp] for a merchant, Hans Franckert, a noble and upright man, who found pleasure in Bruegel's company and met him every day. With this Franckert, Bruegel often went out into the country to see peasants at their fairs and weddings. Disguised as peasants they brought gifts like the other guests,

claiming relationship or kinship with the bride or groom. Here Bruegel delighted in observing the droll behavior of the peasants, how they ate, drank, danced, capered, or made love, all of which he was well able to reproduce cleverly and pleasantly. . . . He represented the peasants—men and women of the Campine and elsewhere—naturally, as they really were, betraying their boorishness in the way they walked, danced, stood still, or moved.

An art lover in Amsterdam, Sieur Herman Pilgrims, owns a *Peasant Wedding* painted in oils, which is most beautiful. The peasants' faces and the limbs, where they are bare are yellow and brown, sunburnt; their skins are ugly, different from those of town dwellers . . .

. . . Many of his compositions of comical subjects, strange and full of meaning, can be seen engraved; but he made many more works of this kind in careful and beautifully finished drawings to which he had added inscriptions. But as some of them were too biting and sharp, he had them burn by his wife when he was on his deathbed, from remorse or fear that she might get into trouble and have to answer for them. . . .

SOURCE: DUTCH AND FLEMISH PAINTERS BY KAREL VAN MANDER. TR. CONSTANT VANDE WALL (MANCHESTER, NH, AYER COMPANY PUBLISHERS, 1936)

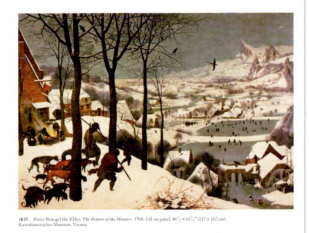

18.37. Pieter Bruegel the Elder. *The Return of the Hunters*. 1568. Oil on panel, 46¹⁄₂ × 63³⁄₄" (117 × 162 cm). Kunsthistorisches Museum, Vienna

654 PART III THE RENAISSANCE THROUGH THE ROCOCO

PRIMARY SOURCES:
Historical documents place art and artists
more securely in the context of their time.

SUMMARY

In the last half of the eighteenth century, Western culture entered the modern era. People were continually adapting to shifting political values, changing socioeconomic conditions, and new scientific theories. Political rebellions occurred in America and France, gradually shifting power from a hereditary royalty and into the hands of citizens. Evolving philosophical outlooks spurred land reform, scientific discoveries, and technological advancements—and vice versa—resulting in the Industrial Revolution in England that eventually spread worldwide. Society was progressing, and a burgeoning moneyed middle class demanded new luxuries, including art. The roots of these changes can be traced to the Enlightenment, a new method of critical thinking that developed in the eighteenth century. Enlightenment thought brought about the establishment of basic human rights, a new moral order, and modern science. Rationalism ruled, with theories based on experience and observation. Living in the modern world today, we continue to feel the effects of these powerful upheavals.

Art reflected this complex era. Styles old and new mingled and evolved. Traces of the Rococo and Baroque remained as new trends emerged. The dominant style, Neoclassicism, emphasized logic and rationality and often featured moralistic themes borrowed from the ancient Greeks and Romans. Romanticism, a simultaneous thread in art, advocated emotion, imagination, and the supremacy of Nature.

ROME TOWARD 1760: THE FONT OF NEOCLASSICISM

Rome, home to treasures from antiquity and the Renaissance, held sway as the world's art center. The city attracted not only a flood of artists seeking inspiration but also the wealthy traveling on the "Grand Tour" of Italy. Fueled by recent archeological discoveries, notably those of Herculaneum and Pompeii, a renewed interest in antiquity gripped scholars and artists. In his influential writings, art critic Johann Winckelmann encouraged a new appreciation of Greek art by espousing its moral and aesthetic superiority. The austere brushwork of Anton Raphael Mengs, the strong linearity of Pompeo Batoni's portraits, and the dramatic solemnity of Gavin Hamilton's moralistic themes laid the foundations of the Neoclassical style.

ROME TOWARD 1760: THE FONT OF ROMANTICISM

Meanwhile, Romanticism emerged. Printmaker and publisher Giovanni Battista Piranesi celebrated ancient Roman civilization in dramatic *vedute* (views) of awe-inspiring monumental architecture that embodied the sublime, a quality associated with vastness, obscurity, power, and infinity that produced feelings of awe, fright, even terror. British statesman Edmund Burke defined the sublime in his treatise *A Philosophical Inquiry into the Origin of Our Ideas of the Sublime and Beautiful*. Piranesi and others increasingly embraced the sublime, reflecting a new audience demand for art that evoked intense emotion, even fright or horror, and that transported them emotionally.

NEOCLASSICISM IN ENGLAND

Antimonarchists and many intellectuals of England, steeped in the Enlightenment, identified with the ancient Romans and emulated that civilization's

government, literature, and art. By extension, they invented Neoclassical art. Neoclassicism was not just gaining popularity, however, and several styles or influences often appeared simultaneously in the same work. Many English artists borrowed themes from Greek and Roman art and literature, although not always those with moralistic messages. Angelica Kauffmann's paintings reflect these dichotomies as she vacillated between erotic and virtuous themes, Rococo grace and Neoclassical austerity.

The tradition of contemporary history painting was born during this period as well. With Enlightenment emphasis on the logical, artists like Benjamin West and John Singleton Copley began conceiving convincing ways to show historic contemporary events through the depiction of accurate costumes and settings. West's *The Death of General Wolfe* and Copley's *Watson and the Shark* offer abundant truthful details mixed with Classical poses, calm dignity, and moral overtones—hallmarks of Neoclassical style.

The Classical revival in architecture appeared in England as early as 1715, with the publication of Colen Campbell's treatise *Vitruvius Britannicus*, and eventually spread to America. Campbell espoused the architecture of the ancients and their descendants, notably Antonio Palladio, and the demand for Palladian-inspired country villas exploded. The Classical revival extended to urban planning, as seen in the resort town of Bath, as well as to décor, embodied in the interiors designed by Robert Adam.

EARLY ROMANTICISM IN ENGLAND

In England, the desire of some people for logic and empiricism coexisted with an equally strong urge for emotion and subjective experiences. In architecture and landscape design, Neoclassical evocations of noble antiquity joined with Romanticism's delight in the exotic and the desire to elicit powerful emotions. The British taste for the sublime translated successfully into garden design, where it combined especially well with the interesting variety of the picturesque and the layered meanings of associationism, both concepts fully developed in England. The concurrent Gothic revival also reflected Romantic sensibilities, with its emphasis on the sublime emotions evoked by melancholic spaces. Painters also felt the dual pull of Neoclassicism and Romanticism. George Stubbs and Joseph Wright often fused both trends, whereas Heinrich Fuseli fully adopted sublime terror, carrying us dramatically into the Romantic era.

NEOCLASSICISM IN FRANCE

France experienced a similar reaction to the Enlightenment, and art began shifting from Rococo flamboyance toward Neoclassical rationalism. First seen in architecture, this Classical revival featured austere geometry and monumental scale, characteristic of structures by Marie-Joseph Peyre and Claude-Nicolas Ledoux. French painters and sculptors formulated their own response to the influential mainstream of thought. Jean-Baptiste Greuze's genre paintings, the sensation of the Paris Salons in the 1760s, embodied Enlightenment emphasis on logic and naturalism, while Jean-Antoine Houdon's sculpted portraits show realistic, classicized versions of the sitter. Yet the climax of French Neoclassicism is the moralizing history paintings of Jacques-Louis David, notably his *Oath of the Horatii*. Building on the tableau vivant made popular by Greuze, David creates a dramatic composition of noble beauty, but one where the undercurrents of horror reflect a taste for the Romantic as well.

CHAPTER 23 ART IN THE AGE OF THE ENLIGHTENMENT, 1750–1789 821

SUMMARIES at the end of each chapter
highlight key concepts.

Acknowledgments

We are grateful to the following academic reviewers for their numerous insights and suggestions on improving Janson:

Susan Altman, Middlesex County College
Michael Amy, Rochester Institute of Technology
Dixon Bennett, San Jacinto College South
Barbara Bushey, Hillsdale College
Barbara Dodsworth, Mercy College
Karl Fugelso, Towson University
Tessa Garton, College of Charleston
Alyson Gill, Arkansas State University
Andrew L. Goldman, Gonzaga University
Marilyn Gottlieb-Roberts, Miami Dade College
Oleg Grabar, Institute for Advanced Study
William Greiner, Olivet Nazarene University
Anthony Gully, Arizona State University
Jean R. Harry, Luzerne County Community College
Andrew Hershberger, Bowling Green State University
Fredrika Jacobs, Virginia Commonwealth University
Victor Katz, Holyoke Community College
Hee-Young Kim, University of Alabama
Ellen Konowitz, SUNY New Paltz
Marybeth Koos, Elgin Community College
Danajean Mabry, Surry Community College
Marian Mazzone, College of Charleston
Charles Morscheck, Drexel University
Andrew M. Nedd, Savannah College of Art and Design
Andrea Pearson, Bloomsburg University
William H. Peck, Detroit Institute of Art
Rob Prestiano, Angelo State University
Wendy Robertson, Humboldt State University
Cynthia Robinson, Cornell University
Susan Ryan, Louisiana State University
Cathy Santore, New York City College of Technology
Carl Sederholm, Brigham Young University
Stephanie Spencer, North Carolina State University
Esther Tornai Thyssen, Sage College of Albany
Lee Ann Turner, Boise State University
Jens T. Wollesen, University of Toronto

Individual chapters of the text were subjected to a rigorous review process by expert reviewers. We thank the following for their incredibly detailed and careful fact-finding analyses of the manuscript:

Ann Jensen Adams, University of California, Santa Barbara
Bernadine Barnes, Wake Forest University
Susan Cahan, University of Missouri-St. Louis
Maura Coughlin, Brown University
Roger J. Crum, University of Dayton
Sharon Dale, Penn State University-Erie, Behrend College
Michael T. Davis, Mount Holyoke College
Marian Feldman, University of California, Berkeley
Laura Gelfand, The University of Akron
Anne Higonnet, Barnard College
Eva Hoffman, Tufts University
Jeffery Howe, Boston College
Charles T. Little, Metropolitan Museum of Art
Patricia Mainardi, Graduate Center, CUNY
Robert Mattison, Lafayette College
David Gordon Mitten, Harvard University
Robert Mode, Vanderbilt University
Elizabeth Otto, SUNY Buffalo
Nassos Papalexandrou, University of Texas-Austin
Pamela Patton, Southern Methodist University
John Pedley, University of Michigan
Elizabeth M. Penton, Durham Technical Community College
Jane Peters, University of Kentucky
Gay Robins, Emory University
Wendy Roworth, University of Rhode Island
John Beldon Scott, University of Iowa
Kenneth E. Silver, Department of Fine Arts, New York University
Catherine Turill, California State University, Sacramento
Eric R. Varner, Emory University
Nancy L. Wicker, University of Mississippi
Jeryldene M. Wood, University of Illinois

SPECIAL THANKS go to Peter Kalb of Ursinus College and Elizabeth Mansfield of the University of the South for their tremendous contributions as editorial consultants.

THE CONTRIBUTORS WOULD LIKE TO THANK THE FOLLOWING INDIVIDUALS FOR THEIR ADVICE AND ASSISTANCE IN DEVELOPING THIS EDITION:
C. Edson Armi, Lea Cline, Holly Connor, Oleg Grabar, Ann Sutherland Harris, Asma Husain, Anthony F. Janson, Calvin Kendall, Frank Lind, Andrea Pearson, Chris Reed, John Beldon Scott, Sonia C. Simon, and Bruce Weber. We would also like to thank the group of talented editors and staff at Pearson Education for all their hard work in bringing this edition to life. Special thanks go to Sponsoring Editor Helen Ronan and Senior Development Editors Roberta Meyer, Karen Dubno, and Carolyn Viola-John. We are also grateful to Production Manager Lisa Iarkowski, Production Editor Harriet Tellem, and the team responsible for acquiring images. Deep thanks go, too, to Sarah Touborg for overseeing the project and bringing this group of collaborators together.

Faculty and Student Resources for Teaching and Learning with *Janson's History of Art*

PRENTICE HALL is pleased to present an outstanding array of high quality resources for teaching and learning with *Janson's History of Art*. Please contact your local Prentice Hall representative for more details on how to obtain these items, or send us an email at art@prenhall.com.

DIGITAL AND VISUAL RESOURCES

THE PRENTICE HALL DIGITAL ART LIBRARY. Instructors who adopt *Janson's History of Art* are eligible to receive this unparalleled resource. Available in a two-DVD set or a 10-CD set, *The Prentice Hall Digital Art Library* contains every image in *Janson's History of Art* in the highest resolution (over 300 dpi) and pixellation possible for optimal projection and easy download. Developed and endorsed by a panel of visual curators and instructors across the country, this resource features over 1,600 images in jpeg and in PowerPoint, an instant download function for easy import into any presentation software, along with a zoom feature, and a compare/contrast function, both of which are unique and were developed exclusively for Prentice Hall.

ONEKEY. is Prentice Hall's exclusive course management system that delivers all student and instructor resources all in one place. Powered by WebCt and Blackboard, OneKey offers an abundance of online study and research tools for students and a variety of teaching and presentation resources for instructors, including an easy-to-use gradebook and access to many of the images from the book.

ART HISTORY INTERACTIVE CD-ROM. *1,000 Images for Study & Presentation* is an outstanding study tool for students. Images are viewable by title, by period, or by artist. Students can quiz themselves in flashcard mode or by answering any number of short answer and compare/contrast questions.

CLASSROOM REPSONSE SYSTEM (CRS) IN CLASS QUESTIONS. Get instant, classwide responses to beautifully illustrated chapter-specific questions during a lecture to gauge students comprehension—and keep them engaged. Contact your local Prentice Hall sales representative for details.

COMPANION WEBSITE. Visit www.prenhall.com/janson for a comprehensive online resource featuring a variety of learning and teaching modules, all correlated to the chapters of *Janson's History of Art*.

FINE ART SLIDES AND VIDEOS. are also available to qualified adopters. Please contact your local Prentice Hall sales representative to discuss your slide and video needs. To find your representative, use our rep locator at www.prenhall.com.

VANGO NOTES: Study on the go with VangoNotes--chapter reviews from your text in downloadable mp3 format. You can study by listening to the following for each chapter of your textbook: Big Ideas: Your "need to know" for each chapter; **Practice Test:** A check for the Big Ideas—tells you if you need to keep studying; **Key Terms:** audio "flashcards" to help you review key concepts and terms; Rapid Review: A quick drill session—use it right before your test. VangoNotes are flexible; download all the material directly to your player, or only the chapters you need.

PRENTICE HALL TEST GENERATOR is a commercial-quality computerized test management program available for both Microsoft Windows and Macintosh environments.

PRINT RESOURCES

TIME SPECIAL EDITION: ART. Featuring stories like "The Mighty Medici," "When Henri Met Pablo," and "Redesigning America," Prentice Hall's TIME Special Edition contains thirty articles and exhibition reviews on a wide range of subjects, all illustrated in full color. This is the perfect complement for discussion groups, in-class debates, or writing assignments. With the TIME Special Edition, students also receive a three-month pass to the TIME archive, a unique reference and research tool.

UNDERSTANDING THE ART MUSEUM by Barbara Beall. This handbook gives students essential museum-going guidance to help them make the most of their experience seeing art outside of the classroom. Case studies are incorporated into the text, and a list of major museums in the United States and key cities across the world is included.

ARTNOTES PLUS. An invaluable slide and study guide for students, ArtNotes Plus contains all of the images from the book in thumbnail form with caption information to illuminate their "art in the dark" experience. In addition, ArtNotes Plus features study questions and tips for each chapter of the book.

ONESEARCH WITH RESEARCH NAVIGATOR helps students with finding the right articles and journals in art history. Students get exclusive access to three research databases: The New York Times Search by Subject Archive, ContentSelect Academic Journal Database, and Link Library.

INSTRUCTOR'S MANUAL AND TEST ITEM FILE is an invaluable professional resource and reference for new and experienced faculty, containing sample syllabi, hundreds of sample test questions, and guidance on incorporating media technology into your course.

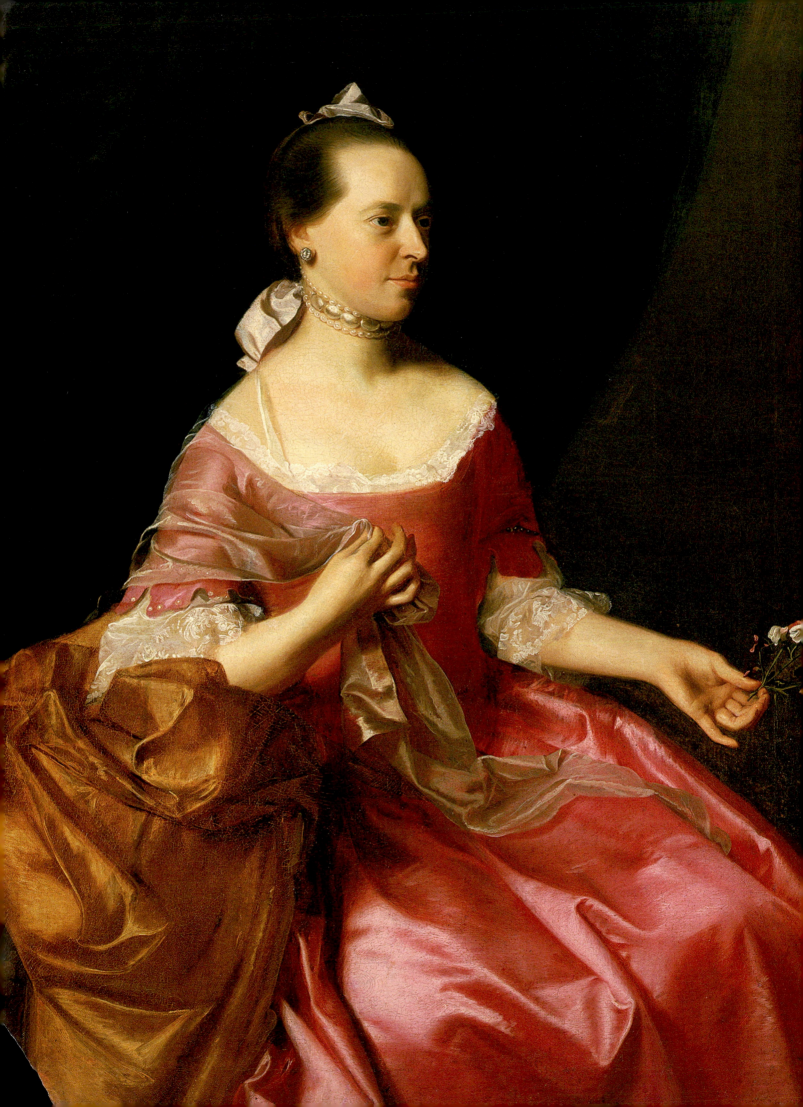

Introducing Art

WHO WAS FREELOVE OLNEY SCOTT? Her portrait (fig. I.1) shows us a refined-looking woman, born, we would guess, into an aristocratic family, used to servants and power. We have come to accept John Singleton Copley's portraits of colonial Bostonians, such as *Mrs. Joseph Scott,* as accurate depictions of his subjects and their lifestyles. But many, like Mrs. Scott, were not what they appear to be. Who was she? Let's take a closer look at the context in which the painting was made.

ART IN CONTEXT

Copley was one of the first American painters to make a name for himself throughout the American colonies and in England. Working in Boston from about 1754 to 1774, he became the most sought after portraitist of the period. Copley easily outstripped the competition of "face painters," as portraitists were derogatorily called at the time, most of whom earned their living painting signs and coaches. After all, no successful British artist had any reason to come to America, for the economically struggling colonies were not a strong market for art. Only occasionally was a portrait commissioned, and typically, artists were treated like craftsmen rather than intellectuals. Like most colonial portraitists, Copley was self-taught, learning his trade by looking at black-and-white prints of paintings by the European masters.

As we can see in *Mrs. Joseph Scott,* Copley was a master at painting textures, all the more astonishing when we realize that he had no one to teach him the tricks of the painter's trade. His illusions are so convincing, we think we are looking at real silk, ribbons, lace, pearls, skin, hair, and marble. Copley's contemporaries also marveled at his sleight of hand. No other colonial painter attained such a level of realism.

I.1. John Singleton Copley, *Mrs. Joseph Scott.* ca. 1765.
Oil on canvas, 69½ × 39½″ (176.5 × 100 cm).
Collection of The Newark Museum, Newark, New Jersey. 48.508

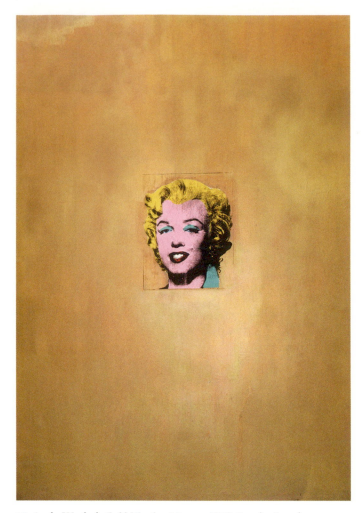

I.2. Andy Warhol. *Gold Marilyn Monroe.* 1962. Synthetic polymer paint, silk-screened, and oil on canvas, 6′11¼″ × 4′7″ (2.12 × 1.39 m). The Museum of Modern Art, New York, Gift of Philip Johnson. © 2006 Andy Warhol Foundation for the Visual Arts/©Artists Rights Society (ARS), New York, ™/© 2005 Marilyn Monroe, LLC by CMG Worldwide Inc., Indianapolis, Indiana 46256 USA.www.MarilynMonroe.com

However, Copley's job was not just to make a faithful copy of what he saw, but to project an image of Mrs. Scott as a woman of impeccable character, limitless wealth, and aristocratic status. The flowers she holds are a symbol of fertility, faithfulness, and feminine grace, indicating that she is a good mother and wife, and a charming woman. Her expensive dress was imported from London, as was her necklace. Copley may have elevated her status a bit more by giving her a pose taken from one of the prints of British or French royalty that he undoubtedly had on hand.

Not only is Mrs. Scott's pose borrowed, but most likely her dress and necklace, as well, for the necklace appears on three other women in Copley portraits. In other words, it was a studio prop. In fact, except for Mrs. Scott's face, the entire painting is a fiction designed to aggrandize the wife of a newly wealthy Boston merchant, who made a fortune selling provisions to the occupying British army. The Scotts were *nouveau riche* commoners, not titled aristocrats. By the middle of the eighteenth century, rich Bostonians wanted to distinguish themselves from their less successful neighbors. Now, after a century of trying to escape their British roots (from which many had fled to secure religious free-

dom), they sought to imitate the British aristocracy, even to the point of taking tea in the afternoon and owning English Spaniels, a breed that in England only aristocrats were permitted to own.

Mr. Scott commissioned this painting of his wife and a portrait of himself, not just to record their features, but to showcase the family's wealth. These pictures were extremely expensive and therefore status symbols, much like a Mercedes or a diamond ring from Tiffany's is today. The portraits were displayed in the public spaces of the house where they could be readily seen by visitors. Most likely they hung on either side of the mantle in the living room, or in the entrance hall. They were not intended as intimate affectionate resemblances destined for the private spaces in the home. If patrons wanted cherished images of their loved ones, they would commission miniature portraits, like the one in fig. 18.28 by Nicholas Hilliard. Miniatures captured the likeness of the sitter in amazing detail and were often so small they could be encased in a locket that a woman would wear on a chain around her neck, or a gentleman would place in the inner breast pocket of his coat, close to the heart. But the scale and lavishness of Copley's portrait add to its function as a status symbol.

If Mrs. Scott's portrait is rich with meaning, so is another image of a woman produced almost 200 years later: Andy

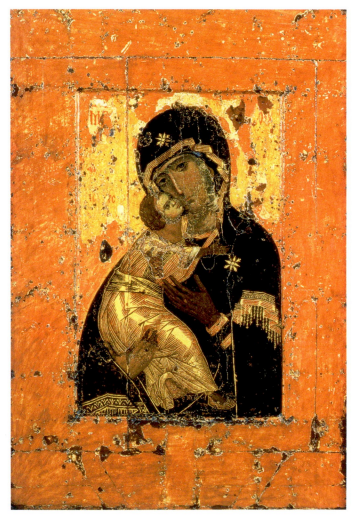

I.3. *Virgin of Vladimir.* Icon, probably from Constantinople. Faces only, 12th century; the rest has been retouched. Tempera on panel, height approx. 31″ (78 cm). Tretyakov Gallery, Moscow

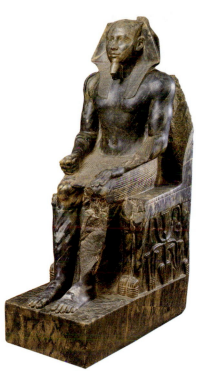

I.4. *Khafra,* from Giza. ca. 2500 BCE. Diorite, height 66″ (167.7 cm). Egyptian Museum, Cairo

Warhol's *Gold Marilyn Monroe* (fig. I.2) of 1962. In a sense, the painting may also be considered a portrait, because it portrays the famous 1950s film star and sex symbol. Unlike *Mrs. Joseph Scott,* however, the painting was not commissioned by Monroe or her family. Warhol chose the subject himself and made the painting to be exhibited in a commercial art gallery, where it could be purchased by a private collector for display in a home. Of course, he hoped ultimately it would end up in a museum, where a great number of people would see it—something Copley never considered because public museums did not exist in his day. In contrast to Copley, Warhol was not obliged to flatter his subject. Nor did he painstakingly paint this picture to create an illusionistic image. *Gold Marilyn Monroe* has no details and no sense of texture, as hair and flesh appear to be made of the same material— paint. Instead, the artist found a famous newspaper photograph of the film star and silkscreened it onto canvas, a process that involves first mechanically transferring the photograph onto a mesh screen and then pressing printing ink through the screen onto canvas. He then surrounded Marilyn's head with a field of broadly brushed gold paint.

Warhol's painting is a pastiche of the public image of Monroe as propagated by the mass media. He even imitates the sloppy, gritty look and feel of color newspaper reproductions of the period, for the four process colors of printing were often misregistered, that is, they did not align properly with the image. The Marilyn we are looking at is the impersonal celebrity of the media, supposedly glamorous with her lush red lipstick and bright blond hair but instead appearing pathetically tacky because of the garish color (blond hair becomes bright yellow) and grimy black ink. Her personality is impenetrable, reduced to a public smile. The painting was prompted, in part, by Monroe's recent suicide. The real Marilyn suffered from depression, despite her glamorous image. Warhol has brilliantly expressed the indifference of the mass media that glorifies celebrities by sat-

urating a celebrity-thirsty public with their likenesses, but tells us nothing meaningful about them and shows no concern for them. Marilyn Monroe's image is about promoting a product, much as the jazzy packaging of Brillo soap pads or Campbell's soup cans is designed to sell a product without telling us anything about the product itself. The packaging is just camouflage. Warhol floats Marilyn's face in a sea of gold paint, imitating icons of Christ and the Virgin Mary that traditionally surround these religious figures in a spiritual aura of golden, heavenly light (fig. I.3). But Warhol's revered Marilyn is sadly dwarfed in her celestial gold, adding to the poignancy of this powerful portrait, which so trenchantly comments on the enormous gulf between public image and private reality.

As we examine the circumstances in which *Mrs. Joseph Scott* and *Gold Marilyn Monroe* were created, we begin to understand how important context is to the look and meaning of works of art, and therefore, to the stories they tell. Although Copley and Warhol shared the context of being American artists, they worked in very different times, with diverse materials and techniques, and for a different type of clientele, all of which tremendously affected the look and meaning of their portraits. Because their art, like all art, served a purpose, it was impossible for either of them to make a work that did not represent a point of view and tell a story, sometimes many stories. Like great works of literature or music, memorable works of art tell powerful stories whose meanings become clearer when we explore the layers of context in which the works were made.

Many factors determine the style and meaning of a work of art and contribute to its powerful presence. For centuries, art created with a political or religious agenda had been used by the state and the church to promote an image of superiority and authority. Ancient Egyptian rulers understood art's power and used it to project their own, sometimes clothing their power in benevolence. Monumental stone sculptures typically depicted Egyptian kings and queens with one hand open for mercy, the other closed in a fist (seen in profile in fig. I.4). Religious images, such as Raphael's *Alba Madonna* (see fig. I.5), expressed the

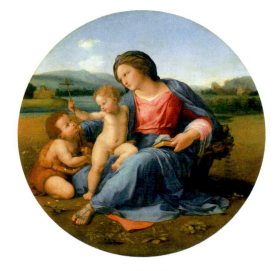

I.5. Raphael. *Alba Madonna.* ca. 1510. Oil on panel, diameter 37¼″ (94 cm). National Gallery of Art, Washington, DC. Andrew Mellon Collection

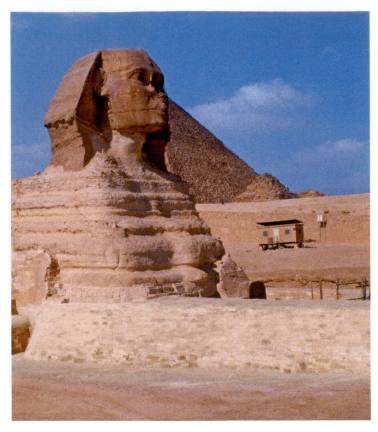

I.6. The Great Sphinx, Giza. ca 2570–2544 BCE. Sandstone, height 65′ (19.81 m)

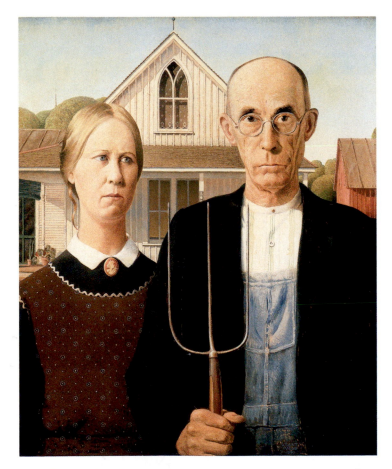

I.7. Grant Wood. *American Gothic.* 1930. Oil on board, 24⅞ × 24⅜″ (74.3 × 62.4 cm). The Art Institute of Chicago, Friends of American Art Collection. Art © Grant Wood/Licensed by VAGA, New York

idealized, perfected state of existence that its pious patron believed was attainable through Catholicism. Art meant for domestic settings, such as many landscape paintings or still lifes of fruit, dead game, or flowers, also carry many messages. Such images are far from simple attempts to capture the splendor and many moods of nature or to show off the painter's finesse at creating a convincing illusionistic image. The carefully rendered natural and man-made objects in Clara Peeters's *Still-Life of Fruit and Flowers* (fig. 20.11) remind a viewer of the pleasures of the senses, but also of their fleeting nature.

Art also has the power to evoke entire historical periods. Images of the pyramids and the Great Sphinx (fig. **I.6**), for example, conjure up the grandeur we associate with ancient Egyptian civilization. Similarly, Grant Wood's famous 1930 painting *American Gothic* (fig. **I.7**) reinforces the perception that humorless, austere, hardworking farmers populated the American Midwest at that time. In the context of popular mythology, the painting has virtually become an emblem of rural America.

Changing Contexts, Changing Meanings

American Gothic has also become a source of much sarcastic humor for later generations, which have adapted the famous pitchfork-bearing farmer and his sour-faced daughter for all kinds of agendas unrelated to the artist's message. Works of art are often appropriated by a viewer to serve in contexts that are quite different from those initially intended, and, as a result, the meanings of such works change radically. The reaction of some New Yorkers to *The Holy Virgin Mary* (fig. **I.8**) by Chris Ofili reflects the power of art to provoke and spark debate, even outrage. The work appeared in an exhibition titled *Sensation: Young British Artists from the Saatchi Collection,* presented at the Brooklyn Museum in late 1999. Ofili, who is British of African descent, made an enormous picture depicting a black Virgin Mary. He used dots of paint, glitter, map pins, and images of genitalia taken from popular magazines to suggest fertility. In African traditions, many representations of females are about fertility. In his painting, Ofili blended an African theme with Christian imagery, inadvertently offending many Westerners unfamiliar with the artist's cultural heritage. Instead of hanging on the wall, this enormous painting rested on two large wads of elephant dung, an arrangement that the artist had used many times for his large canvases since 1991. Elephant dung is held sacred in Zimbabwe, and for Ofili, a devout Catholic, the picture was about the elemental sacredness of the Virgin.

Many art historians, critics, and other viewers found the picture remarkably beautiful—glittering and shimmering with a delicate, ephemeral otherworldly aura. Many Catholic viewers, however, were repulsed by Ofili's homage to the Virgin with its so-called pornographic details. Instead of viewing the work through Ofili's eyes, they placed the painting within the context of their own experience and beliefs. Consequently, they interpreted the depiction of the dung and genitalia (and probably even a black Virgin, although this was never mentioned) as sacrilegious. Within days of the opening of the exhibition, the painting had to be put behind a large Plexiglas barrier. One artist hurled

1.8. Chris Ofili. *The Holy Virgin Mary.* 1996. Paper collage, oil paint, glitter, polyester resin, map pins, and elephant dung on linen, 7′11″ × 5′11¹¹⁄₁₆″ (2.44 × 1.83 m). The Saatchi Gallery, London. © Chris Ofili

horse manure at the facade of the Brooklyn Museum, claiming "I was expressing myself creatively"; another museum visitor sneaked behind the Plexiglas barrier and smeared the Virgin with white paint in order to hide her. But the greatest attack came from New York's Mayor Rudolph Giuliani, a Catholic, who was so outraged he tried to eliminate city funding for the museum. Ultimately, he failed, but only after a lengthy lawsuit by the museum. The public outrage at Ofili's work is one episode in a long tradition that probably goes back to the beginning of image making. Throughout history, art has often provoked outrage, just as it has inspired pride, admiration, love, and respect. The reason is simple. Art is never an empty container; rather, it is a vessel loaded with meaning, subject to multiple interpretations, and always representing someone's point of view.

Social Context and Women Artists

Because the context for looking at art constantly changes, as society changes, our interpretations and insights into art and entire periods evolve as well. For example, when the first edition of this book was published in 1962, women artists were not included, which was typical for textbooks of the time. America, like most of the world, was male-dominated, and history focused on men. Women of that era were expected to be wives and mothers. If they worked, it was to add to the family's income. They were not supposed to become artists, and the few known exceptions were not

taken seriously by historians, who were mostly male. The feminist movement, beginning in the mid 1960s, overturned this restrictive perception of women's roles. As a result, in the last 40 years, art historians—many of them women—have "rediscovered" countless women artists. Many of these women were outstanding artists, held in high esteem during their lifetimes, despite having to struggle to overcome powerful social and even family resistance against women becoming professional artists.

One of these rediscovered women artists is the seventeenth-century Dutch painter Judith Leyster, a follower, if not a student, of Frans Hals. Over the centuries, all of Leyster's paintings were attributed to other artists, including Hals and Gerrit van Honthorst. Or the paintings were labeled "artist unknown." At the end of the nineteenth century, however, Leyster was rediscovered through an analysis of her signature, documents, and style, and her paintings were gradually restored to her name. It was only with the feminist movement that she was elevated from a minor figure to one of the more accomplished painters of her generation, one important enough to be included in the history of art. The feminist movement inspired a new context for evaluating art, one that had an interest in celebrating rather than denying women's achievements, and which was concerned with studying issues relating to gender and how women are portrayed in the arts.

A work like Leyster's *Self-Portrait* (fig. **I.9**), from about 1633, is especially fascinating from this point of view. Because of its size and date, this may have been the painting the artist submitted as her presentation piece for admission into the local painters' guild, the Guild of St. Luke of Haarlem. Women were not encouraged to join the guild, which was a male preserve reinforcing the

1.9. Judith Leyster. *Self-Portrait.* ca. 1633. Oil on canvas, 29⅜″ × 25⅝″ National Gallery of Art, Washington, DC. (72.3 × 65.3 cm). Gift of Mr. and Mrs. Robert Woods Bliss

professional status of men. Nor did women artists generally take on students. Leyster bucked both restrictive traditions as she carved out a career for herself in a man's world. In her self-portrait, she presents herself as an artist, armed with many brushes, suggesting her deft control of the medium, which the presentation picture itself was meant to demonstrate. On the easel is a painting that is a segment of a genre scene (a glimpse of daily life), the type of painting for which she is best known. We must remember that at this time, artists rarely showed themselves working at their easels, toiling with their hands. They wanted to separate themselves from mere artisans and laborers, presenting themselves as belonging to a higher class. As a woman defying male expectations, however, Leyster needed to clearly declare that she was indeed an artist. So she cleverly elevates her status by not dressing as an artist would when painting. Instead, she appears, as her patrons do in their portraits, well dressed and well off. Her mouth is open, in what is called a "speaking likeness" portrait, giving her a casual but self-assured animated quality, as she appears to converse on equal terms with a visitor or viewer. Leyster, along with Artemisia Gentileschi and Elizabeth Vigée-Lebrun, who also appear in this book, was included in a major 1976 exhibition entitled *Women Artists 1550–1950,* which was presented in Los Angeles and Brooklyn, New York, and which played a major role in establishing the importance of women artists.

RECOGNIZING ART

Earlier generations of art historians focused almost entirely on three art forms: sculpture, architecture, and painting, together called the "fine arts." Yet recently, as artists have expanded the materials from which they make art, art historians study a wider variety of media used to express ideas. If we attempt to define art, we realize that it is not simply about a physical form. What we can see or touch in a work of art is only part of the story. The first chapter of this book discusses remarkable prehistoric paintings covering the walls of caves in Spain and France, some dating to ca. 30,000 BCE. The *Hall of the Bulls* (fig. I.10) appears on a wall in Lascaux Cave in the Dordogne region of France, and dates from ca. 16,000 BCE. Although we believe these works served some type of function for the people who made them, the animals they so naturalistically depicted on the walls of their caves were produced before the advent of writing, and we have no idea whether people at the time also thought of these expertly painted forms as we do—as works of art. Did they even have a concept of "art": a special category of communication in which the image played a role other than that of a simple everyday sign, such as a hiker's mark for danger carved on a tree?

In addition to its physical form, then, the question "How do we recognize art?" also depends on how we know something is art—either as an abstract idea or through our senses. The theory that art is also an intellectual product is a very old notion in Western culture. When the Italian Renaissance artist Michelangelo was carving the *David* (see fig. 16.13), he believed his role as sculptor was to use his artistic ability to "release" the form hidden within

I.10. *Hall of the Bulls*, ca. 15,000–10,000 BCE. Lascaux, Dordogne, France

the block of marble he was working on. And the twentieth-century Spanish Surrealist painter Salvador Dali once mischievously remarked that the ideas for his dreamlike paintings (see fig. 28.18) traveled down from the surrounding atmosphere through his generous handlebar moustache. Even those of us who know very little about art and its history have ideas about what art is simply because we have absorbed them through our culture. In 1919, the humorous and brilliant Parisian Marcel Duchamp took a roughly 8 by 4-inch reproduction of Leonardo da Vinci's *Mona Lisa* in the Louvre Museum in Paris and drew a mustache on the sitter's face (fig. I.11). Below he wrote the letters *L.H.O.O.Q.,* which when pronounced in French is *elle a chaud au cul,* which translates, "She has hot pants." With this phrase, Duchamp was poking fun at the public's fascination with the mysterious smile on the Mona Lisa, which began to intrigue everyone in the nineteenth century and had, in Duchamp's time, eluded suitable explanation. Duchamp irreverently suggests that her sexual identity is ambiguous and that she is sexually aroused. With the childish gesture of affixing a moustache to the Mona Lisa, Duchamp also attacked bourgeois reverence for Old Master painting and the notion that oil painting represented the pinnacle of art.

Art, Duchamp is saying, can be made by merely placing ink on a mass-produced reproduction. It is not strictly oil on canvas or cast bronze or chiseled marble sculpture. Artists can use any imaginable media in any way in order to express themselves. He is announcing that art is about ideas that are communicated visually, and not necessarily about the materials it is made from or how closely it corresponds to current tastes. In this deceivingly whimsical work, which is rich with ideas, Duchamp is telling us that art is anything that someone wants to call art, which is not the same as saying it is good art. Furthermore, he is proclaiming that art can be small; *L.H.O.O.Q.* is a fraction of the size of its source, the *Mona Lisa*. By appropriating Leonardo's famous picture and interpreting it very differently from traditional readings, Duchamp suggests that the answer to the question "How do we recognize art?" is not fixed forever, that it can change and be assigned by artists, viewers, writers, collectors, and museum curators, who use it for their own purposes. Lastly, and this is certainly one of Duchamp's many wonderful contributions to

I.11. Marcel Duchamp. *Mona Lisa (L.H.O.O.Q.).* (1919) Rectified readymade; pencil on a reproduction. 7 × 4⅞″ (17.8 × 12 cm). Private collection. ©Artists Rights Society (ARS), New York/ADAGP, Paris/Succession Marcel Duchamp

considered beautiful, and they were selected because they were aesthetically neutral. What interested Duchamp were the ideas that these objects embodied once they were declared art.

L.H.O.O.Q. and the question of its beauty raises the issue of *aesthetics,* which is the study of beauty, its origins and its meanings, principally by philosophers. In the West, an interest in aesthetic concepts dates back to ancient Greece. The Greeks' aesthetic theories reflected ideas and tendencies of their culture. In calling a sculpture such as the *Kritios Boy* beautiful (fig. **I.12**), the Greeks meant that the statue reflected what was generally agreed to be an embodiment of the morally good or perfect: a well-proportioned young male. Even more, this idealized form, both good and beautiful, was thought to inspire positive emotions that would reinforce the character of the good citizen who admired it—an important function in the frequently turbulent city-states.

In the modern world, art historians, as well as artists, are also influenced by a variety of aesthetic theories that ultimately mirror contemporary interests about the direction of society and culture. As our world has come to appear less stable and more fragmented, aesthetic theories about what is true, good, or beautiful also have come to stress the relative nature of aesthetic concepts rather than seeing them as eternal and unchangeable. Many art historians now argue that a work of art can hold up under several,

art, he is telling us that art can be fun; it can defy conventional notions of beauty, and while intellectually engaging us in a most serious manner, it can also provide us with a smile, if not a good laugh.

Art and Aesthetics: Changing Ideas of Beauty

One of the reasons that Duchamp selected the *Mona Lisa* for "vandalizing" had to be that many people considered it the most beautiful painting ever made. Certainly, it was one of the most famous paintings in the world, if not the most famous. In 1919, most people who held such a view had probably never seen it and only knew it from reproductions, probably no better than the one Duchamp used in *L.H.O.O.Q.*! And yet, they would describe the original painting as beautiful, but not Duchamp's comical version. Duchamp called such altered found objects as *L.H.O.O.Q.* "assisted readymades" (for another example, see *The Fountain,* fig. 28.2). He was adamant when he claimed that these works had no aesthetic value whatsoever. They were not to be

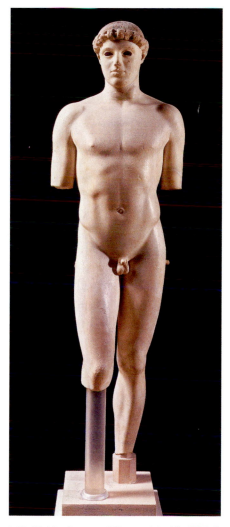

I.12. *Kritios Boy.* ca. 480 BCE. Marble. Height 46″ (116.7 cm). Akropolis Museum, Athens

often conflicting interpretations of beauty or other aesthetic concepts, if those interpretations can be reasonably defended. Thus, despite his claim, Duchamp's assisted readymades can be perceived as beautiful, in ways, of course, that are quite different from those of Leonardo's *Mona Lisa*. The beauty in Duchamp's works derives from their appeal to the intellect; if we understand his messages, his objects appear clever and witty, even profound. His wit and insights about art transformed a slightly altered cheap black-and-white reproduction into a compelling work of art, in a way that is very different from Leonardo's. The qualities that attract us to the *L.H.O.O.Q.*—its cleverness and wit—differ sharply from the skills and values that are inherent in Leonardo's *Mona Lisa*. The intriguing ideas and wit that surround the *L.H.O.O.Q.* place it above a mere youthful prank, and point to a new way of looking at art. Duchamp's innovative rethinking of the nature of art has had a profound effect on artists and aesthetic theory ever since it was made. Our appreciation of Robert Rauschenberg's *Odalisk* (fig. 29.10), created in the late 1950s out of a combination of found materials, including a pillow and a stuffed chicken, and playfully pasted with discarded materials full of sexual allusion, is unthinkable without Duchamp's work.

Quality: In the Mind or the Hand?

Terms like quality and originality are often used in discussing works of art, especially in choosing which works to include or exclude in a book like this. What is meant by these terms, however, varies from critic to critic. For example, in the long history of art, technical finesse or craft has often been viewed as the most important feature to consider in assessing quality. To debunk the myth that quality is all about technique and to begin to get at what it is about, we return to Warhol's *Gold Marilyn Monroe*. The painting is rich with stories: We can talk about how it raises issues about the meaning of art or the importance of celebrity, for example. But Warhol begs the question of the significance of technical finesse in art making, an issue raised by the fact that he may not have even touched this painting himself! We have already seen how he appropriated someone else's photograph of Marilyn Monroe, not even taking his own. Warhol then instructed his assistants to make the screens for the printing process. They also prepared the canvas, screened the image with the colors Warhol selected, and most likely painted the gold to Warhol's specifications, although we do not know this for sure.

By using assistants to make his work, Warhol is telling us that quality is not about the artist's technical finesse or even the artist's physical involvement in making the work, but about how well the artist communicates an idea using visual language. One measure of quality in art is the quality of the statement being made, or its philosophy, as well as the quality of the technical means for making the statement. Looking at *Gold Marilyn Monroe* in the flesh at New York's Museum of Modern Art is a powerful experience. Standing in front of this 6-foot-high canvas, we cannot help but feel the empty glory of America's most famous symbol of female sexuality and stardom. Because the artist's vision, and not his touch, is the relevant issue for the making of this particular work, it is of no consequence that Warhol most likely never

laid a hand to the canvas, except to sign the back. We will shortly see, however, that the artist's touch has often been seen as critical to the perception of originality in a work of art.

Warhol openly declared that his art was not about his technical ability when he called his Manhattan studio "The Factory." He was telling us that art is a commodity, and that he is manufacturing a product, even mass producing his product. The Factory churned out over a thousand, if not thousands, of paintings and prints of Marilyn Monroe, all based on the same newspaper photograph. All Warhol did, for the most part, was sign them, his signature reinforcing the importance many people place on the signature itself as being an essential part of the work. Ironically, most Old Master paintings, dating from the fourteenth through the eighteenth centuries, are not signed, and in fact, artists for centuries used assistants to help make their pictures.

Peter Paul Rubens, an Antwerp painter working in the first half of the seventeenth century and one of the most famous artists of his day, had an enormous workshop that cranked out many of his pictures, especially the large works. His assistants were often artists specializing in flowers, animals, or clothing, for example, and many went on to become successful artists in their own right. Rubens would design the painting, and then assistants, trained in his style, would execute their individual parts. Rubens would come in at the end and finish the painting as needed. The price the client was willing to pay often determined how much Rubens himself participated in the actual painting of the picture; many of his works were indeed made entirely by him. Rubens's brilliant

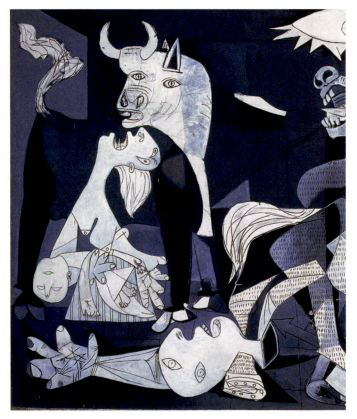

1.13. Pablo Picasso. Detail of *Guernica*. 1937. Oil on canvas, 11'6" × 25'8" (3.51 × 7.82 m). Museo Nacional Centro de Arte Reina Sofia, Madrid. On permanent loan from the Museo del Prado, Madrid. © Estate of Pablo Picasso/Artists Rights Society (ARS), New York

flashy brushwork was in many respects critical to the making of the picture. Not only was his handling of paint considered superior to that of his assistants, the very identity of his paintings, their very life so to speak, was linked to his personal way of applying paint to canvas, almost as much as it was to his dramatic compositions. For his buyers, Rubens's brushwork complemented his subject matter, even reinforced it. Despite the collaborative nature of their production, the artworks made in Rubens's workshop were often striking combinations of the ideas and the powerful visual forms used to communicate them. In that combination lies their originality.

Concepts like beauty, quality, and originality, then, do not refer only to physical objects like pretty, colorful pictures or a perfectly formed marble figure. They are ideas that reside in content and in the perception of how successfully the content is communicated visually. Some of the most famous and most memorable paintings in the history of art depict horrific scenes, such as beheadings (see fig. 19.5), crucifixions (see fig. 18.13), death and despair (see figs. 24.18 and 24.20), emotional distress (see fig.29.9), and the brutal massacre of innocent women and children (fig. **I.13**)). Duchamp's *L.H.O.O.Q.* and Warhol's *Gold Marilyn Monroe* are powerful and riveting. Some would even argue that their complex ideas and unexpected presentations make these works beautiful.

Photography as Art

The first edition of this book did not include photography among the media discussed. Now, four decades later, the artistic merit of photography seems self-evident. When photography was invented in 1839, the art world largely dismissed it as a mechanical process that objectively recorded reality. It was seen as a magical way to capture the detailed likenesses of people and objects without undergoing long artistic training. And, although some artists were intrigued by the often accidental and impersonal quality of the images it produced, the new medium was perceived by many critics as not having sufficient aesthetic merit to be seen in the lofty company of the major forms of fine art—painting and sculpture. Anyone, it seemed, could take a photograph. George Eastman's invention of the hand-held Kodak camera in 1888, allowed photography to become every man's and woman's pastime.

Photography has struggled for a long time to shed its popular, mechanical stigma. In the 1890s, some photographers, like Gertrude Käsebier, attempted to deny the hard, mechanical look of their art by making their prints appear soft, delicate, and fluid (see fig. 26.46). But at the beginning of the twentieth century, Paul Strand and others began to embrace black-and-white photography's hard-edge detail and the abstract results made possible by creative cropping. His *Wire Wheel* of 1917 (fig. 28.43) celebrates the machine age as well as the newest movements in the media of painting and sculpture. By the 1940s, black-and-white photography had gained some status as an art form, but it was not until the 1960s, when photography became an important part of the art school curriculum, that black-and-white photography began to take its place as one of the major art forms. It has taken color photography even longer to achieve serious consideration. But now,

along with video and film, both black-and-white and color photography have been elevated to an important medium. Pictures from the nineteenth and twentieth centuries that once had interested only a handful of photography insiders are intensely sought after, with many museums rushing to establish photography departments and amass significant collections. In other words, it has taken well over 100 years for people to get beyond their prejudice against a mechanical process and develop an eye for the special possibilities and beauty of the medium.

We need only look at a 1972 photograph entitled *Albuquerque* (fig. **I.14**) by Lee Friedlander to see how photography may compete with painting and sculpture in artistic merit. In *Albuquerque,* Friedlander portrays a modern America that is vacuous and lifeless, which he suggests is due to technology. How does he do this? The picture has a haunting emptiness. It has no people, and it is filled with strange empty spaces of walkway and street that appear between the numerous objects that pop up everywhere. A hard, eerie geometry prevails, as seen in the strong verticals of the poles, buildings, hydrant, and wall. Cylinders, rectangles, and circles are everywhere. (Notice the many different rectangles on the background building, or the rectangles of the pavement bricks and the foreground wall.)

Despite the stillness and emptiness, the picture is busy and restless. The vertical poles and the strong vertical elements on the house and building establish a vibrant staccato rhythm. The energy of this rhythm is reinforced by the asymmetrical composition that has no focus or center, as well as by the powerful intersecting diagonals of the street and the foreground wall. (Note how the shadow of the fire hydrant runs parallel to the street.) Disturbing features appear throughout the composition. The street sign—which cannot be seen because it is cropped at the top of the print—casts a mysterious shadow on the wall. A pole visually cuts the dog in two, and the dog has been separated from his attribute, the fire hydrant, as well as from his absent owner. The fire hydrant, in turn, appears to be mounted incorrectly, because it sticks too far out of the ground. The car on the right has been brutally cropped, and a light pole seems to sprout strangely from its hood. The telephone pole in the center of the composition is

I.14. Lee Friedlander. *Albuquerque.* 1972. Gelatin silver print, 11 × 14″. © Lee Friedlander

crooked, as though it has been tilted by the force of the cropped car entering from outside the edge of the picture (of course, the car is parked and not moving). Why do we assume this empty, frenetic quality is human-made? Because the work is dominated by the human-made and by technology. We see telephone poles, electrical wires, crosswalk signs, an ugly machinelike modular apartment building, sleek automobiles, and a fire hydrant. Cropped in the lower left foreground is the steel cover to underground electrical wiring.

Everywhere, nature has been cemented over, and besides a few scraggly trees in the middle ground and distance, only the weeds surrounding the hydrant thrive. In this brilliant print, Friedlander captures his view of the essence of modern America: the way in which technology, a love of the artificial, and a fast, fragmented lifestyle have spawned alienation and a disconnection with nature and spirituality. As important, he is telling us that modernization is making America homogeneous. The title tells us we are in Albuquerque, New Mexico, but without the title, we are otherwise in Anywhere, U.S.A.

Friedlander did not just find this composition. He very carefully selected it and he very carefully made it. He not only needed the sun, he had to wait until it was in the right position (otherwise, the shadow of the fire hydrant would not align with the street). When framing the composition, he very meticulously incorporated a fragment of the utility cover in the left lower foreground, while axing a portion of the car on the right. Nor did the geometry of the picture just happen; he made it happen. Instead of a soft focus that would create an atmospheric blurry picture, he has used a deep focus that produces a sharp crisp image filled with detail, allowing, for example, the individual rectangular bricks in the pavement to be clearly seen. The strong white tones of the vertical rectangles of the apartment building, the foreground wall, and the utility box blocking the car on the left edge of the picture were probably carefully worked up in the darkroom, as was the rectangular columned doorway on the house. Friedlander has exposed the ugliness of modern America in this hard, cold, dry image, and because of the power of its message he has produced an extraordinarily beautiful work of art.

Architecture as Art

Architecture, although basically abstract and dedicated to structuring space in a functional way, can also be a powerful communicator of ideas. For example, we see Gianlorenzo Bernini expressing complex ideas in 1656 when he was asked by Pope Alexander XVII to design a large open space, or piazza, in front of St. Peter's cathedral in Rome. Bernini obliged, creating a space that was defined by a row of columns (a colonnade) resembling arms that appear to embrace visitors, offering comfort (fig. **I.15**) and encouraging worshipers to enter the building. Bernini's design made the building seem to welcome all visitors into a universal (Catholic) church. At about the same time, the French architect Claude Perrault was commissioned to design the East facade of Louis XIV's palace, the Louvre in Paris (fig. **I.16**). The ground floor, where the day-to-day business of the court was carried out, was designed as a squat podium. The second floor,

I.15. St. Peter's, Rome. Nave and facade by Carlo Maderno, 1607–1615; colonnade by Gianlorenzo Bernini, designed 1657

where Louis lived, was much higher and served as the main floor, proclaiming Louis's grandeur. Perrault articulated this elevated second story with a design that recalled Roman temples, thus associating Louis XIV with imperial Rome and worldly power. The controlled symmetry of the design further expresses Louis's control over his court and nation.

In the modern era, an enormously wealthy businessman, Solomon R. Guggenheim, indulged his passion for modern art by commissioning architect Frank Lloyd Wright to design a museum in New York City. One of the boldest architectural statements of the mid-twentieth century, Wright's Solomon R. Guggenheim Museum is located on upper Fifth Avenue, overlooking Central Park (fig. **I.17**). The building, erected from 1956 to 1959, is radically different from the surrounding residential housing, thus immediately declaring that its function is different from theirs. Indeed, the building is radically different from most anything built up until that time. We can say that the exterior announces that it is a museum, because it looks as much like a gigantic sculpture as a functional structure.

Wright conceived the Guggenheim in 1945 to create an organic structure that deviated from the conventional static rectangular box filled with conventional static rectangular rooms. Beginning in the early twentieth century, Wright designed houses that related to the landscape and nature, both in structure and material (fig. 26.42). The structure of his buildings, whether domestic or commercial, reflects the very structure of nature, which he saw as a continuous expansion. His buildings radiate out from a central core or wrap around a central void, but in

I.16. Louis Le Vau, Claude Perrault, and Charles Le Brun. East front of the Louvre, Paris. 1667–1670

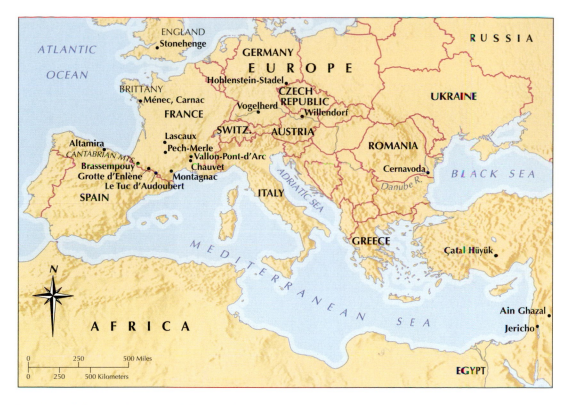

Map 1.1. Prehistoric Europe and the Near East

us to reevaluate many of our assumptions about art and the creative process, and raise fundamental questions, not least of which is why human beings make art at all.

PALEOLITHIC ART

Upper Paleolithic painting, drawing, and sculpture appeared over a wide swath of Eurasia, Africa, and Australia at roughly the same time, between 10,000 and 40,000 years ago (see map 1.1). This time span falls in the Pleistocene era, more commonly known as the Ice Age, when glaciers (the extended polar ice caps), sometimes 10,000 feet thick, covered much of northern Europe, North America, and Eurasia. The Lower and Middle Paleolithic periods extend back as far as 2 million years ago, when earlier species of the *homo genera* lived. While these cultures did make patterned stone tools, they did not make notations or representational imagery of any kind. The end of the most recent Ice Age corresponded with the movement of fully modern humans out of Africa and into Europe, newly habitable as the warming climate caused the glaciers to recede.

Prehistoric paintings were first recognized in 1878 in a cave named Altamira, in the village of Santillana del Mar in northern Spain. Accompanying her father, Count Don Marcelino Sanz de Sautuola, as he scoured the ground for flints and animal bones, 12-year-old Maria looked up to spy bison, painted in bold black outline and filled with bright

earth colors (fig. **1.1**), on the ceiling of the cave. There, and in other more recently discovered caves, the painted and engraved images depict animals as the dominant subject. The greatest variety discovered so far is in the vast cave complex of Chauvet, named after one of the three spelunkers who discovered it in 1994, near Vallon-Pont-d'Arc in southeastern France. Here the 427 animal representations found to date depict 17 species, including lions, bears, and aurochs, in black or red outlines (figs. **1.2**, **1.3**), sometimes polychromatic (containing several colors) and with the use of shading. Here also can be found a finger engraving of a long-eared owl (fig. **1.4**). Marks and shapes appearing to be signs of some sort accompany the animals, or appear alone, such as those shown next to the *Chinese Horse* at Lascaux in the Dordogne region of France (fig. **1.5**). These have been interpreted as weapons or traps, or even insects. Human hands are occasionally stamped in paint on the cave walls, but are usually shown in negative silhouette (see *Materials and Techniques*, page 5). In rare instances, there are larger human or partly human forms. At Chauvet, for instance, archaeologists identified the lower half of a woman painted on a projection of rock. At Les Trois Frères, a site in the French Pyrénées, a human body with its interior muscles and anatomy depicted supports an animal head with antlers. At Lascaux, a male stick figure with a birdlike head lies between a woolly rhinoceros and a disemboweled bison, with a bird-headed stick or staff nearby (fig. **1.6**).

1.17. Frank Lloyd Wright. The Solomon R. Guggenheim Museum, New York. 1956–1959. David Heald © The Solomon Guggenheim Foundation, New York. © Frank Lloyd Wright Foundation, Scottsdale, AZ/Artists Rights Society (ARS), New York

1.18. Frank Lloyd Wright. Interior of the Solomon R. Guggenheim Museum, New York. 1956–59. Robert Mates © The Solomon Guggenheim R. Foundation, New York. © Frank Lloyd Wright Foundation, Scottsdale, AZ/Artists Rights Society (ARS), New York

either case, they are meant to expand or grow like a leaf or crystal, with one form opening up into another.

The Guggenheim is based on a natural form. It is designed around a spiral ramp (fig. **1.18**), which is meant to evoke a spiral shell. The structure also recalls a ceramic vase. It is closed at the bottom and open at the top, and as it rises it widens, until it is capped by a light-filled glass roof. When referring to the Guggenheim, Wright often cited an old Chinese aphorism, "The reality of the vase is the space inside." For the most part, the exhibition space is one enormous room formed by the spiral viewing ramp. Wright wanted visitors to take the elevator to the top of the ramp, and then slowly amble down its 3 percent grade, gently pulled by gravity. Because the ramp was relatively narrow, viewers could not get too far back from the works of art and were forced to have an intimate relationship with the objects. At the same time, they could look back across the open space of the room to see where they had been, comparing the work in front of them to a segment of the exhibition presented on a sweeping distant arc. Or they could look ahead as well, to get a preview of where they were going. The building has a sense of continuity and mobility that Wright viewed as an organic experience. Looking down from the

upper reaches of the ramp, we can see the undulation of the concave and convex forms that reflect the subtle eternal movement of nature. Wright even placed a pool on the ground floor, facing the light entering from the skylight high above. Regardless of their size, no other museum has succeeded in creating a sense of open space and continuous movement as Wright did in the Guggenheim. Nor does any other museum have the same sense of communal spirit; at the Guggenheim everyone is united in one big room (see fig. **1.18**).

EXPERIENCING ART

This book offers you an introduction to many works of art, and provides reproductions of most of them. Yet your knowledge of the objects will be enlarged when you see the works firsthand. No matter how accurate the reproductions in this book—or any other—are, they are just stand-ins for the actual objects. We hope you will visit some of the museums where the originals are displayed. But keep in mind that looking at art, absorbing its full impact takes time and repeated visits. Occasionally, you might do an in-depth reading of an individual work. This would involve carefully perusing details and questioning why they are there. Ideally, the museum will help you understand the art. Often, there are introductory text panels that tell you why the art in a particular exhibition or gallery has been presented together, and there are often labels for individual works that provide further information. Major temporary exhibitions generally have a catalogue, which adds yet another layer of information and interpretation. But text panels, labels, and catalogues generally reflect one person's reading of the work, and there are usually many other ways to approach or think about it.

Although the museum is an effective way to look at art and certainly the most efficient, art museums are relatively new. Indeed, before the nineteenth century, art was not made to be viewed in museums, but in homes, churches, or government buildings. Today we find works of art in galleries, corporate lobbies and offices, places of worship, and private homes. You may find art in public spaces, from subway stations and bus stops to plazas, from libraries and performing art centers to city halls. University and college buildings are often filled with art, and the buildings themselves are art. The chair you are sitting in and the building where you are reading this book are also works of art, maybe not great art, but art all the same, as Duchamp taught us. Even the clothes you are wearing are art. Wherever you find art, it is telling you something and making a statement.

Art is not a luxury, as many people would have us believe, but an integral part of daily life. It has a major impact on us, even when we are not aware of it; we feel better about ourselves when we are in environments that are visually enriching and exciting. Most important, art stimulates us to think. Even when it provokes and outrages us, it broadens our experience by making us question our values, attitudes, and worldview. This book is an introduction to this fascinating field that is so intertwined with our lives. After reading it, you will find that the world will not look the same.

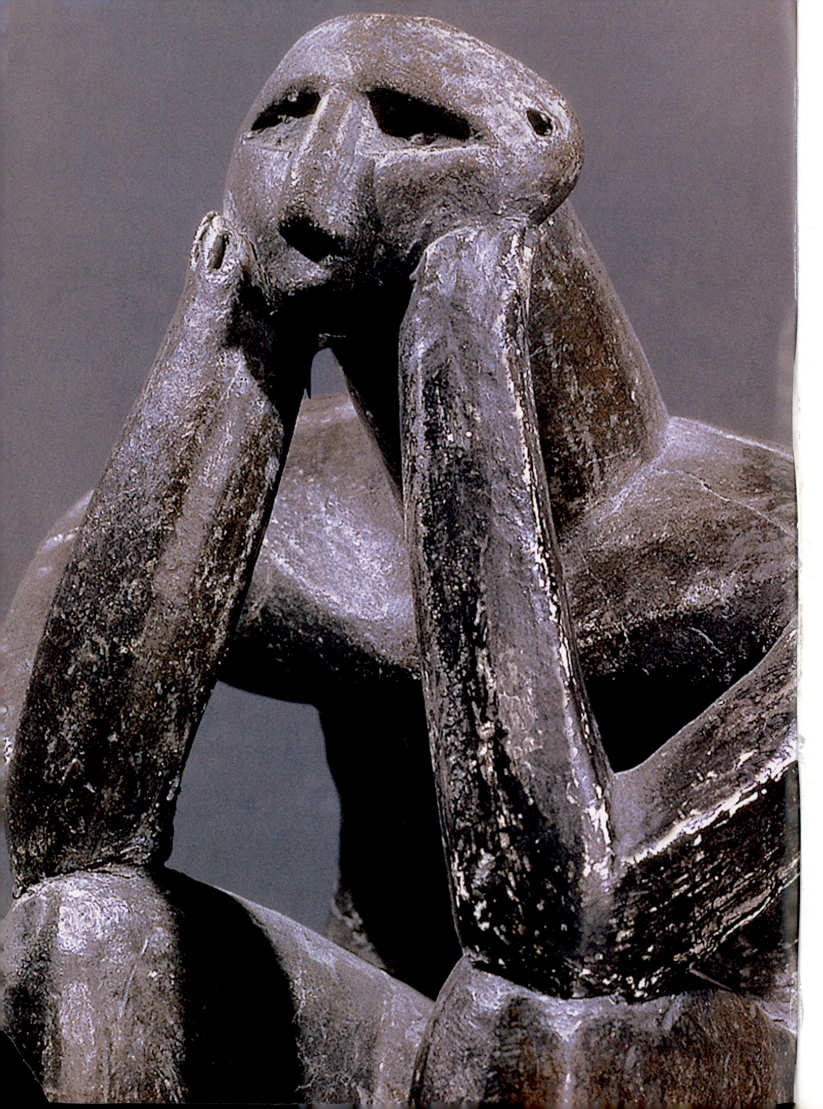

Detail of figure 1.23, Male figure from Cernavoda

Prehistoric Art

WHEN MODERN HUMANS FIRST ENCOUNTERED PREHISTORIC CAVE paintings in the 1870s, they literally could not believe their eyes. Although the evidence indicated that the site at Altamira in Spain dated to around 13,000 BCE, the paintings had been executed with such skill and sensitivity that historians initially considered them forgeries

(see fig 1.1). Since then, some 200 similar sites have been discovered all over the world. As recently as 1994, the discovery of a painted cave in southeastern France (see fig. 1.2) brought hundreds more paintings to light and pushed back the date of prehistoric painting even further, to approximately 30,000 BCE. Some carved objects have been discovered that are equally old.

These oldest forms of art raise more questions than they answer: Why did prehistoric humans expend the time and energy to make art? What functions did these visual representations serve? What do the images mean? A twenty-first–century viewer of prehistoric art may admire the vitality and directness of these works, yet still find it difficult to understand this ancient and alien world. For this prehistoric era there are no texts for historians to consult, so the tools of science and anthropology have contributed to the art historian's attempt to interpret these powerful forms of art, providing evidence for the dates of prehistoric objects and theories for their functions. With new finds being reported with regularity, the study of prehistoric art continues to develop and refine its interpretations and conclusions.

Though fully modern humans have lived on the earth for over 100,000 years, the dates assigned to the earliest objects classed as "art" go back about 40,000 years. Earlier humans had

crafted tools out of stone and fragments of bone, but what inspired them to make detailed representations of forms found in nature? Some scholars suppose that image making and symbolic language as we know it are the result of the new structure of the brain associated with *homo sapiens sapiens*. Art emerges at about the time that fully modern humans moved out of Africa and into Europe, Asia, and Australia, encountering—and eventually displacing—the earlier Neanderthals (*homo neanderthalensis*) of western Eurasia. On each of these continents, we have found evidence of representational artwork or of body decoration contemporary with *homo sapiens sapiens*. Tens of thousands of works survive from this time before history, the bulk of which have been discovered in Europe. Many are breathtakingly accomplished.

The skill with which the earliest datable objects are executed may have been the product of a lengthy and lost period of experimentation in the techniques of carving and painting, so the practice of art making may be much older than the surviving objects. Some scholars disagree. This group argues that a neurological mutation related to the structure of the brain opened up the capacity for abstract thought, and that symbolic language and representational art were a sudden development in human evolution. Whatever led to the ability to create art, whether a gradual evolutionary process, or a sudden mutation, it had an enormous impact on the emergence of human culture, including the making of naturalistic images. Such works force

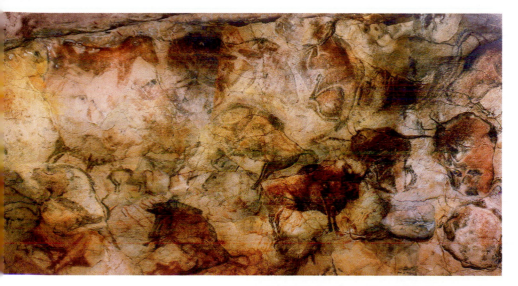

1.1. *Wounded Bison.* ca. 15,000–10,000 BCE. Altamira, Spain

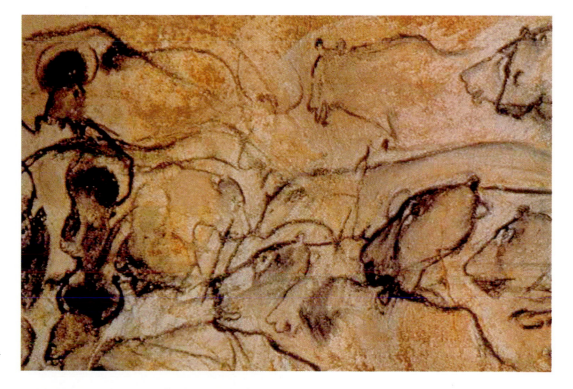

1.2. *Lions and Bison.*
End Chamber, Chauvet Cave.
ca. 30,000–28,000 BCE. Vallon-Pont-
d'Arc, Ardèche Gorge, France

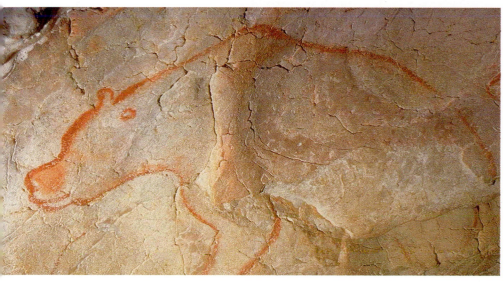

1.3. *Bear.* Recess of the Bears,
Chauvet Cave. ca. 30,000–28,000 BCE.
Vallon-Pont-d'Arc, Ardèche Gorge,
France

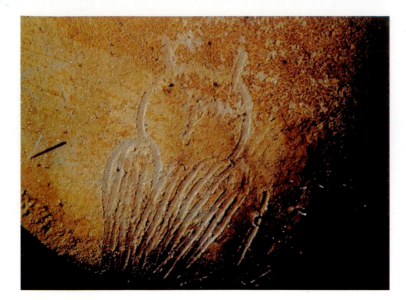

1.4. *Long-Eared Owl.* Chauvet Cave. ca. 30,000–28,000 BCE. Vallon-Pont-d'Arc, Ardèche Gorge, France

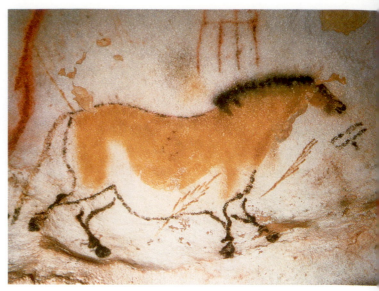

1.5. *Chinese Horse.* Lascaux Cave. ca. 15,000–13,000 BCE. Dordogne, France

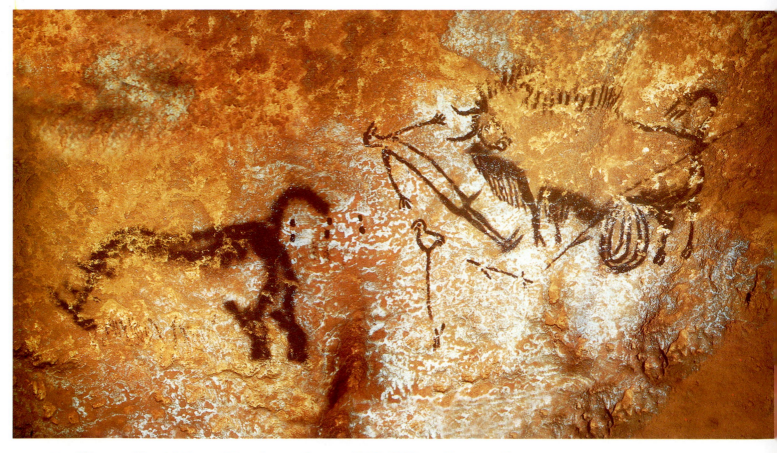

1.6. *Rhinoceros, Wounded Man, and Bison.* Lascaux Cave. ca. 15,000–13,000 BCE. Dordogne, France

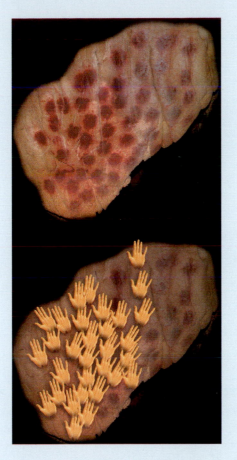

Cave Painting

Artists working in Paleolithic caves used a wide variety of techniques to achieve the images that have survived. Often working far from cave entrances, they illuminated the darkness using lamps carved out of stone and filled with fat or marrow. Archaeologists have found several of these lamps at Lascaux and elsewhere. Sometimes, when the area of rock to be painted was high above ground level, they may have built scaffolds of wood, stabilized against the wall by driving the poles into the limestone surface.

They prepared the surface by scraping the limestone with stone tools, bringing out its chalky whiteness as a background. Some images were then engraved on the wall, with a finger if the limestone was soft enough, or, where it was harder, with a sharp flint. Sometimes they combined this technique with the application of color. Black was created using vegetal charcoal and perhaps charred bones. Ochre, a natural iron ore, provided a range of vivid reds, browns, and yellows. For drawing—outlines of animals, for instance—the charcoal and ochre were deployed in chunks, like a crayon; to generate paint, they ground the minerals into powder on a large flat stone. By heating them to extremely high temperatures, they could also vary the shades of red and yellow. These mineral powders could then be blown through tubes of animal bone or reed against a hand held up with fingers splayed to the rock surface to make hand silhouettes.

To fill in animal or human outlines with paint, they mixed the powders with blenders, which consisted of cave water, saliva, egg white, vegetal or animal fat, or blood; they then applied the colors to the limestone surface, using pads of moss or fur, and brushes made of fur, feather, or chewed stick. Some scholars understand, by experimentation, that pigment was often chewed up in the mouth and then blown or spit directly onto the walls to form images. In some cases, like the spotted horse of Pech-Merle or at Chauvet, paint was applied in dots, leading to what some scholars describe as a "pointilliste" effect. This was achieved by covering the palm with ochre before pressing it against the limestone.

Hand Dots in the Brunel Chamber at Chauvet. Large dots were made by covering the palm with paint and applying it to the wall. In places, fingers are just visible.

Analysis of these marks has yielded rich results: Not only can individual artists be identified by their handprint, but it has even been possible to determine that women and adolescents were at work as well as men.

When they first assessed the Altamira paintings toward the end of the nineteenth century, experts declared them too advanced to be authentic and dismissed them as a hoax. Indeed, though cave art may represent the dawn of art as we know it, it is often highly sophisticated. Like their counterparts at Chauvet and elsewhere, the bison of Altamira were painted from memory, yet their forms demonstrate the painters' acute powers of observation, and an equal skill in translating memory into image. Standing at rest, or bellowing or rolling on the ground, the bison behave in these paintings as they do in the wild. The painters' careful execution enhances the appearance of nature: Subtle shading expresses the contour of a bison's belly, for instance, or a lioness's head, and the forward contour of an animal's far leg is often rendered with a lighter hue to suggest distance. Within the silhouette that defines the shape of the animal, the artist varies the effect of light on the form to suggest its weight or volume. This device, called **modeling**, makes the form look more life like.

Initially, scholars assigned relative dates to cave paintings by using a stylistic analysis, dating them according to the degree of **naturalism** they displayed, that is, how closely the image resembled the actual subject in nature. As naturalism was considered at that time the most advanced form of representation, the more naturalistic the image, the more evolved and, therefore, the more recent it was considered to be. Radiocarbon dating exposed the flaws in this approach. Judged to be more recent in the overall sequence on account of their remarkable naturalism, some of the paintings at Chauvet proved to be among the earliest on record, dating to the Aurignacian period of 32,000 years ago. Indeed, it would be a mistake to assume that naturalism was a Paleolithic artist's—or any artist's—inevitable or only goal. A consistent use of conventions in depicting individual species (bulls at Lascaux depicted in profile but with frontal horns, for instance) defies nature; these are not **optical images**, showing an animal as one would actually see it, but **composite** ones, offering many of the details that go toward making up the animal portrayed, though not necessarily in anatomically accurate positions. As the stick man at Lascaux may illustrate, artists may have judged their success by standards quite removed from naturalism.

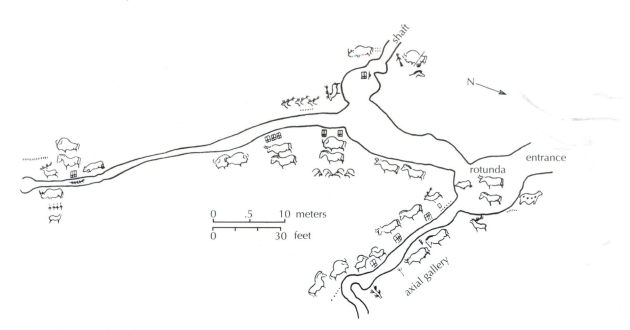

1.7. Schematic plan of Lascaux Cave system (based on a diagram by the Service de l'Architecture, Paris)

Interpreting Prehistoric Painting

As majestic as these paintings can be, they are also profoundly enigmatic: What purpose did they serve? The simplest view, that they were merely decorative—"art for art's sake"—is highly unlikely. Most of the existing paintings and engravings are readily accessible, and many more that once embellished caves that open directly to the outside have probably perished. But some, at Lascaux and elsewhere, lie deep inside extended cave systems, remote from habitation areas and difficult to reach (fig. **1.7**). In these cases, the power of the image may have resided in its making, rather than in its viewing: According to some historians who have attempted to interpret these images, the act of painting or incising the image may have served some ritual or religious purpose.

Art historians often use contemporaneous written texts to supplement their understandings of art. Prehistoric art, however, dates to a time before writing had developed. Works of art are, in fact, among our only "texts" for learning about prehistoric humans. From their initial discovery, scholars turned to approaches developed by ethnographers (anthropologists who study cultural behavior) to interpret these cave paintings and engravings. Most often, the inspiration for these works has been attributed to magico-religious motives. Thus early humans may have perceived an image as equivalent to the animal it represented, and, therefore, to create or possess the image was to exert power over what it portrayed. Image making could have been considered as a force of sympathetic magic, which might improve the success of a hunt. Gouge marks on cave walls indicate that in some cases spears were cast at the images (fig. **1.8**). Similarly, artists may have hoped to stimulate fertility in the wild—ensuring a continuous food supply—by depicting pregnant animals. A magico-religious interpretation might explain the choice to make animals appear lifelike, as well as to fix them within outlines; and yet human fear of being affected by the same magic may account for the decidedly unnaturalistic, abstract quality of the "stick figure" at Lascaux.

More recent theories concerning shamanism—a belief in a parallel spirit world that can be accessed through alternative states of consciousness—have built upon these interpretations, suggesting that an animal's "spirit" was especially evident where a bulge in the wall or ceiling suggested its shape, as with the *Spotted Horses* (fig. 1.8) at Pech-Merle in southwestern France. The artist's or shaman's power merely brought that spirit to the surface. Some scholars have cast the paintings in a central role in early religion, as images for worship, while other interpretations have focused on a painting's physical context. This means examining relationships between figures to determine, in the absence of an artificial

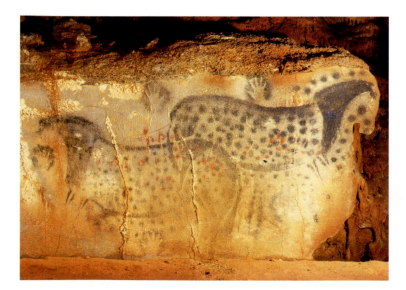

1.8. *Spotted Horses and Human Hands.* Pech-Merle Cave. Dordogne, France. Horses ca. 16,000 BCE; Hands ca. 15,000 BCE; Limestone, approximate length 11'2″ (3.4 m)

1.9. Overlapping animal engravings. ca. 40,000–10,000 BCE. Les Trois Frères, France. Rubbing of the panel done by Abbé Breuil from Begohen Collection

frame, a ground-line or a landscape, whether multiple animal images indicate individual specimens or signify a herd. Such examinations attempt to determine whether these images represent a mythical truth for early communities. Do Lascaux's *Rhinoceros, Wounded Man, and Bison* (fig. 1.6) constitute separate images or the earliest known narrative, telling the gory tale of a hunt or a heroic man's death or possibly a shaman's encounter with his spirit creature? The purpose of engraving multiple animals on top of one another, as at Les Trois Frères (fig. **1.9**), may have been to record animal migrations throughout the passing seasons.

Considering physical context also means recognizing that a cave 15 feet deep and another one over a mile deep are completely different spaces, possibly used for different purposes. Similarly, physical context suggests that the paintings in the spacious Hall of the Bulls at Lascaux and the stick man at the same site, located at the bottom of a 16-foot well shaft, may have functioned quite differently. It also means factoring in the experiential aspect of caves, that is, recognizing that a prehistoric viewer had to contend with a precarious path, eerie flickering lights, echoes near and distant, and the musty smells that permeate subterranean spaces, all of which added texture to the experience of seeing these images (fig. **1.10**).

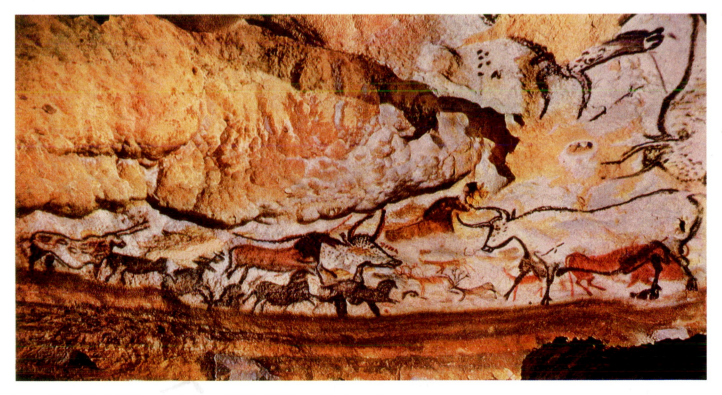

1.10. *Hall of the Bulls.* Lascaux Cave. ca. 15,000–10,000 BCE. Dordogne, France

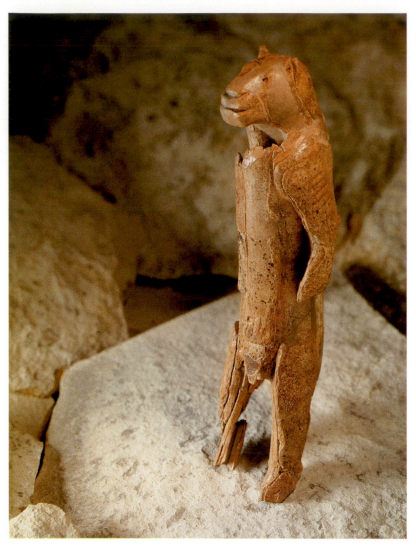

1.11. Hybrid figure with a human body and feline head. ca. 40,000–28,000 BCE. Hohlenstein-Stadel (Baden Wurtemburg), Germany. Mammoth ivory, height 11″ (28.1 cm). Ulma Museum

Most important, recent interpretations have acknowledged that one explanation may not suffice for all times and places. For instance, even if sympathetic magic makes some sense of the *Chinese Horse* from Lascaux with its distended belly (see fig. 1.5), it does little to explain the art at Chauvet, where fully 72 percent of the animals represented were not hunted, as far as can be discerned from the organic remains found in the cave.

Paleolithic Carving

Prehistoric artists also carved and modeled sculptures and **reliefs** in a variety of materials. A large carved figure from Hohlenstein-Stadel in Germany (fig. **1.11**) is slightly more recent than the paintings of Chauvet. At just under a foot high, it represents a standing creature, half human and half feline, crafted out of mammoth ivory. Despite its poor state of preservation, it is clear that creating this figure, with rudimentary stone tools, was an arduous business, involving splitting the dried mammoth tusk, then scraping it into shape and using a sharp flint blade to incise such features as the striations on the arm and the muzzle. Strenuous polishing followed, using powdered hematite (an iron ore) as an abrasive. Exactly what the figure represents is unclear. Like the hybrid figures painted on cave walls, it may represent a human dressed up as an animal,

maybe for hunting purposes. Some prehistorians have named these composite creatures shamans or "sorcerers," who could contact the spirit world through ritualistic behavior.

As in cave paintings, animals were a frequent subject for sculpture. The miniature horse from a cave in Vogelherd along the Danube River in Germany from the Aurignacian period, and the interlocked ibexes of the Magdalenian period, date to the beginning and end of the Upper Paleolithic era (fig. **1.12** and fig. **1.13**). (See *Informing Art*, page 10.) The horse is one of many portable carvings in woolly mammoth ivory dating to around 28,000 BCE. A small hole between its front legs suggests that it was a pendant. The ibexes, carved from reindeer antler around 13,000 BCE, functioned as a spear-thrower. Attached to a spear by the hook at the end of its shaft, it allowed a hunter to propel the weapon more effectively. In both cases, the sculptor had an eye for strong outlines and finished the surface with painstaking care, marking the ibexes' coats with nicks from a stone tool and working up a high polish. Both objects were clearly intended for a functional purpose.

Just as cave artists sometimes transformed bulges in rock walls into painted animals, so, deep within a cave at Le Tuc d'Audoubert in the French Pyrénées, around 13,000 BCE, a sculptor built up a natural outcropping of rock with clay to produce two bison (fig. **1.14**), with a calf originally standing by

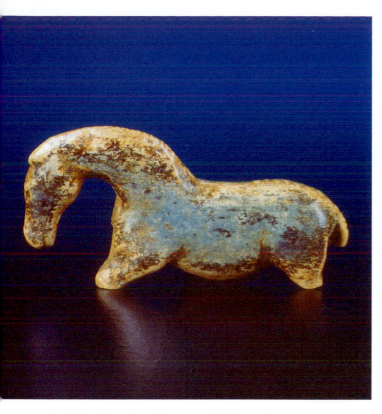

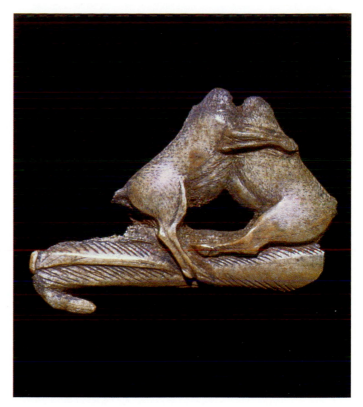

1.12. *Horse*. Vogelherd Cave. ca. 28,000 BCE. Germany. Mammoth ivory, height 2″ (5 cm). Institut für Urgeschichte, Universität Tübingen

1.13. *Spear Thrower with Interlocking Ibexes*. ca. 16,000 BCE. Grotte d'Enlène, Ariège, France. Reindeer antler, 3½ × 2¾″ (9 × 7 cm). Musée de l'Homme, Paris

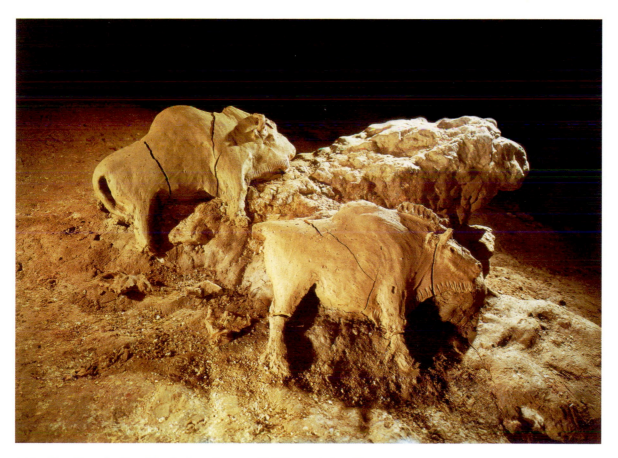

1.14. *Two Bison*. Le Tuc d'Audoubert Cave. ca. 13,000 BCE. Ariège, France. Clay, length 23⅝″ (60 cm)

Telling Time: Labels and Periods

While geologists have developed methods for dividing time based on the age of the Earth, historians have used the human activity of tool making as the defining feature when measuring human time. For the era before the written word (prehistory), the patterns apparent in stone tools serve as the basis for distinguishing different cultures in prehistory. The Stone Age stretches from about 2 million years ago to about 4,000 years ago.

This broad span of time has been divided into the Paleolithic or Old Stone Age (from the Greek *palaio-*, meaning "ancient," and *lithos*, meaning "stone"), the Mesolithic or Middle (*meso-*) Stone Age, and the Neolithic or New (*neo-*) Stone Age. The Paleolithic era spans from 2 million years ago to about 10,000 BCE and the Mesolithic from about 10,000 to 8000 BCE. The Neolithic era spans from about 8000 BCE to about 2000 BCE. At some time during the third millennium BCE, stone tools were replaced by tools made of metal in some parts of the world, ushering in the Bronze Age in Europe and Asia.

Specific human cultures reached these phases at different times: The beginning of the Neolithic era appears to start earlier in western Asia than in Europe, for example. Yet the broad span of the Paleolithic era requires further refinement, and excavations of Paleolithic sites provide another framework for dividing time. The oldest material is at the bottom of an excavation, so the oldest Paleolithic era is called the Lower Paleolithic (ending about 100,000 years ago). The middle layers of Pale-

olithic excavations—thus the Middle Paleolithic era—date from 100,000 years ago to about 40,000 years ago. The most recent layers in such excavations are called the Upper Paleolithic, and date from about 40,000 BCE to around 8000 BCE.

Many sites and different types of tools and tool-making technologies have been used to identify specific culture groups within the Upper Paleolithic period. For example, the Aurignacian culture is named for Aurignac—a site in western France. The objects from this culture date from about 34,000 to 23,000 BCE. The Gravettian culture is named for La Gravette—a site in southwestern France, and dates from about 28,000 to 22,000 BCE. The most recent of these cultures is the Magdalenian, named for a prehistoric site in southwestern France called La Magdaleine, with dates ranging from around 18,000 to 10,000 BCE. Many of these terms were coined in the nineteenth century, when the study of prehistoric culture first took root.

THE PALEOLITHIC AGE

Lower Paleolithic	**2,000,000–100,000 BCE**
Middle Paleolithic	**100,000–40,000 BCE**
Upper Paleolithic	**40,000–10,000 BCE**
Aurignacian	34,000–23,000 BCE
Gravettian	28,000–22,000 BCE
Solutrean	22,000–18,000 BCE
Magdalenian	18,000–10,000 BCE
Mesolithic	**10,000–8000 BCE**
Neolithic	**8000–2000 BCE**

the front legs of the right-hand figure. Each sculpture is about two feet long; their forms swell and taper to approximate the mass of a real bison's form. Yet, despite the three-dimensional character of the representations (notice the fullness of the haunch and shoulder and the shaggy manes), the sculptures share conventions with cave paintings: They are rendered in fairly strict profile, viewable from one side only. Once again the function of the object is unclear: Were such sculptures tools for hunting? Among the human footprints found near this group are those of a 2-year-old child. These, along with a baby's handprint in a cave at Bedeilhac in France, and women's handprints at Chauvet, caution us against reconstructing Paleolithic works of art as the ritual centerpieces of a male-dominated hunting society.

Women were frequent subjects in prehistoric sculpture, especially in the Gravettian period (see *Informing Art*, above), when they far outnumbered men as subject material. In the late nineteenth century, a group of 12 ivory figurines were found together in the Grotte du Pape at Brassempouy in southern France. Among them was the *Dame à la Capuche* or *Woman from Brassempouy* (fig. **1.15**) of about 22,000 BCE. The sculpture is almost complete as it is, depicting only a head and long elegant neck. At merely 1½ inches long, it would rest comfortably in the hand, where it may have been most commonly viewed. Also hand-sized is the limestone carving of the nude *Woman of Willendorf* of Austria, dating somewhat earlier, from about

28,000 to 25,000 BCE (fig. **1.16**). Discovered in 1908, her figure still bears traces of ocher rubbed onto the carved surface. Both figurines are highly abstract. Instead of attempting to render the human figures with the naturalism found in the representations of animals, the artist reduced the female form to basic shapes. On the *Woman from Brassempouy*, the artist rendered the hair schematically with deep vertical gouges crossed by shallow horizontal lines, softened by vigorous polishing. There is no mouth and only the mere suggestion of a nose; the eyes are evocatively suggested by hollowed-out, overhanging eye sockets and holes cut on either side of the bridge of the nose. The quiet power and energy of the figure reside in the dramatic way its meticulously polished surface responds to shifting light, suggesting movement, elegance, and liveliness.

In the case of the *Woman of Willendorf*, the abstract quality of the work appears to stress a potent fertility. This kind of abstraction appears in many other figurines as well; indeed, some incomplete figurines depict only female genitalia. Clearly, facial features are not a priority: The schematically rendered hair covers the entire head. Instead, the emphasis rests on the figure's reproductive qualities: Diminutive arms sit on pendulous breasts, whose rounded forms are echoed in the extended belly and copious buttocks. Genitalia are shown between large thighs. The emphasis on the reproductive features suggests that the sculpture may have been a fertility charm, yet the intention may have been to ensure a successful birth outcome rather than an

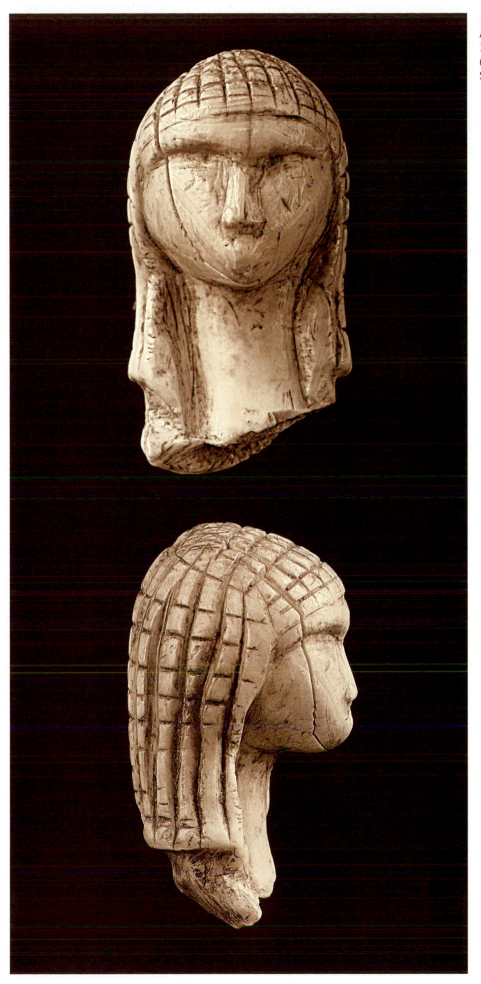

1.15. *Dame à la Capuche (Woman from Brassempouy).* ca. 22,000 BCE. Grotte du Pape, Brassempouy, France. Ivory, height 1½″ (3.6 cm). Musée des Antiquités Nationales, Saint Germain-en-Laye

NEOLITHIC ART

Around 10,000 BCE, the Earth's climate gradually began to warm, and the ice that had covered almost a third of the present-day globe began to recede. As melting glaciers created oceans, land masses were separated by water, and Europe developed more or less the geography it has today. The warming climate encouraged both new vegetation and changing animal populations: Reindeer migrated north, from modern France to Scandinavia; woolly mammoths and many other species became extinct. These changes in plant and animal life inevitably caused human habits to change. The new cultural age that marks the Neolithic period is characterized by a changing relationship between humans and their environment. Whereas previously they had built small huts and found shelter and ritual spaces in caves where the landscape allowed, in the Neolithic period, or New Stone Age, they began to build more substantial structures, settling in fixed places selected for favorable qualities, such as a good water supply, rather than moving with the seasons. Instead of hunting in the wild and gathering what nature supplied, they domesticated animals and plants. The change was gradual and occurred at different moments in different places; indeed, in some areas of the world, hunting and gathering are still the way of life today.

Settled Societies and Neolithic Art

The earliest evidence of these adjustments to environmental shifts is in the fertile regions of the eastern Mediterranean and Mesopotamia, between the Euphrates and Tigris rivers. A small settlement developed in the ninth millennium BCE by the River Jordan at the site of Jericho, of biblical fame, in the present West Bank territory. Over time its inhabitants built houses of sun-baked mud brick on stone foundations. They plastered the floors and crafted roofs of branches and earth. Skeletal remains indicate that they buried the bodies of their dead beneath the floors, though they treated the heads differently. Skulls were displayed above ground, reconstructed with tinted plaster to resemble flesh, with eyes of seashell fragments (fig. 1.17). The subtlety of their modeling, with its gradation of planes and ridges, and the close observation of the interplay between flesh and bone, make these works remarkably lifelike, each as individual as the skulls they encased. Whether these funerary practices reveal an attitude about the afterlife is unclear; at the least, they suggest a respect for the dead or perhaps ancestor worship. As the town grew, expanding to cover some ten acres, and as neighboring settlements came to present a threat, so too a desire for protection developed. Thus, around 7500 BCE, the people of Jericho, now numbering over 2,000, dug a wide ditch and raised a solid stone wall around their town, 5 feet thick and over 13 feet high. Into it they set a massive circular tower, perhaps one of several, 28 feet tall and 33 feet in diameter at the base, with a staircase inside providing access to the summit (fig. 1.18). With this fortification system, built with only the simplest stone tools, monumental architecture was born.

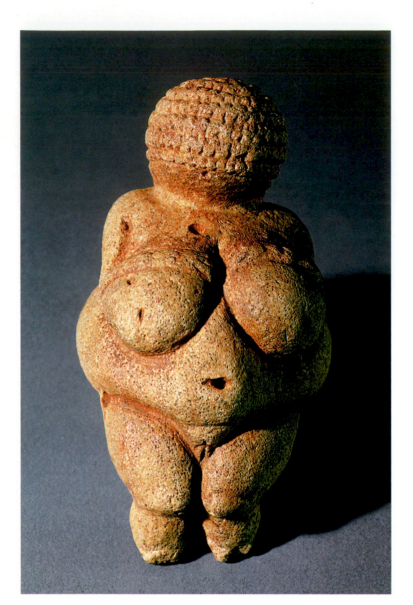

1.16. *Woman of Willendorf*. ca. 28,000–25,000 BCE. Limestone, height $4^3/_8''$ (11.1 cm). Naturhistorisches Museum, Vienna

increase in numbers of pregnancies. Perhaps she was a doll, or a venerable ancestor. In a period when food was scarce, a woman with these proportions may well have been exceptional.

The uncertainty of our interpretation of figures like the *Woman from Brassempouy* and the *Woman of Willendorf* has been further complicated by the terminology applied to them in the past. The *Woman of Willendorf*, like many other Paleolithic female figurines, was named a "Venus" figure. The term dates back to the discovery of the first female figurines in the mid-nineteenth century. Venus is the Roman version of the Greek goddess Aphrodite, who was portrayed as a nude female; nineteenth-century archeologists saw these figures as similar in function, if not in form, to the Roman goddess. Contemporary scholars are still debating the meaning of these female figures, and avoid such anachronisms in terminology. We do not know whether this figure represents a specific woman, or a generic or ideal woman. Indeed, the figure may not represent the idea of woman at all, but rather the notion of reproduction or, as some scholars have argued, the fertile natural world itself.

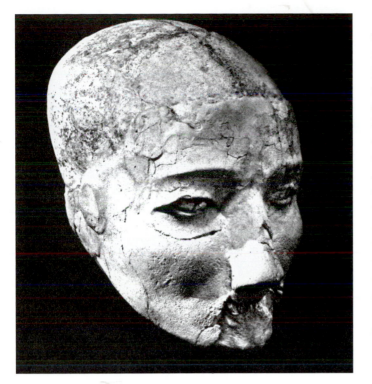

1.17. Neolithic plastered skull. ca. 7000 BCE. Jericho, Jordan. Lifesize. Archaeological Museum, Amman

At Ain Ghazal, near Amman in Jordan, over 30 fragmentary plaster figures, dating to the mid-seventh millennium BCE, represent a starkly different sculptural tradition from the Jericho heads (fig. **1.19**). Some are only bust size, but the tallest statues, when restored, stand up to 3 feet tall, and constitute the first known large-scale sculptures. Conservators have studied the construction technique of these figures, and concluded that large size was the motivating force behind their design, directly resulting in their flat, shallow appearance. These investigations have shown that artists applied plaster to bundles of fresh reeds, bound with cordage, which they kept horizontal during the assembly process. They added the legs separately, then applied paint and set in cowrie shells for eyes, darkened with bitumen (a black, tarlike substance) for pupils. Once the plaster was dry, they stood the fragile figures upright and probably added wigs and clothing. Like the Jericho heads, they may have represented ancestors. However, as some of the bodies are two-headed, these figures may have had a mythical function.

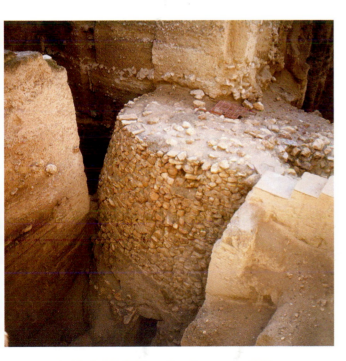

1.18. Early Neolithic wall and tower. ca. 7500 BCE. Jericho, Jordan

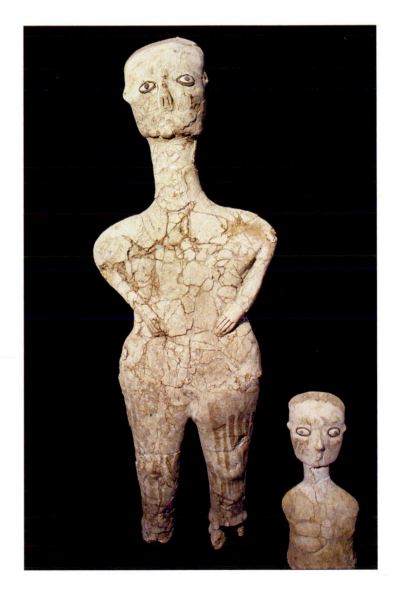

1.19. Human figures. ca. 6750–6250 BCE. Ain Ghazal, Jordan. Height of larger figure 33″ (84 cm). Department of Antiquities, Amman

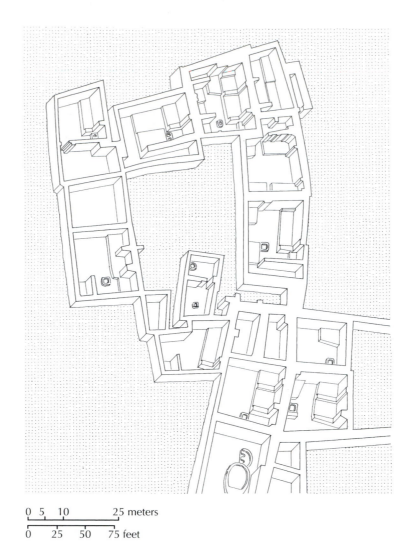

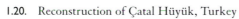

0 5 10 25 meters

0 25 50 75 feet

I.20. Reconstruction of Çatal Hüyük, Turkey

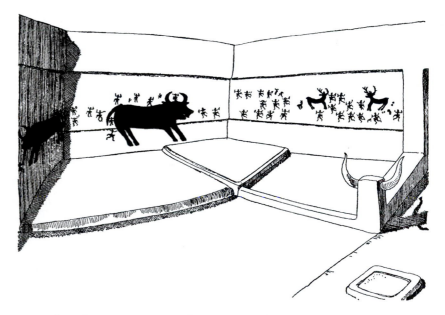

I.21. *Animal Hunt.* Restoration of Main Room, Shrine A.III.1.
ca. 6000 BCE. Çatal Hüyük (after Mellaart)

ÇATAL HÜYÜK In Anatolia (modern Turkey) excavations since 1961 have revealed a Neolithic town at Çatal Hüyük, dating from about 7500 BCE, a thousand years more recent than Jericho (see map 1.1). Flourishing through trade in ores—principally obsidian, a highly valued glasslike volcanic stone, which, when chipped away, made strong, sharp blades—the town developed rapidly through at least 12 successive building phases between 6500 and 5700 BCE. Its most distinctive feature is that it had no streets, and the houses had no doors at ground level: Each mud brick and timber house stood side by side with the next, accessed by ladder through a hole in the roof that doubled as a smoke vent (fig. **1.20**). The advantages of this design were both structural— each house buttressing the next—and defensive, since any attacker would have to scale the outer walls and then face resistance on the rooftops. The rooms inside accommodated all activities, from working and cooking to sleeping, on platforms lining the walls. As at Jericho, burials were beneath the floor.

Some of the rooms at Çatal Hüyük were decorated with bulls' horns and plaster breasts, perhaps to signify fertility (fig. **1.21**). Some archeologists believe that the more ornate rooms functioned as shrines, but this remains speculation. It is clear, however, that most of the rooms were plastered, and often they were painted. Many of the paintings depict animal hunts, with small human figures running around disproportionately large bulls or stags. The images have a static quality, quite unlike the earlier cave paintings that seem in constant motion.

One very unusual painting, found in an early room, appears to depict rows of irregular blocklike houses, and probably represents Çatal Hüyük itself (fig. **1.22**). Above the town, a bright red feature spotted with black and topped with black lines and dots, may represent Hasan Dag, a twin-peaked volcano in view of the town. Unlike cave paintings, where no location is indicated, if this site has been properly interpreted, the focus of this painting is landscape, making it the first of its kind. The painting may indicate a strong sense of community in this early settlement, whose members identified specifically with place.

OVEN-FIRED POTTERY During the Neolithic period, a number of new technologies developed that collectively suggest the beginnings of specialization. As the community could depend on a regular food supply, some members could devote time to acquiring special skills. The new technologies included pottery, weaving, and some smelting of copper and lead. Pottery survives best, since oven-fired pottery is extremely durable, often surviving as discarded shards. Though absent from early Jericho, a great variety of clay vessels painted with abstract forms have been found in regions stretching from Mesopotamia, where pottery may have originated in the sixth millennium BCE, to Egypt and Anatolia, where it survives at Çatal Hüyük (see map 1.1). Pottery has also been discovered at other settlements in Anatolia's central plateau. Archeologists have also found pottery from this period in the Balkans, and by about 3500 BCE the technology of pottery making appears in western Europe.

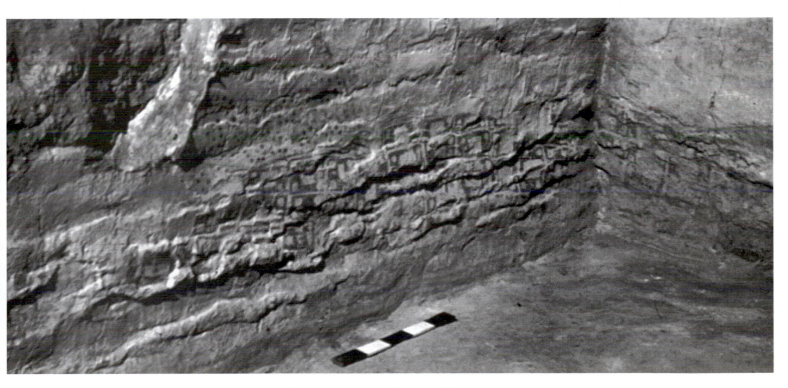

1.22. *View of Town and Volcano.* ca. 6000 BCE. Wall painting, Shrine VII.14. Çatal Hüyük

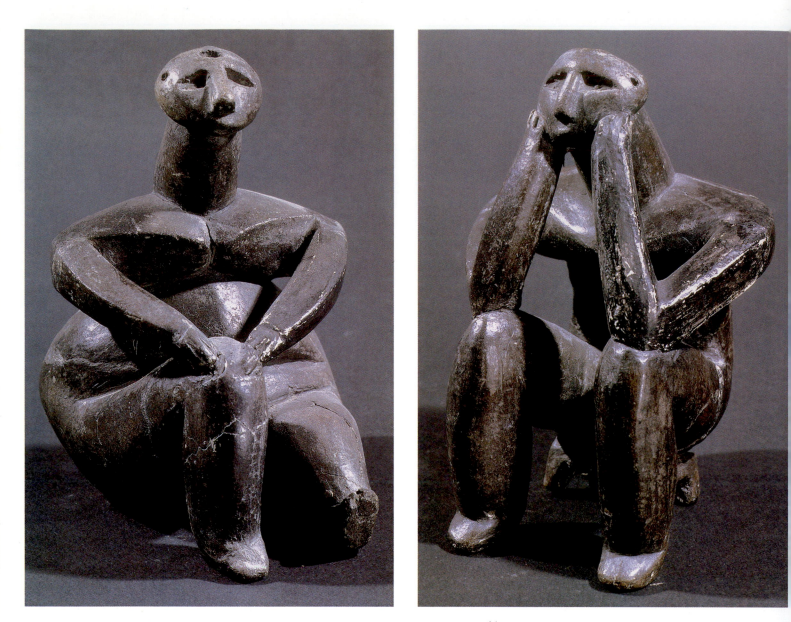

1.23. Female and male figures. ca. 3500 BCE. Cernavoda, Romania. Ceramic, height 4½″ (11.5 cm). National Museum of Antiquities, Bucharest

In Europe, artists also used clay to fashion figurines, such as a woman and man from Cernavoda in Romania, dating from about 3500 BCE (fig. **1.23**). Like the *Woman of Willendorf* and the Ain Ghazal figurines, they are highly abstract, yet here the forms are more linear than rounded: The woman's face is a flattened oval poised on a long, thick neck, and sharp edges articulate her corporeality—across her breasts, for instance, and at the fold of her pelvis. The elbowless arms meet where her hands rest on her raised knee, delineating a triangle and enclosing space within the sculptural form. This in turn emphasizes the figurine's three-dimensionality, encouraging a viewer to look at it from several angles, moving around it or shifting it in the hand. It is the pose that the abstraction highlights; yet, tempting as it may be to interpret it, perhaps as

coquettishness, we should be cautious about reading meaning into it, since gestures can have dramatically different meanings from one culture to another. Found in a tomb, the woman and the accompanying man may represent the deceased, or a companion or mourner for the dead; perhaps they were gifts that had a separate purpose before burial.

Architecture in Europe: Tombs and Rituals

In Europe, concerns about ceremonial burial and ritual, rather than protection, inspired monumental architecture. Individual dwellings were mostly framed in wood, with walls of wattle (branches woven into a frame) and daub (mud or earth dried

around the wattle) and roofs of thatch, which rarely survive. Yet Neolithic people of western and northern Europe defined spaces for tombs and rituals with huge blocks of stone known as **megaliths**. Often they were mounted in a **post-and-lintel** arrangement (with two upright stones supporting a third horizontal capstone). (See fig. **1.25**.) Using this method, they constructed tombs for the dead with one or more chambers, termed *dolmen* tombs, that were both impressive and durable. Other sites, which scholars believe were used as ritual centers, marked out horizontal space in distinct ways. Between 4250 and 3750 BCE at Ménec, in the Carnac region on the south coast of Brittany (see map 1.1), over 3,000 megaliths were set upright at regular intervals in long, straight rows, stretching out over 2 miles. Typically, the smaller stones of about 3 feet in height stand on the eastern end, and, gradually, the height of the stones increases, reaching over 13 feet at the western end (fig. **1.24**). The lines' east–west orientation leads scholars to argue that they gauged the sun's position in the sky at different times of year, functioning as a calendar for an agrarian people whose sustenance depended on the sun's cycle. Quarrying, shaping, transporting, and erecting these blocks was an extraordinary feat, requiring the effective organization of manpower, quite apart from remarkable engineering expertise. The resulting monument, with its simple repeated forms both identical in shape and different as they increased in size, both still and yet cast into motion

ART IN TIME

ca. 10,000 BCE—Earth's climate gradually begins to warm

ca. 7500 BCE—Jericho's fortification system; beginning of monumental architecture

ca. 3500 BCE—Pottery manufacturing appears in Western Europe

ca. 2100 BCE—Final phase of the construction at Stonehenge

by the sun's slow and constant passage, has a calm grandeur and majesty that imposes quiet order on the open landscape.

Often, megaliths appear in circles, known as **cromlechs**. This is the most common arrangement in Britain, where the best-known megalithic structure is Stonehenge, on the Salisbury Plain (figs. **1.25** and **1.26**). What now appears as a unified design is in fact the result of at least four phases of construction, beginning with the excavation of a huge ditch defining a circle some 330 feet in diameter in the white chalk ground, with an embankment of over 6 feet running around the inside. A wide avenue lined with stones led northeast from the circle to a pointed grey sandstone (*sarsen*) megalith, known today as the *heel stone*. Further megaliths were brought inside the circle, so that by about 2100 BCE, Stonehenge had grown into a horseshoe-shaped arrangement of five sarsen *triliths* (two upright stones supporting a third horizontal one). Encircling them was a ring of upright

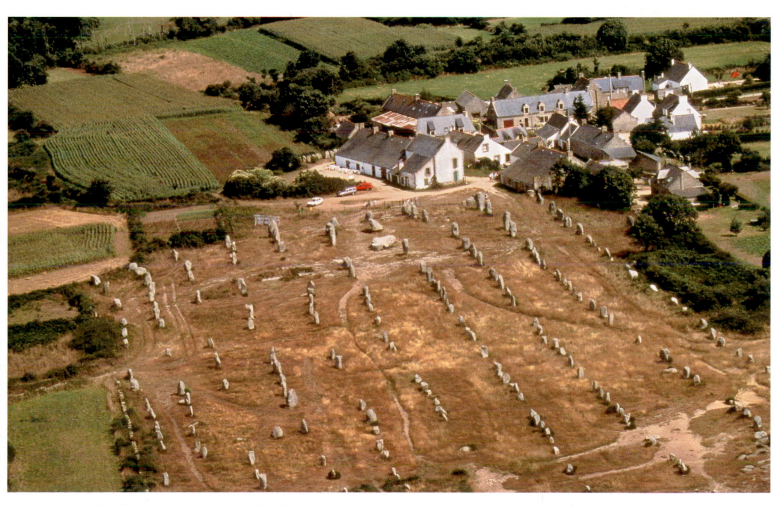

1.24. Menhir alignments at Ménec. ca. 4250–3750 BCE. Carnac, France

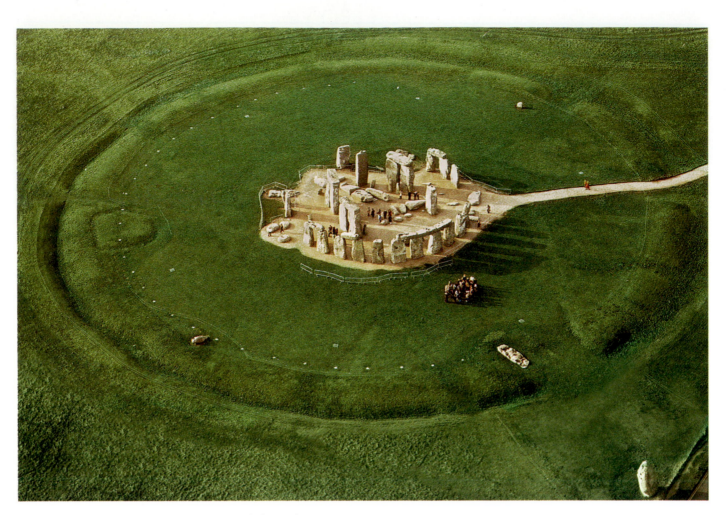

1.25. *Stonehenge* (aerial view). ca. 2100 BCE. Salisbury Plain, Wiltshire, England. Diameter of circle 97′ (29.6 m)

blocks capped with a continuous lintel, and between the rings was a circle of smaller bluestone blocks.

Exactly what Stonehenge signified to those who construct-ed it over the centuries remains a tantalizing mystery. Many prehistorians believe that it, too, functioned at least in part to mark the passing of time. Given its monumentality, most also concur that it had a ritual function; its careful circular arrange-ment supports this conjecture, as circles are central to rituals in many societies. Indeed, these two qualities led medieval observers to believe that Stonehenge was created by King Arthur's magician, Merlin, and it continues to draw crowds on summer solstices. What is certain, however, is that, like Ménec, Stonehenge represents tremendous manpower organization and engineering skill. The largest sarsen trilith, at the center of the horseshoe, soars 24 feet, supporting a lintel 15 feet long and 3 feet thick. The sarsen blocks weigh up to 50 tons apiece, and traveled 23 miles from the Marlborough Downs; the bluestones originated 200 miles away, in the Welsh Preseli Mountains. Just as impressive is that, in their finished state, the blocks reveal evidence of meticulous stone working. Holes hollowed out of the capstones fit snugly over projections on the uprights (form-ing a mortise and tenon joint), to make a stable structure. Moreover, the blocks are tailored to produce the kind of refine-ments usually associated with the Parthenon of Classical

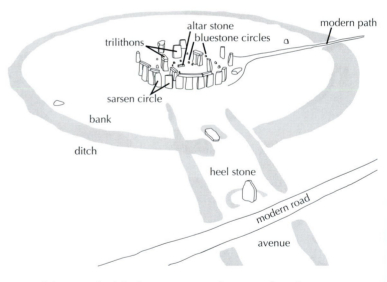

1.26. Diagram of original arrangement of stones at Stonehenge

Athens (see fig. 5.39): Upright megaliths taper in toward the top, with a central bulge, creating a visual impression of the weight they bear, and capturing an energy that gives life to the stones. The lintels are worked in two directions, their faces inclining outward by about 6 inches to appear vertical from the ground, while at the same time they curve around on the hori-zontal plane to make a smooth circle.

SUMMARY

Humans began to express themselves visually during the prehistoric age. They left behind no written records to explain their intentions, however, and thus prehistoric art raises as many questions as it answers. Even so, by the end of the era, people had established techniques of painting, sculpting, and pottery making, and they had begun to construct monumental works of architecture. They also developed a strong sense of the power of images and spaces. They had a recognition of both how to produce impressive shapes, such as those at Altamira and other caves, and how to alter space in sophisticated ways, as seen in the megaliths at Ménec and elsewhere.

PALEOLITHIC ART

During the Stone Age, humans subsisted by hunting animals and gathering other available foods. Yet they found the time—and had the need—to make art. Paleolithic art survives mostly in two forms: paintings on cave walls and smaller objects carved from bone or stone. Its most frequent subject is the animal—most often those animals that people depended on for food. These renderings of animal forms are incredibly lively and naturalistic, though their function and meaning are not well understood. In comparison, when the human figure is depicted, it is much more abstract.

NEOLITHIC ART

During the Neolithic period, humans domesticated animals and raised their own plants for food, leading to a more settled way of life. Architecture was made from more permanent materials than the earlier Paleolithic dwellings. The formation of human communities resulted in increased specialization and new technologies, such as pottery making. Sculpted and painted representations give evidence of developing religious practices and concern for the dead. Other innovations include large-scale stone structures for burial and other monuments, which many scholars see as tools for marking the passage of the seasons.

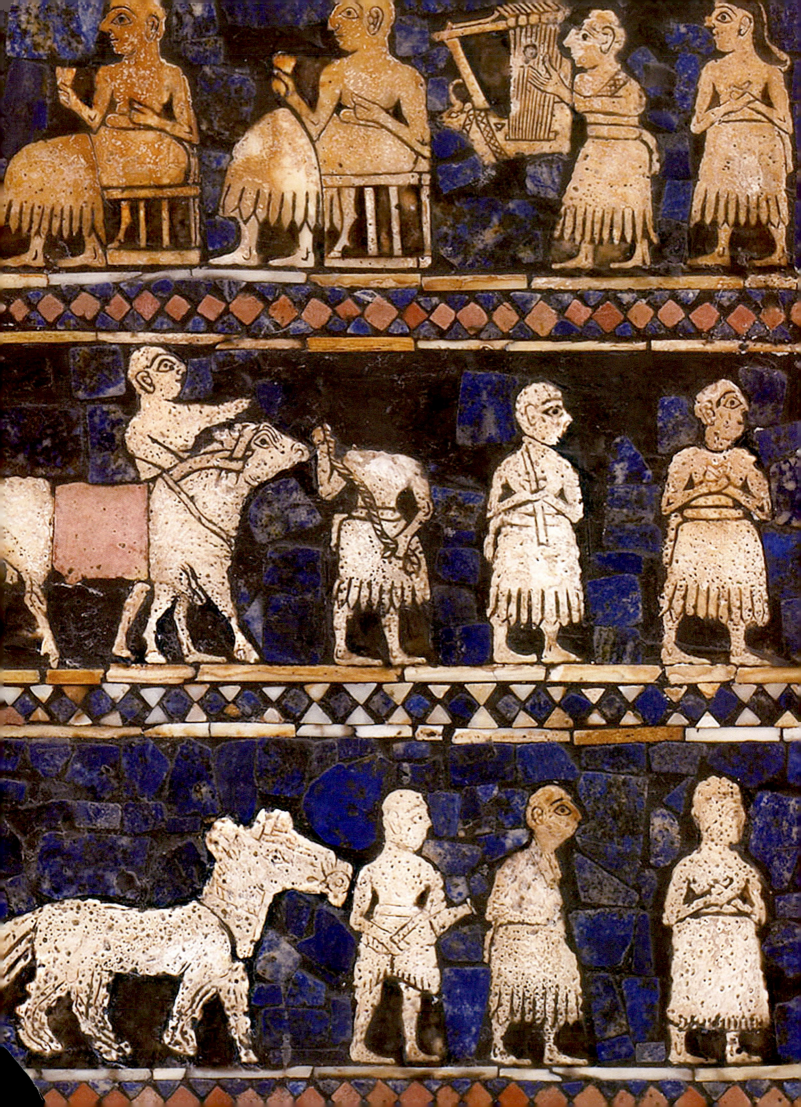

Ancient Near Eastern Art

GROWING AND STORING CROPS AND RAISING ANIMALS FOR FOOD, THE signature accomplishments of Neolithic peoples, would gradually change the course of civilization. Not long before they were freed from following wild animal herds and gathering food to survive, people began to form permanent settlements. By the end of the Neolithic era, these

settlements grew beyond the bounds of the village into larger urban communities. Small rural communities appeared throughout western Asia, but in the fourth millennium BCE, large-scale urban communities of as many as 40,000 people began to emerge in Mesopotamia, the land between the Tigris and the Euphrates rivers. The development of cities had tremendous ramifications for the development of human life and for works of art.

The "land between the rivers" offered many opportunities for the Neolithic farmer. Although today the region is largely an arid plain, written, archaeological, and artistic evidence indicates that at the dawn of civilization it was covered with lush vegetation. By mastering irrigation techniques, populations there were able to exploit the rivers and their tributaries to enrich the fertile soil even further. New technologies and inventions, including the wheel and the plow, and the casting of tools in copper and bronze, increased food production and facilitated trade. As these communities grew and flourished, they developed into city-states with distinct patterns of social organization to address the problems of urban life. The specialization of labor, trade, and economic exchange, the mechanisms for the resolution of disputes, and the construction of defensible walls all required a central authority and government, which developed in response to these needs.

Detail of figure 2.8, *Royal Standard of Ur*

The efficient administration that accompanied this social organization probably generated what may have been the earliest writing system, beginning around 3400 to 3200 BCE, consisting of pictograms pressed into clay with a stylus for the purpose of creating inventories. By around 2900 BCE, the Mesopotamians had refined the pictograms into a series of wedge-shaped signs known as **cuneiform** (from *cuneus*, Latin for wedge). This system was used for early administrative accounts and the Sumerian *Epic of Gilgamesh* in the late third millennium BCE. Cuneiform writing continued through much of the ancient era in the Near East and formed a cultural link between a variety of groups who established power in the region. Different groups adopted cuneiform writing to record their own languages. With the invention of writing, we enter the realm of history.

The geography of Mesopotamia had other profound effects on the civilizations that grew there. Unlike the narrow, fertile strip of the Nile Valley, protected by deserts on either side, where urban communities also began to thrive at around this time, Mesopotamia is a wide, shallow trough, crisscrossed by the two rivers and their tributaries and with few natural defenses. Easily entered from any direction, the region was constantly traversed by people wanting to exploit its fertile soil. Indeed, the history of the ancient Near East is a multicultural one, with city-states constantly warring with one another and only sometimes uniting under a single ruler. Despite frequent

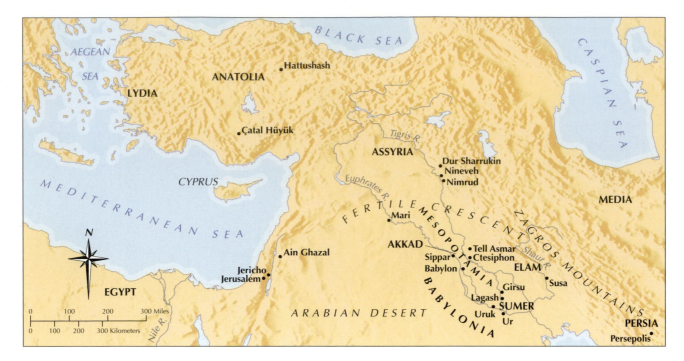

Map 2.1. The Ancient Near East

shifts of power, however, Mesopotamian visual culture retains a surprisingly constant character. Two dominant themes emerge: Art was used to effect and reflect political power; Mesopotamians also used visual narrative, exploring strategies for telling stories through art.

SUMERIAN ART

The first major civilization in Mesopotamia was in the southern region of Sumer, near the junction of the Tigris and Euphrates rivers, where several city-states were founded at some point before 4000 BCE (see map 2.1). These cities flourished under Sumerian control until about 2340 BCE. Just who the Sumerians were is unknown; often scholars can establish linkages between peoples through common linguistic traditions, but Sumerian is not related to any other known tongue. Archeological excavations since the middle of the nineteenth century have unearthed many early clay tablets with cuneiform writing that includes inventories and lists of kings, as well as poetry (fig. 2.1). Many of the earliest excavations concentrated on Sumerian cities mentioned in the Bible, like Ur (the birthplace of Abraham) and Uruk (the biblical Erech). Along with architecture and writing, works of art in the form of pottery, sculpture, and relief inform us about Sumerian society.

For Sumerians, life itself depended on appeasing the gods, who controlled natural forces and phenomena, such as weather and water, the fertility of the land, and the movement of heavenly bodies. Each city had a patron deity, and the residents owed it both devotion and sustenance. The god's earthly steward was the city's ruler, who directed an extensive administrative staff

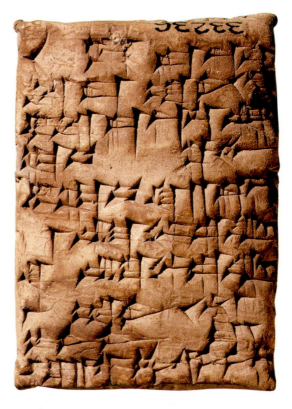

2.1. Babylonian deed of sale. ca. 1750 BCE. This deed graphically shows the impressions made by the stylus in the soft clay. Department of Western Asiatic Antiques, No. 33236. The British Museum, London

Mud Brick

Mud brick was made primarily from local clay. Raw clay absorbs water, and then cracks after drying. As a binding agent and to provide elasticity and prevent cracking, Sumerian builders would add vegetable matter, such as straw, to the clay. By forcing the mud mixture into wooden frames, the brick makers obtained uniformly rectangular bricks. Once molded, the bricks were knocked out of the frames and placed in the sun to bake. To erect walls, builders joined the bricks together with wet clay. One disadvantage of mud brick is that it is not durable. The Sumerians would therefore seal important exterior walls with bitumen, a tar-like substance, or they would use glazed bricks. Interior walls were sometimes covered with plaster.

Mud brick is not a material that readily excites the imagination today (in the way that, for instance, marble does), and because it is so highly perishable, it has rarely survived from ancient times to indicate how Sumerian temples might once have looked. However, more recent comparanda like the kasbahs south of Morocco's Atlas mountains, at Aït Ben Haddou and elsewhere, reveal the extraordinary potential of the material. There, the easy pliability of mud brick allows for a dramatic decorative effect that is at once man-made and in total harmony with the natural colors of the earth. Notice too the geometric designs echoed in the woodwork of doorways and windows. First constructed in the sixteenth century CE, these buildings undergo constant maintenance (recently funded by UNESCO) to undo the weather's frequent damage. Naturally, Sumerian temples may have looked quite different, but the kasbahs serve as a useful reminder that mud bricks are capable of magnificent results.

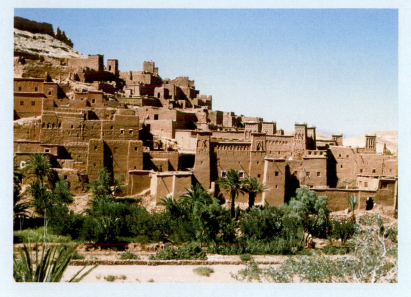

Mud-brick kasbahs at Aït Ben Haddou, Morocco

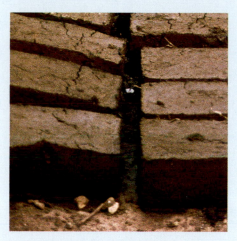

Mud bricks at Aït Ben Haddou, Morocco

based in the temple. As the produce of the city's land belonged to the god, the temple staff took charge of supplying farmers with seed, work animals, and tools. They built irrigation systems, stored the harvest, and distributed it to the people. Centralized food production meant that much of the population could specialize in other trades. In turn, they donated a portion of the fruits of their labor to the temple. (This system is called theocratic socialism.)

Temple Architecture: Linking Heaven and Earth

The temple was the city's architectural focus. Good stone was scarce, and the Sumerians built predominantly with mud brick, covered with plaster. (See *Materials and Techniques*, above).

Scholars distinguish two different types of Sumerian temple. "Low" temples sat at ground level. Usually their four corners were oriented to the cardinal points of the compass. The temple was tripartite: A rectangular cella was lined on its two long sides with rooms serving as offices, priests' quarters, and storage areas. The essential characteristics of "high" temples were similar, except that a platform raised the building above ground level; these platforms were gradually transformed into squat, stepped pyramids known as **ziggurats**. The names of some ziggurats—such as Etemenanki at Babylon, which translates as "House temple, bond between heaven and earth"— suggest that they may have been built as a link or portal to the heavens, a place where priest and god could commune.

Being approximately 40 to 50 feet high (at Warka and Ur), ziggurats functioned analogously as mountains. Rising out of the flat plain, mountains held a sacred status for Sumerians. They carried priests close to divine power, and were the source of water flowing to the valleys. A place of refuge in times of flooding, they also symbolized the Earth's generative power. Indeed, the Sumerian mother goddess was known as the Lady of the Mountain. Significantly, the raised platforms of high

2.2. Remains of the "White Temple" on its ziggurat. ca. 3500–3000 BCE. Uruk (Warka), Iraq

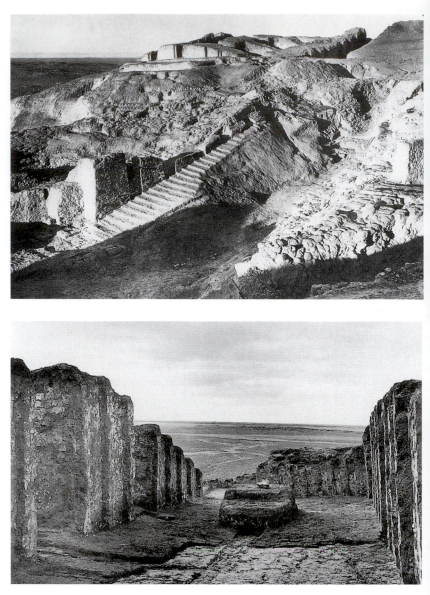

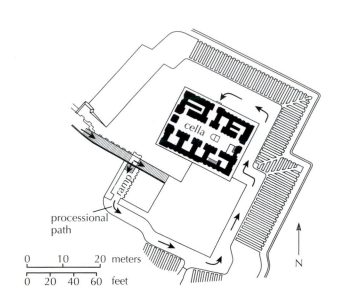

2.3. Plan of the "White Temple" on its ziggurat (after H. Frankfort)

0 10 20 meters
0 20 40 60 feet

2.4. Interior of the cella of the "White Temple"

temples made them more visible. Mesopotamian texts indicate that the act of seeing was paramount. In seeing an object and finding it pleasing, a god might act favorably toward those who made it. The desired response of a human audience, in turn, was wonder. Finally, there was probably a political dimension to the high platform also: It emphasized and maintained the priests' status by visually expressing their separation from the rest of the community. The ziggurat and temple precincts dominated the Sumerian city.

Around 3500 BCE, the city of Uruk (present-day Warka and the biblical Erech) emerged as a center of Sumerian culture, flourishing from trade in its agricultural surplus. One of its temples, the "White Temple," named for its white-washed brick surfaces, was probably dedicated to the sky-god Anu, chief of the Sumerian gods (fig. 2.2). The temple sits on a 40-foot mound constructed by filling in the ruins of older temples with brickwork, suggesting that the site itself was sacred (fig. 2.3). Recessed brickwork articulated its sloped sides. A system of stairs and ramps led counterclockwise around the mound, culminating at an entrance in the temple's long north side. This

indirect approach is a characteristic feature of Mesopotamian temple architecture (in contrast to the direct axial approach typical in Egypt), and the winding ascent mirrored a visitor's metaphorical ascent into a divine realm. From three sides, members of the community could also witness the ceremonial ascent of the elite group of priests and leaders who had exclusive access to the temple. Enough survives of the temple's superstructure to indicate that thick walls with frequent buttressing surrounded a central, rectangular hall called a **cella** housing a stepped altar (fig. 2.4). Along the two longsides of the cella were several smaller rooms, creating an overall tripartite layout typical of the earliest temples.

Uruk was the home of the legendary king Gilgamesh, hero of the epic poem that describes his adventures. In the epic, Gilgamesh is credited with building the city walls and the Eanna, the temple of Inanna or Ishtar. In the Eanna precinct, archeologists found several temples whose walls were decorated with colored stone or painted clay cones set into plaster to form mosaic patterns. (See *Primary Source*, page 25.) The poem describes the temple's gleaming walls, built with "kiln-fired

The Gilgamesh Epic

One of the earliest written epics, the Gilgamesh epic survives on cuneiform tablets. Although the earliest texts to survive come from Akkadian tablets, written after 2150 BCE, the text itself dates to the Sumerian era, about 2800 BCE. The surviving parts of the epic recount the tale of Gilgamesh, the king of Uruk, who first battles, then befriends the wild man Enkidu. When his friend dies, Gilgamesh goes in search of a way to defeat death, but instead returns to Uruk, accepting his own mortality. This excerpt from the beginning of the poem describes (with gaps from the sources) Gilgamesh's accomplishments as king.

Anu granted him the totality of knowledge of all.
He saw the Secret, discovered the Hidden,
he brought information of (the time) before the Flood.
He went on a distant journey, pushing himself to exhaustion,
but then was brought to peace.
He carved on a stone stela all of his toils,
and built the wall of Uruk-Haven,
the wall of the sacred Eanna Temple, the holy sanctuary.

Look at its wall which gleams like copper(?),
inspect its inner wall, the likes of which no one can equal!
Take hold of the threshold stone—it dates from ancient times!
Go close to the Eanna Temple, the residence of Ishtar,
such as no later king or man ever equaled!
Go up on the wall of Uruk and walk around,
examine its foundation, inspect its brickwork thoroughly.
Is not (even the core of) the brick structure made of
 kiln-fired brick,
and did not the Seven Sages themselves lay out its plans?
One square mile is devoted to city, one to palm gardens,
 one to lowlands, the open area(?) of the Ishtar Temple,
three leagues and the open area(?) of Uruk it
 (the wall) encloses.
Find the copper tablet box,
open the . . . of its lock of bronze,
undo the fastening of its secret opening.
Take out and read the lapis lazuli tablet
how Gilgamesh went through every hardship.

SOURCE: *THE EPIC OF GILGAMESH*, TR. MAUREEN GALLERY KOVACS (STANFORD, CA: STANFORD UNIV. PRESS, 1989)

brick." Gilgamesh purportedly carved his tale on a stone marker—which suggests the importance of narrative in Sumerian culture.

Sculpture and Inlay

The cella of Uruk's White Temple would once have contained a cult statue, which is now lost. But a female head dating to about 3100 BCE, found in the Eanna sanctuary of Inanna (goddess of love and war) at Uruk, may offer a sense of what a cult statue looked like (fig. **2.5**). Flat on the back, the face is carved of white limestone, and details were once added in precious materials: a wig, perhaps of gold or copper, secured by the ridge running down the center of the head, and eyes and eyebrows made of colored materials. Despite the absence of these features, the sculpture has not lost its power to impress: The abstraction of its large eyes and dramatic brow contrasts forcefully with the delicate modeling of the cheeks. The head was once attached to a body, presumably made of wood, and the full figure must have stood near life-size.

TELL ASMAR About 500 years after the Uruk head, sculptors began to create a class of limestone, alabaster, and gypsum figures, well illustrated by a group excavated in the 1930s at a temple at Tell Asmar (fig. **2.6**). Ranging in size from several inches to $2\frac{1}{2}$ feet high, these figures probably originally stood in the temple's cella. The figures had been purposely buried near the altar along with other objects, perhaps when the temple was rebuilt or redecorated. Their identities are somewhat controversial: Some scholars have identified the two larger figures as cult statues of Abu and his consort. Most consider the entire group to represent worshipers, who dedicated them in the sanctuary in the hope of being perpetually present before the divinity. Some statues of this kind from elsewhere are even inscribed with the dedicator's name and that of the god.

All but one of the figures in this group stand in a static pose, with hands clasped between chest and waist level. The style is decidedly abstract: On most of the standing male figures, horizontal or zigzag ridges define long hair and a full beard; the arms hang from unusually wide shoulders; hands are clasped around a cup; narrow chests widen to broad waists; and the legs are cylindrical. The male figures wear fringed skirts hanging from a belt in a stiff cone shape, while the women have full-length drapery.

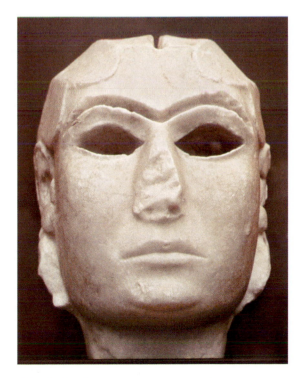

2.5. *Female Head.* ca. 3200–3000 BCE. Uruk (Warka), Iraq. Limestone, height 8″ (20.3 cm). Iraq Museum, Baghdad

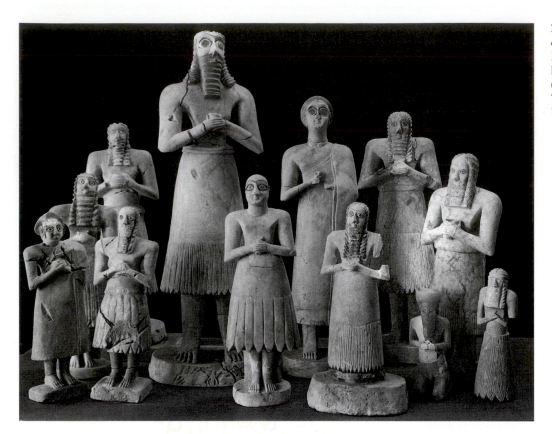

Both the poses and the costumes represent conventions of Sumerian art that later Mesopotamians adopted. Most distinctive are the faces, dominated by wide, almost round eyes, accentuated by dark inlays of lapis lazuli and shells set in bitumen, and by powerful eyebrows meeting over the bridge of the nose. It is all too tempting to read these and other Mesopotamian sculptures through a lens tinted by Christian thought and to see the enlarged eyes as a window to the soul. However, such an interpretation misunderstands the specific cultural context of these images. Scholars infer from surviving texts that seeing was a major channel of communication with gods, and that the sculptures were responding to the god's awe-inspiring nature with eyes wide open in admiration.

THE ROYAL CEMETERY AT UR The Sumerian city of Ur in southern Mesopotamia attracted archeologists because of its biblical associations, but it was in the city's extensive cemetery that Leonard Woolley discovered a wide variety of Sumerian objects in excavations during the 1920s. The cemetery was well preserved under the walls of Nebuchadnezzar II's later city, and contained some 1,840 burials dating between 2600 and 2000 BCE. Some were humble, but others were substantial subterranean structures and contained magnificent offerings, earning them the designation of "Royal Graves," even though scholars remain uncertain whether the deceased were royalty, priests, or members of another elite. The wealthiest burials were accompanied by so-called Death Pits. Foremost among them was the Great Death Pit, in which the bodies of 74 soldiers, attendants, and musicians were interred, apparently drugged before lying down in the grave as human sacrifices. Even in death, the elite maintained

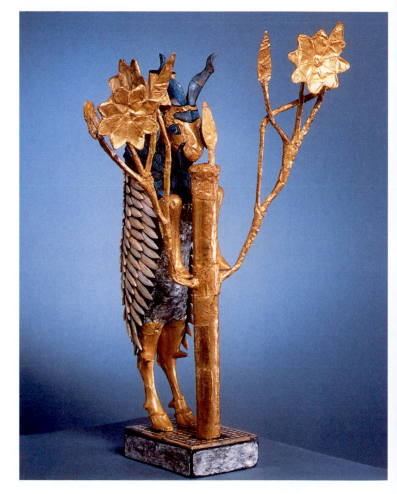

2.7. *Goat in Thicket (Ram and Tree)*, one of the pair from the Great Death Pit in the Royal Cemetery of Ur. ca. 2600 BCE. Muqaiyir, Iraq. Wood, gold, lapis lazuli, height 20" (50.8 cm). University Museum, University of Pennsylvania, Philadelphia

the visible trappings of power and required the services of their retainers. These finds suggest that Sumerians may have believed in an afterlife.

Woolley found many kinds of grave goods in the Royal Cemetery, such as weapons, jewelry, and vessels. Many of the objects display the great skill of Sumerian artists in representing nature. Among them is a pair of wild goats rearing up on their hind legs against a flowering tree, probably used as stands for offerings to a deity (fig. 2.7). Gold leaf is the dominant material, used for the goat's head, legs, and genitals, as well as for the tree and a cylindrical support strut rising from the goat's back. Lapis lazuli on its horns and neck fleece complements the shell fragments decorating the body fleece and the ears of copper. The base is an intricately crafted pattern of red limestone, shell, and lapis lazuli. Images on cylinder seals show that a bowl or saucer would have been balanced on the horns and the support cylinder. The combination of the goat (sacred to the

god Tammuz), and the carefully arranged flowers (rosettes sacred to Inanna), suggests that the sculpture reflects Sumerian concerns about fertility, both of plants and animals.

Visual Narratives

Two objects found within the Royal Cemetery at Ur offer glimpses of the early development of visual narrative in Mesopotamia. The so-called *Royal Standard of Ur*, of about 2600 BCE, consists of four panels of red limestone, shell, and lapis lazuli inlay set in bitumen, originally attached to a wooden framework (fig. 2.8). The damaged side panels depicted animal scenes, while the two larger sections show a military victory and a celebration or ritual feast, each unfolding in three superimposed **registers**. Reading from the bottom, the "war" panel shows charioteers advancing from the left, pulled by *onagers* (wild asses), and riding over enemy bodies. In the middle register, infantry soldiers do battle and escort prisoners of

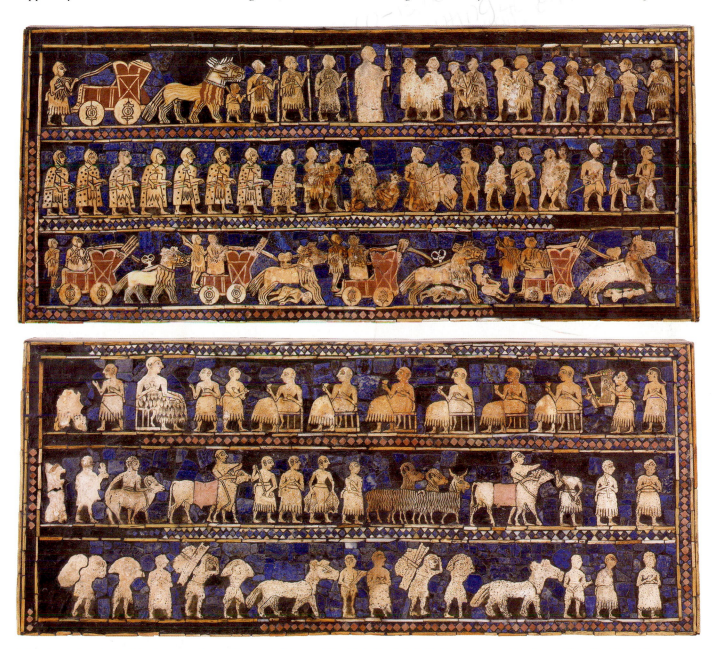

2.8. *Royal Standard of Ur,* front and back sides. ca. 2600 BCE. Wood inlaid with shell, limestone, and lapis lazuli, height 8″ (20.3 cm). The British Museum, London

war, stripped of armor and clothing. At the top, soldiers present the prisoners to a central figure, whose importance the artist signals not just through his position but through his larger size, a device known as **hieratic scale**; his head even breaks through the register's frame to emphasize his importance. In the "peace" panel, figures burdened with booty accompany onagers and, in the center, animals for the banquet, which is already under way in the top register. Seated figures raise their cups to the sound of music from a nearby harpist and singer; a larger figure toward the left of the scene is presumably a leader or king, perhaps the same figure as on the war side. Thus the panels tell a story, unfolding moment by moment as the eye follows the registers, guided by the figures' motion. Despite the action, however, the images have a static quality, emphasized by each figure's isolation (a staccato treatment):

Their descriptive forms (half frontal, half profile) rarely overlap with one another. This, and the contrasting colored materials, give the narrative an easy legibility, even from a distance.

On excavating the *Royal Standard of Ur*, Woolley envisioned it held aloft on a pole as a military standard, and named it accordingly. In fact, it is unclear what the object was used for; it may have been the sounding-box for a stringed instrument, an object that was commonly found in burials. In one of the cemetery's most lavish graves, the grave of "Queen" Pu-abi, Woolley discovered a lyre decorated with a bull's head of gold gilt and lapis lazuli, dating to around 2600 BCE (fig. 2.9), comparable to the lyre depicted on the "standard." On its sounding box, a panel of shell inlaid in bitumen depicts a male figure in a heraldic composition, embracing two human-faced bulls and facing a viewer with a full frontal glare (fig. 2.10). In lower registers, animals perform human tasks such as carrying foodstuffs and playing music. These scenes may have evoked a myth or fable known to contemporary viewers either in written or oral form, perhaps one associated with a funerary context. In some cultures, fantastic hybrid creatures, such as the bulls or the man with a braided, snakelike body in the bottom scene, served the **apotropaic** function of turning away evil forces.

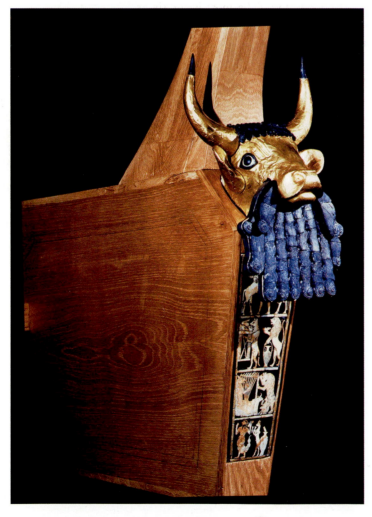

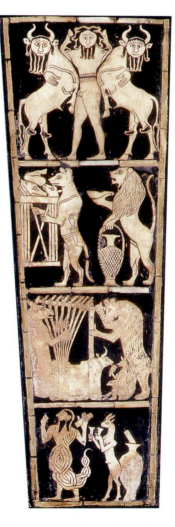

2.9. Bull Lyre, from the tomb of Queen Pu-abi, Ur (Muqaiyir), Iraq. ca. 2600 BCE. Wood with gold, lapis lazuli, bitumen, and shell, reassembled in modern wood support. University Museum, University of Pennsylvania, Philadelphia

2.10. Inlay panel from the soundbox of lyre, from Ur (Muqaiyir), Iraq. ca. 2600 BCE. Shell and bitumen, $12^{1}/_{4} \times 4^{1}/_{2}''$ (31.1 × 11.3 cm). University Museum, University of Pennsylvania, Philadelphia

2.11. *Priest-King Feeding Sacred Sheep*, from vicinity of Uruk (Warka), Iraq. ca. 3300 BCE. Marble cylinder seal, height $2\frac{1}{8}''$ (5.4 cm); diameter $1\frac{3}{4}''$ (4.5 cm). Staatliche Museen zu Berlin, Preussischer Kulturbesitz, Vorderasiatisches Museum

Cylinder Seals

The Mesopotamians also produced vast numbers of cylinder seals, used by the administration to seal jars and secure storerooms. The seals were cylindrical objects usually made of stone, with a hole running through the center from end to end. A sculptor carved a design into the curved surface of the seal, so that when it was impressed on soft clay, a raised, reverse image would unfold, repeated as the cylinder was rolled along. Great quantities of seals and sealings (seal impressions) have survived. Many are of modest quality, reflecting their primarily administrative purpose, but the finest examples display a wealth of detail and a high level of sculptural expertise. With subjects ranging from divine and royal scenes to monumental architecture, animals, and daily activities, the seals provide important information about Mesopotamian existence and values. The example illustrated here appears to show the feeding of the temple herd, which provided a significant portion of the temple's wealth (fig. **2.11**). The human figure's distinctive costume and hat may identify him as a priest-king; some scholars have seen the large vessels as a reference to sacred offerings, and one such vase, measuring nearly three feet in height, was found in the Eanna precinct at Uruk, dating to ca. 3200 BCE.

ART OF AKKAD

Around 2350 BCE, Sumerian city-states began to fight over access to water and fertile land. Gradually, the social organization of the Sumerian city-states was transformed as local "stewards of the god" positioned themselves as ruling kings. The more ambitious tried to enlarge their domains by conquering their neighbors. In many places, Semitic-speaking people (those who used languages in the same family as Hebrew and Arabic) gradually assumed positions of power in the south. Although they adopted many features of Sumerian civilization, they were less bound to the tradition of the city-state. Sargon (meaning "true king") conquered Sumer, as well as northern Syria and Elam (to the east of Sumer) in about 2334 BCE (see map 2.1). With Sargon's power, based in the city of Akkad (a site still unknown, but probably to the northwest of Sumer, near modern Baghdad), Akkadian became the language of authority in Mesopotamia. Sargon's ambitions were both imperial and dynastic. As the absolute ruler of an empire, he combined Sumerian and Akkadian deities in a new pantheon, hoping to break down the

traditional link between city-states and their local gods, and thereby unite the region in loyalty to his personal rule. Under his grandson, Naram-Sin, who ruled from 2254 to 2218 BCE, the Akkadian empire stretched from Sumer in the south to Elam in the east, and then to Syria in the west and Nineveh in the north.

Sculpture: Power and Narrative

Under the Akkadians, the visual arts were increasingly used to establish and reflect the monarch's power, as can be seen in other eras of art history. The most impressive surviving Akkadian work of this kind is a magnificent copper portrait head found in a rubbish heap at Nineveh, dated between 2250 and 2200 BCE and sometimes identified as Naram-Sin himself (fig. 2.12). The face derives its extraordinary power from a number of sources:

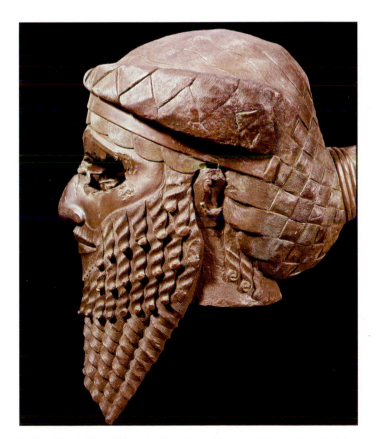

2.12. *Head of an Akkadian Ruler* from Nineveh (Kuyunjik), Iraq. ca. 2250–2200 BCE. Bronze, height 12″ (30.7 cm). Iraq Museum, Baghdad

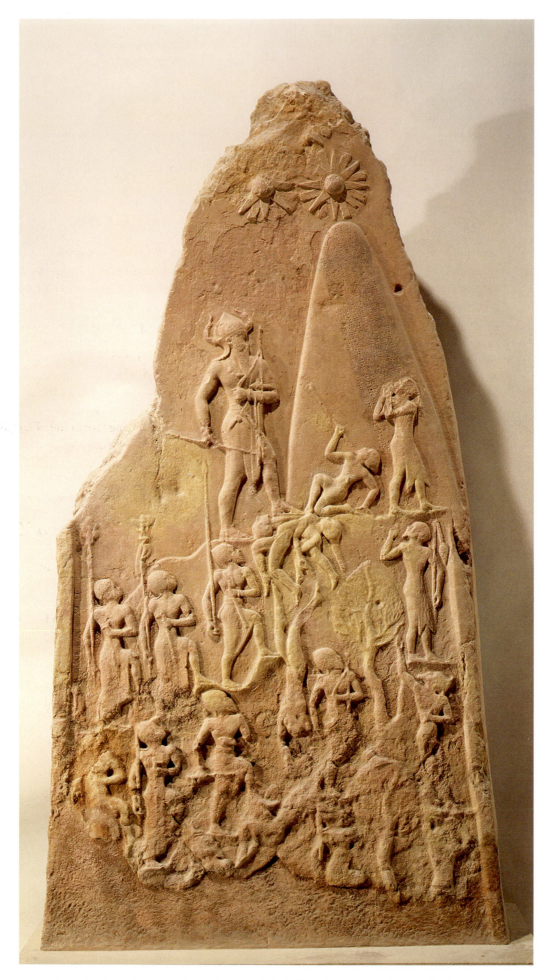

2.13. Stele of Naram-Sin. r. 2254–2218 BCE. Height 6'6″ (2 m). Musée du Louvre, Paris

It was designed to be seen from the front, and this **frontality** makes it appear unchanging and eternal. The abstract treatment of beard and hair (which is arranged like a Sumerian king's) contrasts with the smooth flesh to give the head a memorable simplicity and a strong symmetry, which denote control and order. The intricate, precise patterning of hair and beard testify to the metalworker's expertise in hollow casting (see *Materials and Techniques*, page 124). Furthermore, at a time before metallurgy was widely understood, the use of cast metal for a portrait demonstrated the patron's control of a technology primarily associated with weaponry. In its original form, the portrait probably had eyes inlaid with precious and semiprecious materials, as other surviving figures do. The damage to the portrait was probably incurred during the Medes' invasion of Nineveh in 612 BCE. The enemy gouged out its eyes and hacked off its ears, nose, and lower beard, as if attacking the person represented. Many cultures, even in our own day, practice such acts of ritualized vandalism as symbolic acts of violence or protest.

The themes of power and narrative combine in a 6 1/2-foot **stele** (upright marker stone) erected in the Akkadian city of Sippar during the rule of Naram-Sin (fig. **2.13**). The stele commemorates Naram-Sin's victory over the Lullubi, people of the Zagros mountains in eastern Mesopotamia, in shallow relief. This time the story is not narrated in registers; instead, ranks of soldiers, in composite view, climb the wavy contours of a wooded mountain. Their ordered march contrasts with the enemy's chaotic rout: As the victorious soldiers trample the fallen foe underfoot, the defeated beg for mercy or lie contorted in death. Above them is the king, whose large scale and central position make his identity clear. He stands isolated against the background, next to a mountain peak that suggests proximity to the divine. His horned crown, formerly an exclusive accoutrement of the gods, marks him as the first Mesopotamian king to deify himself (an act that his people did not unanimously welcome). The bold musculature of his limbs and his powerful stance make him a heroic figure. Solar deities shine auspiciously overhead, as if witnessing his victory.

The stele of Naram-Sin still communicated its message of power over a thousand years later. In 1157 BCE, the Elamites

ART IN TIME

ca. 2350 BCE—Conflict begins among Sumerian city-states over access to water and fertile land

After 2150 BCE—Earliest surviving Akkadian tablets of the *Epic of Gilgamesh*

ca. 2100 BCE—**The Great Ziggurat at Ur built, commissioned by King Urnammu**

of southwestern Iran invaded Mesopotamia and seized the stele as war booty. An inscription on the stele records that they installed it in the city of Susa (see map 2.1). By capturing the defeated city's victory monument, they symbolically stole Naram-Sin's former glory and doubly defeated their foe.

NEO-SUMERIAN REVIVAL

The rule of the Akkadian kings came to an end when a mountain people, the Guti, descended from the northeast onto the Mesopotamian Plain and gained control of it. The cities of Sumer rose up in retaliation and drove them out in 2112 BCE, under the leadership of King Urnammu of Ur (the present-day city of Muqaiyir and the birthplace of Abraham), who reestablished Sumerian as the state language and united a realm that was to last a hundred years. As part of his project of renewal, he also returned to building on a magnificent scale.

Architecture: The Ziggurat of Ur

Part of Urnammu's legacy is the Great Ziggurat at Ur of about 2100 BCE, dedicated to the moon god, Sumerian Nanna (Sin in Akkadian) (fig. **2.14**). Its 190- by 130-foot base soared to 50 feet in three stepped stages. The base was constructed of solid mud brick and faced with baked bricks set in bitumen, a tarry material used here as mortar. Although not structurally functional, thick **buttresses** (vertical supporting elements) articulate the walls, giving an impression of strength. Moreover, a multitude of lines pointing upwards from all directions add a dynamic energy

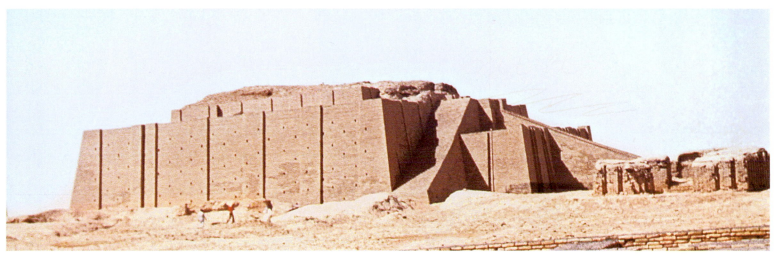

2.14. Great Ziggurat of King Urnammu, Ur. ca. 2100 BCE. Muqaiyir, Iraq

Texts on Gudea Figures from Lagash and Surrounding Areas, ca. 2100

Gudea, the ruler of Lagash, commissioned numerous temples and many figures of himself to be placed in the temples. Many of these figures (compare figs. 2.15 and 2.16) are inscribed with cuneiform texts that provide insight into the function of each image.

In this excerpt, the god Ningirsu speaks to Gudea, encouraging him to rebuild his temple:

When, O faithful shepherd Gudea,
Thou shalt have started work for me on Eninnu, my royal abode,

I will call up in heaven a humid wind.
It shall bring thee abundance from on high
And the country shall spread its hands upon riches
 in thy time.
Prosperity shall accompany the laying of the foundations of
 my house.
All the great fields will bear for thee;
Dykes and canals will swell for thee;
Where the water is not wont to rise
To high ground it will rise for thee.
Oil will be poured abundantly in Sumer in thy time,
Good weight of wool will be given in thy time.

SOURCE: H. FRANKFORT, *THE ART AND ARCHITECTURE OF THE ANCIENT ORIENT*, 4TH ED. (NEW HAVEN: YALE UNIVERSITY PRESS, 1970, P. 98).

to the monument's appearance. Three staircases, now reconstructed, converged at the fortified gateway to the temple. Each 100 steps long, one was set perpendicular to the temple, the other two parallel to the base wall. From the gateway, a fourth staircase (which has perished) rose to the temple proper, which does not survive. The stairways may have provided an imposing setting for ceremonial processions. The surviving foundations are not extensive enough to reconstruct the buildings on top of the ziggurat.

Sculpture: Figures of Gudea

Contemporary to Urnammu's rule in Ur, Gudea became ruler of neighboring Lagash (in present-day Iraq), one of the smaller Sumerian city-states that had retained its independence after the collapse of Akkad. Being careful to reserve the title of king for Lagash's city-god, Ningirsu, Gudea promoted the god's cult through an ambitious rebuilding of his temple. According to

inscriptions, Gudea dreamed that Ningirsu ordered him to build the temple after the Tigris River had failed to rise.

Nothing remains of the building, but some 20 examples survive of distinctive statues representing Gudea, which he had dedicated at the temple and in other shrines of Lagash and vicinity (figs. **2.15** and **2.16**). The statues are a mark of his piety, and they also continue the Akkadian tradition that exalted the king's person. The statues testify to Gudea's enormous wealth, as they are carved of diorite, a dark stone that was as rare and expensive as it was hard to work. Whether standing or seated, the statues are remarkably consistent in appearance: Clothed in a long garment draped over one shoulder, and often wearing a thick woolen cap,

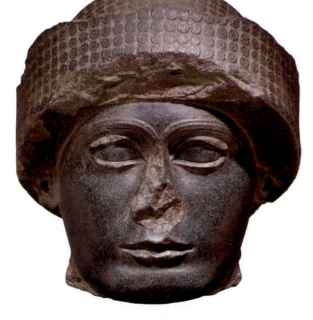

2.15. Head of Gudea, from Lagash (Telloh), Iraq, ca. 2100 BCE. Diorite, 9⅛″ (23.18 cm) high. Museum of Fine Arts, Boston. Francis Bartlett Donation of 1912. 26.289

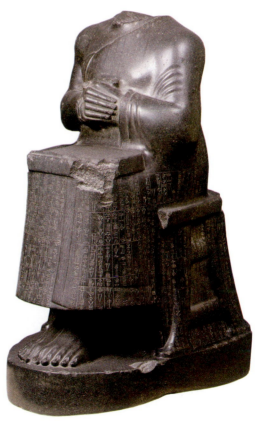

2.16. Seated statue of Gudea holding temple plan, from Girsu (Telloh), Iraq. ca. 2100 BCE. Diorite, height approx. 2′5″ (73.66 cm). Musée du Louvre, Paris

Gudea clasps his hands across his front in a pose similar to statues from Tell Asmar of 500 years earlier. Like those figures, Gudea's eyes are wide open, in awe. The highly polished surface and precise modeling allow light to play upon the features, showcasing the sculptors' skills. The rounded forms emphasize the figures' compactness, giving them an impressive monumentality.

In the life-size seated example shown in figure 2.16, Gudea holds the ground plan of the temple on his lap. Inscriptions on the statue reveal that, to ensure the temple's sanctity, the king had to scrupulously obey the god's instructions. These inscriptions also give Gudea's motivation for building the temple: By obeying the god, he would bring good fortune to his city. (See *Primary Source,* page 32.) Consequently, the king purified the city and swept away the soil on the temple's site exposing the bedrock. He then laid out the temple according to the design revealed to him by Ningirsu, the god of Girsu (present-day Telloh), and helped manufacture and carry mud bricks.

BABYLONIAN ART

The late third and early second millennia BCE were a time of turmoil in Mesopotamia, as city states warred, primarily over access to waterways. The region was then unified for over 300 years under the rule of a Babylonian dynasty. During the reign of its most famous ruler, Hammurabi (r. 1792–1750 BCE), the city of Babylon assumed the dominant role formerly played by Akkad and Ur. Combining military prowess with a deep respect for Sumerian tradition, Hammurabi positioned himself as "the favorite shepherd" of the sun-god Shamash, stating his mission "to cause justice to prevail in the land and to destroy the wicked and evil, so that the strong might not oppress the weak nor the weak the strong." Under Hammurabi and his successors, Babylon became the cultural center of Sumer, and the city retained this prestige for more than a thousand years after its political power had waned.

The Code of Hammurabi

Hammurabi is best known for his law code. It survives as one of the earliest written bodies of law, engraved on a black basalt stele reaching over 7 feet tall (fig. **2.17**). Like the stele of Naram-Sin, the Elamites carried Hammurabi's stele off to Susa. The text, consisting of 3,500 lines of Akkadian cuneiform, begins with an accounting of the temples Hammurabi restored. The largest portion is then devoted to matters of commercial and property law, rulings on domestic issues, and questions of physical assault, detailing penalties to be exacted on noncompliers (including the renowned Old Testament principle of 'an eye for an eye'). (See *Primary Source*, page 34.) The text concludes with a paean on Hammurabi as peacemaker.

At the top of the stele, Hammurabi is depicted in relief, standing with his arm raised in greeting before an enthroned Shamash, whose shoulders emanate sun rays. The sun-god extends his hand, which holds the rope ring and the measuring rod of kingship; this single gesture unifies both the scene's composition and the implied purpose of the two protagonists. The image is a variant of the "introduction scene" found on cylinder seals, where a

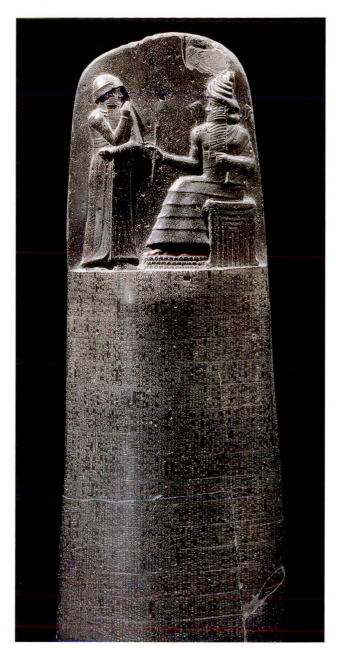

2.17. Upper part of stele inscribed with the Law Code of Hammurabi. ca. 1760 BCE. Diorite, height of stele approx. 7′ (2.1 m); height of relief 28″ (71 cm). Musée du Louvre, Paris

goddess leads a human individual with his hand raised in address before a seated godlike figure who bestows his blessing. Although a supplicant, Hammurabi appears without the benefit—or need—of a divine intercessor, implying an especially close relationship with the sun-god. Although this scene was carved four centuries after the Gudea statues, it is closely related to them in both style and technique. The exceptionally high relief enabled the sculptor to render the eyes in the round, so that Hammurabi and Shamash fix one another in an intense gaze. All the same, the image shares conventions with Akkadian relief, such as the use of a composite view. Yet the smaller scale of Hammurabi compared with the seated god expresses his status as "shepherd" rather than god himself. The symmetrical composition and smooth surfaces result in a legible image of divinely ordained power that is fully in line with Mesopotamian traditions.

The Code of Hammurabi

Inscribed on the stele of Hammurabi in figure 2.17, the Code of Laws compiled by King Hammurabi offers a glimpse at the lives and values of Babylonians in the second millennium BCE.

Prologue

When Anu the Sublime, King of the Anunaki, and Bel, the lord of Heaven and earth, who decreed the fate of the land, assigned to Marduk, the over-ruling son of Ea, God of righteousness, dominion over earthly man, and made him great among the Igigi, they called Babylon by his illustrious name, made it great on earth, and founded an everlasting kingdom in it, whose foundations are laid so solidly as those of heaven and earth; then Anu and Bel called by name, Hammurabi, the exalted prince, who feared God, to bring about the rule of righteousness in the land, to destroy the wicked and the evil-doers; so that the strong should not harm the weak; so that I should rule over the black-headed people like Shamash, and enlighten the land, to further the well-being of mankind....

The Code of Laws [excerpts]

If any one bring an accusation against a man, and the accused go to the river and leap into the river, if he sink in the river his accuser shall take possession of his house. But if the river prove that the accused is not guilty, and he escape unhurt, then he who had brought the accusation shall be put to death, while he who leaped into the river shall take possession of the house that had belonged to his accuser....

If any one bring an accusation of any crime before the elders, and does not prove what he has charged, he shall, if it be a capital offense charged, be put to death....

If any one steal the property of a temple or of the court, he shall be put to death, and also the one who receives the stolen thing from him shall be put to death....

If any one steal cattle or sheep, or an ass, or a pig or a goat, if it belong to a god or to the court, the thief shall pay thirtyfold; if they belonged to a freed man of the king he shall pay tenfold; if the thief has nothing with which to pay he shall be put to death...

If any one break a hole into a house (break in to steal), he shall be put to death before that hole and be buried...

If any one be too lazy to keep his dam in proper condition, and does not so keep it; if then the dam break and all the fields be flooded, then shall he in whose dam the break occurred be sold for money, and the money shall replace the corn which he has caused to be ruined....

If any one be on a journey and entrust silver, gold, precious stones, or any movable property to another, and wish to recover it from him; if the latter do not bring all of the property to the appointed place, but appropriate it to his own use, then shall this man, who did not bring the property to hand it over, be convicted, and he shall pay fivefold for all that had been entrusted to him...

If a man wish to separate from a woman who has borne him children, or from his wife who has borne him children: then he shall give that wife her dowry, and a part of the usufruct of field, garden, and property, so that she can rear her children. When she has brought up her children, a portion of all that is given to the children, equal as that of one son, shall be given to her. She may then marry the man of her heart...

If a son strike his father, his hands shall be hewn off.

If a man put out the eye of another man, his eye shall be put out.

If he break another man's bone, his bone shall be broken.

If a builder build a house for some one, and does not construct it properly, and the house which he built fall in and kill its owner, then that builder shall be put to death.

If it kill the son of the owner, the son of that builder shall be put to death.

If it kill a slave of the owner, then he shall pay slave for slave to the owner of the house....

SOURCE: *WORLD CIVILIZATIONS ONLINE CLASSROOM* "THE CODE OF HAMMURABI" TRANSLATED BY L. W. KING (1910). EDITED BY RICHARD HOOKER WWW.WSU.EDU:8080/2DEE. © 1996.

NOTE: THE EPILOGUE OF *THE CODE OF HAMMURABI,* APPEARS ON P. 230.

ASSYRIAN ART

Babylon fell around 1595 BCE to the Hittites, who had established themselves in Anatolia (modern Turkey). The Hittites then departed leaving a weakened Babylonian state open to other invaders: the Kassites from the northwest and the Elamites from the east. Although a second Babylonian dynasty rose to great heights under Nebuchadnezzar I of Isin (r. 1125–1104 BCE), the Assyrians more or less controlled southern Mesopotamia by the end of the millennium. Their home was the city-state of Assur, named for the god Ashur, located on the upper course of the Tigris.

Art of Empire: Expressing Royal Power

Under a series of able rulers, beginning with Ashur-uballit (r. 1363–1328? BCE), the Assyrian realm expanded, in time covering not only Mesopotamia but surrounding regions as well. At its height, in the seventh century BCE, the Assyrian empire stretched from the Sinai Peninsula to Armenia; even Egypt was successfully invaded about 670 BCE (see map 2.1). The Assyrians drew heavily on the artistic achievements of the Sumerians and Babylonians, but adapted them to their own purpose. Theirs was clearly an art of empire: propagandistic and public, designed to proclaim and sustain the supremacy of the Assyrian civilization, particularly through representations of military power. The Assyrians continued to build temples and ziggurats based on Sumerian models, but their architectural emphasis shifted to royal palaces. These grew to unprecedented size and magnificence, loudly expressing a royal presence and domination.

The expression of Assyrian royal power began well outside the palace, as we can see in the plan for the city of Dur Sharrukin (present-day Khorsabad, Iraq), where Sargon II (r. 721–705 BCE) had his royal residence (fig. 2.18). Much of the city remains unexcavated. It covered an area of nearly a square mile, enclosed

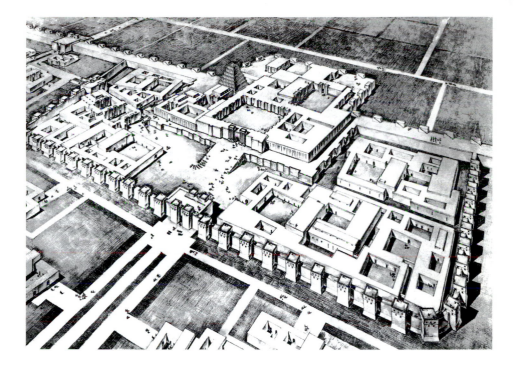

2.18. Reconstruction drawing of the citadel of Sargon II, Dur Sharrukin (Khorsabad), Iraq. ca. 721–705 BCE. After Charles Altman

within an imposing mud-brick fortification wall. To reach the palace, a visitor had to cross the city, passing through exposed plazas and climbing wide ramps. On the northwest side, a walled and turreted citadel enclosed the ziggurat and the palace, shutting them off from the rest of the town and emphasizing their dominant presence. Both structures were raised up on a mound 50 feet high, placing them above the flood plain and expressing the king's elevation above the rest of society. The ziggurat had at least four stages, each about 18 feet high, each of a different color, with a spiral ramp winding around it to the top. Enclosing the temple within the palace makes clear the privileged relationship between the king and the gods.

The palace complex comprised about 30 courtyards and 200 rooms, and this impressive scale was accompanied by monu-

mental imagery. At the gateways stood huge, awe-inspiring guardian figures known as **lamassu**, in the shape of winged, human-headed bulls (fig. **2.19**). The illustration here shows the lamassu of Khorsabad during excavation in the 1840s; masons subsequently sawed up one of the pair for transportation to the Louvre in Paris. The massive creatures are almost carved in the round, yet the addition of a fifth leg, visible from the side, reveals that the sculptor conceived of them as deep relief sculptures on two sides of the stone block, so that the figures are legible both frontally and in profile. Carved out of the limestone, they are, in a sense, one with the building. Texts indicate that lamassu were also cast in bronze, but later melted down so that none now survive. With their tall, horned headdresses and deep-set eyes, and with the powerful muscularity of their legs

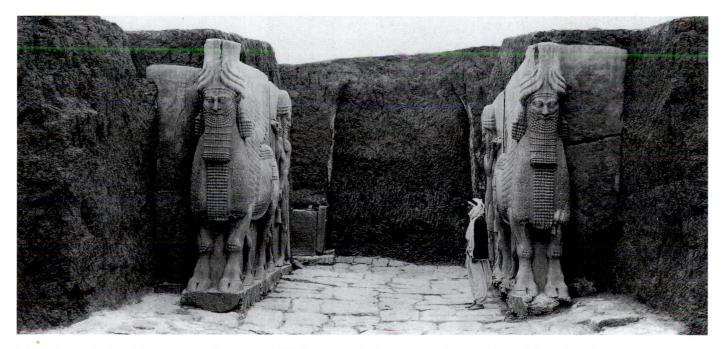

2.19. Gate of the Citadel of Sargon II, Dur Sharrukin (photo taken during excavation). 742–706 BCE. (Khorsabad), Iraq

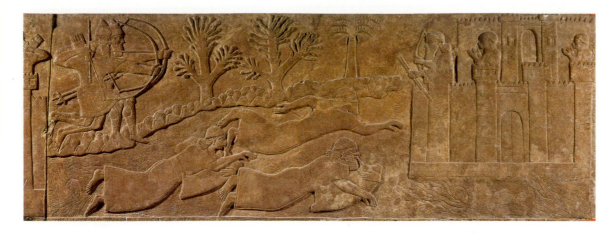

2.20. *Fugitives Crossing River,* from the Northwest Palace of Ashurnasirpal II, Nimrud (Calah), Iraq. ca. 883–859 BCE. Alabaster relief, height approx. 39″ (98 cm). The British Museum, London

and bodies set off by the delicate patterning of the beard and feathers, they towered over an approaching visitor, embodying the king's fearful authority. The Assyrians may have believed the hybrid creatures had the power to ward off evil spirits.

Once inside a royal palace, a visitor would confront another distinctive feature of Assyrian architecture: the upright gypsum slabs called **orthostats**, with which the builders lined the lower walls. Structurally, the slabs protected the mud brick from moisture and wear, but they served a communicative purpose as well. On their surfaces, narrative images in low relief, painted in places for emphasis, glorified the king with detailed depictions of lion hunts in royal gardens and military conquests (with inscriptions giving supplementary information). The Assyrian forces march indefatigably onward, meeting the enemy at the empire's frontiers, destroying his strongholds, and carrying away booty and prisoners-of-war. Actions take place in a continuous band, propelling a viewer from scene to scene, and repetition creates the impression of an inevitable Assyrian triumph. The illustrated detail (fig. **2.20**), from the Palace of Ashurnasirpal II (r. 883–859 BCE) at Nimrud (ancient Kalah, biblical Calah, Iraq), shows the enemy fleeing an advance party by swimming across a river on inflatable animal skins. In their fortified city, an archer—possibly the king—and two women look on with hands raised in emotion. Landscape elements are interspersed with humans, yet there is no attempt to capture relative scale, or to depict all elements from a single viewpoint. This suggests that the primary purpose of the scenes was to recount specific enemy conquests in descriptive detail; depicting them in a naturalistic way was not a major concern.

As in Egypt (discussed in Chapter 3), royal lion hunts were staged events on palace grounds. Animals were released from cages into a square formed by troops with shields. Earlier Mesopotamian rulers hunted lions to protect their subjects, but by the time of the Assyrians, the activity had become more symbolic than real, ritually showcasing the king's strength and serving as a metaphor for military prowess. One of the best known sections of Assyrian relief comes from the North Palace of Ashurbanipal (r. 668–627 BCE) at Nineveh, dating to roughly 645 BCE (fig. **2.21**). The king races forward in his chariot with bow drawn, leaving wounded and dead lions in his wake. As attendants plunge spears into its chest, a wounded lion leaps at the chariot, its body hurled flat out in a clean diagonal line, its claws spread and mouth open in what appears to be pain combined with desperate ferocity. Clearly, the sculptor ennobled the victims of the hunt, contrasting the limp, contorted bodies of the slain animals with the taut leaping lion and the powerful energy of the king's party. Yet we should not conclude that the artist necessarily intended to evoke sympathy for the creatures, or to comment on the cruelty of a staged hunt; it is more likely that by ennobling the lions the sculptor glorified their vanquisher, the king, even more.

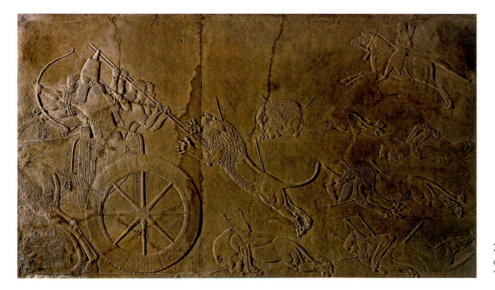

2.21. Lion Hunt relief, from reign of Ashurbanipal. ca. 645 BCE. The British Museum, London

LATE BABYLONIAN ART

Perpetually under threat, the Assyrian Empire came to an end in 612 BCE, when Nineveh fell to the Medes (an Indo-European–speaking people from western Iran) and the resurgent Babylonians. Under the Chaldean dynasty, the ancient city of Babylon had a final brief flowering between 612 and 539 BCE, before it was conquered by the Persians. The best known of these Late Babylonian rulers was Nebuchadnezzar II (r. 604–ca. 562 BCE), the builder of the biblical Tower of Babel, which soared 270 feet high and came to symbolize overweening pride. He was also responsible for the renowned Hanging Gardens of Babylon, considered by the second century BCE to be one of the wonders of the ancient world.

The Royal Palace

The royal palace at Babylon was on almost the same scale as Assyrian palaces, with five huge courtyards surrounded by numerous reception suites. For its decoration, the Late Babylonians adopted the use of baked and glazed brick, molded into individual shapes, instead of facing their structures with carved stone. Glazing brick involved putting a film of glass over the brick's surface. Late Babylonians used it both for surface ornament and for reliefs on a far greater scale.

ART IN TIME

ca. 1792–1750 BCE—Babylon ruled by Hammurabi

ca. 1595 BCE—The Hittites conquer Babylon

ca. 668–627 BCE—Assyrian construction of the North Palace of Ashurbanipal

The vivid coloristic effect of glazed brick appears on the courtyard facade of the Throne Room and the Processional Way leading to the Ishtar Gate and the gate itself, now reassembled in Berlin (fig. 2.22). Against a deep blue background, a procession of bulls, dragons, and other animals, set off in molded brick, is contained within a framework of brightly colored ornamental bands. The animals portrayed were sacred: White and yellow snake-necked dragons were sacred to Marduk, the chief Babylonian god; yellow bulls with blue hair to Adad, the god of storms; and white and yellow lions to Ishtar herself, goddess of love and war. Unlike the massive muscularity of the lamassu, their forms are light and agile-looking, arrested in a processional stride that slowly accompanies ceremonial processions leading to the gate's arched opening.

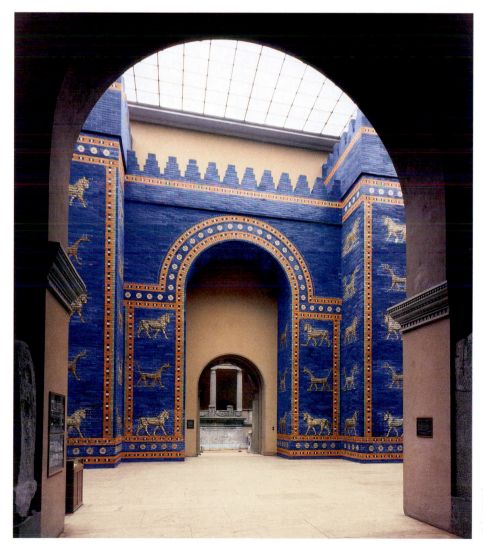

2.22. Ishtar Gate (restored), from Babylon, Iraq. ca. 575 BCE. Glazed brick. Staatliche Museen zu Berlin, Preussischer Kulturbesitz, Vorderasiatisches Museum

REGIONAL NEAR EASTERN ART

Alongside the successive cultures of Mesopotamia, a variety of other cultures developed in areas beyond the Tigris and Euphrates. Some of these peoples invaded or conquered contemporaneous cultures in Mesopotamia, as did the Hittites in the north and the Iranians in the east. Others, such as the seagoing Phoenicians on the Mediterranean coast to the west, traded with the cultures of Mesopotamia and in so doing spread Mesopotamian visual forms to Africa and Europe. Their material culture reflects contacts with Mesopotamian traditions.

The Hittites

When Babylon was overthrown in 1595 BCE, it was the Hittites who were responsible. An Indo-European–speaking people, the Hittites had probably entered Anatolia (present-day Turkey) from southern Russia in the late third millennium BCE and settled on its rocky plateau as one of several independent cultures that developed separately from Mesopotamia. Emerging as a power around 1800 BCE, they rapidly expanded their empire under Hattusilis I 150 years later. Coming into contact with the traditions of Mesopotamia, the Hittites adopted cuneiform writing for their language, preserving details of their history on clay tablets. In addition to invading Mesopotamia, the Hittites established an empire that extended over most of modern Turkey and Syria, which brought them into conflict with the imperial ambitions of Egypt. The Hittite Empire reached its apogee between 1400 and 1200 BCE. Its capital, Hattusa, near the present-day Turkish village of Bogazköy, was protected by fortifications constructed of huge, irregularly shaped stones, widely available in the region. Flanking the gates to the city were massive limestone lions and other guardian figures protruding from the blocks that formed the jambs of the doorway (fig. 2.23). The lion gates at Bogazköy are 7 feet high, and though badly weathered, these figures still impress visitors with their frontal positioning and ferocity. The later Assyrian lamassu (see fig. 2.19) were probably inspired by these powerful guardians.

The Phoenicians

The Phoenicians, too, contributed a distinctive body of work to Near Eastern art. Living on the eastern coast of the Mediterranean in the first millennium BCE in what is now Lebanon, they developed formidable seafaring skills, which enabled them to found settlements further west in the Mediterranean (most notably on the North African coast and in Spain). They became a linchpin and an active participant in a rapidly growing trade in objects—and ideas—between east and west. The Phoenicians were especially skilled in working metal and ivory, incorporating motifs from Egypt and the eastern Mediterranean coast, and in making colored glass. The open-work ivory plaque illustrated here dates to the eighth century BCE, and was found in

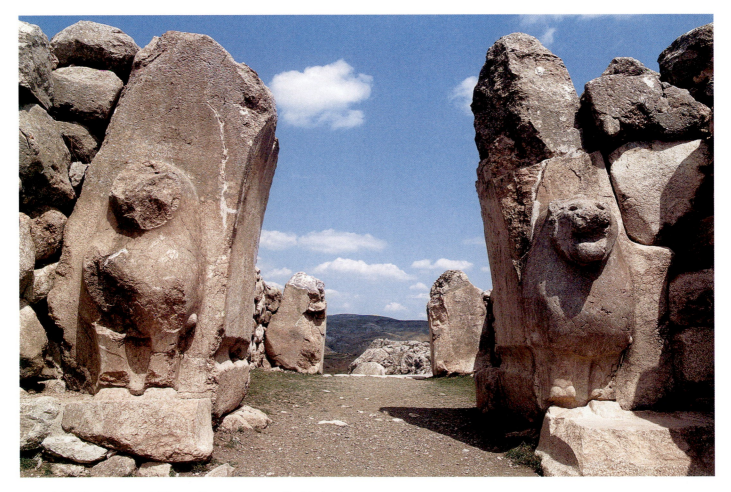

2.23. The Lion Gate. ca. 1400 BCE. Bogazköy, Anatolia (Turkey)

2.24. Ivory plaque depicting a winged sphinx. Phoenician. ca. eighth century BCE. Found at Fort Shalmaneser, Nimrud (ancient Kalhu), northern Iraq. The British Museum

ART IN TIME

1400–1200 BCE—Apogee of the Hittite Empire

612 BCE—Nineveh falls to the Medes and resurgent Babylonians; end of the Assyrian Empire

ca. 604–562 BCE—Reign of the Late Babylonian ruler Nebuchadnezzar II

ca. 575 BCE—Babylonian construction of the Ishtar Gate

the skill of the potter in both the construction of the cup and its sensitive painted design. It foretells the later love of animal forms in the nomadic arts of Iran and Central Asia.

The early nomadic tribes left no permanent structures or records, but the items they buried with their dead reveal that they ranged over a vast area—from Siberia to central Europe, from Iran to Scandinavia. The objects were made of wood, bone, or metal, and share a common decorative vocabulary, including animal motifs used in abstract and ornamental ways.

Fort Shalmaneser at Nimrud, the Assyrian capital where it had probably been taken as booty by the conquering Assyrian kings (fig. 2.24). It captures an Egyptian winged sphinx poised in profile, and though the details are all Egyptian—its wig and apron, the stylized plants—its double crown has been reduced to fit neatly within the panel, suggesting that it was a quality of "Egyptianness" that was important rather than an accurate portrayal of Egyptian motifs. The rounded forms and profile presentation translate the Egyptian motif into a visual form more familiar to Mesopotamian eyes.

IRANIAN ART

East of Mesopotamia, Iran had been inhabited since Neolithic times, starting in about 7000 BCE, when it was a flourishing agricultural center. During that period, Iran became a gateway for migrating tribes from the Asiatic steppes to the north as well as from India to the east. While distinctive, the art of ancient Iran reflects many intersections with the cultures of Mesopotamia.

Early Iranian Art

An example from the region, from a pottery-producing center at Susa on the Shaur River, is the handleless beaker in figure 2.25, dating to about 4000 BCE. Its thin shell of pale yellow clay is decorated with brown glaze showing an ibex (mountain goat), whose forms are reduced to a few dramatic sweeping curves. The circles of its horns reflect in two dimensions the cup's three-dimensional roundness. Racing hounds above the ibex are stretched out to become horizontal streaks, and vertical lines below the vessel's rim are the elongated necks of a multitude of birds. This early example of Iranian art demonstrates

2.25. Painted beaker, from Susa. ca. 5000–4000 BCE. Height 11 1/4″ (28.3 cm). Musée du Louvre, Paris

These belong to a distinct kind of portable art known as nomad's gear, including weapons, bridles, buckles, **fibulae** (large clasps or brooches), and other articles of adornment, as well as various kinds of vessels.

The Persian Empire: Cosmopolitan Heirs to the Mesopotamian Tradition

During the mid-sixth century BCE, the entire Near East came to be dominated by the small kingdom of Parsa to the east of lower Mesopotamia. Under Cyrus the Great (r. 559–530/29 BCE), ruler of the Achaemenid dynasty, the Persians overthrew the king of the Medes, then conquered major parts of Asia minor in ca. 547 or 546 BCE, and Babylon in 538 BCE. Cyrus assumed the title "King of Babylon," along with the broader ambitions of Mesopotamian rulers.

The empire he founded continued to expand under his successors. Egypt fell in 525 BCE, while Greece narrowly escaped Persian domination in the early fifth century BCE. At its height, under Darius I (r. 521–486 BCE) and his son Xerxes (r. 485–465 BCE), the Persian Empire in its territorial reach far outstripped the Egyptian and Assyrian empires combined. Its huge domain endured for two centuries, during which it developed an efficient administration and monumental art forms.

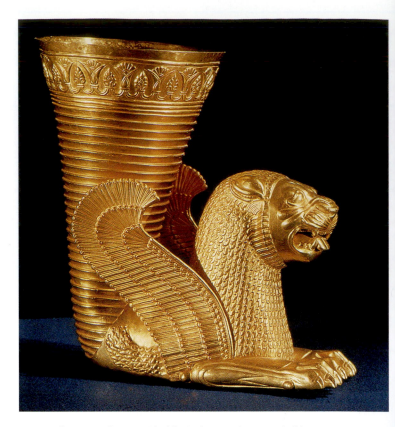

2.27. Rhyton. Achaemenid. 5th–3rd centuries BCE. Gold. Archaeological Museum, Tehran, Iran

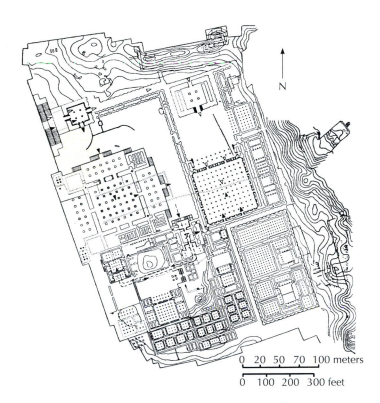

2.26. Plan of Palace of Darius and Xerxes, Persepolis. 518–460 BCE. Solid triangles show the processional route taken by Persian and Mede notables; open triangles indicate the way taken by heads of delegations and their suites

Persian religious beliefs were related to the prophecies of Zoroaster (Zarathustra) and were based on the dualism of good and evil, embodied in Ahuramazda (Light) and Ahriman (Darkness). The cult of Ahuramazda focused its rituals on fire altars in the open air; consequently, Persian kings did not construct religious architecture. Instead they concentrated their attention and resources on royal palaces, at once vast and impressive.

PERSEPOLIS The most ambitious of these palaces, at Parsa or Persepolis, was begun by Darius I in 518 BCE. It was enlarged by subsequent rulers (fig. 2.26). Set on a plateau in the Zagros highlands, it consisted of a great number of rooms, halls, and courts laid out in a grid plan, fortified and raised on a platform. The palace is a synthesis of materials and design traditions from all parts of the far-flung empire, resulting in a message of internationalism. Darius boasts in his inscriptions that its timber came from Lebanon (cedar), Gandhara and Carmania (yaka wood), and its bricks from Babylon. Items used within the palace (such as the **rhyton** or ritual cup in fig. 2.27), were of Sardian and Bactrian gold, Egyptian silver, and ebony, and Sagdianan lapis lazuli and carnelian. To work these materials, the Achaemenids brought in craftsmen from all over the empire, who then returned to their respective homes taking this international style with them. The rhyton in figure 2.27 belongs to the tradition of Mesopotamian hybrid creatures. Made of gold, it is shaped as a senmurv, a mythical creature with the body of a lion sprouting griffin's wings and a peacock's tail.

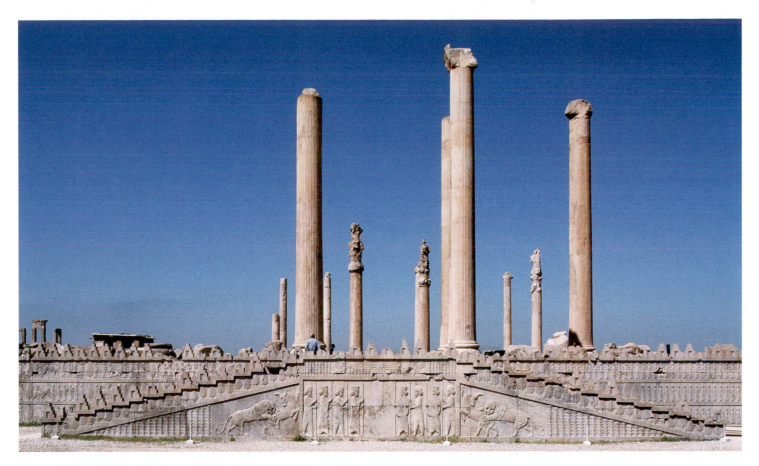

2.28. Audience Hall of Darius and Xerxes. ca. 500 BCE. Persepolis, Iran

Visitors to the palace were made constantly aware of the theme of empire, beginning at the entrance. At the massive "Gate of all the Lands" stood colossal winged, human-headed bulls, like the Assyrian lamassu (see fig. 2.19). Inside the palace, columns were used on a magnificent scale. Entering the 217-foot-square Audience Hall of Darius and Xerxes, or *apadana*, the visitor would see 36 columns, soaring 40 feet up to support a wooden ceiling. A few still stand today (fig. **2.28**). The concept of massing columns may come from Egypt; certainly Egyptian elements are present in the vegetal (plantlike) detail of their bases and capitals. The form of the shaft, however, echoes the slender, fluted column shafts of Ionian Greece (see fig. 5.9). Crowning the column capitals are "cradles" for ceiling beams composed of the front parts of two bulls or similar creatures (fig. **2.29**). The animals are reminiscent of Assyrian sculptures, yet their truncated, back-to-back arrangement recalls animal motifs of Iranian art, such as the rhyton.

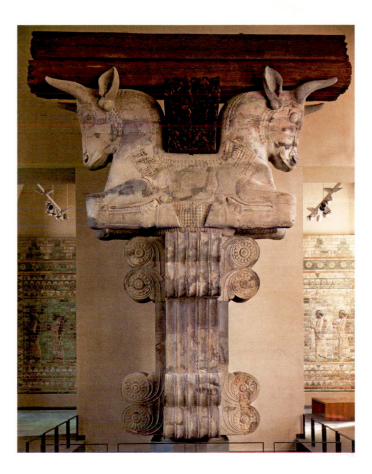

2.29. Bull capital, from Persepolis. ca. 500 BCE.
Musée du Louvre, Paris

Losses Through Looting

The archaeologist's greatest nemesis is the looter, who pillages ancient sites to supply the world's second largest illicit business: the illegal trade in antiquities. The problem is worldwide, but recent publicity has focused on Iraq, where thousands of archaeological sites still await proper excavation. Looters are often local people, living in impoverished conditions but supported and organized by more powerful agents; just as frequently, looters work in organized teams, arriving on site with jackhammers and bulldozers, wielding weapons to overcome whatever meager security there might be. Often employing the most sophisticated tools, such as remote sensing and satellite photographs, they move quickly and unscrupulously through a site, careless of what they destroy in their search for treasure. Loot changes hands quickly as it crosses national borders, fetching vast sums on the market. Little or none of this fortune returns to local hands.

Even more is at stake in these transactions than the loss of a nation's heritage. Only a fraction of the value of an archaeological find resides in the object itself. Much more significant is what its *findspot* can tell archaeologists, who use the information to construct a history of the past. An object's location within a city or building reveals how it was used. A figurine, for instance, could be a fertility object, doll, or cult image, depending on its physical context. The exact level, or stratum, at which an object is found discloses when it was in use. On some sites, stratigraphy yields very precise dates. If an object is discovered far from its place of manufacture, its findspot can even document interactions between cultures.

The 1970 UNESCO Convention requires members to prohibit the importation of stolen antiquities from other member states and offers help in protecting cultural property that is in jeopardy of pillage. To date, 103 countries have joined the convention.

Looters at the archaeological site of Isin, Southern Iraq, January 2004

Reliefs embellishing the platform of the Audience Hall and its double stairway proclaim the theme of harmony and integration across the multicultural empire, in marked contrast to the military narratives of the Assyrians (fig. **2.30**). Long rows of marching figures, sometimes superimposed in registers, represent the empire's 23 subject nations, as well as royal guards and Persian dignitaries. Each of the subject nations wears indigenous dress and brings a regional gift—precious vessels, textiles—as tribute to the Persian king. Colored stone and metals applied to the relief added richness to the wealth of carved detail. The relief is remarkably shallow, yet by keeping the figures' roundness to the edge of their bodies (so that they cast a shadow), and by cutting the background away to a level field, the sculptors created the impression of greater depth. Where earlier Mesopotamian reliefs depict figures that mixed profile and frontal views, most of these figures are depicted in true profile, even though some figures turn their heads back to address those who follow. The repetition of the walking human form contributes to a powerful dynamic quality that guides a visitor's path through the enormous space. The repetition also lends the reliefs an eternal quality, as if preserving the action in perpetual time. This would be especially fitting if, as some scholars believe, the relief represents the recurring celebration of the New Year Festival.

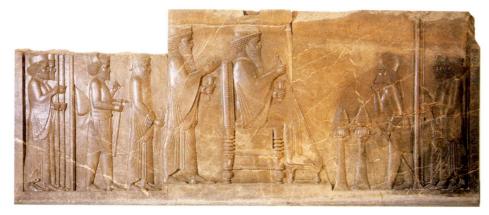

2.30. *Darius and Xerxes Giving Audience.* ca. 490 BCE. Limestone, height 8′4″ (2.5 m). Archaeological Museum, Tehran, Iran

The Achaemenid synthesis of traditions at Persepolis demonstrates the longevity and flexibility of the Near Eastern language of rulership. On a grand scale, the palace provides a dramatic and powerful setting for imperial court ritual.

Mesopotamia Between Persian and Islamic Dominion

Rebuffed in its attempts to conquer Greece, the Persian Empire eventually came under Greek and then Roman domination, but like many parts of the Greek and Roman empires, it retained numerous aspects of its own culture. The process began in 331 BCE with the victory of Alexander the Great (356–323 BCE) over the Persians. He burnt the palace at Persepolis in an act of symbolic defiance. His realm was divided among his generals after his death eight years later, and Seleukas (r. 305–281 BCE) inherited much of the Near East. The Parthians, who were Iranian nomads, succeeded the Seleucids, gaining control over the region in 238 BCE. Despite fairly constant conflict, the Parthians fended off the Romans until a brief Roman success under Trajan in the early second century CE, after which Parthian power declined. The last Parthian king was overthrown by one of his governors, Ardashir or Artaxerxes, in 224 CE. Ardashir (d. 240 CE) founded the Sasanian dynasty, named for a mythical ancestor, Sasan, who claimed to be a direct descendent of the Achaemenids, and this dynasty controlled the area until the Arab conquest in the mid-seventh century CE.

Ardashir's son, Shapur I (r. 240–272 CE), proved to be Darius's equal in ambition, and he linked himself directly to Darius. He greatly expanded the empire, and even succeeded in defeating three Roman emperors in the middle of the third century CE. Shapur commemorated two of these victories in numerous reliefs, including the immense example carved into rock at Naksh-i-Rustam, near Persepolis, where Darius I and his successors had located their rock-cut tombs (fig. 2.31). The subject is a recognizable type: For Romans, this was a stock scene, in which the victor, on horseback, raises his hand in a gesture of mercy to the defeated "barbarian," who kneels before him in submission. This gives the relief an ironic dimension, for the vic-

ART IN TIME

ca. 559–530/529 BCE—Rule of Cyrus the Great, who leads Persians to overthrow the Medes

ca. 518—Construction of the Persian palace at Persepolis begins

ca. 406 BCE—Death of Greek playwright Sophocles, author of *Oedipus Tyrannus*

331 BCE—Alexander the Great defeats the Persians

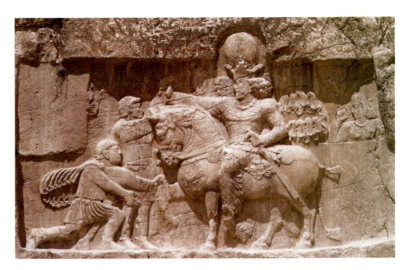

2.31. *Shapur I Triumphing over the Roman Emperors Philip the Arab and Valerian.* 260–272 CE. Naksh-I-Rustam (near Persepolis), Iran

torious Shapur expropriates his enemy's iconography of triumph. Elements of style are typical of late or provincial Roman sculpture, such as the linear folds of the emperor's billowing cloak. But Shapur's elaborate headdress and clothing, his heavily caparisoned horse, and his composite pose are distinctly Near Eastern.

Roman and Near Eastern elements are combined again in Shapur I's palace (242–272 CE) at Ctesiphon, near Baghdad, with its magnificent brick, barrel-vaulted audience hall or *iwan* (fig. 2.32). The exploitation of the arch to span huge spaces was a Roman practice (see fig. 7.68), and it was used here to enclose a

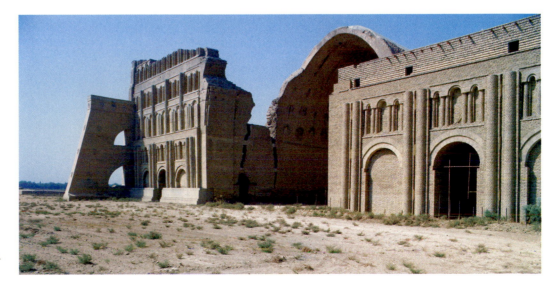

2.32. Palace of Shapur I. 242–272 CE. Ctesiphon, Iraq

space 90 feet high. The facade also reflects Roman models. The registers of arched blank windows or **blind arcades** may derive from Roman facades, such as in the stage buildings in theaters or ornamental fountains (see fig. 7.8). Yet the symmetry and the shallow depth of the arcades create a distinctly eastern surface pattern, subordinated to an awe-inspiring entry way. Shapur I continued the Near Eastern tradition of large-scale royal building.

Metalwork continued to flourish in the Sasanian period, executed in a variety of techniques. Hunting scenes were a popular subject, as seen in figure **2.33**, a late fifth-century CE silver bowl probably representing King Peroz I hunting gazelles.

The bowl was turned on a lathe, and the king and his prey were hammered out from behind (a technique known as *repoussé*) and emphasized in gilt. Details, such as the horns of the animals and the pattern on the quiver, are inlaid with niello, a compound of sulphur. The hunting subject continues a tradition known to Assyrians, and to Egyptians and Romans. Much Sasanian ware was exported to Constantinople (see map 8.1) and to the Christian West, where it had a strong effect on the art of the Middle Ages. Similar vessels would be manufactured again after the Sasanian realm fell to the Arabs in the mid-seventh century CE, and served as a source of design motifs for Islamic art as well (see Chapter 9).

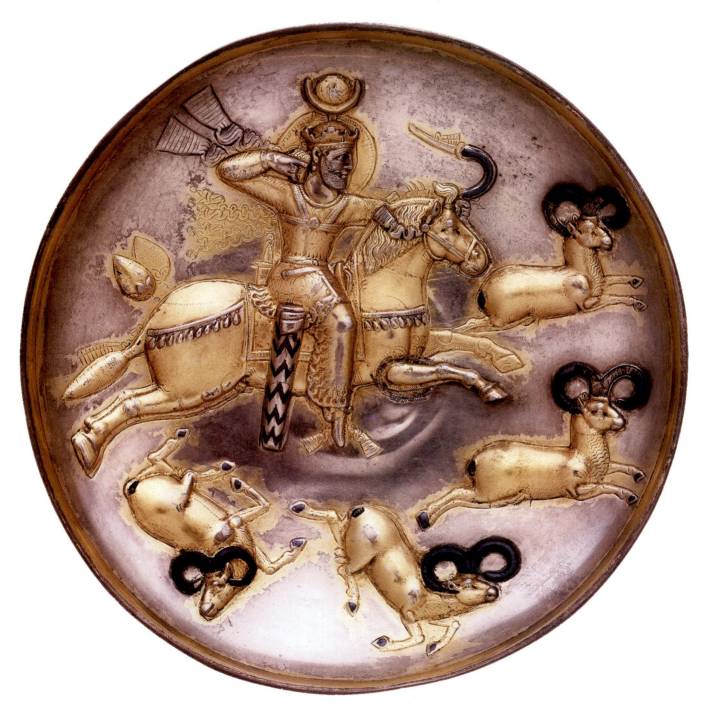

2.33. *King Peroz I Hunting Gazelles*. 457–483 CE.
Silver gilt, engraved, embossed, and inlaid with niello, diameter 8⅝″ (21.9 cm), height 1⅞″ (4.6 cm).
The Metropolitan Museum of Art, New York, Fletcher Fund, 1934 (34.33)

SUMMARY

During the last four millennia BCE, numerous civilizations rose and fell in the fertile lands of Mesopotamia and the neighboring lands in western Asia. Still, their art forms are surprisingly constant. Artists and architects were hired to express the authority of gods and rulers; in doing so, they also played a vital role in maintaining that authority. They produced a multitude of monuments, ranging from magnificent temples and palaces to relief and free-standing sculpture, often on a dizzying scale, as well as small but intricately carved cylinder seals and works in precious metals, ivory, and stone. They also explored sophisticated strategies for telling stories, and for guiding a visitor's movement through space. Mesopotamian art is deeply informed by the constant movement of peoples, objects, and ideas that characterized the time. Even today, deprived of its cultural and political context, it is an art of tremendous power.

SUMERIAN ART

Sumerian art and culture provided a model of visual communication that later groups entering Mesopotamia adapted to their own needs. Sumerian ziggurats offered imposing and highly visible platforms for religious structures and rituals. Surviving examples of Sumerian figure sculpture demonstrate a refined but abstract approach to representing the figure, whether in hard materials that were carved or in more pliable materials that were modeled or cast. The expensive materials used in grave goods for Sumerian elites express the level of resources they controlled as well as their power. Sumerian objects also reveal that culture's interest in telling stories in legible terms. Along with writing, Sumerians recorded aspects of their culture in carved seals.

ART OF AKKAD

At its height, the Empire of Akkad encompassed lands from Sumer to Syria to Nineveh. Akkadian rulers absorbed characteristics of Sumerian art but altered its imagery to create their own language of power; figural representations harked back to Sumerian precedents but expressed the authoritarian nature of Akkadian kingship. One of the most impressive surviving works is the magnificent copper portrait head found at Nineveh.

NEO-SUMERIAN REVIVAL

As the third millenium BCE came to an end, the cities of Sumer returned to the Sumerian language and blended their old artistic traditions with those of the Akkadian traditions. Building great ziggurats to local gods was an act of piety and of power. Following the example of the Akkadians, these Sumerian rulers took pains to represent themselves in permanent materials and in monumental form.

BABYLONIAN ART

After a period of war and turmoil, the region was unified under the rule of the Babylonian dynasty. The most famous ruler of this period was Hammurabi, who combined military prowess with a respect for Sumerian tradition. He is best known for his law code, which is one of the earliest surviving written bodies of law. During this time, the city of Babylon became the cultural center of Sumer.

ASSYRIAN ART

Assyria conquered southern Mesopotamia by the end of the first millennium BCE and in time expanded its boundaries to stretch from the Sinai Peninsula to Armenia. The theme of Assyrian art is the power of the ruler, and both walled cities and sprawling palaces reflect its military culture. Large guardian figures protected the palaces, while numerous reliefs on the walls recounted in great detail the victories and virtues of the king.

LATE BABYLONIAN ART

Before it was conquered by the Persians, the ancient city of Babylon had a brief reflowering. The best known of the Late Babylonian rulers is Nebuchadnezzar II, who was responsible for the famed Hanging Gardens. The royal palace built at this time was decorated with colorful glazed bricks, decorated with a procession of hundreds of sacred animals.

REGIONAL NEAR EASTERN ART

Alongside the variety of cultures within Mesopotamia were various other cultures that developed in areas beyond the Tigris and Euphrates. Some of these groups were invaders or conquerors, and others were traders. Two distinct civilizations among those that flourished alongside and interacted with the Mesopotamian civilizations were the Hittites and the Phoenicians.

IRANIAN ART

Located east of Mesopotamia, ancient Iran became a gateway for migrating tribes, and its art reflects these many intersections. Under the ruler Cyrus the Great, the Persians came to dominate their neighbors and eventually—during the reigns of Darius and his son Xerxes—the entire Near East. One remarkable artistic achievement of the ancient Iranians was the grand palace at Persepolis, which was burnt by a later conqueror, Alexander the Great.

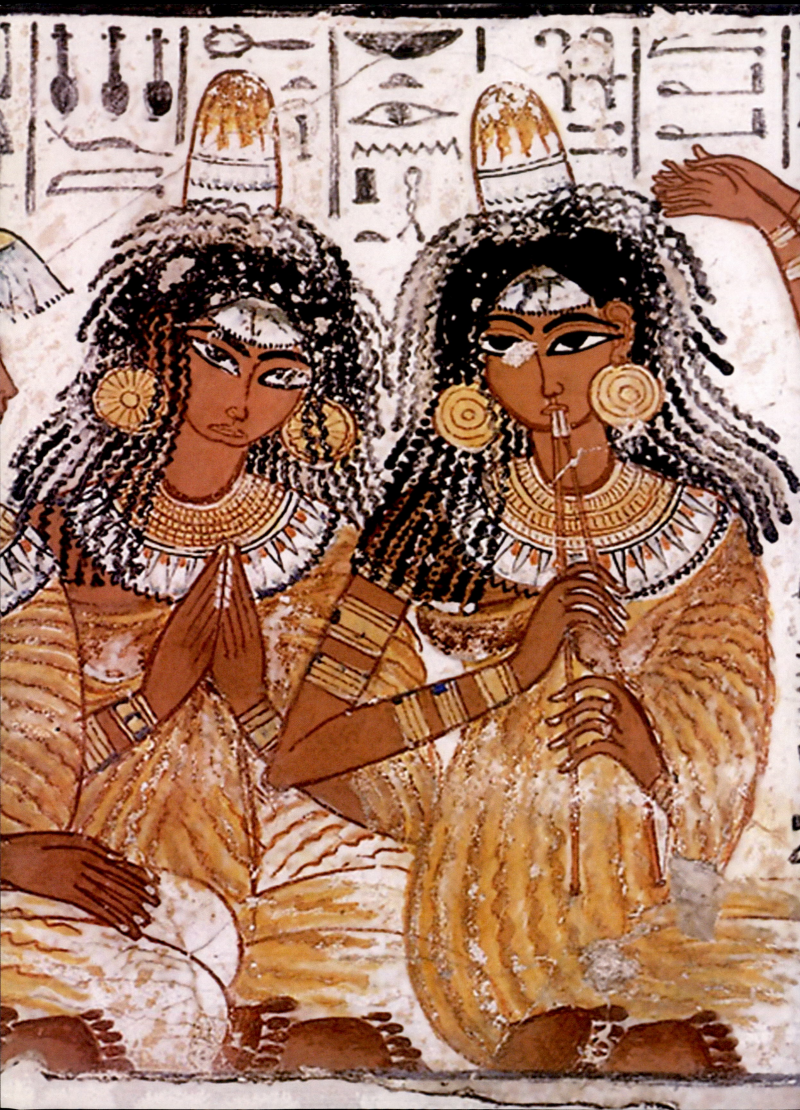

Egyptian Art

EGYPT HAS FASCINATED THE WEST FOR MILLENNIA. THE ANCIENT GREEKS and the Romans knew and admired Egypt, and their esteem passed to collectors and scholars in the Renaissance. Napoleon's incursions into Egypt at the end of the eighteenth century brought artifacts and knowledge back to France and stimulated interest throughout Europe.

European-sponsored excavations have been going on in Egypt since the nineteenth century, sometimes, as with the discovery in 1922 of the tomb of King Tutankhamen, with spectacular results. Modern excavations and research continue to intrigue the contemporary world.

One reason that ancient Egypt enthralls us is the exceptional technique and monumental character of its works of art. Most of these objects come from the monumental tombs that the Egyptians constructed. Egyptian tombs were built to assure a blissful afterlife for the deceased, and the paintings, sculptures, and other objects in them had an eternal purpose. Works of art were meant to accompany the deceased into eternity. Thus, Egyptian art is an art of permanence, not of change. In fact, the Greek philosopher Plato claimed that Egyptian art had not changed in 10,000 years. The reality is more complex, but it is fair to say that Egyptian artists did not strive for change or originality. Rather, they adhered to traditional formulations that expressed specific ideas, so continuity of form and subject is a characteristic of ancient Egyptian art.

Egyptian artists made art mainly for the elite patrons of a society that was extremely hierarchical. Contemporary with the Egyptian development of writing around 3000 BCE was the development of a political and religious system that placed a god-king (called a pharaoh from the New Kingdom on) in charge of the physical and spiritual well-being of the land and its people. Many of the best-known and most evocative works of Egyptian art were made for these powerful rulers. Royal art expresses the multifaceted ways that the king was envisioned: as a human manifestation of the gods, as a god in his own right, as beneficent ruler, and as an emblem of life itself. Royal projects for the afterlife dominated the Egyptian landscape and provided the model for all elite burials. Because the kings commissioned some of Egypt's most impressive tombs, the imagery of kingship intersected with the imagery of the afterlife in powerful ways.

These two categories of art—royal commissions and funerary objects—constitute most of the surviving Egyptian art. Egyptian religion accounts for the predominance of both types of art, and so does the land's geography. Established along the course of the Nile River in North Africa and protected by the surrounding desert, or "red land," Egypt was comprised of two distinct regions. Upper Egypt, in the south, includes the Nile Valley between present-day Aswan and the beginning of the Delta, near ancient Memphis and present-day Cairo. In lower Egypt, in the north, the Nile fans out into a delta. The Nile floods annually, inundating the land on either side along the river. As it recedes, the water leaves a dark strip of soil fertilized by silt. The result is a rich soil that the Egyptians called the "black land." It was irrigated and farmed and regularly produced surplus food. This allowed the Egyptians to diversify and develop a complex culture.

Detail of figure 3.33, *Musicians and Dancers*

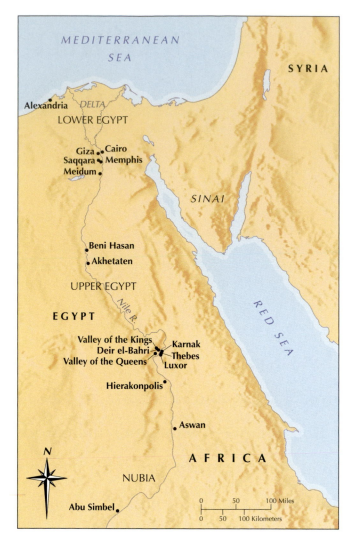

Map 3.1. Ancient Egypt

Egypt's agrarian society depended on the annual flooding of the Nile to survive. The king had to assure the continuity of life through intercession with the gods, who often represented natural forces. The chief deity was the sun, worshiped as the god Ra-Horakhty. But for the Egyptians concerned with a good afterlife, the deities Osiris, his consort Isis, and their son Horus played key roles. The gods took many forms: Ra might appear as a falcon-headed man; Osiris—who was killed and resurrected—as a mummy. The king himself was called the son of Ra and the human embodiment of Horus. As an equal to the gods, he controlled the land, the future, and the afterlife. A large priesthood, an administrative bureaucracy, and a strong military assisted him, but the king could call on anyone to serve him.

PREDYNASTIC AND EARLY DYNASTIC ART

The origins of Egyptian culture stretch back into the Neolithic period. By at least 5000 BCE, humans were growing crops and domesticating animals in the Nile Valley. Settlements there were gradually transformed into urban centers. In Upper Egypt, independent cities shared a rich culture that archaeologists know as

Naqada II/III (from the location where it was first discovered). With time, the culture of Upper Egypt spread northward, ultimately dominating the centers of Lower Egypt. Within a few centuries the cultures of Upper and Lower Egypt were united, and, so tradition has it, the first king of the first dynasty founded the city of Memphis, at the mouth of the Nile Delta (see map 3.1).

The division of Egypt into two distinct regions, Upper and Lower, arises from the Egyptian worldview. Egyptians saw the world as a set of dualities in opposition: Upper and Lower Egypt, the red land of the desert and the black land of cultivation, the god of the earth (Geb) balanced by the sky (Nut), Osiris (the god of civilization) opposed to Seth (the god of chaos). The forces of chaos and order had to be balanced by the king, who must bring *ma'at* (harmony or order) to the world. Recognizing this worldview has led some scholars to reconsider the traditional explanation that Upper and Lower Egypt were independent regions that were unified by King Narmer in the predynastic period. Instead, they have argued that this division was an imaginative construction of the past that came out of the dualistic worldview. Artists would have had to find a visual means to communicate this story of Egypt's origins.

The Palette of King Narmer

The concept of the king as unifier was expressed in the *Palette of King Narmer* (fig. **3.1**), dated around 3000 BCE. The Palette is a stone tablet with a depression at the center for grinding protective paint applied around the eyes. Its size—more than two feet high—implies that it was not for ordinary use, but probably used in a ceremony to grind eye makeup for a cult statue. This ritual function may explain where it was found. Archaeologists discovered the Palette in the temple of Hierakonpolis, where it had been buried along with other offerings to the god Horus.

The Palette is carved on both sides in registers (rows) in shallow relief. At the top of each side, in the center, Narmer's name is written in **hieroglyphs**, within an abstract rendering of the king's palace. Hieroglyphs were a writing system the Egyptians developed at about the same time as the Mesopotamians were inventing cuneiform. Named by the Greeks, who saw them as sacred writings, from *hieros* (sacred), and *graphein* (to write), they were used in both religious and administrative contexts. The Egyptians themselves called them "god's words." On either side of the hieroglyphs, heads of cows represent the sky goddess, locating the king in the sky. On one side of the Palette (shown on the left), King Narmer holds a fallen enemy by the hair, as he raises his mace—an emblem of kingship—against him with the other. The king is shown in the composite view that will be the hallmark of Egyptian two-dimensional art: with a frontal view of eye, shoulders, and arms, but a profile of head and legs. He wears the white crown of Upper Egypt and from the belt of his kilt hangs the tail of a bull, a symbol of power that Egyptian kings would wear as part of their ceremonial dress for 3,000 years. The large scale of his figure compared with others immediately establishes his authority. For his part, the enemy, like the two defeated enemies in the bottom register, is stripped of clothing as an act of humiliation. Behind the king, and standing on his own ground-line, is an attendant carrying the king's sandals.

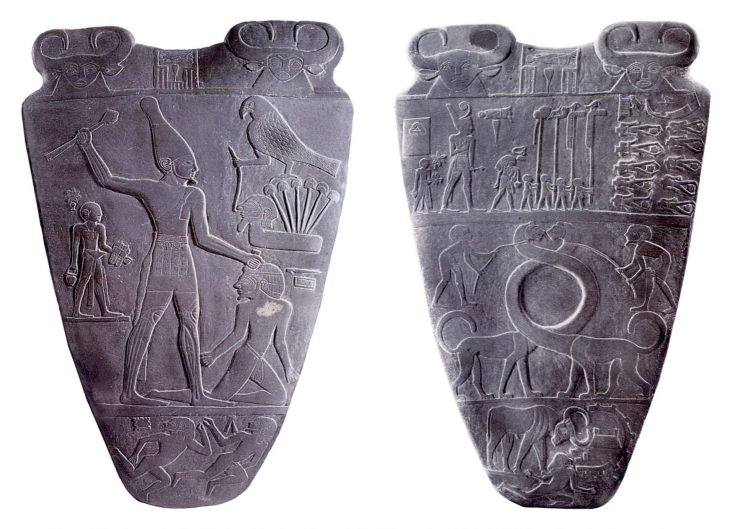

3.1. *Palette of King Narmer* (both sides), from Hierakonpolis. ca. 3150–3125 BCE. Slate, height 25″ (63.5 cm). Egyptian Museum, Cairo

Hieroglyphs identify both the sandal-carrier and the enemy. To the right of Narmer appears a falcon resting on a papyrus stand, which grows from a human-headed strip of land; the falcon holds a rope tethered to the face.

On the other side of the Palette (on the right in fig. 3.1), Narmer appears in the highest register, this time wearing the red crown of Lower Egypt. Flanked by the sandal carrier and a long-haired figure, he follows a group of four standard-bearers to inspect the decapitated bodies of prisoners, arranged with their heads between their legs. In the larger central register, two animals, each roped in by a male figure, twist their long necks to frame a circle in the composition. The symmetrical, balanced motif may represent "*ma'at*" (order). Though their significance in this context is uncertain, similar beasts occur on contemporary Mesopotamian cylinder seals, and may have influenced this design. In the lowest register, a bull representing the king attacks a city and tramples down the enemy. The Palette is significant because it communicates its message by combining several different types of signs into one object. Some of these signs—the king, attendants, and prisoners—are literal representations. Others are symbolic representations, such as the depiction of the king as a bull, denoting his strength. Pictographs, small symbols based on abstract representations of concepts, encode further information: In the falcon and papyrus

group, the falcon represents the god Horus, whom the Egyptians believed the pharaoh incarnated, while the human-headed papyrus stand represents Lower Egypt, where papyrus grew abundantly. A possible interpretation is that this pictograph expresses Narmer's control of that region. Finally, the artist included identifying texts in the form of hieroglyphs. Together, these different signs on the *Palette of King Narmer* drive home historically important messages about the nature of Egyptian kingship: The king embodied the unified Upper and Lower Egypt, specified in the differing crowns he wears on either side of the Palette. Though human, he occupied a divine office, as shown by the placement of his name in the sky, the realm of Horus, a celestial deity.

By the Fifth Dynasty, Horus was perceived as the son of Isis and Osiris. Osiris was the mythical founder of Egypt. His brother Seth (god of chaos) murdered and dismembered him, and scattered his remains. Osiris's consort, Isis, eventually recovered and reassembled them to create the first mummy, from which she conceived her son, Horus, who avenged his father's death by besting Seth in a series of contests. Egyptians saw the king as Horus's manifestation on earth; as such, he provided a physical body for the royal life force (*ka*) that passed from monarch to succeeding monarch. Positioned at the pinnacle of a highly stratified human hierarchy (indicated by his

Old Kingdom Funerary Complexes

During the Old Kingdom, buildings that housed the day-to-day activities of the living were constructed mainly of perishable materials, with the result that little survives. The bulk of archeological evidence comes instead from the funerary sphere, that is, from tombs. The great majority of the population were probably buried in shallow desert graves, but the elite had the resources to build elaborate funerary monuments and provide for their trappings. The survival of these tombs is no accident; they were purposely constructed to last through eternity.

These structures had several important functions. As in many cultures, tombs served the living by giving the deceased a permanent marker on the landscape. They indicated the status of the dead and perpetuated a memory of them. Early elite and royal burials were generally marked by a rectangular mud-brick or stone edifice (fig. **3.2**), known today as a *mastaba*, from the Arabic word for "bench." Its exterior sloping walls were plastered and painted to evoke a niched palace facade. This super-structure might be solid mud brick or filled with rubble, but sometimes it housed storerooms for equipment needed in funerary rituals or a funerary chapel. These monuments also served a critical function in ensuring the preservation of a deceased individual's life force, or *ka*. Egyptians considered the *ka* to live on in

scale), the king stood between mortals and gods, a kind of lesser god, and his role was to enforce order over its opposing force, chaos, which he does here by overcoming foreign foes and establishing visible authority over them.

THE OLD KINGDOM: A GOLDEN AGE

The *Palette of King Narmer* offers an image of kingship that transcends earthly power, representing the king as a divinity as well as a ruler. The kings of the Old Kingdom (Dynasty Three to Dynasty Six, ca. 2649 to 2150 BCE) found more monumental ways to express this notion. Their dynasties and their works of art would be emulated for the following two millennia. (See *Informing Art*, page 51.)

mastaba

shafts

burial chamber

3.2. Group of mastabas (after A. Badawy). 4th Dynasty

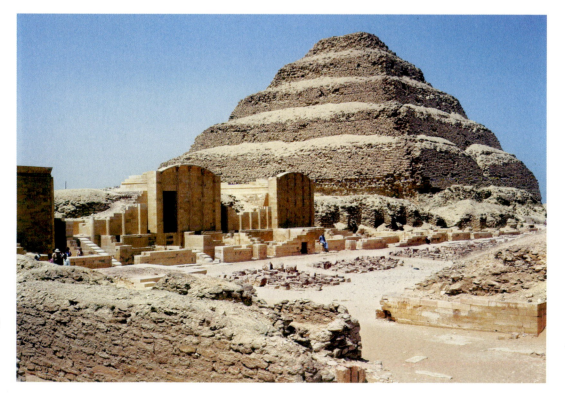

3.3. ~~Imhotep~~ Step Pyramid and Funerary Complex of King Djoser, Saqqara. 3rd Dynasty. ca. 2681–2662 BCE

Major Periods in Ancient Egypt

In Egyptian society, a king's life was the measure of time. To organize the millennia of Egyptian culture, scholars use a chronology devised in the third century BCE by the priest-historian Manetho, who wrote a history of Egypt in Greek for Ptolemy I, based on Egyptian sources. He divided the list of Egyptian kings into thirty-one dynasties, beginning with the First Dynasty shortly after 3000 BCE. Modern scholars have organized the dynasties into kingdoms, beginning with the Old Kingdom, from roughly 2649 BCE to 2150 BCE. The period before this, between prehistory and the First Dynasty, is known as the predynastic period. Further subdivisions include the Middle Kingdom (ca. 2040–1640 BCE) and the New

Kingdom (ca. 1550–1070 BCE). The actual dates for these broad periods and even for the reigns of kings are still being debated, as Manetho's list offered only a relative chronology (that is, the order in which kings succeeded one another) rather than absolute dates.

MAJOR PERIODS IN ANCIENT EGYPT

Before	Predynastic
ca. 2920 BCE	
ca. 2640–2469 BCE	Early Dynastic (Dynasties 1, 2)
ca. 2649–2150 BCE	Old Kingdom (Dynasties 3–6)
ca. 2040–1640 BCE	Middle Kingdom (Dynasties 11, 12)
ca. 1550–1070 BCE	New Kingdom (Dynasties 18–20)

court with *serdab*
funerary temple
step pyramid
stone platform with steps
crescent-shaped markers
sed-festival court between two rows of the shrines of Upper and Lower Egypt
open court
platform for dual *sed*-festival kiosk
enclosure wall
roofed entrance colonnade

0 100 200 meters
0 300 600 feet

3.4. Plan of the funerary district of King Djoser, Saqqara (Claire Thorne, after Lloyd and Müller)

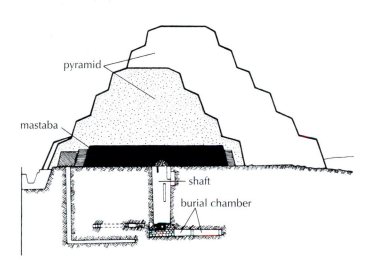

pyramid
mastaba
shaft
burial chamber

3.5. Transverse section of the Step Pyramid of King Djoser, Saqqara

the grave, and in order to do so, it required a place to reside for eternity. This is why embalmers went to such great lengths to preserve the body through mummification (a process that was only perfected in the Eleventh and Twelfth Dynasties). The mummified body, usually placed within a **sarcophagus** (a stone coffin) was interred in a burial chamber at some depth below the *mastaba*, surrounded by chambers for funerary equipment. Should the embalmers' efforts fail and the body decay, a statue could serve as a surrogate home for the *ka*, and so was placed within the burial chamber. Egyptians also equipped their tombs with objects of daily life for the *ka* to enjoy.

THE FUNERARY COMPLEX OF KING DJOSER Out of this tradition the first known major funerary complex emerges, that of the Third Dynasty King Djoser (Netjerikhet), at Saqqara (figs. **3.3**, **3.4**, and **3.5**), who ruled between 2630–2611 BCE. On the west side of the Nile, Saqqara was the **necropolis**, or city of the dead, of the capital city of Memphis in Lower Egypt. Encircling the entire complex is a rectangular enclosure wall of stone

stretching over a mile in length and 33 feet high. Dominating it, and oriented to the cardinal points of the compass, is a stepped pyramid, seen in fig. 3.3 and in a transverse section in fig. 3.5. It began as a 26-foot high mastaba, which originally would have been concealed by the enclosure wall. Over the course of years it rose to its towering 204-foot high form, as progressively diminishing layers of masonry were added, resulting in a staircase, perhaps the means by which the king could ascend to the gods. The treads of the "steps" incline downwards and the uprights outwards, giving the structure an impressively stable appearance. A chamber excavated about 90 feet into the rock beneath the pyramid and lined with Aswan granite contained the burial, accompanied by other chambers for provisions. North of the pyramid was a labyrinthine funerary temple, where offering rituals were performed for the dead king.

The buildings in the burial complex reproduce the palace architecture inhabited by the living king. In the palace, large courts were used to celebrate rituals of kingship. Similarly, a large court to the south of the pyramid may have housed rituals

3.6. Papyrus-shaped half-columns, North Palace, Funerary Complex of King Djoser, Saqqara

of receiving tribute or asserting royal dominion. The smaller oblong court to its east, flanked by shrines of Upper and Lower Egypt, may have been the site of the *sed*-festival, a ceremony that celebrated the king's 30-year jubilee and rejuvenated his power. Both sets of rituals were thought to be enacted by the dead king. Unlike the structures in a palace, many of the buildings in the funerary complex are nonfunctional: Of 14 gateways indicated in the niched enclosure wall, which evokes a palace facade, only one (on the southeast corner) allows entrance, while the rest are false doors. Similarly, chapels dedicated to local gods were simply facades with false doors, their rooms filled with rubble, sand, or gravel. Furthermore, while palaces were built of perishable materials—primarily mud brick—the funerary complex, constructed entirely in limestone, was built to last. Masons dressed the limestone blocks of the enclosure wall to resemble the niched facades of mud-brick architecture. Additionally, the reconstructed facade of a shrine echoes the form of an Upper Egyptian tent building, with tall poles supporting a mat roof that billows in the wind. Engaged columns imitate the papyrus stems or bundled reeds that Egyptian builders used to support mud-brick walls, with capitals shaped to resemble blossoms (fig. **3.6**). Paint over the stone lintels disguises them as wood, and inside the tomb chamber, blue and green tiles covered false doors to imitate rolled up reed matting.

Instead of being used by the living, many elements of the complex served as permanent settings for the dead king to perpetually enact rituals of kingship—rituals that maintained order among the living. The pharaoh's presence in the complex was assured by the installation of a life-sized seated statue of him in a *serdab* (an enclosed room without an entrance) to the east of the funerary temple. Two holes in the *serdab*'s front wall enabled his *ka*, residing in the statue, to observe rituals in his honor and draw sustenance from offerings of food and incense. The entire complex was oriented north-south, and the king's

statue looked out toward the circumpolar stars in the northern sky. Within the precinct dominated by the step pyramid that assisted the ascension of the king toward the sun, his *ka* would remain eternally alive and vigilant.

Inscriptions on fragments of statues found within the complex preserve the name of the mastermind behind its construction, a high official in Djoser's court named Imhotep, who is often identified as the first named architect in history. High priest of the sun-god Ra, Imhotep was credited with advancing Egyptian culture through his wisdom and knowledge of astronomy, architecture, and medicine, and he was so highly regarded within his own time and beyond that he was deified. This complex, the first large-scale building constructed entirely in stone, preserves at least one of his legacies.

The Pyramids at Giza: Reflecting a New Royal Role

Other kings followed Djoser's lead, but during the Fourth Dynasty, ca. 2575–2465, funerary architecture changed dramatically. To the modern eye, the most obvious change is the shift from a step pyramid to a smooth-sided one. A pyramid at Meidum attributed to Sneferu, the founder of the Fourth Dynasty, underlines the deliberateness of the transformation: Originally a step pyramid, its steps were later filled in to produce smooth sides.

The best known pyramids, however, are the three Great Pyramids at Giza (fig. **3.7**), built in commemoration of Sneferu's son, Khufu (the first and largest pyramid), Khafra (a moderately smaller pyramid), and Menkaure (the smallest pyramid). Throughout the ages since their construction, the pyramids have continued to fascinate and enchant—and for good reason. Their lasting grandeur derives both from their sheer monumentality (Khafra's covers 13 acres at the base, and even today rises to a

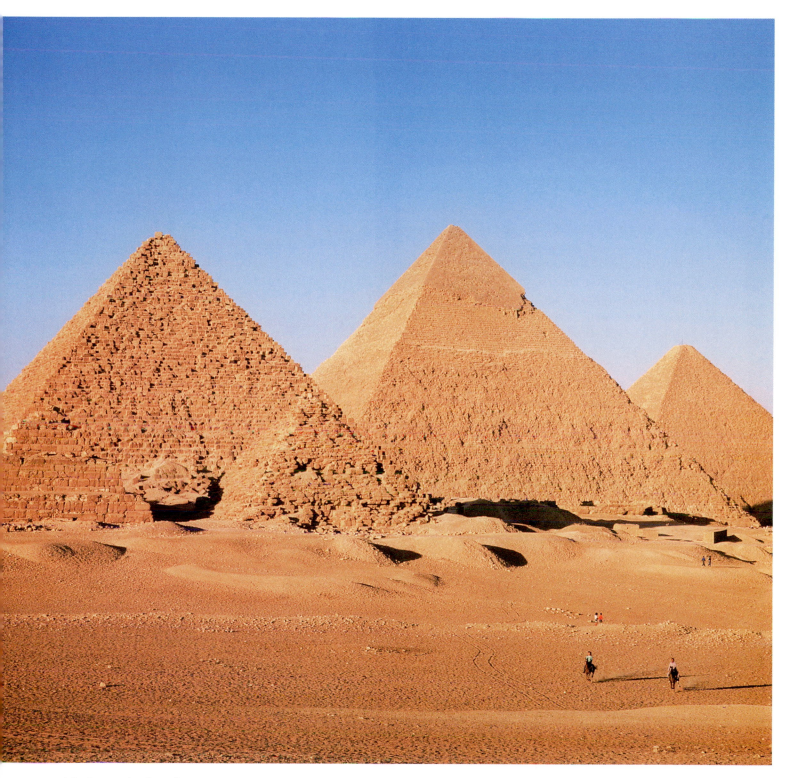

3.7. The Pyramids of Menkaure, ca. 2533–2515 BCE, Khafra, ca. 2570–2544 BCE, and Khufu, ca. 2601–2528 BCE, Giza

Great Pyramids of Giza

White limestone + thin layer of Gold

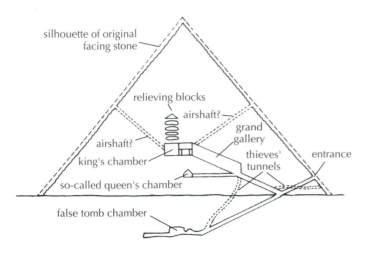

3.8. North–south section of Pyramid of Khufu
(after L. Borchardt)

height of about 450 feet) and from their extraordinary simplicity. On a square plan, their four surfaces, shaped as equilateral triangles, taper up from the desert sand toward the sky. At any time of day, one side will hold the sun's full glare, while another is cast into shadow. Before Islamic builders plundered their stone, each pyramid was dressed with white limestone, preserved only on the pinnacle of the Pyramid of Khafra; at the tip, moreover, each was covered with a thin layer of gold. On the pyramids of Khafra and Menkaure, red granite set off the limestone's whiteness at ground level. The entrance to each pyramid was on its north face, and somewhere within the solid stone mass, rather than below ground, a burial chamber was concealed in the hopes of foiling tomb-robbers (fig. 3.8). Encircling each pyramid was an enclosure wall, and clustered all around are several smaller pyramids and mastabas for members of the royal family and high officials.

Like Djoser's complex at Saqqara and most subsequent royal burials, Fourth Dynasty burials were located on the Nile's west bank, the side of the setting sun, across from living habitations on the east bank (fig. 3.9). Yet unlike Djoser's complex, with its compact form laid out on a north–south axis, those at Giza were set out on an extended east–west axis. At the start of the funeral ceremony, the body was transported westward across the Nile. Once beyond the land under cultivation, the procession reached the valley temple, connected to the Nile by a canal. The valley temple of Khafra features a central T-shaped hallway, where walls and pillars of costly red Aswan granite were set off by floors of white calcite. Light cascaded in through slits in the upper walls and the red granite roof.

Running west from the valley temple into the desert for about a third of a mile, a raised and covered causeway led to the funerary temple, adjoined to the pyramid's east face, where the dead king's body was brought for embalming, and where the living perpetuated the cult for his *ka*. Again, a rich variety of hard stone made for a vivid coloristic effect; relief sculptures probably also decorated the funerary temples, but have mostly perished with time. Next to the valley temple of Khafra stands the Great Sphinx, carved from an outcropping of rock left after quarrying stone (fig. 3.10). (Like the word *pyramid*, *sphinx* is a Greek term.) Damage inflicted under Islamic rule, when residents were uncomfortable with human representation in art, has obscured details of its face, and the top of the head is missing, but scholars believe that a portrait of Khafra (or possibly Khufu) was combined with the crouching body (and thus strength) of a lion. Its huge scale also expresses the king's power.

The change in funerary architecture suggests a shift in the way Egyptians conceived of their ruler. The smooth-sided pyramid was the shape of the *ben-ben*, the sacred stone

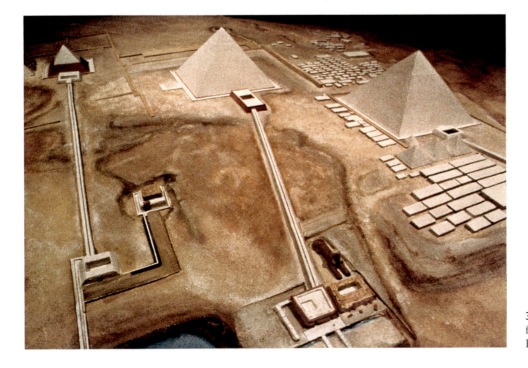

3.9. Model of the Great Pyramids at Giza: from left to right, Menkaure, Khafra, and Khufu.

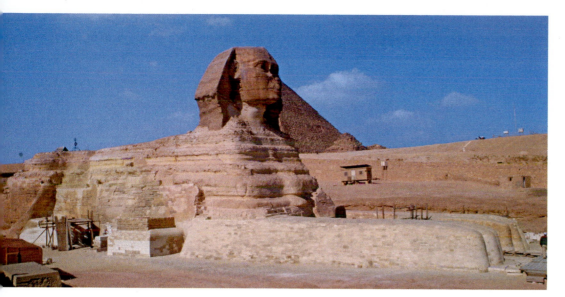

3.10. The Great Sphinx. ca. 2570–2544 BCE. Giza. Sandstone, height 65′ (19.8 m)

relic in Heliopolis, center of the sun cult. This may indicate that these monumental tombs emphasized the solar aspect of the pharaoh's person; indeed, this change in building practice coincides more or less with the pharaoh's adoption of the title "son of Ra" (the sun-god). The change in orientation for the complexes also meant that the pharaoh's funerary temple did not face the northern stars, as before, but the rising sun in the east, signifying eternity through its daily rising and setting. In contrast to the funerary complex for Djoser (see figs. 3.3 and 3.4), the complex at Giza contains no buildings for reenacting rituals of kingship, suggesting that the perpetual performance of these rituals was no longer the dead king's task. Now, his role was to rise to the sun-god on the sun's rays, perhaps symbolized by the pyramid's sloping sides, and to accompany him on his endless cycle of regeneration.

Texts written on the interiors of some later Old Kingdom pyramids express this conception of the role of the king vividly. These pyramid texts were chants or prayers inscribed on the walls inside the pyramid. The *Primary Source* on page 56, from the pyramid of Unis in Saqqara, dates to about 2320 BCE and describes the king's resurrection and ascension.

Representing the Human Figure

Indentations in the paving of the hall in the valley temple of Khafra show that a series of 23 seated statues of the king once lined its walls. Archeologists discovered one of these almost intact and six in poorer condition, interred in the temple floor. The best-preserved statue represents the seated king in a rigidly upright and frontal pose (fig. **3.11**). This pose allowed him to watch—and thus, in a sense, take part in—rituals enacted in his honor; frontality gave him presence. Behind him, the falcon Horus spreads his wings protectively around his head. Like the *Palette of King Narmer*, this sculpture neatly expresses the qualities of kingship. Horus declares the king his earthly manifestation and protégé, and the king's muscular form indicates his power. The smooth agelessness of his face bespeaks his eternal nature, while the sculpture's compact form gives it a

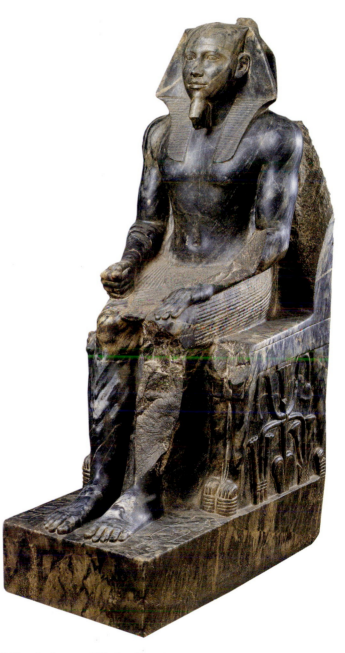

3.11. *Sculpture of Khafra,* from Giza. ca. 2500 BCE. Diorite, height 66″ (167.7 cm). Egyptian Museum, Cairo

Excerpt from the Pyramid Text of Unis (r. 2341–2311 BCE)

King Unis of the Fifth Dynasty built a pyramid at Saqqara on the walls of which were inscribed a series of incantations and prayers for the afterlife of the pharaoh. So-called Pyramid Texts such as these were placed in tombs throughout Egyptian history for both royal and nonroyal burials. Some of their formulas were adapted for different versions of the Book of the Dead. Though their earliest survival is about 2320 BCE, the prayers may have been composed much earlier.

The Resurrection of King Unis

A pale sky darken, stars hide away,
Nations of heavenly bowmen are shaken,
Bones of the earth gods tremble—
All cease motion, are still, for they have looked upon Unis,
 the King,

Whose soul rises in glory, transfigured, a god,
Alive among his fathers of old time, nourished by ancient
 mothers.

The King, this is he! Lord of the twisty ways of wisdom
(whose very mother knew not his name),
His magnificence lights the black sky,
His power flames in the Land of the Risen—
Like Atum his father, who bore him;
And once having born him, strong was the Son more than the Father!

The *Kas* of the King hover about him;
Feminine spirits steady his feet;
Familiar gods hang over him;
Uraei (cobras) rear from his brow;
And his guiding Serpent precedes:
"Watch over the Soul! Be helpful, O Fiery One!"
All the mighty companions are guarding the King!

SOURCE: *ANCIENT EGYPTIAN LITERATURE: AN ANTHOLOGY.* TR. JOHN I. FOSTER (AUSTIN, TX: UNIVERSITY OF TEXAS PRESS, 2001)

solidity that suggests permanence. Intertwined plants—papyrus and perhaps sedge—carved between the legs of his chair are indigenous to Lower and Upper Egypt, indicating the territorial reach of royal authority. Even the material used to carve his image expresses the king's control of distant lands. The stone, diorite, was brought from the deserts of Nubia. A hard stone, it lends itself to fine detail and a high polish, and the strong Egyptian light coming in through the louvred ceiling of the temple and reflected off the white calcite pavement must have made the figure glisten impressively.

A slightly later, three-quarter life-size group carved from schist represents King Menkaure and his chief wife Khamer-ernebty II (fig. **3.12**). Like the statue of Khafra, it is carved in one piece with an upright back slab, and it exhibits a similar rigid frontality. One reason for this may have been the sculpture's intended location and function. Like the Khafra sculpture, the group may have come from the king's valley temple.

Menkaure and his queen Khamerernebty share several characteristics. Of almost identical height, both are frozen in a motionless stride with the left foot forward. Menkaure's headdress echoes the form of Khamerernebty's hair, and though the king is more muscular than his queen, both bodies are characterized by smooth surfaces and a high polish, even though one is draped and the other half nude. (The queen wears a thin dress, hemmed at her ankles.) These common qualities establish an appearance of unity, and king and queen are further unified by the queen's embrace.

In some cases, traces of paint on sculptures show that sculptors added details with color, but whether they always did so to statues carved in high-quality hard stone is a matter of debate. A pair of Fourth Dynasty sculptures representing the seated Rahotep and his wife Nofret, from a mastaba tomb at Meidum, are carved from limestone, a softer stone than diorite, which does not yield such fine surface detail (fig. **3.13**). Here, the artist painted skin tones, hair, garments,

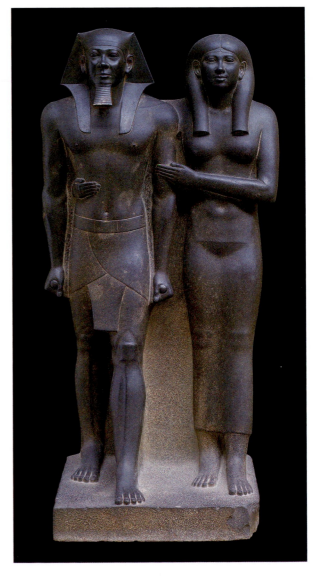

3.12. *Sculpture of Menkaure and His Wife, Queen Khamerernebty II,* from Giza. ca. 2515 BCE. Slate, height 54$\frac{1}{2}$" (138.4 cm). Museum of Fine Arts, Boston. Harvard–Museum of Fine Arts Expedition

human image. Traces of such guidelines are still visible on reliefs and paintings. The system of guidelines began in the Fifth Dynasty with a grid of one vertical line, running through the body at the point of the ear, and as many as seven horizontal lines dividing the body according to a standard module. Over time, the guidelines changed, but the principle of this "canon" remained: Although body part measurements could change from person to person, the relationship between parts stayed constant. With that relationship established, an artist who knew the measurement of a single body part could depict a human portrait at any scale, taking the proportions of other essential forms from copybooks. Unlike the system of perspective we know today, where a figure's size suggests its distance from a viewer, in the Egyptian canon, size signaled social status.

Elite male officials were depicted in two kinds of ideal images, each representing a different life stage. One is a youthful, physically fit image, like Hesy-ra or Khafra. The other is a mature

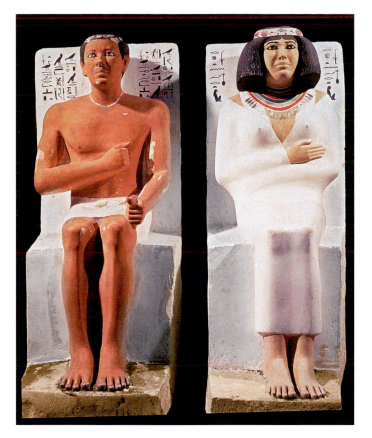

3.13. *Sculpture of Prince Rahotep and His Wife, Nofret.* ca. 2580 BCE. Painted limestone, height 47¼″ (120 cm). Egyptian Museum, Cairo

and jewelry, using the standard convention of a darker tone for a male, a lighter tone for a female. Inscriptions identify the pair and describe their social status: He is a government official and she is a "dependent of the king." Rock crystal pupils so animate the eyes that, in later years, robbers gouged the eyes out of similar figures before looting the tombs they occupied. Like the royal portraits, these figures are represented frontally and with ritualized gestures.

Rigid frontality is the norm for royal and elite sculptures in the round. In relief and painting, there is also a remarkable consistency in stance among royal and elite sculptures. The standard stance, as illustrated on a wooden stele found in the mastaba of a court official of Djoser, Hesy-ra, at Saqqara, is altogether unnaturalistic (fig. **3.14**). As on the *Palette of King Narmer* (fig. 3.1), frontal shoulders and arms and a frontal kilt combine with a profile head (with a frontal eye) and legs; the figure has two left feet, shown with high arches and a single toe. The representation is conceptual or intellectual rather than visual: The artist depicts what the mind knows, not what the eye sees. This artificial stance contributes to the legibility of the image, but it also makes the figure static.

THE CANON In royal and elite sculpture in the round, and in relief and painting, body proportions are also consistent enough that scholars believe artists used guidelines for designing the

3.14. *Relief Panel of Hesy-ra,* from Saqqara. ca. 2660 BCE. Wood, height 45″ (114.3 cm). Egyptian Museum, Cairo

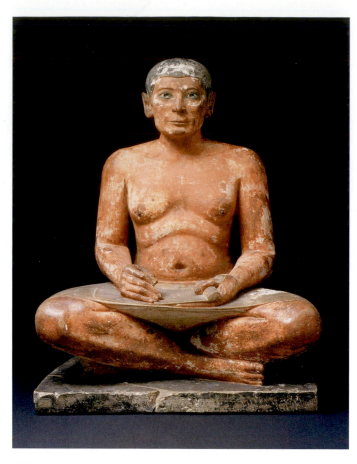

3.15. *Sculpture of Seated Scribe,* from Saqqara. ca. 2400 BCE. Limestone, height 21″ (53.3 cm). Musée du Louvre, Paris

image, often indicated by a paunch, rolls of fat, or slack muscles, and signs of age on the face. A painted limestone figure of a scribe, perhaps named Kay, from his mastaba at Saqqara, is an example of the second type (fig. **3.15**). The scribe is rigidly upright and frontal, like Khafra, but unlike the ageless monarch, his body shows signs of slackening, in the sallow cheeks, sagging jaw, and loose stomach. Since Egyptian society was mostly illiterate, a scribe occupied an elevated position; indeed, seated on the floor, the figure is depicted in the act of writing, the skill in which his status resided. The image suggests his social status: It shows an official who has succeeded in his career, eats well, and relies on subordinates to work on his behalf. A wooden statue of an official named Ka-Aper, also from his mastaba at Saqqara, displays the same phenomenon (fig. **3.16**). Despite the frozen stride, and even stripped of paint, the portrait appears extraordinarily lifelike, with its rock crystal eyes and sensitively carved face; the double chin and generous paunch add to its naturalism, as does the absence of a backslab. Like the scribe, Ka-Aper bears the insignia—the staff—of his office.

These conventions of pose, proportion, and appearance applied only to the highest echelons of society—royalty and courtiers. By contrast, the lower the status of the being represented, the more relaxed and naturalistic their pose. Once the conventions were established, ignoring them could even result in a change of meaning for a figure, especially a change of status, from king or official to servant or captive. The correlation between rank and degree of naturalism is neatly encapsulated in fine low

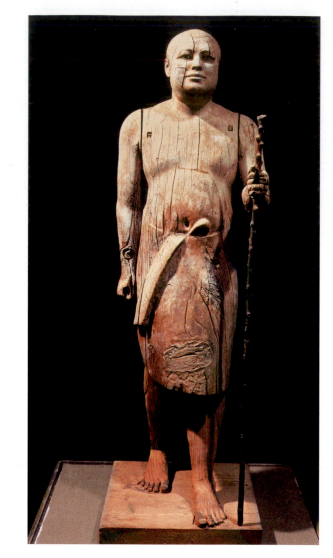

3.16. *Sculpture of Ka-Aper,* from Saqqara. ca. 2450–2350 BCE. Wood, height approx. 3′7″ (109 cm) Egyptian Museum, Cairo

relief paintings in the tomb chapel of Ti, a high official during the Fifth Dynasty, at Saqqara (fig. **3.17**). In the section illustrated here, Ti stands on a boat in a thicket of papyrus, observing a hippopotamus hunt. He stands rigidly in the traditional composite view, legs and head in profile, torso and eye frontal, while hunters, shown on a smaller scale, attack their prey from a second boat in a variety of active poses that more closely resemble nature. Zigzagging blue lines beneath the boats denote the river, where hippopotami and fish—on the lowest rung of the natural world—move freely. Similarly, nesting birds and predatory foxes move freely in the papyrus blossoms overhead.

PAINTINGS AND RELIEFS Like statues in tombs, paintings and reliefs such as these played a role in the Egyptian belief system. Images such as *Ti Watching a Hippopotamus Hunt* allowed the deceased to continue the activities he or she had enjoyed while alive. Yet they also functioned on various metaphorical levels. The conquest of nature, for instance, served as a metaphor for triumph over death. Death was Osiris's realm, as god of the underworld, but so was the Nile his realm because of Osiris's regeneration after Seth had murdered him.

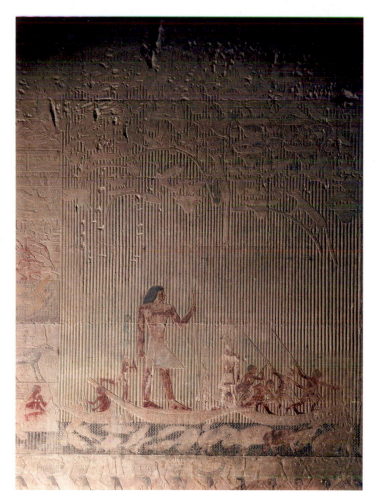

3.17. *Ti Watching a Hippopotamus Hunt.* ca. 2510–2460 BCE.
Painted limestone relief, height approx. 45″ (114.3 cm).
Tomb of Ti, Saqqara

ART IN TIME

2630–2611 BCE—Rule of king D̲...

ca. 2575–2465 BCE—Ancient Egy̲...
construction̲...
at Giza

ca. 2100 BCE—Final phase of c̲...

This led to the turbulent First Interme̲... ̲...g ̲...a
century, when local or regional overlo̲...s ̲...ostered antagonisms
between Upper and Lower Egypt. The two regions were reunit-
ed again in the Eleventh Dynasty, as King Nebhepetra Men-
tuhotep or Mentuhotep II (ca. 2061–2010 BCE) gradually
reasserted regal authority over all of Egypt. The Eleventh and
Twelfth Dynasties make up the Middle Kingdom (ca. 2040–1640
BCE), and much of the art of the period deliberately echoed Old
Kingdom forms, especially in the funerary realm. This art
asserted continuity with earlier rulers, but sculptures of mem-
bers of the royal family also show breaks with tradition.

Royal Portraiture: Changing Expressions and Proportions

A fragmentary quartzite sculpture of Senwosret III
(r. 1878–1841 BCE) suggests a break with convention in the way
royalty is depicted (fig. **3.18**). Rather than sculpting a smooth-
skinned, idealized face, untouched by time—as had been done

Osiris, after all, was the god of fertility and resurrection, to
whom the deceased could be likened. And, because Isis hid
Horus in a papyrus thicket to protect him from Seth, a papyrus
stand was considered a place of rebirth, much like the tomb
itself. Traditionally, too, a boat was the vehicle that carried the
ka through its eternal journey in the afterlife. By contrast, the
hippopotamus, which destroyed crops, was often viewed as an
animal of evil and chaos and thus as the embodiment of the
destructive Seth, who governed the deserts.

The entire painting may have been encoded with meaning
specific to its funerary context. Other Old Kingdom tomb
paintings depict family members buried alongside the principal
tomb owner, or as company for the *ka* in the afterlife. Some
scenes depict rituals of the cult of the dead or portray offerings
and agricultural activities designed to provide the *ka* with an
eternal supply of food. In these scenes, the deceased typically
looks on, but does not take part.

THE MIDDLE KINGDOM: REASSERTING TRADITION THROUGH THE ARTS

The central government of the Old Kingdom disintegrated with
the death of the Sixth Dynasty King Pepy II in around 2152 BCE.

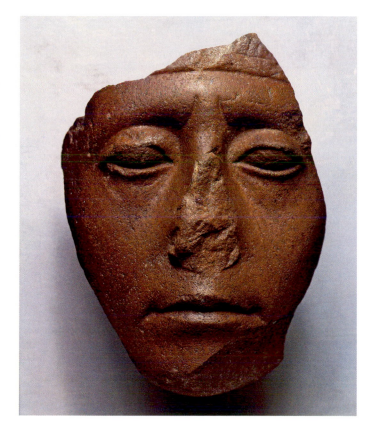

3.18. *Sculpture of Senwosret III* (fragment). ca. 1850 BCE.
Quartzite, height 6½″ (16.5 cm). The Metropolitan Museum of Art,
New York. Purchase, Edward S. Harkness Gift, 1926 (26.7.1394)

Facial expressions or signs of age, however, signify quite different things to different societies, and it is equally likely that the tight-lipped expression reflects a new face of regal authority, projecting firm resolve. The aged face tended to be combined with a youthful, powerful body.

More naturalistic facial expression in royal images was not the only Middle Kingdom innovation. The canon of proportions changed too. If we compare the Old Kingdom sculpture of Queen Khamerernebty (fig. 3.12) with a sculpture of Lady Sennuwy (fig. 3.19), the wife of a provincial governor, found at Kerma in Upper Nubia, the change in proportions is clear. During the Middle Kingdom, women were increasingly depicted with narrower shoulders and waists, and slimmer limbs. Males were depicted with proportionally smaller heads, and without the tight musculature of their Old Kingdom counterparts. These subtle changes distinguish representations of the human body from period to period.

Funerary Architecture

The pattern of burials among court officials and other members of the elite stayed relatively constant during the Middle Kingdom, with most preferring burial in sunken tombs and mastabas. Especially popular at this time were rock-cut tombs, which were already known in the Old Kingdom. Fine examples still exist at Beni Hasan, the burial place of a powerful ruling family of Middle Egypt in the Eleventh and Twelfth Dynasties (fig. 3.20). The tombs were hollowed out of a terrace

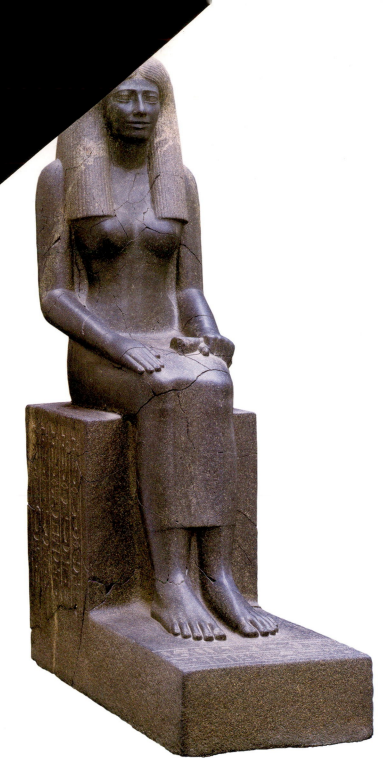

3.19. *Sculpture of the Lady Sennuwy.* ca. 1920 BCE. Granite, height 67³/₄″ (172 cm), depth 45⁷/₈″ (116.5 cm). Museum of Fine Arts, Boston. Harvard University-Boston Museum of Fine Arts Expedition. Photograph © 2006, Museum of Fine Arts, Boston. 14.720

3.20. Rock-Cut Tombs at Beni Hasan, B-H 3-5, 11th and 12th Dynasties. ca. 1950–1900 BCE

for over 1,000 years—the artist depicted a king with signs of age. The king has a creased brow, drooping eyelids, and lines beneath the eyes. Scholars have described the image as "introspective," and read it against the background of Senwosret III's difficult campaign of military expansion in Nubia to the south, seeing the imperfections as visible signs of the king's stress.

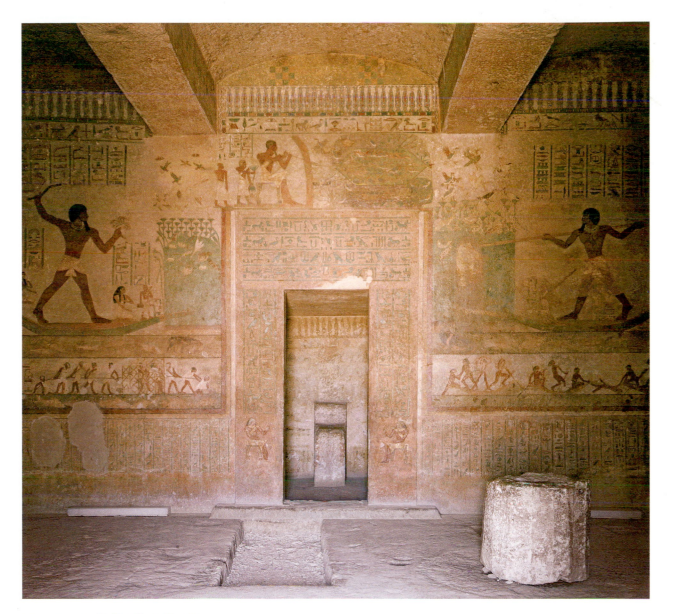

3.21. Interior Hall of Rock-Cut Tomb, B-H 2, Beni Hasan. 12th Dynasty. ca. 1950–1900 BCE

of rock on the east bank of the Nile and offered stunning views across the river. Inside, an entrance vestibule led to a columned hall and burial chamber, where a statue of the deceased stood in a niche (fig. 3.21). As in Old Kingdom tombs, painted relief decorated the walls. The section illustrated in figure 3.22, from the restored tomb of Khnum-hotep, shows workers restraining and feeding oryxes (a type of antelope caught in the desert and raised in captivity as a pet).

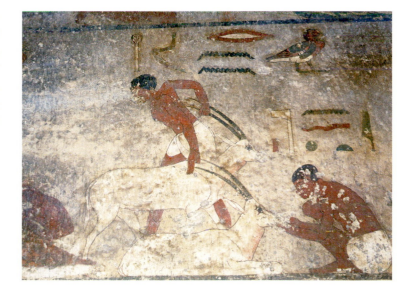

3.22. *Feeding the Oryxes.* ca. 1928–1895 BCE. Detail of a wall painting. Tomb of Khnum-hotep, Beni Hasan

well have been as a fertility charm, to enhance family continuity among the living and regeneration of the dead into a new life in the beyond. The blue-green color of the faience was associated with fertility, the goddess Hathor, and regeneration.

Patrons in the Middle Kingdom revived some of the forms and practices of the Old Kingdom to assert a link to the golden days of the past. Yet stability was not to endure. As the central authority weakened after about 1785 BCE, local governors usurped power. During the Twelfth Dynasty, immigrants from Palestine moved into the Nile Delta, gradually gaining control of the area and forcing the king to retreat southward to Thebes. This group was known as the Hyksos (from the Egyptian for "rulers of foreign lands"), and the era of their control is known as the Second Intermediate Period.

THE NEW KINGDOM: RESTORED GLORY

The Hyksos were finally expelled from Egypt by Ahmose (1550–1525 BCE), first king of the Eighteenth Dynasty. The 500 years after their expulsion, the Eighteenth, Nineteenth, and Twentieth Dynasties, have been designated the New Kingdom, a time of renewed territorial expansion and tremendous prosperity for Egypt, and a time when the arts flourished. Tremendous architectural projects were carried out along the full length of the Nile, centering on the region of Thebes (modern Luxor). Of these projects, many secular buildings, including palaces and forts, were made of mud brick and have since perished. Stone tombs and temples, however, retain a small measure of their former glory.

Royal Burials in the Valley of the Kings

A major difference between the Old Kingdom and the New may be seen in their burial practices. Having witnessed the loss of order that allowed royal burials to be robbed, Eighteenth Dynasty kings abandoned the practice of marking their tombs with pyramids. Instead, tombs were excavated out of the rock face in the Valley of the Kings west of Thebes, with their entrances concealed after burial. Excavations have revealed that in these tombs a corridor led from the entrance deep into the rock to the burial chamber, which was flanked by storage rooms. The burial chamber was decorated with paintings of the king with Osiris, Anubis, and Hathor, funerary deities who assured his passage into the next world. Rituals of the funerary cult took place apart from the tomb, over a rocky outcropping to the east, at a temple on the edge of the land under cultivation.

HATSHEPSUT'S TEMPLE The best preserved example of a New Kingdom funerary temple is that of the female king Hatshepsut, built by her architect Senenmut (ca. 1478–1458 BCE) as shown in figure **3.24**. Hatshepsut was the chief wife—and half sister—of Thutmose II. On his death in 1479 BCE, power passed to Thutmose III, his young son by a minor wife. Designated regent for the young king, Hatshepsut ruled with him as female king until her death in 1458 BCE, claiming that her father, Thutmose I, had intended her as his successor.

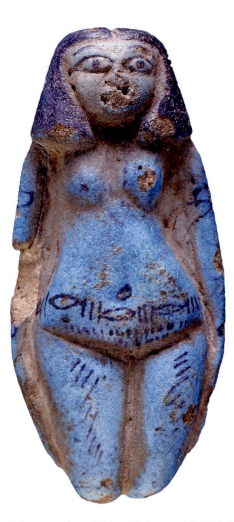

3.23. *Female Figurine,* from Thebes. Faience. 12th–13th Dynasties. Height 3⅓″ (8.5 cm). The British Museum, London. Courtesy of the Trustees

As in the Old Kingdom, tomb paintings were believed to provide nourishment, company, and pastimes for the dead. A wide variety of objects were placed in tombs along with the dead, including objects made of **faience**, a glass paste fired to a shiny opaque finish. The figurine shown in figure **3.23** came from a tomb in Thebes, and represents a schematized woman. Her legs stop at the knees, possibly to restrict her mobility, or because they were not essential to her function. Instead, her breasts and pubic area are delineated, and a painted cowrie shell girdle emphasizes her belly and hips. Her function may

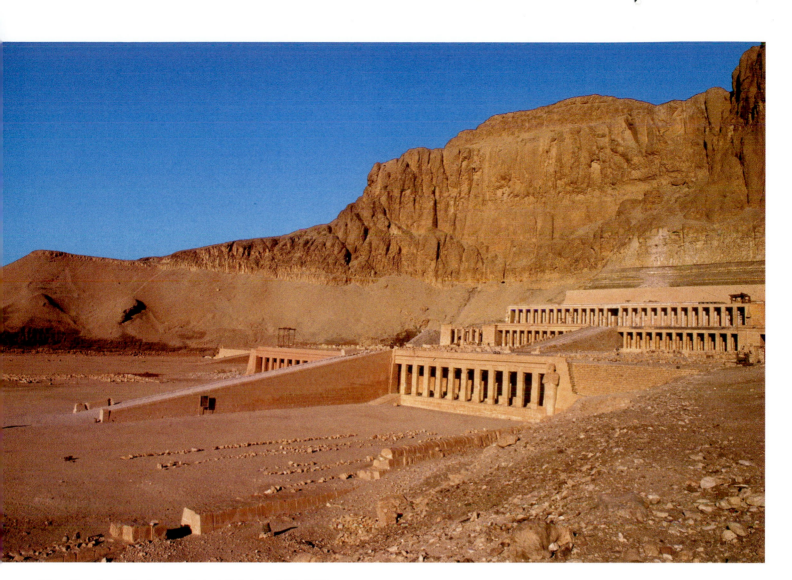

3.24. Temple of Hatshepsut, Deir el-Bahri. ca. 1478–1458 BCE

senenmut (artist)

Nestled in the cliffside at Deir el-Bahri, Hatshepsut's temple sat beside the spectacular Eleventh Dynasty temple of Mentuhotep II (fig. **3.25**), who had reunited Egypt over 500 years earlier during the Middle Kingdom. The architects who designed Hatshepsut's temple may have modeled some of its features after this earlier temple, with its terraces extending into the cliff face, topped with a pyramid or a mastaba. Once joined by a causeway to a valley temple beside the Nile, Hatshepsut's temple is a striking response to its setting. Its ascending white limestone courts, linked by wide ramps on a central axis, echo the desert's strong horizontal ground-line and the cliff top above. A multitude of vertical lines, meanwhile, established by the bright light and shadows of the colonnades, harmonize with the fissures

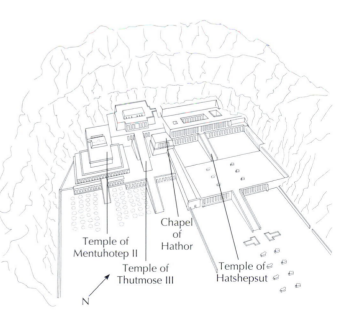

3.25. Reconstruction of Temples, Deir el-Bahri, with temples of Mentuhotep II, Thutmose III, and Hatshepsut (after a drawing by Andrea Mazzei, Archivio White Star, Vercelli, Italy)

of the cliff. With its clean contours, the royal structure imposes order on the less regularized forms of nature, just as the king's role was to impose order on chaos. Trees lined the entrance leading up to the temple, with paired sphinxes facing each other. At the furthest reach of the temple, cut into the rock, a principle sanctuary was dedicated to Amun-Ra, god of the evening sun. Smaller chapels honored Anubis, god of embalming, and Hathor, goddess of the west. An altar dedicated to Ra-Horakhty stood on the upper terrace.

Throughout the complex, painted relief sculptures brought the walls to life, depicting battles, a royal expedition to the land of Punt in search of myrrh trees for the terraces, and scenes of Thutmose I legitimizing his daughter's unusual rule. Sculptures of the king and deities abounded. The red granite example shown in figure 3.26, one of eight colossal statues from the third court, depicts Hatshepsut kneeling as she makes an offering of two jars. Since kingship was defined as a male office, she is dressed in the regalia of a male king: a kilt, a false beard, and the White Crown. Although in some images she is visibly female, in this and many others she appears without breasts.

Sometime after Hatshepsut's death, Thutmose III constructed his own temple between his mother's and Mentuhotep's, with the purpose of eclipsing Hatshepsut's. He designated his own temple as the destination of Amun's divine boat in the Festival of the Wadi, held at Deir el-Bahri. One result of his efforts was the destruction of many images of Hatshepsut and the replacement of her name with his in some of the inscriptions in her temple. Nonetheless, Hatshepshut's temple remains a monument to her memory.

Temples to the Gods

Besides building funerary temples for themselves, Eighteenth Dynasty kings expended considerable resources on temples to the gods, such as the Theban divine triad: Amun, his consort Mut, and their son Khons. At Karnak and nearby Luxor, successive kings constructed two vast temple complexes to honor the triad, and on special festivals the gods' images were conveyed on divine boats along waterways between the temples.

THE TEMPLE OF AMUN-RA At the temple of Amun-Ra at Karnak, a vast wall encircled the temple buildings (fig. **3.27**). Entering the complex, a vistor walked through massive **pylons** or gateways built as monuments to individual kings. (Sometimes, these were dismantled as building proceeded over the years.) As a ceremonial procession moved within the buildings, the pylons marked its progress deeper and deeper into sacred space. Within the complex, a vast **hypostyle** hall was the farthest point of access for all but priests and royalty (fig. **3.28**). Here, a visitor would be awed by a forest of columns, their sheer mass rendering the human form almost

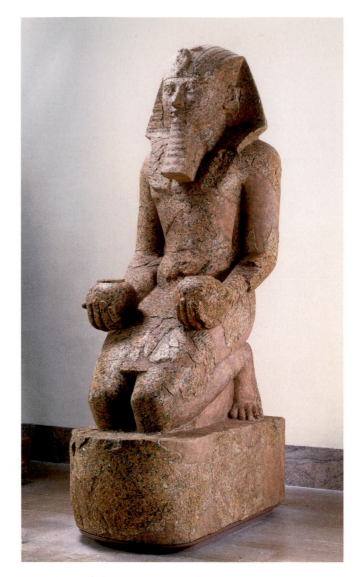

3.26. *Kneeling Figure of Queen Hatshepsut,* from Deir el-Bahri. ca. 1473–1458 BCE. Red granite, height approx. 8′6″ (2.59 m). Metropolitan Museum of Art, New York. Rogers Fund, 1929 (29.3.1)

insignificant. The columns were closely spaced to support a ceiling of stone lintels. Unlike wooden lintels, these had to be kept short to prevent them from breaking under their own weight. The architect nonetheless made the columns far heavier than they needed to be, with the effect that a viewer senses the overwhelming presence of stone all around, heavy, solid, and permanent.

Essential to the temple's ritual functioning was its metaphorical value, symbolizing the world at its inception. The columns of the hypostyle hall represented marsh plants in stylized form: Their capitals were designed to emulate the shape of both papyrus flowers and buds—so that the building evoked the watery swamp of chaos out of which the mound of creation emerged. The temple was thus the king's exhortation in stone to the gods to maintain cosmic order.

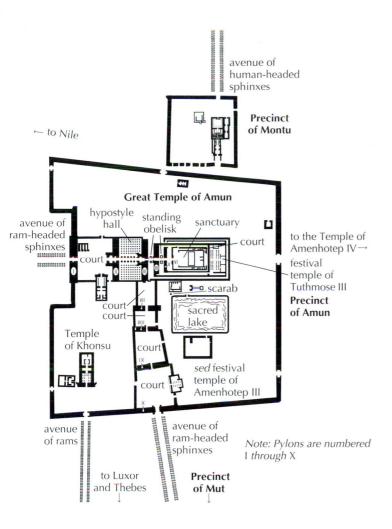

3.27. Plan of Temple of Amun-Ra, Karnak, Thebes.

avenue of
human-headed
sphinxes

**Precinct
of Montu**

← *to Nile*

Great Temple of Amun

hypostyle
hall

standing
obelisk

sanctuary

avenue of
ram-headed
sphinxes

court

court

to the Temple of
Amenhotep IV→

festival
temple of
Tuthmose III

**Precinct
of Amun**

court
court

scarab

sacred
lake

Temple of
Khonsu

court

court

sed festival
temple of
Amenhotep III

avenue
of rams

avenue of
ram-headed
sphinxes

to Luxor
and Thebes
↓

*Note: Pylons are numbered
I through X*

**Precinct
of Mut**
↓

Beyond the hall, a sacred lake allowed the king and priests to purify themselves before entering the temple proper. They proceeded through smaller halls, sun-drenched courts, and processional ways decorated with **obelisks**, tall stone markers topped by pyramid-shaped points, as well as chapels where they would pause to enact ceremonies. Every day the priests would cleanse and robe the images of the gods, and offer sacred meals to nourish them. These rituals were conducted by the king and the priests away from the public eye, gaining power for being shrouded in mystery.

Throughout the complex, the pylons and walls of the halls and the enclosure walls were covered by a distinctively Egyptian form of decoration: **sunken relief**. Rather than carving away the surface around figures to allow them to emerge from the stone, the sculptor cut sharp outlines into the surface of the stone, and modeled the figures within the outlines and below the level of the background. Light shining onto the surface then cast shadows into the outlines, bringing the figures to life without compromising the solid planar appearance of the wall. This type of relief was especially popular for decorating hard stone, since it required less carving away.

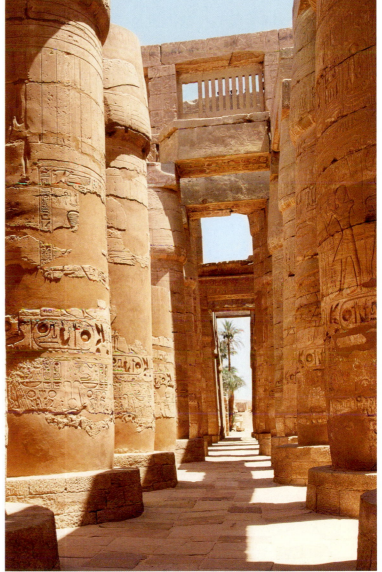

3.28. Hypostyle Hall of Temple of Amun-Ra, Karnak, Thebes. ca. 1290–1224 BCE

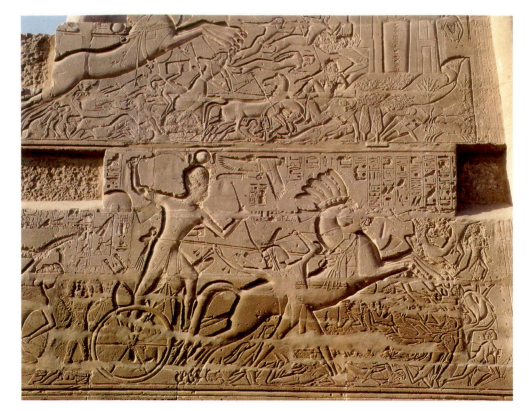

3.29. *Seti I's Campaigns,* Temple of Amun at Karnak, Thebes (exterior wall, north side of hypostyle). ca. 1280 BCE. Sandstone, sunken relief, Egypt

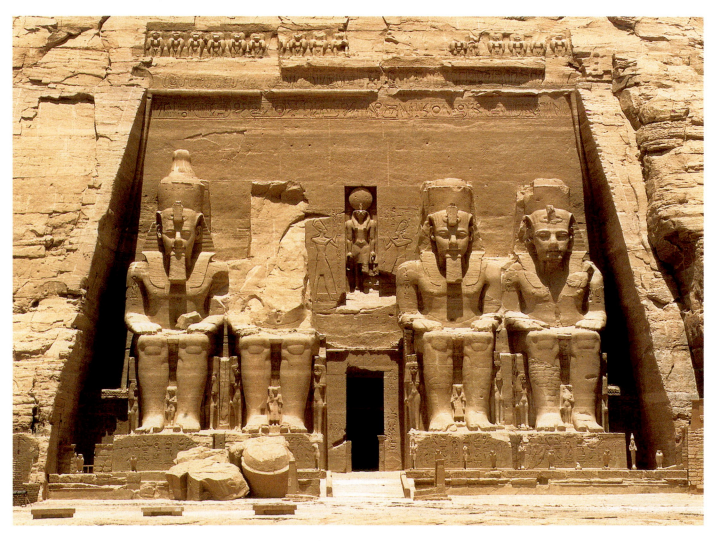

3.30. Temple of Ramses II, Abu Simbel. 19th Dynasty. ca. 1279–1213 BCE

The subject of the reliefs at Karnak was the king's relationship with the gods. The section illustrated in figure **3.29**, from the north exterior wall of the hypostyle hall, shows in an upper register Seti I sacking the Hittite city of Kadesh on the Orontes River, and, in a lower register, hunting, an activity that symbolized military prowess, as it would among the Assyrians (see fig. 2.21). Following convention, the king and his horse-drawn chariot remain frozen against a background filled with hieroglyphs and soldiers, who are much smaller in scale than the king in order to glorify his presence. The figures of the king and his horse are also cut deeper than surrounding figures, so that their outlines are bolder than the rest. Victory seems assured by the king's might and the ruthless efficiency of his forces, although neither battle was, in fact, decisive. By conquering foreign forces, the king established order, *ma'at*.

ABU SIMBEL Seti I's son, Ramses II, who ruled for 67 years during the Nineteenth Dynasty (ca. 1290–1224 BCE), commissioned more architectural projects than any other Egyptian king, including a monumental temple dedicated to himself and Amun, Ra-Horakhty, and Ptah, carved into the sandstone at Abu Simbel on the west bank of the Nile (fig. **3.30**). Location alone made an eloquent statement: With the temple, the king marked his claim to the land of Kush in Lower Nubia, which was the source for the precious resources of gold, ivory, and animal pelts. A massive rock facade substitutes for a pylon, where four huge seated statues of the king almost 70 feet high flank the doorway, dwarfing any approaching visitor. Between the statues' legs, small figures represent members of the royal family. A niche above the entrance holds an image of the sun-god, who is shown as a falcon-headed figure crowned by a sun disk. Flanking this three-dimensional figure are images in relief of Ramses holding out to the god an image of Ma'at, the goddess of order. The image thus demonstrates the king's role as keeper of terrestrial order at the request of the gods. On the interior of the temple, more colossal figures of Ramses were shaped from the same rock as the columns behind them. Their size (32 feet high) and frontality presented an awesome sight to the priests who conducted rituals inside (fig. **3.31**).

Ramses commissioned a second, complementary temple about 500 feet away from his own, in honor of his wife Nefertari and Hathor, a goddess of the afterlife. Here, too, sculptors cut figures into the rock as a facade for the temple, which was colossal in scale but significantly smaller than Ramses' temple. The topographical relationship between the two temples may be significant. Their central axes, when extended forward, intersected in the Nile's life-giving waters, so their locations may express the generative force associated with the royal couple. This relationship is hardly visible today, as the construction of the Aswan Dam in the 1960s submerged the Ramses temple site, leading engineers to move the temple upward nearly 700 feet in order for it to stand above flood levels.

Block Statues

In the New Kingdom a type of sculpture known since the late Old Kingdom experienced new popularity. This was the block statue, where the body, seated on the ground with knees drawn up to the chest and wrapped in a cloak, is reduced to a cubic abstraction. Above the block appears a portrait head, while feet protrude at the bottom; sometimes arms are folded across the knees. Like the more conventional full-body sculptures, these images functioned as seats for the *ka* in the tomb. When they first appear in the Sixth Dynasty, the figures are found in model funerary boats, transporting the dead to the cult center of Osiris at Abydos. They may, therefore, represent the deceased as a being sanctified by this journey in the afterlife. The example illustrated in figure **3.32** may have come from the temple at Karnak. It presents two portraits. Above is the head of Senenmut, a high official in the court of Hatshepsut and Thutmose III and master of works for the temple at Deir el-Bahri. Below Senenmut's head is a very small head, representing Nefrua, daughter of Hatshepsut and

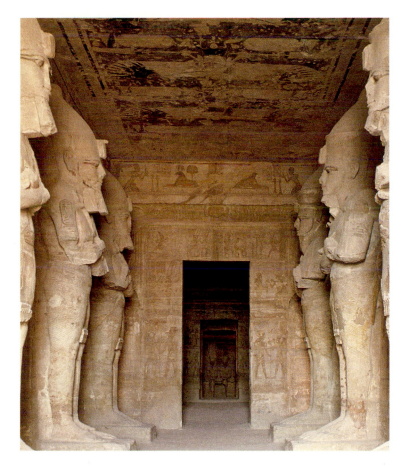

3.31. Interior of Temple of Ramses II, Abu Simbel. 19th Dynasty. ca. 1279–1213 BCE

Thutmose II. Her head emerges from the block in front of Senenmut's face, as if held in an embrace, perhaps reflecting his protective role as her tutor. Omitting anatomical features in favor of the block form left an ample surface for a hieroglyphic text of prayers or dedications.

Images in New Kingdom Tombs

Artists continued to embellish tomb chapels with paintings evoking similar scenes to their Old Kingdom and Middle Kingdom counterparts. In the New Kingdom, however, additional images showed the deceased worshiping deities, most typically Osiris and Anubis, whose interventions could ease their transition to the next world. They would also paint scenes showing a banquet in the tomb chapel that was part of the annual festival of the Wadi at Thebes, when the living would cross to the west bank of the Nile and feast with the dead. Music and dancing were part of the celebration, and a fragment of painting from the tomb of Nebamun at Thebes (ca. 1350 BCE) shows that hierarchical conventions established in the Old Kingdom 1,000 years previously were still in use (fig. **3.33**). While the elite diners sit in rigid composite view in the upper register, musicians and dancers below move freely in pursuit of their crafts. A flute player and a clapper have fully frontal faces, and they even turn the soles of their feet to face a viewer—an extreme relaxation of elite behavior. The nude dancers twist and turn, and the loosened, separated strands of the entertainers' long hair suggests motion. The freedom of movement inherent in these figures has suggested to some scholars that works from contemporary Crete may have been available for these painters to study. Elsewhere, paintings have been attributed outright to artists from this Aegean island

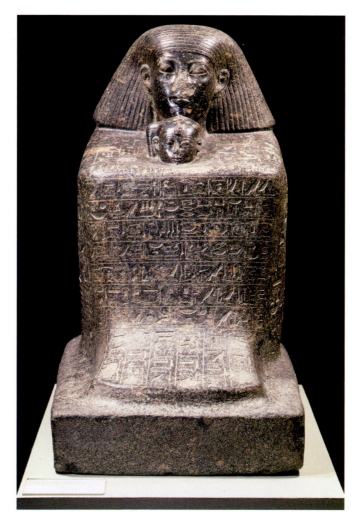

3.32. *Sculpture of Senenmut with Nefrua,* from Thebes. ca. 1470–1460 BCE. Granite, height approx. 3′1½″ (107 cm). Ägyptisches Museum, Berlin

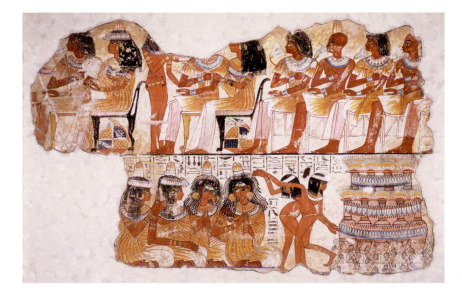

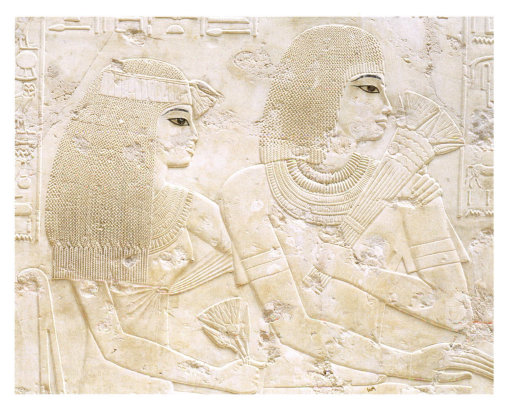

3.33. *Musicians and Dancers,* fragment of a wall painting from the Tomb of Nebamun, Thebes. 1350 BCE. Height 24″ (61 cm). The British Museum, London. Courtesy of the Trustees

3.34. *Mai and His Wife, Urel.* ca. 1375 BCE. Detail of a limestone relief. Tomb of Ramose, Thebes

culture. On the right side, jars indicate that wine was plentiful. Music, dance, and wine were sacred to Hathor, goddess of the West, who could lead the dead through the dangerous liminal phase between death and the afterlife.

New Kingdom artists and patrons also followed Middle and Old Kingdom precedents in designing tomb images. Some reliefs executed for the unfinished tomb in Thebes of Ramose, the vizier for Amenhotep III (ca. 1375 BCE), follow these traditions (fig. **3.34**). The craftsmanship is particularly skilled in this image, which depicts Ramose's brother, Mai, and his wife, Urel. The relief is shallow, but the carving distinguishes different textures masterfully. The composite postures and the gestures of the wife embracing her husband reflect conventions going back at least to the Old Kingdom, though the canon of proportions differs from earlier objects, and some of the naturalism seen in

other New Kingdom works informs the profiles of this couple. Here the united front that husband and wife present through eternity may be compared to a New Kingdom love song that extols the joy of spending "unhurried days" in the presence of one's beloved. (See *Primary Source* on page 70.)

AKHENATEN AND THE AMARNA STYLE

Ramose was the vizier to Amenhotep III, who increased devotion to the sun-god during his reign (1391–1353 BCE). In temple complexes at Karnak and elsewhere, the king built wide open-air courtyards where the sun could be worshiped in its manifestation as a disk (or Aten) in the sky. Devotion to Aten grew more pronounced under his son, Amenhotep IV. Stressing the life-giving force of the sun, Amenhotep IV began to visualize

Love Song

This "Love Song" is written on an ostrakon (a writing tablet) *now in the Cairo Museum. The poem dates to the New Kingdom, sometime between 1300 and 1100* BCE.

Your love, dear man, is as lovely to me
As sweet soothing oil to the limbs of the restless,
As clean ritual robes to the flesh of gods,
As fragrance of incense to one coming home
Hot from the smells of the street.

It is like nipple-berries ripe in the hand,
Like the tang of grainmeal mingled with beer,
Like wine to the palate when taken with white bread.

While unhurried days come and go,
Let us turn to each other in quiet affection,
Walk in peace to the edge of old age.
And I shall be with you each unhurried day,
A woman given her one wish: to see
For a lifetime the face of her lord.

SOURCE: *LOVE SONGS OF THE NEW KINGDOM.* TR. BY JOHN I. FOSTER (AUSTIN, TX: UNIVERSITY OF TEXAS PRESS, 1974)

the god not as the traditional falcon-headed figure, but as a disk, radiating beams terminating in hands. The young pharaoh's attempts to introduce this new cult to traditional religious centers, such as Thebes, were thwarted by a powerful conservative priesthood. In response, Amenhotep IV established a new city devoted entirely to Aten on the Nile's east bank in central Egypt. He named his new city Akhetaten, meaning horizon of Aten (now known as Amarna), and changed his own name to Akhenaten, meaning "beneficial to Aten." Akhenaten's belief in Aten as the source of life found expression in the "Hymn to Aten" sometimes attributed to him. This text (excerpted in end of Part I *Additional Primary Sources*) expresses joy in the rising of the sun each day by describing the world coming to life again at its appearance. Disdaining and refuting the other traditional cults, Akhenaten seems to have intended the cult of Aten to be monotheistic, thus enraging the priests of other cults. His new cult and fledgling city lasted only as long as its founder; after his death the city was razed to the ground. Still, archeological remains suggest that Akhenaten built temples in the contemporary style, using massive pylons and obelisks, as at Karnak, but with an emphasis on open-air courts beneath the sun's glare.

The Amarna Style

Sculptures of Akhenaten and his family break with long-established conventions for depicting royal subjects. In numerous depictions, the figure of Akhenaten exhibits radically different proportions from those of previous kings. Images such as the colossal figure of Akhenaten installed at the temple of Amun-Ra in Karnak between 1353 and 1335 represent the king with narrow shoulders lacking in musculature, with a marked pot belly, wide hips, and generous thighs (fig. **3.35**). His large lips, distinctive nose and chin, and narrow eyes make his face readily recognizable. Scholars have found these unusual portraits puzzling. Some dismiss the images as caricatures, yet such expensive and prominent images must have had the king's

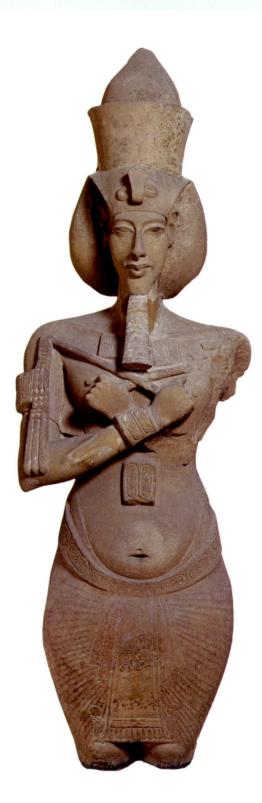

3.35. *Sculpture of Akhenaten,* from Karnak, Thebes. 1353–1335 BCE. Sandstone, height approx. 13′ (3.96 m). Egyptian Museum, Cairo

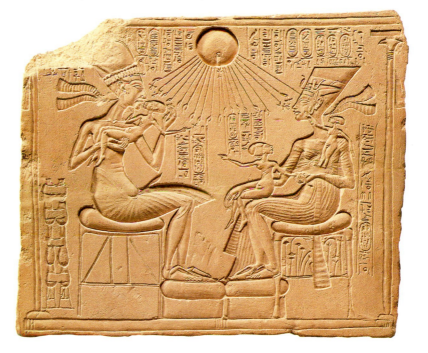

3.36. *Akhenaten and His Family.* ca. 1355 BCE. Limestone, $12^{3}/_{4} \times 15^{1}/_{4}''$ (31.1 × 38.7 cm). Staatliche Museen zu Berlin, Preussischer Kulturbesitz, Ägyptisches Museum

approval. There have also been attempts to diagnose a medical condition from these representations; the king's features have been read as symptoms of Frolich's Syndrome, a hormonal deficiency that produces androgynous characteristics. A more likely explanation is that his "feminized" appearance was intended to capture the androgynous fertile character of Aten as life-giver. The style was not restricted to the king's image, but influenced representations of court officials and others as well.

Group representations of Akhenaten with his family—his consort Nefertiti and three oldest daughters—are remarkable for an apparent intimacy among the figures. This is clear on a sunken relief scene on an altar stele, the kind that Egyptians would have erected in small shrines in their homes and gardens (fig. **3.36**). Beneath the disk of the sun, its life-giving beams are depicted as lines radiating downward with hands at their terminals. The king and his consort sit facing each other on stools. Attenuated reed columns suggest that the scene takes place within a garden pavilion, which is stocked with wine jars. They hold three lively daughters, who clamber on their laps and in their arms, uniting the composition with animated gestures that reach across the relief in marked contrast to the static scenes of other times. The deliberate emphasis on the daughters' childishness marks a change: In the past, children had been represented by a hieroglyphic pictograph of an adult in miniature, sucking on a finger. The emphasis on children epitomizes the regeneration that the royal couple represent, and especially the king as manifestation of the sun-god, Aten.

QUEEN TIY The surprising transience implicit in the children's youthfulness and animated gestures found in figure 3.36 also characterizes a one-third life-size portrait of Akhenaten's mother Queen Tiy, chief wife of Amenhotep III. The sculpture elegantly portrays an aging woman (fig. **3.37**). Using the dark wood of the yew tree, with precious metals and semiprecious stones for details, the artist achieved a delicate balance between idealized features and signs of age. Smooth planes form the cheeks and abstract contours mark the eyebrows, which arch over striking eyes inlaid with ebony and alabaster. Yet we also see careful hints at advancing years in the down-turned mouth and the modeled lines running from the sides of the nose to the mouth.

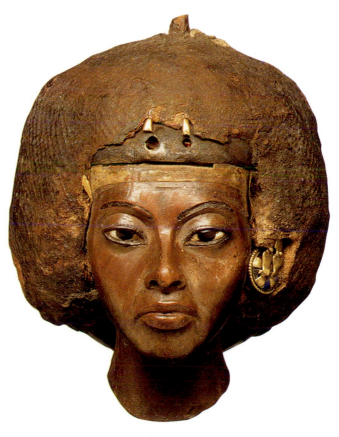

3.37. *Sculpture of Queen Tiy,* from Kom Medinet el-Ghurab. ca. 1352 BCE. Yew, ebony, glass, silver, gold, lapis lazuli, cloth, clay, and wax. Height $3^{3}/_{4}''$ (9.4 cm). Staatliche Museen zu Berlin, Preussischer Kulturbesitz, Ägyptisches Museum

The sculpture went through two stages of design: Initially, the queen wore gold jewelry and had a silver headdress decorated with golden cobras, which identified her with the funerary goddesses Isis and Nephthys. This headdress was subsequently concealed under a wig embellished with glass beads, and topped with a plumed crown, the attachment for which is still extant. Although the sculpture was discovered with funerary paraphernalia for her husband Amenhotep III, these changes indicate that it was adapted to suit the beliefs of Akhenaten's new monotheistic religion. Even a small image played an important role in such rituals.

PORTRAITS OF NEFERTITI As with Akhenaten's images, early depictions of his wife Nefertiti emphasize her reproductive capacity by contrasting a slender waist with large thighs and buttocks. Sculptures from the second half of Akhenaten's reign, however, are less extreme. At Amarna archeologists discovered the studio of the king's chief sculptor, whom court records call "the king's favorite and master of the works." It yielded sculptures at every stage of production: heads and limbs of quartzite and jasper, and torsos of royal statues to which they could be affixed. Plaster casts were found, modeled from clay or wax studies taken from life. The most famous of the sculptures discovered there is a bust of Nefertiti, plastered over a limestone core and painted—a master sculpture, perhaps, from which other images could be copied (fig. **3.38**). The sculpture's left eye lacks the inlay of the right, showing that the bust remained unfinished, but its extraordinary elegance derives from a command of geometry that is at once precise—the face is completely symmetrical—and subtle. This piece and another similar head were abandoned in the workshop when the sculptor moved from Amarna to Memphis after Akhenaten's death in 1335 BCE. The passing of Akhenaten was a death knell for both his cult and for the city he founded.

Tutankhamen and the Aftermath of Amarna

Shortly after Akhenaten's death, a young king ascended the throne. Married to Akhenaten's daughter, perhaps even one of Akhenaten's sons, Tutankhaten was only 9 or 10 when he became king. Perhaps under the influence of the priests of Amun, the young king restored the royal residence to Memphis and resurrected the traditional cults that Akhenaten had neglected. He changed his name to Tutankhamen to reflect the restoration of the king's association with Amun. His reign marked a return to the orthodox religion of Egypt, though he seems to have died without warning at the age of 19. His sudden death has inspired numerous theories about murder and conspiracy, but the most recent scientific studies of his mummy point to natural causes.

Tutankhamen's greatest fame results not from his life, but from his death and the discovery of his tomb in 1922 by the British archeologist Howard Carter. Although it had been

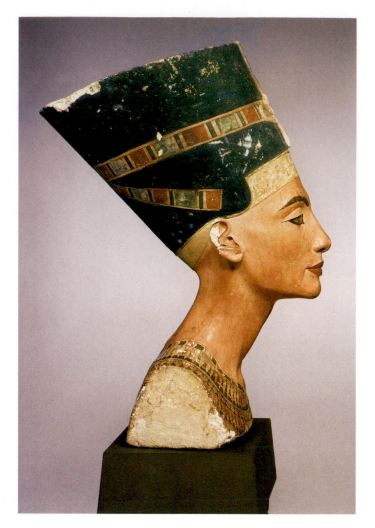

3.38. *Sculpture of Queen Nefertiti.* ca. 1348–1336/5 BCE. Limestone, height 19″ (48.3 cm). Staatliche Museen zu Berlin, Preussischer Kulturbesitz, Ägyptisches Museum

robbed twice, much of the tomb was untouched. With its stairway, corridor, and four chambers, the tomb is uncharacteristically small for a royal burial, leading scholars to suppose that a nonroyal tomb might have been co-opted for the king at the time of his unexpectedly early death. All the same, offerings buried with him lacked nothing in volume or quality. Indeed, the immense value of the objects makes it easy to understand why grave robbing has been practiced in Egypt ever since the Old Kingdom. The tomb contents included funerary equipment, such as coffins, statues, and masks, as well as items used during his lifetime, such as furniture, clothing, and chariots. On many of the objects Tutenkhamen is depicted battling and overcoming foreign enemies, as part of his kingly duty to maintain order amid chaos. The king's mummified corpse was preserved in three coffins, the innermost of which (fig. **3.39**), weighs over 250 pounds in gold. Even more impressive is the exquisite workmanship of its cover, with its rich play of colored inlays against polished gold surfaces. The amount and quality of the objects in the burial of a minor king like Tutankhamen make one lament the loss of the burial finery of more powerful and long-lived pharaohs.

The Book of the Dead

This text is an incantation from Plate III of the Papyrus of Ani in the British Museum, from the latter half of Eighteenth Dynasty. It accompanies the weighing of the soul illustrated in the closely related The Book of the Dead *of Hunefer (see fig. 3.40).*

Saith Thoth the righteous judge of the cycle of the gods great who are in the presence of Osiris: Hear ye decision this. In very truth is weighed the heart of Osiris, is his soul standing as a witness for him; his sentence is right upon the scales great. Not hath been found wickedness [in] him any; not hath he wasted food offering in the temples; not hath he done harm in deed; not hath he let go with his mouth evil things while he was upon earth.

Saith the cycle of the gods great to Thoth [dwelling] in Hermopolis [the god's cult-center along the Nile in Upper Egypt]: Decreed is it that which cometh forth from thy mouth. Truth [and] righteous [is] Osiris, the scribe Ani triumphant. Not hath he sinned, not hath he done evil in respect of us. Let not be allowed to prevail Amemet [Ammut, the devourer of souls] over him. Let there be given to him cakes, and a coming forth in the presence of Osiris, and a field abiding in Sekhet-hetepu [Field of Peace] like the followers of Horus.

3.39. Cover of the coffin of Tutankhamen. 18th Dynasty. Gold, height 72″ (182.9 cm). Egyptian Museum, Cairo

The process of restoring the old religion was continued by Tutankhamen's short-lived successor, the aged Ay. He married Tutenkhamen's widow, perhaps to preserve, rather than usurp, the throne. The restoration of the old religion was completed under Horemheb, who had been head of the army under Tutankhamen and became the last king of the Eighteenth Dynasty. He set out to erase all traces of the Amarna revolution, repairing shattered images of the gods and rebuilding their temples; but the effects of Akhenaten's rule could be felt in Egyptian art for some time to come.

PAPYRUS SCROLLS: *THE BOOK OF THE DEAD*

Inscriptions on walls and furnishings accompanied royal burials like Tutankhamen's, but in the Middle Kingdom the desire to include the prayers and incantations that accompanied kings to the afterlife spread to other classes of patrons. By the New Kingdom patrons commissioned scribes to make illustrated funerary texts such as *The Book of the Dead*, (see *Primary Source*, above) which first appeared in the Eighteenth Dynasty. This text is a collection of over 200 incantations or spells that ultimately derived from the Coffin Texts of the Middle Kingdom, which were copied onto scrolls made of papyrus reeds. The popularity of the *Book of the Dead* in the New Kingdom represents a change in Egyptian beliefs about the afterlife: Any member of the elite could enjoy an afterlife, as long as the deceased had lived in accordance with *ma'at* and could pass tests imposed by the gods of the underworld. Relatives of the deceased generally placed a version of the *Book of the Dead* inside the coffin or wrapped within the mummy bandaging itself in order to ensure that the deceased had the knowledge required to pass the test and progress to the hereafter. Among the scenes depicted in the book are the funeral procession, the weighing of the heart, and the provision of nourishment for the dead.

One of the finest surviving examples is *The Book of the Dead of Hunefer*, dating from about 1285 BCE. The scene illustrated here (fig. **3.40**) represents the weighing of the heart and judgment of the dead by Osiris in Chapter 125 (see *Primary Source*, page 73). It conforms to a well-defined type that many workshops shared. Derived from traditional tomb painting, its imagery has been adapted to the format of the scroll to be a continuous narrative, with protagonists repeated in one scene after another without a dividing framework. At the left, Anubis, the jackal-faced guardian of the underworld, leads Hunefer into the Hall of the Two Truths. Anubis then weighs Hunefer's heart, contained in a miniature vase, against the ostrich feather of Ma'at, goddess of truth and justice, who symbolized divine order and governed ethical behavior. Ma'at's head appears on the top of the scales. Thoth, the ibis-headed scribe, records the outcome. Looking on with keen interest is

Ammut. Made up of the parts of various ferocious beasts—the head of a crocodile, the body and forelegs of a lion, and the hind quarters of a hippopotamus—she was the devourer of those whose unjust life left them unworthy of an afterlife.

The deceased had to swear to each of the deities seen overhead that he or she had lived according to *Ma'at*. Having been declared "true of voice," he is presented by Horus to his father, Osiris, shown with kingly emblems and wrapped in a white mummylike shroud, seated in a pavilion floating above a lake of *natron*, a salt used for preserving the body. Accompanying him are Isis and her sister Nephthys, mother of Anubis and protector of the dead. In front of the throne, the four sons of Horus stand on a white lotus blossom, symbol of rebirth. Also known as the four gods of the cardinal points, they protected the internal organs that were removed as part of the embalming process and placed in containers known as *canopic jars*. Above, Horus, identified by his sacred *udjat* eye (which restored Osiris to health), bears an ostrich feather, representing the favorable judgment of Ma'at. In the afterlife, as on earth, the desire for order was paramount.

LATE EGYPT

Tutankhamen's revival of the cult of Amun and the ancient sources of *The Book of the Dead* demonstrate that New Kingdom Egyptians deeply venerated the traditions of the past.

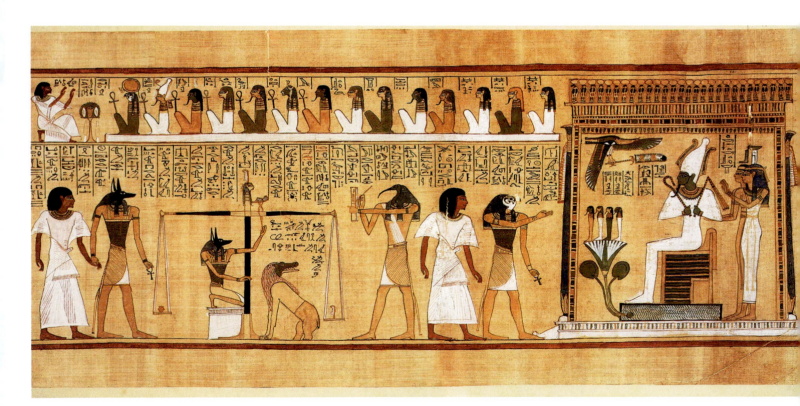

3.40. *The Weighing of the Heart and Judgment by Osiris,* from *The Book of the Dead of Hunefer.* 1285 BCE. Painted papyrus, height 15⅝″ (39.5 cm). The British Museum, London

Building the Pyramids

In spite of much research, many aspects of pyramid design remain a mystery to Egyptologists. Elevations of other types of building—palaces and pylons, for instance—are preserved on the walls of New Kingdom tombs and temples, and a few plans survive. Pyramid architects may have worked from similar guidelines, but no definitive plans exist for their construction. Orienting the pyramids to the cardinal points of the compass appears to have been critical, and was probably achieved by observation of the stars. The greatest deviation is a meager 3 degrees east of north, in the Pyramid of Djoser.

During the Old and Middle Kingdoms, a pyramid's core was built out of local limestone. Quarries are still visible around the Great Pyramids and the Great Sphinx (see fig. a and fig. 3.10). For the casing (the outer surface), Tura limestone and Aswan granite were brought from quarries some distance away, as these are not local materials. Using copper tools, levers, and rope, workers cut channels in the rock and pried out blocks averaging $1\frac{1}{2}$ to 5′ (.5 to 1.5 meters) but sometimes much larger.

(a) Limestone quarry to the north of Khafra Pyramid

Somehow these blocks were hauled overland, on hard-packed causeways built for that purpose. Some scholars believe teams of men or oxen pulled them on sleds. This view is based primarily upon a tomb painting showing 172 men dragging a huge statue of the Twelfth Dynasty Djehutihopte on a sled. When a team of documentary filmmakers attempted to replicate the process using blocks of stone, it proved extraordinarily slow and cumbersome. Yet estimates of 2.3 million stone blocks in the Pyramid of Khufu, constructed within 23 years, suggest that quarries must have moved stone at tremendous rates: approximately 1,500 men had to produce at least 300 blocks a day. In Hatshepsut's mortuary temple, Petrie discovered models of wooden cradles in the shape of a quarter circle. If four cradles were fitted to the four sides of a block of stone, these frames would have allowed a small team of men to roll a block relatively quickly.

Archeological remains of pyramids indicate that methods of construction evolved over time. In early pyramids, a buttressing technique was used, with inclined layers around a central core, diminishing in height from inside out (fig. b). A smooth outer casing of cut stones was then set at an angle to the ground. When this technique proved unstable at the beginning of the Fourth Dynasty, architects turned to courses of stone, built up layer by layer. Outer casing blocks were cut as right-angled trapezoids and set level to the ground as the pyramid rose (fig. c). Scholars believe that workers constructed ramps to raise blocks into place as the monument grew. These would have been dismantled after use, leaving little trace in the archeological record. A linear ramp leading up to one face of the pyramid, made out of debris left over from building, is the simplest solution. As the pyramid grew, however, the slope would have become so steep that steps would have been needed for workers to haul up the blocks. At this point, blocks could have been maneuvered only with levers. A spiraling ramp, which worked its way around the pyramid at a shallower incline, would have concealed the base corners of the pyramid, making calculations difficult for surveyors, and such a ramp would have been hard to construct at the highest levels. Another alternative is a ramp zigzagging up one side of the monument. One scholar proposes that sand and rubble ramps were used for roughly the lowest sixth of the Great Pyramid, followed by stone ramps at the higher levels, resting on the untrimmed outer steps. As the ramps were removed, the outer casing blocks would have been smoothed out to form a slope.

Buttressing Technique
Third Dynasty

(b) Buttressing Technique

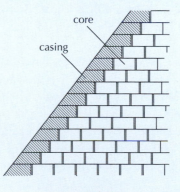

core

casing

Layering Technique
Fourth Dynasty?

(c) Layering Technique

Interpreting Ancient Travel Writers

A great many Greeks went to Egypt; some, as might be expected, for business, some to serve in the army, but also some just to see the country itself.

—Herodotus

One of the primary sources available to art historians is the writing of ancient travelers. Despite the dangers of travel in antiquity, from shipwrecks to thievery, Egypt became a prime destination for curiosity seekers, beginning around 1500 BCE, and peaking during the first and second centuries CE. Locals did what they could to entice travelers. In Roman times, men from Busiris, near Giza, would climb the pyramids' slippery slopes as a tourist attraction. Some early travelers painted or scratched their names on works of art, among them Hadrian's wife Sabina. Others made a crucial—if complex—contribution to our knowledge of ancient monuments by writing about their journeys. Born in the early fifth century BCE in Halicarnassos (modern Bodrum, Turkey), Herodotus spent the best part of his adulthood traveling throughout the Mediterranean and the Near East. His account of his Egyptian travels still survives. In the late first century BCE, the Greek geographer Strabo also wrote a valuable description of his experiences in Egypt and elsewhere.

These authors saw the "great wonders" first hand, at a time when much more survived of them than today. Often their accounts supply vital information for reconstructions, or other details, such as the names of artists, architects, or patrons, but it is an easy mistake to accept their words uncritically. Often, these ancient travelers had different priorities from the modern art historian, and this fact would certainly have affected the accuracy of their accounts. Herodotus, for instance, was much more interested in religion than in works of art or architecture. This results in considerably less detailed or accurate information about artistic monuments than we might desire. It is also all too easy to forget that even ancient travelers visited Egypt at least a millennium after the pyramids and other monuments had been built. Furthermore, they relied on traditions handed down by guides and other locals, who, research shows, were often misinformed. Herodotus insists that the blocks of Khufu's pyramid were all at least 30 feet long, when three feet would have been more accurate. He also attributes the work to slaves, thus denigrating Khufu as a tyrant. Local priests may have broadcast this view in the fifth century BCE to please their Persian rulers. A long tradition among scholars of giving greater credence to classical texts than other types of evidence has led, in many instances, to an undue acceptance of ancient authors' words as "truth," even when archeological evidence paints a different picture.

Even as Ramses II extended the borders of his realm to the south and the east during his reign, the cult centers at Luxor and Karnak absorbed great wealth and exerted great influence. About 1076 BCE, barely 70 years after the end of the reign of Ramses III, priests exerted more and more power, until the cult of Amun dominated Egypt during the Twenty-first Dynasty. Thereafter, successive groups of foreigners, including Nubians, Persians, and Macedonians controlled the area.

The final phase of ancient Egypt belongs to the history of Greece and Rome. Alexander the Great conquered Egypt and then founded the city of Alexandria before his death in 323 BCE. His general, Ptolemy (d. 284 BCE), became king of the region, and established a dynasty that lasted nearly 300 years, until the death of Ptolemy XIV, Cleopatra's son by the Roman dictator Julius Caesar. In 30 BCE, the Roman ruler Octavian, soon to be the Roman Emperor Augustus, claimed Egypt as a Roman province. Nevertheless, Egypt flourished economically under the Greeks and Romans. In the Ptolemaic period, Alexandria became one of the most vibrant centers of culture and learning in the Hellenistic world, and its port ensured a lively trade, reaching as far as China and India. In Roman times, the Nile's life-giving waters made Egypt the chief source of grain in the empire, earning it the title of Rome's granary.

But in addition to this commercial function, Egypt provided Rome and its successors with inspiring models of kingly power and imagery that lasted through the ages. For some 3,000 years, from the era of the pyramids to the time of the Ptolemies, Egyptian kings built magnificent structures that expressed their wealth and their control over the land and its resources. All aspects of royal patronage demonstrated the intimate link between the king and the gods. Building in stone and on a grand scale, Egyptian kings sought to impress a viewer with the necessity and inevitability of their rule. The formulas for representing the power of the king are as old as Egypt itself.

Egyptian kings and other elite patrons built structures for both the living and the dead. The objects and images placed in their tombs for the afterlife offer a modern viewer a glimpse of the material goods that they enjoyed in their lifetimes. The tombs provided safe haven for the body and the soul (*ka*) of the deceased. They were built to endure, and they were equipped with numerous representations of the dead. These representations were also designed to last by virtue of being made of the most permanent of materials. Permanence was also sought through the consistent use of conventions for representing the patron. The longevity of Egyptian art forms testifies to the longevity of Egyptian social structure, political organization, and beliefs.

SUMMARY

Ancient Egypt flourished along the Nile River in North Africa. Its society was extremely hierarchical, and artists produced paintings, sculptures, and other objects—many of which have survived the millennia in an excellent state of preservation—for elite patrons, including the all-powerful god-kings and their royal families. Exceptional technique and monumentality are common characteristics of Egyptian art, which quickly developed a conservative tradition of form and subject.

Complex religious beliefs and rituals stressed the importance of the afterlife, and much of the wide range of ancient Egyptian art objects produced over thousands of years were made for the elaborate tombs of the ruling class. Modern excavations and research continue to add new finds and information to this bounty.

PREDYNASTIC AND EARLY DYNASTIC EGYPT

Although historians continue to debate the specific chronology of ancient Egypt, modern scholars group the dynasties into three major periods: the Old, Middle, and New Kingdoms. The periods preceding the Old Kingdom are referred to as predynastic and early dynastic Egypt. The art of the first dynasties of Egyptian rule established a pattern that patrons and artists would follow for millennia. Elite patrons commissioned funerary structures and furnishings as well as sculptures and paintings that depicted them in idealized and timeless forms.

THE OLD KINGDOM

The Old Kingdom endured for five centuries, and its rulers commissioned works of art that would be emulated for the following two millennia. Artists followed a formula for representing idealized human figures according to an evolving set of proportions. And since Egyptians believed that the *ka*, or life force, of an individual lived on in the grave, embalmers went to great lengths to preserve the body for eternity after death. Among the most significant achievements of the Old Kingdom are the burial complex of Djoser at Saqqara and the three massive pyramids built at Giza, each tomb representing the ruler's immense religious and political power.

THE MIDDLE KINGDOM

The Middle Kingdom lasted roughly four hundred years, following a period of governmental disintegration that occurred at the end of the Old Kingdom. It was a time during which artists deliberately echoed Old Kingdom forms, especially in the funerary realm, but one innovation of the Middle Kingdom was a more naturalistic expression on royal images. Also popular during this time were rock-cut tombs, rather than pyramids, for the burial of the elite. Like their predecessors, these tombs have elaborately designed and brightly painted wall relief decorations.

THE NEW KINGDOM

Lasting roughly five centuries, the New Kingdom followed the expulsion of the Hyksos from Egypt. It was an era of renewed territorial expansion and tremendous prosperity, and the arts flourished. Major building projects were carried out along much of the Nile, especially around Thebes (present-day Luxor). Monumental funerary complexes were built for rulers, including the magnificent and well-preserved cliffside temple of Hatshepsut. Kings spent considerable sums on structures dedicated to the gods, too, such as the massive temple of Amun-Ra at Karnak and the famed temple at Abu Simbel, which honored the gods and the god-king who commissioned it, Ramses II.

AKHENATEN AND THE AMARNA STYLE

The King Akhenaten established a new city devoted to the sun-god Aten at Akhetaten (now called Amarna). Refuting other traditional religious cults, Akhenaten intended the cult of the Aten to be monotheistic, which enraged the priests of the other religious cults. The new cult and its city were razed after Akhenaten's death, though portraits of the king, his wife Nefertiti, and their family survive. These works break with long-established conventions of portraiture and include rare examples of apparent intimacy among the figures. Akhenaten was succeeded by short-lived kings, including Tutankhamen, whose tomb—when discovered in 1922—was found to house a staggering volume of exquisite treasures.

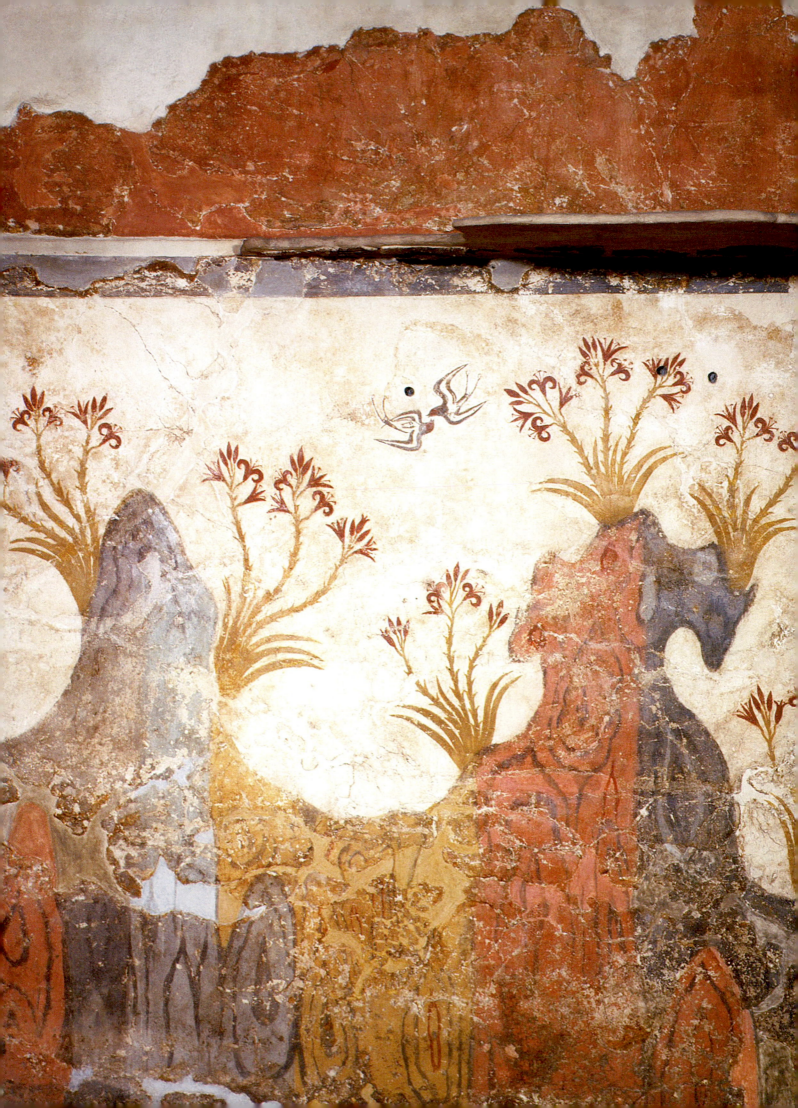

Aegean Art

THE MEDITERRANEAN WAS ONE OF THE PRIMARY HIGHWAYS THAT connected the cultures of antiquity. With Egypt and North Africa on the south, Asia on the east and Europe on the west and north, this body of water brought disparate cultures into contact for both trade and war. One branch of the Mediterranean between Greece and Turkey, called the Aegean

Sea by the Greeks, was the site of a legendary war and its aftermath, at Troy (see map 4.1). Several closely related but distinct cultures developed on islands and peninsulas adjacent to the Aegean in the third and second millennia BCE.

The Cycladic culture was named for the islands forming an irregular circle north of Crete. The British archeologist Sir Arthur Evans named the culture on the island of Crete Minoan, for the legendary King Minos, son of the Greek god Zeus, and a mortal princess, Europa. The culture on the mainland is called Helladic, from the Greek *Hellas*, the name of a legendary ancestor. Together, these separate cultures formed a civilization we know today as Aegean, after the sea that both separates and unites them.

Until the second half of the nineteenth century, Aegean civilization was known principally from the *Iliad* and the *Odyssey*, epic tales of gods, kings, and heroes attributed to the eighth-century BCE Greek poet Homer. His story of the siege of Troy and its aftermath still excites the modern imagination. Prompted by these stories, and curious to determine whether they had a factual basis, Heinrich Schliemann, a German archeologist, excavated sites in Asia Minor and Greece during the 1870s. Taking his lead from the German, Arthur Evans began excavations in Crete, beginning in 1900. Since then, a great deal of

archeological evidence has come to light, some consistent with, but much contradicting, Homer's tales. Although writing has been found in Minoan and Mycenaean contexts, scholars can decipher little of it. (Note the absence of *Primary Sources* in this chapter.) Consequently, we understand less about Aegean civilization than we do about the cultures of Egypt or the ancient Near East.

There is evidence of human habitation throughout the Aegean as early as the Paleolithic period, though settlements spread and grew mainly in the Neolithic and Early Bronze Ages. Scholars divide the Aegean Bronze Age into three phases: Early, Middle, and Late, each of which is further sub-divided into three phases, I, II, and III. Archeologists often prefer these relative dates over absolute dates, because the chronology of the Aegean Bronze Age is so open to debate. The Early phase (ca. 3000–2000 BCE) corresponds roughly to the Predynastic and Old Kingdom period of Egypt, and Sumerian and Akkadian culture in Mesopotamia. The Middle phase (ca. 2000–1600 BCE) is contemporaneous with the Middle Kingdom in Egypt and the rise of Babylon in Mesopotamia. And the Late phase (ca. 1600–1100 BCE) occurs at the same time as the Second Intermediate Period and the start of the New Kingdom in Egypt, the Hittite overthrowing of Babylon, and the rise of the Assyrians in Mesopotamia. A mass destruction of Aegean sites, from a cause still unknown to us, led to significant depopulation in about 1200 BCE, and,

Detail of figure 4.9, *Spring Fresco*

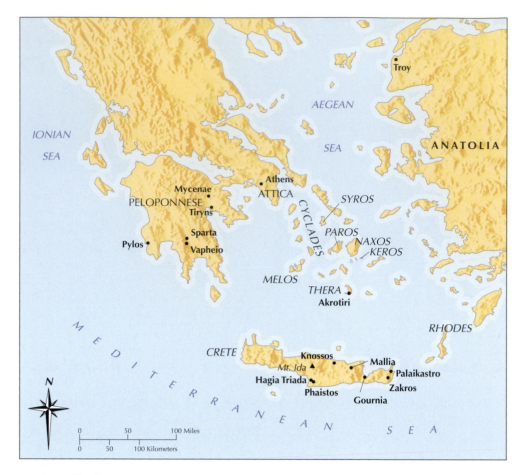

Map 4.1. The Bronze Age Aegean

despite a slight resurgence, by 1100 BCE the Aegean Bronze Age had come to an end.

These cultures each produced distinct art forms. Stylized marble representations of the human figure and frescoes are paramount in the Cyclades. Large palaces with elaborate adornments on their walls dominate on Crete. Citadels and grave goods remain from the Greek mainland. Because we can read and understand only a small part of Minoan and Mycenaean writing, their works of art provide valuable insights into their practices and ideals. That the tales of Homer and Greek myths look back to these cultures testifies to their importance to the development of later Greek culture.

EARLY CYCLADIC ART

Information about the culture of the Cyclades comes entirely from the archeological record. Only a limited range of objects survive, but this record indicates that wealth accumulated on the Cycladic islands early in the Bronze Age as trade developed, especially in obsidian, a dark volcanic stone.

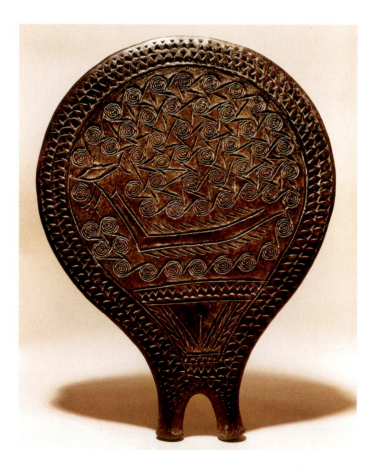

4.1. "Frying pan," from Chalandriani, Syros. Early Cycladic II. ca. 2500–220 BCE. Terra cotta, diameter 11″ (28 cm), depth 2³⁄₈″ (6 cm). National Archaeological Museum, Athens

One mark of this growing wealth is found in funerary practice. In the beginning of the Early Bronze Age in the Cyclades, around 2800 BCE, the islanders started to bury their dead in stone-lined pits sealed with stone slabs, known as cist graves. Although they lacked large-scale markers, some of these graves contained offerings, such as weapons, jewelry, and pottery. Pottery was handmade in the Early Cycladic period. In addition to drinking and eating vessels, potters produced flat round objects with handles, known today as "frying pans" because of their shape (fig. **4.1**). They were decorated with incised or stamped spirals and circles, and sometimes with abstract renderings of ships. The frying pans may have been palettes for mixing cosmetics, or, once polished, they may have served as an early kind of mirror.

Some Cycladic burials included striking figures, usually female, carved from the local white marble. The Early Cycladic II example illustrated here represents the most common type (fig. **4.2**). The figure is nude, with arms folded across the waist, and toes extended. The flat body is straight-backed, while a long, thick neck supports a shieldlike face at a slight angle. The

ART IN TIME

- ca. 2800 BCE—Cycladic islanders start to bury dead in stone-lined pits
- **ca. 2500 BCE—White marble Cycladic figurines**
- ca. 2575–2465—Ancient Egypt's Fourth Dynasty; construction of the three Great Pyramids at Giza

artist used abrasives, probably emery from the island of Naxos, to distinguish some of the details on the figure, such as a long, ridgelike nose, small pointed breasts, a triangular pubic area, and eight toes. Traces of pigments on a few surviving figures indicate that other details were painted on, including eyes, hair, jewelry, and body markings similar to tattoos.

The figures are of many sizes (the largest reaching 5 feet long and the smallest only a few inches), but their form is consistent enough that scholars speak of a governing canon of proportions, as they do of Egyptian sculptures (see Chapter 3). All the same, a number of them are clearly outside this canon.

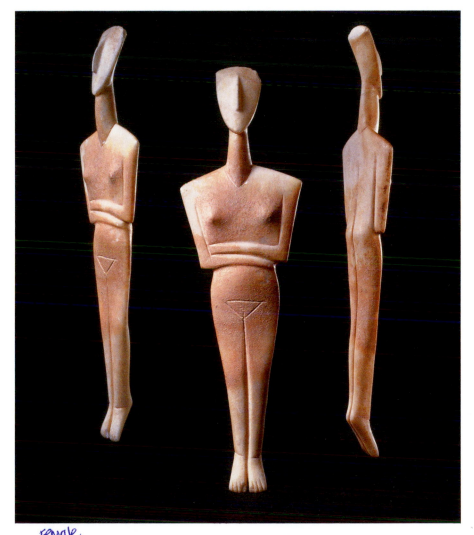

4.2. Figure, Cyclades. ca. 2500 BCE. Marble. Height 15¾" (40 cm). Nicholas P. Goulandris Foundation. Museum of Cycladic Arts, Athens. N.P. Goulandris Collection, No. 206

Some of the figures appear to be pregnant, some are male, and a distinct group depicts musicians, such as flute players or the harp player illustrated in figure **4.3**.

What did these figures represent, and what was their function? Scholars have offered several possible answers. For many years, archeologists called them Cycladic "idols," and pictured them playing a central role in a religion focusing on a mother goddess. More recently scholars have offered at least two plausible explanations for the figures' functions. Perhaps they were manufactured purely for funerary purposes, representing servants or surrogates for human sacrifices, or even for the body of the deceased. Alternatively, they may have functioned in Cycladic daily life before burial, possibly within household shrines. Although most have been found in a reclining position, they may also have been propped upright. The largest figures may have been cult statues. Some examples show signs of repair with wire, which is a strong indication that they were used—and cherished—before being deposited in graves.

Most likely, no single explanation applies to all of them. The greatest obstacle to determining their significance and function is our lack of knowledge about their **provenance**, that is, where and how they were found and their subsequent history. The style of the figures, particularly their simplicity and clear geometry, appeals to a twentieth and twenty-first century aesthetic that favors understated and unadorned geometric forms. Those qualities and the luscious white marble used to form the figures have led to their widespread appearance on the art market, often without any record of archeological context. To have a clearer sense of how to interpret these figures, archeologists need to study them within their original contexts, whether that is in a burial context or in living quarters.

The carved figures of women and musicians that survive from these Aegean islands seem to look back to Paleolithic and Neolithic figures, such as the *Woman of Willendorf* (fig. 1.16). Yet the characteristic pattern of these figures—the canon that they followed—is distinct to these islands (and to Crete, where some examples have surfaced). The tradition of making figural imagery in the marble native to these islands would become a dominant feature of later Greek art.

MINOAN ART

Archeologists have found a wider range of objects and structures on Crete than on the Cyclades. This large island, lying south of the Cyclades, and about 400 miles northwest of Alexandria, Egypt, stretches over 124 miles from east to west, divided by mountain ranges, and with few large areas of flat, arable land (see map 4.1). Consequently, communities tended to be small and scattered. The island's geography, then, along with continuous migration throughout the Bronze Age, encouraged diversity and independence among the population. Centuries later, Homer assessed the island in this way: "There are many men in it, beyond counting, and 90 cities. They have not all the same speech; their tongues are mixed. There dwell Achaeans, there great-hearted native Cretans, there Cydonians, and Dorians in three divisions, and noble Pelasgians."

Homer and the Greeks associated Crete with the legendary King Minos, subsequently the Bronze Age culture on the island has become known as Minoan. The major flowering of Minoan art occurs about 2000 BCE, when Crete's urban civilizations constructed great "palaces" at Knossos, Phaistos, and Mallia. At this time, too, the first Aegean script, known as Linear A, appeared. Scholars call this the First Palace period, comprising what is known as Middle Minoan I and II. Little evidence of this sudden spurt of large-scale building remains, as all three early centers were heavily damaged, probably by an earthquake, in about 1700 BCE. A short time later, the Minoans built new and even larger structures on the same sites. This phase constitutes the Second Palace period, which includes Middle Minoan III and Late Minoan IA, and IB. These centers, too, were demolished by an earthquake in about 1450 BCE. After that, the palaces at Phaistos and Mallia were abandoned, but the Mycenaeans, who gained control of the island almost immediately, occupied Knossos.

The Palace at Knossos

The buildings of the Second Palace period are our chief source of information for Minoan architecture. The largest is the structure at Knossos, which its excavator, Arthur Evans, dubbed the Palace of Minos (figs. **4.4** and **4.5**). In fact, the city

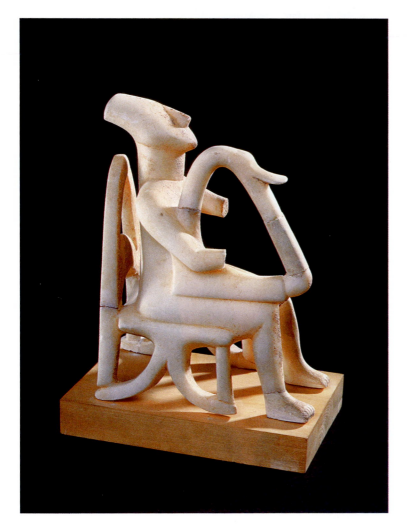

4.3. *Harpist*, from Amorgos, Cyclades. Latter part of the 3rd millennium BCE. Height 8½" (21.5 cm). Museum of Cycladic Art, Athens

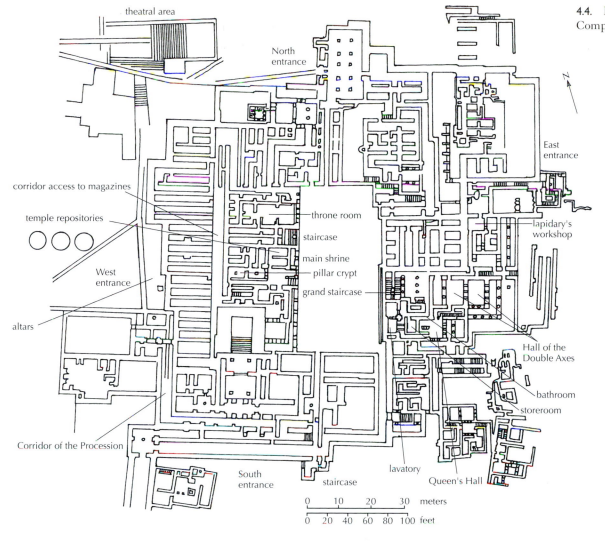

theatral area

North entrance

East entrance

corridor access to magazines

temple repositories

throne room

staircase

main shrine

pillar crypt

grand staircase

lapidary's workshop

West entrance

altars

Hall of the Double Axes

bathroom

storeroom

Corridor of the Procession

South entrance

staircase

lavatory

Queen's Hall

0 10 20 30 meters

0 20 40 60 80 100 feet

4.5. Reconstruction of the Palace Complex, Knossos, Crete

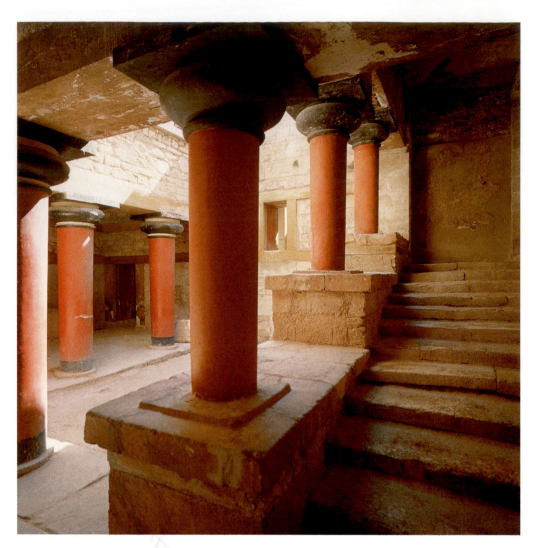

4.6. Staircase, east wing, Palace Complex. ca. 1500 BCE. Knossos, Crete

of Knossos may have been the most powerful Cretan center of the Middle and Late Bronze Age, with its most impressive structures dating between 1700 and 1400 BCE. Much of the palace was reconceived and reconstructed in concrete by Arthur Evans, who worked there between 1900 and 1932 (see *The Art Historian's Lens*, page 85). The palace consisted of courts, halls, workshops, storerooms (housing vast clay jars for oil and other provisions), and perhaps residential quarters, linked by corridors, staircases, and porticoes. Interior spaces were lit and ventilated by frequent light wells (as seen in fig. **4.6**). Other amenities in the palace included a system of clay pipes for drainage.

Walls were framed with timbers and constructed of rubble masonry or mud brick. Some of the walls were of ashlar masonry, giving them a more ornamental appearance. Columns, often made of wood with a stone base, supported the porticoes. Their form was unusual: A smooth shaft tapered downward from a generous cushionlike capital. Often the shaft was oval in cross-section rather than round. Wall paintings suggest that both components were painted,

the capital black and the shaft red or white. The origin of this type of column remains a mystery.

At first glance, the palace's plan (see fig. 4.4) has a confusing and haphazard appearance. Its mazelike quality probably explains why later Greek legend referred to the palace as the labyrinthine home of the Minotaur, the half-human, half-bull creature who devoured Athenian youths offered to him in tribute and whom Theseus killed after penetrating the maze. The island geography may have served as a natural defense for the palace. No exterior fortifications protected it from attack, so the mazelike arrangement of rooms may have been part of an internal defensive strategy; certainly entrances were not emphasized.

Nevertheless, the palace's design does have an underlying logic. Its core is a large central court, onto which important rooms opened. The court divides the plan on an approximately north–south axis. On the west side, a corridor running north–south separates long, narrow storerooms on the far west from rooms of less uniform shapes closer to the court; the latter rooms may have performed a

Two Excavators, Legend, and Archeology

In the mid-nineteenth century, most scholars believed that Homer's epic tales, the *Iliad* and the *Odyssey*, of the Trojan War and its aftermath, were merely the stuff of legend. But just a few decades later, that view had radically changed. Two extraordinary men were key figures in bringing about that change. One of them was Heinrich Schliemann (1822–1890). The German-born son of a minister, Schliemann became quite wealthy through a succession of business ventures and retired at the age of 41. From a young age he had been fascinated by Homer's world of gods and heroes, vowing to learn ancient Greek (one of about 15 languages he would eventually master). He became convinced that Homer's poetry was supported by a historical framework, and during his extensive travels, Schliemann learned that a handful of archeologists thought the Turkish site of Hissarlik was the probable site of Homer's Troy. After gaining permission from the Turkish government to excavate there, he began working officially in 1871. Among the spectacular finds he described in print was "Priam's Treasure," a hoard of vessels, jewelry, and weapons made of precious metals and named after Homer's king of Troy. Then, turning his attention to Mycenae, Schliemann discovered the shaft graves of Circle A, some of which contained magnificent objects, such as the gold mask in figure 4.27.

Schliemann was also intrigued by the site of Knossos on Crete, but he was unable to purchase the land. The opportunity fell instead to Arthur Evans (1851–1941), son of a renowned British naturalist, and himself the Keeper of the Ashmolean Museum at Oxford. By 1900 he had begun excavating the so-called Palace of Minos at Knossos with extraordinary results. In 1911, in recognition of his contribution to the field of archeology, Evans was knighted.

Scholars have judged these two early archeologists very differently. Schliemann's excavation technique was deemed destructive and Schliemann himself considered little more than a treasure hunter. Some scholars question whether he discovered Priam's Treasure as a hoard, or whether he assembled sporadic finds to make more of a news splash. Tales of his excavations have been embellished into myth in their own right. By some accounts, Schliemann had his Greek wife Sofia model ancient jewelry; it was also said that, after finding a gold mask at Mycenae, he telegraphed a Greek newspaper with the words "I have gazed on the face of Agamemnon." Only recently have scholars recognized the unfairness of assessing Schliemann by modern scientific standards, and they have acknowledged his critical role in igniting scholarly and popular interest in the pre-Hellenic world.

Evans's reputation has fared better than Schliemann's, largely because of his close attention to *stratigraphy*, that is, using layers of deposit in excavations to gauge relative time. This technique had been developed by geologists in the seventeenth and eighteenth centuries and is still used today in a refined form. Evans used it to assess the relative positions of walls and other features, and it led him to establish a relative chronology for the site as a whole. His designations of Early, Middle, and Late Minoan periods defined an essential historical framework for the Aegean world as a whole in the Bronze Age. Evans's work at Knossos included a considerable amount of reconstruction. His interventions help to make the site comprehensible to laypeople, but can also mislead an unknowing viewer. In fact, much of what a visitor sees at Knossos was built, not by Minoans, but by Evans. One significant consequence of Evans's restorations at Knossos is that they have kindled debate among conservators about how much to restore and how to differentiate visually between ancient ruin and modern reconstruction.

ceremonial role. An east–west corridor divides the east wing into (perhaps) a workshop area on the north side, and grander halls on the south. The palace appears to grow outwards from the court, and using flat (rather than pitched) roofs would have greatly facilitated the building of additions. Compared to Assyrian and Persian palaces, such as the palace of Sargon II (fig. 2.18) or the palace of Darius and Xerxes at Persepolis (fig. 2.26), the overall effect of the Palace at Knossos is modest; individual units are relatively small and the ceilings low. Still, the richly decorated walls of some of the interiors created an elegant appearance. We should also remember that much of what remains belongs to subterranean or ground-floor levels, and archaeologists have long believed that grander rooms existed on an upper level, which have not survived.

Exactly how the palaces of Crete functioned, and who lived in them, is debated even today. Arthur Evans described the complex as a "palace" (assigning royal names to various rooms) when he first excavated it, and the term stuck, regardless of its accuracy. Evans conceived of the complex as a palace or an elite residence for several reasons. Partly, he was reacting to other recent discoveries on the Mycenaean mainland, described subsequently, and partly to the presence of a grand Throne Room. But the social and political realities of Evans's own homeland may have been even more influential. He would have been very familiar with the many large palaces commanded by the extended royal family of late Victorian England. In fact, excavation of the complex at Knossos suggests that many kinds of activities occurred there. Extensive storage areas support a hypothesis that the palace was a center of manufacturing, administration, and commerce. Additionally, ceremonial places, such as the great court with its triangular raised causeway, and small shrines with religious paraphernalia, suggest that political and ritual activities occurred there too. There is no reason to believe that the Minoans segregated these activities as neatly as we tend to do today. Moreover, we have no evidence suggesting that the functions of the various palaces, at Knossos and elsewhere, were identical, or that they remained constant over time.

Wall Paintings: Representing Rituals and Nature

Grand rooms within the palaces at Knossos and elsewhere were decorated with paintings. Most of them were found in extremely fragmentary condition, so what we see today is the result of extensive restoration, which may not always be entirely reliable. The frescoes are characterized by vibrant mineral colors, applied to wet or dry plaster in broad washes without shading; wide bands of geometric patterns serve as elaborate frames. The subjects that appear most frequently among the paintings at Knossos go a long way toward supporting a hypothesis of ritual activity there. For instance, a miniature Second Palace Period painting, dating to around 1500 BCE, depicts a crowd of spectators attending a ritual or a game (fig. 4.7) and is known as the *Grandstand Fresco*. A tripartite building appears in the center. Scholars identify this structure as a shrine because of the stylized bulls' horns on its roof and in front of its facade. On either side sit two groups of animated women, bare-breasted and dressed in flounced skirts. Above and below, countless disembodied heads, rendered with simple, impressionistic black strokes, denote the crowd in a shorthand technique, on a swath of brown for males and white for females. They are smaller in scale than the central women, suggesting lesser importance. The fresco may represent an event that took place in the palace's central court, as remains of a tripartite shrine were found on the west side of the court.

Many other Minoan paintings use nature as their subject. A painting found in fragments in a light well has been restored to a wall in the room Arthur Evans called The Queen's Megaron in Knossos' east wing (fig. 4.8). Blue and yellow dolphins swim peacefully against a blue-streaked cream background, cavorting with small fish. Within the upper and lower frames, multi-lobed green forms represent plants or rocks. Sinuous outlines suggest the creatures' form, while the curving, organic elements throughout the composition animate the painting. Such lively representations of natural forms occur frequently in Minoan art in a variety of media. The many images of sea creatures probably reflect the Minoans' keen awareness of and respect for the sea. The casualness of Minoan images contrasts forcefully with the rigidity and timelessness of many Egyptian representations, though there is good evidence for contact between Minoan artists and Egypt.

PAINTED LANDSCAPES IN A SEASIDE TOWN In the middle of the second millennium BCE, a volcano erupted on the Cycladic island of Thera (present-day Santorini), about 60 miles north of Crete. The eruption covered the town of Akrotiri in a deep layer of volcanic ash and pumice. Beginning in 1967, excavations directed by Spyridon Marinatos and then Christos Doumas uncovered houses dating from the Middle Minoan III phase (approximately 1670–1620 BCE) preserved up to a height of two stories. On their walls was an extraordinary series of paintings. Landscapes dominate. In a small ground-floor room, a rocky landscape known as the Spring Fresco occupies almost the entire wall surface (fig. 4.9). The craggy terrain undulates dramatically, its dark outline filled with rich washes of red, blue, and ocher—colors that were probably present in the island's volcanic soils—with swirling black lines adding texture within. Sprouting from its surface, lilies flower in vivid red trios, while swallows dart between them, painted in a few graceful black lines.

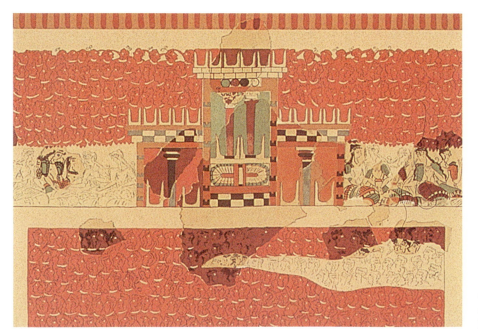

4.7. *Grandstand Fresco*, from Knossos, Crete. ca. 1500 BCE Archaeological Museum, Iráklion, Crete

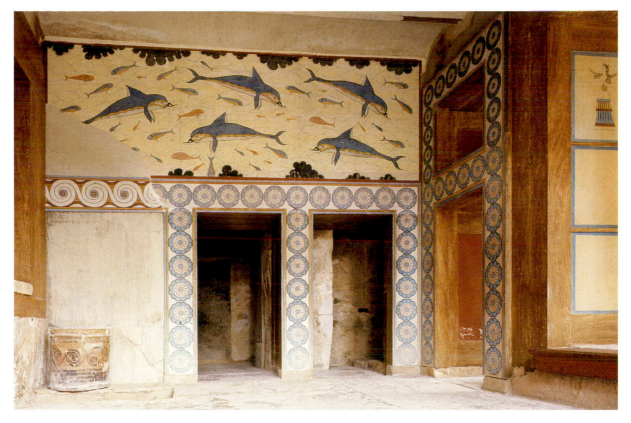

4.8. The Queen's Megaron. ca. 1700–1300 BCE, from Knossos, Crete. Archaeological Museum, Iráklion, Crete

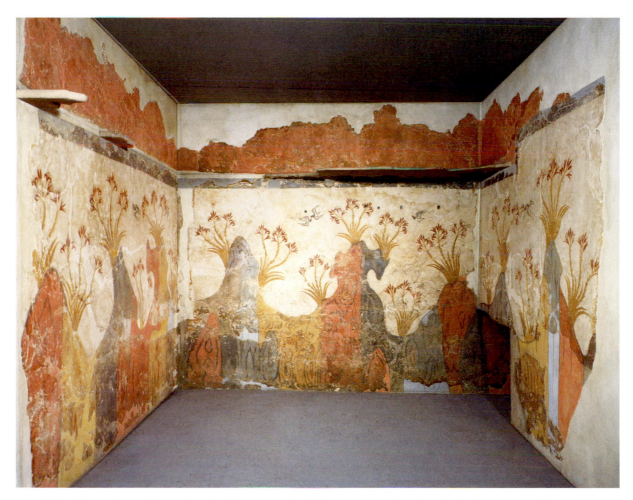

4.9. *Spring Fresco*. Fresco from Akrotiri, Thera. ca. 1600–1500 BCE. National Archaeological Museum, Athens

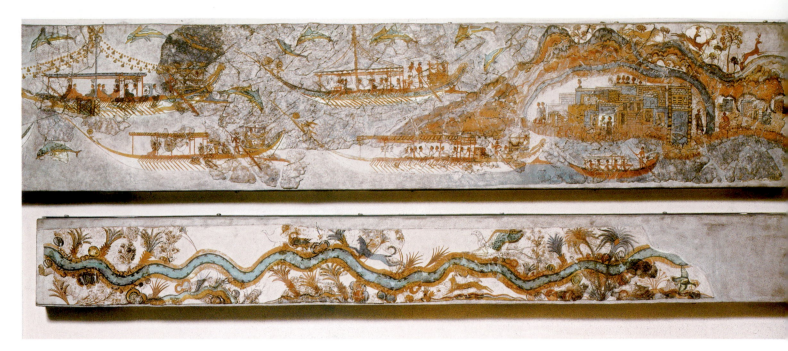

4.10. *Flotilla Fresco*, from Akrotiri, Thera. ca. 1600–1500 BCE. National Archaeological Museum, Athens

In other rooms at Akrotiri, humans are inserted into the landscape, often life-size, and sometimes smaller, as in a painting that decorated the upper section of at least three walls in a large second floor room (fig. **4.10**). The scene reflects the town's role as a harbor: A fleet of ships ferries passengers between islands, set within a sea full of leaping dolphins. The ships vary, some under sail and some rowed by oarsmen, but all are carefully described by the painter's brush. The same is true of the islands, each of which has a port city with detailed stone architecture. Crowds of people watch the spectacle from streets, rooftops, and windows. The painting may represent an actual event—a memorable expedition to a foreign land, perhaps, or an annual festival.

Minoan Pottery

Like the wall paintings, Minoan painting on pottery was inspired by the natural world of the Aegean. Minoan potters sensitively painted their vessels with lively organic forms that enhance the curving shapes of the vases. By the Middle and Late Minoan periods, pottery was manufactured on the wheel, allowing for a variety of rounded forms and many sizes. While large and rough vessels were used for storage, the finest wares, which were often very thin-walled, were made for palace use.

KAMARES WARE An organic approach to pottery appears in the shape of the vase in figure **4.11**, of the Middle Minoan II period (about 1800 BCE), which came from Phaistos in southern Crete. Its neck curves upward into a beak shape, which the vase painter has emphasized by giving it an eye. The vase is decorated with bold curvilinear forms in white, red, orange, and yellow against a black background. This style, known as Kamares

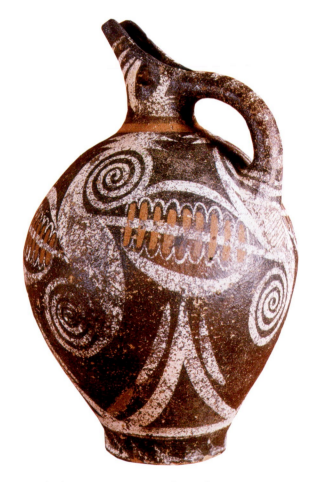

4.11. Beaked jug (Kamares ware), from Phaistos. ca. 1800 BCE. Height $10\frac{5}{8}''$ (27 cm). Archaeological Museum, Iráklion, Crete

ware, first appears at the beginning of the Middle Minoan phase and was named after the cave on Mount Ida where it was first discovered. The painted forms are abstract and endow the vessel with a feeling of life and movement.

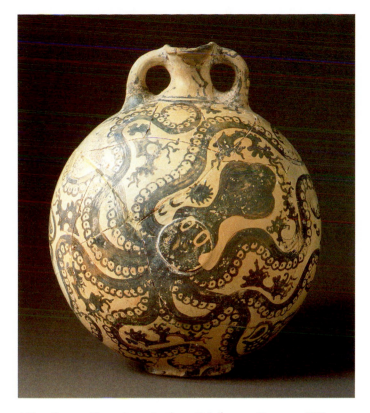

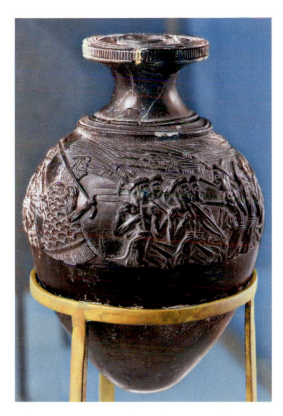

4.12. *Octopus Vase*, stirrup jar from Palaikastro, Crete. ca. 1500 BCE. Height 11″ (28 cm). Archaeological Museum, Iráklion, Crete

4.13. *Harvester Vase*, from Hagia Triada. ca. 1500–1450 BCE. Stone/steatite. Width 4½″ (11.3 cm). Archaeological Museum, Iráklion, Crete

MARINE MOTIFS Marine motifs became even more prevalent in the slightly more recent Minoan pottery of the Late Minoan IB phase. A vivid example of this "marine style" is a stirrup jar, which has two round handles flanking its narrow spout, decorated with a wide-eyed black octopus with swirling tentacles, contrasted against the eggshell-colored clay (fig. **4.12**). Clumps of algae float in the spaces between the tentacles. As with Minoan wall paintings, an extraordinarily dynamic and naturalistic quality characterizes the painting. Moreover, the painting's forms express the shape of the vessel they decorate: The sea creature's rounded contours emphasize the jar's swollen belly, while the curves of its tentacles echo the curved handles at the neck. Exactly beneath the spout, the end of a tentacle is curled to define a circle of the same size as the jar's opening.

Carved Minoan Stone Vessels

From an early date, Minoan artists also crafted vessels of soft stone, either from black steatite (serpentine), which was locally available, or from stones imported from other Aegean islands. They carved it with tools of a harder stone, hollowing out the interior with a bow-driven drill and then finishing surfaces with an abrasive, probably emery, from the Cycladic island of Naxos. Traces of gold reveal that the stone was then gilded. Archeologists suppose that many of these stone vessels had a ceremonial use. Fragments of such works were discovered at Hagia Triada on the southern side of Crete, including the black steatite vessel illustrated here (fig. **4.13**). This type of

vessel is called a **rhyton (plural rhyta)**: It has a large hole at the top and a smaller hole at the base, and was used for pouring liquid offerings or drinking.

Only the upper part of the rhyton in figure 4.13, called the *Harvester Vase*, survives. Twenty-seven slim, muscular men, mostly nude to the waist and clad in flat caps and pants, seem to move around the vessel with lively rhythm and raucous energy. Their dynamic movement echoes the animated imagery on Minoan pots and wall paintings. Hoisting long-handled tools over their shoulders, four bare-headed singers bellow with all their might. Their leader's chest is so distended that his ribs press through his skin. A single long-haired male in a scaly cloak, holding a staff, seems to head the procession. The leader of the singers holds a *sistrum*, a rattle that originated in Egypt. The detail of the sistrum and the composite depiction of the men's bodies provide evidence of contact between Crete and Egypt.

Interpretations of the scene depend partly on identifying the tools carried by the crowd and the objects suspended from their belts. If they are hoes and bags of seed corn, then the subject may be a sowing festival; if, instead, they are winnowing forks and whetstones, it is more likely a harvest festival. Alternatively, some scholars see the scene as a warriors' triumph, while still others see a representation of forced labor. In the absence of further evidence, either archeological or written, debates about the meaning of the image will certainly continue.

Another magnificent rhyton in the shape of a bull's head comes from Knossos, and dates to the Second Palace period

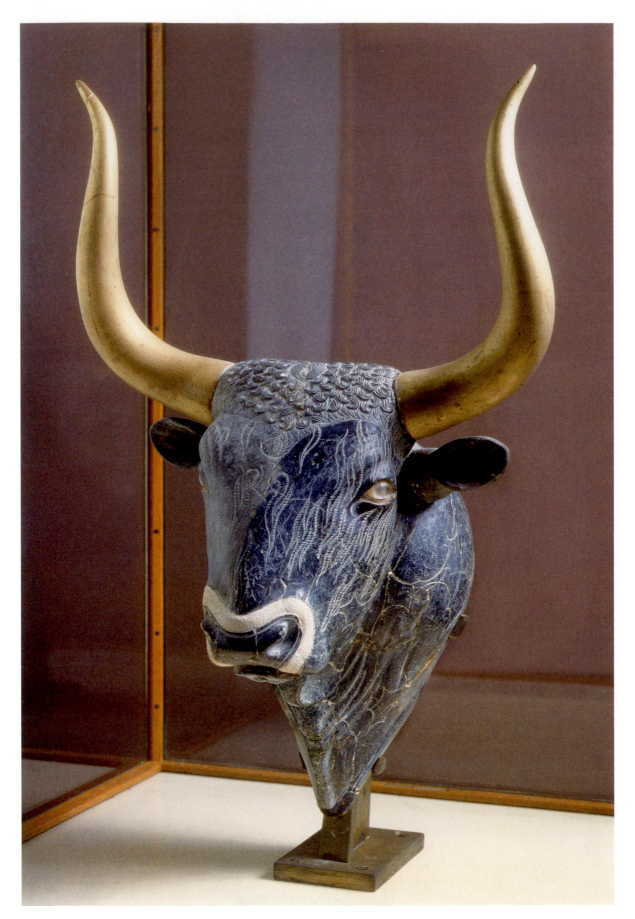

4.14. Rhyton in the shape of a bull's head, from Knossos. ca. 1500–1450 BCE. Serpentine, steatite, crystal, and shell inlay (horns restored). Height 8⅛″ (20.6 cm). Archaeological Museum, Iráklion, Crete

(about 1500–1450 BCE) (fig. **4.14**). Like the *Harvester Vase*, it is carved from steatite, with white shell inlaid around the muzzle. For the eye, the artist inserted a piece of rock crystal, painted on the underside with a red pupil, black iris, and white cornea, so that it has a startlingly lifelike appearance. The horns, now restored, were of gilded wood. Light incisions dusted with white powder evoke a shaggy texture and variegated color in the animal's fur. The vessel was filled through a hole in the neck, and a second hole below the mouth served as a spout. Similar vessels were discovered elsewhere in Crete, for instance at the Palace at Zakros, on the east coast of Crete. Egyptian tomb paintings of about the same time (1500–1450 BCE) depict Cretans carrying bull-headed rhyta, suggesting that the civilizations with which they traded identified Minoans with such vessels. The prevalence of the bull motif, coupled with evidence of altars decorated with horns, suggest that bulls played a part in Minoan religious ritual. Rhyta are often found smashed to pieces. Although later vandals or earthquakes might account

ART IN TIME

ca. 1792–1750 BCE —Babylon ruled by Hammurabi

ca. 1700–1400 BCE—Minoan Construction of the Second Palace at Knossos

ca. 1628 —Volcanic eruption on Thera

ca. 1500–1450 BCE—*Octopus Vase*, an example of Minoan "marine style" pottery

ca. 1450 BCE —Earthquake demolishes Knossos and other Minoan centers; Mycenaeans invade Crete

for such damage, their smashed state suggests that ceremonial vessels were ritually destroyed after use.

Religious life on Minoan Crete centered on natural places deemed sacred, such as caves, mountain peak tops, or groves. No temples or large cult statues have been discovered. Archeologists did find two small-scale **faience** statuettes from the Middle Minoan III phase (about 1650 BCE) at Knossos. One example shows a female figure raising a snake in each hand and wearing a headdress topped by a feline creature (fig. **4.15**). She wears a flounced skirt similar to those worn by women in the *Grandstand Fresco* (fig. 4.7), and bares her breasts. Her tiny waist is another feature that appears consistently in Minoan representations of humans, like the men on the *Harvester Vase* (fig. 4.13). In some ancient religions, snakes are associated with earth deities and male fertility, just as the bared breasts of this statuette suggest fecundity. Moreover, the statuettes were found in pits known as the Temple Repositories. These were sunk in the floor of a room on the west side of the central court. The statuettes' placement there, and accompanying remnants of furniture from the shrine, have led scholars to associate them with a mother goddess, yet they could just as easily have been ritual attendants.

Late Minoan Art

Scholars are still debating what brought Minoan civilization to an end. Some have argued that the eruption of the volcano on the island of Thera may have hastened the culture's decline. Recent discoveries and dating of the volcanic ash from this eruption, however, indicate that the civilization on Crete survived this natural disaster, though it may have been weakened by it. About 1450 BCE (Late Minoan II), the palaces at Crete were taken over by invaders from the Greek mainland, whom archeologists call Mycenaeans. They established themselves in the palace at Knossos until around 1375 BCE, when Knossos was destroyed and the Mycenaeans abandoned most of the sites of Crete. During the period of their rule, however, the artists at Knossos worked in styles that had developed in Minoan times.

The fragmentary *Toreador Fresco* dates from the Mycenaean occupation of Knossos (Late Minoan II–IIIA), and

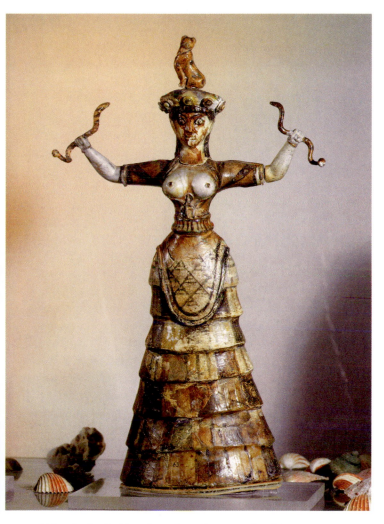

4.15. *Snake Goddess*, from the palace complex, Knossos. ca. 1650 BCE. Faience. Height 11⅝″ (29.5 cm). Archaeological Museum, Iráklion, Crete

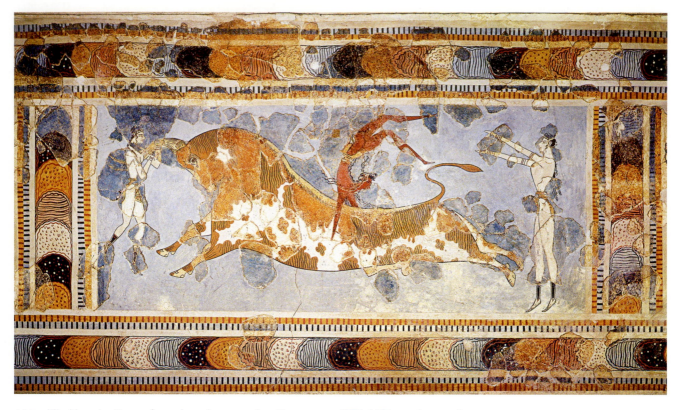

4.16. *The Toreador Fresco*, from the palace complex, Knossos. ca. 1550–1450 BCE (restored). Height including upper border approx. 24½″ (62.3 cm). Archaeological Museum, Iráklion, Crete

appears to have been one of a series that decorated an upper room in the northeast part of the palace (fig. **4.16**). Scholars have interpreted this bull-leaping scene as a ritual game in which performers vaulted over a bull's back. Against a deep blue background, a white-skinned figure clad in a kilt clasps the horns of a huge bull, painted with sinuous contours at a full gallop. Behind the bull, a similar white-skinned figure stands on tiptoe with arms outstretched, while above the bull's back, a dark-skinned figure performs a backward somersault. The figures have long limbs and improbably small waists, yet they are painted in true profile. The painting's washes of color and animated though somewhat stylized poses demonstrate the continuity of Minoan practice into the Late period.

Scholars continue to debate the meaning of this painting. Although most agree that bull jumping had a ritual function, the purpose of the activity and the identity of the participants is unclear. Following the widespread Mediterranean convention for distinguishing gender by skin tone, Evans identified the light-skinned figures as female and the darker one as male. Others have seen all three figures as sequential representations of the same person, taking part in a coming of age initiation ceremony in which boys emerge masculine from their earlier "feminine" guise. Many scholars see the presence of women in prominent roles in Minoan imagery as evidence of their importance in ritual activities.

MYCENAEAN ART

By the time the Mycenaeans conquered Crete, they had been building cities of their own on the Greek mainland since the start of the Late Helladic period. They probably made early contact with Minoan Crete, which had important influences on their own culture. Once again, the material remains offer the best clues about this culture. From the dating of Mycenaean sites and the objects discovered in them, archeologists place the height of the culture between about 1500 BCE and 1200 BCE (Late Helladic III). The most imposing remains are the citadels at sites that Homer named: Mycenae, Pylos, and Tiryns. The culture takes its name from the first of these, the legendary home of Agamemnon, the king who led the Greek forces in Homer's Trojan War.

Architecture: Citadels

At the beginning of the Second Palace Period on Crete, growing settlements throughout the Greek mainland, including at Mycenae itself (fig. **4.17**), centered around large structures known as citadels (when fortified) or palaces. In some of them, most particularly Pylos on the southern coast of the Peloponnesian region (see map 4.1), clay tablets have been found inscribed with a second early writing system. Dubbed Linear B because of its linear character and because it drew, in part, from earlier Minoan Linear A, the system was decoded by Michael Ventris in 1952. The tablets proved to have been inventories and archival documents, and the language of Linear B is now considered an early form of Greek. The inhabitants of these Late Bronze Age sites, therefore, were the precursors of the Greeks of more recent times.

The Linear B tablets refer to a *wanax* ("lord" or "king"), suggesting something of a Mycenaean social order. Mycenaean citadels and palaces may have incorporated royal residences. Many of them were gradually enclosed with imposing exterior walls, often expanded and improved in several building phases, and constructed so as to exploit the topography of the site.

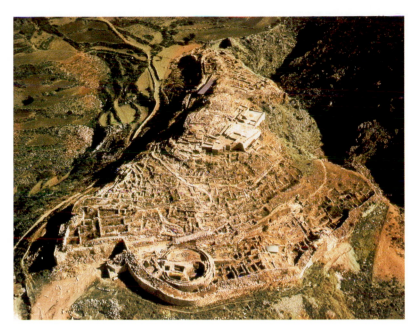

4.17. Aerial view of Mycenae, Greece. ca. 1600–1200 BCE

These fortifications were constructed of large stone blocks laid on top of each other, creating walls that were at times 20 feet thick. These walls, and tunnels leading from them to wells that would provide water during a siege, have led scholars to regard the Mycenaeans as quite different from the Minoans, with a culture focused primarily on warfare.

The contrast is often stated in terms that imply an essential character difference between nature-loving Minoans and war-mongering Mycenaeans. We should note, however, that the fortifications date to after the destruction of Minoan centers, so the Mycenaeans may have been responding to a new set of political and social circumstances. Homer's characterizations of the kings of this era and, in fact, his entire narrative of the Trojan War, only reinforced modern ideas about the Mycenaeans as warlike. The poet himself described the city of Tiryns, set on a rocky outcropping in the plain of Argos in the northeastern Peloponnesus, as "Tiryns of the Great Walls." The inhabitants here fortified their citadel in several stages around 1365 BCE (figs. **4.18**, **4.19**).

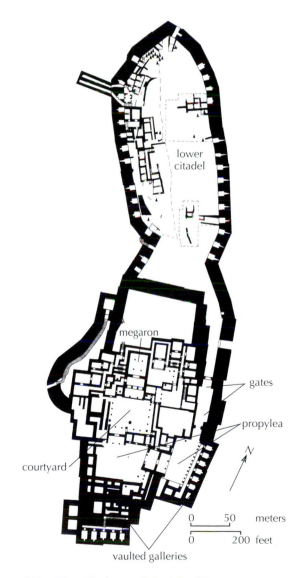

4.19. Plan of palace and citadel at Tiryns, Greece. ca. 1400–1200 BCE

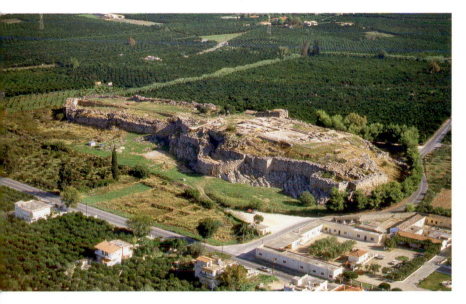

4.18. Aerial view of Tiryns, Greece. ca. 1400–1200 BCE

Cyclopean Masonry

The fortifications at Tiryns, Mycenae, and elsewhere were built of massive blocks of limestone, each weighing as much as 5 tons. For most of the wall, the blocks were hardly trimmed, and were thus irregularly shaped (or polygonal), wedged together with smaller stones and packed clay, but no mortar. This form of construction seems to be heavily influenced by Hittite construction at sites such as Bogazköy, Anatolia (see fig. 2.23). At entrances or other highly visible places, such as the Lion Gate (see fig. 4.22), builders sometimes used a technique known today as ashlar masonry. Blocks of conglomerate stone—incorporating pebbles and sediments—were cut with a saw and then *dressed*, that is, smoothed, with a hammer, and laid in regular courses.

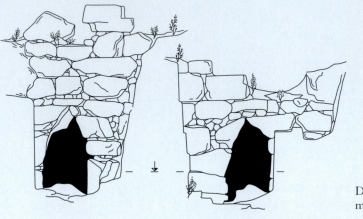

Drawing showing cyclopean masonry construction

Like the slightly later walls at Mycenae, those at Tiryns were built of massive blocks of limestone, weighing as much as 5 tons. For most of the wall, the blocks were irregularly shaped (or polygonal), wedged together with smaller stones and fragments of pottery. At entrances or other highly visible places, the stones might be saw-cut and dressed, or smoothed with a hammer. In its final form, the outer wall at Tiryns was a full 20 feet thick, and a second inner wall was just as impressive. Centuries later, the Greeks were so awed by the massiveness of these walls that they declared them the work of the Cyclopes, a mythical race of one-eyed giants. Even today, the walls are termed "Cyclopean." (See *Materials and Techniques*, above.)

The fortifications at Tiryns were carefully designed to manipulate a visitor's approach to the residents' military advantage, as the slightly earlier Hittite fortifications also did (see fig. 2.23). A narrow walled ramp circled the walls, so that an aggressor approaching in a clockwise direction would have the nonshield-bearing side vulnerable to attack by defenders on the walls. If an aggressor reached the entrance, two sets of fortified **propylons** (gateways) presented further obstacles, between which the attacker could be trapped and attacked from above. Within the walls, rooms and passages known as **casemates** provided storage for weapons. They also offered safety for townspeople or soldiers during an attack (fig. 4.20). The gallery at Tiryns was built using a **corbel** technique: The stones are laid so that each course of masonry projects slightly beyond the course below it, until the span is covered when the walls meet in an irregular arch (fig. 4.21). When, as here, a corbel is used to roof an entire space, it is called a **corbel vault**.

A corbel arch was also used to great effect at the Lion Gate at Mycenae of about 1250 BCE. The Lion Gate formed a principal entrance into the citadel at Mycenae, and was built when the city walls were enlarged to improve its defenses (fig. 4.22). Two massive stone posts support a huge lintel to form the opening. Above the lintel, a corbel arch directs the weight of the heavy wall to the strong posts below it. The corbel thus relieves the weight resting on the vast stone lintel, which itself weighs 25 tons; it is known as a relieving triangle. To seal the resulting gap, a triangular grey limestone slab was inserted above the lintel, carved with a huge pair of animals, probably lionesses (though they may be sphinxes or griffins). They stand in a **heraldic pose**, mirror images of each other, with their front paws on altars of a Minoan style, and flanking a tapering Minoan style column. Dowel holes in their necks suggest that their heads were added in wood or a different stone, such as steatite or white marble. At almost 10 feet high, this relief is the first large-scale sculpture known on the Greek mainland. The column between the animals may have supported another element of some kind. The lionesses function as guardians, and their tense, muscular bodies, and symmetrical design suggest an influence from the Near East. The concept of animal guardians at the gate of a palace may have been suggested by similar structures such as the Hittite Lion Gate at Bogazköy, Anatolia (fig. 2.23). Mycenaeans ventured all over the Mediterranean, including Egypt and Anatolia, and Hittite records suggest contact with a people who may have been the Mycenaeans.

The walls of Mycenaean citadels protected a variety of buildings (see fig. 4.17). These interior structures were built of rubble

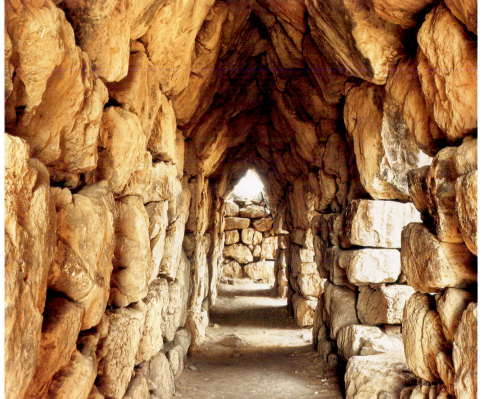

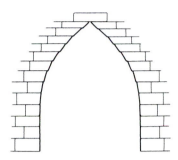

4.21. Drawing: Corbel arch

in a timber framework, as in Minoan palaces, sometimes faced with limestone. The dominant building was a **megaron**, a large rectangular audience hall. At Tiryns (see fig. 4.19) the megaron lay adjacent to an open courtyard. Two columns defined a deep porch that led into a vestibule and then into the hall. The hall contained a throne and a large central hearth of stuccoed clay, surrounded by four columns supporting the roof beams. Above

the hearth, the ceiling was either left open to the sky or covered by a raised roof, allowing smoke to escape and light to enter.

The design of a megaron is essentially an enlarged version of simple houses of earlier generations; its ancestry can be traced back to Troy in 3000 BCE. A particularly well-preserved example of a megaron survives at the southern Peloponnesian palace of Pylos of about 1300 BCE. There, the hearth is set into a plastered

4.22. The Lion Gate, Mycenae, Greece. ca. 1250 BCE

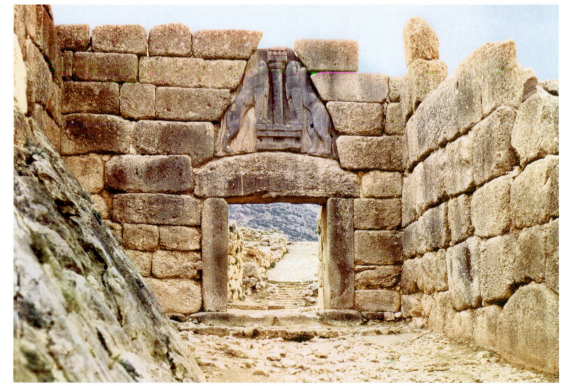

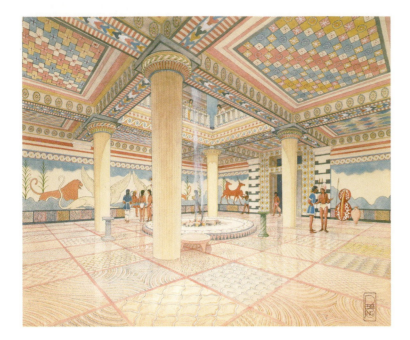

4.23. Reconstruction of megaron at Pylos, ca. 1300–1200 BCE

floor decorated to resemble flagstones of varied ornamental stone (fig. 4.23). A rich decorative scheme of wall paintings and ornamental carvings enhanced the megaron's appearance. The throne stands against the northeast wall, flanked on either side

by painted griffins, similar to those decorating the throne room at Knossos, elaborated under Mycenaean rule. Other elements of the decoration, such as the shape of the columns and the ornament around the doorways, reveal Minoan influence at Pylos.

Mycenaean Tombs and Their Contents

At the end of the Middle Helladic period at Mycenae, the ruling elite began to bury their dead in deep rectangular shafts, marking them at ground level with stones shaped like stelai. The burials were distributed in two groups (known as Grave Circles A and B), which later generations eventually set off and monumentalized with a low circular wall. As time passed, the elite built more dramatic tombs, in a round form known as a *tholos*. Over 100 tholoi are known on the mainland, nine of them near Mycenae.

One of the best preserved and largest of these tombs is at Mycenae. Dubbed the "Treasury of Atreus," after the head of the clan that Homer placed at Mycenae, it dates to about 1250 BCE (Late Helladic III B). A great pathway, or *dromos*, lined with ashlar masonry, carefully cut and fitted, led to a spectacular entrance (fig. 4.24). The door slopes inward, in a style associated with Egyptian construction. Flanking the opening were columns of Egyptian green marble, carved with spirals and zigzags (fig. 4.25). Above the doorway, small columns framed decorative marble bands that concealed a relieving triangle over the lintel.

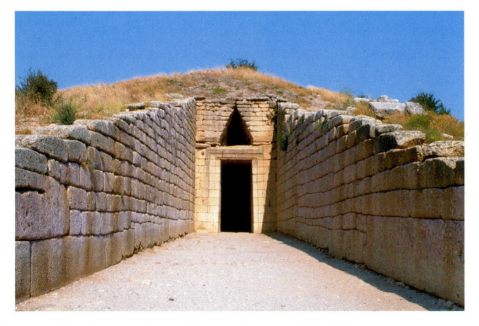

4.24. "Treasury of Atreus," Mycenae, Greece. ca. 1300–1250 BCE

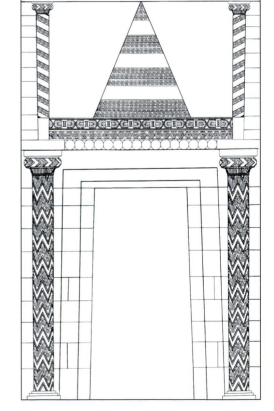

4.25. Reconstruction of the facade of "Treasury of Atreus," Mycenae, Greece. ca. 1300–1250 BCE

4.26. Interior of "Treasury of Atreus," Mycenae, Greece. ca. 1300–1250 BCE

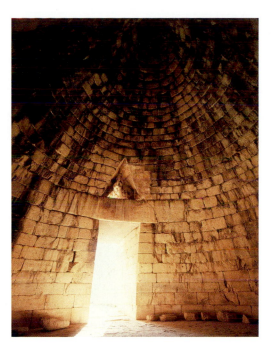

The tomb itself consisted of a large circular chamber excavated into sloping ground and then built up from ground level with a corbel vault: Courses of ashlar blocks protruded beyond one another up to a capstone (fig. **4.26**). When built in rings rather than parallel walls (as at Tiryns, fig. 4.21), the corbel vault results in a beehive profile for the stone roof. Earth covered the structure, helping to stabilize the layers of stone and creating a small hill, which was encircled with stones. The vault rose 43 feet over a space 48 feet in diameter. Such a large unsupported span would not be seen again until the Pantheon of Roman times. The ashlar blocks of the vault may once have been decorated with gilded rosettes to resemble a starry sky. To one side of the main room, a small rectangular chamber contained subsidiary burials.

METALWORK Like the Great Pyramids of Egypt, these monumental *tholos* tombs exalted the dead by drawing attention to themselves. As a result, they also attracted robbers throughout the ages, and the grave goods that once filled the "Treasury of Atreus" have long been dispersed. Many of the earlier shaft graves also contained lavish burial goods, ranging from luxurious clothing and furniture to fine weaponry. On excavating Grave Circle A, Schliemann discovered five extraordinary death masks of hammered gold, covering the faces of dead males. Although far from naturalistic, each mask displays a distinct treatment of physiognomy: Some are bearded while others are clean-shaven. This suggests that the masks were somewhat individualized to correspond to the deceased's appearance. On finding the example illustrated in figure **4.27** in 1876, Schliemann told the press, "I have gazed into the face of Agamemnon." Since modern archeology places the mask between 1600 and 1500 BCE, and the Trojan War—if it happened—would date to about 1300–1200 BCE, this would certainly not be a mask of Agamemnon. But the mask may

represent a Mycenaean king of some stature, given the expense of the materials and the other objects found near it. Among the weapons in the graves were finely made ornamental bronze dagger blades. Such blades were often inlaid with spirals or figural scenes in gold, silver, and **niello** (a sulfur alloy that bonds with silver when heated, to produce a shiny black

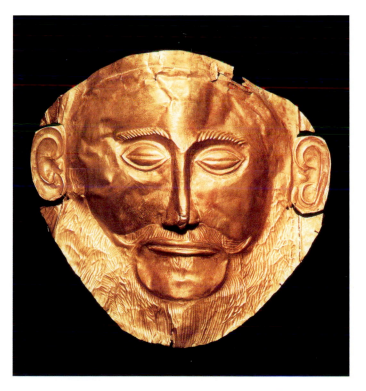

4.27. *Mask of Agamemnon*, from a shaft grave in Circle A, Mycenae. ca. 1600–1500 BCE. Gold. Height 12″ (35 cm). National Archaeological Museum, Athens

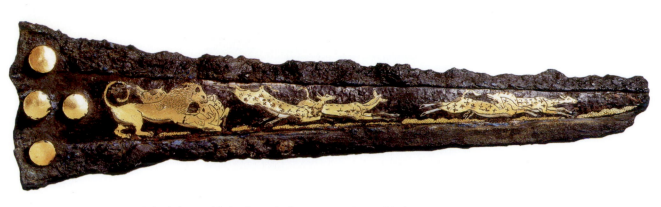

4.28. Inlaid dagger blade, from shaft grave IV, Grave Circle A, Mycenae, Greece. ca. 1600–1550 BCE. Length 9³⁄₈″ (23.8 cm). National Archaeological Museum, Athens

metallic finish). The example in figure **4.28** depicts a lion preying on gazelles; the lion's predatory strength is associated with the dagger's owner.

THE *VAPHIO CUPS* While the burial method used in the shaft graves is distinctively Mycenaean, the treasures found within them raise an interesting question about the interactions between Minoans and Mycenaeans. Many objects show Minoan influence, while others appear so Minoan that they must have come from Crete or been created by Cretan craftsmen. Two gold cups from a Mycenaean tomb at Vaphio near Sparta, in the southern Peloponnesus, are particularly intriguing (fig. **4.29**). Probably crafted between 1500 and 1450 BCE, the cups are made of two skins of gold: The outer layer was embossed with scenes of bull-catching—a theme with Minoan roots—while the inner lining is smooth. A cylindrical handle was riveted to one side. On one cup, bull-trappers try to capture the animal with nets, while on the other, a cow set out to pasture is a lure to entice a bull into

captivity. The subject matter of the cups suggests that they refer to one another, yet they are not, strictly speaking, a pair. One cup has an upper border framing the scene, but the other does not, and stylistic analyses suggest that each cup was crafted by a different artist. Where the cups or the artists originated is a matter of debate. For some, the "finer" cup (with the pasture scene) is Minoan on account of its peaceful quality, and the other a more violent Mycenaean complement made by a Mycenaean—or a Minoan—artist. What the cups underline is how little we understand about the interplay between, and the movements of, Minoan and Mycenaean artists, and, indeed, how arbitrary and subjective our attempts to distinguish between them may be.

Sculpture

As in Crete, Mycenaean religious architecture apparently consisted of modest structures set apart from the palaces. At these small shrines the Mycenaeans worshipped a wide variety of gods. Names recorded on Linear B tablets indicate that some of

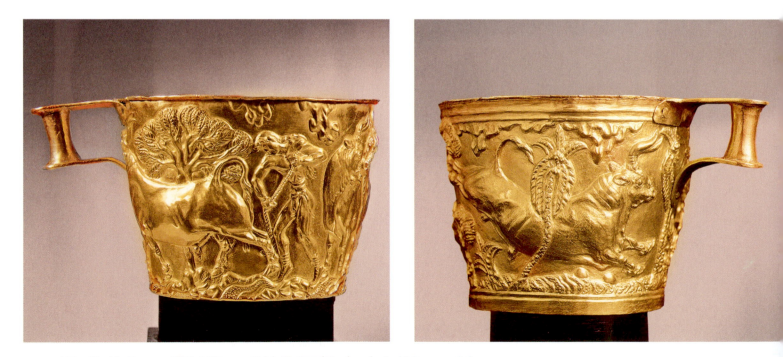

4.29. *Vaphio Cups.* ca. 1500–1450 BCE. Gold. National Archaeological Museum, Athens

these gods, such as Poseidon, are the predecessors of the later Olympian gods of Greece. The Greek Poseidon was the god of the sea, a divinity who must have been of some importance to the seafaring Mycenaeans.

Free-standing sculptures are rare, but one small, finely carved ivory group depicting two kneeling women with a young child was found in a shrine next to the palace at Mycenae in 1939 (fig. **4.30**). The women wear flounced skirts similar to the one worn by the Minoan *Snake Goddess* (fig. 4.15), suggesting that the work came from Crete or was carved by an artist from Crete working on the Greek mainland for Mycenaean patrons. But the material is ivory that probably originated in Syria or Egypt, documenting Mycenaean trade links. The figures' intertwined limbs and the child's unsettled pose describe a transient moment that will change in an instant. For some scholars, the close physical interaction among the figures suggests that this small object is a rendering of a family group, including grandmother, mother, and child. Others argue that it represents three separate divinities, one of whom takes the form of a child.

This tiny sculpture is made of imported ivory in a Minoan style for a Mycenaean patron. Along with the Treasury of Atreus, with its echoes of Egypt, and the Lion Gate, a blend of Minoan and Near Eastern influences, this object and others that survive from Bronze Age Greece reveal a culture with contacts throughout the Mediterranean. Whether those contacts came as a result of war or trade, the culture of Mycenaean Greece was receptive to the ideas and forms of other regions. Despite its warlike and dynamic character, Mycenaean civilization collapsed around 1200 or 1100 BCE, probably in the chaos caused by the arrival of new peoples on the Greek mainland. Whether or not the inhabitants of these powerful citadels actually took part in the legendary 10-year-long siege of Troy in Asia Minor, their descendents believed they did. For the Greeks, for the poet Homer, the Mycenaean Age was an age of heroes.

ART IN TIME

ca. 1600–1500 BCE—Mycenaean death masks of
hammered gold

ca. 1500–1200 BCE—Height of Mycenaean culture

ca. 1290–1224 BCE—Rule of ancient Egyptian pharaoh Ramses II

ca. 1250 BCE—**Construction of the Lion Gate at Mycenae**

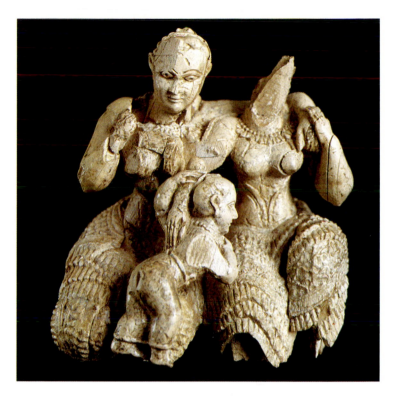

4.30. *Three Deities*, from Mycenae. 14th–13th century BCE. Ivory. Height 3″ (7.5 cm). National Archaeological Museum, Athens. Ministry of Culture Archaeological Receipts Fund. 7711

SUMMARY

The Mediterranean Sea was a highway that brought the various civilizations of antiquity into contact with one another for both trade and war. During the third and second millennia BCE, several closely related but distinct cultures developed on the islands and peninsulas in and adjacent to the Aegean Sea. These include the Cycladic culture, named for islands north of Crete; the Minoan culture, which constructed and decorated so-called palaces on Crete; and the Mycenaean culture, which left behind remarkable citadels and grave goods on the Greek mainland. The distinct art forms produced by each of these groups provide insights into the practices and ideals of ancient Aegean peoples.

EARLY CYCLADIC ART

The most characteristic art forms of the Cycladic islands of the third millennium BCE are carved marble figures of women and musicians. Although both the meaning and the function of these sculptures are obscure, the clean geometry and smooth surfaces of their abstracted forms hold great appeal for modern viewers.

MINOAN ART

Despite over a hundred years of archeological research on Crete and other sites in the Aegean, Minoan culture remains mysterious. The large and complex palaces that dominated the landscape of Crete probably served as administrative and ritual centers as well as residences. These structures were adorned with numerous frescoes and wall paintings and other decorative elements that represent, among other things, the natural world in lively, animated forms. Minoan pottery, sculpture, and ritual objects, which demonstrate organic and dynamic compositions, exhibit a high degree of craftsmanship.

MYCENAEAN ART

The Mycenaeans were named for the fortified settlement of Mycenae in the Peloponnesian region of mainland Greece. Their citadels—with huge walls, massive fortifications, and defensive layouts—suggest a culture concerned with defense, if they were not overtly warlike themselves. Nevertheless, the luxurious objects placed in Mycenaean burial sites and the lavish adornment of their palaces reveal that this group was open to influences from around the Mediterranean. Minoan, Egyptian, and Mesopotamian elements all contributed to Mycenaean art.

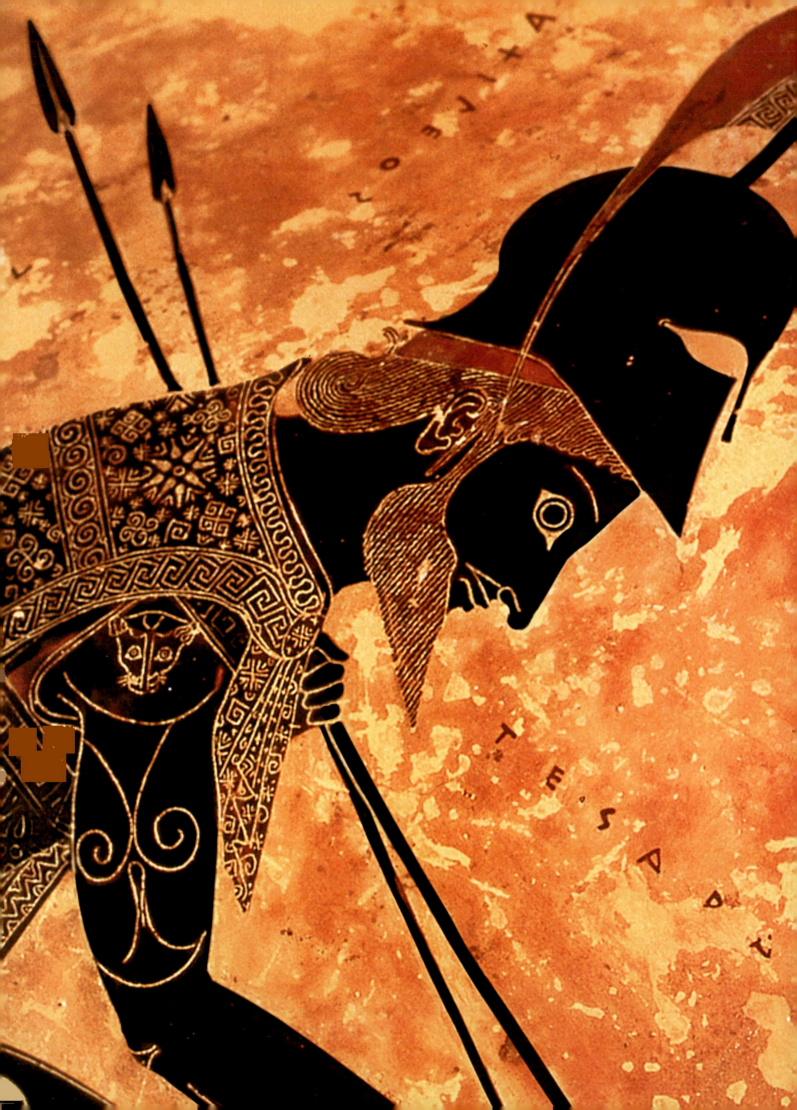

Greek Art

NO MATTER HOW ACCOMPLISHED THEY MIGHT BE, THE WORKS OF ART we have discussed so far seem alien to us. The ancient cultures that produced them were so different from our own that we find few references in those works to our own time. Greek architecture, sculpture, and painting, however, are immediately recognizable as the ancestors of

Western civilization, despite their debts to earlier art. A Greek temple reminds us of countless government buildings, banks, and college campuses; a Greek statue recalls countless statues of our own day; and a Greek coin is little different from those we use today. This is neither coincidental nor inevitable. Western civilization has carefully constructed itself in the image of the Greek and Roman worlds. For an art historian trying to understand the visual culture of those worlds, this presents a special challenge: It is tempting to believe that something familiar on the surface holds the same significance for us as it did for the Greeks or the Romans, but scholars have discovered time and time again that this is a dangerous fallacy.

Another complication in studying Greek art arises because there are three separate, and sometimes conflicting, sources of information on the subject. First, there are the works themselves—reliable, but only a small fraction of what once existed. Second, there are Roman copies of Greek originals, especially sculptures. These works tell us something about important pieces that would otherwise be lost to us, but copies pose their own problems. Without the original, we cannot determine how faithful the copy is, and sometimes multiple copies present several versions of a single original. To make things even more complicated, a Roman copyist's notion of a copy was quite different from ours. A Roman copy was not necessarily intended as a strict imitation, but allowed for interpreting or adapting the work according to the taste or skill of the copyist or the wishes of the patron. Moreover, the quality of some Greek sculpture owed much to surface finish, which, in a copy, is entirely up to the copyist. If the original was bronze and the copy marble, the finish would differ dramatically. In some rare cases, apparent copies are of such high quality that we cannot be sure that they really are copies.

The third source of information about Greek works is literature. The Greeks were the first Western people to write at length about their own artists. Roman writers incorporated Greek accounts into their own; many of these have survived, although often in fragmentary condition. These written sources offer a glimpse of what the Greeks themselves considered their most important achievements in architecture, sculpture, and painting. This written testimony has helped us to identify celebrated artists and monuments, though much of it deals with works that have not survived. In other cases, surviving Greek works that strike us as among the greatest masterpieces of their time are not mentioned at all in literature. Reconciling the literature with the copies and the original works, and weaving these strands into a coherent picture of the development of Greek art, has been the difficult task of archeologists and ancient art historians for several centuries.

Detail of figure 5.26, *Achilles and Ajax Playing Dice*

The Greek Gods and Goddesses

All early civilizations and preliterate cultures had creation myths to explain the origin of the universe and humanity's place in it. Over time, these myths evolved into complex cycles that represent a comprehensive attempt to understand the world. The Greek gods and goddesses, though immortal, behaved in very human ways. They quarreled, and had children with each other's spouses and often with mortals as well. They were sometimes threatened and even overthrown by their own children. The principal Greek gods and goddesses, with their Roman counterparts in parentheses, are given below.

ZEUS (Jupiter): son of Kronos and Rhea; god of sky and weather, and king of the Olympian deities. After killing Kronos, Zeus married his sister HERA (Juno) and divided the universe by lot with his brothers: POSEIDON (Neptune) was allotted the sea, and HADES (Pluto) was allotted the Underworld, which he ruled with his queen PERSEPHONE (Proserpina).

Zeus and Hera had several children:

ARES (Mars), the god of war

HEBE, the goddess of youth

HEPHAISTOS (Vulcan), the lame god of metalwork and the forge

Zeus also had numerous children through his love affairs with other goddesses and with mortal women, including:

ATHENA (Minerva), goddess of crafts, including war, and thus of intelligence and wisdom. A protector of heroes, she became the patron goddess of Athens, an honor she won in a contest with Poseidon. Her gift to the city was an olive tree, which she caused to sprout on the Akropolis.

APHRODITE (Venus), the goddess of love, beauty, and female fertility. She married Hephaistos, but had many affairs. Her children were HARMONIA, EROS, and ANTEROS (with Ares); HERMAPHRODITOS (with Hermes); PRIAPOS (with Dionysos); and AENEAS (with the Trojan prince Anchises).

APOLLO (Apollo), with his twin sister ARTEMIS, god of the stringed lyre and bow, who therefore both presided over the civilized pursuits of music and poetry, and shot down transgressors; a paragon of male beauty, he was also the god of prophecy and medicine.

ARTEMIS (Diana), with her twin brother, APOLLO, virgin goddess of the hunt and the protector of young girls. She was also sometimes considered a moon goddess with SELENE.

DIONYSOS (Bacchus), the god of altered states, particularly that induced by wine. Opposite in temperament to Apollo, Dionysos was raised on Mount Nysa, where he invented winemaking; he married the princess Ariadne after the hero Theseus abandoned her on Naxos. His followers, the goatish satyrs and their female companions, the nymphs and humans who were known as maenads (bacchantes), were given to orgiastic excess. Yet there was another, more temperate side to Dionysos' character. As the god of fertility, he was also a god of vegetation, as well as of peace, hospitality, and the theater.

HERMES (Mercury), the messenger of the gods, conductor of souls to Hades, and the god of travelers and commerce.

The great flowering of ancient Greek art was just one manifestation of a wide-ranging exploration of humanistic and religious issues. Artists, writers, and philosophers struggled with common questions, still preserved in a huge body of works. Their inquiries cut to the very core of human existence, and have formed the backbone of much of Western philosophy. For the most part, they accepted a pantheon of gods, whom they worshiped in human form. (See *Informing Art*, above.) Yet they debated the nature of those gods, and the relationship between divinities and humankind. Did fate control human actions, or was there free will? And if so, what was the nature of virtue?

Greek thinkers conceived of many aspects of life in dualistic terms. Order (*cosmos*, in Greek) was eternally opposed to disorder (*chaos*), and both poles permeated existence. Civilization, which was, by definition, Greek, stood in opposition to an uncivilized world beyond Greek borders; all non-Greeks were "barbarians," named for the nonsensical sound of their languages to Greek ears ("bar-bar-bar-bar"). Reason, too, had its opposite: the irrational, mirrored in light and darkness, in man and woman. In their literature and in their art, the ancient Greeks addressed the tension between these polar opposites.

THE EMERGENCE OF GREEK ART: THE GEOMETRIC STYLE

The first Greek-speaking groups came to Greece about 2000 BCE. These newcomers brought with them a new culture that soon evolved to encompass most of mainland Greece, as well as the Aegean Islands and Crete. By the first millennium BCE the Greeks had colonized the west coast of Asia Minor and Cyprus. In this period we distinguish three main subgroups: the Dorians, centered in the Peloponnese; the Ionians, inhabiting Attica, Euboea, the Cyclades, and the central coast of Asia Minor; and the Aeolians, who ended up in the northeast Aegean (see map 5.1). Despite their cultural differences and their geographical dispersal, the Greeks had a strong sense of kinship, based on language and common beliefs. From the mid-eighth through the mid-sixth centuries BCE, there was a wave of colonization as the Greeks expanded across the Mediterranean and as far as the Black Sea. At this time, they founded important settlements in Sicily and southern Italy, collectively known as Magna Graecia, and in North Africa.

After the collapse of Mycenaean civilization, art became largely nonfigural for several centuries. In the eighth century BCE, the oldest Greek style that we know in the arts developed,

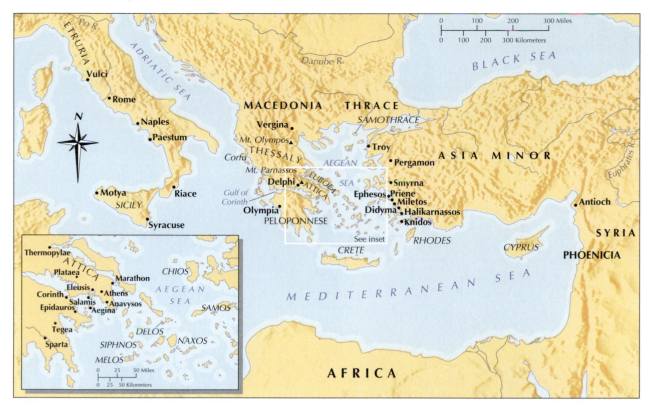

Map 5.1. The Ancient Greek World

known today as the Geometric. Images appeared at about the time the alphabet was introduced (under strong Near Eastern influence). It was contemporaneous, too, with the work of the poet Homer (or a group of poets), who wrote the lasting epic poems *The Iliad* and *The Odyssey*, tales of the Trojan War and the return of one of its heroes, Odysseus, home to Ithaka. We also have works in painted pottery and small-scale sculpture in clay and bronze. The two forms are closely related: Pottery was often adorned with the kinds of figures found in sculpture.

Geometric Style Pottery

As quickly as pottery became an art form, Greek potters began to develop an extensive, but fairly standardized, repertoire of vessel shapes (fig. 5.1). Each type was well adapted to its function, which was reflected in its form. As a result, each shape presented unique challenges to the painter, and some became specialists at decorating certain types of vases. Larger pots often attracted the most ambitious craftsmen because they provided a more generous field on which to work. Making and decorating

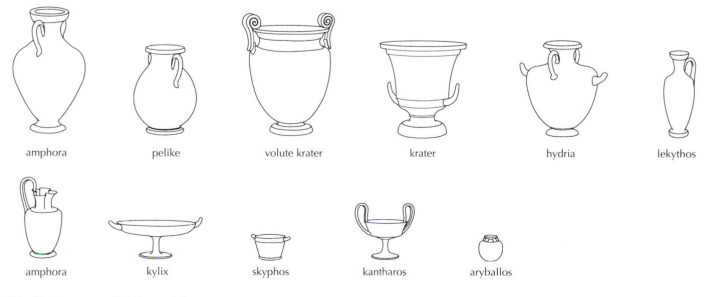

amphora pelike volute krater krater hydria lekythos

amphora kylix skyphos kantharos aryballos

5.1. Some common Greek vessel forms

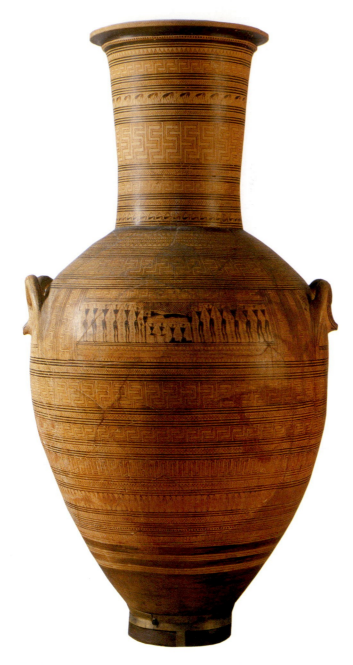

placed the ashes of their cremated dead inside vases, choosing the vase's shape according to the sex of the deceased. A woman's remains were buried in a *belly-handled amphora*, a type of vase more commonly used for storing wine or oil; a man's ashes were placed in a *neck-amphora*. A *krater*, a large bowl-like vessel in which Greeks normally mixed wine with water, had also been used as a burial marker since the early first millennium (see fig. 5.1). The shape of the example illustrated here shows that the deceased was a woman; its sheer monumentality indicates that she was a woman of considerable means.

The amphora is a masterpiece of the potter's craft. At over 5 feet tall, it was too large to be thrown in one piece. Instead, the potter built it up in sections, joined with a clay slip. A careful proportional scheme governed the vessel's form: Its width measures half of its height and the neck measures half the height of the body. The artist placed the handles so as to emphasize the widest point of the body. Most of the vase's decoration is given over to geometric patterns dominated by a *meander pattern*, also known as a *maze* or *Greek key pattern* (fig. **5.3**), a band of rectangular scrolls, punctuated with bands of lustrous black paint at the neck, the shoulder, and the base. The geometric design reflects the proportional system of the vase's shape. Single meander patterns run in bands toward the top and bottom of the neck; the triple meander encircling the neck at the center emphasizes its length. The double and single meanders on the amphora's body appear stocky by contrast, complementing the body's rounder form. Above the triple meander on the neck, deer graze, one after the other, in an identical pattern circling the vase. This animal frieze prefigures the widespread use of the motif in the seventh century BCE. At the base of the neck, they recline, with their heads turned back over their bodies, like an animate version of the meander pattern itself, which moves ever forward while turning back upon itself.

5.2. Late Geometric belly-handled amphora by the Dipylon Master, from the Dipylon Cemetery, Athens. ca. 750 BCE. Height 5′1″ (1.55 m). National Archaeological Museum, Athens

vases were complex processes, usually performed by different artisans. At first painters decorated their wares with abstract designs, such as triangles, "checkerboards," and concentric circles. Toward 800 BCE human and animal figures began to appear within the geometric framework, and in the most elaborate examples these figures interacted in narrative scenes.

The vase shown here, from a cemetery near the later Dipylon gate in the northwestern corner of Athens, dates to around 750 BCE (fig. **5.2**). Known as the Dipylon Vase, it was one of a group of unusually large vessels used as grave monuments. Holes in its base allowed liquid offerings (libations) to filter down to the dead below. In earlier centuries, Athenians had

guilloche

acanthus

palmette

meander

rosette

egg-and-dart

5.3. Common Greek ornamental motifs

In the center of the amphora, framed between its handles, is a narrative scene. The deceased lies on a bier, beneath a checkered shroud. Flanking her are standing figures with their arms raised above their heads in a gesture of lamentation; an additional four figures kneel or sit beneath the bier. Rather than striving for naturalism, the painter used solid black geometric forms to construct human bodies. A triangle represents the torso, and the raised arms extend the triangle beyond the shoulders. The scene itself represents the *prothesis*, part of the Athenian funerary ritual when the dead person lay in state and public mourning took place. A lavish funeral was an occasion to display wealth and status, and crowds of mourners were so desirable that families would hire professional mourners for the event. Thus the depiction of a funeral on the burial marker is not simply journalistic reportage but a visual record of the deceased person's high standing in society.

Archeologists have found Geometric pottery in Italy and the Near East as well as in Greece. This wide distribution is a sign of the important role of not only the Greeks but also the Phoenicians, North Syrians, and other Near Eastern peoples as agents of diffusion all around the Mediterranean. What is more, from the second half of the eighth century onwards, inscriptions on these vases show that the Greeks had already adapted the Phoenician alphabet to their own use.

Geometric Style Sculpture

A small, bronze sculptural group representing a man and a centaur dates to about the same time as the funerary amphora, and there are distinct similarities in the way living forms are depicted in both works of art (fig. **5.4**). Thin arms and flat, triangular chests contrast with more rounded buttocks and legs. The heads are spherical forms, with beards and noses added. The artist cast the group in one piece, uniting them with a common base and their entwined pose. The group was probably found in the sanctuary at Olympia. Judging by its figurative quality, and by the costliness of the material and technique, it was probably a sumptuous votive offering. The figures obviously interact, revealing the artist's interest in narrative, a theme that persists throughout the history of Greek art. Whether the artist was referring to a story known to his audience is hard to say. The figures' helmets tell us that their encounter is martial, and the larger scale of the man may suggest that he will be the victor in the struggle. Many scholars believe he represents Herakles, son of Zeus and a Greek hero, who fought centaurs many times in the course of his mythical travails.

THE ORIENTALIZING STYLE: HORIZONS EXPAND

Between about 725 and 650 BCE, a new style of pottery and sculpture emerged in Greece that reflects strong influences initially from the Near East and later from Egypt. Scholars know this as the Orientalizing period, when Greek art and culture rapidly absorbed a host of Eastern motifs and ideas, including

ART IN TIME

ca. 8th century BCE—Homer writes *The Iliad* and *The Odyssey*

776 BCE—First Olympic Games

ca. 753 BCE—Rome founded

ca. 750 BCE—*Dipylon Vase*

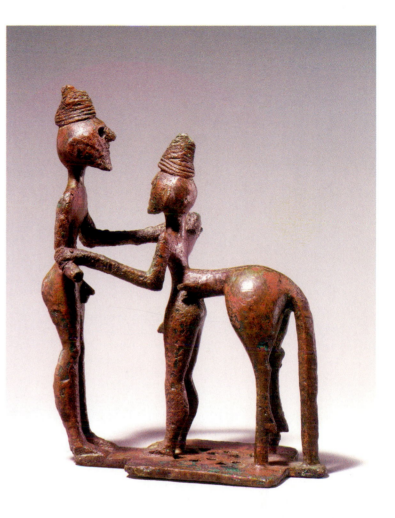

5.4. *Man and Centaur*, perhaps from Olympia. ca. 750 BCE. Bronze. Height $4\frac{3}{8}''$ (11.1 cm). The Metropolitan Museum of Art, New York. Gift of J. Pierpont Morgan, 1917. 17.190.2072

hybrid creatures such as griffins and sphinxes. This absorption of Eastern ideas led to a vital period of experimentation, as painters and sculptors mastered new forms.

Miniature Vessels

The Orientalizing style replaced the Geometric in many Greek city-states, including Athens. One of the foremost centers of its production, though, was Corinth, at the northeastern gateway to the Peloponnese. This city became a leader in colonizing ventures in the west and came to dominate the trade in exports. Corinthian workshops had a long history of pottery production.

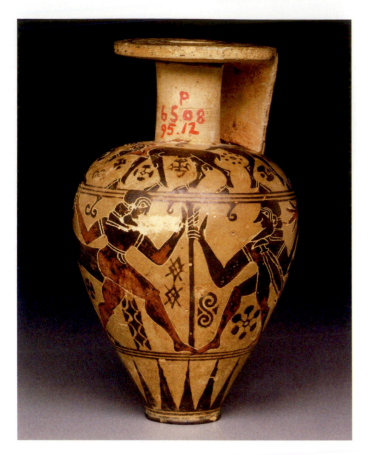

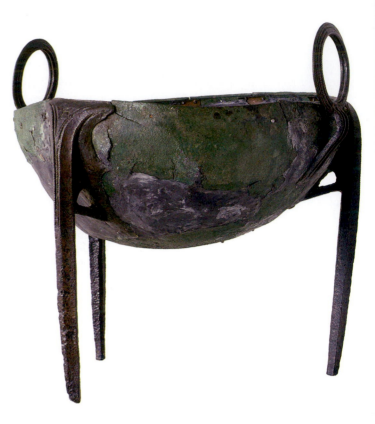

5.5. The Ajax Painter. Aryballos (perfume jar). Middle Protocorinthian IA, 690–675 BCE. Ceramic. Height $2^7/_8''$ (7.3 cm), diameter $1^3/_4''$ (4.4 cm). Museum of Fine Arts, Boston. Catharine Page Perkins Fund. Photograph © 2006, Museum of Fine Arts, Boston. 95.12

5.6. Geometric tripod cauldron from Olympia. 8th century. Height $2'1^1/_2''$ (65 cm). Olympia Museum

Vase painters learned to make a refined black gloss slip, which they used to create silhouette or outline images. They could also incise the slip to add detail and vivacity to their work. They particularly specialized in crafting miniature vessels like the vase shown here, which is a Proto-Corinthian *aryballos* or perfume jar, dating to about 680 BCE (fig. **5.5**). Archeologists have discovered vessels like this one throughout the Greek world, left in sanctuaries as dedications to the gods, or buried as grave goods. Despite its small size, intricate decoration covers the vase's surface. Around the shoulder stalks a frieze of animals, reminiscent of Near Eastern animal motifs and of the early example seen on the Dipylon Vase (see figs. 2.25 and 5.2). Bands of real and imaginary animals are a hallmark of Corinthian and other Orientalizing wares, covering later vases from top to bottom. A *guilloche pattern* ornaments the handle, and meander patterns cover the edge of the mouth and the handle (see fig. 5.3). The principal figural frieze offers another early example of pictorial narrative, but the daily life scenes of Geometric pottery have yielded to the fantastic world of myth. On one side, a stocky nude male wielding a sword runs toward a vase on a stand. On the side shown here, a bearded male struggles to wrest a scepter or staff from the grasp of a centaur. According to one theory, the frieze represents a moment in Herakles' conflict with a band of centaurs on Mount Pholoë. In Greek mythology, centaurs were

notoriously susceptible to alcohol, and the mixing bowl for wine represented on the other side may indicate the reason for their rowdiness. Others interpret the "Herakles" figure as Zeus, brandishing his thunderbolt or lightning. No matter how one reads this scene, there is no doubt that it was meant to evoke a mythological reality.

BRONZE TRIPODS During the Geometric period, Greeks would sometimes set up bronze tripod cauldrons in sanctuaries as dedications to the gods (fig. **5.6**). The gesture was an act of piety, but it was also a way of displaying wealth, and some of the tripod cauldrons reached monumental proportions. From the early seventh century BCE, a new type of monumental vessel was introduced—the Orientalizing cauldron. Around the edge of the bowl, bronze-workers might attach *protomes*, images of sirens (winged female creatures), and griffins—both were fantasy creatures that were known in the Near East. The cast *protome* shown here, from the island of Rhodes, is a magnificently ominous creature, standing watch over the dedication (fig. **5.7**). The boldly upright ears and the vertical knob on top of the head contrast starkly with the strong curves of the neck, head, eyes, and mouth, while its menacing tongue is silhouetted in countercurve against the beak. The straight lines appear to animate the curves, so that the dangerous hybrid seems about to spring.

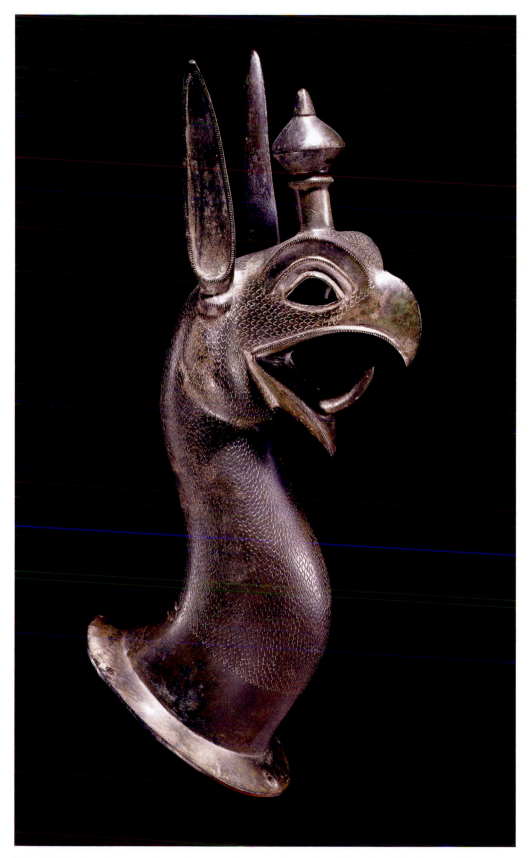

5.7. Griffin-head protome from a bronze tripod-cauldron, from Kameiros, Rhodes. ca. 650 BCE. Cast bronze. The British Museum, London

ART IN TIME

ca. 680 BCE—Corinthian *aryballos*

mid-7th century BCE—Black-figured vase-painting
technique develops

ca. 650 BCE—Greeks establish trading posts in Egypt

ca. 620 BCE—Draco codifies Athenian laws

ARCHAIC ART: ART OF THE CITY-STATE

During the course of the seventh and sixth centuries BCE, the Greeks appear to have refined their notion of a *polis*, or city-state. Once merely a citadel, the place of refuge in times of trouble, the city came to represent a community and an identity. City-states, as they are known, were governed in several different ways, including monarchy (from *monarches*, "sole ruler"), aristocracy (from *aristoi* and *kratia*, "rule of the best"), tyranny (from *tyrannos*, "despot"), oligarchy (from *oligoi*, "the few," a small ruling elite), and, in Athens, democracy (from *demos*, "the people"). The road to democracy moved slowly, starting with Solon's reforms at the end of the sixth century in Athens. Even by the time of Perikles' radical democratic reforms of 462 BCE, women played no direct role in civic life, and slavery was the accepted practice in Athens, as it was everywhere in the Greek world. With the changing ideal of the city-state came a change in its physical appearance.

The Rise of Monumental Temple Architecture

At some point in the seventh century BCE, Greek architects began to design temples using stone rather than wood. The earliest were probably built at Corinth, in a style known as Doric, named for the region where it originated. From there the idea spread across the isthmus that connects the Peloponnesos to the mainland and up the coast to Delphi and the island of Corfu, then rapidly throughout the Hellenic world. The Ionic style soon developed on the Aegean Islands and the coast of Asia Minor. The Corinthian style did not develop until the fourth century BCE (see page 142). Greeks recognized the importance of this architectural revolution at the time: Architects began to write treatises on architecture—the first we know of—and the personal fame they achieved through their work has lasted to this day.

Writing in Roman times, the architect Vitruvius described the Doric and Ionic styles, and his discussions of them have been central to our understanding of Greek architecture. However, our readings of his text have been mediated through early modern commentators and illustrators, who wrote of Doric and Ionic "orders" rather than "types," which is a better translation of Vitruvius' "*genera*." The distinction is important: "Order" suggests an immutable quality, a rigid building code, when in fact we find a subtle but rich variation in surviving Greek architecture.

The essential, functioning components of Doric and Ionic temples are very similar, though they may vary according to the size of the building or regional preferences (fig. **5.8**). The nucleus of the building—in fact, its reason for existing—is its main chamber, its **cella** or **naos**. This chamber housed an image of the god to whom the temple was dedicated. Often, interior columns lined the cella walls and helped to support the roof, as well as visually framing the cult statue. Approaching the cella is a porch or **pronaos**, and in some cases a second porch was added behind the cella, making the design more symmetrical and providing space for religious paraphernalia. In large temples, a colonnade or **peristyle** surrounds the central unit of cella and porches, and the building is known as a **peripteral temple**. The peristyle commonly consists of six to eight columns at front and back, and usually 12 to 17 along the sides, counting the corner columns twice; the very largest temples of Ionian Greece had a double colonnade.

The peristyle added more than grandeur: It offered worshipers shelter from the elements. Being neither entirely exterior nor entirely interior space, it also functioned as a transitional zone, between the profane world outside and the sanctity of the cella. Some temples were set in sacred groves, where the columns, with their strong vertical form, integrated the temple with its environment. Echoed again inside the cella, the columns also integrated the exterior and interior of the building. Most Greek temples are oriented so that the entrance faces east, toward the rising sun. East of the temple is usually the altar, the truly indispensable installation for the performance of ritual. It was on the altar that Greeks performed sacrifices, standing before the cult statue and the worshiping community of the Greek polis.

Differences between the Doric and Ionic styles are apparent in a head-on view, or elevation. Many of the terms Greeks used to describe the parts of their buildings, shown in figure **5.9**, are still in common usage today. The building proper rests on an elevated platform, normally approached by three steps, known as the **stereobate** and **stylobate**. A **Doric column** consists of the shaft, usually marked by shallow vertical grooves, known as *flutes*, and the *capital*. The capital is made up of the flaring, cushionlike **echinus** and a square tablet called the **abacus**. The *entablature*, which includes all the horizontal elements that rest on the columns, is subdivided into the *architrave* (a row of stone blocks directly supported by the columns); the *frieze*, made up of alternating triple-grooved **triglyphs** and smooth or sculpted *metopes*; and a projecting horizontal cornice, or *geison*, which may include a gutter (*sima*). The architrave in turn supports the triangular **pediment** and the roof elements (the raking geison and raking sima).

Ionic temples tend to rest on an additional leveling course, or *euthynteria*, as well as three steps. An **Ionic column** differs from a Doric column in having an ornate base of its own, perhaps used at first to protect the bottom from rain. Its shaft is more slender, with less tapering, and the capital has a double scroll or *volute* below the abacus, which projects strongly beyond the width of the shaft. The Ionic column lacks the muscular quality of its

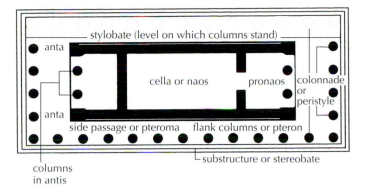

5.8. Ground plan of a typical Greek peripteral temple (after Grinnell)

stylobate (level on which columns stand)

anta

cella or naos pronaos colonnade or peristyle

anta

side passage or pteroma flank columns or pteron

columns in antis

substructure or stereobate

mainland cousin. Instead, it evokes a growing plant, something like a formalized palm tree, and this it shares with its Egyptian predecessors, though it may not have come directly from Egypt. Above the architrave, the frieze is continuous, rather than broken up visually into triglyphs and metopes.

Whether Doric or Ionic, the temple structure was built of stone blocks fitted together without mortar, requiring that they be precisely shaped to achieve smooth joints. Where necessary, metal dowels or clamps fastened the blocks together. With rare

exceptions, columns were made up of sections, called drums. The shaft was fluted after the entire column was assembled and in position. The roof was made of terra-cotta tiles over wooden rafters, and wooden beams were used for the ceiling. Fire was a constant threat.

Just how either style came to emerge in Greece, and why they came together into succinct systems so quickly, are still puzzling questions. Remains of the oldest surviving temples show that the main features of the Doric style were already

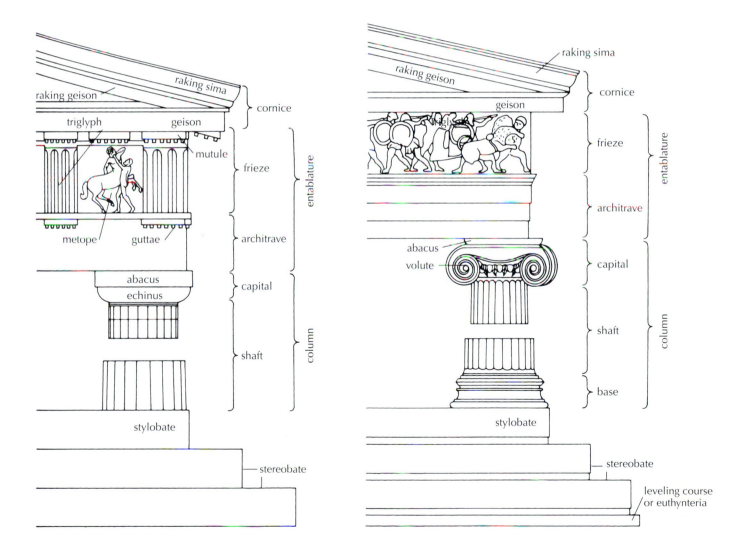

5.9. Doric and Ionic styles in elevation

well established soon after 600 BCE. Early Greek builders in stone seem to have drawn upon three sources of inspiration: Mycenaean and Egyptian stone architecture, and pre-Archaic Greek architecture in wood and mud brick. It is possible that the temple's central unit, the cella and porch, derived from the plan of the Mycenaean megaron (see fig. 4.19), either through continuous tradition or by way of revival. If true, this relationship may reflect the revered place of Mycenaean culture in later Greek mythology. The shaft of the Doric column tapers upward, not downward like the Minoan-Mycenaean column. This recalls fluted half-columns in the funerary precinct of Djoser at Saqqara (see fig. 3.6), of over 2,000 years earlier. Moreover, the very notion that temples should be built of stone and have large numbers of columns was an Egyptian one, even if Egyptian temples were designed for greater internal traffic. Scholars assume that the Greeks learned many of their stone-cutting and masonry techniques from the Egyptians, as well as some knowledge of architectural ornamentation and geometry. In a sense, a Greek temple with its peristyle of columns might be viewed as the columned court of an Egyptian sanctuary turned inside out.

Some scholars see the development of Doric architecture as a petrification (or turning to stone) of existing wooden forms, so that stone form follows wooden function. According to this view, at one time triglyphs masked the ends of wooden beams, and the droplike shapes below, called **guttae** (see fig. 5.9), are the descendants of wooden pegs that held them in place. Metopes evolved out of boards that filled gaps between the triglyphs to guard against weather. **Mutules** (flat projecting blocks), for their part, reflect the rafter ends in wooden roofs. Some derivations are more convincing than others, however. The vertical subdivisions of triglyphs hardly seem to reflect the forms of three half-round logs, as scholars suggest, and column flutings need not be developed from tool marks on a tree trunk, since Egyptian builders also fluted their columns and yet rarely used timber for supporting members. The question of how far stylistic features can be explained in terms of function faces the architectural historian again and again.

DORIC TEMPLES AT PAESTUM The early evolution of Doric temples is evident in two unusually well-preserved examples located in the southern Italian polis of Paestum, where a Greek colony flourished during the Archaic period. Both temples are dedicated to the goddess Hera, wife of Zeus; the Temple of Hera II, however, was built almost a century after the Temple of Hera I, the so-called Basilica (fig. 5.10). The differences in their proportions are striking. The Temple of Hera I (on the left, fig. 5.10) appears low and sprawling—and not just because so

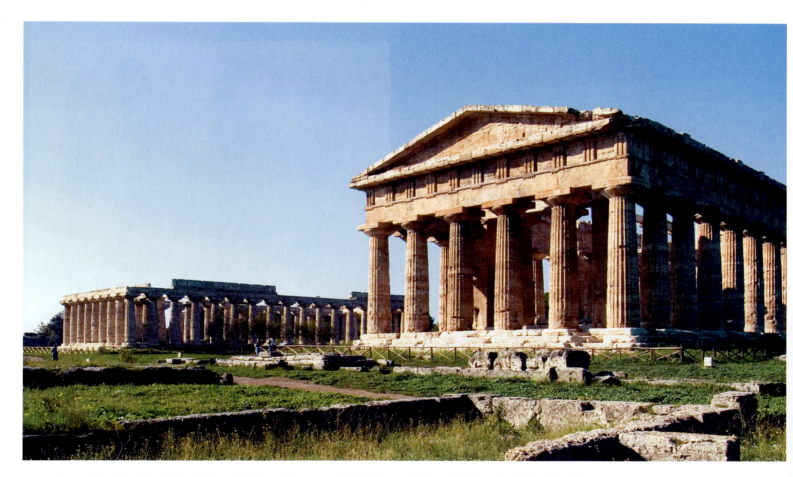

5.10. The Temple of Hera I ("Basilica"), ca. 550 BCE, and the Temple of Hera II ("Temple of Poseidon"), ca. 500 BCE. Paestum

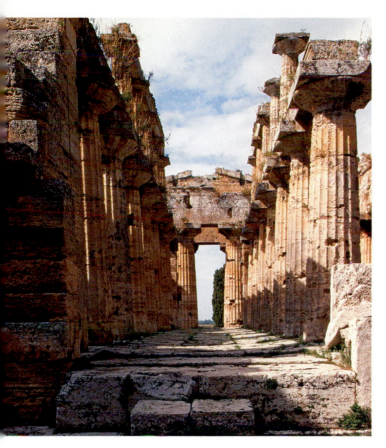

much of the entablature is missing—whereas the Temple of Hera II looks tall and compact. This is partly because the temple of Hera I is *enneastyle* (with nine columns across the front and rear), while the later temple is only *hexastyle* (six columns). Yet it is also the result of changes to the outline of the columns. On neither temple are the column shafts straight from bottom to top. About a third of the way up, they bulge outward slightly, receding again at about two thirds of their height. This swelling effect, known as **entasis**, is much stronger on the earlier Temple of Hera I. It gives the impression that the columns bulge with the strain of supporting the superstructure and that the slender tops, although aided by the widely flaring, cushionlike capitals, can barely withstand the crushing weight. The device adds an extraordinary vitality to the building—a sense of compressed energy waiting to be released.

The Temple of Hera II is among the best preserved of all Doric temples (fig. **5.11**), and shows how the ceiling was supported in a large Doric temple. Inside the cella, the two rows of columns each support a smaller set of columns in a way that makes the tapering seem continuous despite the architrave in between. Such a two-story interior is first found at the Temple of Aphaia at Aegina around the beginning of the fifth century BCE. That temple is shown here in a reconstruction drawing (fig. **5.12**), which illustrates the structural system in detail.

5.11. Interior, Temple of Hera II. ca. 500 BCE

5.12. Sectional view (restored) of the Temple of Aphaia, Aegina

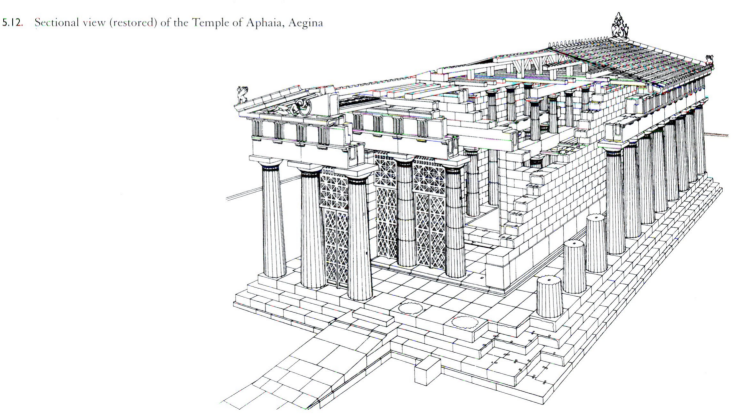

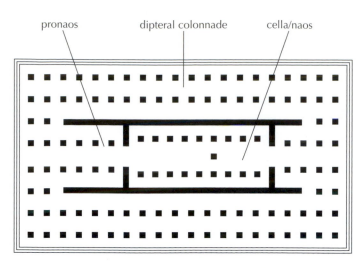

pronaos dipteral colonnade cella/naos

5.13. Restored plan of the Temple of Artemis at Ephesos,
Turkey. ca. 560 BCE

EARLY IONIC TEMPLES The Ionic style first appeared about a half-century after the Doric. With its vegetal decoration, it seems to have been strongly inspired by Near Eastern forms. The closest known parallel to the Ionic capital is the *Aeolic* capital, found in the region of Old Smyrna, in eastern Greece, and in the northeast Aegean, itself apparently derived from North Syrian and Phoenician designs. The earliest Ionic temples were constructed in Ionian Greece, where leading cities erected vast, ornate temples in open rivalry with one another. Little survives of these early buildings. The Temple of Artemis at Ephesos gained tremendous fame in antiquity, and numbered among the seven wonders of the ancient world. The Ephesians hired Theodoros to work on its foundations in about 560 BCE, shortly after he and another architect, Rhoikos, had designed a vast temple to Hera on the island of Samos. The architects, Chersiphron of Knossos and Metagenes, his son, wrote a treatise on their building. Like the temple on Samos, the temple at Ephesos was *dipteral*, with two rows of columns surrounding it (fig. **5.13**). Along with the vegetal capitals, this feature emphasized the forestlike quality of the building. The Temple of Artemis was larger than Hera's temple, and it was the first monumental building to be constructed mostly of marble. These Ionic colossi had clear symbolic value: They represented their respective city's bid for regional leadership.

Stone Sculpture

According to literary sources, Greeks carved very simple wooden sculptures of their gods in the eighth century BCE, but since wood deteriorates, none of them survive. Yet, in about 650 BCE, sculptors, like architects, made the transition to working in stone, and so began one of the great traditions of Greek art. The new motifs that distinguished the Orientalizing style from the Geometric had reached Greece mainly through the importation of ivory carvings and metalwork from the Near East, reflecting Egyptian influences as well. But these transportable objects do not help to explain the rise of monumental stone architecture and sculpture, which must have been based on careful, on-the-spot study of Egyptian works and the techniques used to produce them. The opportunity for just such a close study was available to Greek merchants living in trading camps in the western Nile delta, by permission of the Egyptian king Psammetichus I (r. 664–610 BCE).

KORE AND KOUROS Early Greek statues clearly show affinities with the techniques and proportional systems used by Egyptian sculptors. Two are illustrated here, one a small female figure of about 630 BCE, probably from Crete (fig. **5.14**), the other a life-size nude male youth of about 600 BCE (fig. **5.15**), known as the New York Kouros because it is displayed in the Metropolitan Museum of Art. Like their Egyptian forerunners (see figs. 3.11 and 3.12), the statues are rigidly frontal, and conceived as four distinct sides, reflecting the form of the block from which they were carved. The female statue stands with feet placed firmly together, her left arm by her side, and her right arm held up to her breast. Like Menkaure, the Greek male youth is slim and broad-shouldered; he stands with his left leg forward, and his arms by his sides, terminating in clenched fists. His shoulders, hips, and knees are all level. Both figures have stylized, wiglike hair like their Egyptian counterparts, but there are significant differences. First, the Greek sculptures are truly free-standing, separated from the back slab that supports Egyptian stone figures. In fact, they are the earliest large stone images of the human figure in the history of art that can stand on their own. More than that, Greek sculptures incorporated empty space (between the legs, for instance, or between arms and torso), whereas Egyptian figures remained immersed in stone, with the empty spaces between forms partly filled. Early Greek

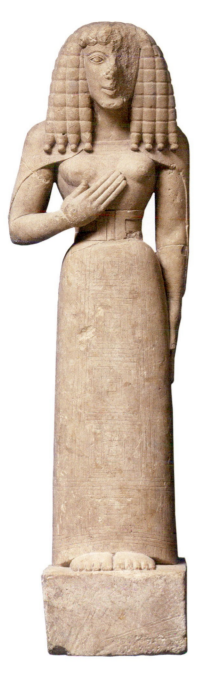

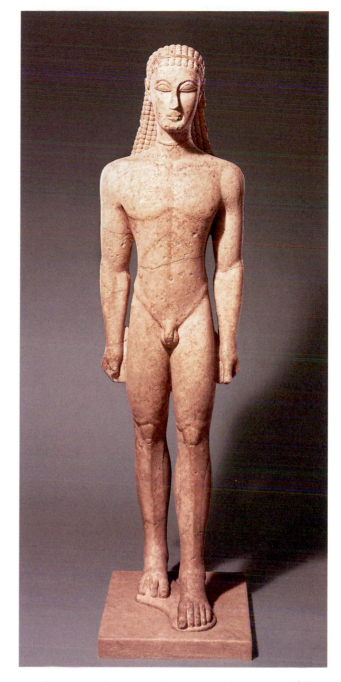

5.14. *Kore (Maiden)*. ca. 630 BCE. Limestone. Height 24½″ (62.3 cm). Musée du Louvre, Paris

5.15. *Kouros (Youth)*. ca. 600–590 BCE. Marble. Height 6′1½″ (1.88 m). The Metropolitan Museum of Art, New York

sculptures are also more stylized than their Egyptian fore-bears. This is most evident in the large staring eyes, emphasized by bold arching eyebrows, and in the linear treatment of the anatomy: The male youth's pectoral muscles and rib cage appear almost to have been etched onto the surface of the stone, rather than modeled like Menkaure's. Like most early Greek female sculptures, this one is draped. She wears a close-fitting garment which reveals her breasts but conceals her hips and legs; in fact, the skirt has more in common with Egyptian block statues than with Queen Khamerernebty

(see fig. 3.12). While the Greek female statue and Menkaure are clothed, the male youth is nude. These conventions reflect the fact that public nudity in ancient Greece was acceptable for males, but not for females.

Dozens of Archaic sculptures of this kind survive through-out the Greek world. Some were discovered in sanctuaries and cemeteries, but most were found in reused contexts, which complicates any attempt to understand their function. Scholars describe them by the Greek terms for maiden (**kore**, plural *korai*) and youth (**kouros**, plural *kouroi*). These terms gloss over the

difficulty of identifying them more precisely. Some are inscribed, with the names of artists ("'So-and-so' made me") or with dedications to various deities, chiefly Apollo. These, then, were votive offerings. But in most cases we do not know whether they represent the donor, a deity, or a person deemed divinely favored, such as a victor in athletic games. Those placed on graves may have represented the person buried beneath; yet in rare cases a kouros stands over a female burial site.

No clear effort was made to individualize the statues as portraits, so they can represent the dead only in a general sense. It might make most sense to think of the figures as ideals of physical perfection and vitality shared by mortals and immortals alike, given meaning by their physical context. What is clear is that only the wealthy could afford to erect them, since many were well over life size and carved from high quality marble. Indeed, the very stylistic cohesion of the sculptures may reveal their social function: By erecting a sculpture of this kind, a wealthy patron declared his or her status and claimed membership in ruling elite circles.

DATING AND NATURALISM The Archaic period stretches from the mid-seventh century to about 480 BCE. Within this time frame, there are few secure dates for free-standing sculptures. Scholars have therefore established a dating system based upon the level of naturalism in a given sculpture. According to this system, the more stylized the figure, the earlier it must be. Comparing figures 5.15 and **5.16** illustrates how this model works. An inscription on the base of the latter identifies it as the funerary statue of Kroisos, who had died a hero's death in battle. Like all such figures, it was painted, and traces of color can still be seen in the hair and the pupils of the eyes. Instead of the sharp planes and linear treatment of the New York Kouros (fig. 5.15), the sculptor of the kouros from Anavysos modeled its anatomy with swelling curves; looking at it, a viewer can imagine flesh and sinew and bones in the carved stone. A greater plasticity gives the impression that the body could actually function. The proportions of the facial features are more naturalistic as well. In general, the face has a less masklike quality than the New York Kouros, though the lips are still drawn up in an artificial smile, known as the *Archaic smile*, that is not reflected in the eyes. Based on these differences, scholars judge the Anavysos Kouros more "advanced" than the New York Kouros, and date it some 75 years later. Given the later trajectory of Greek sculpture, there is every reason to believe that this way of dating Archaic sculpture is more or less accurate (accounting for regional differences and the like). All the same, it is worth emphasizing that it is based on an assumption—that sculptors, or their patrons, were striving toward naturalism—rather than on factual data.

The kore type appears to follow a similar pattern of development to the kouros. With her blocklike form and strongly accented waist, for instance, the kore of figure **5.17** seems a direct descendant of the kore in figure 5.14. On account of her heavy woolen garment (or *peplos*), she is known as the *Peplos Kore*. The left hand, which once extend-

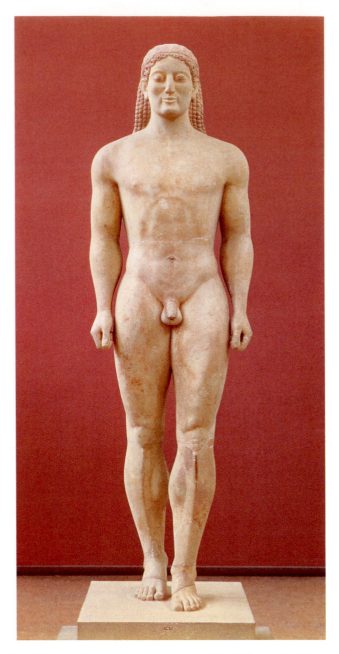

5.16. *Kroisos (Kouros from Anavysos)*. ca. 540–525 BCE. Marble. Height 6′4″ (1.9 m). National Museum, Athens

ed forward to offer a votive gift, must have given the statue a spatial quality quite different from that of the earlier kore figure. Equally new is the more organic treatment of the hair, which falls over the shoulders in soft, curly strands, in contrast to the stiff wig in figure 5.14. The face is fuller, rounder, and the smile gentler and more natural than any we have seen so far, moving from the mouth into the cheeks. Scholars therefore place this statue a full century later than the work shown in figure 5.14.

All the same, there is more variation in types of kore than in types of kouros. This is partly because a kore is a clothed figure and therefore presents the problem of how to relate body and drapery. It is also likely to reflect changing habits or local styles of dress. The kore of figure **5.18**, from about a decade later than the *Peplos Kore*, has none of the latter's severity. Both were

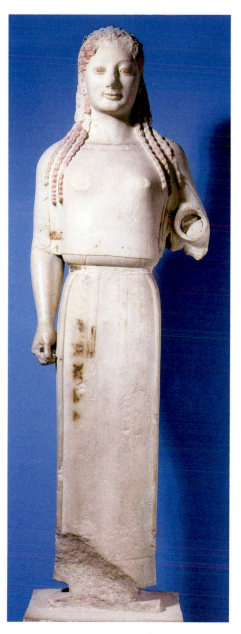

5.17. *Kore in Dorian Peplos*, known as *Peplos Kore*. ca. 530 BCE. Marble. Height 48″ (122 cm). Akropolis Museum, Athens

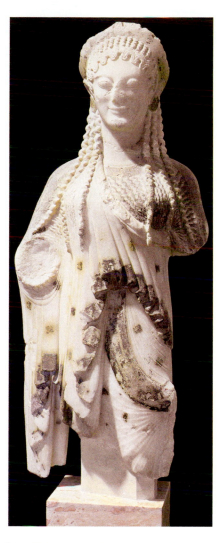

5.18. *Kore*, from Chios (?). ca. 520 BCE. Marble. Height 21⅞″ (55.3 cm). Akropolis Museum, Athens

found on the Akropolis of Athens, but she probably came from Chios, an island of Ionian Greece. Unlike the korai discussed so far, this kore wears the light Ionian *chiton* under the heavier diagonally-shaped *himation*, which replaced the peplos in fashion. The layers of the garment still loop around the body in soft curves, but the play of richly differentiated folds, pleats, and textures has almost become an end in itself. Color played an important role in such works, and it is fortunate that so much of it survives in this example.

Architectural Sculpture: The Building Comes Alive

Soon after the Greeks began to build temples in stone, they also started to decorate them with architectural sculpture. Indeed,

early Greek architects such as Theodoros of Samos were often sculptors as well, and sculpture played an important role in helping to articulate architecture and to bring it to life. Traces of pigment show that these sculptures were normally vividly painted—an image that is startlingly at odds with our conception of ancient sculpture as pristine white marble.

The Egyptians had been covering walls and columns with reliefs since the Old Kingdom. Their carvings were so shallow (for example, see fig. 3.29) that they did not break the continuity of the surface and had no weight or volume of their own. Thus they were related to their architectural setting in the same sense as wall paintings. This is also true of the reliefs on Assyrian, Babylonian, and Persian buildings (for example, see figs. 2.21 and 2.22).

In the Near East, however, there was another kind of architectural sculpture, which seems to have begun with the Hittites: the guardian monsters protruding from the blocks that framed the gateways of fortresses or palaces (see fig. 2.23). This tradition may have inspired, directly or indirectly, the carving over the Lion Gate at Mycenae (see fig. 4.22).

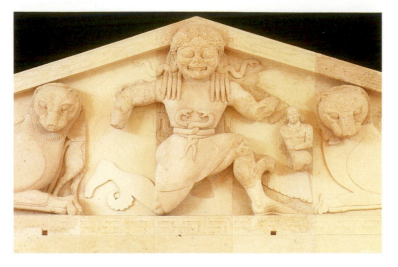

5.19. Central portion of the west pediment of the Temple of Artemis at Corfu, Greece. ca. 600–580 BCE. Limestone. Height 9'2". (2.8 m). Archaeological Museum, Corfu, Greece

THE TEMPLE OF ARTEMIS, CORFU That the Lion Gate relief is, conceptually, an ancestor of later Greek architectural sculpture is clear when one considers the facade of the early Archaic Temple of Artemis on the island of Corfu, built soon after 600 BCE (figs. **5.19** and **5.20**). There, sculpture is confined to a triangle between the ceiling and the roof, known as the *pediment*. This area serves as a screen, protecting the wooden rafters behind it from moisture. The pedimental sculpture is displayed against this screen.

Technically, these carvings are in high relief, like the guardian lionesses at Mycenae. However, the bodies are so strongly undercut that they are nearly detached from the background, and appear to be almost independent of their architectural setting. Indeed, the head of the central figure actually overlaps the frame; she seems to emerge out of the pediment toward a viewer. This choice on the sculptor's part heightens the impact of the figure and strengthens her function. Although the temple was dedicated to Artemis, the figure represents the snake-haired Medusa, one of the Gorgon sisters of Greek mythology. Medusa's appearance was so monstrous, so the story went, that anyone who beheld her would turn to stone. With the aid of the gods, Perseus beheaded her, guiding his sword by looking at her reflection in his shield.

Traditionally, Medusa has been thought of as a protective visual device, but recent approaches argue that she served as a visual commentary on the power of the divinity. She is conceived as a mistress of animals exemplifying the goddess' power and her dominance over Nature. Two large feline creatures flank Medusa, in a heraldic arrangement known from the Lion Gate at Mycenae, and from many earlier Near Eastern examples. To strengthen the sculptures' message, the artist included narrative elements in the pediment as well. In the spaces between and behind the main group, the sculptor inserted a number of subsidiary figures. On either side of Medusa are her children, the winged horse Pegasus, and Chrysaor, who will be born from drops of her blood, shed when Perseus decapitates her. Logically speaking, they cannot yet exist, since Medusa's head is still on her shoulders; and yet their presence in the heraldic arrangment alludes to the future, when Perseus will have claimed the Gorgon's power as his own—just as the sculptor has here, in the service of Artemis. The sculptor has fused two separate moments from a single story, in what is known as a *synoptic narrative*, bringing the story to life. Two additional groups filled the pediment's corners, possibly depicting Zeus and Poseidon battling the giants (a gigantomachy), a mortal race who tried to overthrow the gods. Like the central figures, they strike a cautionary note, since the gods destroyed them for their overreaching ambitions.

With their reclining pose, the felines fit the shape of the pediment comfortably. Yet in order to fit Pegasus and Chrysaor between Medusa and the felines, and the groups into the corners, the sculptor carved them at a significantly smaller scale than the dominant figures. Later solutions to the pediment's awkward shape suggest that this one, which lacks unity of scale, was not wholly satisfactory.

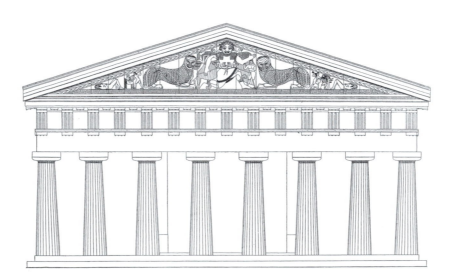

5.20. Reconstruction drawing of the west front of the Temple of Artemis at Corfu (after Rodenwaldt)

Aside from filling the pediment, Greeks might affix free-standing figures, known as **acroteria** (often of terra cotta) above the corners and center of the pediment, softening the severity of its outline (see fig. 5.21). Greek sculptors also decorated the frieze. In Doric temples, such as at Corfu, where the frieze consists of triglyphs and metopes, they would often decorate the latter with figural scenes. In Ionic temples, the frieze was a continuous band of painted or sculpted decoration. Moreover, in Ionic buildings, female statues or **caryatids** might substitute for columns to support the roof of a porch, adding a further decorative quality (see figs. 5.21 and 5.53).

THE SIPHNIAN TREASURY, DELPHI These Ionic features came together in a treasury built at Delphi shortly before 525 BCE by the people of the Ionian island of Siphnos. Treasuries were like miniature temples, used for storing votive gifts; typically, they had an ornate quality. Although the Treasury of the Siphnians no longer stands, archeologists have been able to create a reconstruction from what survives (figs. **5.21** and **5.22**). Supporting the architrave of the porch were two caryatids. Above the architrave is a magnificent sculptural frieze. The detail shown here (fig. 5.22) depicts part of the mythical battle of the Greek gods against the giants, who had challenged divine authority. At the far left, the two lions who pull the chariot of the mother goddess Cybele tear apart an anguished giant. In front of them, Apollo and Artemis advance together, shooting arrows into a phalanx of giants. Their weapons were once added to the sculpture in metal. Stripped of his armor, a dead giant lies at their feet. As in the Corfu pediment, the tale is a cautionary one, warning mortals not to aim higher than their natural place in the order of things. Though the subject is mythical, its depiction offers a wealth of detail on contemporary weaponry and military tactics.

Astonishingly, the relief is only a few inches deep from front to back. Within that shallow space, the sculptors (more than one hand is discernible) created several planes. The arms and legs of those nearest a viewer are carved in the round. In the second and third layers, the forms become shallower, yet even those farthest from a viewer do not merge into the background. The resulting relationships between figures give a dramatic sense of the turmoil of battle and an intensity of action not seen before in narrative reliefs.

As at Corfu, the protagonists fill the sculptural field from top to bottom, enhancing the frieze's power. This is a dominant characteristic of Archaic and Classical Greek art, and with time, sculptors executing pedimental sculpture sought new ways to

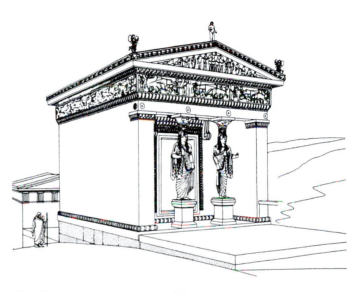

5.21. Reconstruction drawing of the Treasury of the Siphnians. Sanctuary of Apollo at Delphi. ca. 525 BCE

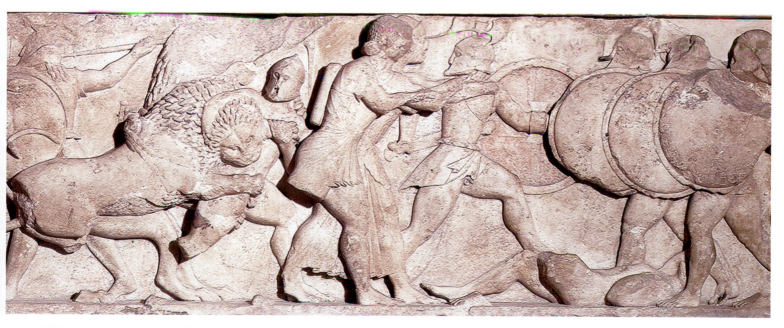

5.22. *Battle of the Gods and Giants,* from the north frieze of the Treasury of the Siphnians, Delphi. ca. 530 BCE. Marble. Height 26″ (66 cm). Archaeological Museum, Delphi

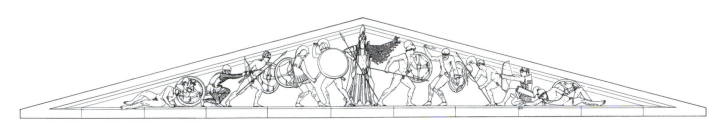

5.23. Reconstruction drawing of the east pediment of the Temple of Aphaia, Aegina (after Ohly)

fill the field while retaining a unity of scale. Taking their cue, perhaps, from friezes such as that found on the Siphnian Treasury, they introduced a variety of poses, and made great strides in depicting the human body in naturalistic motion. This is well illustrated in the pediments of the Temple of Aphaia at Aegina, an island in the Saronic Gulf visible from Attica (see fig. 5.12).

PEDIMENTS OF THE TEMPLE OF APHAIA AT AEGINA. The Temple of Aphaia's original east pediment was probably destroyed by the Persians when they took the island in 490 BCE. The Aeginetans commissioned the present one (fig. 5.23) after defeating the Persians at the battle of Salamis in 480 BCE. It depicts the first sack of Troy, by Herakles and Telamon, king of Salamis. The west pediment, which dates from about 510–500 BCE, depicts the second siege of Troy (recounted in *The Iliad*) by Agamemnon, who was related to Herakles. The pairing of subjects commemorates the important role played by the heroes of Aegina in both battles—and, by extension, at Salamis, where their navy helped win the day. The elevation of historical events to a universal plane through allegory was typical of Greek art.

The figures of both pediments are fully in the round, independent of the background that they decorate. Those of the east pediment were found in pieces on the ground. Scholars continue to debate their exact arrangement, but the relative position of each figure within the pediment can be determined with reasonable accuracy. Since the designer introduced a wide range of action poses for the figures, their height, *but not their scale*, varies to suit the gently sloping sides of the pedimental field (fig. 5.23). These variances in height can be used to determine the figures' original positions. In the center stands the goddess Athena, presiding over the battle between Greeks and Trojans that rages on either side of her. Kneeling archers shoot across the pediment to unite its action. The symmetrical arrangement of the poses on the two halves of the pediment creates a balanced design, so that while each figure has a clear autonomy, it also exists within a governing ornamental pattern.

If we compare a fallen warrior from the west pediment (fig. 5.24) with its counterpart from the later east pediment (fig. 5.25) we see some indication of the extraordinary advances sculptors made toward naturalism during the decades that separate them. As they sink to the ground in death, both figures present a clever solution to filling the awkward corner space. Yet while the earlier figure props himself up on one arm, only a precariously balanced shield supports the later warrior, whose full weight seems to pull him irresistibly to the ground.

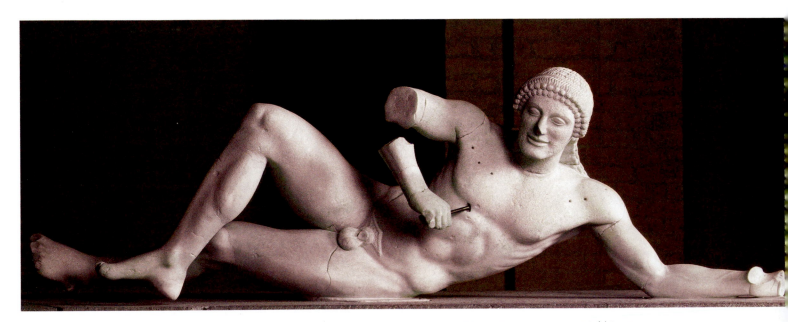

5.24. Dying Warrior, from the west pediment of the Temple of Aphaia. ca. 500–490 BCE. Marble. Length 5′2½″ (1.59 m). Staatliche Antikensammlungen und Glyptothek, Munich

Both sculptors aimed to contort the dying warrior's body in the agonies of his death: The earlier sculptor crosses the warrior's legs in an awkward pose, while the later sculptor more convincingly twists the body from the waist, so that the left shoulder moves into a new plane. Although the later warrior's anatomy still does not fully respond to his pose (note, for instance, how little the pectorals stretch to accommodate the strenuous motion of the right arm), his body is more modeled and organic than the earlier warrior's. He also breaks from the head-on stare of his predecessor, turning his gaze to the ground that confronts him. The effect suggests introspection: The inscrutable smiling mask of the earlier warrior yields to the suffering and emotion of a warrior in his final moments.

Vase Painting: Art of the Symposium

In vase painting, the new Archaic style would replace the Orientalizing phase as workshops in Athens and other centers produced extremely fine wares, painted with scenes from mythology, legend, and everyday life. The vases illustrated in these pages were used to hold wine, but were not meant for everyday use. The Greeks generally poured their wine from plainer, unadorned vases. Decorated vases were reserved for important occasions, like the symposium (symposion), an exclusive drinking party for men and courtesans; wives and other respectable citizen women were not included. Participants reclined on couches around the edges of a room, and a master of ceremonies filled their cups from a large painted mixing bowl (a krater) in the middle of the room. Music, poetry, storytelling, and word games accompanied the festivities. Often the event ended in lovemaking, which is frequently depicted on drinking cups. Yet there was also a serious side to symposia, as described by Plato and Xenophon, centering on debates about politics, ethics, and morality. The great issues that the Greeks pondered in their philosophy, literature, and theater—the nature of virtue, the value of an individual man's life, or mortal relations with the gods, to name a few—were mirrored in, and prompted by, the images with which they surrounded themselves.

After the middle of the sixth century BCE, many of the finest vessels bear signatures of the artists who made them, indicating the pride that potters and painters alike took in their work. In many cases, vase painters had such distinctive styles that scholars can recognize their work even without a signature, and modern names are used to identify them. Dozens of vases (in one instance, over 200) might survive by the same hand, allowing scholars to trace a single painter's development over many years.

The difference between Orientalizing and Archaic vase painting is largely one of technique. On the aryballos from Corinth (see fig. 5.5), the figures appear partly as solid silhouettes, partly in outline, or as a combination of the two. Toward the end of the seventh century BCE, influenced by Corinthian products, Attic vase painters began to work in the **black-figured technique**: The entire design was painted in black silhouette against the reddish clay; and then the internal details were incised into the design with a needle. Then, white and purple were painted over the black to make chosen areas stand out. The technique lent itself to a two-dimensional and highly decorative effect. This development marks the beginning of an aggressive export industry, the main consumers of which were the Etruscans. Vast numbers of black-figured vases were found in Etruscan tombs. Thus, although in terms of conception these vases (and later red-figured vessels) represent a major chapter in Greek (and specifically Athenian) art, if we think about their actual use, painted vases can be considered a major component of Etruscan culture, both visual and funerary.

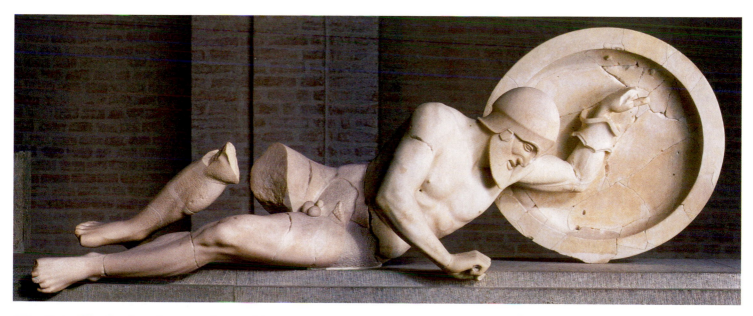

5.25. Dying Warrior, from the east pediment of the Temple of Aphaia. ca. 480 BCE. Marble. Length 6′ (1.83 m). Staatliche Antikensammlungen und Glyptothek, Munich

A fine example of the black-figured technique is an Athenian amphora signed by Exekias as both potter and painter, dating to the third quarter of the sixth century BCE (fig. **5.26**). The painting shows the Homeric heroes Achilles and Ajax playing dice. The episode does not exist in surviving literary sources, and its appearance here points to the wide field of traditions that inspired Exekias. The two figures lean on their spears; their shields are stacked behind them against the inside of a campaign tent. The black silhouettes create a rhythmical composition, symmetrical around the table in the center. Within the black paint, Exekias has incised a wealth of detail, focusing especially upon the cloaks of the warriors; their intricately woven texture contrasts with the lustrous blackness of their weapons.

The extraordinary power of this scene derives from the tension within it. The warriors have stolen a moment of relaxation during a fierce war; even so, poised on the edge of their stools, one heel raised as if to jump at any moment, their poses are edgy. An inscription in front of Ajax, on the right, reads "three," as if he is calling out his throw. Achilles, who in his helmet slightly dominates the scene, answers with "four," making him the winner. Yet many a Greek viewer would have understood the irony of the scene, for when they return to battle, Achilles will die, and Ajax will be left to bear his friend's lifeless body back to the Greek camp, before falling on his own sword in despair. Indeed, Exekias himself would paint representations of the heroes' tragic deaths. This amphora is the first known representation of the gaming scene, which subsequently became very popular, suggesting that individual vase paintings did not exist in artistic isolation; painters responded to one another's work in a close and often clever dialogue.

Despite its decorative potential, the silhouettelike black-figured technique limited the artist to incision for detail. Toward the end of the sixth century BCE, painters developed the reverse procedure, leaving the figures red and filling in the background. This **red-figured technique** gradually replaced the older method between 520 and 500 BCE. The effects of the change would be felt increasingly in the decades to come, but they are already discernible on an amphora of about 510–500 BCE, signed by Euthymides (fig. **5.27**). No longer is the scene so dependent on profiles. The painter's new freedom with the brush translates into a freedom of movement in the dancing revelers he represents. They cavort in a range of poses, twisting their bodies and showing off Euthymides' confidence in rendering human anatomy. The shoulder blades of the central figure, for instance, are not level, but instead reflect the motion of his raised arm. The turning poses allow Euthymides to tackle foreshortening, as he portrays the different planes of the body (the turning shoulders, for instance) on a single surface. This was an age of intensive and self-conscious experimentation; indeed, so pleased was Euthymides with his painting that he inscribed it with a taunting challenge to a fellow painter, "As never Euphronios." On a slightly later *kylix* (wine cup) by Douris, dating to 490–480 BCE, Eos, the goddess of dawn, tenderly lifts the limp body of her dead son, Memnon, whom Achilles killed after their mothers sought the intervention of Zeus (fig. **5.28**). Douris traces the contours of limbs beneath the drapery, and balances vigorous outlines with more delicate secondary strokes, such as those indicating the anatomical details of Memnon's body. The dead weight of Memnon's body contrasts with the lift of Eos' wings, an ironic commentary, perhaps, on how Zeus decided between the two warriors by weighing their souls on a scale that tipped against Memnon. After killing him, Achilles stripped off Memnon's armor as a gesture of humiliation, and where the figures overlap in the image, the gentle folds of Eos' flowing chiton set off Memnon's nudity. His vulnerability in turn underlines his mother's desperate grief at being unable to help her son.

At the core of the image is raw emotion. Douris tenderly exposes the suffering caused by intransigent fate, and the callousness of the gods who intervene in mortal lives. As we saw on the pediment from Aegina, depictions of suffering, and how humans respond to it, are among the most dramatic developments of late Archaic art. In this mythological scene, Athenians may have seen a reflection of themselves during the horrors of the Persian Wars. Indeed, the vase is brought into the realm of everyday life by its inscription, with the signatures of both painter and potter, as well as a dedication typical of Greek vases: "Hermogenes is beautiful."

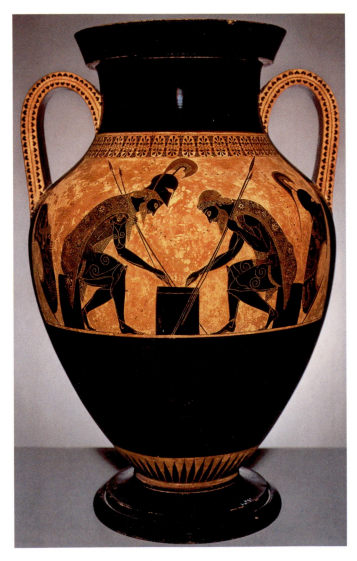

5.26. *Achilles and Ajax Playing Dice.* Black-figured amphora signed by Exekias as painter and potter. ca. 540–530 BCE. Height 2′ (61 cm). Vatican Museums

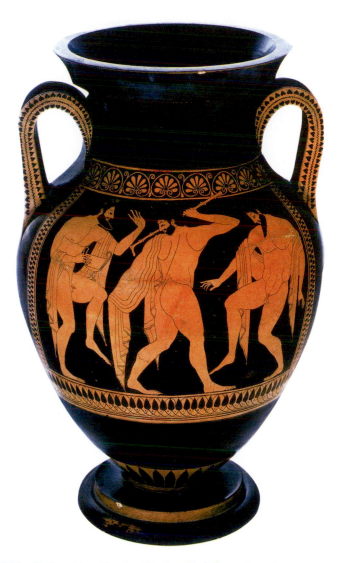

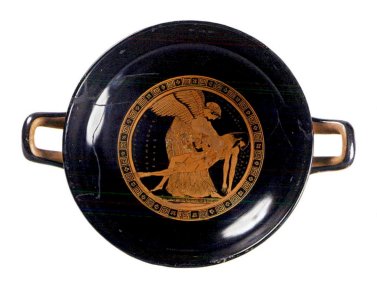

ART IN TIME

7th century BCE—Doric and Ionic styles develop

600 BCE—Temple of Artemis, Corfu

early 6th century BCE—Sappho's poetry flourishes

ca. 500 BCE—Red-figured vase-painting technique
becomes popular

490 BCE—Greeks defeat the Persians at the Battle
of Marathon

5.27. Euthymides. *Dancing Revelers*. Red-figured amphora.
ca. 510–500 BCE. Height 2′ (60 cm). Museum Antiker Kleinkunst,
Munich

5.28. Douris Painter. *Eos and Memnon*. Interior of an Attic
red-figured kylix. ca. 490–480 BCE. Diameter $10\frac{1}{2}''$ (26.7 cm).
Musée du Louvre, Paris

THE CLASSICAL AGE

The beginning of the fifth century BCE brought crisis. A num-
ber of Ionian cities rebelled against their Persian overlords.
After Athens came to their support, the Persians invaded the
Greek mainland, under the leadership of Darius I. At the Battle
of Marathon in 490, a contingent of about 10,000 Athenians,
with a battalion from nearby Plataea, repulsed a force of about
90,000 Persians. Ten years later, an even larger force of Persians
returned under Darius' son, Xerxes I. Defeating a Spartan force
at Thermopylae, they took control of Athens, burning and pil-
laging temples and statues. The Greeks fought the Persians
again at Salamis and Plataea in 480–479, finally defeating them.
These battles were defining, watershed moments for the
Greeks, who first faced destruction in their cities, and then
emerged triumphant and confident after the horrors of Persian
invasion. At least in Athens, the Persian destruction of public
monuments and space are visible in the archeological record,
and, for archeologists and art historians, signals the end of the
Archaic period and the emergence of the Classical era.

The struggle against the Persians was a major test for the
recently established Athenian democracy, which emerged victo-
rious and more integrated at the end of the war. Athens also
became the leader of a defensive alliance against the Persians,
which evolved quickly into a political and economic empire that
facilitated many architectural and artistic projects. Scholars
describe the period stretching from the end of the Persian Wars
to the death of Alexander the Great in the late fourth century as
the Classical Age. This was the time when the playwrights
whose names are still so familiar—Aristophanes, Aeschylus,
Sophocles, and Euripides—were penning comedies and
tragedies for performance in religious festivals, and thinkers
like Socrates and Plato, and then Aristotle, engaged in their
philosophical quests. Perhaps the most influential political
leader of the day was Perikles, who came to the forefront of
Athenian public life in the mid-fifth century BCE, and played a
critical role in the city's history until his death in 429 BCE. An
avid patron of the arts, he focused much of his attention on
beautifying the city's highest point or Akropolis.

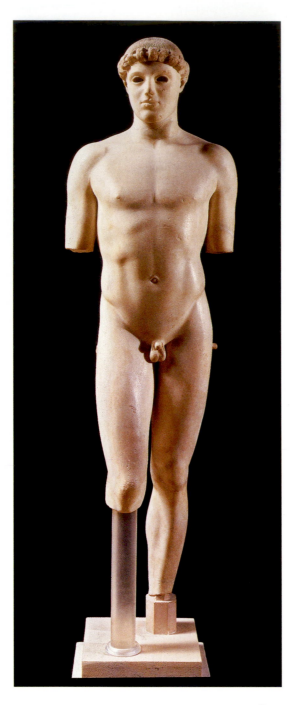

5.29. *Kritios Boy.* ca. 480 BCE. Marble. Height 46″ (116.7 cm). Akropolis Museum, Athens

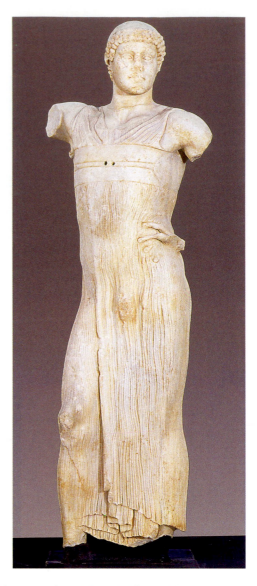

5.30. Charioteer from Motya, Sicily. ca. 450–440 BCE. Marble. Museo Giuseppe Whitaker, Motya

Classical Sculpture

Among the many statues excavated from the debris the Persians left behind after sacking the Athenian Akropolis in 480 BCE, there is one kouros that stands apart (fig. **5.29**). Sometimes attributed to the Athenian sculptor Kritios, the work has come to be known as the *Kritios Boy.* Archeologists can date it to shortly before the Persian attack on account of its findspot, and it differs significantly from the Archaic kouroi discussed above (see figs. 5.15 and 5.16), not least because it is the first known statue that stands in the full sense of the word. Although the earlier figures are in an upright position—instead of reclining, sitting, kneeling, or running—their stance is really an arrested

walk, with the weight of the body resting evenly on both legs. This pose is unnaturalistic and rigid. Like earlier kouroi, the *Kritios Boy* has one leg forward, yet an important change has occurred. The sculptor has allowed the youth's weight to shift, creating a calculated asymmetry in the two sides of his body. The knee of the forward leg is lower than the other, the right hip is thrust down and in, and the left hip up and out. The axis of the body is not a straight vertical line, but a reversed S-curve. Taken together, these small departures from symmetry indicate that the weight of the body rests mainly on the left leg, and that the right leg acts as a prop to help the body keep its balance.

The *Kritios Boy* not only stands; he stands at ease. The artist has masterfully observed the balanced asymmetry of this relaxed natural stance, which is known to art historians as **contrapposto** (Italian for "counterpoise"). The leg that carries the main weight is called the engaged leg, the other, the free leg. This simple observation led to radical results, for with it came a recognition that if one part of the body is engaged in a task, the other parts respond. Bending the free knee results in a slight swiveling of

the pelvis, a compensating curvature of the spine, and an adjusting tilt of the shoulders. This unified approach to the body led artists to represent movement with a new naturalism. Indeed, even though the *Kritios Boy* is at rest, his muscles suggest motion, and the sculpture has life; he seems capable of action. At the same time, the artist recognized that strict adherence to nature would not always yield the desired result. So, as in the later Parthenon (see pages 132 and 134), refinements are at work in the *Kritios Boy*. The sculptor exaggerated the line of muscles over the pelvis in order to create a greater unity between thighs and torso, and a more fluid transition from front to back. This emphasized the sculpture's three-dimensionality, and encouraged a viewer to move around the figure.

The innovative movement in the musculature gives a viewer the sense, for the first time, that muscles lie beneath the surface of the marble's skin, and that a skeleton articulates the whole as a real organism. A new treatment of the flesh and the marble's surface add to this impression. The flesh has a sensuousness, a softness that is quite alien to earlier kouroi, and the sculptor worked the surface of the marble to a gentle polish.

Gone, also, is the Archaic smile, presumably as a result of close observation of a human face. The face has a soft fleshiness to it, especially marked around the chin, which will be characteristic of sculpture in the early Classical period. The head is turned slightly away from the front, removing the direct gaze of earlier kouroi and casting the figure into his own world of thought.

We see a similar sensuousness in a sculpture discovered in the Greco-Punic settlement of Motya in western Sicily (see map 5.1 and fig. **5.30**). Like the *Kritios Boy*, it represents a youth standing in a sinuous contrapposto, his head turned from a frontal axis. This youth wears the tunic of a charioteer, with a wide chest band. The sculptor has used the fine fabric to "mask" the full curves of the body, revealing the flesh while simultaneously concealing it.

The *Kritios Boy* marks a critical point in Greek art. One of the changes it engendered was a whole-hearted exploration of the representation of movement, and this was a hallmark of early Classical sculpture. A magnificent nude bronze dating to about 460–450 BCE, recovered from the sea near the coast of Greece, illustrates this well (fig. **5.31**).

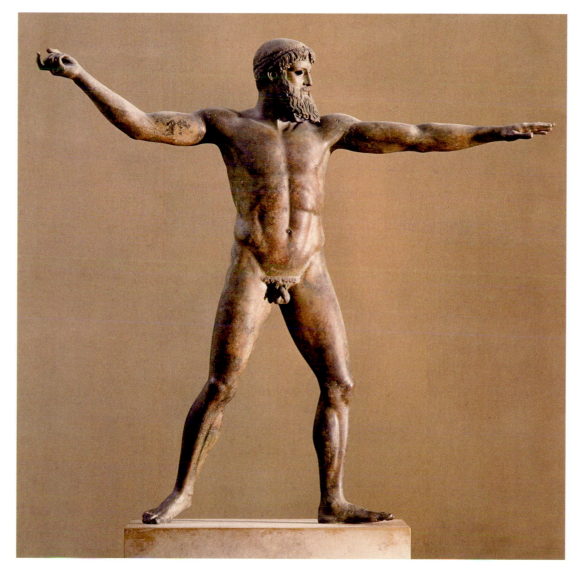

5.31. *Zeus or Poseidon*. ca. 460–450 BCE. Bronze. Height 6′10″ (1.9 m). National Archaeological Museum, Athens. Ministry of Culture Archaeological Receipts Fund. 15161

The Indirect Lost-Wax Process

The Zeus or Poseidon (fig. 5.31) is one of the earliest surviving Greek statues that was made by the indirect lost-wax process. This technique enables sculptors to create spatially freer forms than they can in stone. Projecting limbs are made separately and soldered onto the torso, and no longer need be supported by unsightly struts. Compare, for example, the freely outstretched arms of the Zeus with the strut extending from hip to drapery on the *Knidian Aphrodite* (fig. 5.60).

The Egyptians, Minoans, and early Greeks had often made statuettes of solid bronze using the *direct* lost-wax process. The technique was simple. The sculptor modeled his figure in wax; covered it with clay to form a mold; heated out the wax; melted copper and tin in the ratio of 9 parts to 1 in a crucible; and poured this alloy into the space left by the "lost wax" in the clay mold. Yet because figures made in this way were solid, the method had severe limitations. A solid-cast life-size statue would have been prohibitively expensive, incredibly heavy, and prone to developing unsightly bubbles and cracks as the alloy cooled. So from the eighth through the sixth centuries BCE, the Greeks developed the indirect lost-wax method, which allowed statues to be cast hollow and at any scale.

First, the sculptor shaped a core of clay into the basic form of the intended metal statue. He then covered the clay core with a layer of wax to the thickness of the final metal casting, and carved the details of the statue carefully in the wax. The figure was then sectioned into its component parts—head, torso, limbs, and so on. For each part, a heavy outer layer of clay was applied over the wax and secured to the inner core with metal pegs. The package was then heated to melt the wax, which ran out. Molten metal—usually bronze, but sometimes silver or gold—was then poured into the space left by this "lost wax." When the molten metal cooled, the outer and inner molds were broken away, leaving a metal casting—the statue's head, torso, arm, or whatever. The sculptor then soldered these individual sections together to create the statue. He completed the work by polishing the surface, chiseling details such as strands of hair and skin folds, and inlaying features such as eyes, teeth, lips, nipples, and dress patterns in ivory, stone, glass, copper, or precious metal.

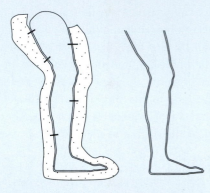

The indirect lost-wax process

At almost 7 feet tall, it depicts a spread-eagle male figure in the act of throwing. Scholars identify it either as Zeus casting a thunderbolt, or Poseidon, god of the sea, hurling his trident. In a single figure, the sculptor captures and contrasts vigorous action and firm stability. The result is a work of outright grandeur, revealing the god's awe-inspiring power. The piece shows off not only the artist's powers of observation and understanding of bodies in motion, but also an extraordinary knowledge of the strengths of bronze, which allowed the god's arms to be stretched out without support. (See *Materials and Techniques*, above.) Some ten years later, in about 450 BCE, Myron created a bronze statue of a discus thrower, the *Diskobolos,* which earned great renown in its own time. Like most Greek sculptures in bronze, it is known to us only from Roman copies (fig. **5.32**) (See end of Part I, *Additional Primary Sources.*) If the bronze Zeus or Poseidon suggested impending motion by portraying the moment before it occurred, Myron condensed a sequence of movements into a single pose, achieved through a violent twist of the torso that brings the arms into the same plane as the legs. The pose conveys the essence of the action by presenting the coiled figure in perfect balance.

THE *DORYPHOROS*: IDEALS OF PROPORTION AND HARMONY Within half a century of the innovations witnessed in the *Kritios Boy*, sculptors were avidly exploring the body's articulation. One of those sculptors was Polykleitos of Argos, whose most famous work, the *Doryphoros (Spear Bearer)* (fig. **5.33**), is known to us through numerous Roman copies. In this sculpture, the contrapposto is much more emphatic than in the *Kritios Boy*, the turn of the head more pronounced. The artist seems to delight in the possibilities it offers, examining exactly how the anatomy on the two sides of the body responds to the pose. The "working" left arm balances the "engaged" right leg in the forward position, and the relaxed right arm balances the "free" left leg. Yet, in the sculpture, Polykleitos did more than study anatomy. He explored principles of commensurability, *symmetria*, where part related to part, and all the parts to the whole. He also addressed *rhythmos* (composition and movement). Through the *Doryphoros*, Polykleitos proposed an ideal system of proportions, not just for the individual elements of the body but for their relation to one another and to the body as a whole. According to one ancient writer, it came to be known as his *kanon* (**canon** meaning "rule" or "measure"). (See end of Part I, *Additional Primary Sources.*)

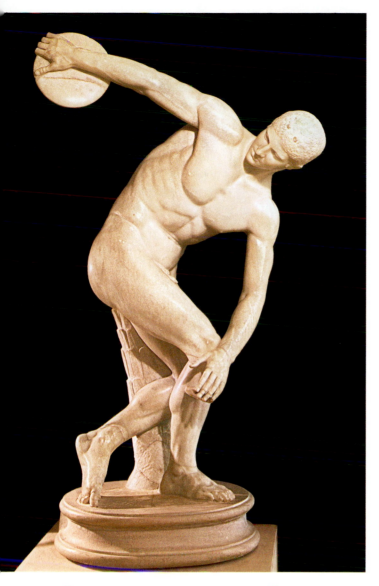

5.32. *Diskobolos (Discus Thrower)*. Roman marble copy after a bronze original of ca. 450 BCE by Myron. Life-size. Museo delle Terme, Rome

(excellence or virtue). Thus contemplation of harmonious proportions could be equated with the contemplation of virtue. (See *Primary Source*, page 127.)

We cannot know how much of the Doryphoros' original appearance is lost in the copy-making process: Bronze and marble differ greatly in both texture and presence. Surviving Greek bronzes are extremely rare, and when a pair of

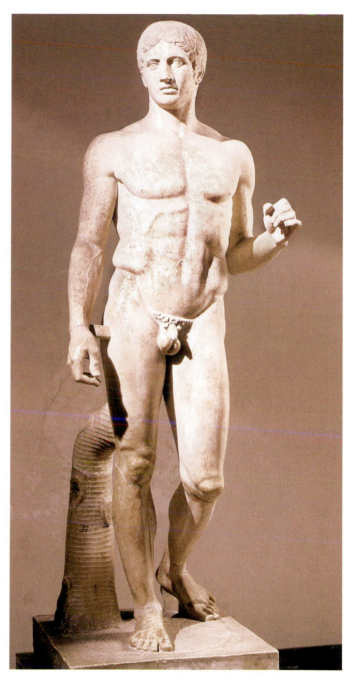

5.33. *Doryphoros (Spear Bearer)*. Roman copy after an original of ca. 450–440 BCE by Polykleitos. Marble. Height 6′6″ (2 m). Museo Archeologico Nazionale, Naples

Egyptian artists had earlier aimed to establish guidelines for depiction based on proportion. Yet for Polykleitos, the search for an ideal system of proportions was more than an artist's aid: It was rooted in a philosophical quest for illumination, and based in a belief that harmony (*harmonia*)—in the universe, as in music and in all things—could be expressed in mathematical terms. Only slightly later than this sculpture, Plato would make numbers the basis of his doctrine of ideal forms, and acknowledge that the concept of beauty was commonly based on proportion. Philosophers even referred to works of art to illustrate their theories. Beauty was more than an idle conceit for Classical Athenians; it also had a moral dimension. Pose and expression reflected character and feeling, which revealed the inner person and, with it, *arete*

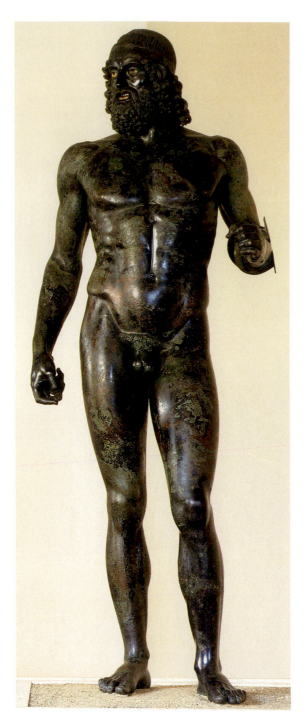

5.34. Riace Warrior A, found in the sea off Riace, Italy. ca. 450 BCE. Bronze. Height 6′8″ (2.03 m). Museo Archeologico, Reggio Calabria, Italy

over–life-size figures was found in the sea near Riace, Italy, in 1972, they created a sensation (fig. **5.34**). As figure 5.34 illustrates, the state of preservation is extremely good, and shows off to advantage the extraordinarily fine workmanship. In the fifth century BCE, bronze was the material of choice for free-standing sculptures, and sculptors used a refined version of the lost-wax technique familiar to Near Eastern artists. The process differs radically from cutting away stone, since the technique is additive (the artist builds the clay model in the first phase of the process.) Further, where marble absorbs

light, a bronze surface reflects it, and this led sculptors to explore a variety of surface textures—for hair and skin, for instance. Different materials could be added for details: These statues have ivory and glass-paste eyes, bronze eyelashes, and copper lips and nipples. Statue A (known as the *Riace Warrior A*), shown here, has silver teeth. Just who these figures represented is still unknown: a pair of heroes, perhaps, or warriors. They may have formed part of a single monument. Though they strike similar poses, the men have differing body types, which has led some scholars to date them apart and attribute them to two separate sculptors. They could just as easily be the work of a single artist exploring the representation of character and age.

THE SCULPTURES OF THE TEMPLE OF ZEUS, OLYMPIA The challenge of filling the shape of a temple pediment may well have helped to fuel the urge to understand human motion. The Temple of Aphaia at Aegina suggests as much; here the designer filled the elongated triangle with figures in a variety of different poses, from standing to reclining. The two pediments of the Temple of Zeus at Olympia are highpoints of the early Classical style. They were carved about 460 BCE, perhaps by Ageladas of nearby Argos, and have been reassembled in the local museum at Olympia. Spoils from a victory of Elis over its neighbor Pisa in 470 BCE provided funds for the temple's construction. The east pediment reflects the victory, with mythology providing an analogy for current events, as at Aegina. The subject is Pelops' triumph over Oinomaos, king of Pisa, in a chariot race for which the prize was the hand of the ruler's daughter, Hippodameia. Pelops (for whom the Peloponnesos is named) held a position of special importance to the Greeks, for he was thought to have founded the games at Olympia. But because he won by trickery, he and his descendants, who included Agamemnon, King of Mycenae, lived under a curse. His example, therefore, served as a warning to Olympic contestants as they paraded past the temple.

The west pediment represents the struggle of the Lapiths, a tribe from Thessaly, with the Centaurs (a *centauromachy*) (fig. **5.35**). Centaurs were the offspring of Ixion, king of the Lapiths, and Hera, whom he tried to seduce while in Olympos. In punishment for his impiety, Ixion was chained forever to a fiery wheel in Tartarus. As half-brothers of the Lapiths, the centaurs were invited to the wedding of the Lapith king Peirithoös and Deidameia. Unable to tolerate alcohol, the centaurs became drunk and got into a brawl with the Lapiths, who subdued them with the aid of Peirithoös' friend Theseus.

At the center of the composition stands the commanding figure of Apollo. His outstretched right arm, the strong turn of his head, and his powerful gaze show his active engagement in the drama, as he wills the Lapiths' victory. At the same time, his calm, static pose removes him from the action unfolding around him; he does not physically help. To the left of Apollo, the Centaur king, Eurytion, has seized Hippodameia. Both figures' forms are massive and simple, with soft contours and undulating surfaces. The artist has entangled them in a com-

Aristotle (384–322) BCE

The Politics, from Book VIII

The Politics is a counterpart to Plato's Republic, *a treatment of the constitution of the state. Books VII and VIII discuss the education prescribed for good citizens. Drawing is included as a liberal art—that is, a skill not only useful but also conducive to higher activities. Yet painting and sculpture are said to have only limited power to move the soul.*

There is a sort of education in which parents should train their sons, not as being useful or necessary, but because it is liberal or noble. . . . Further, it is clear that children should be instructed in some useful things—for example, in reading and writing—not only for their usefulness, but also because many other sorts of knowledge are acquired through them. With a like view they may be taught drawing, not to prevent their making mistakes in their own purchases, or

in order that they may not be imposed upon in the buying or selling of articles [works of art], but perhaps rather because it makes them judges of the beauty of the human form. To be always seeking after the useful does not become free and exalted souls. . . .

The habit of feeling pleasure or pain at mere representations is not far removed from the same feeling about realities; for example, if any one delights in the sight of a statue for its beauty only, it necessarily follows that the sight of the original will be pleasant to him. The objects of no other sense, such as taste or touch, have any resemblance to moral qualities; in visible objects there is only a little, for there are figures which are of a moral character, but only to a slight extent, and all do not participate in the feeling about them. Again, figures and colours are not imitations, but signs, of character, indications which the body gives of states of feeling. The connexion of them with morals is slight, but in so far as there is any, young men should be taught to look. . . . at [the works] of Polygnotus, or any other painter or sculptor who expresses character.

SOURCE: *THE POLITICS* BY ARISTOTLE, ED. BY STEPHEN EVERSON (NY: CAMBRIDGE UNIVERSITY PRESS, 1988)

pact group, full of interlocking movements, which is quite different from the individual conflicts of the Aegina figures. Moreover, the artist expressed their struggle in more than action and gesture: Anguish is mirrored in the face of the Centaur, whose pain and desperate effort contrast vividly with the calm on the young bride's face. In setting the centaurs' evident suffering against the emotionlessness of the Lapiths, the pediment draws a clear moral distinction between the bestial Centaurs and the humans, who share in Apollo's remote nobility. Apollo, god not only of music and poetry but also of light and reason, epitomizes rational behavior in the face of adversity. By

partaking in divine reason, humans triumph over animal nature. This conflict between the rational and the irrational, order and chaos, lay at the heart of Greek art, both in its subject matter and in its very forms. It exposes the Greeks' sense of themselves, representing civilization in the face of barbarianism—always neatly encapsulated in the Persians.

Like the west pediment, the east pediment may have a had a topical relevance, encouraging fair play among the Olympic competitors. The metopes were certainly topical, since they depict the labors of Herakles, Pelops' great-grandson, who according to legend laid out the stadium at Olympia. Narrative scenes had been a

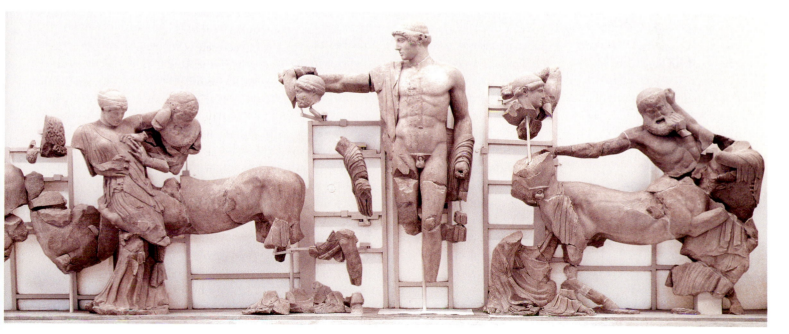

5.35. Photographic reconstruction (partial) of the *Battle of the Lapiths and Centaurs*, from the west pediment of the Temple of Zeus at Olympia. ca. 460 BCE. Marble, slightly over life-size. Archaeological Museum, Olympia

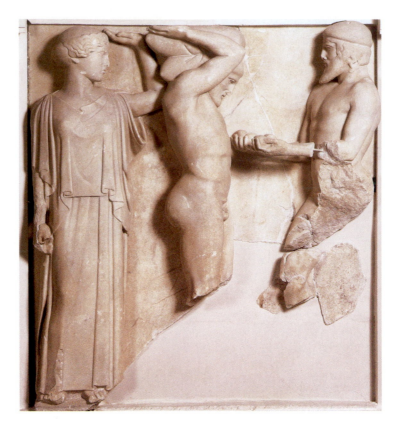

5.36. *Atlas Bringing Herakles the Apples of the Hesperides.* ca. 460 BCE. Marble. Height 63″ (160 cm). Archaeological Museum, Olympia

feature of metopes since the early sixth century BCE, but at Olympia the pictorial and dramatic possibilities are fully exploited for the first time. The example illustrated here, which was featured prominently over the entrance on the east side of the temple, shows Atlas returning to Herakles with the apples of the Hesperides (fig. **5.36**). Atlas was one of the Titans, the race of gods before the Olympians, and it was his charge to hold the Earth on his shoulders. By agreeing to hold the world for him, Herakles persuaded Atlas to go to the gardens of the Hesperides to fetch the apples in fulfillment of one of his labors. On returning, Atlas refused to accept his burden back, until Herakles cheated him into doing so. The metope shows Herakles supporting a cushion (which held the globe) on his shoulders, with the seemingly effortless support of a young Athena. He looks on almost in astonishment as he tries to conjure up a way to trick Atlas into giving up the apples. This is not the grim combat so characteristic of Archaic Greek art (as we saw in figs. 5.24 and 5.25); the burly Herakles has taken on the thoughtful air that is central to the Classical spirit. The figures have all the characteristics of early Classical sculpture: "doughy" faces, an economy of pose and expression, and simple, solemn drapery.

Architecture and Sculpture on the Athenian Akropolis

The Athenian Akropolis had been a fortified site since Mycenaean times, around 1250 BCE (figs. **5.37** and **5.38**). During the Archaic period, it was home to at least one sizeable temple dedicated to the city's patron goddess, Athena, as well as several smaller temples or treasuries, and numerous statues. In 480 BCE, the Persians demolished the buildings and tore down the statues. For over 30 years, the Athenians left the sacred monuments in ruins, as a solemn reminder of the Persians' ruthlessness. In the mid-fifth century BCE, however, this changed with the emergence of Perikles into political life. Perikles' ambitions for Athens included making the city—with a population of about 150,000—the envy of the Mediterranean world. His projects, which the democratic assembly approved, began on the Akropolis. Individually and collectively, the structures there have come to exemplify the Classical phase of Greek art at its height (see *Primary Source*, page 131). In these monuments, artists continued to grapple with ways of creating harmony through principles of commensurability.

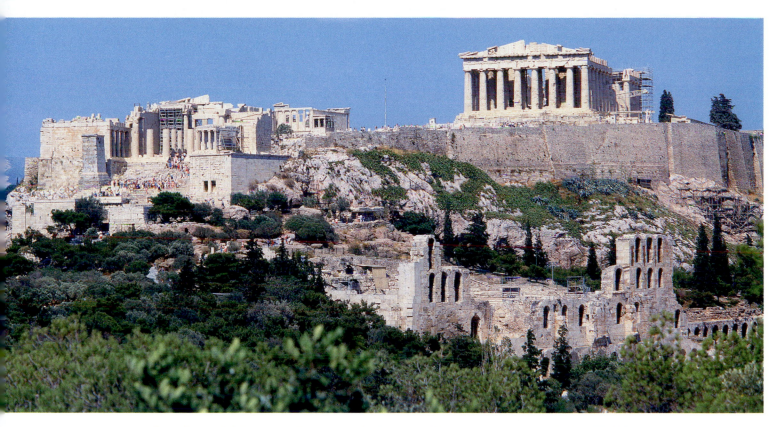

5.37. Akropolis (view from the west), Athens. The Propylaea, 437–432 BCE; with the Temple of Athena Nike, 427–424 BCE

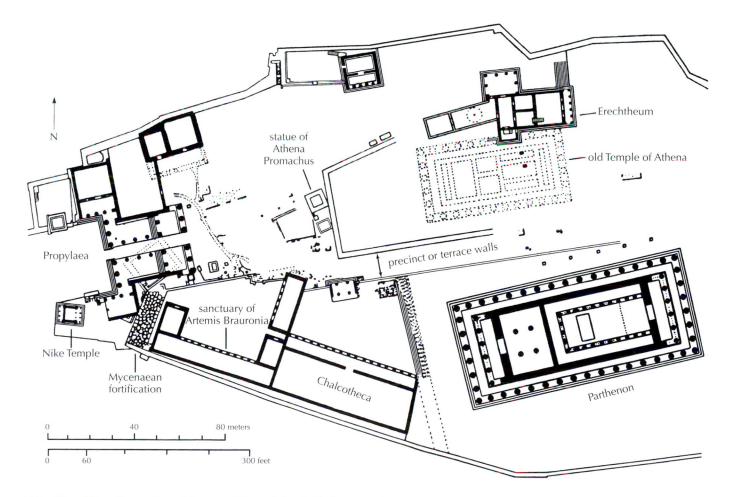

N

statue of
Athena
Promachus

Erechtheum

old Temple of Athena

Propylaea

precinct or terrace walls

Nike Temple

sanctuary of
Artemis Brauronia

Mycenaean
fortification

Chalcotheca

Parthenon

| 0 | | 40 | | 80 meters |
| 0 | 60 | | | 300 feet |

5.38. Plan of the Akropolis at Athens in 400 BCE (after A. W. Lawrence)

THE PARTHENON The dominant temple on the Akropolis, and the only one to be completed before the onset of the Peloponnesian War, is the Parthenon (fig. **5.39**), a structure conceived to play a focal role in the cult of Athena on the Akropolis. There is no evidence that it was used directly for cult practices; there is no altar to the east, which was the principal focus of Greek ritual practice and cult. The chief center of cult practice remained on the site of the Erechtheion, north of the Parthenon (see fig. 5.53). Built of gleaming white marble from the nearby Mount Pentelikon, the Parthenon stands on a prominent site on the southern flank of the Akropolis. It dominates the city and the surrounding countryside, a brilliant landmark against the backdrop of mountains to the north, east, and west. Contemporary building records, and a biography of Perikles written by Plutarch, show that two architects named Iktinos and Kallikrates oversaw its construction in the short interval between 447 and 432 BCE. To meet the expense of building the largest and most lavish temple of its time on the Greek mainland, Perikles resorted in part to funds collected from the Delian League, a group of states allied with Athens for mutual defense against the Persians. Perhaps the Persian danger no longer seemed real; still, the use of these funds weakened Athens' position in relation to its allies. Centuries later, Greek writers still remembered accusations against Perikles for adorning the city "like a harlot with precious stones, statues, and temples costing a thousand talents."

Regardless of one's preference for Archaic or Classical proportions, when read against the architectural vocabulary of Classical Greece the Parthenon is an extraordinarily sophisticated building (fig. 5.39). Its parts are fully integrated with one another, so that its spaces do not seem to be separated, but to melt into one another. Likewise, architecture and sculpture are so intertwined that discussion of the two cannot be disentangled. The temple stood near the culminating point of a grand procession that would wind its way through the city and onto the Akropolis during the Panathenaic festival in Athena's honor, and as magnificent as it was to observe from a distance, it was also a building to be experienced. Imitating the grandiose temples of Archaic Ionia, the Parthenon featured an octastyle (8-column) arrangement of its narrow ends. It was unusually wide, offering a generous embrace and enough space for an interior arrangement of a U-shaped colonnade and an enormous statue of Athena, the work of the famed sculptor Pheidias. She stood with one hand supporting a personification

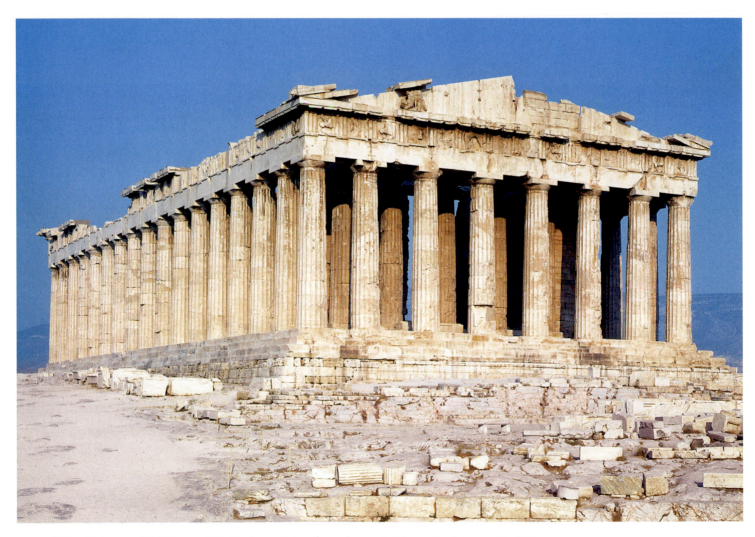

5.39. Iktinos and Kallikrates. The Parthenon (view from the west). Akropolis, Athens. 447–432 BCE

Plutarch (ca. 46–after 119 CE)

Parallel Lives of Greeks and Romans, from the lives of Perikles and Fabius Maximus

A Greek author of the Roman period, Plutarch wrote Parallel Lives *to show that ancient Greece matched or exceeded Rome in its great leaders. Comparing Perikles (d. 429 BCE) with Fabius Maximus (d. 203 BCE), he concludes that Perikles' buildings surpass all the architecture of the Romans. Plutarch is the only ancient source to say that Pheidias was the overseer of Perikles' works.*

But that which brought most delightful adornment to Athens, and the greatest amazement to the rest of mankind; that which alone now testifies for Hellas that her ancient power and splendour, of which so much is told, was no idle fiction—I mean his construction of sacred edifices. . . . For this reason are the works of Perikles all the more to be wondered at; they were created in a short time for all time.

Each one of them, in its beauty, was even then and at once antique; but in the freshness of its vigour it is, even to the present day, recent and newly wrought. Such is the bloom of perpetual newness, as it were, upon these works of his, which makes them ever to look untouched by time, as though the unfaltering breath of an ageless spirit had been infused into them.

His general manager and general overseer was Pheidias, although the several works had great architects and artists besides. Of the Parthenon, for instance, with its cella of a hundred feet in length, Kallicrates and Iktinus were the architects. . . .

By the side of the great public works, the temples, and the stately edifices, with which Perikles adorned Athens, all Rome's attempts at splendour down to the times of the Caesars, taken together, are not worthy to be considered, nay, the one had a towering preeminence above the other, both in grandeur of design, and grandeur of execution, which precludes comparison.

SOURCE: *PLUTARCH'S LIVES*, VOL. 3, TR. BY BERNADOTTE PERRIN (CAMBRIDGE: HARVARD UNIVERSITY PRESS, 1916)

of Victory, and a shield resting against her side. The figure was made of ivory and gold (a combination known as *chryselephantine*), supported on a wooden armature (fig. **5.40**). It was extraordinarily valuable, and the building's forms drew visitors in to view it. Like all peripteral temples, the encircling colonnade gave the impression that the temple could be approached from all sides. Entry to the cella was mediated through a prostyle porch of six columns (where the columns stand in front of the side walls, rather than between them). A similar arrangement mediated access to the Ionic opisthonaos (rear room) of the building. The porches are unusually shallow. This allowed light into the cella, which otherwise came in through two large windows on either side of the main entrance to the cella. In its combination of a well-lit interior and the rational articulation of the interior space with a colonnade, the Parthenon breaks with traditions and initiates a new interest in the embellishment of interior space.

Compared with the Temple of Hera II at Paestum (see fig. 5.10, right), the Parthenon appears far less massive, despite its greater size. One of the reasons for this is a lightening and an adjusting of proportions since the Archaic period. The columns are much more slender, their tapering and entasis less pronounced, and the capitals are smaller and less flaring. The diameter of the columns was determined in part by practical necessity: Both for convenience and economy, the architects reused many drums from the unfinished first Parthenon. Yet how the columns related to the rest of the building was a matter for new design. The spacing of the columns, for instance, is wider than in earlier buildings. The entablature is lower in relation to the height of the columns and to the temple's width, and the cornice projects less. The load carried by the Parthenon columns seems to have decreased, and as a result the supports appear able to fulfill their task with a new sense of ease.

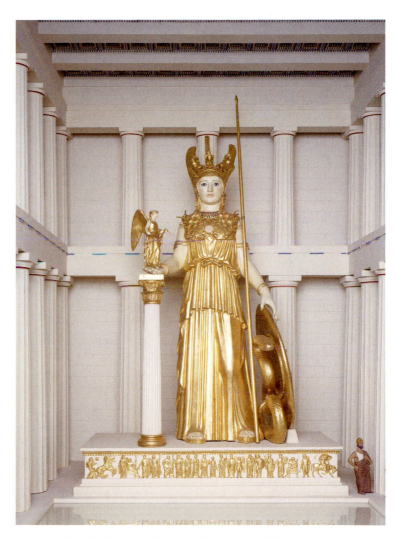

5.40. Model of *Athena Parthenos*, by Pheidias. ca. 438 BCE. Royal Ontario Museum, Toronto

The governing principle behind the proportion was a ratio of $9:4$ or $2x+1:x$. Thus, for instance, the eight (x) columns across the facades are answered by seventeen ($2x+1$) columns along the sides. Additionally, the ratio of the spacing between each column to the diameter at the lowest point of the column was also $9:4$. It was not just a matter of design convenience, but an attempt to produce harmony through numerical relationships. Libon of Elis first used this proportional scheme in the Temple of Zeus at Olympia. The formula was used pervasively throughout the Parthenon, though never dogmatically, always allowing for minor adjustments.

Despite the relative precision the formula dictated, intentional departures from the strict geometric regularity of the design were built into the Parthenon (and other temples). For instance, the columns are not vertical, but lean in toward the cella (the corner columns in two directions), and the space between the corner column and its neighbors is smaller than the standard interval adopted for the colonnade as a whole. Moreover, the stepped platform on which the temple rests is not fully horizontal, but bows upward, so that the center of the long sides is about four inches higher than the corners. This curvature is reflected up through the temple's entablature, and every capital of the colonnade is slightly distorted to fit the bowed architrave. That these irregularities were intentional is beyond doubt, as masons tailor-made individual blocks to accommodate them. Exactly why they were desirable is less clear.

When these irregularities were first introduced into temple architecture, some 100 years earlier, they may have been intended to solve drainage problems. Yet in the Parthenon, they are so exaggerated that scholars consider them to be corrections of optical illusions. For instance, when viewed from a distance, absolutely straight horizontals appear to sag, but if the horizontals curve upward, they look straight. When seen close up, a long straight line seems to curve like the horizon; by exaggerating the curve, the architects could make the temple appear even larger than it was. These two apparently contradictory theories could work in tandem, since there would be different optical distortions depending on a viewer's vantage point. What is certain is that these refinements give the temple a dynamic quality that might otherwise be lacking. Rather than sitting quietly on its platform, the swelling forms give the building an energy, as if it were about to burst out of its own skin; through the refinements, the temple comes alive.

The Parthenon is often viewed as the perfect embodiment of Classical Doric architecture. Although this may be the impression from the outside, it is far from true. At architrave level within the peristyle, a continuous sculpted frieze runs around all sides of the building, in a variation of the Ionic style (see fig. 5.9). Moreover, while most of the temple's columns are Doric, four tall, slender columns in the rear room were Ionic. Even if Doric is the dominant style, Ionic is clearly present.

THE PARTHENON SCULPTURES The largest group of surviving Classical sculptures comes from the Parthenon, which had a more extensive decorative program than any previous temple. The sculptures have a vivid and often unfortunate history. The temple was converted into a church, probably in the sixth century CE, and much of the decoration on the sacred east side was destroyed or vandalized. In 1687, cannon fire from Venetian forces ignited ammunition that the Turkish forces were storing in the temple. The west pediment figures survived the explosion, but not the war's aftermath. A crane used in the process of removing the sculptures, so that the Venetian commander could take them back to Venice, dropped the figures, shattering them. Over 100 years later, Lord Elgin, British ambassador to Constantinople, removed what he could of the temple's decoration and shipped it to England between 1801 and 1803. In 1816, needing money, he sold them to an ambivalent British Museum. The Elgin Marbles, as they are known, are housed today in a purposely constructed wing of the museum, and stand at the heart of a heated debate on the repatriation of national treasures. Other fragments of the Parthenon's sculptural decoration are on display in museums throughout Europe.

Thirteen years before the explosion in the Parthenon, an artist named Jacques Carrey was traveling in Athens as part of the retinue of the French ambassador to the Ottoman court. He executed a series of drawings of surviving Parthenon sculptures, which have become invaluable resources for understanding the decorative program as a whole (fig. 5.41). Primarily from these drawings and from literary sources, we know that the west pediment portrayed the divine struggle between Athena and Poseidon for Athens. The east pediment represented the birth of Athena from the head of Zeus, in the presence of other deities. All but the central figures survive, and Carrey's drawing allows for a confident reconstruction of their arrangement. Bursting from the left corner is the upper body of Helios, the sun god, whose rearing horses draw him into view. Balancing him in the right corner, Selene, the moon goddess, or Nyx, the night, sinks away with her horses. These celestial gods define the day's passing, and together they place the scene in an eternal cosmic realm. To the right of Helios is a nude male figure in a semi-reclining position, thought to be Dionysos (fig. 5.42). On the other side of the pediment is a closely knit group of three female deities, usually identified as Hestia, Dione, and Aphrodite (fig. 5.43).

As a group, the pediment figures are strikingly impressive. Like the architecture into which they are embedded, their forms are strong and solid, yet their implied power contrasts with their languid poses and gains strength from the contrast. The nude male figure's power resides in the simple force and naturalism of his anatomy, giving him the appearance of a figure sculpted with an easy confidence. The female group is a masterpiece of swirling drapery, which disguises the sheer bulk of the marble. The garments cling to their

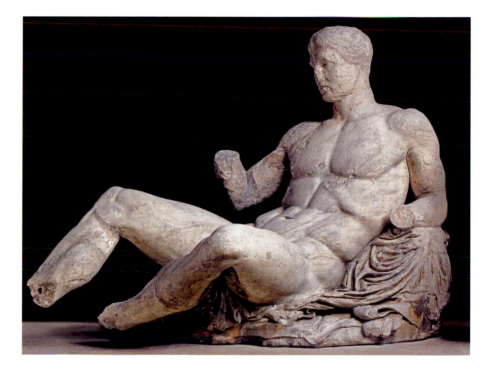

5.41. Jacques Carrey. Drawings of the east pediment of the Parthenon. 1674 CE. Bibliothèque Nationale, Paris

5.42. Dionysos from the east pediment of the Parthenon. ca. 438–432 BCE. Marble, over–life-size. The British Museum, London

5.43. Three Goddesses, from the east pediment of the Parthenon. ca. 438–432 BCE. Marble, over life-size. The British Museum, London

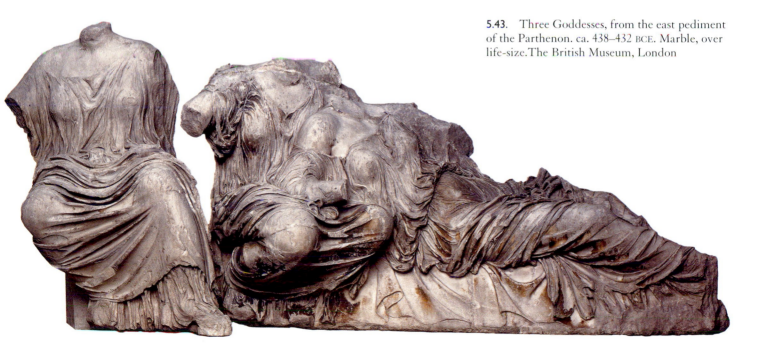

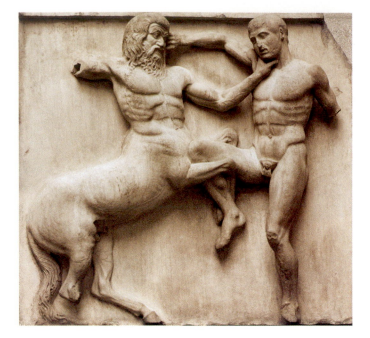

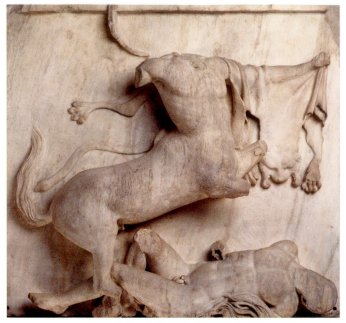

5.44. Lapith and Centaur, metope from the south side of the Parthenon. ca. 440 BCE. Marble. Height 56″ (142.2 cm). The British Museum, London

5.45. *Lapith and Centaur,* metope from the south side of the Parthenon. ca. 440 BCE. Marble. Height 56″ (142.2 cm). The British Museum, London

bodies beneath in a "wet look," both concealing and revealing them. Yet here drapery does not follow the lines of the body so much as struggle with them, twisting around the legs in massive folds. The effect is extraordinary: Although a viewer can only see the deities from a frontal vantage point, as if the figures were two-dimensional, the curves of the deeply cut folds echo their forms *in section* (i.e., along a plane made by an imaginary vertical slice from front to back), and thereby broadcast their three-dimensionality. The sculptor could better express Nature through the appearance of truth than through truth itself. This optical device is a sculptural equivalent of the deliberate distortions in the temple's architecture.

Running the whole way around the building (rather than just at the ends) was a full program of metopes, numbering 92 in all, depicting scenes of violent action. On the west side, the metopes showed the battle of the Greeks against the Amazons (an *Amazonomachy*), a mythical race ruled by their warrior women. Metopes on the north side portrayed the Sack of Troy (the *Ilioupersis*), the conclusion of the Trojan War, when the Greeks fought the Trojans over the abduction of Helen, wife of Menelaus, brother of the king of Mycenae. On the east side, the gods fought the giants, as they did on the Temple of Artemis at Corfu. Little survives of any of these pictorial cycles. The metopes of the south side, however, are relatively well preserved, and mostly depict the battle of the Lapiths and the Centaurs. The four cycles come together to form a meaningful whole: All depict the tension between the civilized and uncivilized worlds, between order and chaos; and all are therefore allegories for the Athenian victory over the Persians. Historical fact is cloaked in the guise of myth, where the triumph of order over chaos has a preordained inevitability.

The quality of the metopes varies dramatically, and reminds us of the vast crews of workers who must have been engaged in completing the Parthenon in such a short period: The two pediments and frieze were executed in less than 10 years (ca. 440–432 BCE). One can usefully compare, for instance, the awkward twists of figure **5.44** with the balletlike choreography of figure **5.45**. Both artists aimed to fill the sculptural field, and both sought to intertwine the wrestling figures—yet with radically different results.

A visitor to the Parthenon could see the pediments and metopes from a distance, but to see the frieze, a viewer had to come closer and walk parallel to the building. In a continuous sculpted band, some 525 feet long (see fig. **5.46**), the frieze depicts a procession, moving from west to east, propelling the viewer around the building. Horsemen jostle with musicians, water carriers, and sacrificial beasts, overlapping to create the illusion of a crowd, even though the relief is only inches deep. Frenzied animals emphasize the calm demeanor of the figures (fig. **5.47**), who have the ideal proportions of the *Doryphoros*.

The most problematic aspect of the relief is the detail in figure **5.48**, from the center of the east end of the temple. Five unidentified figures are represented, three of them young. Two of the young figures carry cushioned stools on their heads, while the third, in a group with one of the adults,

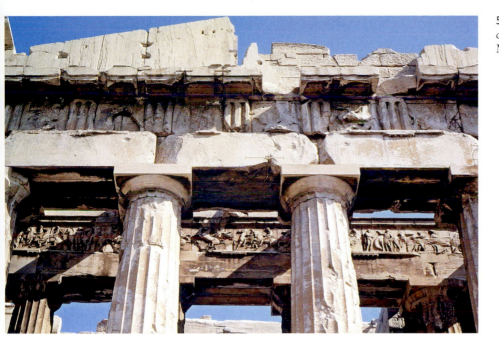

5.46. Frieze above the western entrance of the cella of the Parthenon. ca. 440–432 BCE. Marble. Height 43" (109.3 cm).

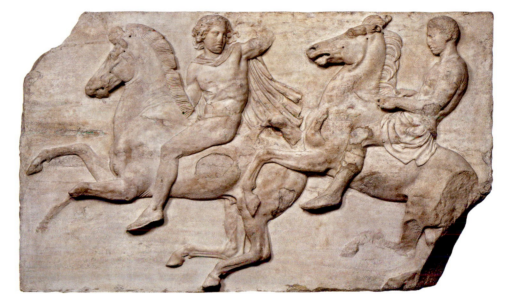

5.47. *Horsemen,* from the west frieze of the Parthenon. ca. 440–432 BCE. Marble. Height 43" (109.3 cm). The British Museum, London

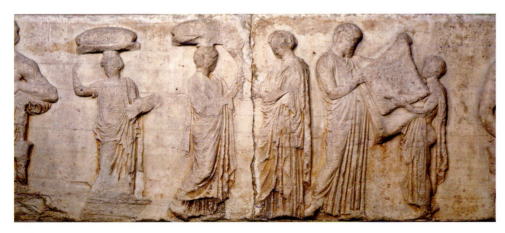

5.48. East frieze of the Parthenon. ca. 440 BCE. Marble, height 43" (109.3 cm). The British Museum, London

The Parthenon Frieze: A New Interpretation

The center portion of the east end of the Parthenon has long troubled scholars. The seated figures to the left and right of this center area are carved on a larger scale than the rest of the figures. They clearly represent the Olympian gods. If the rest of the frieze represents the Panathenaic procession, then the whole frieze, and the east end in particular, conspicuously lacks a unity of place (that is, the action unfolds in more than one place). A recent theory solves this problem by placing the entire frieze in the realm of myth. In this interpretation, the scene in question depicts the three daughters of King Erechtheus. According to Athenian myth, the oracle at Delphi demanded the death of one of his daughters if Athens was to be saved from its enemies. Here, one of the daughters calmly receives the garment in which she is to be sacrificed. The myth had obvious resonance for Athens after its victory over the Persians, and the playwright Euripides made it the subject of a tragedy. This theory is highly controversial, and hinges on whether the younger figure to the right is a girl or a boy, as scholars increasingly believe. Whatever the solution to this problem, the iconography of the frieze integrated Athenians and divine space, time, and ritual practice in a unity that reflected the Athenians' sense of superiority and self-confidence. The problem of the frieze is exacerbated by the discovery, during the building's recent preservation and reconstruction, that the pronaos featured another frieze in its upper well. Nothing survives of this frieze, but if it was thematically connected with the frieze around the cella, we are lacking a crucial piece of evidence for a secure identification and interpretation of the iconography.

handles a piece of cloth. According to the traditional view, the cloth is a new robe for Athena, woven by Athenian girls and women and depicting Athena's triumph against the giants in the gigantomachy. The procession is the Panathenaic procession, part of a festival held annually to honor Athena in the presence of the other Olympian gods, and which was celebrated on a grander scale every four years. The figures and their groupings are typical of the participants in these processions, and the frieze represents an idealized event, rather than a specific moment. Some scholars have suggested that this "heroicized" representation honors the 192 Athenians slain at the battle of Marathon (the first important Greek victory over the Persians, when approximately 6,400 Persians were killed), on the basis that the frieze may originally have had a like number of equestrian figures. The earlier Parthenon, a structure started after 490 BCE and burned by the Persians, had honored their sacrifice. If this view is correct and the frieze represents the Panathenaic procession, it is remarkable in that it exalts mortal Athenians by depicting them in a space usually reserved for divine and mythological scenes. For an alternative interpretation of the late frieze, see *The Art Historian's Lens*, above.

THE PHEIDIAN STYLE The Parthenon sculptures have long been associated with the name of Pheidias, who, according to the Greek biographer Plutarch, was chief overseer of all the artistic projects Perikles sponsored. (See *Primary Source*, page 131.) By the time Perikles hired him, Pheidias's huge sculpture of Athena Parthenos, and a second chryselephantine colossus of a seated Zeus in the Temple of Zeus at Olympia, aroused extreme admiration, not only due to their religious roles, but also because of their vast size and the sheer value of the materials employed. Pheidias was also responsible for an equally large bronze sculpture of Athena that stood on the Akropolis facing the Propylea. These are the only works directly attributed to his hand, and none of them survives; small-scale copies made in later times convey little of their original majesty. He may have worked personally on the Parthenon's architectural sculpture, which undoubtedly involved a large number of masters, but he may have simply been a very able supervisor. We therefore know very little about Pheidias's artistic style.

Nevertheless, Pheidias has come to be associated with the Parthenon style, which is often synonymous with the "Pheidian style." The term conveys an ideal that was not merely artistic but also philosophical: The idealized faces and proportions of the Athenians elevate them above the uncivilized world in which they operate. They share the calmness of the gods, who are aware of, yet aloof from, human affairs as they fulfill their cosmic roles.

Given the prominence of the Parthenon, it is hardly surprising that the Pheidian style should have dominated Athenian sculpture until the end of the fifth century and beyond, even though large-scale sculptural enterprises gradually dwindled because of the Peloponnesian War. It is clearly evident in one of the last of these projects, a balustrade built around the small Temple of Athena Nike on the Akropolis in about 410–407 BCE (see fig. 5.52). Like the Parthenon frieze, it shows a festive procession, but the participants are not citizens of Athens but winged personifications of Victory (*Nikai*). One Nike is taking off her sandals, indicating that she is about to step on holy ground (fig. **5.49**). Her wings keep her stable, so that she performs this normally awkward act with elegance and ease. The Pheidian style is most evident in the deeply cut folds of her "wet look" garments, which cling to her body and fall in deep, wild swags between her legs.

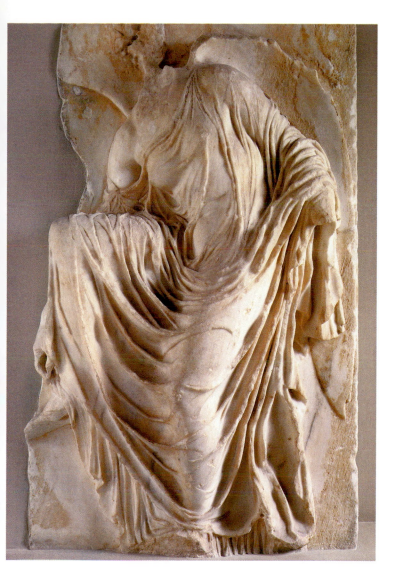

5.49. *Nike,* from the balustrade of the Temple of Athena Nike. ca. 410–407 BCE. Marble. Height 42″ (106.7 cm). Akropolis Museum, Athens

THE PROPYLAEA During the year that the Parthenon was dedicated, 437 BCE, Perikles commissioned another costly project: the monumental entry gate at the western end of the Akropolis, called the Propylaea (see fig. 5.37). Mnesikles was the architect in charge, and he completed the main section in five years; the remainder was abandoned with the onset of the Peloponnesian War. The entire structure was built of marble and included refinements similar to those used in the Parthenon. Mnesikles ably adapted elements of a Doric temple to a totally different task, and to an irregular and steeply rising site. Conceived on two levels, the design transforms a rough passage among rocks into a magnificent entrance to the sacred precinct. Only the eastern porch (or facade) is in fair condition today. It resembles a Classical Doric temple front, except for the wide opening between the third and fourth columns, which allowed traffic to pass onto the Akropolis; this feature appears often in Ionian architecture. Flanking the western

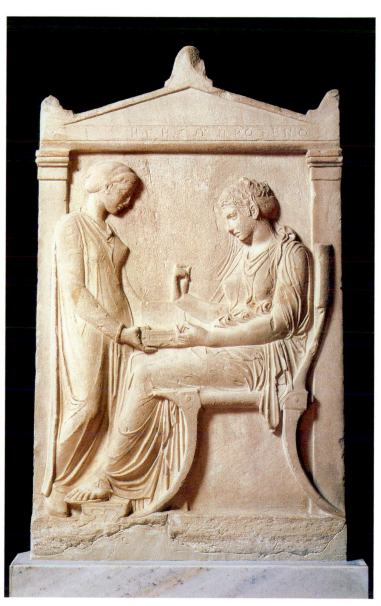

On the Grave Stele of Hegeso (fig. **5.50**), also from the last years of the fifth century BCE, the Pheidian style is again recognizable in the drapery, but also in the smooth planes of the idealized faces, and in the quiet mood of the scene. The artist represented the deceased woman seated on an elegant chair, in a simple domestic scene that became standard for sculpted and painted funerary markers for young women. She has picked a piece of jewelry from a box held by a girl servant and seems to contemplate it. The delicacy of carving is especially clear in the forms farthest away from a viewer, such as the servant's left arm, or the veil behind Hegeso's right shoulder. Here the relief merges with the background, strengthening the illusion that the background is empty space rather than a solid surface. This stele is a particularly fine example of a type of memorial that Athenian sculptors produced in large numbers from about 425 BCE onward. Their export must have helped to spread the Pheidian style throughout the Greek world.

5.50. *Grave Stele of Hegeso.* ca. 410–400 BCE. Marble. Height 59″ (150 cm). National Archaeological Museum, Athens

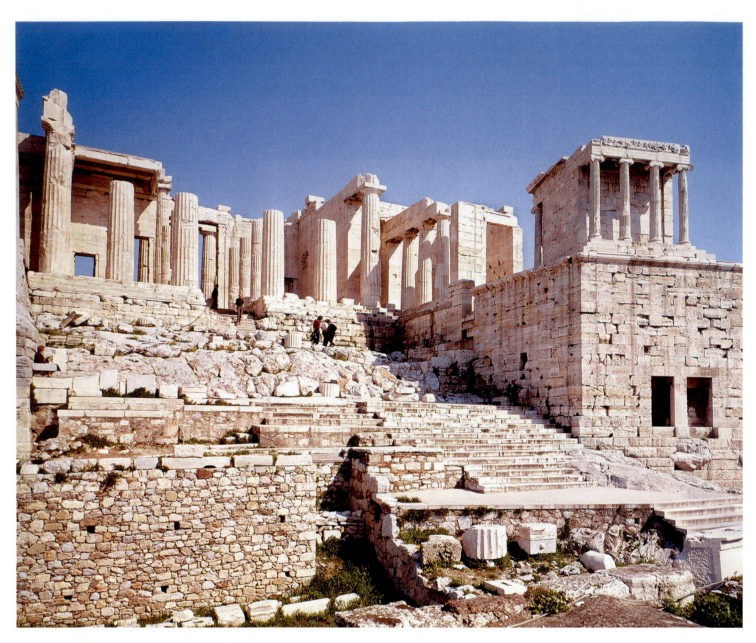

5.51. Mnesikles. The Propylaea, 437–432 BCE (view from the west). Akropolis, Athens

porch (fig. **5.51**) were two wings, of unequal size because of constraints imposed by the terrain (fig. 5.38). The larger one to the north contained a picture gallery *(pinakotheke),* the first known instance of a public room specially designed for the display of paintings. Placed along the central passageway through the Propylaea were two rows of slender Ionic columns, echoing the Ionic columns in the Parthenon.

THE TEMPLE OF ATHENA NIKE The architects who designed the Parthenon and the Propylea included Ionic elements for a reason that may have had as much to do with politics as with design. In pre-Classical times, the only Ionic structures on the Greek mainland had been small treasuries, like the Siphnian Treasury (fig. 5.21), built by eastern Greek

states at Delphi in their regional styles. When Athenian architects used the Ionic style, Perikles may have been making a deliberate symbolic gesture, attempting to unite the disparate regions of Greece in an international style. The Akropolis, in fact, houses the finest surviving examples of the Ionic style. One is the small Temple of Athena Nike, to the south of the Propylaea (fig. 5.52). It was probably built between 427 and 424 BCE from a design prepared 20 years earlier by Kallikrates to celebrate the Athenian victory over the Persians. The decorative quality of the Ionic style, with proportions that are finer than those found in the Doric style, made it a natural choice for the little, jewel-like building. Standing on a projecting bastion, it was the first structure that a visitor to the Akropolis would see.

THE ERECHTHEION A second, larger Ionic temple stood alongside the Parthenon. The Erechtheion was built between 421 and 405 BCE, and was probably another of Mnesikles' projects (fig. 5.53). As with the Propylaea, the architect had to deal with a difficult terrain: Not only did the site slope, but it already accommodated various shrines associated with the mythical founding of Athens that could not be moved. Beneath it, for instance, was the spot where, so the Athenians believed, Poseidon and Athena competed for custody of Athens, a contest depicted on the east pediment of the Parthenon (see fig. 5.41). In addition to the olive tree that Athena gave the city in the contest, the temple included the saltwater pool that sprang up where Poseidon threw his trident. The Erechtheion was therefore designed to serve several religious functions at once. Its highly irregular plan included four rooms, as well as a basement on the western side (see fig. 5.38). The main, eastern room was dedicated to Athena Polias (Athena as the City Goddess) and contained the old cult image, an amorphous piece of olive wood that was the most sacred object of cult in Athens; the western room was sacred to Poseidon. Another room held a cult of Erechtheus, a legendary king of Athens who promoted the worship of Athena and for whom the building is named.

Instead of a west facade, the Erechtheion has two porches attached to its flanks. A very large one dedicated to Poseidon faces north and served as the main entrance, while a smaller one juts out toward the Parthenon. The latter is the famous

ART IN TIME

ca. 480 BCE—*Kritios Boy*

478 BCE—Delian League founded

458 BCE—Aeschylus writes the trilogy *Oresteia*

ca. 447 BCE—Perikles orders construction of Parthenon

431–404 BCE—Peloponnesian War

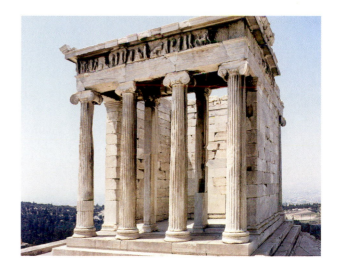

5.52. Temple of Athena Nike. 421–405 BCE (view from the east). Akropolis, Athens

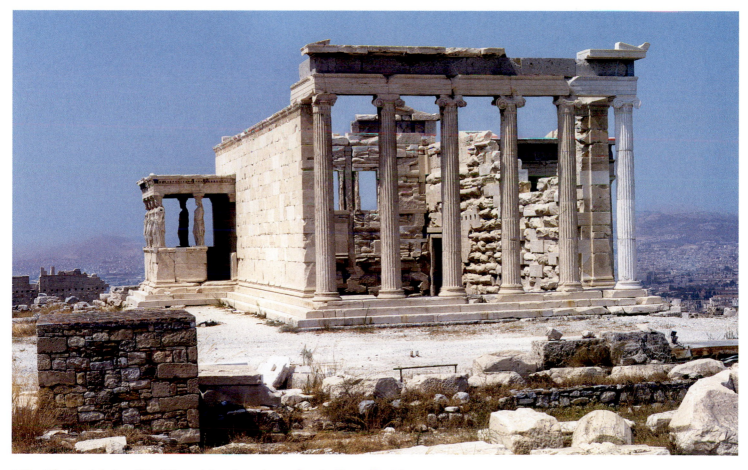

5.53. The Erechtheion. 421–405 BCE (view from the southeast). Akropolis, Athens.

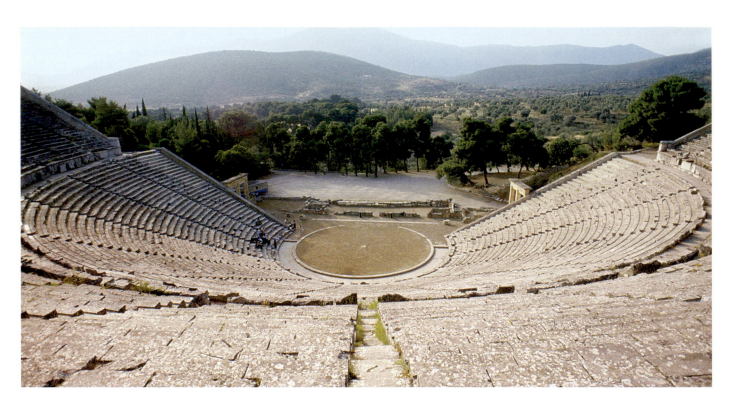

5.54. Theater, Epidauros. Early third to second centuries BCE

Porch of the Maidens (see fig. 5.53, left), so named because its roof is supported by six caryatids on a high parapet, instead of by columns. Vitruvius wrote that these figural columns represented the women of Caryae, a city-state in the Peloponnese that formed an alliance with the Persians in the Persian Wars. When the war was over, the triumphant Greeks killed the men of Caryae, and took the women as slaves, forcing them nonetheless to retain their fine clothing and other marks of their former status as a visible reminder of their shame. Thus, Vitruvius continues, architects designed images of these women to bear the burden of their state's dishonor in perpetuity. Vitruvius' explanation for the origin of caryatids is inconsistent with the fact that they appear in Greek architecture well before the Persian Wars in the Siphnian Treasury; but it

may reveal an added significance of the caryatids for the Athenians after the war. The Erechtheion's pediments remained bare, perhaps for lack of funds at the end of the Peloponnesian War, and little survives of the sculptural frieze. However, the carving on the bases and capitals of the columns and on the frames of doorways and windows, is extraordinarily delicate and rich. Indeed, according to stone inscriptions detailing construction expenses for the building, it cost more than the temple's figural sculpture.

Although they were built over several decades, the buildings of the Periklean Akropolis were clearly intended as a programmatic unit. The solid, stately forms of the Doric Parthenon and Propylea complemented the lighter, more decorative style of the Temple of Athena Nike and the Erechtheion.

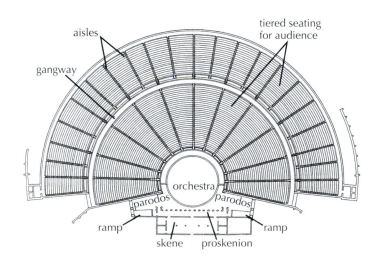

5.55. Plan of the Theater, Epidauros (after Picard-Cambridge)

THE LATE CLASSICAL PERIOD

By the end of the fifth century BCE, Athens' supremacy was on the wane. Conflict between Athens and the Peloponnesian cities of Corinth and Sparta had begun in about 460 BCE, and gradually escalated into the great Peloponnesian War of 431–404, which Athens lost. During the fourth century, the Greek city-states were constantly at odds with one another. In 338, Philip II, who had acceded to power in the kingdom of Macedon, to the north, exploited Greek disunity by invading Greece, and decisively defeated the Athenians and Thebans at the Battle of Chaironeia in central Greece.

Late Classical Architecture: Civic and Sacred

Two noteworthy changes in monumental architecture occurred in the late fifth and fourth centuries. One was a shift in emphasis: As well as constructing temples, architects explored a wide range of building types. Many of these building types—stoas, meeting houses for the council, and the like—had long existed, but now took on grander form. Theaters, for instance, became more formalized. They had long been part of the religious landscape of Greek cities, since choral performances and, later, plays were central to sacred festivals of Dionysos. The basic prerequisites for a theater were a hillside, on which an audience could sit (the *cavea*), and a level area for the performance (the *orchestra*).

THE THEATRE AT EPIDAUROS These essentials gradually took on architectural form, leading to the magnificent stone theater in the sanctuary of the healing god Asklepios at Epidauros (figs. **5.54** and **5.55**). The theater was constructed in the early third century BCE, and the upper tier was not completed until the second century. Row upon row of stone seats lined the sloping hillside, covering slightly more than a semicircle. To facilitate entry and circulation, the seats were grouped in wedge-like sections (*cunei*), separated by staircases; a wide horizontal corridor divides the upper and lower sections. Action took place in the level circle at the center, behind which a stage building (*skene*) served as a backdrop and contained utility rooms for storage and dressing. This form is familiar to every theatergoer, even today, a testament to its success. Because it was open to the sky, no roof supports obstructed viewing of the performance, and many of the seats offered spectacular views across the landscape as well. Yet perhaps the most astonishing feature of the theater is its extraordinary acoustics, which can still be experienced: Its funnel shape carries even the slightest whisper audibly up to the highest points of the auditorium.

THE MAUSOLEUM AT HALIKARNASSOS In Halikarnassos (present-day Bodrum, in southwest Turkey; see map 5.1), this tendency toward monumentalization resulted in a vast tomb built for Mausolos by his wife and sister Artemisia. Mausolos ruled Caria from 377 to 353 BCE as satrap for the Persians. Such was the renown of this sepulcher in antiquity that it was counted among the seven wonders of the ancient world, and by Roman imperial times its title, the Mausoleum, had become the term used to describe any monumental tomb. Designed by Pytheos of Priene, the tomb stood reasonably intact until the thirteenth century CE, when an earthquake brought down the upper sections. Then, in the late fifteenth and early sixteenth centuries, the Knights of St. John used the remains as a source of squared stone to refortify the local castle. Still later, in 1857, the British archeologist Charles Newton excavated the site and removed many sculptural fragments to the British Museum. Danish excavations have continued to yield important information at the site, and when coupled with literary evidence, these permit reconstructions, though none has met with universal approval (see end of Part I, *Additional Primary Sources*). One hypothesis appears in figure **5.56**. The tomb was rectangular in plan, and soared 140 feet high in at least three sections, covered with sculpture. The sections included a high podium, an Ionic colonnade, and a pyramidal roof, where steps climbed to a platform supporting a statue of Mausolos or one of his ancestors in a chariot.

The grouping of these elements within a single monument is further evidence of a growing diversity in architecture. They may also have had a propagandistic function. The Mausoleum celebrated Mausolos as hero-founder of Halikarnassos. It combined the monumental tomb-building tradition of Lycia with a Greek peristyle and sculpture, and an Egyptian pyramid. It may therefore have expressed Carian supremacy in the region and the symbiosis of Greek and non-Greek civilizations that might be achieved through founding a Carian empire headed by Halikarnassos.

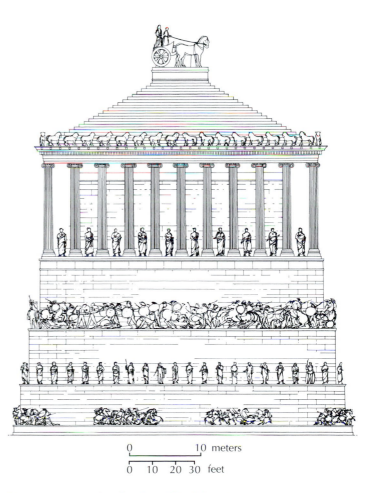

5.56. Reconstruction drawing of the Mausoleum at Halikarnassos. ca. 359–351 BCE. (From H. Colvin)

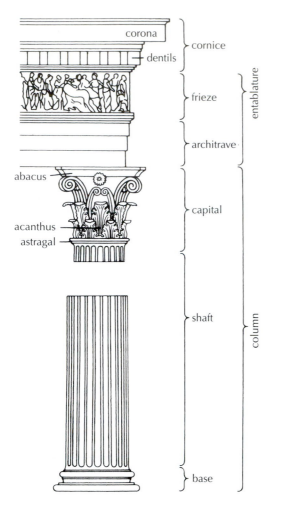

5.57. Corinthian style in elevation

(Diagram labels, top to bottom:)
corona — cornice
dentils
frieze — entablature
architrave
abacus — capital
acanthus
astragal
shaft — column
base

CORINTHIAN CAPITAL The other major change in architecture that took place in the late fifth century BCE was the development of the **Corinthian capital** (fig. **5.57**). The Corinthian capital was an elaborate substitute for the Ionic. Writing about four centuries later in Italy, Vitruvius ascribed its invention to the metalworker Kallimachos. Its shape is an inverted bell covered with the curly shoots and leaves of an acanthus plant, which seem to sprout from the top of the column shaft. At first, Corinthian capitals were only used in temple interiors, perhaps because of the conservative nature of Greek architecture, or because of the perceived sanctity of its vegetal forms. It was not until the second century BCE that Corinthian columns appeared on the exteriors of buildings. The capital in figure **5.58** belongs to a circular shrine or *tholos* at Epidauros designed by Polykleitos the Younger. The circular form of the shrine was a symptom of the preoccupation with new types of buildings. Its elaborate interior continues the tradition, begun with the Parthenon, of stressing the articulation of interior space.

LATE CLASSICAL SCULPTURE The Pheidian style, with its apparent confidence in the transcendence of the Athenian city-state, did not survive the devastating defeat of Athens in the Peloponnesian War. At the end of the fifth century, a clear shift in mood is visible in sculpture, which seems to reflect a new—and less optimistic—view of man's place in the universe.

Scholars have attempted to match surviving sculptures with several of the fourth-century sculptors named in literary sources. Among them was Skopas of Paros. According to the Roman writer Pliny, he was one of four masters chosen to work on the Mausoleum of Halikarnassos, and his dynamic style has been recognized in some parts of a frieze from the tomb depicting the battle of the Greeks and the Amazons. He is best known, though, for the way he infused emotion into the faces of those he depicted. A fragmentary head from a pediment of the Temple of Athena Alea at Tegea of about 340 BCE is either by Skopas himself, or an artist deeply influenced by his work (fig. **5.59**). A lionskin covering the head identifies it as either Herakles or his son Telephos. The smooth planes and fleshy treatment of the face are characteristic of Classical art, as seen on the Parthenon. What is new, however, is how the sculptor cut the marble away sharply over the eyes toward the bridge of the nose to create a dark shadow. At the outer edge, the eyelid bulges out to overhang the eye. This simple change charges the face with a depth of emotion not seen before, enhanced by the slightly parted lips and the sharp turn of the head.

PRAXITELES If the Greeks were less confident of their place in the late Classical period, they were also less certain of their relationship to fate and the gods. This is reflected in the

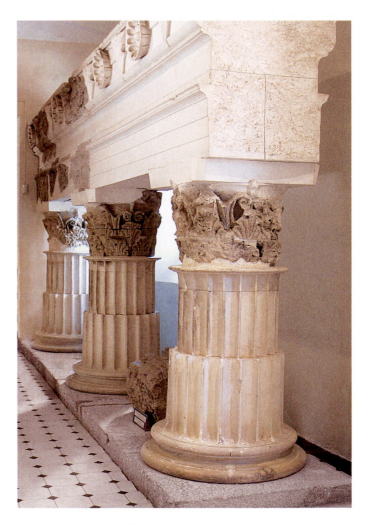

5.58. Polykleitos the Younger. Corinthian capital, from the Tholos at Epidauros. ca. 350 BCE. Museum, Epidauros, Greece

5.59. Head of Herakles or Telephos, from the west pediment of the Temple of Athena Alea, Tegea. ca. 340 BCE. Marble. Height $1'\frac{1}{2}''$ (31.75 cm). Stolen from the Archaeological Museum, Tegea

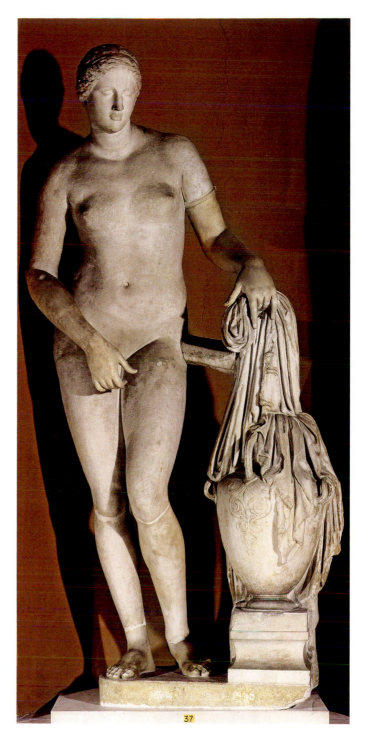

5.60. *Aphrodite of Knidos.* Roman copy after an original of ca. 340–330 BCE by Praxiteles. Marble. Height 6'8" (2 m). Musei Vaticani, Rome

work of Praxiteles, who was at work at roughly the same time as Skopas. He executed a number of statues of divinities, choosing marble as a material over bronze. Where fifth-century artists had stressed the gods' majesty, Praxiteles bestowed on them a youthful sensuousness that might, perhaps, suggest their wilful capriciousness toward humans. His most famous work is a sculpture of Aphrodite, dating to about 340–330 BCE (fig. **5.60**). Pliny records that the people of Kos commissioned a nude statue of Aphrodite from the master sculptor, but rejected it in favor of a draped version. The inhabitants of Knidos purchased the nude statue, and profited from the risk: Her fame spread fast, and visitors came from far and wide to see her. (See end of Part I, *Additional Primary Sources*.) Perhaps it was her nudity that drew so much attention: She was the first nude monumental statue of a goddess in the Greek world. Yet even if until this point artists had reserved female nudity principally for representations of slaves or courtesans, the clinging drapery of the fifth century had exposed almost as much of the female anatomy as it concealed. Her appeal may have resided just as much in the blatant eroticism of her image as in her nudity. A viewer catches Aphrodite either as she is about to bathe or as she is rising from her bath. With her right hand, she covers her genitals in a gesture of modesty, while grasping for a robe with her left. Her head is slightly turned, so she does not engage a viewer's gaze directly, but a viewer is made complicit with the

sculpture, willingly or not, by having inappropriately witnessed the goddess in her nudity. Perhaps, in her capriciousness, Aphrodite intended to be surprised as she bathed; the uncertainty for a viewer augments the erotic quality of the image. By some accounts, the Knidians displayed Praxiteles' sculpture in a circular shrine with entrances at front and back, so visitors could view her from all sides.

Praxiteles' Aphrodite is known to us only through Roman copies. More complicated is a group representing Hermes holding

the infant Dionysos (fig. **5.61**). The Roman writer Pausanias mentions seeing such a statue by Praxiteles in the Temple of Hera at Olympia, where this marble was found in 1877. It is of such high quality that art historians have long regarded it as a late work by Praxiteles himself. Now, however, most scholars believe it to be a fine copy of the first century BCE because of the strut support and unfinished back; analysis of the tool marks on the surface of the marble support this date. Still, the group has all the characteristics of Praxitelean sculpture. Hermes is more slender in proportion than Polykleitos' *Doryphoros* (see fig. 5.33), and the contrapposto is so exaggerated as to have become a fully relaxed and languid curve of the torso. The anatomy, so clearly defined on the *Doryphoros*, is blurred to suggest a youthful sensuousness rather than athletic prowess. The surface treatment of the marble is masterful, contrasting highly polished skin with rough, almost expressionistic hair. The group has a humorous quality typical of Praxiteles' work as well: The messenger god originally dangled a bunch of grapes in front of Dionysos, whose keen interest and attempts to reach for

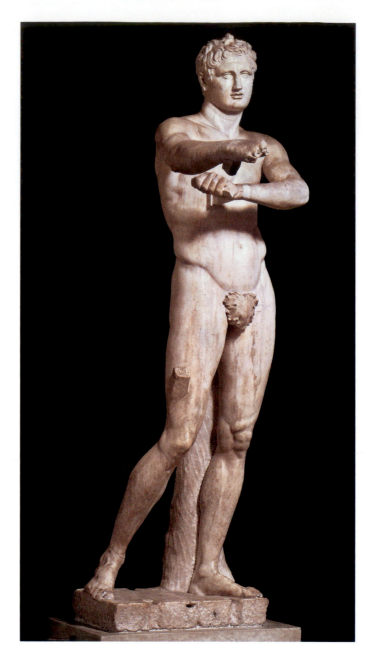

5.62. *Apoxyomenos (Scraper)*. Roman marble copy, probably after a bronze original of ca. 330 BCE by Lysippos. Height 6′9″ (2.1 m). Musei Vaticani, Rome

them foretell his eventual role as the god of wine. Yet, depending upon a viewer's mood (or worldview), Hermes' distant gaze may also hold a callous disregard for the child's efforts.

LYSIPPOS A third great name in fourth-century sculpture is Lysippos, who had an extremely long career. It may have begun as early as about 370 BCE and continued almost to the end of the century. Known from Roman copies, his *Apoxyomenos* (a youth scraping oil from his skin with a strigil) dates to about 330 BCE and is in clear dialogue with Polykleitos' *Doryphoros* (fig. **5.62**; see fig. 5.33). Lysippos prefers more slender proportions for his athlete, calculating the length of the head as one-eighth of the body's length, rather than one-seventh as Polykleitos had (see end of Part I, *Additional Primary Sources*). The *Apoxyomenos* leans further back into his contrapposto, too—a sign of Praxiteles' influence—and the diagonal line of the free leg suggests freedom of movement.

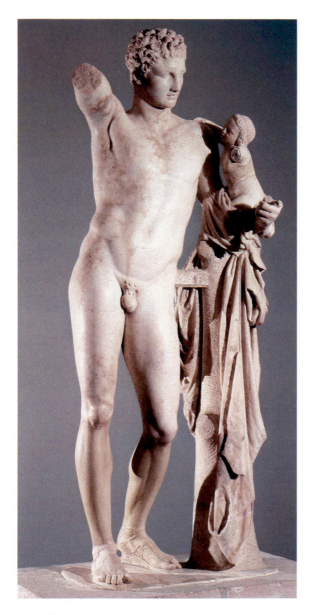

5.61. *Hermes*. Roman copy after an original of ca. 320–310 BCE by Praxiteles. Marble. Height 7′1″ (2.16 m). Archaeological Museum, Olympia

Most innovative, however, is the positioning of the athlete's arms. The outstretched arm reaches forward into a viewer's space. Since the arm is foreshortened in a frontal view, it entices the viewer to move around the sculpture to understand the full range of the action; Lysippos thereby breaks the primacy of the frontal view for a standing figure. The athlete's left arm bends around to meet the right at chest height, so the sculpture deliberately contains space within its composition. Lysippos challenges the stark opposition between sculpture and its environment; the two begin to merge. This device is symptomatic of a new interest in illusionism in the late Classical and Hellenistic ages.

Painting in the Late Classical Age

Written sources name some of the famous painters of the Classical age, and reveal a good deal about how painting evolved, but they rarely include enough detail to describe what it looked like. The great age of Greek painting began early in the Classical period with Polygnotos of Thasos and his collaborator, Mikon of Athens, who both worked as sculptors as well. Polygnotos introduced several innovations into painting, including the "representation of emotion and character [and the] use of patterns of composition," which became as central to Classical painting as they were to sculpture. He was also first to depict women in transparent drapery, and to forgo the notion of a single ground-line, placing figures instead at varying levels in a landscape setting.

The depiction of figures at different levels seems to have influenced a contemporary vase painter, known today as the Niobid Painter, whose name vase is shown in figure **5.63**. In the myth illustrated on this calyx krater (a wine-mixing bowl), Apollo and Artemis, sibling gods of hunting, shoot down the sons and daughters of Niobe, who had foolishly boasted that she had more and more beautiful children than their mother, Leto. Each of the figures has his or her own ground-line, which undulates to suggest a rocky terrain. Artemis and Apollo stand above two of their

victims, who are sprawled over boulders, but it seems clear that we should understand that the terrain recedes into the distance.

Significant technical differences separated wall painting from red-figured vase painting. Much closer to wall painting was a medium reserved almost exclusively for funerary purposes: white-ground vase painting. Artists working in this technique painted a wide range of colors onto a white slip background, and favored a type of oil flask used in funerary rituals, known as a *lekythos*. The example illustrated here dates to the last quarter of the fifth century BCE, and scholars attribute it to the Reed Painter (fig. **5.64**). A disconsolate young man sits on

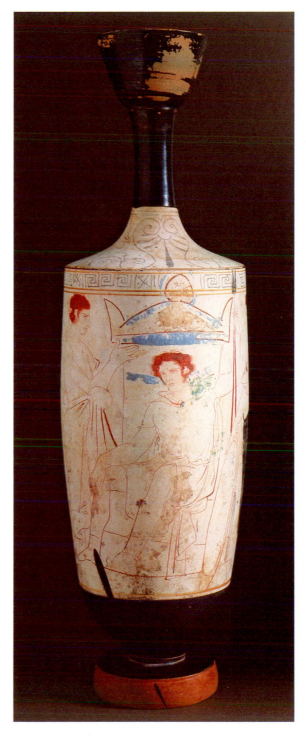

5.64. Reed Painter. White-ground lekythos. ca. 425–400 BCE. National Archaeological Museum, Athens

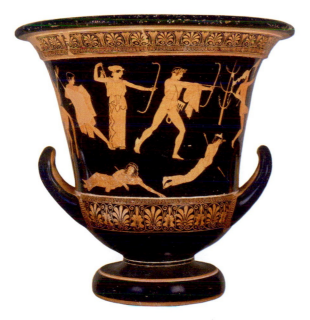

5.63. Niobid Painter. Red-figured calyx krater, from Orvieto. ca. 460–450 BCE. Musée du Louvre, Paris

ART IN TIME

- 387 BCE—Plato founds the Academy in Athens
- 351 BCE—Demosthenes delivers the first of his three orations titled *Phillipics*
- **340 BCE—Lysippos' *Apoxyomenos***
- 338 BCE—Phillip II of Macedon invades Greece
- 335 BCE—Aristotle founds his school of philosophy, the Lyceum, in Athens

the steps of a tomb. A woman on the right holds his helmet, while a second man stands to the left with one arm raised in a gesture of farewell. Black outlines define the scene, filled with washes of vivid color. Some blue still survives on parts of the tomb and the seated man's cloak, and brown in the figures' hair, but most of the colors have long vanished, since fugitive paints sufficed for a vessel not intended for prolonged or repeated use. The freedom of the technique allowed the painter to explore foreshortening and depth, and to achieve a remarkably expressionistic effect with a few fluid lines. The deceased man's deepset brooding eyes give some indication of the kind of emotion painters could capture. In view of its artistic advantages, one might expect wider use of the white-ground technique. Such, however, was not the case. Instead, from the mid-fifth century on, the impact of monumental painting gradually eclipsed vase painting. In some cases, vase painters tried to reproduce large-scale compositions, and their success was limited.

THE AGE OF ALEXANDER AND THE HELLENISTIC PERIOD

In 336 BCE, Philip II of Macedon died. His kingdom passed to his son Alexander. Alexander the Great is one of the romantic figures of history, renowned for his military genius, personal charm, and prowess. Upon coming into power, he embarked upon a great campaign of conquest, conquering Egypt and then the Persians, before continuing on to Mesopotamia, and into present-day Afghanistan. In 323 BCE, having founded over 70 cities, he died at the age of 33. His conquests dramatically changed the face of the Greek world, expanding it into unknown areas, creating new political alignments, and breaking down cultural boundaries.

Alexander the Great died without appointing a successor. The years following his death were fraught with struggles among members of his family and his generals, as each tried to establish himself as Alexander's sole successor; none succeeded. By about 275 BCE, Alexander's lands had coalesced into three main kingdoms, which would dominate the Mediterranean until the Romans gradually assumed control. Ptolemy inherited Egypt and founded a dynasty that reigned until Octavian, later the Roman emperor Augustus, defeated Cleopatra VII in 31 BCE. In the east, the Seleucid family captured Babylon in 312 BCE.

From Syria they ruled a kingdom which, at its largest, extended from present-day western Turkey through to Afghanistan. They lost control of a small pocket of territory around Pergamon to the Attalids, who bequeathed their city to the Romans in 133 BCE. By 64 BCE, the Seleucid kingdom had shrunk to a small area in northern Syria, and then came under Roman control. Most sought after was Alexander's ancestral Macedon, which fell into the hands of the Antigonids in 276 BCE, who controlled it until the Roman conquest in 168 BCE. Within these kingdoms, powerful cities grew—among them, Alexandria, Antioch, and Pergamon—with teeming populations drawn from all over the new Greek world. They vied with one another for cultural preeminence, and art played a large part in the rivalry. Hellenistic culture was dramatically different from that of Classical times. The expansion of Greek dominance meant that Greek cultural institutions were imposed over a vast territory; yet those institutions commingled with the strong cultural traditions of the indigenous peoples to create a rich and diverse society.

Architecture: The Scholarly Tradition and Theatricality

Within the cultural centers of the Hellenistic world, academies emerged, fostering avid debate among scholars in a wide range of fields. They engaged, among other things, in a close analysis of the arts, and developed canons by which they could judge works of literature, art, and architecture. In architecture, this led, predictably, to a heightened interest in systems of proportions, recorded in architectural treatises by practitioners of the day. Vitruvius asserts that the leading protagonist in this movement was Pytheos, an architect from Priene, who may have been one of the architects responsible for the Mausoleum of Halikarnassos (see fig. 5.56). His treatise, like most, does not survive, but Vitruvius notes that he was especially dismissive of the Doric style because problems with the spacing of corner triglyphs made the style impossible to impose without

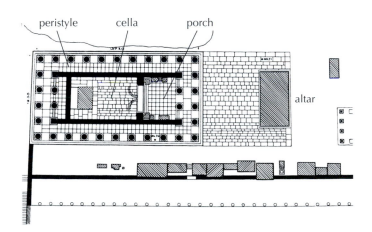

5.65. Pytheos, plan of Temple of Athena, Priene. 334 BCE

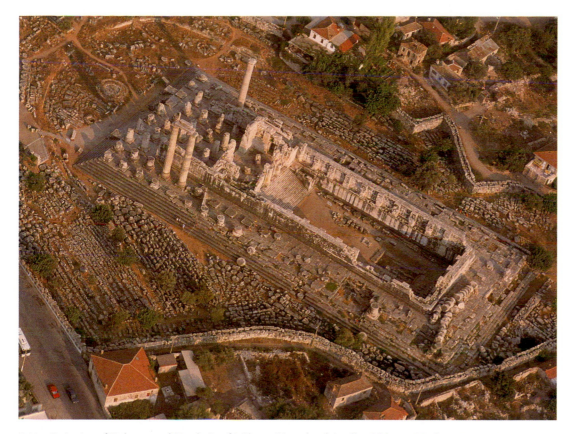

5.66. Paionios of Ephesos and Daphnis of Miletos. Temple of Apollo. Didyma, Turkey. Begun 313 BCE

compromise. Pytheos worked instead in the Ionic style, as seen in his temple to Athena at Priene, dedicated in 334 BCE (fig. **5.65**). The temple's colonnade had 6 columns by 11 and a grid of squares, each 6 by 6 Attic feet (each Attic foot is slightly longer than the English foot), that dictated the proportions of all of its component elements.

Proportions controlled the elevation as well: For instance, the columns were 43 Attic feet high and the entablature was 7 feet high—for a total of 50 feet, half the external length of the cella. Unlike the Parthenon and other classical temples, in the Temple of Athena at Priene there were no deviations from the rule, and no refinements. The temple is a work of the intellect, the product of a didactic tradition, rather than a compromise between theory and practice. In fact, Vitruvius faults Pytheos precisely for his inability to differentiate between the two.

At the same time as this scholarly tradition flourished, the relaxation of architectural guidelines and the combination of architectural types that had occurred in the late Classical period heralded another development in the Hellenistic period. This was a new penchant for dramatic siting, impressive vistas, and surprise revelations. Scholars have termed this movement theatricality, and it balanced and complemented the scholarly tradition. As the glory of Athens declined, the Athenians and other Greeks came to think of themselves less as members of a city-state and more as individuals; architecture, in turn, began to cater more and more to a personal experience, often manipulating visitors toward a meaningful revelation.

THE TEMPLE OF APOLLO, DIDYMA Begun in about 300 BCE and still unfinished by the end of the Roman period, the Temple of Apollo at Didyma is good example of architectural theatricality (figs. **5.66** and **5.67**). The huge temple was built on the site and the scale of an archaic temple destroyed by the Persians in 494 BCE. Its ground plan and design appear to have been established by the renowned Hellenistic architects Paionios of Ephesos and Daphnis of Miletos.

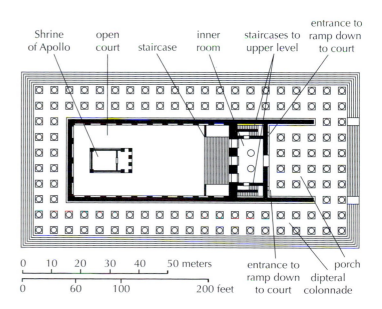

5.67. Plan of Paionios of Ephesos and Daphnis of Miletos, Temple of Apollo, Didyma, Turkey. Begun 313 BCE

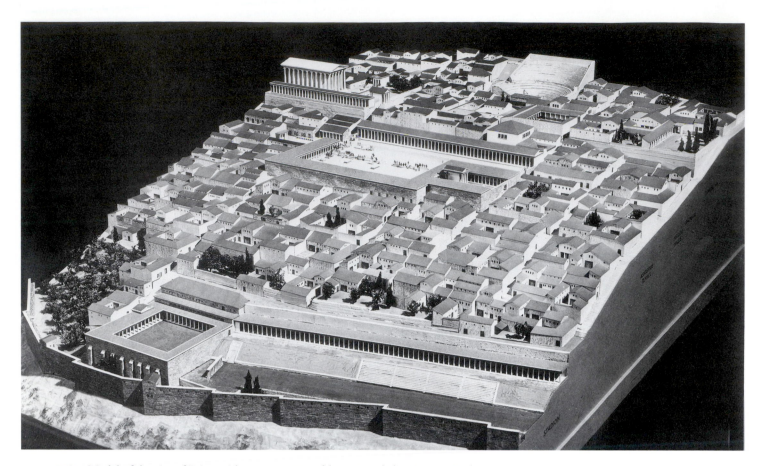

5.68. Model of the city of Priene, 4th century BCE and later. Staatliche Museen, Berlin.

The temple stood in a grove of sacred trees and from the outside appeared very similar to other large-scale Ionic buildings of the area. Placed on a high stylobate, seven massive steps above ground level, the temple was surrounded by two rows of tall columns. A visitor would naturally expect the temple's interior to repeat the format of canonical Greek religious buildings such as the Parthenon, but, in fact, the temple's architects constantly defied these expectations, as visitors were led to dramatic vistas, perhaps intended to heighten the religious experience.

Although the temple appeared to be accessible from all sides, its steps were far too high for comfortable climbing. Instead, visitors climbed a set of shallower steps at the front, entering the porch through vast columns, set to mimic the forest of trees around the building. As expected, an opening led to the cella, but this cella stood at approximately 5 feet off the ground, making access impossible. On this platform, scholars believe, the oracular priestess uttered her prophecies, pronouncing to those standing below in the porch. For those wishing to enter further into the building, the path led to the right or left of this elevated opening, where dark barrel-vaulted tunnels led downward. For a Greek visitor, a barrel-vaulted tunnel suggested a cave, or a dark interior, yet these passages did not lead to a covered interior cella, but a vast open courtyard drenched with bright sunshine: A revelation, it must have seemed, after the confinement of the tunnels.

At the end of this courtyard was the shrine itself, a small and simple Ionic building dedicated to Apollo. Near the shrine were sacred laurel bushes and a spring of holy water. Turning back from the shrine, the visitor faced another astonishing sight: The tunnels through which he or she had entered the courtyard were dwarfed by comparison with a wide, steep staircase leading up to a pair of towering engaged Corinthian columns. These may have signaled that the room that lay beyond them was the innermost sanctuary where the priestess resided. Just who this visitor might be is uncertain, since little is known of the goings-on inside Greek temples, yet the processional quality of this inner staircase and the large scale of the inner courtyard suggest the possibility that large crowds of worshipers would have gathered there to witness ritual ceremonies. Also unknown is the function of small staircases leading off from the sanctuary and up to the roof that covered the colonnades. Building inscriptions describe them as "labyrinths," and indeed the ceiling above them is carved with a brightly painted meander pattern (see fig. 5.3), the Egyptian hieroglyphic sign for a maze. Maintenance needs may explain their existence, but a role in a revelatory drama in honor of Apollo could do so just as well. As a whole, the temple manipulated visitors along unexpected paths, and offered constant surprises. This theatricality was a feature of a number of other buildings of this time.

The Temple of Apollo is remarkable for another reason besides the surprise experience it offered. Inside the courtyard under a strong raking light, archeologists unexpectedly discovered diagrams incised (so lightly they were barely visible) upon its walls. These etchings revealed scale drawings for aspects of the building's design, ranging from capital decoration to column entasis. They provide an extremely rare insight into the design process in Greek building, which is otherwise poorly understood. These etchings suggest that a building's design was drawn onto its existing surfaces as it rose, and was then polished off as those surfaces were properly finished. This temple's chance incompletion preserved the design drawings in place.

City Planning

Early Greek cities such as Athens grew organically, transforming gradually from small settlements to larger urban developments. Streets were typically winding, and building blocks were irregular. From the seventh century BCE onwards, colonization offered an opportunity to conceive cities as a whole, and to assess different types of city planning. Hippodamos of Miletos was the first to write a treatise on the subject, advocating grid planning—that is, laying out the streets of a city in intersecting horizontals and verticals, a pattern still used in many Western cities today. For an architect, the rectilinear grid offered the advantage of regularity; for an inhabitant of the city, it meant a new ease of orientation. Hippodamos designed the Piraeus, near Athens, in the mid-fifth century BCE, with a grid plan. When the inhabitants of Priene relocated their city to avoid flooding, in approximately 350 BCE, the grid plan of their new city was therefore nothing new (fig. **5.68**). As the model demonstrates, the rigid grid plan ignored the city's sloping terrain. Some longitudinal axes through the city had staircases to climb straight, steep inclines. Although stairs would have helped pedestrians navigate hilly streets, they must have been impassable by wheeled vehicles.

PERGAMON: A THEATRICAL PLAN A visitor to the city of Pergamon would have had a dramatically different experience. There, in the early second century BCE, Eumenes II, ruler of Pergamon, and his architects avoided a grid as they planned an expansion of the city (fig. **5.69**). The residential areas lay mainly on the plain of the Kaikos River; nearby was the towering Akropolis. The new design followed and exploited the dramatic rise in terrain from one to the other, apparently assigning symbolic meaning to the ascent as well. On the lower levels were the amenities of everyday life, such as the market place. As the road climbed the southern slope of the Akropolis, it passed through vaulted entrance tunnels to emerge at three *gymnasia* (schools); the first was for boys, the second for ephebes (adolescents aged 15–17), and the third and highest for young men. Further up the road were sanctuaries to Hera and Demeter, both important goddesses for the city.

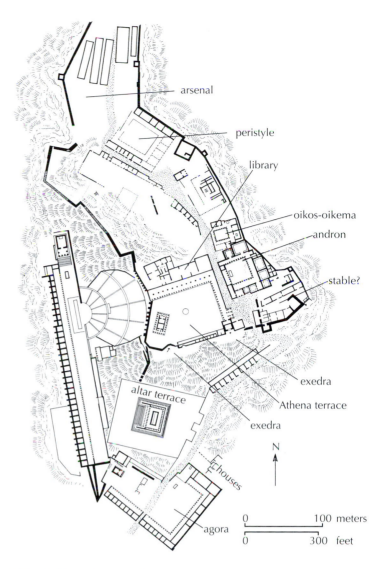

5.69. Plan of Pergamon, Turkey

The road snaked on, following the terrain, past an *agora* or marketplace from earlier times, now chiefly used for legal and political purposes, to the Akropolis proper, where a magnificent altar court was dedicated to the supreme god, Zeus (see figs. 5.73 and 5.74). Further up and to the east was a shrine for the Hero Cult, a Heroön. A long portico temporarily obscured any view of the great crescendo of the journey up to the Akropolis; passing through it, a visitor entered the sanctuary of Athena, where the city's oldest temple stood, and, alongside it, Eumenes' famous library, with a larger than life-size version in marble of Athena Parthenos. This sanctuary marked the privileged place of learning in Pergamene culture. On its own, the temple was not remarkable. Yet it took meaning from the symbolic journey necessary to reach it. From the sanctuary, a visitor could look out over the steep cavea or seating area of the Theater of Dionysos across the plain's breathtaking panorama. Behind and beyond the sanctuary, to the northeast, were the royal residence and barracks for the guard. Like the sanctuary, the residence offered magnificent views of the river and the receding countryside, and cool breezes

blowing through the valley and up to the Akropolis must have provided relief from the fierce summer sun. At every turn, the city's design took into account a visitor's experience. Its impressive vistas and sudden surprises are hallmarks of the theatricality found in Hellenistic architecture.

Hellenistic Sculpture: Expression and Movement

The Hellenistic period saw dramatic changes in Greek sculpture as well as in city designs. Fourth-century sculptors had led the way in expressing emotion and exploring three-dimensional movement, and Hellenistic artists made further radical strides in these directions. Both result in heightened drama and viewer involvement. That said, one can make only broad generalizations about Hellenistic sculpture, as it is notoriously difficult to date and to attribute to a firm place of origin. Often it is style alone that leads scholars to ascribe a sculpture to this period. Even that is not always straightforward: Although there is good evidence of a dialogue between them, sculptors were working throughout such a vast territory that numerous local influences were at play, making the body of material much less unified than Classical sculpture.

PORTRAITURE One of the earliest developments in sculpture in this period was an interest in portraiture. If individuals were depicted at all in the Archaic period, they were represented by

5.71. *Portrait Head,* from Delos. ca. 80 BCE. Bronze. Height 12¾″ (32.4 cm). National Archaeological Museum, Athens. Ministry of Culture Archaeological Receipts Fund. 14612

5.70. Lysippos. *Portrait of Alexander the Great, the "Azara herm."* Marble. Height 27″ (68 cm). Roman copy after an original of the late 4th century BCE. Musée du Louvre, Paris

the all-purpose figures of kouroi and korai. Individual likenesses were unknown in art of the Classical period, which sought a timeless ideal. A copy of a famous sculpture of Perikles dating from about 425 BCE, for instance, differs from the idealized youths of the Parthenon frieze only in that the Perikles is bearded and wears a helmet. Later, in the mid-fourth century, portraiture became a major branch of Greek sculpture, and it continued to flourish in Hellenistic times. One of the catalysts for this change was Alexander the Great himself. Recognizing the power of a consistent visual image, he retained Lysippos to sculpt his portraits, allowing no other sculptor to do so. No surviving original preserves Lysippos' touch, but scholars consider the so-called "Azara herm" to be relatively faithful to its model (fig. **5.70**). To be sure, there is an idealized quality about the face: Its planes are smooth, especially around the brow. Yet individuality comes through in the unruly hair, raised at the front in Alexander the Great's characteristic cowlick (or *anastole*), and in the twist of the head on the neck, which takes the portrait out of a timeless realm and animates it with action. Moreover, the general does not engage with a viewer, but has a distant and passionate gaze. These characteristics would come to be emblematic of Alexander the Great, and Hellenistic and Roman generals would adopt them as attributes in their own portraiture. With this portrait of Alexander, the individual comes to inhabit the sculpture, and portraiture as a genre began to develop.

As with so many Greek sculptures, original Hellenistic portraits are extremely rare. One is a vivid bronze head from Delos, a work of the early first century BCE (fig. 5.71). Unlike the Romans, the Greeks did not isolate an individual's personality in bust portraits, but considered it to animate the full body. Thus this head is just a fragment of a full-length statue. The man's identity is not known. He may have been a trader: The island of Delos was a lively trading port, and many merchants there became extremely wealthy. This portrait fuses the heroic qualities of Alexander's likeness—the whimsical turn of the head, for instance, and the full head of hair—with uneven surfaces. The fluid modeling of the somewhat flabby features, the uncertain mouth, and the furrowed brows suggest an introspective individual—though, as with Egyptian portraiture, it is risky to read psychological traits into works of another culture.

Hellenistic sculptors, like architects, seem to have wanted to engage their audience in the experience of their work, and favored dramatic subjects depicted with full emotion. The dying trumpeter, preserved in a Roman copy, is an early example (fig. 5.72). The sculpture probably belonged on one of two statue bases found in the Sanctuary of Athena on the Akropolis of Pergamon, and it commemorated Attalos I's defeat of the Gauls in about 233 BCE. Gone is the Classical tradition of referring to the enemy by analogy with a mythological conflict (see figs. 5.44 and 5.45). Instead, the sculptor carefully identifies the enemy as a Gaul through his bushy hair and moustache, and by the torque, or braided gold band, that he wears around his neck. Gone, too, is any attempt to suggest the inferiority of the vanquished. The Gaul dies nobly, sinking quietly to the ground or struggling to prop himself up, as blood pours from a wound in his chest. His body is powerful, his strength palpable. He faces his agonies alone, mindless of any viewer. A viewer, in turn, is drawn in by the privateness of the moment, and drawn around the sculpture by the pyramidal composition and the foreshortening witnessed from every angle. The dying trumpeter was probably one sculpture in a group, but the victor, so present in Classical battle scenes, was absent. The monument celebrates the conqueror's valor by exalting the enemy he overcame; the greater the enemy, the greater the victory. The Roman writer Pliny records a famous sculpture by Epigonos of a trumpet player, and it is likely that this Roman copy reflects that work. If so, Epigonos must have been a leading figure in the emotional and dramatic style of the Hellenistic period.

DRAMATIC VICTORY MONUMENTS Sculptures decorating the Great Altar of Zeus at Pergamon exemplify the highly emotional, dramatic style at its height (figs. 5.73 and 5.74). The monument dates to about 180 BCE, when Eumenes II, son and successor of Attalos I, built it to commemorate territorial victories over Pontos and Bithynia and the establishment of a grand victory festival, the *Nikephoria*. The altar stood high on a podium within a large rectangular enclosure surrounded by an Ionic colonnade. A wide staircase at the front provided access. The altar and its enclosure, which both go by the name of the Great Altar, originally stood on a terrace on the Pergamene Akropolis. A German team excavated the monument from 1878 to 1886, and its entire west front, with the great flight of stairs leading to its entrance, has

5.72. Epigonos of Pergamon (?). *Dying trumpeter*. Perhaps a Roman copy after a bronze original of ca. 230–220 BCE, from Pergamon, Turkey. Marble, life-size. Museo Capitolino, Rome

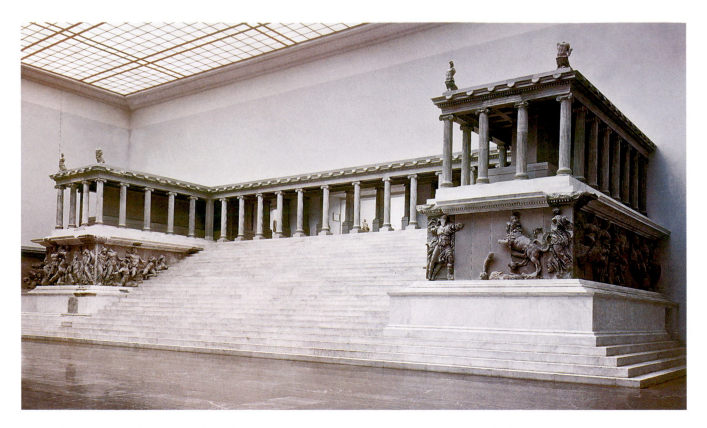

5.73. The west front of the Great Altar of Zeus at Pergamon (restored). Staatliche Museen zu Berlin, Preussischer Kulturbesitz, Antikensammlung

been reconstructed in Berlin (fig. **5.73**). The vast enclosure belongs to a long Ionian tradition of massive altars, but the Pergamene altar is by far the most elaborate of those that survive. Its boldest feature is a frieze encircling the base, which extends over 400 feet in length and over 7 feet in height. Its subject, the battle of the gods and giants, was a frequently used theme in architectural sculpture. Here, as before, it worked allegorically, symbolizing Eumenes' victories. Never before, however, had the subject been treated so extensively or so dramatically. About 84 figures crowd the composition, interspersed with numerous animals. This was no mean feat: The sculptors must have relied upon research by scholars (such as Krates of Mallos, a renowned Stoic theoretician and literary critic), working in the Pergamene library, to identify protagonists for this great battle. They may also have assisted with creating a balanced and meaningful composition, for despite the chaotic appearance of the mélée, clear guiding principles lurk behind it. Scholars still struggle to understand the principles fully, even though inscriptions preserve the names of some of the gods on the molding in the entablature above the frieze. The giants' names appear on the base molding. On the eastern frieze, facing the great Propylon into the sanctuary and the rising sun, were the Olympian gods. The most prominent position belonged to Athena, patron goddess of Pergamon. On the south, drenched in sun, were heavenly lights such as Helios; on the shadowy north

were divinities of the night. Deities of the earth and sea were on the west. Compositional parallels unified the four sides. The frieze is direct evidence of the Hellenistic scholarly tradition at work.

On the other hand, the frieze is deeply imbued with Hellenistic theatricality. The figures are carved so deeply, and in places so forcefully undercut, that they are almost in the round. On the staircase, they seem to spill out onto the steps and climb alongside an ascending visitor. The high relief creates a vivid interplay of light and dark. Muscular bodies rush at each other, overlapping and entwined (fig. **5.74**). The giants' snaky extremities twist and curl, echoed in their deeply drilled tendrils of ropelike hair. Wings beat and

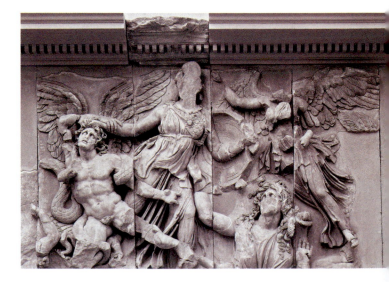

5.74. *Athena and Alkyoneus,* from the east side of the Great Frieze of the Great Altar of Zeus at Pergamon ca. 166–156 BCE. Marble. Height 7'6"(2.29 m). Staatliche Museen zu Berlin, Preussischer Kulturbesitz, Antikensammlung

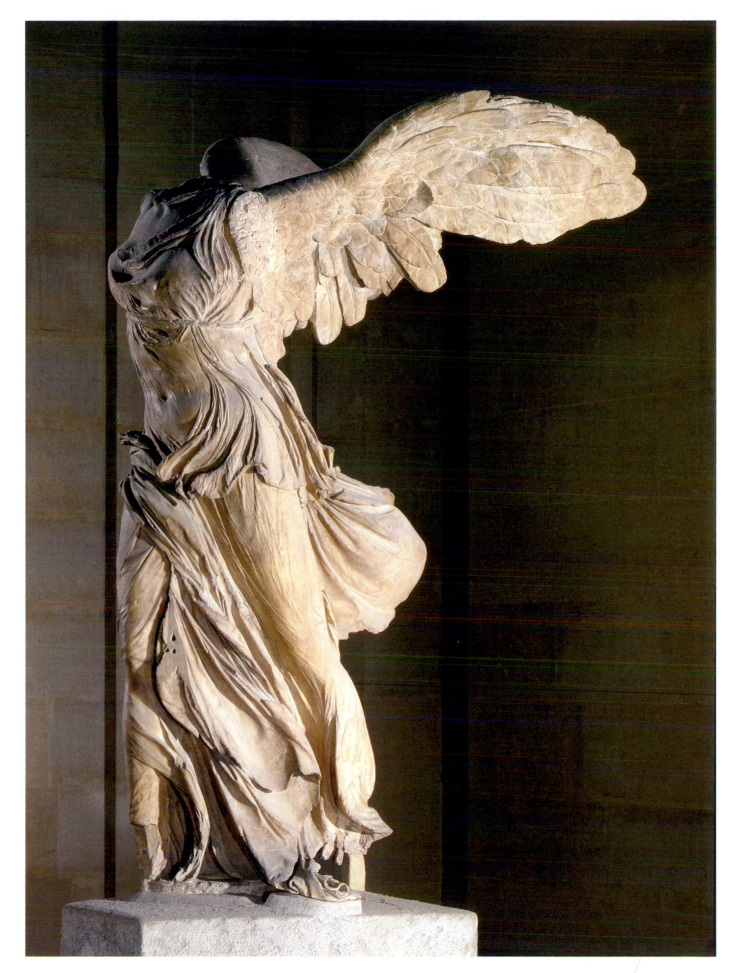

5.75. Pythokritos of Rhodes (?). *Nike of Samothrace*. ca. 190 BCE. Marble. Height 8′ (2.44 m). Musée du Louvre, Paris

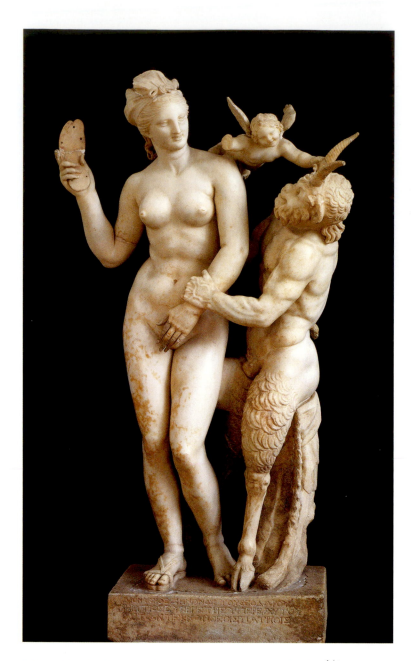

5.76. *Aphrodite, Pan, and Eros.* Marble. ca. 100 BCE. Height 4¼′ (1.32 m). National Archaeological Museum, Athens

garments blow furiously in the wind or twist and wind around those they robe, not to reveal the anatomy beneath but to create motion; wings and garments have a life of their own and a texture that contrasts with the smoothness of the giants' flesh. The giants agonize in the torment of their defeat, their brows creased in pain, their eyes deepset in an exaggerated style reminiscent of Skopas. A writhing motion pervades the entire design, and links the figures in a single continuous rhythm. This rhythm, and the quiet classicism of the gods' faces, so starkly opposed to the giants' faces, create a unity that keeps the violence of the struggle from exploding its architectural frame—but only just. For the first time in the long tradition of its depiction, a viewer has a visceral sense of what a terrible cosmic crisis this battle would be.

The weight and solidity of the great **gigantomachy** make it a fitting frieze for its place on the building's platform. A second, lighter frieze encircled the inside of the colonnade, and may have been executed at a slightly later date. This frieze portrays the life of Telephos, son of Herakles and legendary founder of Mysia, the region of Pergamon.

Dramatic location and style combine in another victory monument of the early second century BCE, the Nike (Victory) of Samothrace (fig. **5.75**). The sculpture probably commemorates the naval victories of Eudamos, an admiral in command of the fleet at Rhodes, over Antiochos the Great and the forces of his Seleucid kingdom in 190 BCE. Both the Rhodian marble of the sculpture's base, and a variety of evidence from inscriptions, suggest that the sculpture comes from Rhodes, and may well be

the work of the renowned artist Pythokritos from that island. The victory goddess is probably landing on the prow of a ship, as if to bestow a crown of victory upon Eudamos. Alternatively, she could be about to take flight. Her massive wings soar out behind her, stretching the limits of the marble's tensile strength. The lift of the wings makes the whole statue appear weightless, despite the great mass of stone. In a new variant of the contrapposto, neither leg holds the body's full weight. It is the wings, and the drapery, that give such energy to the sculpture. The drapery swirls around the goddess's body, exposing her anatomy and stressing the sensuous curves of her body. Yet it has its own function as well: The swirling drapery suggests the headwind she struggles against, which, in turn, balances the rushing forward thrust of her arrival. The drapery, in a sense, creates the environment around the figure.

This sculpture is a rare instance of a monument being found, in 1863, in its original location—in the Sanctuary of the Great Gods at Samothrace. The stone prow stood high on a terrace overlooking the theater and the sea, within a pool of water that must have reflected the Nike's white marble forms. The pool was raised above a second water basin filled with rocks, to evoke a coastline.

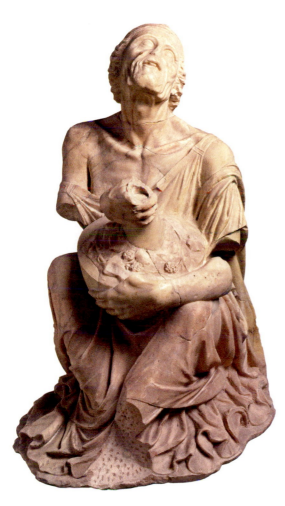

5.77. *Drunken Old Woman*. Roman copy of an original of late 3d or late 2d century BCE. Marble. Height 3′ (0.92 m). Glyptothek, Munich

ART IN TIME

336–323 BCE—Reign of Alexander the Great

ca. 300 BCE—Construction begins on the Temple of Apollo, Didyma

264–241 BCE—First Punic War

86 BCE—Sack of Athens

30 BCE—Egypt falls to Rome

PLAYFULNESS IN SCULPTURE Scholars use the term *baroque* to describe the extreme emotions, extravagant gestures, and theatrical locations that characterize the Great Altar of Zeus and the Nike of Samothrace. The term was first used to describe seventeenth-century CE art, and scholars of Hellenistic art borrowed it on recognizing similarities between the two styles. With its extraordinarily dramatic qualities, the Hellenistic baroque style has tended to eclipse the many other contemporary movements in sculpture. One of these other movements is a penchant for works of a light hearted and sometimes faintly erotic quality. They appear to be a reaction to the weightiness of the baroque style, and sometimes they have an element of parody to them, suggesting that the sculptor hoped to reduce the grand themes of the Classical and baroque styles to a comical level. These works are somewhat inadequately described by the term *rococo*, which is also borrowed from scholarship on later European art. Some of these works represent amorous interactions between divine or semidivine and human figures. In the example shown here, dating to about 100 BCE, Aphrodite wields a slipper to fend off the advances of a lecherous Pan, the half-man, half-goat god of the forests (fig. **5.76**). Eros hovers mischievously between them. With her sensuous roundness and her modest hand gesture, the goddess clearly recalls Praxiteles' bathing Aphrodite on Knidos (see fig. 5.60). Here, the erotic possibilities that Praxiteles dangled provocatively in the air are unambiguously answered, and by a humorously undesirable partner. Rather than grasping for her drapery to preserve her dignity, the majestic Aphrodite is reduced to grabbing a slipper in self-defense.

HELLENISTIC REALISM Scholars have sometimes grouped these light hearted sculptures together with a series of works depicting unidealized and realistic everyday life. Their genre is known as *Hellenistic realism*, and a sculpture of a drunken old woman illustrates it well (fig. **5.77**). Known from Roman copies, this piece has at times been ascribed to Myron of Thebes, who may have worked at Pergamon. The evidence is slim, and the figure may be a better fit with the cultural context of Alexandria, where realism seems to have been particularly prevalent. The woman is crouched on the ground, clasping a wine bottle, her head flung far back. Wrinkles cover her face, and the skin on her exposed shoulder and chest sags

J. J. Winckelmann and *The* Apollo Belvedere

Despite the best efforts of contemporary art historians, many assessments of art today are deeply informed by a notion of beauty rooted in Greek classicism. This bias has been present through the ages since antiquity; but its abiding power is also the legacy of a pioneering German antiquarian, Johann Joachim Winckelmann, who is often called the father of art history. Born in Stendal in Prussia in 1717, Winckelmann studied in Halle and Jena before becoming librarian for Count Heinrich von Bünau near Dresden. It was in von Bünau's library that he gained an education in the visual arts, which led to his first publication, *Reflections on the Imitation of Greek Works of Art in Painting and Sculpture*, in 1755. In that same year he moved to Rome, and was soon appointed librarian and advisor to Cardinal Alessandro Albani. In 1764, after the publication of his seminal *History of Art of Antiquity*, he became papal antiquary and director of antiquities in Rome. *Unpublished Antiquities*, of 1767, was his last work before his rather ignominious death a year later at the hands of a petty criminal.

The impact of his works has been enormous. He was first, for instance, to determine that most Greek sculptures (which he often conflated with their Roman copies) represented not historical figures but mythological characters. Even more significant was his contention that Greek art captured an ideal beauty that transcended Nature. He established a model for the development of art that divided art history into periods that coincided with political events. The Older Style was the precursor to the High or Sublime Style. Next came the Beautiful Style, and finally the Style of the Imitators. In ancient art, these correspond to the Archaic, fifth-century Classical, Late Classical, and Hellenistic and Roman periods. This progression from rise to eventual decline still lies at the heart of most studies of art history, regardless of the era. When it came to assigning works of art to these phases, Winckelmann was, in a sense, trapped by his own scheme. Reluctant to allot works he admired to the "decline" phase of Hellenistic and Roman art, he often dated sculptures much too early; such was the case with the *Laocoön* (see page 179), which he placed in the fourth century BCE, and The *Apollo Belvedere*, which he considered a Greek original.

The *Apollo Belvedere* was first discovered in the fifteenth century, and quickly made its way into the collection of Pope Julius II. It represents the god in an open pose, with his left arm outstretched, perhaps to hold a bow. Winckelmann was only one of many antiquarians to be profoundly moved by the statue. Combined in its form he perceived both power and desirability, and he penned a rhapsodic description of it that is tinged with eroticizing overtones. "I forget all else at the sight of this miracle of art," he wrote. "My breast seems to enlarge and swell with reverence." Few scholars share his enthusiasm for the piece today. Its significance for art

historians resides more in its modern reception — the role it played for admiring Renaissance artists, for instance — than in its place in ancient culture. As for its date, most scholars now identify it as a second-century CE copy or interpretation of a Greek original, sometimes attributed to Leochares, who worked at the end of the fourth century BCE.

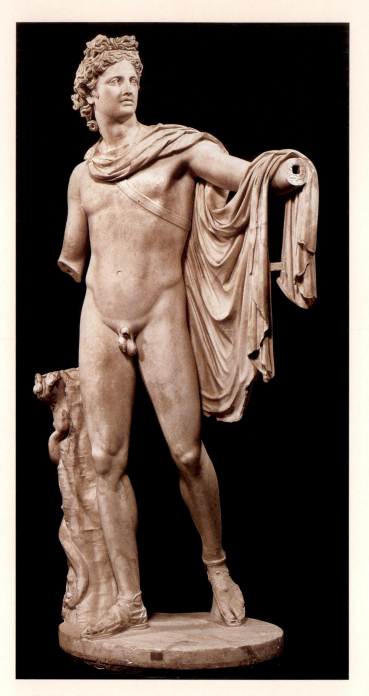

Apollo Belvedere. Roman marble copy, probably of a Greek original of the late 4th century BCE. Height 7′4″ (2.3 m). Musei Vaticani, Rome

with age. Her garment flows around her, forming a solid pyramid out of which she seems to rise. She wears a buckled tunic, which identifies her as a member of an affluent social class. Other sculptures of this kind focus on the ravaging effects of a rustic life on the poor—an old shepherdess, for instance; yet in

this sculpture, the artist explores drunkenness and old age. Without further insights into the cultural context for the image, it is hard to know if the sculptor intended to offer a sympathetic view of his subject, exalting her nobility, or to engage in a hard social commentary.

5.78. *The Abduction of Persephone.* Detail of a wall painting in Tomb I, Vergina, Macedonia. ca. 340–330 BCE

Hellenistic Painting

It was in the fourth century BCE that Greek wall painting came into its own. Pliny names a number of leading artists, but no surviving painting can be attributed to them to give proof to his words (see *Primary Source*, page 230). All the same, paintings are preserved in Macedonian tombs, several of which have come to light and keep being discovered in northern Greece (in the region of Macedonia). They offer a tantalizing glimpse of what painters could accomplish. Discovered recently, in 1976, these tombs are of great importance because they contain the only relatively complete Greek wall paintings to come to light. The section shown here illustrates the abduction of Persephone (fig. **5.78**), and comes from a small tomb at Vergina, dating to about 340–330 BCE. The subject is appropriate to the funereal setting. Pluto, ruler of the underworld, abducts Persephone to be his queen. Thanks to

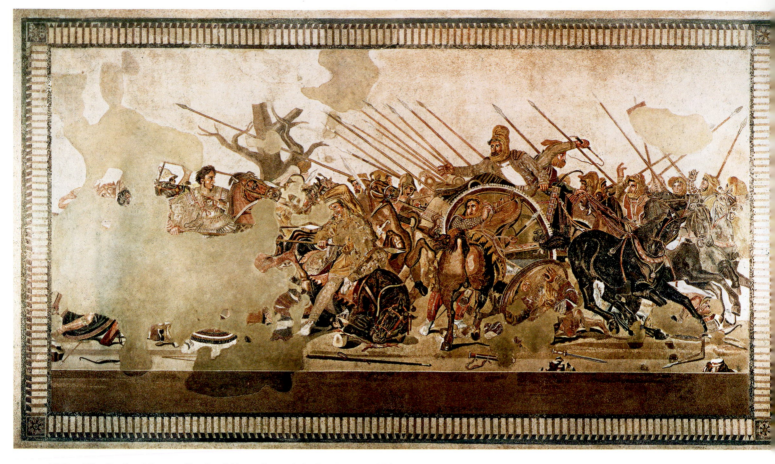

5.79. *The Battle of Issos* or *Battle of Alexander and the Persians*. ca. 100 BCE.
Mosaic copy from Pompeii of a Hellenistic painting of ca. 315 BCE. 8′11″ × 16′9½″
(2.7 × 5.1 m). Museo Archeologico Nazionale, Naples

Zeus' intervention, Persephone would be allowed to return to the world of the living for six months of every year. Here, the artist has chosen the moment when Pluto seizes Persephone into his speeding chariot, her handmaiden rearing back in fright and horror. This is the dramatic moment, before Persephone knows that Zeus will find a compromise, when her futile struggle seems the only possible escape from the underworld. The painting captures all of the drama of the myth. Persephone flings her body backward, while the chariot rushes onward with her captor; their bodies cross as a sign of their conflict. The chariot plunges toward a viewer, its wheel sharply foreshortened. Masterful brushwork animates the scene. With swift flourishes, the artist sends hair and drapery flying in the air, and lends plasticity to the figures' garments. Hatchwork rounds out the bodies' flesh, as on the arms and shoulders. The colors are brilliant washes, with shading for texture. Literary sources attribute the discovery of *shading* (the modulation of volume by means of contrasting light and shade), known as *skiagraphia,* to a painter named Apollodorus, who was using the technique perhaps as early as the fifth century BCE. They also associate spatial perspective with

Agatharchos and the art of stage scenery during the heyday of Athenian drama. The exploration and perfection of both devices during the course of the fourth century illustrate the fascination with illusionism at this time.

Roman copies and imitations also provide a general sense of what Greek wall painting might have looked like. According to Pliny, at the end of the fourth century BCE, Philoxenos of Eretria painted Alexander the Great's victory over Darius III at Issos. This subject is shown in an exceptionally large and masterful floor mosaic from a Pompeian house of about 100 BCE (fig. **5.79**). The scene depicts Darius and the fleeing Persians on the right and, in the badly damaged left-hand portion, the figure of Alexander. It is likely that this is a close copy of a Hellenistic painting from the late fourth century BCE. The picture follows the four-color scheme (yellow, red, black, and white) that is known to have been widely used at that time. (See *Primary Source*, page 230.) The crowding, the air of frantic excitement, the powerfully modeled and foreshortened forms, and the precise shadows place the scene in the fourth century, as does the minimal treatment of landscape, suggested by a single barren tree to the left of center.

SUMMARY

After waves of immigration, invasion, and colonization, Greek culture emerged by about the eighth century BCE. Centered in mainland Greece, the Aegean Islands, and Crete—but by the mid-sixth century BCE extending into southern Italy, northern Africa, and coastal Asia Minor—the disparate Greeks were united by a shared language and common beliefs. The first known practitioners of analytical thought, ancient Greeks struggled with philosophical questions that endure today. The dualism of the world, and humans' place in it, became a longstanding theme in all their arts. Because so much of Western society is inspired by Greece, these artworks may seem comfortably familiar. Yet it is essential not to impose our own interpretations, for these works often held radically different meanings for the Greeks. We must instead look to the archeological and literary records, placing Greek artworks within the proper contexts to understand their true significance.

Throughout more than seven centuries, devastating wars with their own and neighboring peoples continually shaped Greek culture and art. Trade and travel were common through extensive networks crisscrossing Asia Minor and the Mediterranean region. Fluid exchanges brought new influences, which Greek artists admired and absorbed, just as Greek culture itself affected those in distant lands.

GEOMETRIC PERIOD

About the eighth century BCE, the Greeks began developing a repertoire of pottery forms whose painted decoration shows the oldest known Greek style: the Geometric style. Characteristic rectilinear meanders and geometric patterns cover the so-called *Dipylon Vase* of about 750 BCE. Adding a narrative quality to this funerary amphora are images of animals and humans. Sculptors also modeled similar small figures in clay and bronze. Many painted vases bear inscriptions, and, indeed, this was the era of Homer's epic writings and the introduction of the alphabet.

ORIENTALIZING STYLE

Between 725 and 650 BCE, nascent Greek city-states grew prosperous, and citizens sought luxury commodities from trade partners in Asia Minor, the East, and Egypt. Greek artists rapidly assimilated Eastern influences, experimenting with new techniques and developing an orientalizing style. The port city of Corinth dominated ceramic production, and vase painters developed a black gloss slip to create outlined and silhouetted images with incised details. Sirens, griffins, and other Eastern mythical motifs abound on both miniature and monumental vessels.

ARCHAIC PERIOD

The beginnings of democracy emerged as Athens pushed to the forefront amid Greece's powerful and increasingly well-defined city-states. During this period of intense creativity, the great traditions of monumental stone sculpture and temple architecture appeared. Inspired by Egyptian examples, sculptors and builders experimented with proportional systems and adorned structures with larger than life-size figures. The two temples dedicated to Hera at Paestum and the Temple of Artemis at Ephesos show the development of the Doric and Ionic styles as well as that of a relatively standard temple plan, with its central cella and porch. Large-scale sculpture enlivened architecture, notably the Temple of Artemis and the later Temple of Aphaia, whose pediments reveal artists' search for solutions to fitting lively narrative scenes into the awkward triangular

space. Meanwhile, increasingly naturalistic and free-standing figures such as kouroi and korai are testaments to the Greek preoccupation with representing ideals of physical perfection. Vase painting saw important advancements as well, including the black-figured and red-figured techniques.

THE CLASSICAL AGE

Athens faced crises in the fifth century BCE when it was threatened by devastating Persian invasions. Yet out of the destruction of war, the city rebuilt itself into a political and economic empire. The ambitious statesman Perikles greatly influenced Athenian society and politics, and soon all the arts flourished, from the vivid tragedies of Aeschylus to the profound philosophies of Plato to the sophisticated architecture of Iktinos and Kallikrates. Sculptors made great strides in the naturalistic representation of the human form; the contrapposto stance of the *Kritios Boy* marks a critical point in Greek art, and sculptors took up the challenge of showing realistic movement in both stone and bronze. In sculptural programs for the Temple of Zeus at Olympia and the Athenian Akropolis, artists continued to explore complex narrative and dualistic themes.

Under Perikles' direction, Athens emerged from the ruins of war as the showplace of the Mediterranean region. The brilliance of the Parthenon reflects the splendor of the city at this time. On the sacred site of the Akropolis, the Parthenon—with its refined proportions, extraordinary sculpture, and pleasing harmony—has come to represent the height of Classical Greek art. Construction was also underway on other monuments of the Akropolis, including the Propylaea, the Temple of Athena Nike, and the Erechtheion, although such grand building projects dwindled with the onset of the Peloponnesian War.

THE LATE CLASSICAL PERIOD

The Peloponnesian War of 431–404 BCE brought an end to Athenian supremacy. It was followed by a century of internecine fighting among Greek city-states and, finally, the invasion of Greece by Philip II of Macedon in 338 BCE. Noteworthy during this period was the elaboration of a wider range of existing architectural types, such as meeting houses, theaters, and mausoleums. The Corinthian capital also developed from the Ionic style. The uncertain, somewhat pessimistic, mood of the age is best reflected in sculpture. The works of Praxiteles convey the capriciousness of the gods toward humans, whereas Lysippos' *Apoxyomenos* breaks into a viewer's space with its outstretched, foreshortened arm. Intense emotion and illusionistic depictions of space became hallmarks of wall and vase painting as well, seen especially on funerary vases painted with the white-ground technique.

THE AGE OF ALEXANDER
AND THE HELLENISTIC PERIOD

Alexander took control in 336 BCE upon the death of his father, Philip II, and the vast kingdom he created expanded Greek influence. Rivalries after Alexander's death in 323 BCE resulted in three separate kingdoms—the Ptolemaic, the Seleucid, and the Macedonian—each with powerful cities teeming with diverse societies. With the dissolution of city-states, Greeks increasingly saw themselves as individuals, and the arts, once again, reflect this new outlook.

The plans of buildings, such as the Temple of Apollo at Didyma and of the city of Pergamon, offered a more personal experience via unexpected paths, breathtaking panoramas, and dramatic theatricality. Hellenistic sculpture also favored heightened drama and increased viewer involvement, building on Late Classical works. Emotional subjects and dramatic realism prevailed; portraiture developed as a genre and flourished thanks to the patronage of Alexander the Great. Wall paintings display masterful brushwork, delicate shading, and spatial perspective.

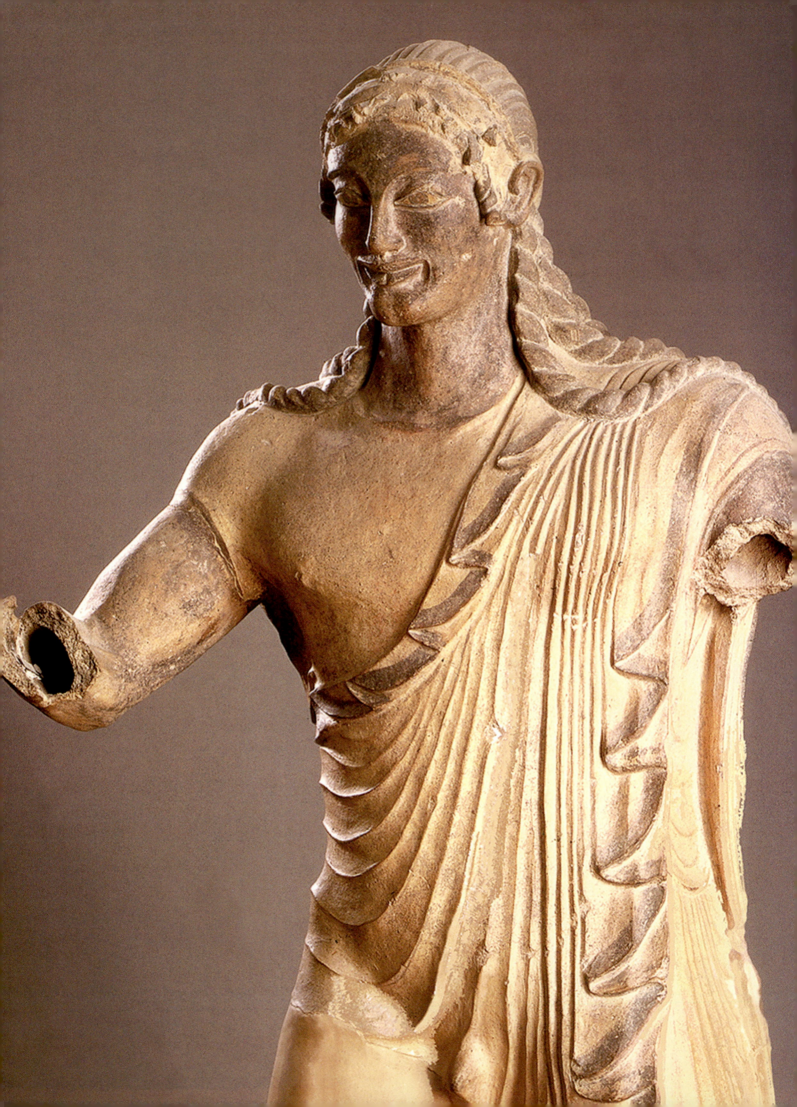

Etruscan Art

EARLY ETRUSCAN CULTURE, KNOWN AS VILLANOVAN, APPEARED ON THE Italian peninsula in the tenth century BCE. Exactly who the Etruscans were remains a mystery; even in antiquity, writers disputed their origins. The Classical Greek historian Herodotus believed that the Etruscans had left their homeland of Lydia in Asia Minor in about 1200 BCE. By his account, they

settled in what is now Tuscany, Umbria, and Lazio, roughly in the area between present-day Florence and Rome (see map 6.1). Others claimed the Etruscans were an indigenous people. Wherever they came from, the Etruscans had strong cultural links with both Asia Minor and the ancient Near East. In fact, their visual culture is a rich blend of distinctly Etruscan traits and influences from the east and from Greece. Etruscans were sailors and merchants who traveled throughout the Mediterranean, and since from the eighth century BCE Greek city-states had established colonies in Italy, contact between these cultures was inevitable. Toward the end of the eighth century they began to use the Greek alphabet, which makes it possible to read their inscriptions, that survive in the thousands; but since their language is unrelated to any other, we cannot always understand their meaning.

The Etruscans reached the height of their power in the seventh and sixth centuries BCE, coinciding with the Archaic age in Greece. Because of the close relationship between Etruscan art forms and those of Greece, scholars define the stylistic periods of Etruscan art with terms that are similar to those of Greek art (see table on next page). Their cities rivaled those of the Greeks; their fleet dominated the western Mediterranean and protected a vast commercial network that competed with the Greeks and

Phoenicians; and their territory extended from the lower Po Valley in the north as far as Naples in the south. But, like the Greeks, the Etruscans never formed a unified nation. They remained a loose federation of individual city-states, united by a common language and religion, but given to conflict and slow to unite against a common enemy. This may have been one cause of their gradual downfall. In 474 BCE, the Etruscan fleet was defeated by the navy of its archrival, Syracuse. And during the later fifth and fourth centuries BCE, one Etruscan city after another fell to the Romans. By 270 BCE, all of the Etruscan city-states had lost their independence to Rome, although many continued to prosper, if we are to judge by the splendor of their tombs during this period of political struggle.

The bulk of our information about Etruscan culture comes from art, and especially from the numerous monumental tombs that they furnished with sculptures and paintings. The objects from these funerary structures attest to the reputation of the Etruscans as fine sculptors and metalworkers. Large numbers of Attic painted vases have also been found in these tombs, offering great insight into the history of Greek art, and demonstrating the close trade ties that Etruscans had with Greece. The tombs themselves provide us with information about Etruscan building practices, and they are often painted with scenes that offer a glimpse of Etruscan life. All of these art forms were passed on to the Romans, who transformed them for their own purposes.

Detail of figure 6.16, *Apollo*

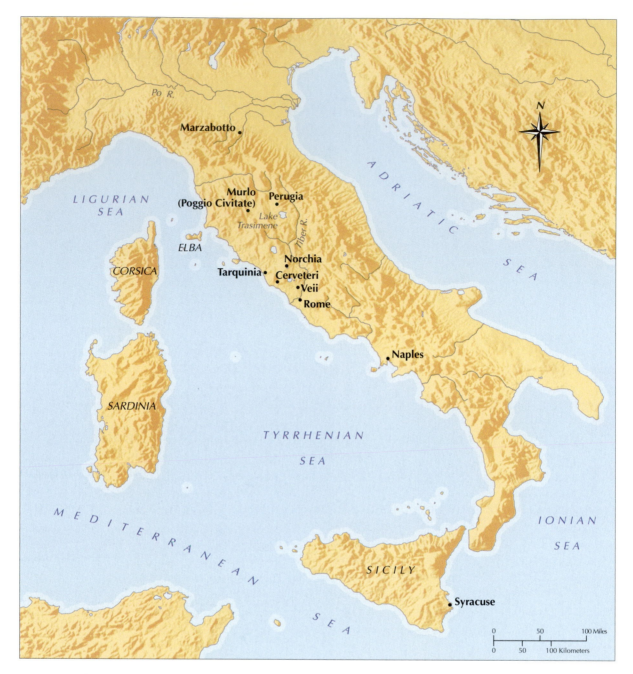

Map 6.1. Italy in Etruscan Times

FUNERARY ART

As with burials elsewhere in prehistoric Europe, Italian Iron Age burials were modest. The deceased were either buried in shallow graves or cremated and the ashes, contained in a pottery vessel or cinerary urn, placed in a simple pit. Buried with

some of the dead were offerings of weapons for men and jewelry and weaving implements for women. Early in the seventh century BCE, as Etruscans began to bury their dead in family groups, funerary customs for both men and women became more elaborate, and the tombs of the wealthy were gradually transformed into monumental structures.

Tombs and Their Contents

Named for the amateur archeologists who excavated it, the Regolini-Galassi Tomb at Cerveteri is an early example of this more elaborate burial practice, dating to the so-called Orientalizing phase of the mid-seventh century, when Etruscan arts show a marked influence of Eastern motifs. Etruscans carved their tombs out of the local volcanic stone or formed mounds called *tumuli*. These were grouped together outside the living spaces of Etruscan towns to create a *city of the dead*, or

necropolis. In this example, the long *dromos* (plural, *dromoi*) or pathway leading into the tomb is roofed with corbeled vaults built of horizontal, overlapping courses of stone blocks, similar to the casemates at Tiryns (see fig. 4.20). Among the grave goods found in the Regolini-Galassi Tomb was a spectacular **fibula** (fig. **6.1**). A fibula resembled a brooch or a decorative safety pin, and often served to hold a garment together at the neck. At 11 ½ inches in length, this magnificent example is a *tour de force* of the goldsmith's art (see *Materials and Techniques*, page 164) and justifies the fame Etruscan goldsmiths enjoyed in antiquity. Covering the lower leaflike portion are 55 gold ducks in the round. On the upper portion, which is shaped as a three-quarter-moon, pacing lions are defined in repoussé. The workmanship is probably Etruscan, but the animal motifs suggest the Etruscans were familiar with the art works of Near Eastern cultures (see fig. 2.11). The profile pose and erect stance of the lions in repoussé may derive from Phoenician precedents. Also found in tombs of this time are precious objects imported from the ancient Near East, such as ivories.

The Regolini-Galassi Tomb is but one of many "tumulus tombs" or mounds built at necropoli near Cerveteri over the course of several centuries until about 100 BCE (fig. **6.2**). The local stone of the region is a soft volcanic rock known as *tufa*, which is easy to cut and hardens after prolonged exposure to the air. Those responsible for building the *tumuli* would excavate into bedrock, cutting away a path and burial chambers. They used the excavated stone to build a circular retaining wall around the tomb chambers, and piled up soil above it. There were often several *dromoi* (pathways) in a single mound, leading to independent networks of chambers (fig. **6.3**).

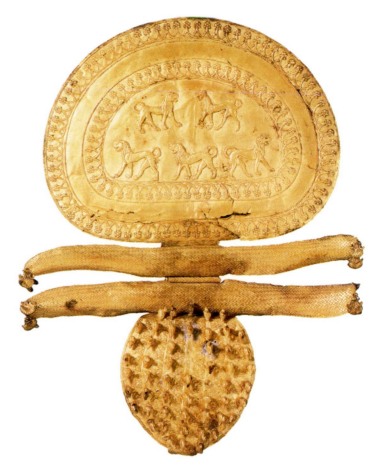

6.1. Fibula from Regolini-Galassi Tomb, Cerveteri. Gold. ca. 670–650 BCE. 11½″ long. Musei Vaticani, Museo Gregoriano Etrusco, Città del Vaticano, Rome

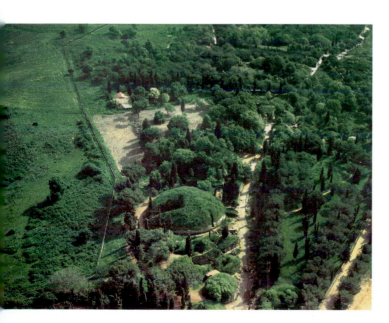

6.2. Aerial view of part of Banditaccia Cemetery. 7th–2d centuries BCE. Cerveteri, Italy

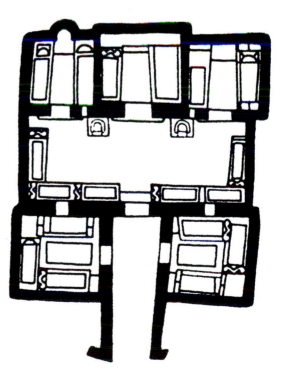

6.3. Plan of Tomb of the Shields and Chairs. ca. 550–500 BCE. Cerveteri, Italy

Etruscan Gold-Working

Early in their history, the Etruscans became talented metalworkers, with special proficiency in gold working. The goldsmith responsible for the fibula in figure 6.1 was a master of two complex techniques: filigree and granulation.

Filigree is the art of soldering fine gold wires—singly or twisted together into a rope—onto a gold background. The goldsmith used this process to outline the ornamental decoration and two-dimensional animals on the fibula's surface. Etruscan artists were so expert that they could even create open-work designs independent of a back-plate.

Granulation describes the process of soldering tiny gold balls or grains onto a background. Skilled Etruscan artists worked with grains as small as .004 of an inch (.14 mm), using them to decorate large areas, or to define linear or geometric patterns. Alternatively, they might employ them in conjunction with embossed designs, or in a mass to create a silhouette against the background; finally, they might cover the background with grains, leaving a design in silhouette.

Mastery of granulation was lost in early medieval Europe, as tastes changed and different gold-working techniques were preferred. Various methods are used today, but scholars do not know how Etruscan goldsmiths prepared the grains. Perhaps they placed fragments of gold in a crucible, separating the fragments with charcoal. When heated, the gold would melt into separate balls, kept apart by the charcoal, which was then removed. Alternatively, they may have poured molten gold into water from a height, or into a charcoal-filled vessel. When the liquid metal reached the water, it would cool into solid form; pouring it from a height would assure that tiny grains would form into small balls. For all but the simplest designs (which were applied straight to the background),

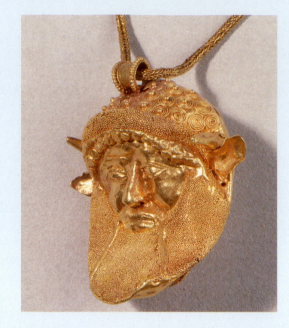

Pendant representing the head of Acheloos, decorated with granulation. 6th century BCE. Louvre, Paris

the grains were probably arranged in a design engraved on a stone or metal plate. The goldsmith then lowered a piece of adhesive-covered papyrus or leather, fixed to the end of a tube, over the design, to pick up the grains. They could then be treated with solder and transferred to the gold back-plate.

The layout of the burial chambers could vary widely, and scholars have tended to believe that these dwellings of the dead evoked the plans of contemporary houses. This may be true, but it is impossible to confirm given the scant evidence for Etruscan residences. In any case, sculptors often carved chairs or beds out of the rock to furnish the chambers. A late example, the Tomb of the Reliefs at Cerveteri, has everything the dead might want in the afterlife, applied in stucco onto the walls (fig. **6.4**). The piers and the wall surfaces between the niches are covered with reproductions of weapons, armor, household implements, and small domestic animals. Two damaged busts may once have represented the dead or underworld deities. While the concept of burying items that would be of service in the afterlife is reminiscent of Egyptian funerary practice, replicas of actual items differ markedly from what is found in Egyptian tombs.

Decoration of a very different kind enlivened the tombs of the necropolis further north at Tarquinia. Here, where tombs consist of chambers sunk into the earth with a steep underground *dromos* leading to each, vibrant paintings cover the walls. Painted onto the plaster while it was wet, these images

offer a glimpse into the activities enjoyed by the deceased. Pictured here is a scene from the Tomb of Hunting and Fishing, dating to about 530–520 BCE (fig. **6.5**) during the Archaic period. At one end of the low chamber is a marine panorama. In the vast expanse of water and sky, fishermen cast fishing lines from a boat, as brightly colored dolphins leap through the waves. A sling-shot artist stands on a rocky promontory and aims his fire at large birds in bright red, blue, and yellow that swoop through the sky. Unlike Greek landscape scenes, where humans dominate their surroundings, here the figures are just one part of a larger scheme. The exuberance of the colors and gestures, too, are characteristically Etruscan. All the same, here as in most tombs, the treatment of drapery and anatomy reveals that Etruscan tomb painters were deeply influenced by developing Greek painting. In fact, great numbers of Attic painted vases were discovered in Etruscan tombs.

The Etruscan artist seems to have conceived of the scene as a view from a tent or hut, defined by wide bands of color at cornice level and roofed with a light tapestry. Hanging from the cornice are festive garlands of the kind probably used during funerary rituals. In many tombs, the gable is filled

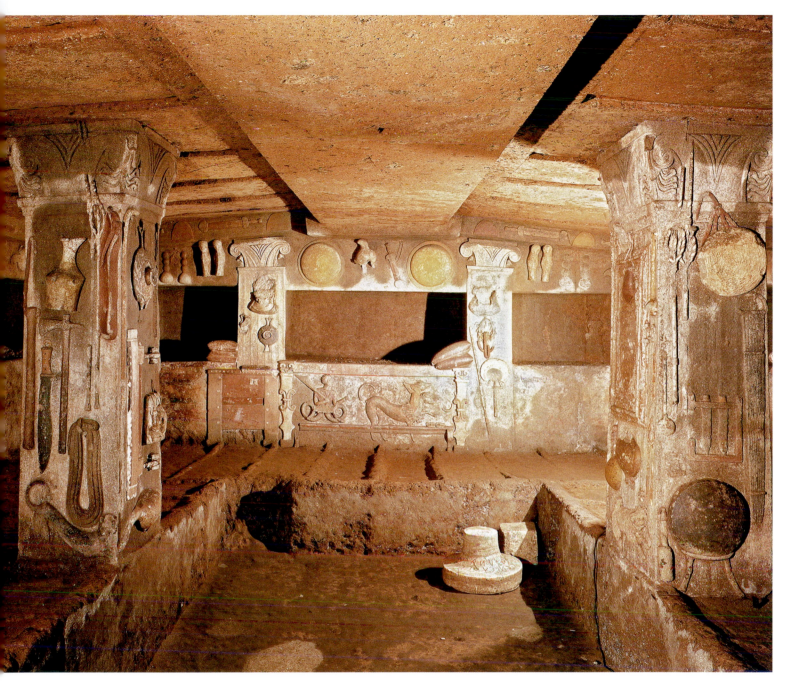

6.4. Burial chamber, Tomb of the Reliefs. 3rd century BCE. Cerveteri, Italy

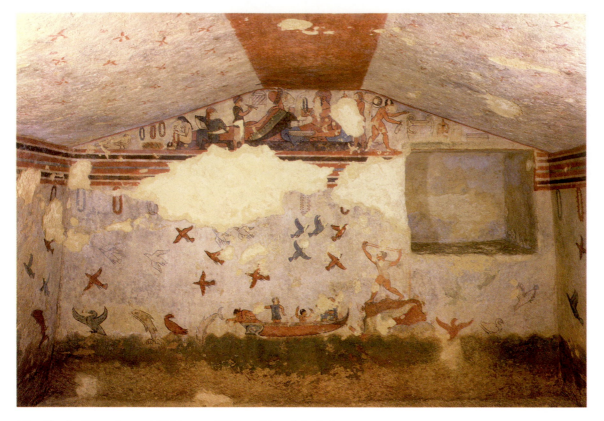

6.5. Tomb of Hunting and Fishing. ca. 520 BCE. Tarquinia, Italy

with images of animals—leopards, sometimes, or fantastic hybrids—perhaps used as guardian figures to ward off evil. Above this scene, a man and woman recline together at a banquet, where musicians play their instruments and servants wait on them. One draws wine from a large mixing bowl, or krater, while another makes wreaths. In contrast to Greek drinking parties (*symposia*), which were reserved for men and courtesans, Etruscan scenes of banqueting include respectable women who recline together with men. Paintings of banquets appear frequently in Etruscan tombs; athletic games were another common subject, as were scenes with musicians and dancers, such as the lively example illustrated here from the Tomb of the Triclinium, dating to about 470–460 BCE (fig. **6.6**).

The deeper purpose of these paintings is less clear. They may record and perpetuate rituals observed on the occasion of

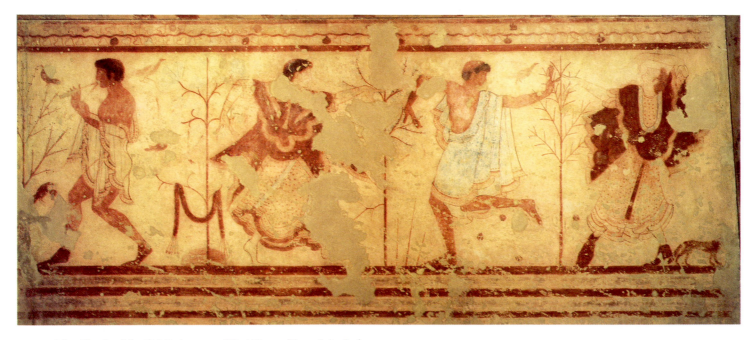

6.6. Tomb of the Triclinium. ca. 470–460 BCE. Tarquinia, Italy

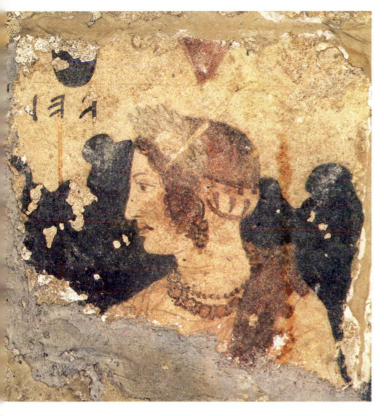

6.7. Tomb of Orcus. 350–300 BCE. Tarquinia, Italy

ART IN TIME

ca. 600s–500s BCE—The height of Etruscan power

ca. 520 BCE—**Etruscan terra-cotta sarcophagi from Cerveteri**

ca. 518—Construction of the Persian palace at Persepolis begins

ca. 480–336 BCE—Classical period in Greece

270 BCE—All Etruscan city-states had lost their independence to Rome

the funeral (the games, in fact, are probably the forerunners of Roman gladiatorial contests). Or, like Egyptian tomb paintings, they may have served as provisions for the afterlife of the deceased. At the heart of the problem of interpretation lies our general ignorance about Etruscan beliefs concerning death and the afterlife. Roman writers described them as a highly religious people, and their priests are known to have read meaning into the flight of birds in different sectors of the sky. Yet, as mysterious as these paintings are, they constitute a large part of our evidence for understanding Etruscan beliefs. In a few tombs, the paintings seem to reflect Greek myths, but in a sense these paintings merely compound the problem, since we cannot be sure whether the Etruscans intended the same meaning as Greek artists.

However we interpret these images of the archaic and classical times, it is clear that a distinct change in the content of tomb paintings begins in the late classical period during the fourth century BCE. The Tomb of Orcus at Tarquinia, dating to the second half of the fourth century BCE, illustrates this well (fig. **6.7**). The fragmentary painting depicts the head of a noble woman, whom an inscription identifies as a member of the Velcha family. Her pale face is silhouetted against a dark cloud, and the exuberant palette of the earlier period, with its bright reds and yellows, gives way to a somber range of darker colors. At this time, funerary images are often set in a shadowy underworld, or depict processions taking the deceased to a world of the dead. An overwhelming sense of sadness now replaces the energetic mood of the Archaic and Classical period. It is possible that dark subjects reflected difficult times. During the latter part of the fourth century BCE, the Romans conquered

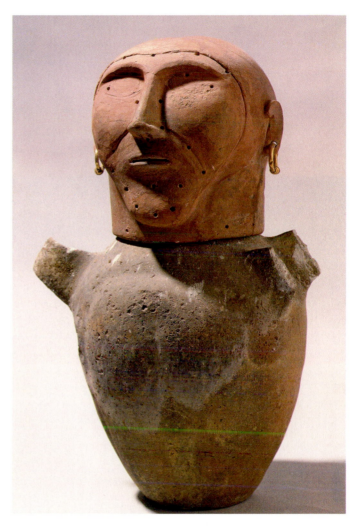

6.8. Human-headed cinerary urn. ca. 675–650 BCE. Terra cotta, height $25\frac{1}{2}''$ (64.7 cm). Museo Etrusco, Chiusi, Italy

Etruscan cities and forced them into subordination. In some tombs of this later period, ominous demons of death appear, painted green and blue.

Similar changes appear in the containers used for the remains of the dead. In the Orientalizing period, the pottery urns traditionally used for ashes gradually took on human shapes (fig. **6.8**). The lid became a head, perhaps intended to represent the deceased, and body markings appeared on the

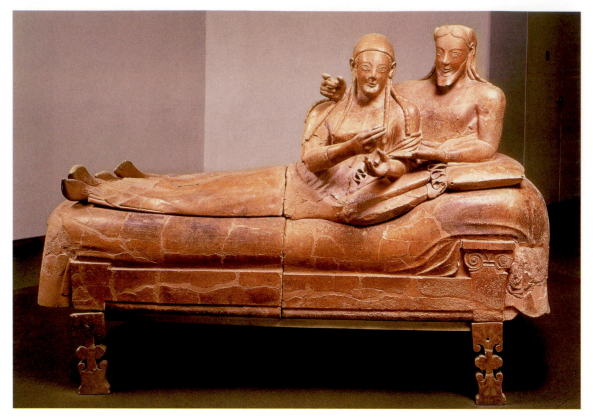

6.9. Sarcophagus, from Cerveteri. ca. 520 BCE. Terra cotta, length 6'7" (2 m). Louvre

vessel itself. Hair and jewelry may have been attached where holes appear in the terra-cotta surface. Sometimes the urn was placed on a sort of throne in the tomb, which may have indicated a high status for the deceased.

In Cerveteri, two monumental sarcophagi of the Archaic period were found, molded in terra cotta in two separate halves. One of them, dating to about 520 BCE, is shown here

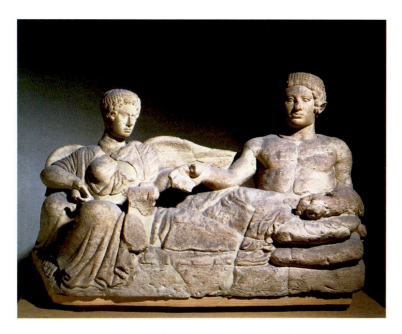

6.10. *Youth and Female Demon.* Cinerary container. Early 4th century BCE. Stone (*pietra fetida*), length 47" (119.4 cm). Museo Archeologico Nazionale, Florence

(fig. **6.9**). The lid is shaped like a couch, and reclining side by side on top are full-length sculptures of a man and woman, presumably a married couple. Instead of a pillow, a wineskin (a soft canteen made from an animal skin) cushions the woman's left elbow, and the man has his arm around her shoulders. Both figures once held out objects in their hands—a cup or an *alabastron* (a perfume container), perhaps, or an egg, symbol of eternity. Despite the constraints of the Archaic style, with its abstract forms and rigid poses, the soft material allows the sculptor to model rounded forms and capture the extraordinary directness and vivacity that are characteristic of Etruscan art. The entire work was once painted in bright colors, which have been revealed more clearly in a recent cleaning.

The change in mood, from optimistic to somber, that characterizes tomb paintings between the fifth and fourth centuries is just as apparent in funerary objects, as can be seen if we compare the sarcophagus in figure 6.9 with a cinerary container made of soft stone soon after 400 BCE (fig. **6.10**). As in wall paintings of this period, a woman sits at the foot of the couch. Yet she is not the young man's wife. Her wings identify her as demon from the world of the dead, and the scroll in her left hand may record his fate. He wears his mantle pulled down around his waist, in the Etruscan style. The two figures at either end of the couch create a balanced composition, but the separation of the figures marks a new mood of melancholy associated with death, which each individual must face alone. Still, wealthy Etruscans continued to bury their dead together in family tombs, and the familial context for cinerary urns like this one must have gone some way toward mitigating the isolation of death (fig. **6.11**). Moreover, while cinerary urns of this

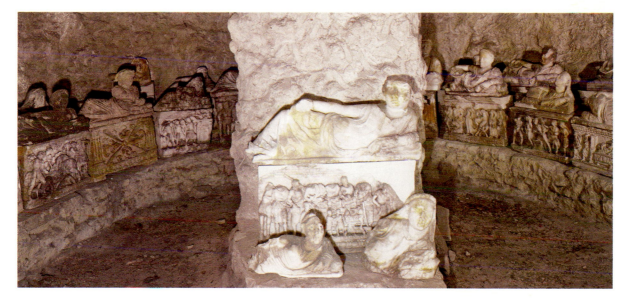

6.11. Funerary urns in the Inghirami Tomb. Hellenistic period. Volterra, Italy

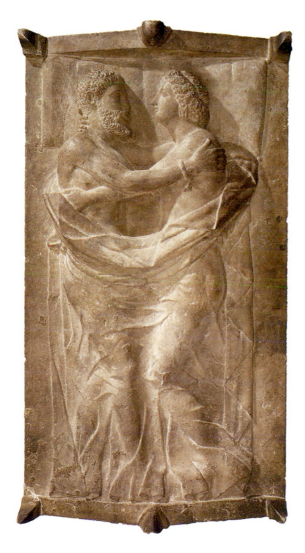

6.12. Sarcophagus lid of Larth Tetnies and Thanchvil Tarnai. ca. 350–300 BCE. Marble, length 7′ (2.13 m). Museum of Fine Arts, Boston. Gift of Mrs. Gardner Brewer, © 2006, Museum of Fine Arts, Boston. 86.145 a-b

kind were typical, most with a single figure reclining on the lid, a few grander sarcophagi survive. On the lid of one are carved a man and woman in a tender embrace, lying under a sheet as if in their marital bed (fig. **6.12**). The coiffures and beard reflect Greek fashion, and the sides of the chest feature battle scenes influenced by Greek iconography, yet the finished product is definitively Etruscan.

ARCHITECTURE

According to Roman writers, the Etruscans were masters of architectural engineering, town planning, and surveying. Almost certainly, the Romans learned from them, especially in the areas of water management (drainage systems and aqueducts) and bridge building, but how much they learned is hard to determine, since little Etruscan or early Roman architecture is still standing. Built predominantly with wood or mud brick, these structures typically did not survive. Additionally, many Etruscan towns lie beneath existing Italian hill towns, and permanent materials used in their building have often been reused.

Etruscan cities generally sat on hilltops close to a navigable river or the sea. In some places, massive defensive walls were added, from the seventh century BCE on. A late example of civic architecture survives from the city of Perugia, where sections of a fortification wall and some of its gates still stand. The best known of these is the Porta Marzia (the Gate of Mars) of the second century BCE, the upper portion of which is encased in a later wall (fig. **6.13**). It is an early example of a *voussoir* arch, built out of a series of truncated wedge-shaped stones called **voussoirs** set in a semicircle using a disposable wooden framework during construction. Once they were in place, they were remarkably strong; any downward thrust from above (the weight of the wall over the void, for instance) merely strengthened their bond by pressing them more tightly against one

6.13. Porta Marzia. 2d century BCE. Perugia, Italy

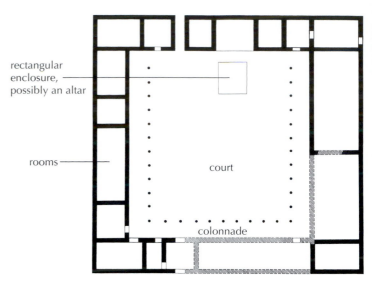

6.14. Plan of residential complex. 6th century BCE. Murlo (*Poggio Civitate*), Italy

another. Above the arch, and separated by engaged pilasters, sculpted figures of Tinia (the Etruscan equivalent of Zeus or Jupiter) and his sons (equivalent to Castor and Pollux) with their horses look out over a balustrade. The arch is visual proof of the confluence of cultures so prevalent in the Mediterranean in the last centuries before the Common Era.

City Planning

The hilltops of Etruria did not lend themselves to grid planning, yet there is good evidence at sites like Marzabotto that when the Etruscans colonized the flatlands of the Po Valley in northern Italy, from the sixth century BCE on, they laid out newly founded cities as a network of streets. These centered on the intersection of two main thoroughfares, one running north and south (the *cardo*) and one running east and west (the *decumanus*). The resulting four quarters could be further subdivided or expanded, according to need. This system seems to reflect the religious beliefs that made the Etruscans divide the sky into regions according to the points of the compass. The Romans also

adopted it for the new colonies they founded throughout Italy, western Europe, and North Africa, and for military camps.

Little survives of the houses that composed Etruscan towns. Unlike tombs, they were built with a packed-earth technique (pisé) similar to wattle and daub or adobe, with only the base made of stone. Even these stone footprints are hard to discern, since the hilltops favored by the Etruscans have been inhabited more or less continually since their days. In a few places, however, the remains of monumental building complexes have been excavated. These may have been palaces or large villas. An especially fine example existed at Poggio Civitate (present-day Murlo) in the sixth century BCE, where numerous rooms framed a large central courtyard (fig. **6.14**). This kind of architecture may be the conceptual forerunner of typically Roman atrium houses (see fig. 7.50).

Temples were built of mud brick and wood, and once again only the stone foundations have survived. Early temples consisted of little more than modest rectangular *cellas* (rectangular rooms for holding cult figures). Later temples were profoundly influenced by the innovative design of the massive Temple of Jupiter Optimus Maximus on the Capitoline Hill in Rome, ruled at the time by Etruscan kings (see fig. 7.1). As a result, they are characterized by a tall base, or podium, with steps only on the front (fig. **6.15**). The steps lead to a deep porch, supported by rows of columns, and to the cella beyond, which was often subdivided into three compartments. The roof, made of terracotta tiles, hung well over the walls in wide eaves, to protect the mud bricks from rain.

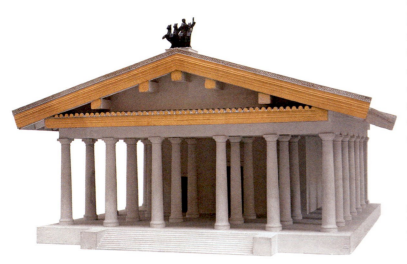

6.15. Reconstruction of an Etruscan temple, as described by Vitruvius. Museo delle Antichità Etrusche e Italiche, Università di Roma "La Sapienza"

ART IN TIME

ca. 1000 BCE—Appearance of Etruscan culture on the
Italian peninsula

500s BCE—Etruscans begin colonizing the flatlands south
of Rome

447–432 BCE—Construction of the Parthenon in Athens

331 BCE—Defeat of the Persians by Alexander the Great

**200s BCE—Surviving Etruscan gate, the Porta Marzia,
built in Perugia**

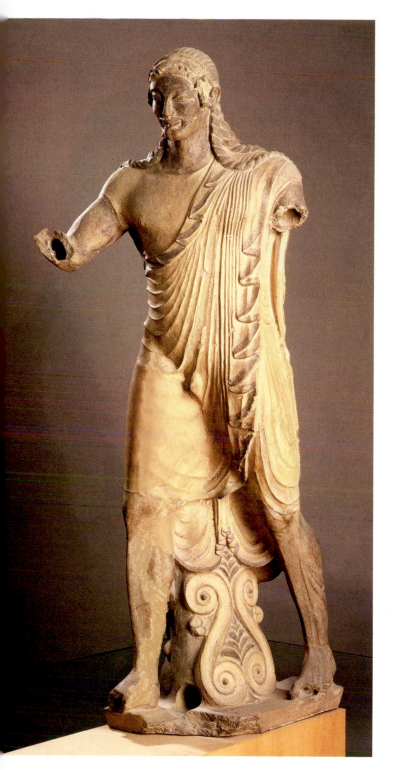

6.16. *Apollo (Aplu)*, from Veii. ca. 510 BCE.
Terra cotta, height 5′9″ (1.75 m).
Museo Nazionale di Villa Giulia, Rome

SCULPTURE

As with their Greek counterparts, Etruscan temples were high-
ly ornate, but where Greeks used marble to adorn their tem-
ples, Etruscans had little access to this material. The decoration
on Etruscan temples usually consisted of brightly painted terra-
cotta plaques that covered the architrave and the edges of the
roof, protecting them from dampness. After about 400 BCE,
Etruscan artists sometimes designed large-scale terra-cotta
groups to fill the pediment above the porch. The most dramat-
ic use of sculpture, however, was on the ridgepole—the hori-
zontal beam at the crest of a gabled roof. Terra-cotta figures at
this height depicted not only single figures but narratives. One
of the most famous surviving temple sculptures comes from
Veii, a site some 14 miles north of Rome. Both Roman texts and
archeological evidence indicate that Veii was an important
sculptural center by the end of the sixth century BCE.

Dynamism in Terra Cotta and Bronze

The late sixth-century Temple at Veii was probably devoted to
Menrva, Aritimi, and Turan. Four life-size terra-cotta statues
crowned the ridge of the roof. (Similar examples appear in the
reconstruction model, fig. 6.15.) They formed a dynamic and
interactive group representing the contest of Hercle (Hercules)
and Aplu (Apollo) for the sacred hind (female deer) in the pres-
ence of other deities. The best preserved of the figures is Aplu
(fig. **6.16**). He wears a mantle with curved hem later known to
Romans as a toga. The drapery falls across his form in orna-
mental patterns and exposes his massive body, with its sinewy,
muscular legs. The stylistic similarity to contemporary Greek
kouros and kore figures signals the influence Greek sculpture
must have had on the Etruscans. But this god moves in a hur-
ried, purposeful stride that has no equivalent in free-standing
Greek statues of the same date. Rendered in terra cotta, which
allowed greater freedom for the sculptor to experiment with
poses, this is a purely Etruscan energy. These sculptures have
been attributed to a famous Etruscan sculptor, Vulca of Veii,
known from Latin literary sources.

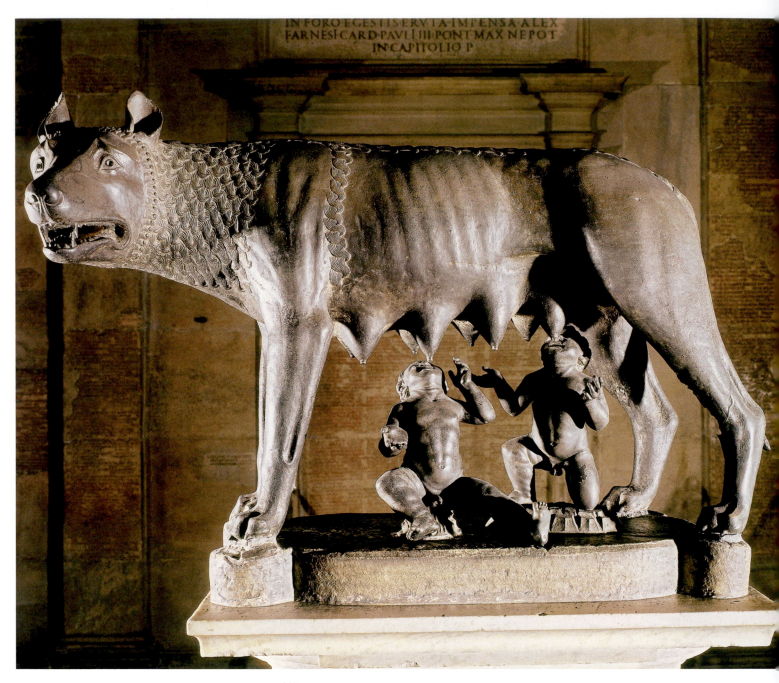

6.17. *She-Wolf.* ca. 500 BCE. Bronze, height 33½″ (85 cm). Museo Capitolino, Rome

Etruscan sculptors also demonstrated extraordinary skill as bronze casters. One of the most renowned works of Etruscan sculpture is the bronze *She-Wolf* now housed in the Capitoline Museum in Rome (fig. **6.17**). It dates from the fifth century BCE, and almost certainly, judging by its workmanship, it was made by an Etruscan artist. The stylized, patterned treatment of the wolf's mane and hackles sets off the smoothly modeled muscularity of her body, tensed for attack. Simple lines add to her power: The straight back and neck contrast with the sharp turn of the head toward a viewer, highlighting her ferocity. So polished is the metal's surface that it almost seems wet; her fangs seem to glisten. The early history and subject matter of this statue is unknown. However, evidence suggests that it was highly valued in later antiquity, particularly by the Romans. According to legend, Rome was founded in 753/52 BCE by the twin brothers Romulus and Remus, descendants of refugees from Troy in Asia Minor. Abandoned as babies, they were nourished by a she-wolf in the wild. Later Romans may have seen in this Etruscan bronze a representation of their legendary mother wolf. The early fourth-century CE emperor Maxentius built a grand palace in Rome, and there, in a large *exedra* (alcove) framed by a walkway, archeologists found a statue base with fittings that exactly match the footprints of the she-wolf. The twin babies Romulus and Remus beneath her were added between 1471 and 1473, probably by Antonio Polaiuolo, to resemble Roman coin representations of the lactating she-wolf with the babies.

The Etruscan concern with images of the dead might lead us to expect an early interest in portraiture. Yet the features of funerary images such as those in figures 6.9 and 6.10 are stylized rather than individualized. Not until a century later, toward 300 BCE, did individual likenesses begin to appear in Etruscan sculpture. Greek portraiture may have influenced the change, but terra cotta, the material of so much Etruscan sculpture, lent itself to easy modeling of distinctive facial features. Some of the finest Etruscan portraits are heads of bronze statues, such as the portrait of a boy illustrated here (fig. **6.18**). The artist was a master of his craft, exploiting the full range of surface finishes possible in bronze, from the rough eyebrows to the striated locks of hair to the smooth, modeled flesh.

A life-size bronze sculpture of an orator known today as *L'Arringatore* (the *Orator*) shows how impressive these full length sculptures once were (fig. **6.19**). Most scholars place this sculpture in the early years of the first century BCE. It comes from Lake Trasimene, in the central Etruscan territory, and

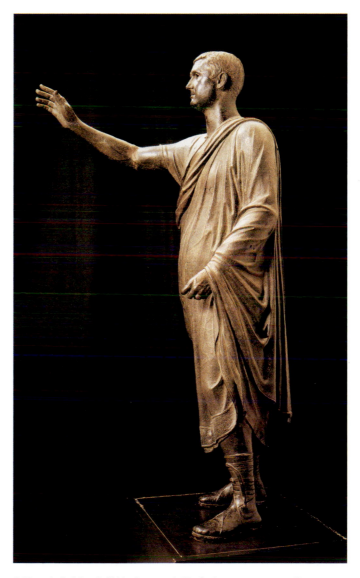

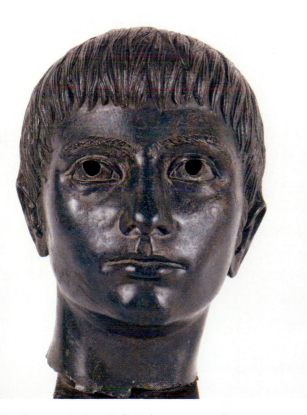

6.18. *Portrait of a Boy*. Early 3rd century BCE. Bronze, height 9″ (23 cm). Museo Archeologico Nazionale, Florence

6.19. *Aule Meteli (L'Arringatore)*. Early 1st century BCE. Bronze, height 71″ (280 cm). Museo Archeologico Nazionale, Florence

SCULPTURE

ca. 510 BCE—The Etruscan Temple at Veii

ca. 500 BCE—Etruscan bronze She-Wolf sculpture

ca. 450–440 BCE—Doryphoros of Polykleitos

ca. 300 BCE—Appearance of individual likenesses in
Etruscan art

bears an Etruscan inscription that includes the name Aule Meteli (*Aulus Metellus* in Latin), presumably the name of the person it represents. The inscription shows that the workmanship is Etruscan, yet the high boots mark the subject as a Roman, or at least an official appointed by the Romans. The raised arm, a gesture that denotes both address and salutation, is common to hundreds of Roman statues. The sculpture raises inevitable questions about the roles of artist and patron in the conquered Etruscan territories. The high quality of the casting and finishing of these bronze works bears out the ancient Etruscans' fame as metalworkers. Their skill is hardly surprising in a land whose wealth was founded on the exploitation of copper, iron, and silver deposits.

From the sixth century BCE on, Etruscans produced large numbers of bronze statuettes, mirrors, and other objects for domestic use and for export. The backs of mirrors were often engraved with scenes taken from Etruscan versions of Greek myths devoted to the loves of the gods. Such amorous subjects were entirely appropriate for objects used for self-admiration.

The design on the back of a mirror created soon after 400 BCE (fig. **6.20**) is of a different genre, and shows how the Etruscans adapted Greek traditions as their own. Within an undulating wreath of vines stands a winged old man, one foot raised upon a rock. An inscription identifies him as the seer Chalchas, an Etruscan version of the Greek seer Chalchas known from Homer's *Iliad*. Yet this is the full extent of the borrowing, for the winged genius is engaged in a pursuit that was central to Etruscan ritual: He is gazing intently at the liver of a sacrificial animal, searching for omens or portents.

The Etruscans believed that the will of the gods was expressed through signs in the natural world, such as thunderstorms or, as we have seen, the flight of birds, or even the entrails of sacrificed animals. In fact, they viewed the liver as a sort of microcosm, divided into sections that corresponded to the 16 regions of the sky. By reading natural signs, those priests who were skilled in the arts of *augury*, as this practice was called, could determine whether the gods approved or disapproved of their acts. These priests enjoyed great prestige and power, and long after Etruscan culture had been subordinated to the Romans, they continued to thrive. The Romans themselves consulted them before any major public or private event. As the Roman philosopher and statesman Seneca wrote: "This is the difference between us and the Etruscans. . . . Since they attribute everything to divine agency, they are of the opinion that things do not reveal the future because they have occurred, but that they occur because they are meant to reveal the future." Mirrors, too, were valued for their ability to reveal the future, which is probably why this scene is represented here.

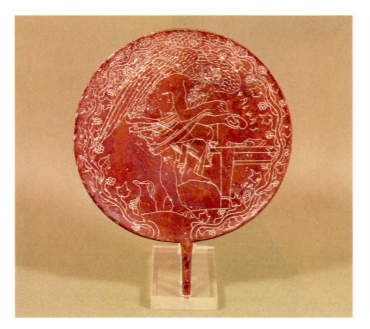

6.20. Engraved back of a mirror. ca. 400 BCE. Bronze, diameter 6″ (15.3 cm). Musei Vaticani, Museo Gregoriano Etrusco, Città del Vaticano, Rome

SUMMARY

Etruscan culture appeared on the Italian peninsula around 1000 BCE. The ancient Etruscans were skilled sailors and merchants whose wealth was founded on the exploitation of available copper, iron, and silver deposits. Most of what survives today comes from their numerous tombs. Artists crafted objects ranging from small-scale jewelry to life-size figures. Some of the objects are made from materials—such as ivory—that were acquired through trade. Etruscan priests enjoyed great prestige and power, even after their culture had become subordinate to that of the Romans.

FUNERARY ART

The Etruscans began to bury their dead in family groups early in the seventh century BCE. Over time, tomb construction for the wealthy became more monumental. Many tombs were carved out of local volcanic stone and included spectacular grave goods, including precious objects of gold and ivory. Some tombs were decorated with vibrant wall paintings, and housed beguiling funerary objects such as terra-cotta sarcophagi that depict reclining figures.

ARCHITECTURE

Etruscan cities generally sat on hilltops close to a navigable river or the sea. There is good evidence that some cities in the flatlands were laid out as a network of streets, a system adopted by the Romans. Very little Etruscan architecture is still standing, since their houses and temples were built of packed earth and mud brick. However, a rare example of their civic architecture does survive in a stone gate in the city of Perugia.

SCULPTURE

The Etruscans embellished their temples with terra-cotta decorations. Common decorations included brightly painted plaques and groupings of sculpted figures. Fine sculptures in bronze also survive, reflecting the masterful talents of Etruscan metalworkers.

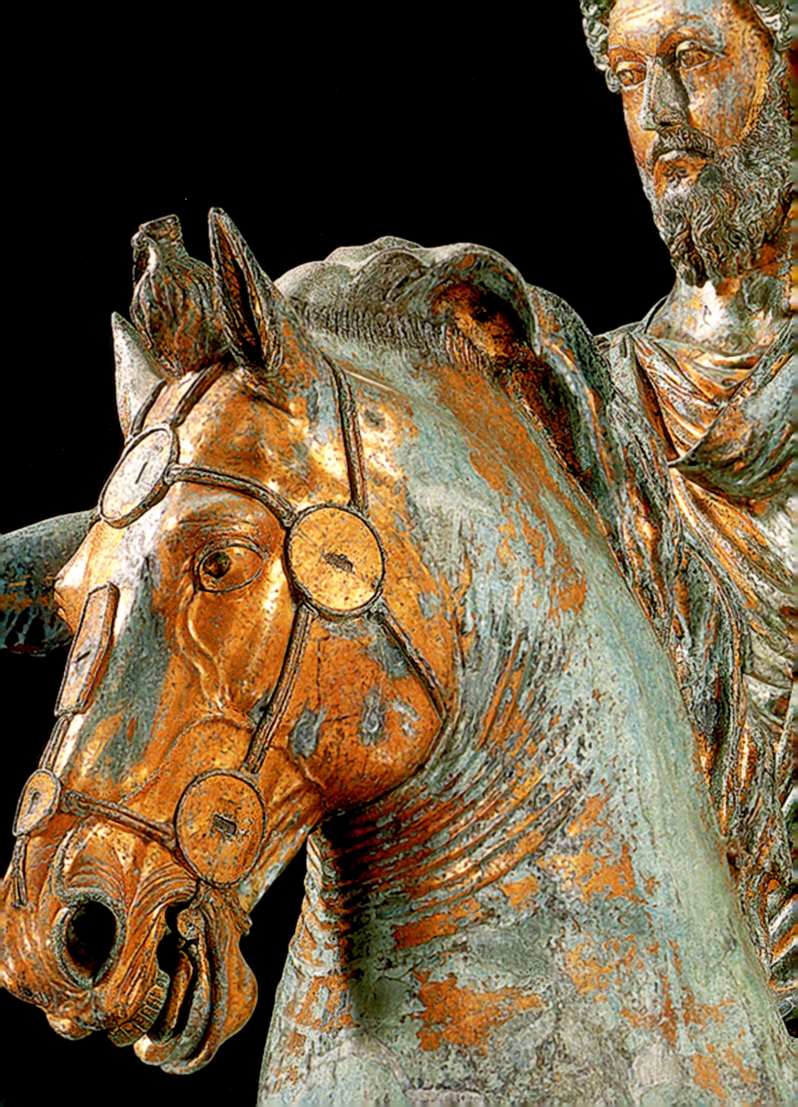

Roman Art

OF ALL THE CIVILIZATIONS OF THE ANCIENT WORLD, THE MOST accessible to modern scholars is the culture of ancient Rome. A vast literary legacy, ranging from poetry and histories to inscriptions that recorded everyday events, reveals a great deal about Roman culture. The Romans also built vast numbers of monuments throughout their

empire, which are extraordinarily well preserved. Yet there are few questions more difficult to address than "What is Roman art?"

Much of Roman public art draws heavily on Greek styles, both Classical and Hellenistic. In the nineteenth and early twentieth centuries, influenced by early art historians like Winckelmann (see *The Art Historian's Lens*, page 179), art connoisseurs exalted Greek classicism as the height of stylistic achievement, and they considered Roman art derivative, the last chapter, so to speak, of Greek art history. This view changed radically in the ensuing years, especially as pure connoisseurship began to give way to other branches of art history. Scholars are now more interested, for instance, in the roles of a work of art in its social and political contexts. Yet regardless of how one judges artists in Rome for drawing so consistently on Greek styles, it was by no means the only style at play in the Roman world. There were phases of distinct "Egyptomania" in Rome, for instance; and works of art created in the provinces or by the nonelite have their own style, as do those of late antiquity.

Roman art was the art of both Republic and Empire, the art of a small city that became a vast empire. It is an art created by Roman artists, but also by Greeks; the greatest architect of Trajan's time may have been from Damascus. Perhaps the most

Detail of figure 7.21, *Equestrian Statue of Marcus Aurelius*

useful way to think of Roman art is to see it as an art of *syncretism*—an art that brings diverse elements together to produce something entirely new, with an extremely strong message-bearing potential. Syncretism was a profoundly Roman attitude, and was probably the secret to Rome's extraordinarily successful expansion. From the very start, Roman society was unusually tolerant of non-Roman traditions, as long as they did not undermine the growing state. The populations of newly conquered regions were not, on the whole, subordinated to Roman custom, and many were eventually accorded the rights of citizenship. Their gods were hospitably received in the capital. Roman civilization integrated countless other cultures, leading to a remarkably diverse world.

EARLY ROME AND THE REPUBLIC

According to Roman legend, Romulus founded the city of Rome in 753/52 BCE, in the region known as Latium, on a site near the Tiber River. But archeological evidence shows that people had lived there since about 1000 BCE. From the eighth to the sixth centuries BCE, Rome expanded under a series of kings. This "regal period" ended with a series of Etruscan kings who substantially improved the city. They built the first defensive wall around the settlement, drained and filled the swampy plain of the Forum, and built a vast temple on the Capitoline Hill, thus making an urban center out of what had been little

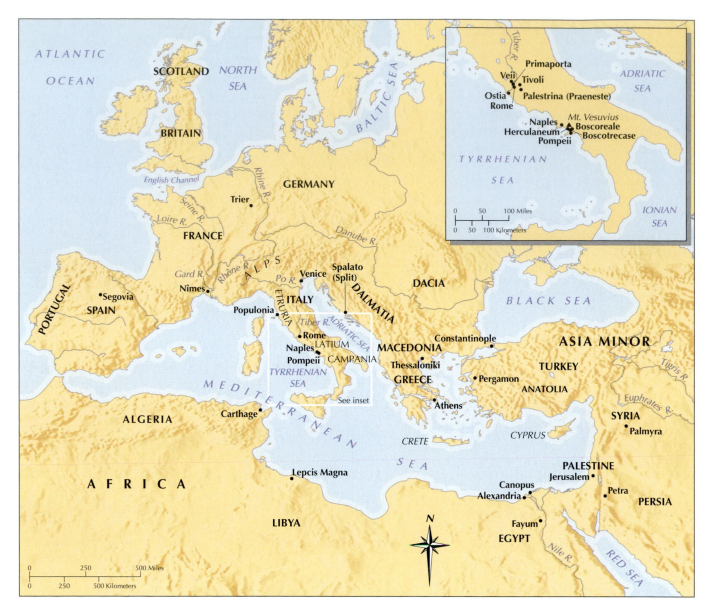

Map 7.1. The Ancient Roman World

more than a group of villages. The kings established many of Rome's lasting institutions, such as the priesthoods and the Roman techniques of warfare. In about 509 BCE, according to literary sources, the Romans expelled the last of the Etruscan kings. During the following century, the Roman elite gradual-ly established the Republic, with an unwritten constitution.

Under the Republic, a group of elected magistrates, headed by two consuls, and with a Senate serving as an advisory coun-cil, managed the affairs of the growing state. A series of popular uprisings lasting over the next 200 years led to greater rights and representation for the nonelite. All Roman men who owned the required level of property were obliged to enter the army, and indeed military service was a prerequisite for political office. During the course of the Republic, Rome gradually took control of the Italian peninsula. First Rome and its ally, the Latin League, destroyed the southern Etruscan city of Veii in 396 BCE. The Gauls, from the north, sacked Rome in 390 BCE,

but this seems only to have spurred Rome on to greater con-quest. More than 40 years later, the Latin cities lost their inde-pendence, and by 275 BCE Rome controlled all of Italy, including the Greek colonies of the south. It soon engaged in the first of the three Punic (Latin for "Phoenician") Wars against the North African city of Carthage. The wars ended with the deci-sive razing of the city in 146 BCE. During the second century all of Greece and Asia Minor also came under Roman control. This led to the dramatic influx of Greek art and culture into Rome.

From about 133 BCE to 31 BCE, the Late Republic was in turmoil. Factional politics, mob violence, assassination, and competition among aristocratic families, led to the breakdown of the constitution and to civil war. Julius Caesar became per-petual dictator in 46 BCE, a position that other senators were unable to tolerate. Two years later, he was assassinated in Rome's Senate house. His heir, Octavian, took vengeance on the assassins, Brutus and Cassius, and then eliminated his own

Recognizing Copies: The Case of the Laocoön

In one of the most powerful passages of the *Aeneid*, Vergil describes the punishment of Laocoön. According to legend, Laocoön was a priest at the time of the Trojan War. He warned the Trojans against accepting the wooden horse, the famous gift that hid invading Greeks within. The goddess Minerva, on the side of the Greeks, punished Laocoön by sending two giant serpents to devour him and his sons. Vergil describes the twin snakes gliding out of the sea to the altar where Laocoön was conducting a sacrifice, strangling him in their terrible coils, turning sacrificer into sacrificed. (See end of Part I *Additional Primary Sources*.)

In January of 1506, a sculptural group depicting Laocoön and his sons writhing in the coils of snakes was unearthed on the Esquiline Hill in Rome. Renaissance humanists immediately hailed the group as an original Greek sculpture describing this brutal scene. It was, they thought, the very sculpture praised by Pliny the Elder in his *Natural History* (completed in 77 CE). Pliny believed the Laocoön that stood in Titus' palace to be the work of three sculptors from Rhodes: Hagesandros, Polydorus, and Athenodorus. Within the year after its discovery on the Esquiline Hill, the group had become the property of Pope Julius II, who installed it in his sculpture gallery, the Belvedere Courtyard in the Vatican. The sculpture quickly became a focus for contemporary artists, who both used it as a model and struggled to restore Laocoön's missing right arm (now bent behind him in what is considered the correct position). Its instant fame derived in part from the tidy convergence of the rediscovered sculpture with ancient literary sources: The masterpiece represented a dramatic moment in Rome's greatest epic and was described by a reputable Roman author.

The Laocoön group caught the rapt attention of the eighteenth-century art historian J. J. Winckelmann (see *The Art Historian's Lens*, page 156). He recognized a powerful tension between the subjects' agonizing death throes and a viewer's pleasure at the work's extraordinary quality. Such was his admiration that he could only see the piece as a Classical work, and dated it to the fourth century BCE; any later and it would be Hellenistic, a period that he characterized as a time of artistic decline. So began a wide debate on not only the date of the sculpture but also its originality. For many scholars, the writhing agony of the Trojan priest and his sons bears all the hallmarks of the Hellenistic baroque style, as seen in the gigantomachy (the war between gods and giants) of the Great Altar of Zeus at Pergamon (see figs. 5.73 and 5.74). A masterpiece of the Hellenistic style, it should date to the third or second century BCE. On the other hand, evidence from inscriptions links the three artists named by Pliny to sculptors at work in the mid-first century BCE, making the

sculpture considerably later and removing it from the apogee of the Hellenistic age. Yet there are cases of artists' names being passed down through several generations, and it is not at all clear that the group is in fact the sculpture Pliny admired.

Pliny specified that Laocoön was sculpted from a single piece of marble, and this sculpture is not; even more telling is the fact that a slab of Carrara marble—which was not available until the reign of Augustus (r. 27 BCE–14 CE)—is incorporated into the altar at the back. Is the sculpture then an early imperial work? Or is this much-lauded masterpiece a Roman copy of a Hellenistic work? If so, does that reduce its status? As if this were not debate enough, a recent contention takes Laocoön out of the realm of antiquity altogether, identifying it instead as a Renaissance work by none other than Michelangelo. Evidence cited includes a pen study by the artist depicting a male torso resembling Laocoön's, dating to 1501. At this point, all that can be said with certainty about Laocoön is that the tidy picture imagined by sixteenth-century admirers has become considerably murkier.

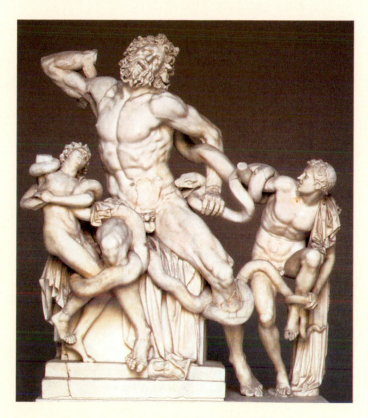

Laocoön Group, 1st century CE. Marble. Height 7′ (2.1 m). Musei Vaticani, Museo Pio Clementino, Cortile Ottagono, Città del Vaticano, Rome

rival for power, Mark Antony. In 27 BCE, the Senate named Octavian as Augustus Caesar, and he became *princeps*, or first citizen. History recognizes him as the first Roman emperor. During the course of the Republic, and continuing into the Empire, magistrates commissioned works of architecture and sculpture to embellish the city as well as to enhance their own careers. Designs of both architecture and sculpture were strongly influenced by conquests abroad and by the development of new building technologies in Rome.

Architecture: The Concrete Revolution

It is probably fair to say that Roman architecture has had a more lasting impact on western building through the ages than any other ancient tradition. It is an architecture of power, mediated through the solidity of its forms, and through the experience of those forms. Roman builders were clearly indebted to Greek traditions, especially in their use of the Doric, Ionic, and Corinthian styles, yet the resultant buildings were decidedly Roman.

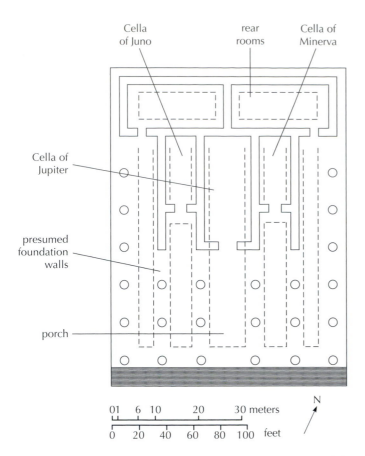

Cella of Juno rear rooms Cella of Minerva

Cella of Jupiter

presumed foundation walls

porch

01 6 10 20 30 meters

0 20 40 60 80 100 feet

N

7.1. Restored plan of Temple of Jupiter Optimus Maximus, Capitoline Hill, Rome. Dedicated ca. 509 BCE

The great Temple of Jupiter Optimus Maximus on the Capitoline Hill was the first truly monumental building of Rome (fig. 7.1). Its construction began under two sixth-century BCE kings, Tarquinius the Ancient and Tarquinius the Proud, but the temple was dedicated by one of Rome's first consuls. The temple was built on a monumental scale, new to the Italian peninsula, but evoking the massive Ionic temples of eastern Greece. It stood on a high masonry platform, with steps leading up to the facade. Six wooden columns marked the front, and six columns flanked each side. Two rows of columns supported the roof over a deep porch. Later Roman historians tell us that an Etruscan artist, Vulca of Veii, crafted a vast terra-cotta acroterion for the peak of the pediment, representing Jupiter in a four-horse chariot. Three parallel cellas with walls of wood-framed mud brick accommodated cult statues of Jupiter, Juno, and Minerva, and recent excavations suggest that there were two additional rooms arranged across the rear, accessed from the lateral colonnades. Greek influence is evident in the rectilinear forms, the use of columns, and a gabled roof; yet the high podium and the emphatic frontal access set it apart. These features would characterize most Roman temples in the following centuries.

Although the practice of borrowing Greek forms began early in the Republic, it was particularly marked during the period of Rome's conquest of Greece, when architects imitated Greek building materials as well as essential architectural forms. After celebrating a triumph over Macedonia in 146 BCE, the general Metellus commissioned Rome's first all-marble temple and

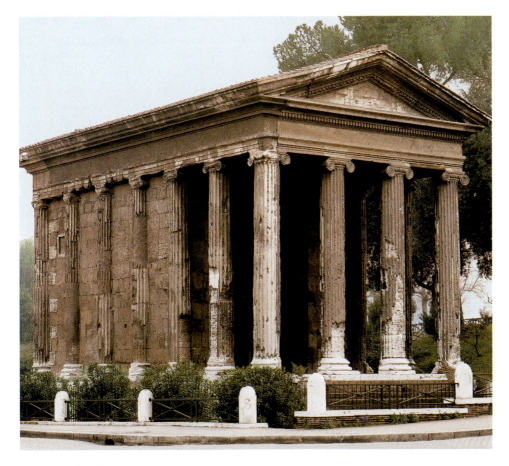

7.2. Temple of Portunus, Rome. ca. 80–70 BCE

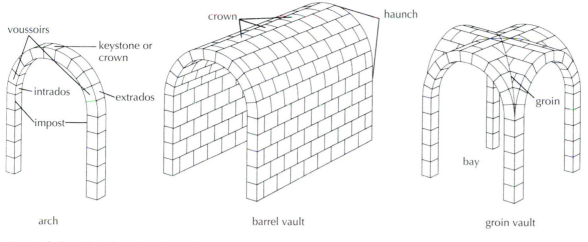

voussoirs

keystone or crown

intrados

extrados

impost

crown

haunch

groin

bay

arch

barrel vault

groin vault

7.3. Arch, barrel vault, and groin vault

hired a Greek architect, Hermodorus, for the job. It no longer survives, but was probably close in form to the remarkably well-preserved temple to the harbor god Portunus, near the Tiber, often misnamed the Temple of Fortuna Virilis (fig. **7.2**). Dating from 80 to 70 BCE, the temple is in the Italic style: It stands on a podium, and engaged lateral columns (instead of a true peristyle) emphasize the frontal approach. All the same, the Ionic columns have the slender proportions of Classical Greek temples, and a white marble stucco covering their travertine and tufa shafts, bases, and capitals deliberately evoked the translucent marbles used by Greek architects.

Roman architects quickly combined the rectilinear forms so characteristic of Greek architecture with the curved form of the **arch** (fig. **7.3**). An arch might be free-standing, a monument in its own right, or applied to a building, often to frame an entrance. True arches are assembled with wedge-shaped voussoirs, as seen in the Etruscan Porta Marzia at Perugia (see fig. 6.13), and are extremely strong, in contrast to corbeled arches (see fig. 4.20). Voussoir arches were not a Roman or an Etruscan invention: Egyptian builders had used them, as well

as their extension, the **barrel vault**, as early as about 2700 BCE, but mainly in underground tombs and utilitarian buildings, rather than for monumental public buildings. Mesopotamian builders employed them for city gates and perhaps other purposes as well, and Greeks architects used them for underground structures or simple gateways. The Romans, however, put them to widespread use in public buildings, making them one of the hallmarks of Roman building.

It was the development of concrete, however, that was a catalyst for the most dramatic changes in Roman architecture. Concrete is a mixture of mortar and pieces of aggregate such as tufa, limestone, or brick. At first, Roman architects used it as fill, between walls or in podiums. Yet on adding *pozzolana* sand to the mortar, they discovered a material of remarkable durability (which would even cure under water), and they used it with growing confidence from the second century BCE onward. Despite its strength, it was not attractive to the eye, and builders concealed it with facings of stone, brick, and plaster (fig. **7.4**). These facings had no structural role. They changed with the passing years, and therefore provide archeologists

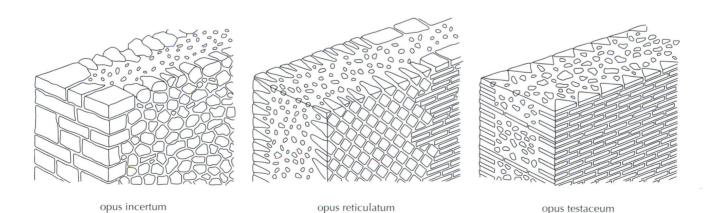

opus incertum

opus reticulatum

opus testaceum

7.4. Diagram illustrating Roman concrete facings. Left: *opus incertum*, used mainly in 2nd to early 1st centuries BCE. Middle: *opus reticulatum*, used in 1st century BCE and 1st century CE. Right: *opus testaceum*, used from mid-1st century CE onward

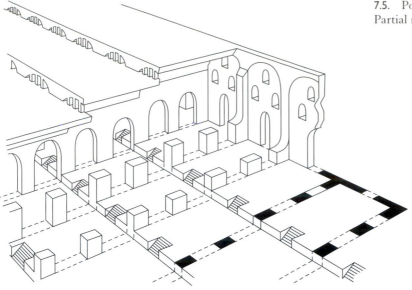

with an invaluable tool for dating Roman buildings. The advantages of concrete were quickly evident: It was strong and cheap, and could be worked by relatively unskilled laborers. It was also extraordinarily adaptable. By constructing wooden frameworks into which the concrete would be poured, builders could mold it to shapes that would have been prohibitively time-consuming, if not outright impossible to make using cut stone, wood, or mud brick. In a sense, the history of Roman architecture is a dialogue between the traditional rectilinear forms of the Greek and early Italic post-and-lintel traditions on the one hand, and the freedoms afforded by this malleable material on the other.

Two quite different Republican structures demonstrate concrete's advantages. The Porticus Aemilia of the early second century BCE is the earliest known building in Rome constructed entirely of concrete. Named after the magistrates who contracted for its earliest phase, it was a huge warehouse in Rome's commercial port area, used to sort and then store goods offloaded from river boats. Its dimensions were simply staggering: It stretched 1,600 Roman feet along the Tiber and was 300 feet deep. As the partial reconstruction in figure **7.5** illustrates, the architects took advantage of the new material to create a remarkably open interior space. Soaring barrel vaults roofed 50 transverse corridors, built in four rising sections to accommodate the sloping terrain. Arches pierced the walls supporting the vaults, so that workers could see easily from one storage area to the next, and air could circulate freely.

East of Rome, in the foothills of the Apennines, the town of Palestrina (ancient Praeneste) was home to another masterpiece of concrete construction (figs. **7.6** and **7.7**). The spectacular

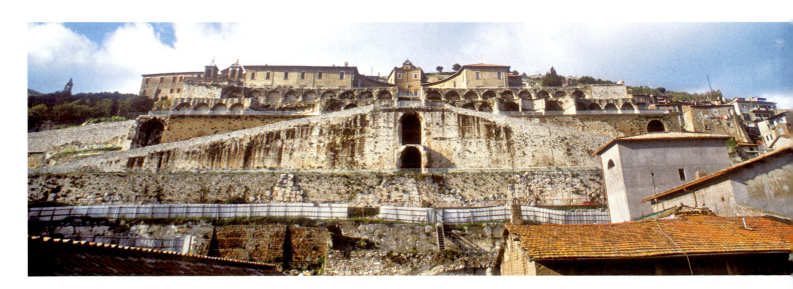

7.6. Sanctuary of Fortuna Primigenia, Praeneste (Palestrina). Early 1st century BCE

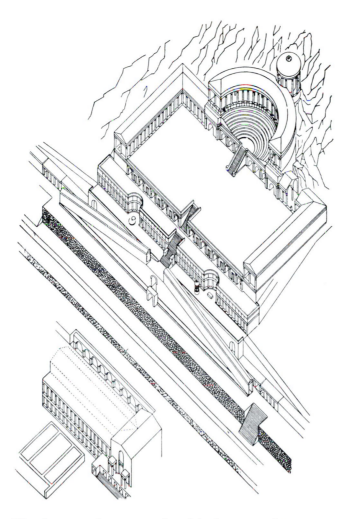

7.7. Axonometric reconstruction of the Sanctuary of Fortuna Primigenia, Praeneste

sanctuary to the goddess Fortuna Primigenia, dated to the late second or early first century BCE, was an oracular center where priests interpreted divine will by drawing lots. Here, architects used concrete to mold structures over the entire surface of a hillside and to craft spaces that controlled and heightened a visitor's experience. The sanctuary ascended in seven levels. At the bottom stood an early temple, a basilica (see page 224), and a senate house for civic meetings. The upper terraces rose in a grand crescendo around a central axis, established by a series of statue niches and staircases. A visitor climbed lateral staircases to the third terrace, where steep covered ramps, roofed with sloping barrel vaults, led upward. A bright shaft of daylight beckoned from the end of the ramp, where an open landing provided the first of several stunning views across the countryside.

On the fourth level were the altars, framed within colonnaded *exedrae*. Barrel vaults roofed the colonnades, inscribing a half-circle both horizontally and vertically (*annular* barrel vaults). Their curved forms animate the straight lines, since columns set in a semicircle shift their relationship to the environment with every step a visitor takes. A wide central staircase leads still farther upward to the next level. After the confinement of the ramps, its steps were exposed, giving a sense of vulnerability. On this level were shops, where sou-

venirs and votive objects were probably on sale. A visitor on this terrace stood directly over the voids of the barrel vaults below, suggesting a tremendous confidence in the structure. The next terrace was a huge open court, surrounded on three sides by double colonnades. The visitor continued to a small theater topped by a double annular colonnade. Here religious performances took place against the magnificent backdrop of the *campagna* beyond, and in full sight of the goddess, whose circular temple crowned the complex. Its diminutive size drew grandeur from the vast scale of the whole—all accomplished with concrete. The hugely versatile material plays easily with the landscape, transforming nature to heighten a visitor's religious experience.

If scholars are correct in assigning the sanctuary's construction to the early first century BCE, it may well belong to the dictatorship of Sulla (82–79 BCE), who won an important civil war victory against his enemies at Palestrina. It is even possible that he commissioned the complex as an offering to Fortuna and a monument to his own fame. What is certain is that the first century BCE was a turning point in the use of architecture for political purposes. One of the most magnificent buildings of this time was the vast theater complex of Pompey, which would remain Rome's most important theater in antiquity.

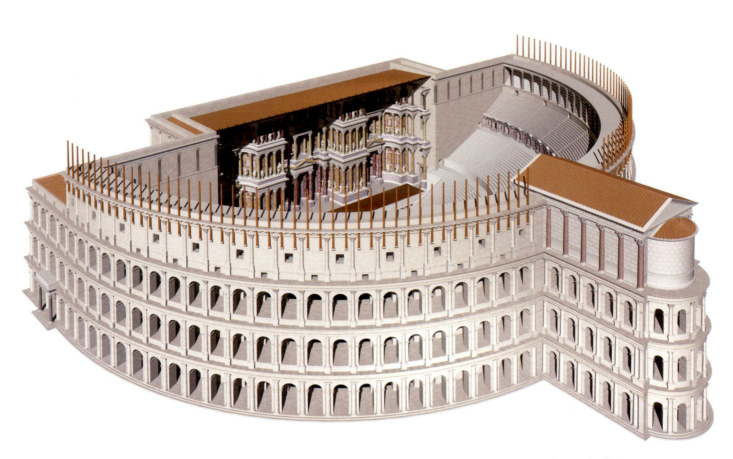

7.8. Theater Complex of Pompey, Rome. Dedicated in 55 BCE. Provisional reconstruction by James E. Packer and John Burge

Like Sulla, and Julius Caesar after him, Pompey maneuvered his way into a position of sole authority in Rome and used architecture to express and justify his aconstitutional power. To commemorate his conquests, he conceived of a theater on the Field of Mars, just outside the northern city boundary, dedicated to his patron goddess Venus Victrix (the Conqueror) (fig. **7.8**). Traces of its superstructure are embedded in later buildings on the site, and its curved form is still reflected in the street plan. Moreover, its ground plan is inscribed on an ancient marble map of the city, carved in the early third century CE, and new excavations directed by James Packer promise to uncover more of its vaulted substructure. The reconstruction in figure 7.8 is therefore provisional, a combination of archeological evidence and conjecture; it is likely to change as new evidence emerges. In some respects, Pompey's theater resembled its Greek forbears, with sloping banks of seats in a semicircular arrangement, a ground-level orchestra area, and a raised stage for scenery. In other significant ways, however, it was radically different. It was not, for instance, nestled into a preexisting hillside. Instead, the architect created an artificial slope out of concrete, rising on radially disposed barrel vaults, which buttressed one another for a strong structure. Concrete, in other words, gave the designer freedom to build independent of the

landscape. The curved seating *cavea*, moreover, was a true half-circle, rather than the extended half-circle of Greek theaters. At the summit of the cavea were three shrines and a temple dedicated to Venus. The curved facade held statues personifying the nations Pompey had subdued. Beyond the theater, and adjoining it behind the stage building, porticoes defined a vast garden containing valuable works of art, such as sculptures, paintings, and tapestries, many of which had been brought to Rome from Greece. These public gardens were Pompey's gift to the people of Rome—an implicit way of winning favor.

Pompey's theater-portico complex dwarfed the smaller, scattered buildings that individual magistrates had commissioned up to that point. It was also Rome's first permanent theater. As in Greece, plays were an essential component of religious ceremonies, and the buildings that accommodated them had always been built of wood, assembled for the occasion and then dismantled. In fact, elite Romans spoke out against the construction of permanent theaters on moral grounds. Pompey circumvented such objections by claiming that his theater was merely an appendage to the temple of Venus at its summit, and in building the complex he set the precedent for the great forum project of Julius Caesar, and the imperial fora that would follow (see page 203).

Sculpture

RELIEF SCULPTURE Like architecture, sculpture often commemorated specific events, as it did in the ancient Near East (see figs. 2.20 and 2.21). Classical Greek sculpture disguised historical events in mythical clothing—a combat of Lapiths and Centaurs, for instance, or Greeks and Amazons (see figs. 5.44, 5.45, and 5.47)—and this convention broke down only slightly in the Hellenistic period. The Romans, by contrast, did represent actual events, developing a form of sculpture long known as historical relief—although many were not historically accurate. The reliefs shown in figure **7.9** probably decorated a base for a statuary group, which scholars place near the route of triumphal processions through Rome. Once known as the Altar Base of Domitius Ahenobarbus, it is now sometimes called the Base of Marcus Antonius. One long section shows a *census*, a ceremony during which individuals recorded property with the state to establish qualification for military service. On the left side, soldiers and civilians line up to be entered into the census. Two large figures flanking an altar represent a statue of Mars, god of war, and the officiating censor, who probably commissioned the monument. Attendants escort a bull, a sheep, and a pig to sacrifice at an altar, marking the closing ceremony of the Census.

Belonging to the same monument, the remaining reliefs depict a *thiasos* (procession) across the sea for the marriage of the sea-god Neptune and a sea-nymph, Amphitrite. But these reliefs are in an entirely different style. The swirling motion of the marriage procession and its Hellenistic forms contrast dramatically with the overwhelmingly static appearance of the census relief and the stocky proportions of its figures. Moreover, the

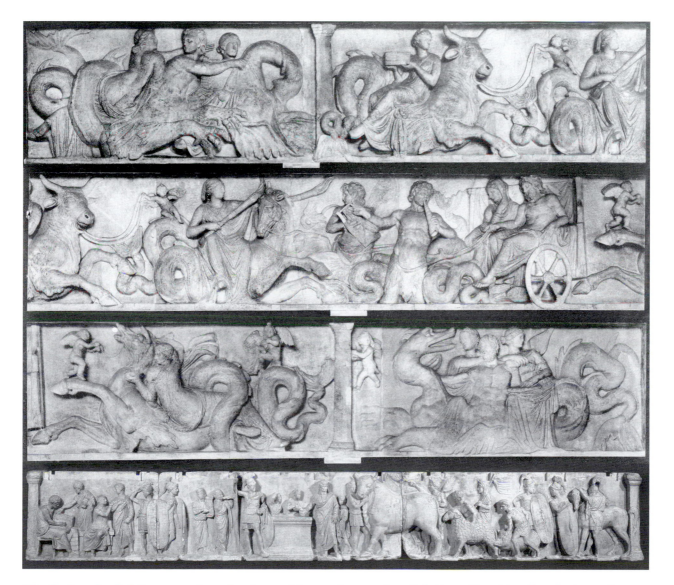

7.9. Sculptural reliefs from statue base, showing sea thiasos and census. So-called Altar of Domitius Ahenobarbus or Statue Base of Marcus Antonius. Late 2d to early 1st century BCE. Marble. Musée du Louvre, Paris, and Glyptothek, Staatliche Antikensammlungen, Munich

Cicero (106–43 BCE)

Letters to Atticus I. 9–10 (67 BCE, Rome)

Marcus Tullius Cicero was a leading politician and orator in Rome during the turbulent days of the late Republic. He is known through his extensive writings, which include orations, rhetorical and philosophical treatises, and letters. Like many other Roman statesmen, he filled his many houses and villas with works of Greek art, either original or copied. Atticus was his childhood friend, who maintained communication with Cicero after moving to Athens and served as his purchasing agent for works of art.

IX

Cicero to Atticus, Greeting

Your letters are much too few and far between, considering that it is much easier for you to find someone coming to Rome than for me to find anyone going to Athens. Besides, you can be surer that I am at Rome than I can be that you are in Athens. The shortness of this letter is due to my doubts as to your whereabouts. Not knowing for certain where you are, I don't want private correspondence to fall into a stranger's hands.

I am awaiting impatiently the statues of Megaric marble and those of Hermes, which you mentioned in your letter. Don't hesitate to send anything else of the same kind that you have, if it is fit for my Academy. My purse is long enough. This is my little weakness; and what I want especially are those that are fit for a Gymnasium. Lentulus promises his ships. Please bestir yourself about it. Thyillus asks you, or rather has got me to ask you, for some books on the ritual of the Eumolpidae.

SOURCE: CICERO, LETTERS TO ATTICUS, IN 3 VOLS. TR. BY E.O. WINSTEDT (1912–1918)

panels are carved out of different marbles. Scholars suppose that the sea-thiasos sections were not original to this context, but were brought as spoils from Greece to grace a triumphal monument—proof, as it were, of conquest. The census relief, by contrast, was carved in Rome to complement the thiasos. Together, the reliefs may represent the patron's proud achievements.

FREE-STANDING SCULPTURE Romans put Greek sculpture to other uses as well. In a series of letters, Cicero, a lawyer and writer of the mid-first century BCE, asks his friend Atticus in Athens to send him sculptures to decorate his villa. (See *Primary Source*, above.) Requests such as this, scholars believe, were not unusual: The gradual conquest of Greece in the second century BCE had led to a fascination with Greek works of art, which had flooded into Rome as booty. So intense was the fascination, in fact, that in the late first century BCE, the poet Horace commented ironically, "Greece, having been conquered, conquered her wild conqueror, and brought the arts into rustic Latium." Paraded through the streets of Rome as part of the triumphal procession, the works of art ended their journey by decorating public spaces, such as the Theater Portico of Pompey (see fig. 7.8).

These glistening bronze and marble works provoked reaction. For most, it seems, they were a welcome sign of Rome's cultural advance, more visually pleasing than indigenous sculptures in less seductive materials like terra cotta. A few strident voices spoke out against them. Most vociferous was Cato ("The Moralist"), for whom traditional Roman art forms symbolized the staunch moral and religious values that had led to, and justified, Rome's political ascent. Whatever his objections, elite Romans assembled magnificent collections of Greek art in their homes, and through their display they could give visual expression to their erudition. The Villa of the Papyri in Herculaneum preserved an extensive collection *in situ*, partially reconstructed in the Getty Museum in Malibu, California. When Greek originals were not available, copyists provided alternatives in the styles of known Greek artists. (See *Materials and Techniques*, page 188 and *The Art Historian's Lens*, page 179.) The stylistic borrowings also had a bold political dimension, showing that Rome had bested the great cultures of Greece.

PORTRAIT SCULPTURE Literary sources reveal that the Senate and People of Rome honored successful political or military figures by putting their statues on public display, often in the Roman Forum, the civic heart of the city. The custom began in the early Republic and continued until the end of the Empire. Many of the early portraits were bronze and have perished, melted down in later years for coinage or weaponry. A magnificent bronze male head dating to the late fourth or early third century BCE, a mere fragment of a full-length figure, gives a tantalizing sense of how these statues once looked (fig. **7.10**). At the time of its discovery in the sixteenth century, antiquarians dubbed it "Brutus," after the founder and first consul of the Republic. Strong features characterize the over-life-size portrait: a solid neck, a square jaw accentuated by a short beard, high cheek-bones, and a firm brow. The image derives its power not from Classical idealization or the stylized qualities of, for instance, the portrait of an Akkadian ruler (see fig. 2.12), but from the creases and furrows that record a life of engagement. The slight downward turn of the head may indicate that it once belonged to an equestrian portrait, raised well above a viewer.

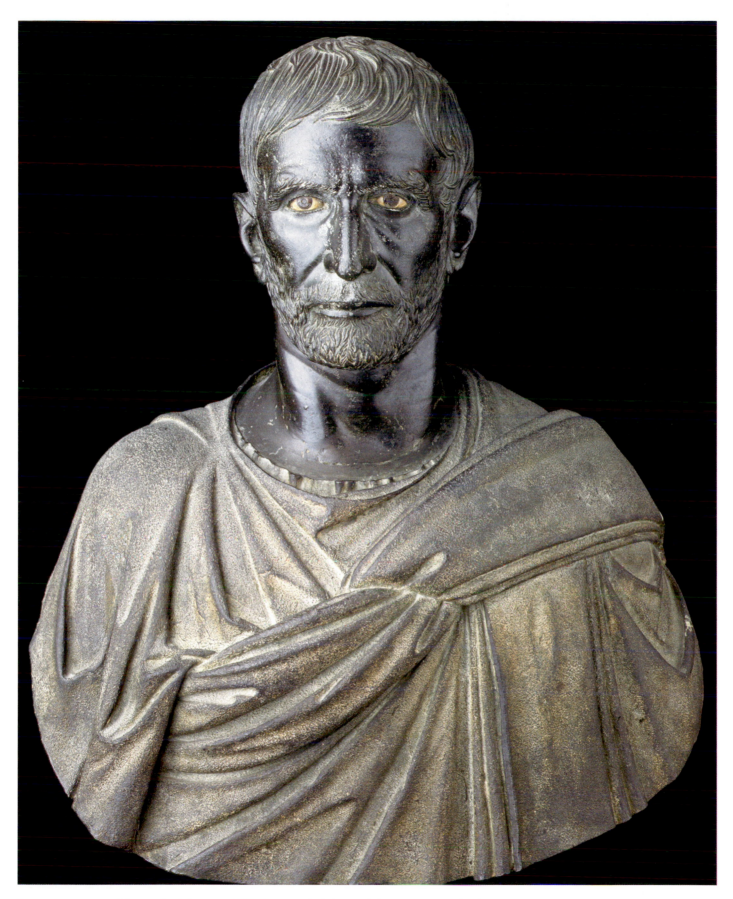

7.10. *Brutus*. Late 4th or early 3rd century BCE. Bronze. Slightly over life-size. Museo del Palazzo dei Conservatori, Rome

MATERIALS AND TECHNIQUES

Copying Greek Sculptures

In order to satisfy a growing demand for Greek sculptures, artists set up copying workshops in Athens and Rome, where they produced copies of famous "masterpieces." Some of these copies may have been relatively close replicas of the originals; others were adaptations, where the copyist's own creativity came freely into play. Given the paucity of surviving Greek originals, it is often difficult for scholars to determine the appearance of the original, and thus to distinguish replica from adaptation. One clue to recognizing a marble copy (a true replica or a free adoption) of a bronze original is to look for the use of struts to strengthen the stone, since marble has a different tensile strength from bronze (see the tree trunk and the strut at the hip in fig. 5.33).

Scholars have long believed that Roman copyists used a pointing machine, similar to a kind that was used in the early nineteenth century, but evidence from unfinished sculptures now suggests a different technique, known as triangulation, using calipers. By establishing three points on the model, and the same three points on a new block of stone, an artist can calculate and transfer any other point on the model sculpture to a new place on the copy. The sculptor takes measurements from each of the three points on the original to a fourth new point, and, using those measurements, makes arcs with the calipers from each of the three points on the new block of stone. Where the arcs intersect is the fourth point (see figure) on the copy. In order to alter the scale from original to copy, the artist simply multiplies or divides the measurements. Having taken a number of points in this way, the sculptor cuts away the stone between the points, using a chisel. The accuracy of the resultant copy depends upon how many points the sculptor takes.

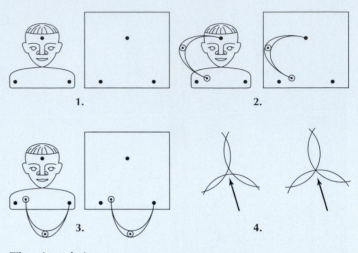

The triangulation process

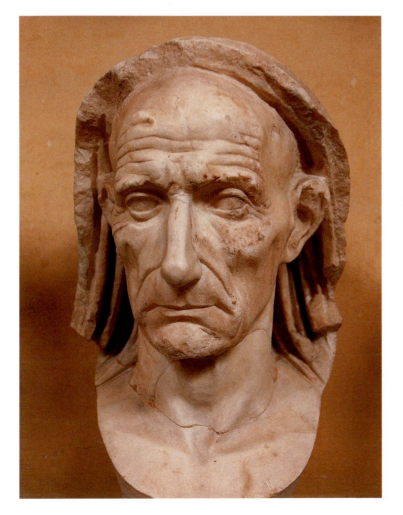

7.11. Veristic male portrait. Early 1st century BCE. Marble. Life-size. Musei Vaticani, Rome.

The majority of Republican portraits date to the end of the second century and the first century BCE, and were carved from stone. Most represent men at an advanced age (fig. **7.11**). Wrinkles cover their faces, etching deep crags into their cheeks and brows. Distinguishing marks—like warts, a hooked nose, or a receding hairline—are played up rather than smoothed over. In the example illustrated here, the man's bald head was once covered, suggesting that he was represented as a priest. Although there is no way of knowing what the sitter looked like, the images appear overly realistic, so that scholars term the style **veristic**, from the Latin *verus*, meaning "true." For a twenty-first-century viewer, these images are anything but idealized. Yet it is worth bearing in mind that each culture constructs its own ideals. To Romans, responsibility and experience came with seniority, and most magistracies had minimum age requirements. An image marked by age therefore conveyed the requisite qualities for winning votes for political office.

Where the impetus to produce likenesses came from is a mystery that scholars have been anxious to solve. Some trace it to a Greek custom of placing votive statues of athletes and other important individuals in sacred precincts, and indeed some Roman portraits were executed in a Hellenic style. Hellenistic ruler portraits played a part too; portraits of Pompey have the

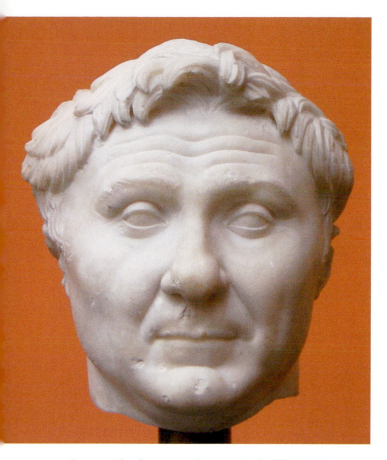

7.12. *Pompey.* Claudian copy of a portrait of ca. 50 BCE. From the Licinian tomb on Via Salaria, Rome. Ny Carlsberg Glyptothek, Copenhagen

ART IN TIME

ca. 509 BCE—The Romans turn against the monarchy, expelling the last kings

ca. 484–425 BCE—Life of the Greek historian Herodotus

ca. 300 BCE—**Roman bronze head, *Brutus***

by 275 BCE—**All of Italy controlled by Rome**

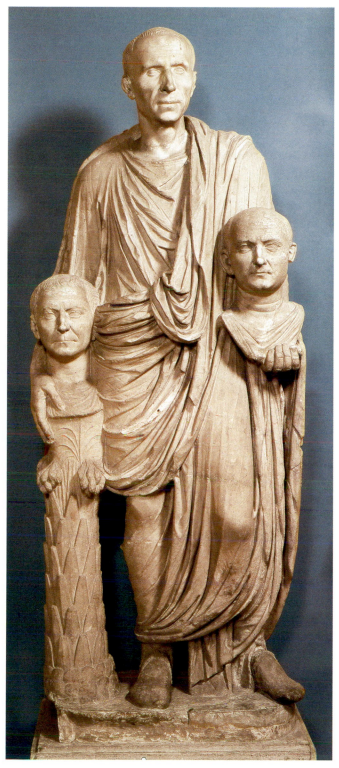

7.13. Togate male portrait with busts. Late 1st century BCE. Marble. Life-size. Museo Montemartini, Rome

tousled hair of Alexander the Great, and his trademark cowlick, to evoke the youthful leader's charisma (fig. **7.12**, and see fig. 5.70). For others, its roots lie in an Italic practice of storing ancestral masks in the home to provide a kind of visual genealogy, in a society where a good pedigree was the most reliable stepping-stone to success in a public career. Polybius, a Greek historian of the mid-second century BCE, recounts that before burying a family member, living relatives would wear these ancestral masks in a funerary procession, parading the family's history in front of bystanders (See *Primary Source*, page 190). His words have often been used to explain the statue illustrated in figure **7.13**, representing a male figure in a toga carrying two portrait busts. Yet, although the sculpture probably *is* commemorative, the three-dimensional busts are quite distinct from masks. Somewhat ironically, the figure's own head does not belong to the statue, but comes from another sculpture altogether.

Scholars can rarely give a name to individuals portrayed in this type of Republican portrait. Inscriptions identifying the subject are scarce, and the coin portraits that help to identify later public figures only appear from the mid-first century BCE on. By contrast, we can readily identify individuals represented in a related class of monument. In the late Republic and Augustan periods, emancipated slaves commissioned group portraits in relief, which

Polybius (ca. 200–ca. 118 BCE)

Histories, from Book VI

Polybius was a Greek historian active during the Roman conquest of his homeland. His Histories *recount the rise of Rome from the third century* BCE *to the destruction of Corinth in 146* BCE. *In Book VI he considers cultural and other factors explaining Rome's success.*

Whenever any illustrious man dies, … they place the image of the departed in the most conspicuous position in the house, enclosed in a wooden shrine. This image is a mask reproducing with remarkable fidelity both the features and complexion of the deceased. On the occasion of public sacrifices they display these images, and decorate them with much care, and when any distinguished member of the family dies they take them to the funeral, putting them on men who seem to them to bear the closest resemblance to the original in stature and carriage. These representatives wear togas, with a purple border if the deceased was a consul or praetor, whole purple if he was a censor, and embroidered with gold if he had celebrated a triumph or achieved anything similar. They all ride in chariots preceded by the fasces, axes, and other insignia … and when they arrive at the rostra they all seat themselves in a row on ivory chairs. There could not easily be a more ennobling spectacle for a young man who aspires to fame and virtue. For who would not be inspired by the sight of the images of men renowned for their excellence, all together and as if alive and breathing? … By this means, by this constant renewal of the good report of brave men, the celebrity of those who performed noble deeds is rendered immortal. … But the most important result is that young men are thus inspired to endure every suffering for the public welfare in the hope of winning the glory that attends on brave men.

SOURCE: *POLYBIUS: THE HISTORIES*, VOL. 3, TR. BY W.R. PATON (CAMBRIDGE, MA: HARVARD UNIVERSITY PRESS, 1923)

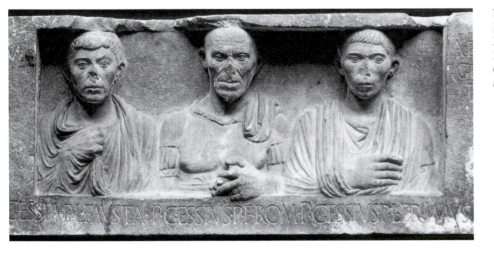

7.14. Funerary relief of the Gessii. ca. 50 BCE. Marble. Height × width × depth, $25^9/_{16} \times 80^1/_2 \times 13^3/_8''$ (65 × 204.5 × 34 cm). Museum of Fine Arts, Boston, Archibald Cary Coolidge Fund. Photograph © 2006, Museum of Fine Arts, Boston. 37.100

they mounted on roadside funerary monuments (fig. **7.14**). The figures are usually shown in shoulder-length truncated busts, surrounded by a long rectangular frame. The very fact that they are depicted visually reflects their freed status; other visual cues reinforce it, such as a ring, either painted or carved on a man's hand, or the joined right hands of a man and woman, symbolizing marriage, which was not legal among slaves. An inscription names the figures and records their status as freed persons. In this example, the freed slaves' one-time owner appears in the center of the relief.

Painting

Lamentably few free-standing portraits come from known archeological contexts. As well as placing portraits in homes and public places, Romans appear to have displayed them in tombs. Tombs were more than just lodging places for the dead. They were the focus of routine funerary rituals, and during the course of the Republic they became stages for displaying the feats of ancestors in order to elevate family status. Paintings, both inside and out, served this purpose well.

A tomb on the Esquiline Hill in Rome yielded a fragmentary painting of the late fourth or early third century BCE, depicting scenes from the conflict between the Romans and a neighboring tribe, the Samnites (fig. **7.15**). A toga-clad figure

7.15. Esquiline tomb painting. Late 4th or early 3rd century BCE. $34^1/_2 \times 17^3/_4''$ (87.6 × 45 cm). Museo Montemartini, Rome

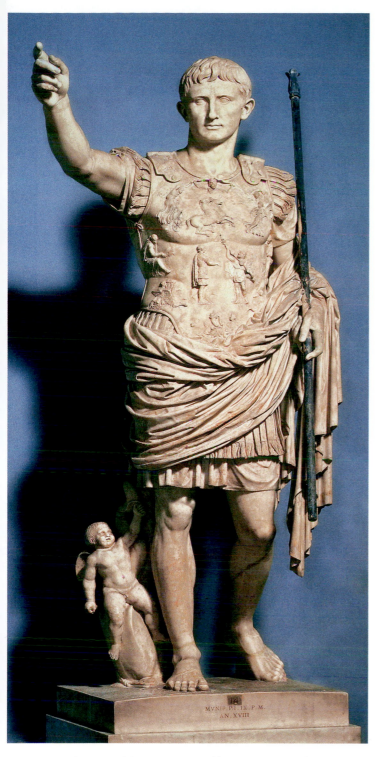

7.16. *Augustus of Primaporta*. Possibly Roman copy of a statue of ca. 20 CE. Marble. Height 6'8" (2.03 m). Musei Vaticani, Braccio Nuovo, Rome

on the upper right is labeled Quintus Fabius, and may have been the tomb's owner. He holds out a spear to the Samnite Fannius on the left, who wears golden greaves and loincloth. Behind Fannius is a crenelated city wall, and in the lower registers are scenes of battle and parlay. The labels in the upper register suggest that the images record specific events, relating

ART IN TIME

200–150 BCE—**Porticus Aemilia in Rome, earliest known building constructed entirely of concrete**

106 BCE—Birth of the Roman orator and statesman Cicero

100s BCE—Greece and Asia Minor controlled by Rome

80–70 BCE—**Construction of the Temple of Portunus in Rome**

the subject matter to the relief sculptures discussed previously. Literary sources state that Roman generals made a practice of commissioning panel paintings of their proudest military moments, which they might display in a triumphal procession before installing them in a public building such as a temple.

THE EARLY EMPIRE

The last century of the Republic witnessed a gradual breakdown of order in Rome, as ambitious individuals vied for sole authority in the city. Julius Caesar's assassination on the Ides of March of 44 BCE was a last-ditch effort to safeguard the constitution. In 27 BCE, the Senate declared Octavian as Augustus Caesar. Insisting that the Republic was restored, he ushered in a new era of peace. In fact, with Augustus, monarchy was reintroduced to Rome, and would endure through several dynasties, with only periodic challenges, until the gradual transfer of power to Constantinople (beginning in about 330 CE). The birth of the Roman Empire brought a period of greater stability to the Mediterranean region than had previously been known. Roman domination continued to spread, and at its largest extent in the time of Trajan (98–117 CE) the Empire stretched through most of Europe, as far north as northern England, through much of the Middle East including Armenia and Assyria, and throughout coastal North Africa. Romanization spread through these regions. Roman institutions—political, social, and religious—mingled with indigenous ones, leading to a degree of homogenization through much of the Roman world. Increasingly, the emperor and his family became the principal patrons of public art and architecture in Rome. Often, these public monuments stressed the legitimacy of the imperial family.

Portrait Sculpture

When Julius Caesar was assassinated, his adopted son and heir, Octavian, was only 18 years old. By the time he had avenged Caesar and overpowered Mark Antony and Cleopatra, he was no more than 35. The veristic portrait style so characteristic of the Republic would have done little to capture his youthful charisma; in fact, it might well have served to underline the aconstitutional nature of his authority in Rome. As Pompey had before him, Octavian turned instead to a more Hellenizing style. Until his death in his late seventies, his portraits depict him as an ageless youth, as seen in the Primaporta statue, discovered in the house of his wife Livia at Primaporta (fig. **7.16**).

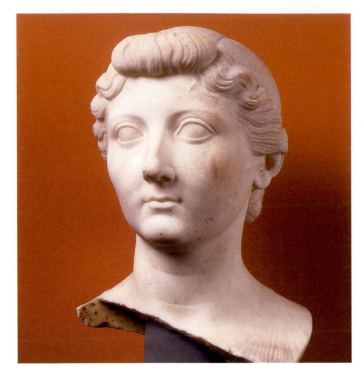

7.17. Portrait of Livia, from the Fayum. After 14 CE. Marble. Ny Carlsberg Glyptothek, Copenhagen

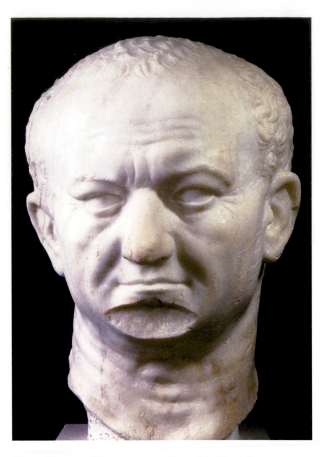

7.18. *Portrait of Vespasian.* ca. 75 CE. Marble. Life-size. Museo Nazionale Romano

The emperor appears in battle dress with his arm raised in a gesture of address. The portrait appears to combine a series of references to previous works of art and historical events in an effort to strengthen Augustus' claim to authority.

Both the contrapposto stance, and the smooth features of his face, are strongly reminiscent of Polykleitos' Doryphoros (see fig. 5.33). The resemblance is so strong that we can assume that Augustus turned deliberately to this well-known image. There was good reason for this kind of imitation: The Classical Greek style evoked the apogee of Athenian culture, casting Augustan Rome as Greece's successor (and conqueror) in cultural supremacy. The style was chosen for other members of the imperial family as well, such as Livia, whose portraits resemble images of Greek goddesses (fig. **7.17**). Even Augustus' hair is similar to that of the Doryphoros—except, that is, at the front, where the locks part slightly over the center of the brow, a subtle reference to Alexander the Great, another youthful general, whose cowlick was such a distinctive feature of his portraits (see fig. 5.70).

Next to Augustus' right ankle, a cupid playfully rides a dolphin, serving as a strut to strengthen the marble. Most Romans would have recognized that Cupid, or Eros, the son of Venus, symbolized Augustus' claim of descent from the goddess of love through his Trojan ancestor Aeneas. The dolphin would

have evoked the sea, and specifically the site off the coast of Actium where Augustus had prevailed over Mark Antony and Cleopatra. By associating Augustus with historical or divine figures, these references projected an image of earthly and divinely ordained power, thereby elevating the emperor above other politicians.

The iconography of Augustus' breastplate serves a similar purpose by calling attention to an important diplomatic victory in 20 BCE, when the Parthians returned standards that they had captured, to Roman shame, in 53 BCE. A figure usually identified as Tiberius, Augustus' eventual successor, or the god Mars, accepts the Roman standards from a Parthian soldier, possibly Phraates IV, the Parthian king. Celestial gods and terrestrial personifications frame the scene, giving the event a cosmic and eternal significance. This diplomatic victory took on momentous proportions in Augustan propaganda. The scene suggests that the portrait dates to about 19 BCE. The emperor is barefoot, which usually denotes divine status. Later in the Roman period, or in the Eastern Empire, emperors might be depicted as gods while still alive, but with Caesar's legacy still fresh in Roman minds, it is not likely that Augustus would have been so presumptuous. Some scholars conclude that the statue is a posthumous copy of a bronze original dating to about 20 BCE.

The Primaporta Augustus offers a good example of a tendency in Roman art to express a message through references to earlier works. Naturally, not all Romans would have understood all the references in any given work, but the frequency of visual "quotations" suggests that Romans, like many other ancient peoples, were extremely visually astute. In fact, the history of Roman portraiture, as with many other branches of Roman art, is one of constant association with, and negation of, (or conscious turning away from) past images. Portraits of Augustus' dynastic successors, for instance, look very much like the first emperor from whom they drew their authority, even though they were rarely (or at best distantly) related by blood. With the emperor Vespasian, founder of the Flavian dynasty, there was a return to a more veristic style of portrait (fig. **7.18**). Scholars reason that this maneuver was part of a deliberate attempt to restore social order when he came into power in 69 CE, after a year of civil war. A soldier by background, Vespasian justified his authority through his military success, and appealed to the rank and file through this harshly matter-of-fact image. Several years later, Trajan's portraits revived the classicism associated with Augustus, imitating his full cap of hair and the smooth planes of his face, to portray a man frozen in eternal middle age. His successor, Hadrian, took the Greek style even further. Nicknamed "The Greekling" for his admiration of Greek culture, he adopted the full beard that was characteristic of Greek philosophers (fig. **7.19**); ancient reports that he was trying to conceal scars from acne are unlikely to be true. It was in his reign that sculptors began to carve the pupils and irises of the eyes, rather than painting them.

Imperial portraits such as these exist in great multitudes. On the whole, they fall into a number of types, suggesting that there was a master portrait, often executed for a specific occasion, that would be copied for dissemination within and outside of Rome; sculptors would copy these copies, in turn, leading to a ripple effect around the empire. Nonimperial portraits also survive in great numbers. Scholars can rarely identify them, but date them on the basis of similarities with members of the imperial family. When dealing with female portraits, hairstyles are especially useful since they change relatively rapidly. Livia's relatively simple coiffure, with a roll, or *nodus*, at the front (see fig. 7.17) is a far cry from the towering hairstyle of Domitia Longina, wife of Domitian, one of Vespasian's sons (fig. **7.20**). Built around a framework, her hair was a masterpiece in itself, and its representation in sculpture reflected her status, as well as affording the sculptor a valuable opportunity to explore contrasts of texture between skin and hair, and to drill deep into the marble for a strong play of light and shadow.

Beginning in the second half of the second century CE, Roman portraits gradually take on a more abstract quality. It is especially marked in the treatment of the eyes, whose heavy lids lend them a remote quality. This is perceptible in a spectacular gilded bronze portrait of Marcus Aurelius, which survived the melting pot in the medieval period because Christians misidentified it as Constantine the Great, champion

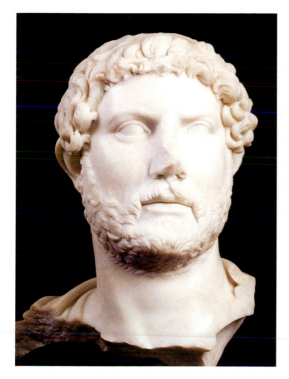

7.19. *Portrait of Hadrian.* After 117 CE. Marble. Museo Nazionale Romano, Rome

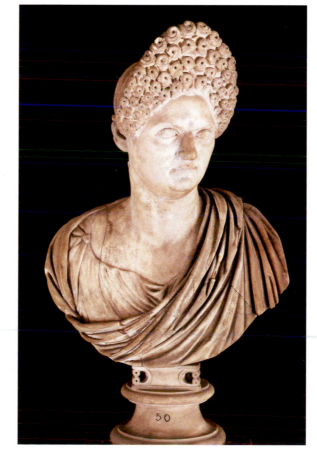

7.20. *Portrait of Domitia Longina.* Late 1st century CE. Marble. Height 2′ (.608 m). Courtesy of San Antonio Museum of Art, San Antonio, Texas. Gift of Gilbert M. Denman, Jr.

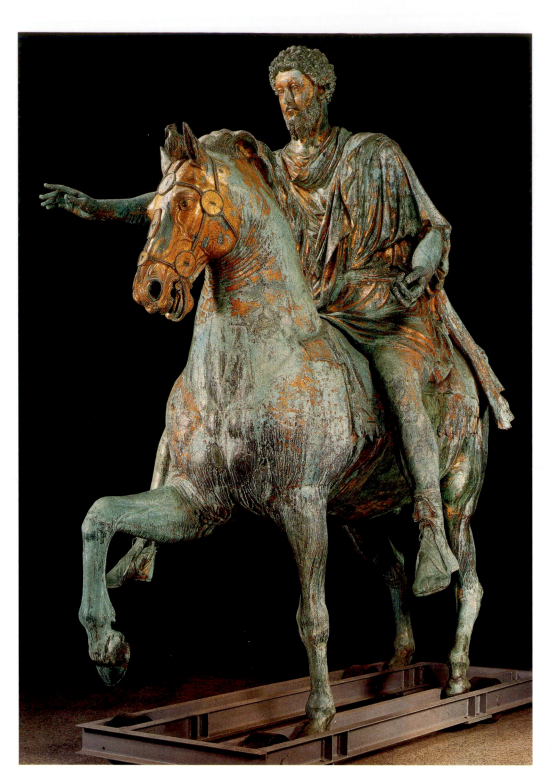

7.21. *Equestrian Statue of Marcus Aurelius.* 161–180 CE. Bronze, over–life-size. Museo del Palazzo dei Conservatori, Rome

of Christianity (fig. 7.21). With one arm outstretched in a gesture of mercy, the emperor sits calmly astride a spirited horse, whose raised front leg once rested on a conquered barbarian. Like the portrait of Hadrian and the vast majority of second- and third-century male portraits, Marcus Aurelius is bearded. Like Hadrian, too, Marcus Aurelius was interested in philosophy, and his Stoic musings still survive as the "Meditations," and such abstract concerns are reflected in the sculpture of the time. For example, abstract qualities are clear in an exquisite marble portrait of Marcus Aurelius' wife Faustina the Younger (fig. 7.22). While her features appear subtly idealized,

her eyelids fall in languid fashion over her pupils. The patterned, decorative treatment of her hair underlines the stylized quality of the whole. Just as Marcus Aurelius' military cloak establishes his public role as a general, so Faustina's tunic and cloak were signs of the modesty befitting a Roman matron. The empress bore her husband two sons, and they accompanied him on his military campaigns, thereby earning her the title Mother of the Camps. Her life embodied the cardinal feminine virtues, for which her husband later consecrated her a goddess: piety to home and family, as well as fertility, modesty, and fidelity.

Relief Sculpture

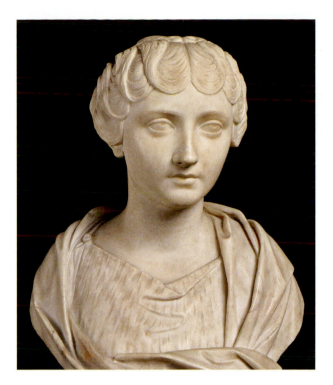

The Republican practice of commissioning narrative reliefs to record specific events continued well into the Empire. They were mounted on public buildings and monuments, such as the *Ara Pacis Augustae*, or Altar of Augustan Peace (fig. **7.23**). The Senate and People of Rome vowed the altar in 13 BCE on the occasion of Augustus' safe return from Spain and Gaul, and it was dedicated in 9 BCE. It stood inside a marble enclosure, which was open to the sky and richly sculpted over its entire surface. On east and west sides, flanking two entrances, relief panels represent allegorical figures, or personifications, and figures from Rome's legendary past. On the west end, a fragmentary panel shows a she-wolf suckling the infants Romulus and Remus, under the watchful eyes of the shepherd Faustulus, who discovered and adopted them. In a second relief, Aeneas (or perhaps, according to a recent interpretation, Numa, second

7.22. *Portrait of Faustina the Younger.* ca. 147–148 CE. Marble. Height 23⅝″ (60 cm). Museo Capitolino, Rome.

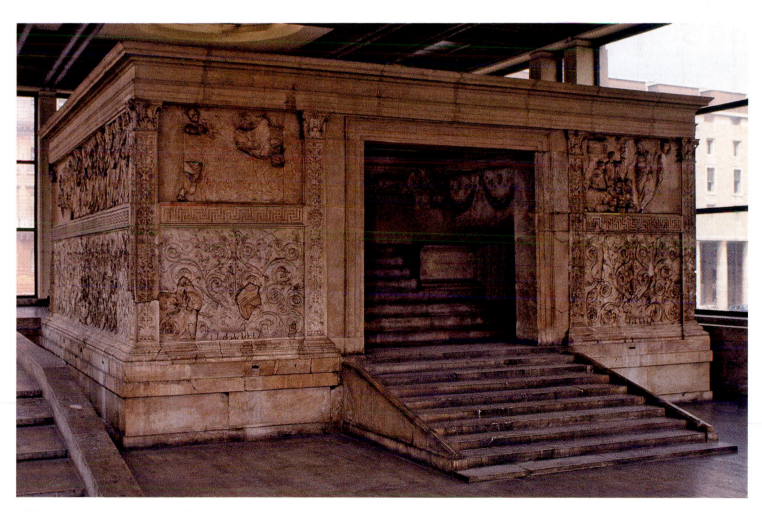

7.23. Ara Pacis Augustae, west facade. 13–9 BCE. Marble. Width of altar approx. 35′ (10.7 m). Museum of the Ara Pacis, Rome

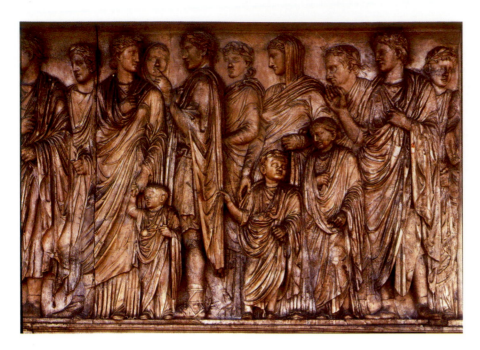

7.24. Ara Pacis Augustae, Imperial Procession south frieze. 13–9 BCE. Marble. Height 63″ (1.6 m). Rome

king of Rome) makes a sacrifice at an altar of roughly hewn stones. At the east end, a relief depicting the goddess Roma seated on her weapons balances a panel with a female figure (the goddess Venus or Ceres, perhaps, or Peace, Iatlia, or Mother Earth) embodying the notion of peace. Together, the panels express the message of peace that Augustus was intent on promoting, in contrast with the bleakness of the preceding civil wars. The same message was implicit in the acanthus relief that encircles the enclosure in a lower register. Vegetation unfurls in rich abundance, populated with small creatures such as lizards and frogs.

On north and south sides, the upper register contains continuous procession friezes that portray specific members of the imperial family interspersed with the college of priests and senators (fig. **7.24**). The friezes seem to record a particular event—a sacrifice, perhaps, or the moment of the altar's dedication. A large gap in the relief falls exactly on the figure of Augustus, whose action, if depicted, would probably have revealed the occasion. Still, the friezes are significant for a number of reasons. In their superficial resemblance to the Greek Parthenon frieze (see figs. 5.46–5.48) they bear witness, once again, to the preference for Greek styles in the age of Augustus. They also include a number of eminent women from the imperial family,

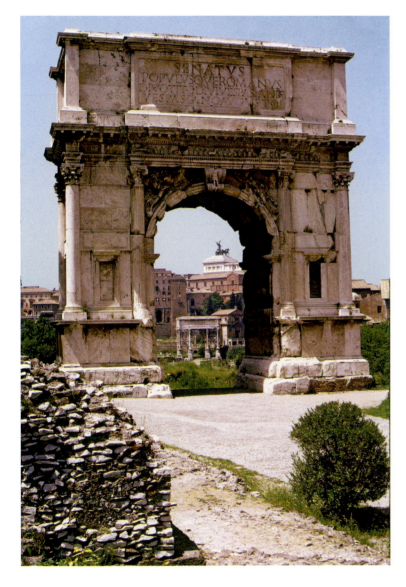

7.25. Arch of Titus, Rome. ca. 81 CE. Marble

including Livia, and small children. One scholar has convincingly argued that their inclusion represents the importance of family and dynasty, as well as a reference to moral legislation the emperor enacted to curb adultery and promote childbirth among the elite.

Reliefs also decorated free-standing arches. Triumphant generals first erected arches during the Republic, though no early examples survive. Through the ages, many of the arches celebrated triumphs, but they also served as commemorative monuments for the dead. Their enduring impact on western architecture is readily understandable: As with free-standing columns, their chief *raison d'être* was to express a visual message. Often they stood at or near an entrance to a public space, and framed the transition, or *liminal* area (from *limen*, Latin for "threshold") between one place and another. Many societies consider liminal spaces unsettling and in need of protection; the lamassu of Mesopotamia, one might note, guarded doorways (see fig. 2.19). The Arch of Titus, son and successor of Vespasian, stands at the far eastern end of the Roman Forum. It is the earliest surviving free-standing arch in Rome, though a good portion of it is the product of Valadier's restoration from 1822 to 1824 (fig. **7.25**). The arch may have been a triumphal

monument, but given that its inscription and a small relief panel describe Titus specifically as a god, it is more likely that it commemorates his apotheosis (or divinization) after his death in 81 CE. Its principal sculptural relief panels are located within the bay, and both refer to the triumph after the conquest of Jerusalem in 70 CE. In one of them, soldiers carry booty through the streets, including a seven-branched menorah (a Jewish candelabra) and other sacred objects taken from the Temple in Jerusalem (fig. **7.26**). The panel marks an important move toward illusionism in the portrayal of space. Two ranks of figures appear, carved in different levels of relief. The sculptor cut the background figures in such shallow relief that they seem to fade into the distance. The procession breaks away abruptly at the sides, so that it seems to continue beyond a viewer's line of sight. On the right, it disappears through a triumphal arch, placed at an oblique angle to the background so that only the nearer half actually emerges in relief, giving the illusion of spatial depth. The panel even bulges out slightly at the center, so that it seems to turn right in front of a viewer situated inside the arch's bay, making the viewer a part of the action. In the other panel, Titus rides in triumph in a chariot, raised above a teeming crowd, signified, again, through differing levels of relief

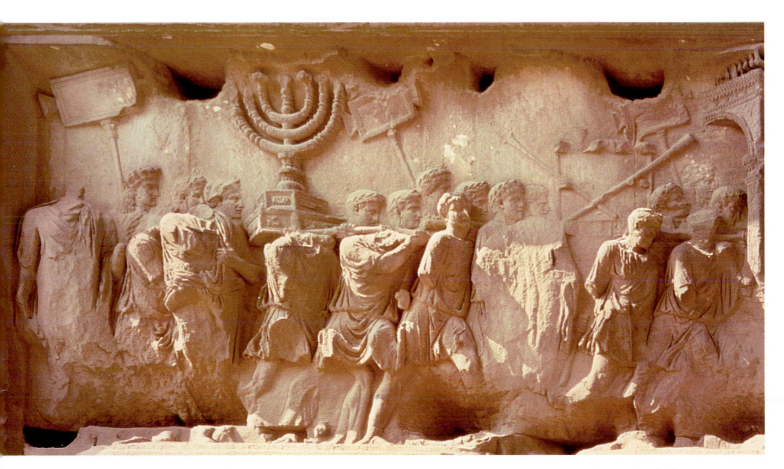

7.26. Relief in bay of Arch of Titus, showing procession of spoils from the Temple in Jerusalem. ca. 81 CE. Marble. Height 7′10″ (2.39 m). Rome

Josephus (37/8–ca. 100 CE)

The Jewish War, from Book VII

The Jewish soldier and historian Josephus Flavius was born Joseph Ben Matthias in Jerusalem. He was named commander of Galilee during the uprising of 66–70 CE against the Romans in the reign of Nero. After surrendering, he won the favor of the general Titus Flavius Sabinus Vespasian and took the name Flavius as his own. Josephus moved to Rome, where he wrote an account of the war (75–79 CE) and Antiquities of the Jews *(93 CE). The following passage from his history of the rebellion describes the triumphal procession into Rome following the Sack of Jerusalem in 70 CE, which is depicted on the Arch of Titus (figs. 7.26, 7.27).*

It is impossible to give a worthy description of the great number of splendid sights and of the magnificence which occurred in every conceivable form, be it works of art, varieties of wealth, or natural objects of great rarity. For almost all the wondrous and expensive objects which had ever been collected, piece by piece, from one land and another, by prosperous men—all this, being brought together for exhibition on a single day, gave a true indication of the greatness of the Roman Empire. For a vast amount of silver and gold and ivory, wrought into every sort of form, was to be seen, giving not so much the impression of being borne along in a procession as, one might say,

of flowing by like a river. Woven tapestries were carried along, some dyed purple and of great rarity, others having varied representations of living figures embroidered on them with great exactness, the handiwork of Babylonians. Transparent stones, some set into gold crowns, some displayed in other ways, were borne by in such great numbers that the conception which we had formed of their rarity seemed pointless. Images of the Roman gods, of wondrous size and made with no inconsiderable workmanship, were also exhibited, and of these there was not one which was not made of some expensive material....

The rest of the spoils were borne along in random heaps. The most interesting of all were the spoils seized from the temple of Jerusalem: a gold table weighing many talents, and a lampstand, also made of gold, which was made in a form different from that which we usually employ. For there was a central shaft fastened to the base; then spandrels extended from this in an arrangement which rather resembled the shape of a trident, and on the end of each of these spandrels a lamp was forged. There were seven of these, emphasizing the honor accorded to the number seven among the Jews. The law of the Jews was borne along after these as the last of the spoils. In the next section a good many images of Victory were paraded by. The workmanship of all of these was in ivory and gold. Vespasian drove along behind these and Titus followed him; Domitian rode beside them, dressed in a dazzling fashion and riding a horse which was worth seeing.

SOURCE: J. J. POLLITT. *THE ART IN ROME, C. 753 B.C.–A.D. 337*, SOURCES AND DOCUMENTS. (NJ: CAMBRIDGE UNIVERSITY PRESS, 1983)

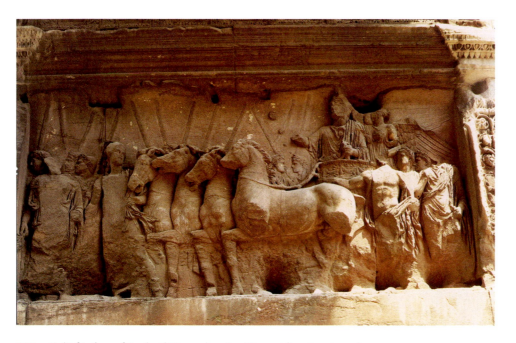

7.27. Relief in bay of Arch of Titus, showing Titus riding in triumph

(fig. **7.27**). The horses appear in profile, but the chariot is frontal, giving the illusion that the procession is coming toward a viewer before turning sharply. Standing behind the emperor, a personification of victory crowns him for his success. Additional personifications—Honor and Virtue, perhaps or Roma—accompany the chariot. Their presence, and the absence of Vespasian, whom the Jewish historian Josephus places in the scene, sound a cautionary note for those who would read Roman visual narratives

as historically accurate depictions of events. (See *Primary Source*, above.) These narratives are constructed to express a version of events that serves the patron's ideology.

The exploration of space and narrative strategies come into full bloom in the Column of Trajan (fig. **7.28**). The column was erected between 106 and 113 CE in small court to the west of Trajan's Forum (see figs. 7.33 and 7.35), and its base would serve as a burial chamber for his ashes after his death in 117. Soaring about

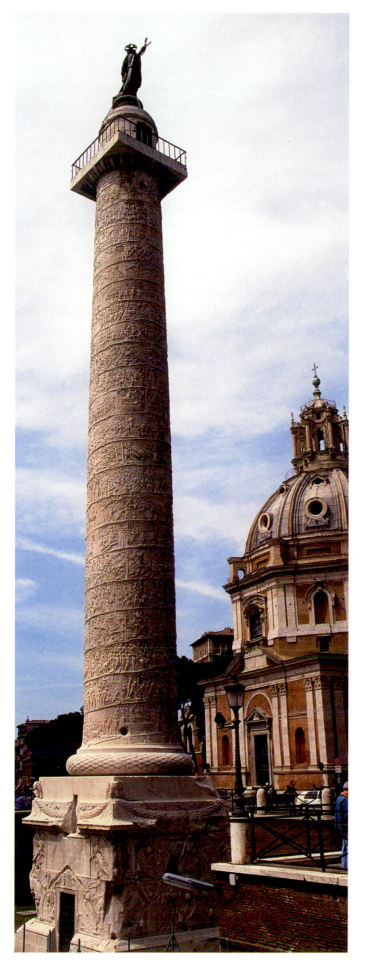

150 Roman feet high, it supported a gilded statue of the emperor, lost in medieval times. Winding through the interior of its shaft was a spiral staircase leading to a viewing platform, from which a visitor could look out over Trajan's extraordinary building complex. Free-standing columns had been used as commemorative monuments in Greece from Hellenistic times on, but the sheer scale of Trajan's Column, and its role as a belvedere, make it nothing short of a world wonder. Its design is often credited to Apollodorus, who served as Trajan's military architect. However, art historians have tended to focus not on the engineering feat it represents, but on the 656-foot-long continuous narrative relief that winds around the column in a counterclockwise direction, celebrating the emperor's victorious campaigns against the Dacians (in present-day Romania).

The narrative begins with the Roman army's crossing of the Danube to reach Dacian territory (fig. 7.29). The river appears as a large personification. To the left are riverboats loaded with supplies and a Roman town on a rocky bank. A second band shows Trajan speaking to his soldiers, and soldiers building fortifications. In the third, soldiers construct a garrison camp and bridge as the Roman cavalry sets out on a reconnaissance mission; and in the fourth, foot soldiers cross a stream while, to the right, the emperor addresses his troops in front of a Dacian fortress. These scenes are a fair sampling of events shown on the column. Among the more than 150 episodes, combat occurs only rarely. The geographic, logistic, and political aspects of the campaign receive more attention, much as they do in Julius Caesar's literary account of his conquest of Gaul.

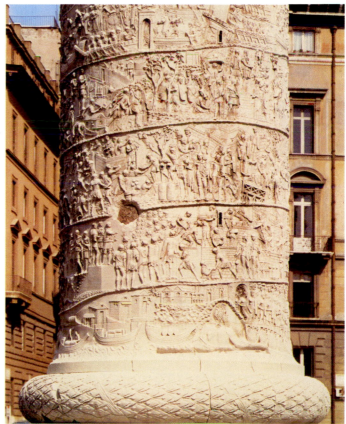

7.28. Column of Trajan, Rome. 106–113 CE. Marble. Height 125′ (38 m)

7.29. Lower portion of the Column of Trajan, Rome. 106–113 CE. Marble. Height of relief band approx. 50″ (127 cm)

Individual scenes are not distinctly separate from one another. Sculptors placed trees and buildings in such a way as to suggest divisions, but the scenes still merge into a continuous whole, with important protagonists, such as Trajan, appearing multiple times. Visual continuity was thus preserved without sacrificing the coherence of each scene. Although Assyrian and Egyptian artists created visual narratives of military conquests, this relief is by far the most ambitious composition so far in terms of the number of figures and the density of the narrative. Understanding it is a complicated matter. Continuous illustrated **rotuli** (scrolls) make a likely inspiration for the composition, except that none survive from the time before the column's construction. More problematic is how a viewer was supposed to read the narrative. In order to follow its sequence, one has to keep turning around the column, head inclined upwards. Above the fourth or fifth turn, details become hard to make out with the naked eye, even if the addition of paint made the sculpture more vivid.

It might have been possible to view the upper spirals from balconies on surrounding buildings in antiquity, but the format would still have required encircling motion. These problems have led scholars to propose strategies for reading the narrative. They have long noted that the relief is formulaic; that is, a fairly limited number of stock scenes are repeated again and again. These include, for instance, sacrifice scenes, the emperor addressing his troops, or soldiers constructing forts and dismantling enemy cities. Though the scenes are not identical, they are similar enough to be readily recognized at a distance, making the upper spirals more legible. The designer may also have aligned important and representative scenes on the cardinal axes of the column, so that a viewer could grasp an abbreviated version of the whole from a single standpoint. Yet there is always the possibility that the designer intended viewers to have to turn around the column in order to read its narrative. The column was, one recalls, Trajan's tomb, and an encircling motion would be entirely consistent with a widespread Roman funerary ritual known as the *decursio*, in which visitors to a tomb walked around it to protect the dead buried within, to keep harmful spirits in the grave, and to pay perpetual homage to the deceased.

Exactly when the classicizing phase of Roman sculpture, still so evident on the Column of Trajan, starts to yield to the more abstract qualities of Late Antiquity is a matter of some debate. A critical turn may have occurred with the column base of Antoninus Pius and his wife Faustina the Elder. Antoninus died in 161 CE. His successors, Marcus Aurelius and Lucius Verus, erected a 50-foot porphyry column in his honor, surmounted by his statue. Its white marble base is all that survives. One side bears an inscription. On another, a winged figure bears the emperor and his wife to the heavens, while personifi-

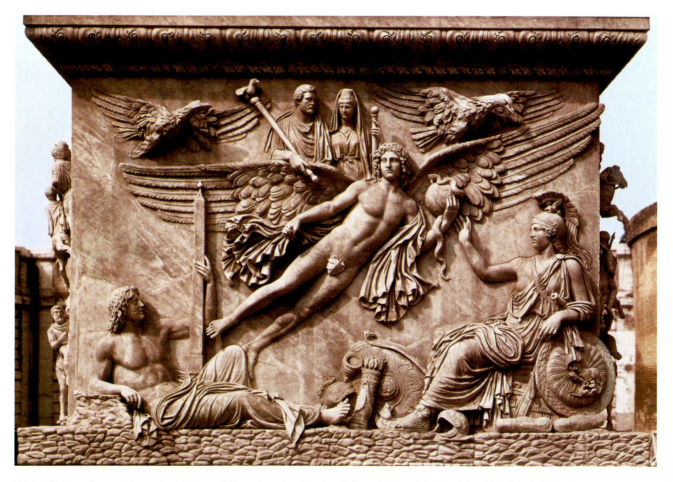

7.30. Column base of Antoninus Pius and Faustina. *Apotheosis* relief. ca. 161 CE. Marble. Musei Vaticani, Rome

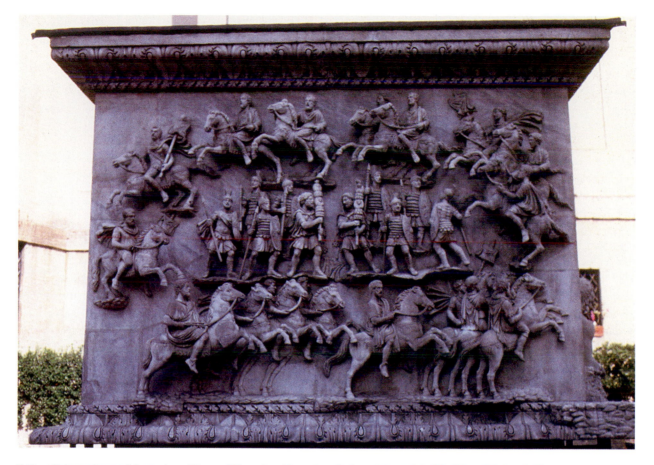

7.31. Column base of Antoninus Pius and Faustina. *Decursio* relief. ca. 161 CE. Marble. Musei Vaticani, Rome

7.32. Funerary relief of a butcher and a woman. Mid-2d century CE. Marble. 13½″ × 26½″ (34.5 × 67.3 cm). Staatliche Kunstsammlungen, Dresden

cations of the Field of Mars (where the cremation took place) and Rome look on (fig. **7.30**). The figures have lithe, Classical proportions, and their faces are idealized, with smooth, even planes and ageless features. On the two remaining sides of the base, Roman cavalry men ride in a counterclockwise circle around a group of infantry men, in nearly identical scenes that probably represent the ritual walk around the funerary pyre, the *decursio* (fig. **7.31**). The sculptural style of these scenes is quite unlike the apotheosis scene. The soldiers have stocky, squat proportions, and the action unfolds in a bird's-eye perspective, while the soldiers are viewed from the side. Both of these factors find parallels in sculpture commissioned in the provinces and in nonelite circles. Figure **7.32** gives an example of a nonelite style, in a funerary relief commemorating a butcher and a woman. The image has a flatness that is quite different from the illusionistic treatment of space on the panels of the Arch of Titus (see figs. **7.26** and **7.27**) The figures are stocky, and the butcher's head is large in proportion to his body. The artist's priority was probably legibility: The panel would have been mounted on the facade of a tomb and needed to be legible from a distance. The linear treatment of the image and the boldness of forms served this goal well. The introduction of these qualities into imperial commissions in Rome signals a change in the way messages were expressed in state art.

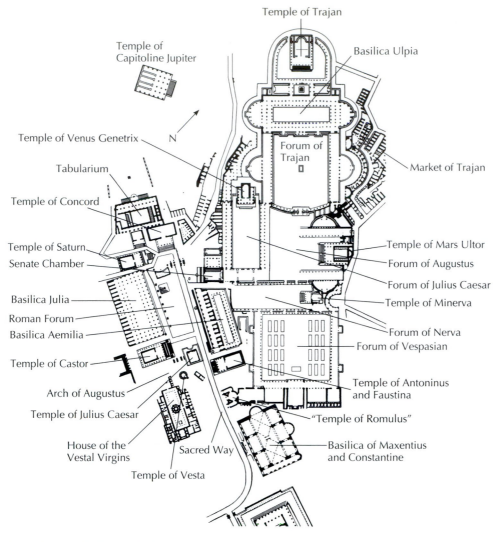

Temple of Trajan

Temple of Capitoline Jupiter

Basilica Ulpia

Temple of Venus Genetrix

N

Forum of Trajan

Market of Trajan

Tabularium

Temple of Concord

Temple of Saturn

Senate Chamber

Temple of Mars Ultor

Forum of Augustus

Forum of Julius Caesar

Temple of Minerva

Basilica Julia

Roman Forum

Basilica Aemilia

Forum of Nerva

Forum of Vespasian

Temple of Castor

Temple of Antoninus and Faustina

Arch of Augustus

Temple of Julius Caesar

"Temple of Romulus"

House of the Vestal Virgins

Sacred Way

Basilica of Maxentius and Constantine

Temple of Vesta

7.33. Plan of the Imperial Forums, Rome

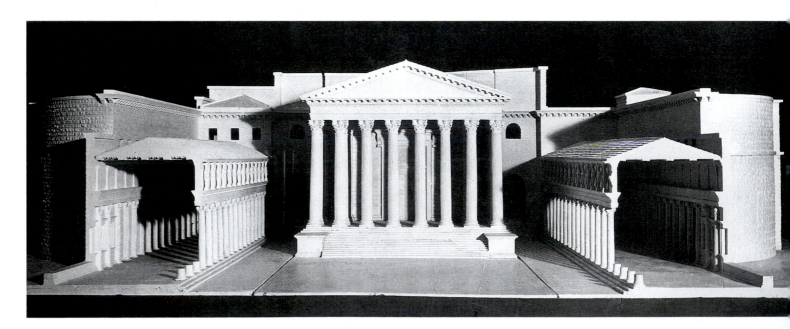

7.34. Forum of Augustus, Rome. Dedicated in 2 BCE. Model by Italo Gismondo

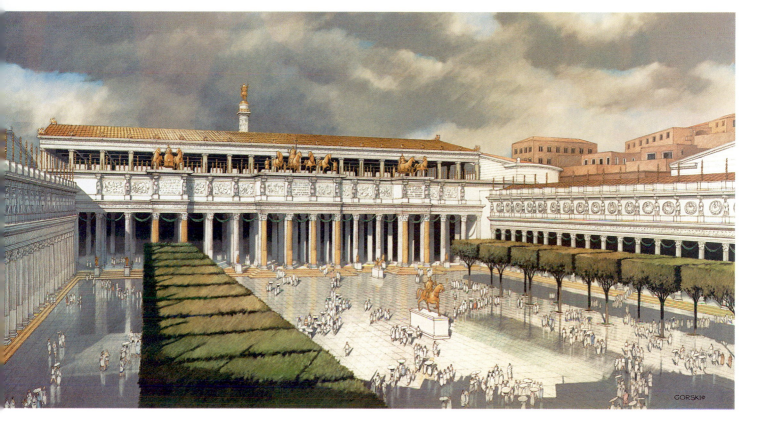

7.35. Forum of Trajan, Rome. Restored view by Gilbert Gorski

Architecture

Pompey's theater complex was the first of a series of huge urban interventions by Rome's autocrats designed to curry favor with the populace. Julius Caesar and Augustus each followed it with a forum, setting a tradition that Vespasian, Domitian, and Trajan all followed. As the plan in figure **7.33** reveals, these forums were closely connected to each other topographically and drew significance from their proximity. A visitor entered the Forum of Augustus directly from that of his divinized ancestor Caesar, cementing the connection immediately. Augustus' Forum consisted of a large open plaza with porticoes lining the long sides (fig. **7.34**). At the end of the plaza was a large temple to Mars the Avenger, which Augustus had vowed after Caesar's assassination. When compared with the free forms of the Sanctuary of Fortuna at Praeneste, Augustus' Forum is overwhelmingly rectilinear and classically inspired, as was most Augustan architecture. This deliberate choice evoked the pinnacle of Greek achievement in fifth-century Athens, and the effect was underlined through the pervasive use of marble, made available from

newly opened quarries at Carrara. Sculpture filled the complex. The porticoes housed full-length, labeled portraits of great men from Rome's legendary past and recent history, suggesting a link between the past and the present. In the attic of the porticoes, engaged **caryatids** (supporting columns in the shape of draped female figures) flanked shields decorated with heads of Jupiter Ammon (god of the Sahara, sometimes described as Alexander the Great's father). The carved women replicated the figures on the south porch of the Erechtheion on the Athenian Akropolis, where Augustus' architects were engaged in restoration work. Augustus' Forum took on many functions previously accommodated by Rome's historic buildings such as the Temple of Capitoline Jupiter, and by diverting state activities and rituals to an arena associated with his name, Augustus unambiguously placed himself at the head of Roman public life.

The largest of all the imperial fora was Trajan's, financed with the spoils of his wars against the Dacians. Recently published reconstructions of the complex give some sense of its former magnificence (fig. **7.35**). Located alongside Augustus'

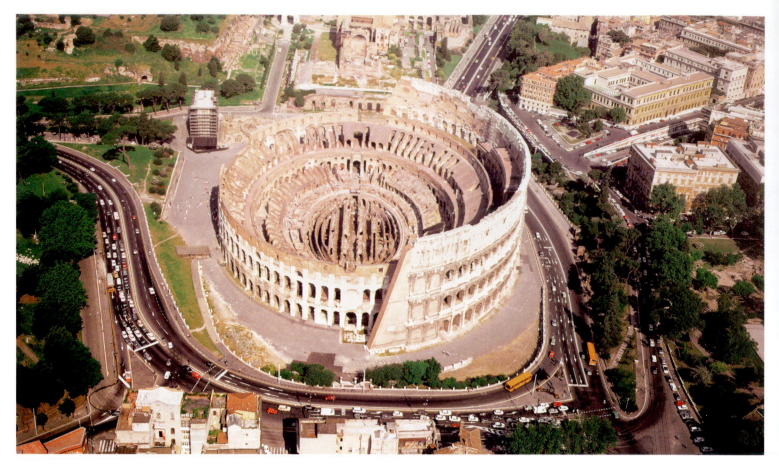

7.36. Colosseum, Rome. 72–80 CE

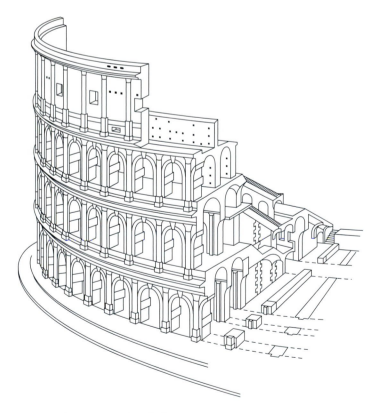

7.37. Colosseum, sectional view

Forum, it adapted many of that forum's features to new effect. In place of the caryatids in the portico attics, for instance, were statues of captive Dacians carved from exotic marbles. Beyond a basilica at the far end, two libraries and a temple defined a small courtyard, where Trajan's Column stood (see figs. 7.28 and 7.29). The Forum's message is clear: The Dacian Wars brought Rome great benefit. As in so many societies, the ruling elite hoped to dispel the starker realities of war through visual propaganda.

As well as constructing a magnificent forum in the name of peace, Vespasian was the first to construct a permanent amphitheater in Rome for the gladiatorial games that were so central to Roman entertainment (figs. **7.36**, **7.37**, and **7.38**). Earlier gladiatorial shows had taken place in the Roman Forum, with temporary wooden bleachers for spectators. Vespasian died before completing the Colosseum, and his son Titus inaugurated it in 80 CE with over 100 days of games, at a cost of over 9,000 animal lives. In terms of sheer mass, it was one of the largest single buildings anywhere: It stood 159 feet high, 616 feet 9 inches long, and 511 feet 11 inches wide, and could hold 45,000 to 50,000 spectators. Concrete, faced with travertine, was the secret of its success. In plan, 80 radial barrel-vaulted wedges ringed an oval arena. Each barrel vault buttressed the next, making the ring

ART IN TIME

ca. 20 CE—**The original** *Augustus of Primaporta*
23/24–79 CE—Pliny the Elder; wrote *Natural History*
106–113 CE—**The Column of Trajan erected in Rome**
117–125 CE—**Construction of the Pantheon in Rome**

remarkably stable. The wedges sloped down from the outside to the ringside to support seating, as in Pompey's theater, and accommodated within the wedges were countless stairways and corridors, designed to ensure the smooth flow of traffic to and from seating areas and the arena. During the hottest days, sailors stationed nearby could rig huge canvas sheets over the seating areas to provide shade. Dignified and monumental, the exterior reflects the structure's interior organization. Eighty arched entrances led into the building, framed with engaged Tuscan columns (which resembled Doric columns but had simple bases). On the second story, engaged Ionic columns frame a second set of arches, and on the third are engaged Corinthian columns. Engaged Corinthian pilasters embellish the wall on the fourth.

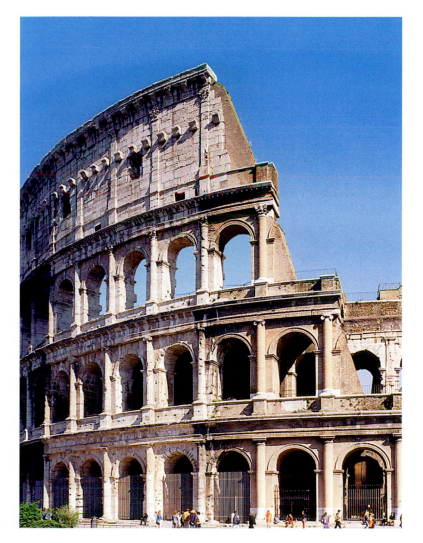

7.38. Colosseum, exterior

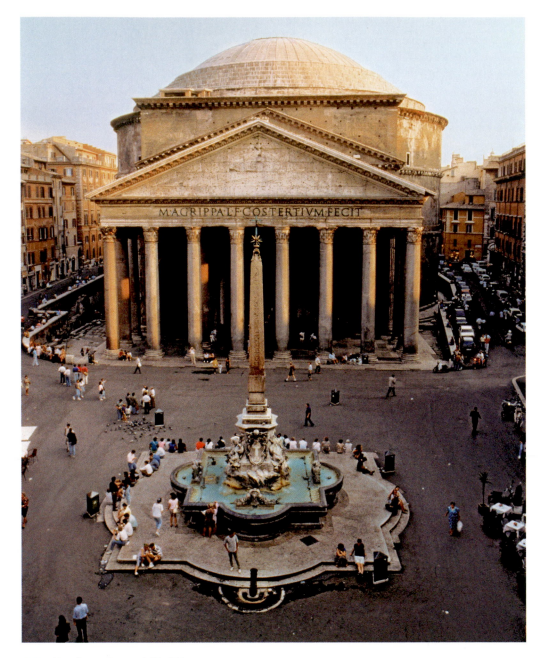

7.39. Pantheon, Rome. 117–125 CE

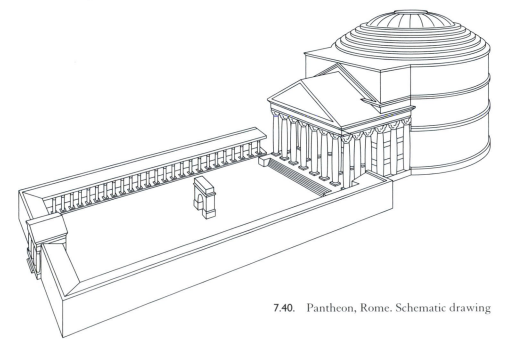

7.40. Pantheon, Rome. Schematic drawing

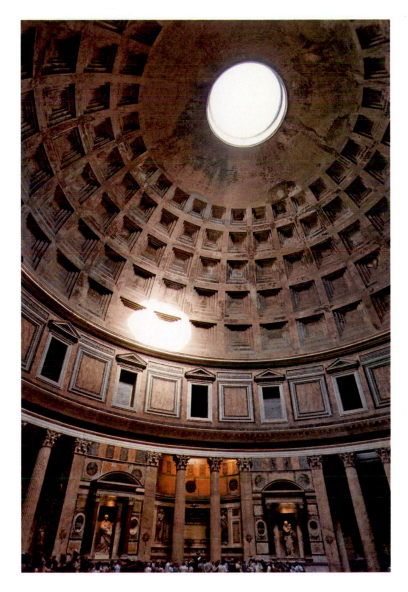

Of all the masterpieces Roman architects accomplished with concrete, the Pantheon is perhaps the most remarkable (fig. **7.39**). As its name suggests, the temple was consecrated to all the gods. In origin this was a Hellenistic concept, and it included living and deceased members of the ruling family among the gods. Augustus' right-hand man, Agrippa, had built the first Pantheon on the site. A fire in 80 CE destroyed this temple, and Domitian built a reconstruction, which perished after a lightning strike. The existing Pantheon is the work of Hadrian's architect, or perhaps even Hadrian himself, since he was an accomplished architect. As an act of piety, Hadrian chose to leave Agrippa's name in the inscription. The building dates between 117 and 125 CE, and its form appears to be quite different from the preceding temples. One of the best-preserved pagan temples of Rome, it owes this status to its transformation into a church in the early seventh century CE. All the same, the temple's surroundings have changed sufficiently through the ages to alter a visitor's experience of the building quite profoundly.

In Roman times, the Pantheon stood, raised on a podium, at the south end of a large rectangular court (fig. **7.40**). Porticoes framed the three remaining sides of the court and extended on the south right up to the sides of the temple's pedimented porch. In doing so, they hid the temple's circular drum from view. A visitor approaching the temple's broad octastyle facade would have been struck by the forest of massive monolithic grey and pink granite columns soaring upward; but in most other respects, the temple's form would have been extremely familiar, evoking an expectation of a rectangular cella beyond the huge bronze doors, sheltering a large cult statue. Yet a surprise was in store. On stepping across the threshold, all that was perceptible was a glowing shaft of light, slicing through the shadows from high overhead (figs. **7.41** and **7.42**). As the visitor's eyes slowly grew accustomed to the darkness, a vast circular hall took form, with seven large niches at ground level at the cardinal points. Engaged pilasters and bronze grilles decorated an attic level, and high above soared an enormous dome, pierced with a 27-foot hole or **oculus** onto the sky. Dome and drum are of equal height, and the total interior height, 143 feet, is also the dome's

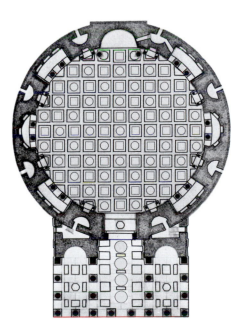

7.42. Plan of the Pantheon

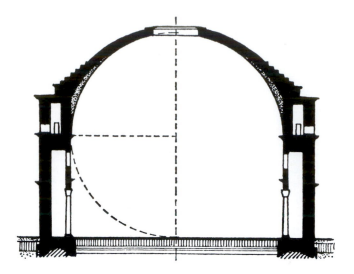

7.43. Transverse section of the Pantheon

diameter (fig. **7.43**). Many viewers in antiquity would have associated the resultant sphere with notions of eternity and perfection, and the dome's coffered surface, once emblazoned with bronze rosettes, must have evoked a starry night sky.

For a visitor entering the cella, there was no obvious cue to point out where to go, except toward the light at the center. In fact, the dome's **coffers** only make sense perspectively from directly beneath the oculus. Once a visitor reached the center, molded space and applied decoration combined to provide a stunning effect. Beginning in the Renaissance, scholars have found fault with the Pantheon's architect for neglecting to align the ribs between the dome coffers with the pilasters in the attic zone and the ground-floor columns. Yet, the absence of continuous vertical lines between top and bottom means that, visually speaking, the dome is not anchored. The optical effect is that it hovers unfettered above the visitor—who feels, paradoxically, both sheltered and exposed. The dome seems to be in perpetual motion, spinning overhead in the same way as the heavens it imitates. An all-but-imperceptible rise in the floor at the center exaggerates this sensation, which can incite an unnerving feeling similar to vertigo. A visitor's instinct, in response, is to take refuge in the safety of the curved wall. The building is all experience, and photographs do it no justice. This is the place, so literary sources relate, where Hadrian preferred to hold court, greeting foreign embassies and adjudicating disputes. The temple's form cast the emperor in his authoritative position as controller of his revolving universe. He must have appeared like a divine revelation before his guest, who was already awed and completely manipulated by the building that enclosed them.

The Pantheon is the extraordinary result of a developed confidence in the potential and strength of concrete. The architect carefully calibrated the aggregate as the building rose,

7.44. Scenic Canal, Hadrian's Villa at Tivoli, ca. 130–138 CE

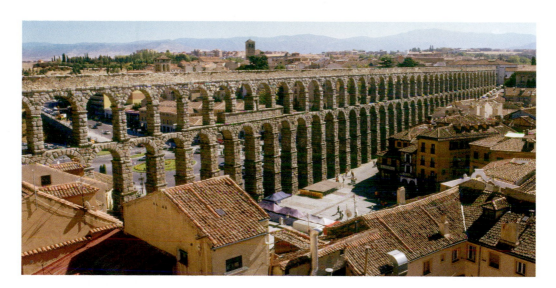

7.45. Aqueduct, Segovia. 1st or early 2d century CE

from travertine to tufa, then brick, and finally pumice, to reduce its weight. The dome's weight is concentrated on eight wide pillars between the interior alcoves, rather than resting uniformly on the **drum** (see fig. 7.42). The alcoves, in turn, with their screens of columns, visually reduce the solidity of the walls, and colored marbles on all the interior surfaces add energy to the whole. As in Trajan's Forum, the marbles were also symbolic. They underlined the vast reach of imperial authority, assuming trade with or control over Egypt (grey and rose-pink granite, porphyry), Phrygia (Phrygian purple and white stone), the island of Teos (Lucullan red and black stone), and Chemtou in Tunisia (Numidian yellow stone).

From the start of the Empire, the emperor's principal residence was on the Palatine Hill in Rome (from which the term "palace" derives). Yet, like many members of the elite, the emperor had several properties, many of which were outside of Rome. The most famous imperial property is the Villa of Hadrian at Tibur (present-day Tivoli). Built on the site of a Republican villa, this residence was a vast sprawling complex of buildings, some or all of which Hadrian may have designed himself. The villa's forms appear to follow the natural line of the landscape, but in fact massive earthworks rearranged the terrain to accommodate the architecture and to allow for impressive vistas, cool retreats, and surprise revelations. Water was a common feature, in pools and running channels, adding sound and motion, reflecting light, and offering coolness in the summer heat. Throughout the villa were mosaics, paintings, and sculptures. Some of these works of art may have been collected during the emperor's extensive travels, especially in Egypt and Greece. A desire to evoke the far-flung regions of the Empire may also have inspired some of the buildings: A fourth-century CE biography claims that Hadrian "built up his villa at Tibur in an extraordinary way, applying to parts of it the renowned names of provinces and places, such as the Lyceum, the Academy, the *prytaneum*, the Canopus, the *Poecile*, and Tempe. And so as to omit nothing, he even fashioned 'infernal

regions.'" This statement has led modern scholars to give fanciful names to many parts of the villa. Few of them are based in archeological evidence, and they lead visitors to faulty conclusions about the buildings' functions. The canal shown in figure **7.44** has long been known as the Canopus, after a town in Egypt. Only recently have more neutral terms been proposed for the villa's components, in this case the "Scenic Canal."

ART AND ARCHITECTURE IN THE PROVINCES

The spread of Rome's authority over a wide geographical reach had a profound impact on artistic and architectural production in those areas as well. Since history is typically constructed by those in power, it is often hard to assess the reactions of local peoples to foreign control. To be sure, Roman rule brought some benefits. Roman engineers had mastered the art of moving water efficiently, and the new Roman aqueducts that sprang up in urban centers around the empire must have improved local standards of living immeasurably. A striking aqueduct still stands at Segovia in Spain, dating to the first or early second century CE (fig. **7.45**). It brought water from Riofrío, about 10 $\frac{1}{2}$ miles (17 km) away, flowing for most of its length through an underground channel. Approaching the town, however, architects built a massive bridge stretching 2,666 feet (813 m) long and up to 98 feet (30 m) high to span a valley. One hundred and eighteen arches support the water channel, superimposed in two registers at the highest point. Like most provincial builders, the architects used a local stone, in this case a granite, assembled without mortar and left unfinished to give an air of strength. Despite the obvious advantages the aqueduct provided, it also illustrates how Roman architecture could effect dominion. The arches—such a quintessentially Roman form—march relentlessly across the terrain, symbolically conquering it with their step. Even the act of moving water was a conquest of a kind, a conquest of Nature.

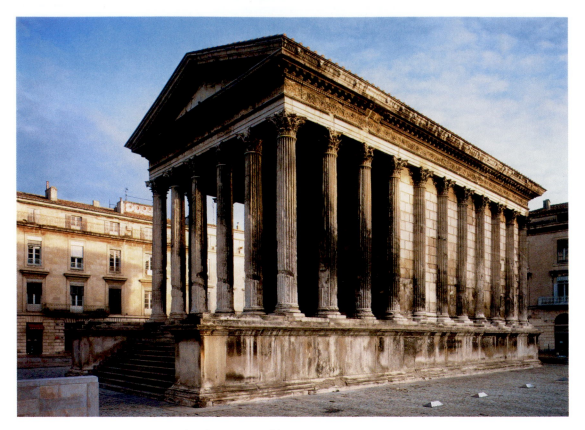

7.46. Maison Carrée, Nîmes. Early 2d century CE (?)

Romans carried their way of life with them across the Empire, constructing theaters and amphitheaters in a Roman style, and temples to accommodate their rituals. A well-preserved temple (fig. **7.46**) known as the Maison Carrée (Square House) survives in the French town of Nîmes (ancient Nemausus). A typical Roman temple, it stands on a high podium, with a frontal staircase. Six Corinthian columns across the front lead into a deep porch and to the cella; engaged columns decorate the cella's exterior walls. Reconstructing an inscription in bronze letters on its architrave from the evidence of dowel holes, scholars have long thought the temple to be dedicated to Rome and Augustus during the Augustan age. Acanthus scrolls in the frieze appeared to be reminiscent of the Ara Pacis, and the masonry style showed similarities to that of the Temple of Mars the Avenger in Augustus' Forum. Indeed, scholars considered the temple evidence for traveling workshops, practicing their craft in Rome and the provinces. Recent research has cast doubt on this view, however, illustrating the danger that historians may construct the very history they are looking for. As it turns out, the dowel holes could support any number of different inscriptions; and the module employed throughout the building only came into use under Trajan. The building could even be a temple dedicated to Trajan's wife, Plotina, known from literary sources.

In some cases, indigenous building traditions combined with Roman styles to powerful new effect. This appears to be the case with the extraordinary rock-cut facade known as El

Khasneh, or the Treasury, at the site of Petra in present-day Jordan (fig. **7.47**). This facade is the first sight to greet a visitor who wanders through the long, twisting gorge known as the Siq, leading to the town center. The Nabataeans, a nomadic people who settled this area before the Romans took control in 106 CE, would bury their wealthy dead in tombs cut out of the rosy pink sandstone cliffs, and some scholars have seen El Khasneh as one of their monuments. Most agree, however, that it belongs to the Trajanic or Hadrianic period. Carved from the living rock, the monument resembles a temple facade, with six columns beneath an architrave decorated with floral designs and a pediment. In a second story, lateral columns support the angles of a broken pediment. Between them is a tholos with a conical roof, surmounted by an ornamental finial. In more recent times, locals imagined that pirates had stored their treasure in the finial, lending the monument its name; bullet holes show how they tried to knock it to the ground. The facade is a striking amalgamation of a Nabataean concept with Roman decorative features—the Corinthian column capitals, for instance, and the vegetal designs. The architectural elements are not structural, and this allows for a freedom and fantasy quality in the design, not unlike the fantasy vistas of Second Style wall paintings (see page 216). This playful treatment of once-structural elements became popular in the provinces and in Rome in the second century CE, and scholars sometimes describe it as a baroque phase, for its similarities to Italian baroque architecture. The monument's function may have

changed for Roman usage as well: Relief sculptures between the columns seem to represent figures from the cult of Isis, suggesting that it was a temple. In some cases, inscriptions and other written documents indicate who commissioned monuments in the provinces; the patron might be local, a Roman official, or even the emperor himself. More often, as in this case, there is no such evidence, which makes it hard to determine meaning in a choice of style.

Sculpture in the Roman provinces also has a distinctive look—the result, generally, of a merging of different traditions. The sculpture illustrated in figure **7.48** is a limestone funerary relief from Palmyra in Syria from the second half of the second century CE. It once sealed the opening to a burial within a characteristically Palmyrene monument, a tower tomb. An Aramaic inscription identifies the subject as Tibnan, an elite woman, who holds a small child in one arm. The language bespeaks her origin, and the strict frontality, large staring eyes, and local dress and headband set her apart from the elite women of Rome (see figs. 7.17, 7.20, and 7.22). All the same, the portrait has distinctly Roman qualities: Tibnan raises her right hand, for instance, to hold her veil, in a gesture that is well known in Rome (see fig. 7.14) and signified chastity (or *pudicitia*, defined as loyalty to one's husband). The portrait neatly encapsulates the dual identity of this provincial woman, who is both Roman and Palmyrene.

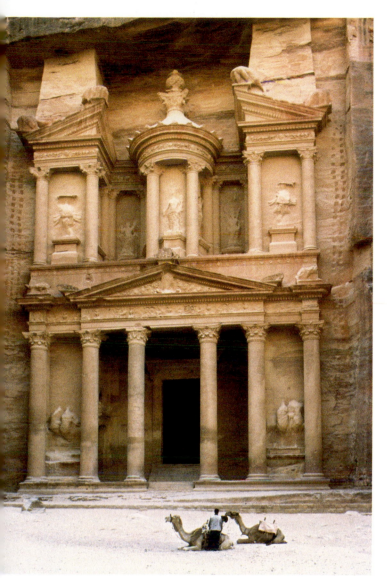

7.47. El Khasneh, Petra, Jordan. Probably early 2d century CE

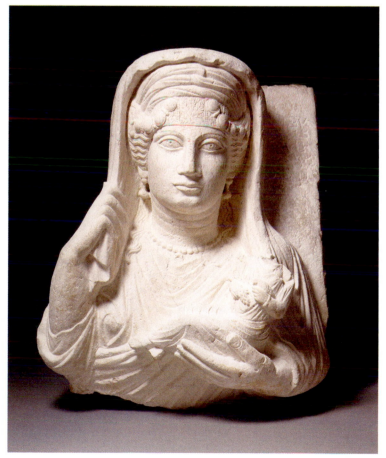

7.48. Funerary relief of Tibnan, from Palmyra, Syria. ca. 150–200 CE. Painted limestone. Musée du Louvre, Paris

Vitruvius

Vitruvius was a Roman architect who wrote a treatise on architecture during the time of Julius Caesar and Augustus. Scholars have used his comments on painting to reconstruct domestic decorative schemes, and to gain an understanding of the general development of Roman painting techniques and styles.

Book 7, Chapter 5: Correctness in Painting: General Remarks

1. In the remaining rooms, that is, the spring, autumn, and summer quarters, also in atria and peristyles, the ancients have established certain secure principles for painting, based on secure phenomena. For a painting is an image of that which exists or can exist, like those of people, buildings, ships, and other things with definite and certain bodies, of which examples may be found and depicted in imitation. On this principle, the ancients who established the beginnings of painting plaster first imitated the varieties and placement of marble veneers, then of cornices and the various designs of ochre inlay.

2. Later they entered a stage in which they also imitated the shapes of buildings, and the projection into space of columns and pediments, while in open spaces like exedrae, because of the extensive wall space, they painted stage sets in the tragic, comic, or satyric style, and adorned their walkways, because of their extensive length, with varieties of landscape, creating images from the known characteristics of various places. For ports, promontories, seashores, rivers, springs, straits, shrines, sacred groves, mountains, herds, and shepherds are depicted, some places are portrayed in monumental painting with the likenesses of the gods or the skillfully arranged narrations of myths, such as the Trojan battles, or the wanderings of Ulysses through various landscapes, and other subjects that have been created according to nature on similar principles.

3. But these paintings, which had taken their models from real things, now fall foul of depraved taste. For monsters are now painted in frescoes rather than reliable images of definite things. Reeds are set up in place of columns, as pediments, little scrolls, striped with curly leaves and volutes candelabra hold up the figures of aediculae, and above the pediments of these, several tender shoots, sprouting in coils from roots, have little statues nestled in them for no reason, or shoots split in half, some holding little statues with human heads, some with the heads of beasts.

4. Now these things do not exist nor can they exist nor have they ever existed, and thus this new fashion has brought things to such a pass that bad judges have condemned the right practice of the arts as lack of skill. How, pray tell, can a reed really sustain a roof, or a candelabrum the decorations of a pediment, or an acanthus shoot, so soft and slender, loft a tiny statue perched upon it, or can flowers be produced from roots and shoots on the one hand and figurines on the other? Yet when they see these deceptions, people never criticize them, but rather take delight in them, nor do they ever notice whether any of these things are possible or not. Minds beclouded by feeble standards of judgment are unable to recognize what exists in accordance with authority and the principles of correctness. Neither should pictures be approved that are not likenesses of the truth, nor, if they are made elegant through art, is that any reason why favorable judgment should immediately be passed on them, not unless their subjects follow sound principles without interference. . . .

But it will not be out of place to reveal why false reasoning wins out over truth: the ancients invested their labor and energy in competition to win approval for their skill, but now, [fresco painters] pursue approval through the deployment of colors and their elegant appearance, and whereas refinement of craftsmanship once increased the reputation of works, now sovereign extravagance makes it no longer desirable.

The greatest body of painting to survive from the Roman world is wall painting (see page 214). Yet the sands of Fayum, in Lower Egypt, have preserved a magnificent group of painted portraits, once attached over the faces of the embalmed, mummified bodies of the dead (fig. **7.49**). The earliest of them appear to date from the second century CE. Artists painted them on wooden panels in a technique known as **encaustic**, which involves suspending pigments in hot wax. The mixture can be opaque and creamy, like oil paint, or thin and translucent. The medium is extremely durable, and the panels retain an extraordinary freshness; the wax also gives them a luster that brings them vividly to life. Their quality varies dramatically. At their best, these portraits have a haunting immediacy, largely the result of the need to work quickly before the hot wax set. The woman pictured here wears a deep crimson tunic and a wealth of jewelry. Rows of black circles denote the ringlets of her hair, bound with a golden diadem. Her appearance is Roman, yet the portrait itself speaks of her local identity, since she was buried in the Egyptian, not the Roman, fashion.

DOMESTIC ART AND ARCHITECTURE

The Romans are one of the few ancient peoples to leave abundant evidence of domestic architecture and its decoration. The burial of the cities of Pompeii and Herculaneum after the eruption of Vesuvius in 79 CE, so tragic for those who perished, preserved an invaluable legacy for the archeologist; and such was the durability of Roman domestic construction that houses survive elsewhere as well, as far afield as Morocco and Jordan. Their unusually good state of preservation has meant that houses buried by Vesuvius have dominated scholarly discussion, as they will here; yet although Roman houses around the empire have many common qualities, they also differ from one region to the next, to cater, for instance, to local climates. In any given region, there were also discrepancies between the dwellings of the very rich and the very poor. One should be cautious, therefore, about conceiving of a "typical" Roman house.

Scholars describe elite Roman houses by their Latin name, *domus*, known from Vitruvius and other ancient writing (see end of Part I *Additional Primary Sources*). The most distinctive

feature of a single-family dwelling is an **atrium**, a square or oblong central hall lit by an opening in the roof, answered by a shallow pool, or *impluvium*, in the ground to collect rainwater. This kind of house may owe its origin, in part at least, to elite Etruscan residences like the complex at Murlo (see fig. 6.14). The atrium was the traditional place for keeping portraits of ancestors. Its airy quality confers an element of grandeur upon

ART IN TIME

early 100s CE—*Aqueduct built at Segovia, Spain*

ca. 46–120 CE—*Life of the Greek biographer Plutarch*

early 100s CE—**Construction of El Khasneh in Petra, Jordan**

100s CE—**The earliest painted portraits from the Fayum, Lower Egypt**

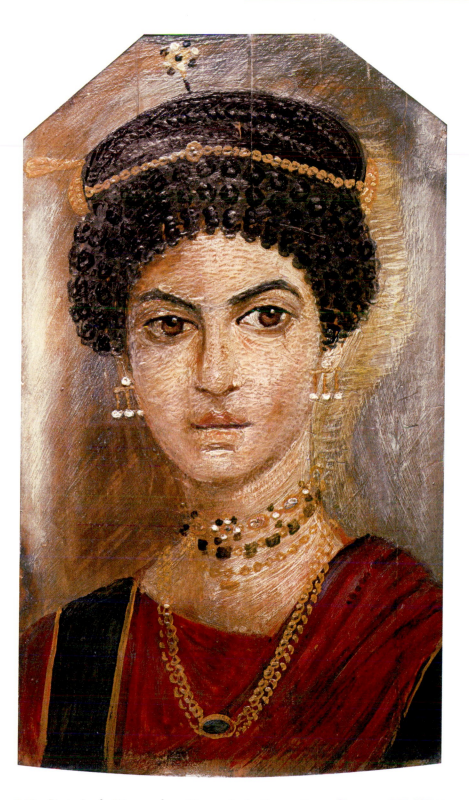

7.49. Portrait of a Woman, from Hawara in the Fayum, Lower Egypt. ca. 110–130 CE. Encaustic on wooden panel. Royal Museum of Scotland. © Trustees of the National Museum of Scotland

the house, visible here in the House of the Vettii (fig. **7.50**). Other rooms, such as bedrooms (*cubicula*), are grouped around the atrium, which often leads on to a **tablinum**, the principal reception room, where family records were kept. Beyond the tablinum is a garden, surrounded by a colonnade (the **peristyle**). Additional rooms might be attached at the back of the house. Walls facing the street did not typically have windows, but one should not be misled into believing that Roman houses were particularly private. Rooms flanking the entryway were frequently used as shops, and the front door often stood open. Roman society was based on a client–patron relationship, and clients routinely visited their patrons in their homes. The householder also conducted business in his home, even, at times, in the cubicula. A visitor's access to the different parts of the house depended on his relationship with the owner, however, and most visitors would be greeted in the larger central rooms.

In Rome and its port city Ostia there are many surviving examples of **insulae** (literally "islands"), or city blocks. These are less elegant than the houses described previously, and have many features of a present-day apartment block. An insula was generally a good-sized concrete-and-brick building (or chain of buildings) around a small central court. On the ground floor were shops and taverns open to the street; above were living quarters for numerous families. Some had as many as five stories, with balconies above the second floor.

Compared with Greek painting, Roman domestic painting survives in great abundance. Most of it is wall painting, and it comes mainly from Pompeii and Herculaneum, and also from Rome and its environs. Examples of Roman paintings mostly

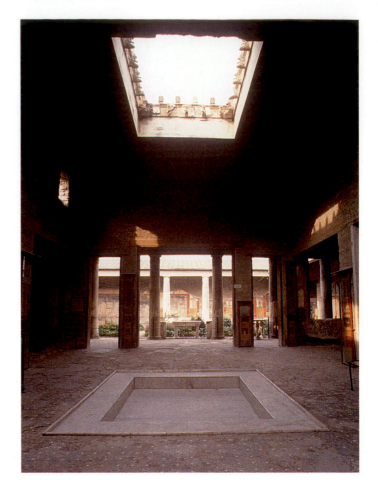

7.50. Atrium of the House of the Vettii, Pompeii. 2d century BCE–79 CE

August Mau (1840–1909 produced what remains the scheme that underpins all stylistic analysis of Pompeian decor: he divided the wall painting into four 'Styles,' each representing a phase in the chronology of Pompeian painting, from the second century BCE to the final eruption in 79 CE.

1. 'The First, or Incrustation, style': the wall is painted (and moulded in stucco) to imitate masonry blocks, no figured scenes. Second century BCE.

2. 'The Second, or Architectural, style': characteristically featuring illusionistic architectural vistas. *c.*100—15 BCE.

3. 'The Third, or Ornate, style': the vistas here give way to a delicate decorative scheme, concentrating on formal ornament. *c.*15 BCE.—50 CE.

4. 'The Fourth, or Intricate, style': a more extravagant painterly style, parading the whole range of decorative idioms. *c.*50 CE.

7.51. August Mau's Four Styles of Pompeian wall painting

7.52. First Style painting in the Samnite House, Herculaneum. Late 2d century BCE

date to a span of less than 200 years, from the end of the second century BCE to the late first century CE. Given the public character of a domus, these paintings were more than mere decoration: They also testified to a family's wealth and status.

Basing his analysis partly on Vitruvius' discussion of painting, the late nineteenth-century German art historian August Mau distinguished four phases of Roman wall painting (fig. 7.51). The four styles are not canonical, but have proved useful as general guidelines. (See *Primary Source*, page 212.) In the First Style, dating to the late second century BCE, artists used paint and stucco to imitate expensive colored marble paneling, as in the Samnite House at Herculaneum (fig. 7.52). Examples of this style have also survived in the eastern Mediterranean. Starting about 100 BCE, Second Style painters sought to open up the flat expanse of the wall by including architectural features and figures. In a room in the Villa of the Mysteries just outside Pompeii, dating from about 60 to 50 BCE, the lower part of the wall, beneath the dado, and the upper section above the cornice level, are painted in rich mottled colors to resemble exotic stone (fig. 7.53). In between, figures interact as if on a narrow ledge set against a deep red background, articulated by upright strips of black resembling stylized columns.

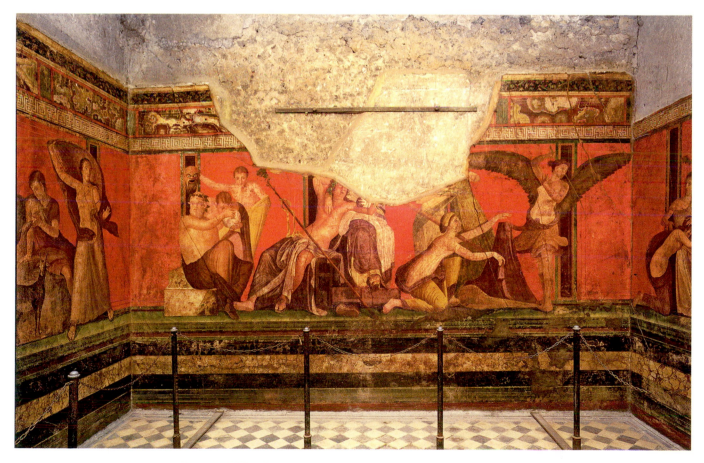

7.53. Second Style wall painting from the Villa of the Mysteries, Pompeii. *Scenes of Dionysiac Mystery Cult*. ca. 60–50 BCE

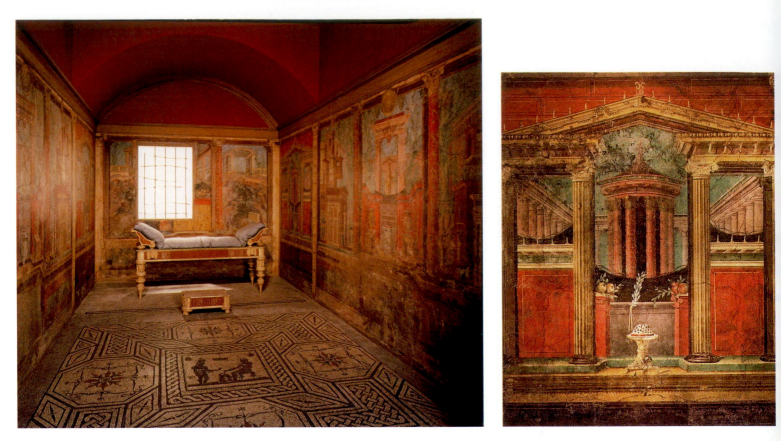

7.54. Second Style wall painting from the Villa of Publius Fannius Synistor at Boscoreale, near Pompeii. Mid-1st century BCE. Fresco on lime plaster. Height: 8'8½" × Length 19'7⅛" × width 10'11½" (265.4 × 583.9 × 334 cm). The Metropolitan Museum of Art, New York, Rogers Fund, 1903 (03.14.13)

The figures are engaged in various rites associated with the Dionysiac mysteries, one of the so-called mystery religions originating in Greece. The scene may represent an initiation into womanhood or marriage, conducted in the presence of Dionysos and Ariadne with a train of satyrs and sileni. The solidity of the near life-size figures, the bold modeling of their bodies in paint, and their calm but varied poses lend a quiet power and vivid drama to the room.

In some cases, Second Style artists employed architectural vistas to open the wall onto a fantasy realm, suggesting another world beyond the room. This movement may reflect architectural backdrops in contemporaneous theaters. An example from the Villa of Publius Fannius Synistor at Boscoreale, near Pompeii, now reconstructed in the Metropolitan Museum of Art in New York, illustrates this effect well (fig. **7.54**). A painted parapet wall runs around the lower part of the surface.

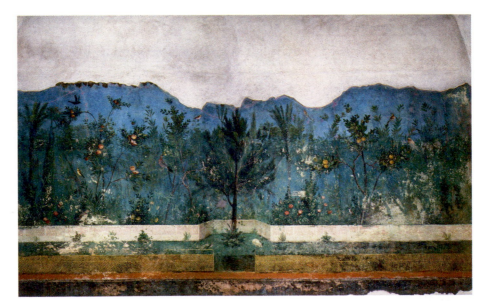

7.55. Wall painting of garden, from the Villa of Livia at Primaporta. ca. 20 BCE. Museo delle Terme, Rome

Resting on it are columns, supporting a cornice. These architectural features make up a foreground. Receding away from it, in a range of different perspectives, stoas and tholoi and scenic gazebos mingle with one another in a maze of architectural fantasy, flooded with light to convey a sense of open space. A viewer struggles to disentangle the structures from one other; their size and spatial relationships are hard to determine. The world of the painting is a world inaccessible to those who view it, hovering just out of reach. In the Villa of Livia at Primaporta, the world beyond the trellis fence and low garden wall is an idyll of nature, a garden filled with flowers, fruit trees, and birds (fig. **7.55**). Although its lushness beckons, this garden is another fantasy world made only for looking. A different form of perspective is in use here, known as atmospheric perspective: As plants and animals recede into the background, their forms become less distinct, suggesting distance.

The Third Style dominated wall decoration from about 20 BCE until at least the middle of the first century CE. In this phase, artists abandoned illusionism in favor of solid planes of intense colors like black and red, often articulated with attenuated architectural features and imitation panel paintings. A good example comes from the Villa of Agrippa Postumus at Boscotrecase, of about 10 BCE (fig. **7.56**). Slender columns sit on a narrow ledge and define a delicate *aedicula* (a small, shrine-like structure), but they are pure decoration. There is no pretence of structural integrity. The Fourth Style, which prevailed at the time of the eruption of Vesuvius, was the most intricate of the four, uniting aspects of all three preceding styles to create an extravagant effect. The Ixion Room in the House of the Vettii (fig. **7.57**) combines imitation marble paneling, framed mythological scenes resembling panel pictures set into the wall, and fantastic architectural vistas receding into space.

7.56. Third Style wall painting from Villa of Agrippa Postumus, Boscotrecase. ca. 10 BCE. Fresco on lime plaster. Height: 91³/₄″ (233.05 cm). Metropolitan Museum of Art, New York, Rogers Fund, 1970 (20.192.1)

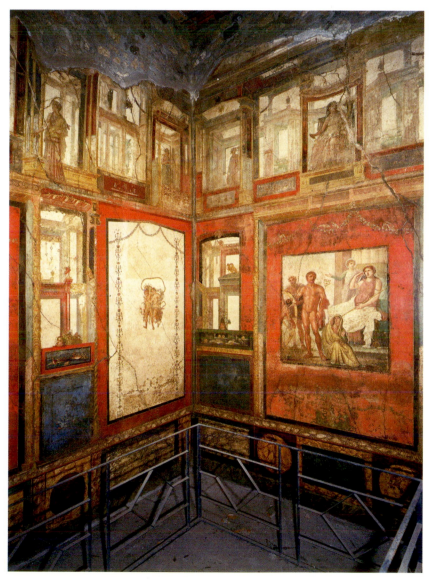

7.57. Fourth Style wall painting, Ixion Room, House of the Vettii, Pompeii. 63–79 CE

Philostratus (170–247 CE)

The Imagines

The Greek author Philostratus lived and taught in Athens and Rome in the third century CE. His work distinguishes him as a Sophist, a practitioner of rhetoric. The Imagines is a series of discussions of paintings, purportedly belonging to a wealthy collector in Neapolis (present-day Naples). Whether or not the paintings really existed is relatively unimportant, since the text was not designed to be a set of descriptions, but to teach students methods for viewing.

Xenia 1

It is a good thing to gather figs and also not to pass over in silence the figs in this picture. Purple figs dripping with juice are heaped on vine-leaves: and they are depicted with breaks in the skin, some just cracking open to disgorge their honey, some split apart, they are so ripe. Near them lies a branch, not bare, by Zeus, or empty of fruit, but under the shade of its leaves are figs, some still green and 'untime-ly', some with wrinkled skin and over-ripe, and some about to turn, disclosing the shining juice, while on the tip of the branch a sparrow buries its bill in what seems the very sweetest of the figs. All the ground is strewn with chestnuts, some of which are rubbed free of the burr, others lie quite shut up, and others show the burr breaking at the lines of division. See, too, the pears on pears, apples on apples, both heaps of them and piles of ten, all fragrant and golden. You will say that their redness has not been put on from the outside, but has bloomed from within. Here are gifts of the cherry tree, here is fruit in clusters heaped in a basket, and the basket is woven, not from alien twigs, but from branches of the plant itself. And if you look at the vine-sprays woven together and at the clusters hanging from them and how the grapes stand out one by one, you will certainly hymn Dionysos and speak of the vine as 'Queenly giver of grapes'. You would say that even the grapes in the painting are good to eat and full of winey juice. And the most charming point of all this is: on a leafy branch is yellow honey already within the comb and ripe to stream forth if the comb is pressed; and on another leaf is cheese new curdled and quivering; and there are bowls of milk not merely white but gleaming, for the cream floating upon it makes it seem to gleam.

7.58. Still life painting of peaches and water jar, from Herculaneum. ca. 50 CE. Museo Archeologico Nazionale, Naples

Framed within these Fourth Style designs there might be **still life** panels, which usually take the form of *trompe l'oeil* niches or cupboards, presenting objects on shelves. A twenty-first century viewer finds little unusual about this, yet visual studies of mundane, inanimate objects are not otherwise known until the early modern period. The driving force in these Roman paintings was not a narrative, as in many paintings of the time, but a close analysis of life. The example illustrated here depicts green peaches and a jar half filled with water (fig. **7.58**). Touches of white paint capture the effect of light playing on the surface of the jar and the water within, and shadows form around the peaches. The shadows fall in different directions, suggesting that the artist was more interested in using them to forge a spatial relationship between the peaches and their surroundings than to indicate a single source of light. It is possible, too, that the painting reflects the movement of shadow as the artist worked.

Like the Ixion painting in the House of the Vettii (see fig. 7.57), many Roman paintings were of Greek themes. The few painters' names that are recorded show that at least some of them were of Greek origin. There are also sufficient cases of paintings (or individual elements of paintings) closely resembling one another to indicate that artists used copybooks; in some cases, they may have been working from a Greek original, adapting the image freely to their own purposes. The Alexander Mosaic in the House of the Faun is a possible instance of a famous Greek painting being copied in Pompeii, albeit into a different medium (see fig. 5.79). Given the scarcity of Greek mural paintings, however, it is a rare case when a clear connection can be demonstrated between Greek original and Roman copy. Given the evident innovation in Roman painting in general, there is no reason to suppose that Roman artists were not fully capable of creating their own compositions and narratives when they chose. In recent years, scholarship has become less preoccupied with tracing Greek influences in Roman paintings, and more focused on ways in which ensembles of paintings affected experience or dictated

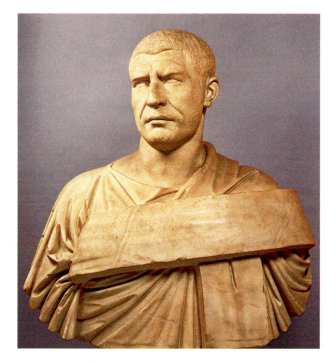

7.59. Portrait of Philip the Arab. 244–249 CE. Marble. Life-size. Musei Vaticani, Braccio Nuovo, Città del Vaticano, Rome

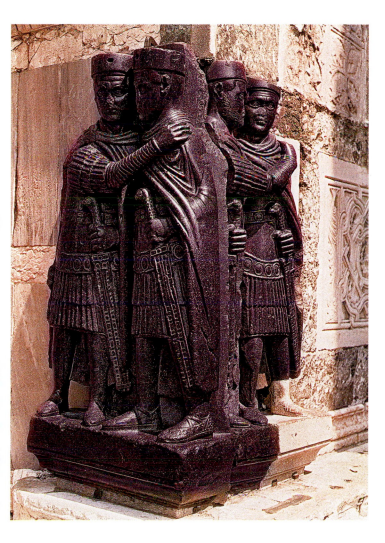

7.60. Portrait group of the Tetrarchs. ca. 305 CE. Porphyry. Height 51″ (129.5 cm). Basilica of San Marco, Venice

movement throughout a house and expressed the owner's status. In fact, there exists a genre of ancient literature known as *ekphrasis* that is a learned exposition on the subject of a real or imagined painting. (See *Primary Source*, page 218.) On the basis of these writings, scholars believe that homeowners sometimes conceived their paintings as conversation pieces for their guests, who might discuss them as they dined. Designing a painting program, then, takes on a new level of importance for what it might subtly disclose about the patron's erudition, status, or aspirations.

THE LATE EMPIRE

Portrait Sculpture

During Marcus Aurelius' reign, incursions at the empire's German and Danubian borders were a constant threat. Succeeding him in 180 CE, his son Commodus was assassinated in 192 CE. The imperial administration then hit an all-time low when, in 193 CE, the throne was auctioned off to the highest bidder. After a brief respite under the Severan dynasty, Rome entered a half century of civil war, when a long succession of emperors came to power and quickly fell through violence. Imperial portraits of this time share a harsh, soldierly quality, intended to appeal to where the power lay. Beards and hair are cropped short, with individual strands of hair often etched with a quick chip of the chisel that scholars term negative carving (fig. **7.59**). The twist of the head, the furrowed brow and the generally careworn features present the army with a man of action as their leader.

Imperial authority was finally restored in the reign of Diocletian (r. 284–305 CE). His approach was to impose rigid order on all aspects of civil as well as military life. Recognizing the emperor's vulnerability, he also chose to divide authority among four rulers, known as the tetrarchs. Two were senior emperors, the Augusti; and two juniors, the Caesars. Terms of power were to be limited, and the Caesars were to succeed the Augusti. To this period date two porphyry sculptural groups now immured in the Basilica of San Marco in Venice, probably originally mounted on columns (fig. **7.60**). Each group shows

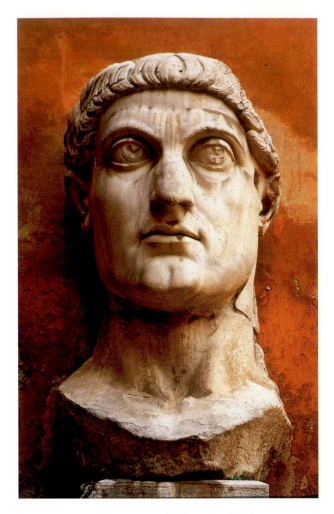

7.61. *Portrait of Constantine the Great.* Early 4th century CE. Marble. Height 8' (2.4 m). Museo del Palazzo dei Conservatori, Rome

two men in elaborate military dress, with flat Pannonian caps and bird-headed sword hilts. The figures are locked in a close embrace, and they are all but indistinguishable from one another (except that in each group, one is bearded, the other close-shaven). Their proportions are squat and unnaturalistic, their facial features abstract rather than individualized. The portraits suggest that authority resides in the office of emperor, not in the individual who holds the office. The sameness of the portraits underlines the tetrarchs' equality, while their embrace stresses unanimity and solidarity. The choice of material speaks volumes too: Porphyry, a hard Egyptian stone of deep purple color, had long been reserved for imperial portraits.

In the early fourth century, with the gradual dissolution of the tetrarchy, Constantine the Great rose to power, overcoming his chief rival, Maxentius, at the battle of Milvian Bridge in Rome in 312. The colossal head of figure **7.61** is one fragment of a vast seated portrait that once occupied an apse in a huge basilica (see figs. 7.68 and 7.69). The head alone is 8 feet tall, and the dominant feature of the face is the eyes, which are disproportionately large. Deeply carved, they gaze into a faraway distance; combined with the stiff frontality of the face, they give the image an abstract and iconic quality. Some scholars associate changes like these with a new spirituality in the later Empire, exemplified by Constantine's adherence to Christianity. Perhaps the eyes gaze at something beyond this world; perhaps they are a window to the soul. At the same time, a soft modeling to the cheeks and mouth renders the portrait more naturalistic than its tetrarchic predecessors. Moreover, the full cap of hair, and the absence of a beard, appear to be direct references to Trajan and Augustus, great emperors of the past whose achievements still gave the office its authority.

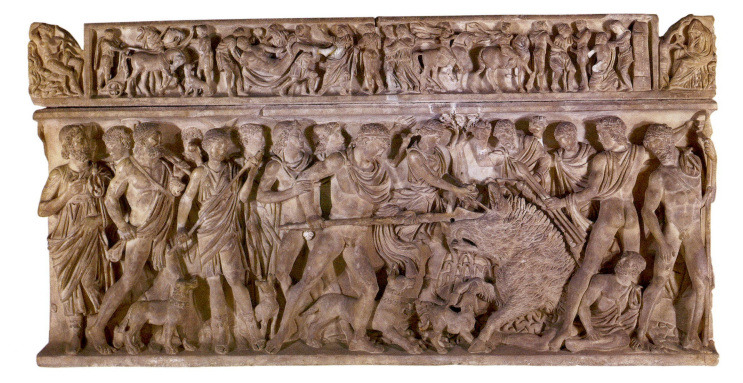

7.62. *Meleager Sarcophagus.* ca. 180 CE. Marble. Galleria Doria Pamphili, Rome

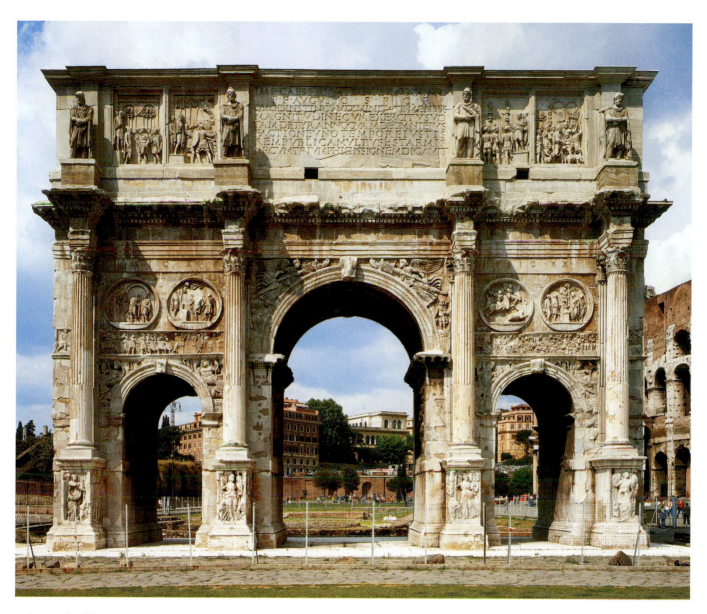

7.63. Arch of Constantine, Rome. 312–315 CE.

Relief Sculpture

The second century CE witnessed a shift in funerary custom among Romans. Inhumation gradually took the place of cremation for all but the imperial family, who continued to be cremated. This led to a greatly increased demand for marble sarcophagi in place of cinerary urns, and they were decorated with a profusion of designs, which were soon passed from shop to shop, probably in pattern books of some kind. Preferences changed over time. For example, under Marcus Aurelius, patrons favored battle sarcophagi. Later, in the third century, biographical and historical scenes preserved aspects of the deceased's life. The most popular scenes were taken from Greek mythology. Their purpose may have been to glorify the deceased through visual analogy to the legendary heroes of the past; they may equally have expressed the owner's erudition. Figure **7.62** illustrates a moment from the myth of Meleager. In Homer's account, Meleager saved Calydon from a ferocious boar, sent by Artemis to ravage his father's land; he then died in a battle over its pelt. Meleager was an example of noble *virtus*, or manly prowess. For his heroism and death in the service of country, he earned immortality. The relief's style owes much to Greek sculpture, but the crowding of the entire surface with figures is entirely Roman.

In 315 CE, the Senate and People of Rome dedicated the triple-bayed Arch of Constantine near the Colosseum to celebrate Constantine's ten-year anniversary and conquest of Maxentius (fig. **7.63**). One of the largest imperial arches, what makes it most unusual is that little of the sculptural relief that covers its

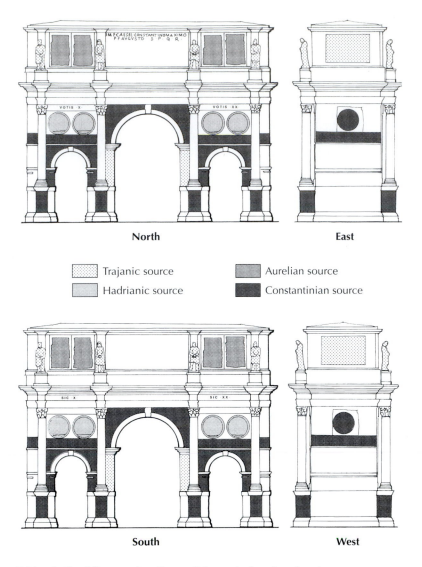

North

East

Trajanic source Aurelian source

Hadrianic source Constantinian source

South

West

7.64. Arch of Constantine, Rome. Schematic drawing showing reused sculpture

surface was designed for this monument (fig. **7.64**). The free-standing Dacian captives on the attic probably originated in Trajan's Forum, as did the Great Trajanic Frieze on the ends of the attic and inside the central bay. Eight hunting and sacrifice tondi above the lateral bays once belonged to a Hadrianic monument, and eight Aurelian panels on the attic may have decorated an arch to Marcus Aurelius. When the Arch was constructed, sculptors recarved the heads of earlier emperors to resemble Constantine and his co-emperor Licinius a modern restoration replaced some of them with heads of Trajan.

Scholars describe sculptural and architectural borrowings of this kind by the modern term **spolia**, derived from the Latin *spolium*, meaning "hide stripped from an animal," a term primarily used for spoils taken in war. No ancient testimony survives to acknowledge or explain the practice, and the spolia raise all manner of questions—such as how Romans perceived the

stripping of one monument in favor of another, and what became of the original monument, presuming that it was still standing. In a renowned assault on Late Antique sculpture in the 1950s, art historian Bernard Berenson condemned the use of spolia as evidence of a pervasive decline in form in Late Antiquity, which he attributed to a mass exodus of craftsmen and artists from a city tottering on the brink of destruction. Other scholars, assuming that Romans recognized style differences as we do, see the spolia as part of a legitimation ideology, suggesting that they expressed the qualities of "emperorness." By leaning on the reputations and successes of "good" rulers of the past, Constantine may have hoped to harness the reputations that they had earned during their lifetimes, as well the nostalgic idealization that had accrued to those reputations through intervening years. Constantine had every reason to legitimize his authority: Maxentius had been a formidable opponent, with

his efforts to reposition Rome at the center of the Empire through a policy of revivalism. Moreover, as the first openly Christian emperor, Constantine risked alienating a pagan Senate. If this interpretation is correct, it is not entirely dissimilar from readings of the Republican statue base, partly made up of Greek reliefs, as seen in figure 7.9.

To complement the borrowed pieces, Constantinian artists carved bases for the columns that flank the bays, a continuous relief to encircle the arch just above the lateral bays, and roundels for the sides of the arch. The scene illustrated here depicts Constantine speaking to the Senate and people of Rome from the speaker's platform or **rostrum** in the Forum, after his entry into Rome in 312 CE (fig. **7.65**). Figures crowd the scene. Their heads are disproportionately large, their bodies stocky, and their poses unnaturally rigid. Lines carved on the flat surface render anatomical details in place of modeling. The artist eschewed the devices used on the Arch of Titus panels to give an illusion of depth; a second row of heads arranged above the first indicates recession (see figs. 7.26 and 7.27). Berenson judged the style of the Constantinian reliefs just as harshly as the act of spoliation. Yet their abstract quality makes them unusually legible from a distance, which is how they would have been seen. A careful order governs the composition, with the emperor occupying the center and shown fully frontal; other figures turn and focus attention on him. Buildings in the background are sufficiently distinct to make the setting recognizable even today as the Roman Forum. The artists chose to privilege the message-bearing potential of the reliefs over any attempt at illusionism or naturalism.

Architecture

By the time of the late Empire, architects in Rome had more or less abandoned the straightforward use of post-and-lintel construction. Their interests appear to have focused instead on exploring the interior spaces that concrete made possible. Column, architrave, and pediment took on decorative roles, superimposed on vaulted brick-and-concrete cores. Imperial bath buildings demonstrate this well. By the beginning of the third century CE, public baths were a long-established tradition in Roman life. Emperors had routinely embellished the city with baths as an act of benefaction. Romans who did not have private baths within their own homes expected to bathe publicly most days, but the baths served other functions as well. They became a place of social interaction, where business might be conducted and the wealthy might flaunt their troops of slaves. The Baths of Caracalla, built between 211

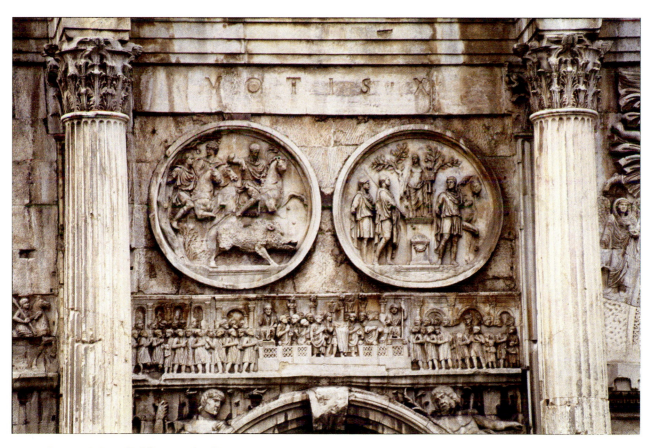

7.65. Constantinian relief from Arch of Constantine, Rome

7.66. Baths of Caracalla, Rome, ca. 211–216 CE

and 216 CE, were the most extensive and lavish of their kind (figs. **7.66** and **7.67**). Set within a rectangular perimeter wall, they included the essentials for bathing facilities: a cold room (*frigidarium*), a circular hot room (*caldarium*), and a warm room (*tepidarium*), as well as a vast swimming pool (*natatio*), changing rooms, and exercise areas (*palaestra*). Lecture halls, libraries, and temples made for a multifaceted experience within its walls. By the time of the construction of Caracalla's baths, the general layout of a bath complex had become standardized. So had the technology necessary to heat the warm

rooms. Their floors were raised above the ground on brick piers, and hot air was directed from a furnace into the open space between. This is known as a *hypocaust* system. All the same, the sheer scale of Caracalla's complex must have been astounding: The principal block measured an immense 656 feet (220 m) by 374 feet (114 m). The largest room, the frigidarium, was roofed with three vast groin vaults. Luscious marble panels revetted the walls, and sculptures set in alcoves animated the halls.

The design was influential. When Maxentius commissioned a vast basilica for the center of Rome, the architects looked to the massive uninterrupted spaces of the bath buildings for inspiration. Basilicas (from the Greek *basileus*, meaning "king") had a long history in Rome. Since the Republic, they had served as civic halls, and they soon became a standard feature of Roman towns. One of their chief functions was to provide a dignified setting for the courts of law that dispensed justice in the name of the emperor. Vitruvius prescribed principles for their placement and proportions, but in practice they never conformed to a single type and varied from region to region. The Basilica of Maxentius (figs. **7.68** and **7.69**) was built on an even grander scale than the Baths of Caracalla and was probably the largest roofed interior in Rome. It was divided into three aisles, of which only the north one still stands. Transverse barrel vaults covered the lateral aisles, and the wider, taller central aisle was covered with three massive groin vaults. Since a groin vault, like a canopy,

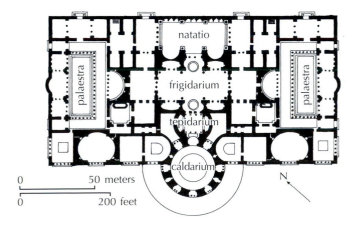

7.67. Plan of Baths of Caracalla, Rome. ca. 211–216 CE

has its weight and thrust concentrated at the four corners (see fig. 7.3), the upper walls of the nave could be pierced by a large clerestory. As a result, the interior of the basilica must have had a light and airy quality despite its enormous size. The building had two entrances: through a transverse vestibule at the east end, and through a stepped doorway on the south, leading from the Roman Forum. Apses faced each of the entrances. On overcoming Maxentius, Constantine

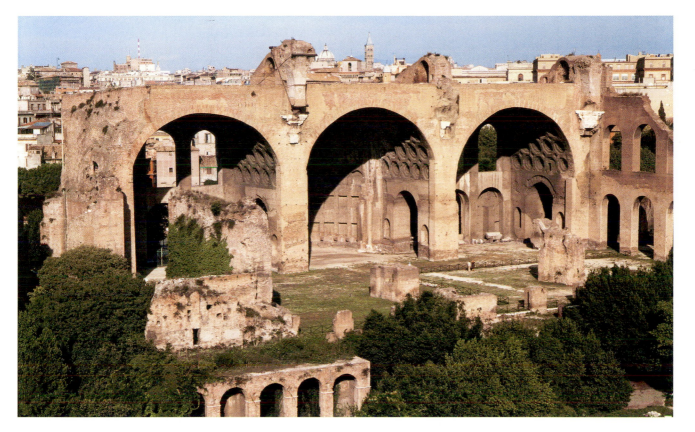

7.68. Basilica of Maxentius, renamed Basilica of Constantine. ca. 307 CE. Rome

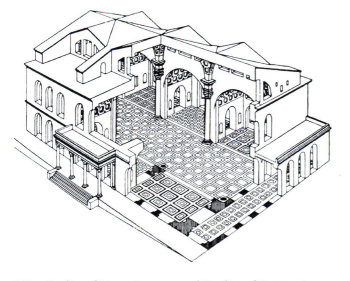

7.69. Basilica of Maxentius, renamed Basilica of Constantine. Reconstruction (after Huelsen)

expropriated the basilica, giving it his own name and placing his colossal portrait in the western apse (see fig. 7.61). Expropriations of this kind were not uncommon in Rome, and show how critical it was to have a physical presence in the city.

LATE ROMAN ARCHITECTURE IN THE PROVINCES

By the early second century, Roman emperors were no longer exclusively from Italy; Trajan came from Spain and Septimius Severus was from North Africa. Both emperors embellished their native cities with new construction. Severus' home, Lepcis Magna, in present-day Libya, remains remarkably well preserved. The emperor was responsible for a grand new forum there, and a magnificent basilica with a long central aisle closed by an apse at either end (fig. **7.70**).

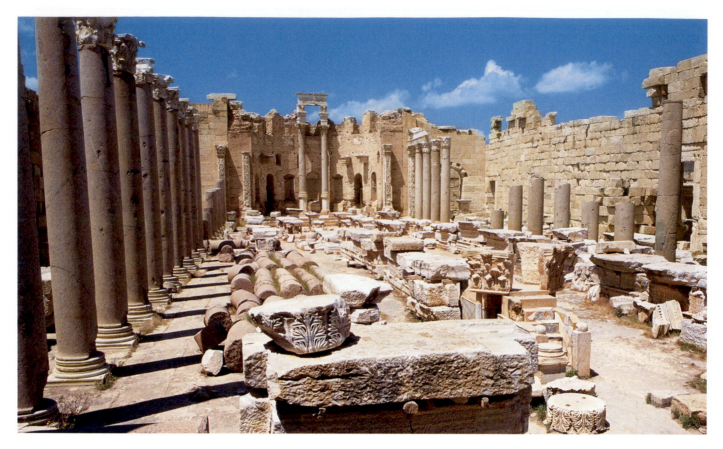

7.70. Basilica, Lepcis Magna, Libya. Early 3rd century CE

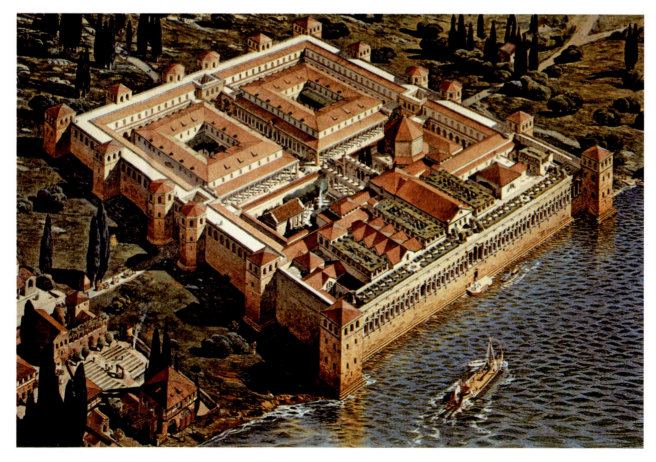

7.71. Palace of Diocletian, Spalato, Croatia. ca. 300 CE

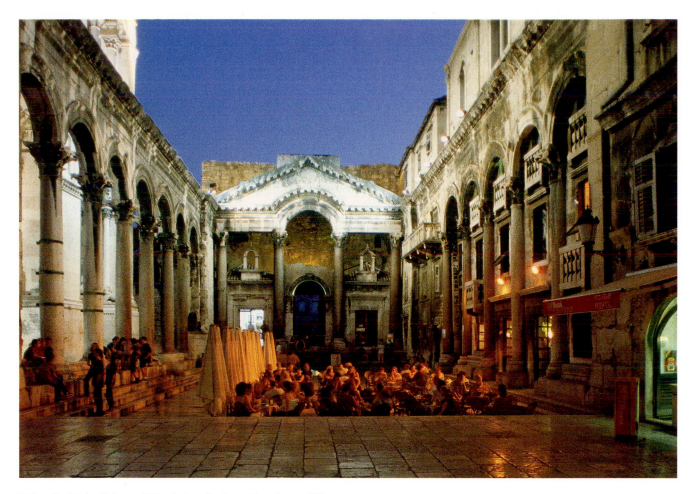

7.72. Peristyle, Palace of Diocletian, Spalato, Croatia. ca. 300 CE

Colonnades in two stories provide access to the side aisles, which were lower than the nave to permit clerestory windows in the upper part of the wall. The wooden ceiling has long since perished.

Developments in Roman architecture after Diocletian came to power appear to go hand-in-hand with the profound changes he made to society. Nowhere is this more obvious than in his palace at Spalato (in Croatia) overlooking the Adriatic Sea, built for his abdication in 305 CE (figs. **7.71** and **7.72**). Although intended as a residence, it is essentially a military fort, with defensive walls, gates, and towers. As in a military camp, two intersecting colonnaded streets stretched between the gates and divided the rectangular space enclosed within the walls, measuring about 650 by 500 feet (198 by 152 m), into four major blocks. The street from the main gate led to a sunken peristyle court. Columns on two sides support arcuated lintels, used only sporadically since the early Empire and popular in Late Antiquity. They direct a visitor's gaze to the far end of the court, where a frame is achieved between the two central columns by setting an arcuated lintel within a pediment. It was here that the former emperor made his public appearances. Behind this grand entrance was a vestibule, opening on to the audience hall. To the left of the peristyle court was a large octagonal mausoleum, now used as a cathedral. Loosely based upon the Pantheon (see figs. 7.39 to 7.43), this type of imperial mausoleum would be one of the prototypes for Christian martyria, burial places of martyred saints. To the right of the court was a small temple dedicated to Jupiter, Diocletian's patron god. The topographical relationship between mausoleum and temple implied an equivalency between emperor and god.

When Diocletian divided authority between the tetrarchs, each of them established a capital in a different region of the empire and embellished it with appropriate grandeur. Constantius Chlorus, father of Constantine the Great, made his seat

ART IN TIME

ca 300 CE—Diocletian builds his palace in
Spalato (Croatia)
early fourth century CE—Constantius Chlorus constructs a basilica
in Trier, Germany

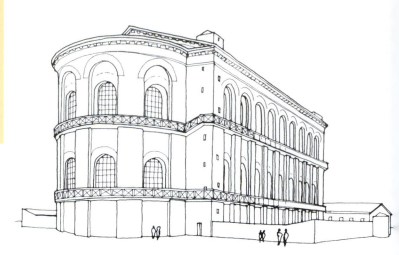

7.73. Basilica of Constantius Chlorus, Trier, Germany.
Early 4th century CE

at Trier, in present-day Germany. There he, too, constructed a basilica, which now functions as a church (figs. **7.73** and **7.74**). In its design, the Classical forms have dissolved entirely, leaving vast abstract expanses in both solid and void. The great mass of its walls is broken by elongated arches, serving now as visual buttresses framing the windows, beneath which were balconies. As vast as the interior was, the architect directed his skill toward achieving the illusion of even greater dimensions. The windows in the apse are significantly smaller than those in the side walls, and the apse ceiling is lower than the ceiling over the main hall. Both devices give the appearance that the apse recedes much farther into the distance than it actually does. Not only did this make the building appear grander, but the apse was where the emperor—or his image—would hold sway, and the altered dimensions would have had the effect of making him appear significantly larger than life. The vocabulary of Roman building had changed, in other words, but it was still an architecture of power.

During the course of about a millennium, Rome grew from a small city to the capital of a massive, culturally diverse empire. Those years witnessed huge developments in architecture, due as much to changes in technology as to political motivations. Post-and-lintel construction combined with the free forms made possible by concrete, and then dissolved in favor of new abstract concepts of space. In the provinces, architecture brought some improvements in standards of living, but it also helped to secure Roman control, exerting a constant Roman presence far from the center of administration. Sculpture and painting abounded within public and private buildings. Often sculpture carried a strong political message, its style chosen to best reinforce its content. As with architecture, an abstract style came to dominate sculpture in late antiquity, due perhaps to an increased spirituality and to a change in concepts of rulership. A wealth of surviving houses and paintings reveals that art played a powerful role in the home as well as in more public places, projecting an image of its patron for others to see.

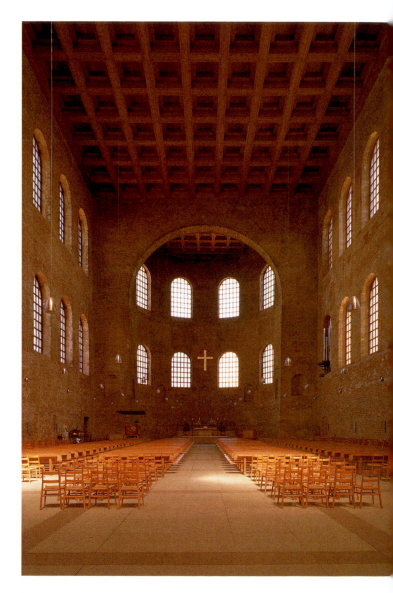

7.74. Interior of Basilica of Constantius Chlorus, Trier, Germany.
Early 4th century CE

SUMMARY

During the course of about a millennium, Rome grew from a small city to the capital of a massive and culturally diverse empire. Those years witnessed major developments in architecture, due as much to changes in technology as to political motivations. In the provinces, architecture brought some improvements in standards of living, but also helped to secure Roman control, exerting a constant Roman presence far from the center of administration. Painting and sculpture abounded within public and private buildings—sculpture often carrying a strong political message, its style chosen to best reinforce its content.

THE REPUBLIC

Roman builders were indebted to Greek predecessors, especially in the use of the Doric, Ionic, and Corinthian styles. Roman architects, however, used forms—such as the arch—that made their buildings decisively Roman. The use of concrete as a building material was exploited fully by the Romans, and its use allowed them to create remarkably open interior spaces, as seen in the Porticus Aemilia. Political leaders also used architecture, as well as sculpture, to express and justify their power and to commemorate specific events.

THE EARLY EMPIRE

During the age of Augustus, Roman portrait sculpture turned from the earlier veristic style of the Republic to a more classicizing style associated with ancient Greece. Augustus was portrayed as an ageless youth throughout his reign, and later emperors Trajan and Hadrian continued this stylistic tradition. The practice of commissioning narrative reliefs to record specific events remained popular, as seen in the Ara Pacis and the Column of Trajan. Early imperial masterpieces of concrete construction include the Colosseum and the Pantheon, both in Rome.

ART AND ARCHITECTURE IN THE PROVINCES

As ancient Rome's authority spread over a wide geographical reach, it had a great impact on the art, architecture, and daily life of those regions. Roman rule brought practical benefits, such as aqueducts to move water. It also introduced a way of life that included frequent public entertainments and Roman religious practices, both of which are reflected in the theaters, amphitheaters, and temples constructed from one end of the Empire to the other.

DOMESTIC ART AND ARCHITECTURE

When the eruption of Mt. Vesuvius buried the cities of Pompeii and Herculaneum, it also preserved a wealth of houses, wall paintings, mosaics, and everyday objects. This invaluable legacy reveals that art played a powerful role in the home as well as in more public places, projecting an image of its patron for others to see. Roman houses also survive in places as far afield as Morocco and Jordan as well as in Ostia, Italy.

THE LATE EMPIRE

Not long after the death of Marcus Aurelius, the Roman Empire entered a period of instability that lasted almost 100 years, until the reign of the emperor Diocletian. In late antiquity, an abstract style came to dominate Roman architecture and sculpture, possibly due to an increased interest in spirituality, and to changing concepts of rulership. An example of this change is a porphyry statuary group representing the four emperors of the Tetrarchy, now in Venice.

LATE ROMAN ARCHITECTURE IN THE PROVINCES

Some rulers who reigned during the later years of the Roman Empire were born or lived outside Italy. Septimius Severus, who came from Lepcis Magna in Libya, embellished his native city with new structures, and Diocletian built a fortified palace at Spalato in Croatia. During the Tetrarchy, the four emperors ruled the Empire from four capitals outside of Rome, and they furnished these cities with new public buildings, such as Constantius Chlorus' basilica in Trier, Germany.

The Code of Hammurabi

Epilogue
Hammurabi, the Protecting King Am I.

I have not withdrawn myself from the men, whom Bel gave to me, the rule over whom Marduk gave to me, I was not negligent, but I made them a peaceful abiding-place. I expounded all great difficulties, I made the light shine upon them. With the mighty weapons which Zamama and Ishtar entrusted to me, with the keen vision with which Ea endowed me, with the wisdom that Marduk gave me, I have uprooted the enemy above and below (in north and south), subdued the earth, brought prosperity to the land, guaranteed security to the inhabitants in their homes; a disturber was not permitted.

The great gods have called me, I am the salvation-bearing shepherd, whose staff is straight, the good shadow that is spread over my city; on my breast I cherish the inhabitants of the land of Sumer and Akkad; in my shelter I have let them repose in peace; in my deep wisdom have I enclosed them. That the strong might not injure the weak, in order to protect the widows and orphans, I have in Babylon the city where Anu and Bel raise high their head, in E-Sagil, the Temple, whose foundations stand firm as heaven and earth, in order to declare justice in the land, to settle all disputes, and heal all injuries, set up these my precious words, written upon my memorial stone, before the image of me, as king of righteousness.

The king who rules among the kings of the cities am I. My words are well considered; there is no wisdom like mine. By the command of Shamash, the great judge of heaven and earth, let righteousness go forth in the land: by the order of Marduk, my lord, let no destruction befall my monument. In E-Sagil, which I love, let my name be ever repeated; let the oppressed, who have a case at law, come and stand before this my image as king of righteousness; let him read the inscription, and understand my precious words: the inscription will explain his case to him; he will find out what is just, and his heart will be glad, so that he will say: . . .

SOURCE: *WORLD CIVILIZATIONS ONLINE CLASSROOM,* "THE CODE OF HAMMURABI." TR. LW KING, 1910, ED. RICHARD HOOKER, 1996, WWW.WSU.EDU:8080/~DEE

A Hymn to Aten

This text was inscribed on a tomb in Amarna, the capital established by Ahkenaten. It gives voice to the character of Ahkenaten's belief in the Aten (disk) of the sun. This is the opening stanza.

> Earth brightens when you dawn in lightland,
> When you shine as Aten of daytime;
> As you dispel the dark,
> As you cast your rays,
> The Two Lands are in festivity.

> Awake they stand on their feet,
> You have roused them;
> Bodies cleansed, clothed,
> The arms adore your appearance.
> The entire land sets out to work,
> All beasts browse on their herbs;
> Trees, herbs are sprouting,
> Birds fly from their nests.
> Their wings greeting your *ka*.
> All flocks frisk on their feet,
> All that fly up and alight,
> They lived when you dawn for them,
> Ships fare north, fare south as well,
> Roads lie open when you rise;
> The fish in the river dart before you,
> Your rays are in the midst of the sea.

SOURCE: AMELIE KUHRT *THE ANCIENT NEAR EAST,* VOL. I. (LONDON: ROUTLEDGE, 1995)

Pliny the Elder (23–79 CE)

Natural History

The earliest preserved history of art appears in the work of the Roman naturalist and historian Pliny, who lived at the beginning of the Roman Imperial period and died in the eruption of Mount Vesuvius that destroyed Pompeii. Pliny says nothing about vase painting. For him the great era of painting began in the fifth century BCE, and its high point came in the fourth century BCE. Pliny lists the names and works of many artists who are otherwise unknown today. His anecdotes reveal the primacy placed on illusionism by Greeks and Romans. Pliny's work influenced Renaissance writers of art history, including Ghiberti and Vasari.

from Book 35 (on Greek painting)

The origin of painting is obscure. . . . All, however, agree that painting began with the outlining of a man's shadow; this was the first stage, in the second a single colour was employed, and after the discovery of more elaborate methods this style, which is still in vogue, received the name of monochrome. . . .

Four colours only—white from Melos, Attic yellow, red from Sinope on the Black Sea, and the black called "atramentum"—were used by Apelles, Action, Melanthios and Nikomachos in their . . . works; illustrious artists, a single one of whose pictures the wealth of a city could hardly suffice to buy. . . .

Apollodoros of Athens [in 408–405 BCE] was the first to give his figures the appearance of reality. [He] opened the gates of art through which Zeuxis of Herakleia passed [in 397 BCE]. The story runs that Parrhasios and Zeuxis entered into competition, Zeuxis exhibiting a picture of some grapes, so true to nature that the birds flew up to the wall of the stage. Parrhasios then displayed a picture of a linen curtain,

realistic to such a degree that Zeuxis, elated by the verdict of the birds, cried out that now at last his rival must draw the curtain and show his picture. On discovering his mistake he surrendered the prize to Parrhasios, admitting candidly that he had deceived the birds, while Parrhasios had deluded himself, a painter. . . .

Apelles of Kos [in 332–329 BCE] excelled all painters who came before or after him. He of himself perhaps contributed more to painting than all the others together; he also wrote treatises on his theory of art. . . .

Nikomachos' . . . pupils were his brother Ariston, his son Aristeides and Philoxenos of Eretria, who painted for king Kassander the battle between Alexander and Dareios, a picture second to none [compare fig. 5.79].

from Book 34 (on bronze)

Besides his Olympian Zeus, a work which has no rival, Pheidias made in ivory the Athena at Athens, which stands erect in the Parthenon. . . . He is rightly held to have first revealed the capabilities of sculpture and indicated its methods.

Polykleitos . . . made an athlete binding the diadem about his head, which was famous for the sum of one hundred talents which it realized. This . . . has been described as "a man, yet a boy": the . . . spear-bearer [see fig. 5.33] as "a boy, yet a man." He also made the statue which sculptors call the "canon," referring to it as to a standard from which they can learn the first rules of their art. He is the only man who is held to have embodied the principles of his art in a single work. . . . He is considered to have brought the scientific knowledge of statuary to perfection, and to have systematized the art of which Pheidias had revealed the possibilities. It was his peculiar characteristic to represent his figures resting their weight on one leg; . . .

Myron . . . [made an] athlete hurling the disk [see fig. 5.32], a Perseus, . . . and the Herakles which is near the great Circus in the temple of the great Pompeius. . . . He was more productive than Polykleitos, and a more diligent observer of symmetry. Still he too only cared for the physical form, and did not express the sensations of the mind. . . .

Lysippos produced more works than any other artist, possessing, as I have said, a most prolific genius. Among them is the man scraping himself [see fig. 5.62]. . . . In this statue the Emperor Tiberius took a marvelous delight, . . . he could not refrain from having the statue removed into his private chamber, substituting another in its place. . . . His chief contributions to the art of sculpture are said to consist in his vivid rendering of the hair, in making the heads smaller than older artists had done, and the bodies slimmer and with less flesh, thus increasing the apparent height of his figures. There is no word in Latin for the canon of symmetry which he was so careful to preserve, bringing innovations which had never been thought of before into the square canon of the older artists, and he often said that the difference between himself and them was that they represented men as they were, and he as they appeared to be. His chief characteristic is extreme delicacy of execution even in the smallest details.

from Book 36 (on marble)

The art of [marble] sculpture is much older than that of painting or of bronze statuary, both of which began with Pheidias. . . .

Praxiteles . . . outdid even himself by the fame of his works in marble. . . . Famous . . . throughout the whole world, is the Aphrodite which multitudes have sailed to Knidos to look upon [see fig. 5.60]. He had offered two statues of Aphrodite for sale at the same time, the second being a draped figure, which for that reason was preferred by the people of Kos with whom lay the first choice; the price of the two figures was the same, but they flattered themselves they were giving proof of a severe modesty. The rejected statue, which was bought by the people of Knidos, enjoys an immeasurably greater reputation. King Nikomedes subsequently wished to buy it from them, offering to discharge the whole of their public debt, which was enormous. They, however, preferred to suffer the worst that could befall, and they showed their wisdom, for by this statue Praxiteles made Knidos illustrious. . . .

Bryaxis, Timotheos, and Leochares were rivals and contemporaries of Skopas, and must be mentioned with him, as they worked together on the Mausoleion [fig. 5.56]. This is the tomb erected by Artemisia in honour of her husband Mausolos, . . . and its place among the seven wonders of the world is largely due to these great sculptors. The length of the south and north sides is 163 feet; the two facades are shorter, and the whole perimeter is 440 feet; its height is 25 cubits [37 $\frac{1}{2}$ feet], and it has thirty-six columns. . . . The sculptures of the eastern front are carved by Skopas, those on the north by Bryaxis, on the south by Timotheos, and on the west by Leochares. . . . Above the colonnade is a pyramid, of the same height as the lower structure, consisting of twenty-four retreating steps rising into a cone. On the apex stands a chariot and four horses in marble made by Pythis. . . .

SOURCE: *THE ELDER PLINY'S CHAPTERS ON THE HISTORY OF ART.* TR. K. JEX-BLAKE. (LONDON, NY: MACMILLAN, 1896)

Vergil (70–19 BCE)

The Aeneid, from Book II

Vergil was among the greatest Latin poets and the chief exponent of the Augustan age in literature. The Aeneid is an epic poem about the hero Aeneas, who fled Troy when it was destroyed by the Greeks and settled in Italy. Book II tells of the fall of Troy, including the punishment by Minerva of Laocoön for trying to warn the Trojans against the trick wooden horse. The sculptural rendition of Laocoön shown in The Art Historian's Lens, *page 179, closely resembles Vergil's description.*

Laocoön, by lot named priest of Neptune,
was sacrificing then a giant bull
upon the customary altars, when
two snakes with endless coils, from Tenedos
strike out across the tranquil deep. . . .

They lick their hissing jaws with quivering tongues.
We scatter at the sight, our blood is gone.
They strike a straight line toward Laocoön.
At first each snake entwines the tiny bodies
of his two sons in an embrace, then feasts
its fangs on their defenseless limbs. The pair
next seize upon Laocoön himself,
who nears to help his sons, carrying weapons.
They wind around his waist and twice around
his throat. They throttle him with scaly backs;
their heads and steep necks tower over him.
He struggles with his hands to rip their knots,
his headbands soaked in filth and in dark venom,
while he lifts high his hideous cries to heaven,
just like the bellows of a wounded bull.

SOURCE: *THE AENEID OF VIRGIL*. TR. ALLEN MANDLEBAUNI. (NY: BANTAM BOOKS, A DIVISION OF RANDOM HOUSE INC., 1971)

Vitruvius (1st Century BCE)

On Architecture

Vitruvius, like Pliny, was a Roman writer who admired the achievements of the Greeks. He was an architect under Julius Caesar and Augustus, and his treatise on architecture (ca. 35–25 BCE) reflects the classicizing taste of his time. Vitruvius' work was a principal source for Renaissance architects seeking the revival of antiquity. His account of the origin of the Greek Styles is partly mythic, partly rational conjecture. His suggestions for appropriate domestic spaces for people of different professions and status have helped scholars reconstruct the rituals of Roman life.

Book 6, Chapter 5: Correctness (Decor)

Once these things have been set out with regard to the regions of the heavens, then it is time to note also by what principles the personal areas of private buildings should be constructed for the head of the family and how public areas should be constructed with outsiders in mind as well. Personal areas are those into which there is no possibility of entrance except by invitation, like cubicula, triclinia, baths and the other rooms that have such functions. Public areas are those into which even uninvited members of the public may also come by right, that is, vestibules, cavaedia, peristyles, and any rooms that may perform this sort of function.

And so, for those of moderate income, magnificent vestibules, tablina, and atria are unnecessary, because they perform their duties by making the rounds visiting others, rather than having others make the rounds visiting them. ... for moneylenders and tax collectors public rooms should be more commodious, better looking, and well secured, but for lawyers and orators they should be more elegant, and spacious enough to accommodate meetings. For the most prominent citizens, those who should carry out their duties to the citizenry by holding honorific titles and magistracies, vestibules should be constructed that are lofty and lordly, the atria and peristyles at their most spacious, lush gardens and broad walkways refined as properly befits their dignity.

Book 4, Chapter 1: The Discovery of Symmetries

[Greeks in Ionia] decided to build a temple for Panionian Apollo like the ones they had seen in Achaea, and they called this temple "Doric" because they had first seen a temple of this type in the cities of the Dorians.

6. When they had decided to set up columns in this temple, lacking symmetries for them, and seeking principles by which they might make these columns suitable for bearing loads yet properly attractive to behold, they measured a man's footprint and compared it with his height. When they discovered that for a man, the foot is one-sixth of his height, they applied this ratio to the column, and whatever diameter they selected for the base of the column shaft, they carried its shaft, including the capital, to a height six times that amount. Thus the Doric column came to exhibit the proportion, soundness, and attractiveness of the male body.

7. After this, the Ionians also built a temple to Diana, seeking a new type of appearance, they applied the same ratio based on footprints to a woman's slenderness, and began making the diameter of the columns measure one-eighth their height, so that their appearance would be more lofty. Instead of a shoe, they put a spira underneath as a base, and for the capital, as if for hair, they draped volutes on either side like curled locks. The front they adorned with moldings and festoons arranged in the place of tresses, and they let flutes down the whole trunk of the column to mimic, in matronly manner, the folds of a stola. Thus they derived the invention of columns from two sets of criteria: one manly, without ornament, and plain in appearance, the other of womanly slenderness, ornament, and proportion.

8. Later generations, more advanced in the elegance and subtlety of their aesthetic judgment, who delighted in more attenuated proportions, established that the height of the Doric column should be seven times the measure of its diameter, and the Ionic column should be nine times the width. For that type of column is called Ionic, because it was first made by the Ionians.

Discovery of Corinthian Symmetries

Now the third type, which is called Corinthian, imitates the slenderness of a young girl, because young girls, on account of the tenderness of their age, can be seen to have even more slender limbs and obtain even more charming effects when they adorn themselves. 9. It is said that the invention of this type of capital occurred in the following manner. A young Corinthian girl of citizen rank, already of marriageable age, was struck down by disease and passed away. After her burial, her nurse collected the few little things in which the girl

had delighted during her life, and gathering them all in a basket, placed this basket on top of the grave. So that the offering might last there a little longer, she covered the basket with a roof tile.

This basket, supposedly, happened to have been put down on top on an acanthus root. By springtime, therefore, the acanthus root, which had been pressed down in the middle all the while by the weight of the basket, began to send out leaves and tendrils, and its tendrils, as they grew up along the sides of the basket, turned outward, when they met the obstacle of the corners of the roof tile, first they began to curl over at the ends and finally they were induced to create coils at the edges.

Book 4, Chapter 2: Architectural Ornament

The craftsmen of old, ... placed joists that protruded from the interior walls to the outer edges [of the buildings]. ... Subsequently they decided that these projecting joists should be cut off where they protruded beyond the plane of the walls, and because the result looked unattractive to them, they fitted plaques in front of the cuttings, which were shaped as triglyphs are made today, and they painted these with blue wax so that the cut ends of the joists would not offend the viewer.

And thus the covered sections of the joists in Doric works began to take on the arrangement of the triglyphs and, between the joists, the metopes.

3. Afterward various architects in various other buildings extended the projecting beams perpendicular to the triglyphs and leveled off the projections. From this, just as triglyphs derived from the arrangement of beams, so from the projection of the rafters the principle of mutules beneath the cornice was discovered. This is generally what happens in stone and marble works, in which the mutules are reshaped by slanted cutting, because they are an imitation of the rafters. ... Thus, for Doric works the principle underlying the triglyphs and mutules was derived from these imitations.

SOURCE: VITRIVIUS: TEN BOOKS ON ARCHITECTURE. TR. INGRID D. ROWLAND; COMMENTARY THOMAS NOBLE HOWE. (NY: CAMBRIDGE UNIVERSITY PRESS, 1999)